The Maori Collections of the British Museum

The Maori Collections of the British Museum

Dorota C. Starzecka, Roger Neich,
Mick Pendergrast

THE BRITISH MUSEUM PRESS

© 2010 The Trustees of the British Museum

Dorota Starzecka, Roger Neich and Mick Pendergrast have asserted
their right to be identified as the authors of this work.

Published in 2010 by The British Museum Press
A division of The British Museum Company Ltd
38 Russell Square, London WC1B 3QQ

www.britishmuseum.org

A catalogue record for this book is available from the British Library

ISBN 978-0-7141-2594-7

Editing and project management by Sean Kingston Publishing Services

Printed and bound in Hong Kong by Printing Express

The product group used in this book is sourced from well-managed
forests, controlled sources and recycled wood or fibre. The
manufacturing processes conform to the environmental regulations of
the country of origin.

Contents

Preface

Aotearoa–New Zealand was one of the last places on earth to be settled by humans, about 900 years ago. Using celestial navigation techniques, the first inhabitants of Aotearoa arrived from islands to the north-east. They were to create one of the most dynamic and resilient Polynesian cultures in the vast Pacific region.

Maori people most closely identify with tribal descent groups, each associated with a particular area of land. Within each group, talented individuals may be trained in particular areas of expertise. In the past the role of canoe carver was one of the most prestigious. Large projects took place under the patronage of a chief, and it was the support of leaders and the tribal collective that enabled skill and creativity to flourish and distinctively Maori art forms to emerge in the centuries following settlement.

Maori artistic creations, like other precious resources and possessions, are referred to as taonga. They are considered to have a life force of their own and are revered as ancestral manifestations, with genealogical connections to their present-day descendants. Taonga are an expression of relationships with the gods, with ancestors, with tribal lands, and with each other.

The strength of this catalogue is the opportunity it presents for the reinvigoration and establishment of relationships. As a comprehensive, historic study of the British Museum's Maori collection supported by meticulous archival research, it reveals names of makers, tribal owners, collectors and traders, tracing the history of specific taonga following their departure from Aotearoa. Drawing on the expertise of the authors in specific Maori art forms, with additional comments by David Simmons, tribal attributions are offered for many taonga which in many cases previously had the simple annotation 'New Zealand'.

A great proportion of the taonga in the collection moved through a tumultuous and rapidly changing landscape. The nineteenth century included periods of war and dramatic political upheaval brought about by colonization, leading to large-scale movement of people and objects. Some objects now in the Museum's collections were part of exchanges made between Maori and the British, and represent a desire on the part of the Maori to forge alliances and to draw these powerful foreigners into relationships bound by reciprocal obligation and mutual respect, as practised within Maori culture. Maori artists adapted quickly to new conditions: carvers became proficient in the use of metal tools and experimented with new, dynamic forms, while other imported materials such as coloured wool were incorporated in completely new ways into woven garments.

Today Maori art is being produced in a dazzling range of media, and expresses many bold and nuanced ideas about New Zealand cultural and political life, as well as perpetuating ancestral connections with the past and with more traditional art forms. The Museum continues to collect examples of contemporary Maori art, which echo the innovative, adaptive approach of past practitioners, embracing new materials such as perspex and synthetic fibres.

Contemporary objects are also regarded as taonga and, like older material, must be treated in a particular way, particularly when being prepared for display. From the 1990s, and largely due to the efforts of Dorota Starzecka and subsequent curators, the Museum has increasingly engaged with Maori in New Zealand and in the UK, and recognized the integral role of Maori in maintaining the 'warmth' of taonga in a museum context. We thank all who have led and participated in the proper ritual preparation of the taonga for exhibitions including 'Maori' (1998) and 'Power and Taboo: Sacred Objects from the Pacific' (2006), as well as permanent displays such as those in the galleries titled 'Enlightenment' (opened 2003) and 'Living and Dying', where a display focused on the meeting house in Maori society has recently been installed. The Maori collections are amongst the most frequently visited in the Department of Africa, Oceania and the Americas, and we also thank those artists, researchers and community members who have orated and sung to the taonga, and who have generously offered their expertise and supported the Museum's efforts to accurately represent Maori culture from afar.

The museum is greatly indebted to Dorota Starzecka, former Assistant Keeper of Oceania, and New Zealand scholars Roger Neich and Mick Pendergrast for this publication. They have worked over many years, often in collaboration with Maori colleagues, to increase the body of knowledge associated with the Maori collection, and to produce a catalogue which makes this available to the public. An exploration of particular aspects of Maori material culture accompanies each section, providing context and enabling the reader to appreciate the unique aspects of the collection. It is the most exhaustive and thoroughly researched account of the British Museum's collection of taonga Maori to date, and will long remain the authoritative reference volume on this material.

Neil MacGregor
Director, British Museum

Foreword and acknowledgements

This catalogue is the final result of the long-term research project on the British Museum's Maori collections, and reflects close cooperation between the Museum staff and New Zealand scholars. The high point of the project was 'Maori: Art and Culture', a major exhibition held in the British Museum in 1998. In the foreword to the book of the same name accompanying the exhibition (1996, second edition 1998), a promise was made that in a few years' time the results of this project would be published 'as a definitive catalogue of the British Museum's Maori collections' which would be 'a valuable source of information for anybody interested in Maori culture, but most of all for the Maori people themselves who will know exactly what taonga [treasures] there are in the British Museum and what is known about them'. The publication of this catalogue is the fulfilment of this promise.

Records of the British Museum's Maori collections are available on the Museum's database. These records are always a work in progress as new information is added to them. This catalogue, on the other hand, contains all the information about the objects known to the authors at the time of writing (it does not include, however, unworked bones, ventifacts or material acquired since 2000). Nevertheless, the catalogue does not aspire to be the last word on these collections. There is still a great deal of further research to be done, for example on the Cook Collection, the material acquired from the United Services Institution or the Wellcome Collection, and we would welcome any comments, corrections or additional information about the material contained in the catalogue. We hope the catalogue will be useful to museum curators and, most of all, to Maori people themselves, for it will answer questions so often asked by them about the Museum's Maori taonga.

Throughout the work on the catalogue we enjoyed the constant interest and unflagging support of Jonathan King, former Keeper of the British Museum's Department of Africa, Oceania and the Americas (2004–10), and of its Head of the Oceanic collections, Lissant Bolton, for which we owe them our profound thanks. Our thanks go also to the staff of the Museum's Centre for Anthropology Library for their cheerful help in tracing references, to Jim Hamill and Sovati Louden-Smith for help with Departmental Archives, to Harry Persaud of the Department's Pictorial collections for his help in solving computer problems, and to Michael Row of the Photographic Service for persevering with this project. Our very special heart-felt thanks go to Jill Hasell, Curatorial Assistant of the Oceanic section, whose extremely helpful comments and suggestions helped us so often and who had done a great deal of preparatory work on the catalogue. Our thanks are also due to Marjorie Caygill, retired Assistant to the British Museum's Director, for drawing our attention to various old papers in the Museum archives that have a bearing on the Maori collections, and to Stephanie Clarke, British Museum Archivist. We thank Veronica Johnston, retired curator from the Leeds Museum, for her help in solving some problems and assisting with terminology connected with textiles and basketry. The participation of Roger Neich and Mick Pendergrast was generously supported over several years by the Auckland Museum and the British Museum, and the financial assistance from the British Council in Wellington and the New Zealand Tourism Board in London made their study visits to London possible. For his long-term commitment to this project Roger Neich has benefited from the support of a Marsden Research Grant from the Royal Society of New Zealand and his concurrent appointment at the University of Auckland. Thanks are also due to Esther and Jeff Jessop for the hospitality extended to Roger Neich and his wife, and to Mick Pendergrast, during their visits to London.

We are grateful for the permission of Her Majesty Queen Elizabeth II to quote from the Diary of King George V in the Royal Archives at Windsor and for permission to reproduce photographs of objects from the Royal Collection on loan to the British Museum. We thank the Alexander Turnbull Library (National Library of New Zealand) in Wellington for permission to quote extracts from Frederick Huth Meinertzhagen's letters, the Canterbury Museum in Christchurch for permission to quote from the Diaries of Frederick Huth Meinertzhagen, and Steve Lowndes, former Director of the Akaroa Museum, for reading and transcribing these diaries for us. We thank especially Lord Polwarth for making available to us, and for his permission to quote from, the journals of his ancestor, Walter Lorne Campbell, partner in New Zealand of Frederick Huth Meinertzhagen, whose Maori collection is the largest in the British Museum's holdings of Maori material; without these journals our knowledge of Meinertzhagen and his collecting would have been woefully inadequate; we are also grateful to Patrick Parsons of Napier for drawing our attention to the existence and location of these journals.

Finally we thank Teresa Francis at the British Museum Press and our editor Sean Kingston for their encouragement, support and patience.

Geographical map of New Zealand

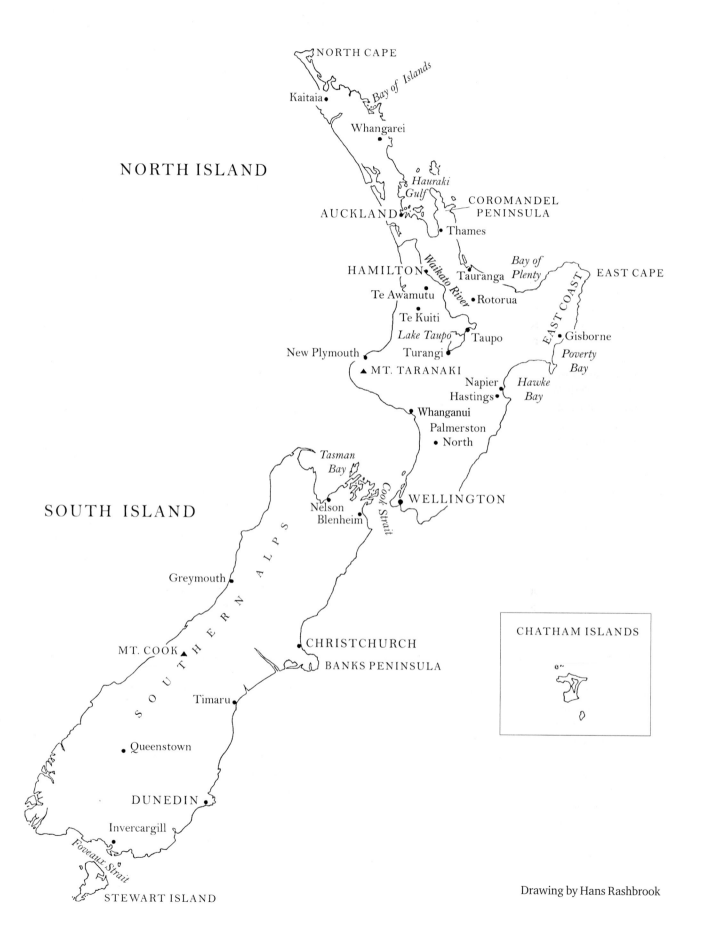

NORTH CAPE

Kaitaia

Bay of Islands

Whangarei

NORTH ISLAND

Hauraki
Gulf

COROMANDEL
PENINSULA

AUCKLAND

Thames

HAMILTON

Waikato River

Tauranga

Bay of
Plenty

EAST CAPE

Te Awamutu

Rotorua

Te Kuiti

Lake Taupo

Taupo

EAST COAST

Gisborne

New Plymouth

Turangi

Poverty
Bay

▲ MT. TARANAKI

Napier

Hastings

Hawke
Bay

Whanganui

Palmerston
North

Tasman
Bay

SOUTH ISLAND

Nelson
Blenheim

Cook Strait

WELLINGTON

Greymouth

SOUTHERN ALPS

CHRISTCHURCH

MT. COOK ▲

BANKS PENINSULA

Timaru

Queenstown

DUNEDIN

Invercargill

Foveaux Strait

STEWART ISLAND

CHATHAM ISLANDS

Drawing by Hans Rashbrook

The study of Maori culture between the British Museum and New Zealand

Introduction

Ever since the time of Captain Cook's visits to New Zealand and the arrival of Maori artefacts back in Great Britain, there has been a special connection in the study of Maori material culture between these two countries, and even more specifically, between the British Museum and New Zealand. Other museums in Great Britain also began to collect Maori artefacts at this early period, but the British Museum became the main pivot between students of Maori material culture in these two countries. For many decades this interest was largely limited to academics and scholars, but some of their books and articles brought certain items within the British Museum Collection to the attention of a wider New Zealand public. Beyond these, there was a vague realization among New Zealanders that a large collection of Maori artefacts was held at the British Museum. Eventually, beginning after the First World War, more complete lists of the British Museum and other Maori collections were brought back to New Zealand by scholars such as H.D. Skinner, followed later by David Simmons and Bernard Kernot in the 1970s, and an increasing number of New Zealanders in the 1980s and 1990s. Unfortunately, however, very little of this information was ever published or made available to students or the interested public. Most recently, Dorota Starzecka of the British Museum has visited New Zealand to give lectures on the British Museum's Maori Collection, to carry out fieldwork and to collect contemporary Maori art, leading up to the British Museum's Maori exhibition of 1998.

Surveying the 816 publications devoted exclusively to Maori art in the years to 1984, Hanson and Hanson (1984) noted that its study has been largely a New Zealand enterprise. Of these works, 74% (607) had been published in New Zealand, and fewer than 6% (46) were published in languages other than English. Gathercole (1979) and Hanson and Hanson (1990) have charted the significance of some of these publications in relation to changing theoretical interests within museums and academia, and to cultural change within Maori society. Through these years, there has been a broad shift from detailed descriptive studies of Maori material culture to studies of Maori art, and then to studies of the contemporary significance of Maori art. Consequently, in more recent times the British Museum Collection has started to play an active cultural role again within Maori and wider New Zealand society. These developments, stimulated by the British Museum's special exhibition, 'Maori: Art and Culture', in 1998, have made the publication of a complete catalogue of the collection even more necessary.

Early English private collectors and dealers

These individuals did not publish on Maori material culture, but they were quite familiar with it through their collecting activities in England. So many Maori artefacts had been brought back to the United Kingdom and Ireland by early explorers, military and administration personnel and missionaries that large numbers were soon circulating in the auction and collectors' scene. Thus, Maori material culture items figured very prominently in the earlier British auction sale catalogues. Most prominent among these knowledgeable British ethnographic collectors were Sir Ashton Lever, Sir Hans Sloane, William Bullock, Augustus Henry Lane Fox Pitt Rivers and Henry Syer Cuming (Waterfield and King 2006). Of the early dealers, George Humphrey (up to 1826) and later Stevens' Auction House accounted for a major portion of the trade in Pacific artefacts. Many Maori items passed through the hands of these people, and some ended up in the British Museum Collection.

Most important among these private collectors by virtue of their later connections with the British Museum were Henry Christy and Augustus Wollaston Franks. When Christy bequeathed his collection to the British Museum in 1865 it is said to have included more than 1,000 ethnographic items, and many Maori pieces were among them. Franks added many more ethnographic items to the Christy Collection, both from his own private collecting activities and then as an employee of the British Museum from 1851 to 1896 (Caygill and Cherry 1997).

Later English private collectors

Among the well-known later English private artefact collectors, several were active in searching out Maori items (see introductory essay in Oldman 2004; Waterfield and King 2006). Of these, some wrote and published articles in periodicals on Maori material culture, most notably James Edge-Partington and Harry Beasley.[1] Along with his friend Charles Heape of Manchester, James Edge-Partington published many Maori items, including some from his own collection and some from the British Museum, in his privately printed series, beginning in 1890, of hand-drawn Pacific artefact studies (Edge-Partington and Heape 1969). Similarly, William Oldman of London, who probably dealt with more Maori objects than any other English dealer, made a significant contribution to the study of Maori material culture with his fully illustrated and annotated Maori collection catalogue, first published in parts by the Polynesian Society commencing in 1935 (Oldman 2004). Also to be included in this group is Major-General Horatio Gordon Robley who, after military duty in New Zealand in 1864–5, continued to collect and write about Maori topics, especially tattoo (Robley 1896)

and Maori nephrite artefacts (Robley 1915). Robley offered his collection for sale to the British Museum of Natural History in 1901, which passed the offer on to the British Museum as a more appropriate place, but the Museum declined to purchase it:

> I have been thinking about your lot of New Zealand things, and I am afraid I cannot do anything with regard to purchase at present. My official funds are exhausted, and the Museum already owes a good deal to my private account, so that both my usual avenues are for the present closed. If you can hold until April something may be done.'
>
> (BM PE correspondence: C.H. Read, 22 October 1901).

The negotiations about the purchase, however, were never reopened.

Other European writers on Maori material culture

Other writers from a variety of institutions in Britain and continental Europe have been active in the study of Maori art and material culture. They had no direct association with the British Museum, but their work has been important in the wider field of Maori studies. An important but little recognized article, in German, on the development of the spiral in Maori art was written by the eminent art historian Alois Riegl (1890), based on his examination of the Andreas Reischek collection of Maori artefacts in Vienna. But we had to wait another 68 years for a comprehensive descriptive catalogue of the Reischek Collection, again in German, by Irmgard Moschner (1958).

Basing his research on early explorers' accounts and museum collections in Britain, Henry Ling Roth, the curator of the Bankfield Museum in Halifax, produced an article on Maori tattoo (Roth 1901). In 1919, at the request of H.D. Skinner of the Otago Museum, Dunedin, Roth prepared a manuscript catalogue of Maori items in the Bankfield Museum for the use of researchers in New Zealand, but it was never published (McDougall and Croft 2005). He went on to publish his major study of Maori textiles (Roth 1979, facsimile reprint of 1923), a pioneering and seminal work in the detailed study of Maori technology. Unique among this group, George Pitt-Rivers (1924 and 1927) actually carried out fieldwork in New Zealand, along the Whanganui River in February 1923, resulting in some observations on the 'passing of the Maori race and the decay of Maori culture' (Pitt-Rivers 1924: 48). Guided by Elsdon Best, the ethnographer of the Dominion Museum, Wellington, he found some of the evidence of this 'decay' in the new 'poorly carved' and 'garish' (Pitt-Rivers 1924: 64) painted bargeboards replacing the fine old carvings that were discarded from the meeting house at Koriniti on the Whanganui River.

In recent times, Peter Gathercole, formerly of the Cambridge and Oxford university museums and the University of Otago in Dunedin, has written extensively on many aspects of Maori material culture, including the collections associated with the voyages of Captain James Cook (Hanson and Hanson 1984: 22 and 97) and, with A. Clarke, a survey of Oceanian collections in the United Kingdom and the Irish Republic (1979).

British Museum personnel

Curators and others serving in the British Museum since the days of Augustus Franks contributed an irregular scatter of articles on Maori artefacts. T.A. Joyce (1906, 1928 and 1936)

and B.A.L. Cranstone (1952) were on the curatorial staff, as was O.M. Dalton who collaborated with Joyce in the writing of the famous *British Museum Handbook to the Ethnographical Collections* (British Museum 1925, originally published 1910) under the direction of Charles Hercules Read, the Keeper of the Department. This handbook included a substantial section on the Maori collections and wider Maori culture. When the unique and puzzling Kaitaia carving was discovered in a North Auckland swamp in 1920, the New Zealand High Commissioner in London sought Joyce's opinion on its authenticity and possible cultural origin, but apparently without obtaining any firm conclusion.[2] Charles Praetorius (1900 and 1901) was associated with the British Museum as a photographer, illustrator and lithographer, and contributed twelve plates of drawings and the bookplate for Edge-Partington's ethnographic album.

Although never officially on the curatorial staff of the Museum, James Edge-Partington as a long-serving volunteer in the Pacific section was the scholar most responsible for developing and researching the Maori collections and retaining an interest in Maori material culture at the British Museum. His research and publications provided the intellectual capital that kept the British Museum up to date on Maori topics during the later nineteenth and early twentieth centuries. As a young man of independent means, James Edge-Partington had travelled widely in Australia and the Pacific Islands between 1879 and 1881, including a total of 86 days in New Zealand. Again in 1897, he travelled the length of New Zealand, establishing contacts with all the leading museum curators and private collectors. In his role at the British Museum, Edge-Partington was especially interested in identifying artefacts collected on Cook's voyages and modern forgeries of Maori items. He became very active in seeking additions to the British Museum's Maori Collection, both from private sources in the United Kingdom and through his contacts with museums and collectors in New Zealand. His published research on Maori material culture shows the extent of his close scholarly relationship with New Zealand researchers, especially Alexander Turnbull, a collector in Wellington, Augustus Hamilton at the Dominion Museum in Wellington, and Henry Skinner at the Otago Museum in Dunedin.

New Zealand museum personnel and academics

An early frequent New Zealand visitor to the United Kingdom was the ethnographic and natural history collector Sir Walter Buller who, while never employed in a museum, had extensive contacts with museums in New Zealand and Europe. Most of his writing was on New Zealand birds, but he did contribute a detailed article (Buller 1893) on a Maori shark-toothed knife in the Hunterian Museum, Glasgow. Buller also presented famous Maori carvings to museums in Paris and Berlin (Neich 2001: 357 and 359).

James Edge-Partington clearly became the main link between the British Museum and New Zealand museums. On 12 April 1897 (BM PE correspondence) Augustus Hamilton wrote to Franks asking his opinion about Part I of his *Maori Art* (first issued 1896, full publication 1901), and requesting photographs of specific Maori items in the British Museum Collection, presumably for the later sections of the work. Charles Read replied on 31 July 1897, telling Hamilton that

Franks was dead, but that Read had placed the copy of *Maori Art* Part I into the British Museum library and was arranging for the photographs to be supplied. Hamilton had identified the items that he wanted photographed from the drawings in Edge-Partington's ethnographic *Album*. Hamilton subsequently sent on all the following parts of his *Maori Art* to the British Museum.

Hamilton included many British Museum Maori items in his subsequent writings (1901), as did Elsdon Best occasionally in some of his writings treating many aspects of Maori material culture, although neither writer ever visited the British Museum. Best (1925a) simply reproduced many of Edge-Partington's sketches of British Museum Maori musical instruments, along with several British Museum photographs.

In 1908 the New Plymouth artefact collector and museum benefactor W.H. Skinner visited the British Museum and was most appreciative of Joyce's assistance in his study of the collection, especially in his sketching and measuring of the Maori canoe sail (BM PE correspondence: W.H. Skinner, 4 January 1911). In the same letter, Skinner asked Joyce for advice on university ethnography courses in England, as his son H.D. Skinner intended to study there. While recuperating in the United Kingdom from war wounds, H.D. Skinner took the opportunity to study Maori and Moriori collections in museums and private collections. He contributed a short summary article of his surveys to the *Journal of the Polynesian Society* (1917) and deposited lists of Maori objects in British museums with the Dominion Museum, Wellington, but they remained unpublished and virtually unknown. The results of his Moriori researches were included in his Bishop Museum monograph (1923).

Some time after the discovery of the unique Kaitaia carving in 1920, the New Zealand private collector and author T.E. Donne wrote to T.A. Joyce at the British Museum and to the British collector A.W.F. Fuller with photographs, asking their opinion of the object. They were both sceptical of its authenticity.[3]

Considered as a follower of Best with regard to Maori material culture studies, Sir Peter Buck (Te Rangi Hiroa 1950) apparently did not study the British Museum collections at first hand until 1933, by which time his focus had moved on to tropical Polynesia. In his detailed study of Maori music, Johannes Andersen (1934), the librarian at the Alexander Turnbull Library in Wellington, reproduced several of the British Museum musical instruments. While living in London, Sir Raymond Firth (1931) had already examined and published the unique Maori plaited sail in the British Museum. Another New Zealander living and working in England after the Second World War was the collector and dealer in Maori artefacts Kenneth Athol Webster. As part of these activities, Webster became involved in the repatriation of the Edward Armytage Collection of Maori jade, which he published in a detailed fully illustrated catalogue (Webster 1948).

Another mode of study

As part of their ongoing relationship with the British Museum, James Hector of the Colonial Museum in Wellington, and later, when it was renamed the Dominion Museum, Augustus Hamilton, as well as H.D. Skinner of the Otago Museum, sent Maori artefacts – mostly adze blades, worked stone and bone material, and fish-hooks collected from the surface of Maori archaeological sites – to be included in the British Museum Collection for comparative study purposes.

Some selected plaster casts of Maori items in the British Museum Collection were supplied to New Zealand museums at various times in the early nineteenth century. There may also have been earlier orders for casts. Twelve plaster casts of small carved Maori artefacts, including *wakahuia*, flutes, a feeding funnel and the famous skull-bone tiki from the British Museum Collection were presented to Auckland Museum by James Edge-Partington in 1901. In 1905, Hamilton wrote to Read at the British Museum requesting that two casts of unspecified Maori carvings be prepared and packed by Messrs Brucciani for shipping to the museum in Wellington (BM PE correspondence: A. Hamilton, 25 November 1905). At Auckland Museum in 1903, the curator Thomas Cheeseman commissioned the famous Rotorua Ngati Tarawhai carver Anaha Te Rahui to produce replicas of four of the *kotaha* dart throwers in the British Museum. Anaha is said to have worked from plaster casts supplied by the British Museum, but he may also have been supplied with the fine drawings of them included in Edge-Partington's (1899a) article. His replicas were very successful and were used for many years in Auckland Museum displays in the absence of any other original *kotaha* in the Auckland collection. In Wellington, some time prior to his death in 1906, the Te Ati Awa carver Jacob Heberley attempted to carve a replica of a British Museum *kotaha* (**610**), probably working from a photograph, but his rendering resulted in a confused two-dimensional carving (Neich 1991: 107–9). At the Dominion Museum, Wellington, in 1909, Augustus Hamilton commissioned a local European carver and repairer of Maori artefacts, Mr J. Alton, to carve a replica of the British Museum's northern *tuere* prow (**15**), working from a plaster cast supplied by the British Museum.

Bringing together New Zealand scholars and British collections

The increasing ease and speed of international travel gave New Zealand museum personnel and academics new opportunities to study Maori collections in Britain and Europe in detail at first hand. One of the first to take advantage of these opportunities was Roger Duff, ethnologist and soon-to-be-appointed Director of the Canterbury Museum in Christchurch, travelling on a British Council scholarship. Although Duff did not publish specifically on the Maori collections in Britain, his experience of these collections did inform his later writings, especially the catalogue to his 'No Sort of Iron' exhibition (1969); and while in Britain he was instrumental in organizing the New Zealand government's purchase of the W.O. Oldman Collection (Oldman 2004). Following closely on Duff's trail was Terry Barrow from the Dominion Museum. While studying for his Ph.D. at Cambridge University and the Diploma of the Museum Association, London, Barrow inspected most major Maori collections in Great Britain, subsequently publishing on several items in the British Museum Collection (1959, 1961a and b, 1962, 1969, 1972 and 1984). For most of 1978, David Simmons of Auckland Museum carried out study visits to 69 museums with Maori collections in Europe and the United Kingdom, including the British Museum. Back at Auckland Museum, his

intensive documentary and photographic records were made generally available to students and the interested public, with several items from the British Museum being published in his subsequent books and articles (Simmons 1981, 1985, 1986a and b, 1997 and 2001; Simmons and Te Riria 1983; Te Riria and Simmons 1989). Among other New Zealand visitors to the British Museum Maori Collection, Bernard Kernot of Victoria University, Wellington, and Janet Davidson, then of Otago University, compiled detailed records on certain aspects of the British Museum Collection but did not publish them. Similarly, Athol Anderson, then of Otago University, and Dimitri Anson of the Otago Museum in Dunedin, and David Butts of Massey University in Palmerston North made brief visits to the collection. Margery Blackman, Honorary Curator of Ethnographic Textiles and Costume at the Otago Museum in Dunedin, made an intensive study of the Maori cloaks in the British Museum during the 1990s (1998).

Maori artists and scholars

As part of the Maori cultural revival of the 1970s and 1980s, and encouraged by the increasing cooperation between the British Museum and New Zealand museums, several indigenous Maori scholars, writers and artists made their own studies of the British Museum Collection. An earlier pioneer of this development was Maggie Papakura (Makereti) of Rotorua, who had come to live and study in Oxford in 1912, with her book including descriptions of material culture items being published posthumously in 1938 (Makereti 1986). Two of the most famous and accomplished traditional Maori women weavers, Diggeress Te Kanawa of Ngati Maniapoto and Emily Schuster of Ngati Tarawhai, studied early plaiting

and weaving techniques in the British Museum Maori Textiles Collection in 1988. Maori carver and contemporary artist John Bevan Ford made several visits to study the collection during the 1980s, some of which he published in his essay on the history of Maori art (Ford n.d.). Maori writer, scholar, tattooist and university teacher Ngahuia Te Awekotuku spent almost six months in 1994 using the British Museum as her base to study English museum collections. The documentary records she gathered were later used widely in her university teaching. Maori musician and university teacher Hirini Melbourne concentrated on a study of the unique and comprehensive musical instruments collection of the British Museum in 1995. Other Maori visitors have included the artist Elizabeth Mountain-Ellis, the weaver Erenora Hetet and the National Museum of New Zealand board member Maui Pomare. Conservator Rangi Te Kanawa worked for a few months at the British Museum on an exchange with British Museum conservator Allyson Rae, who worked at the National Museum in Wellington. Maori artist, photographer and university teacher Maureen Lander of Auckland University has made intensive studies of Maori weaving and featherwork in the British Museum Collection, incorporating ideas from these into her own artworks and using her documentation to aid and stimulate her students' projects.

Notes

1 Edge-Partington 1899a–d, 1900a–c, 1901a–c, 1902, 1903a and b, 1906, 1907, 1909a and b, 1910, 1913 and 1915; Beasely 1915, 1919, 1924, 1927, 1928, 1934, 1935a–c and 1938.
2 BM PE correspondence: T.E. Donne, 25 August 1921 and 22 September 1921, A.W.F. Fuller, 7 September 1921.
3 BM PE correspondence: T.E. Donne, 25 August 1921 and 22 September 1921; A.W.F. Fuller, 7 September 1921.

A history of Maori collections in the British Museum

The Museum and the Department

The British Museum – the oldest national, public, secular museum in Britain – was founded in 1753 by Act of Parliament. Its three founding collections were Sir Hans Sloane's collection of books, manuscripts, coins, antiquities, natural history specimens and curios, the Cottonian Library (begun by Sir Robert Cotton and maintained by the family until 1700, when it was given to the nation) and the Harleian manuscripts (collected by the first and second Earls of Oxford).

Sloane was a renowned physician who moved in scientific circles and spent two years in Jamaica after appointment as a physician to the Governor. Throughout his life he amassed a huge and famous collection, the popularity of which was such that in 1748 the Prince and Princess of Wales came to see it. The Prince was impressed, 'esteeming it an ornament to the nation; and express'd his sentiment how much it must conduce to the benefit of learning, and how great an honour will redound to Britain, to have it established for publick use to the latest posterity' (*Gentleman's Magazine* 18: 301, quoted in Miller 1973: 40). In his will, Sloane offered his collection to the King for the nation for £20,000 (far less than its worth) to be paid to his two daughters, specifying that it was not to be divided and that it should stay 'chiefly in and about the City of London … where they may, by the great confluence of people, be of most use' (Miller 1973: 41). When the King appeared indifferent, Sloane's trustees appealed to Parliament, which gave approval to the purchase of the collection for the nation, and to the acquisition of a building in which to house it; the funds required for the purpose to be raised through a public lottery. The building purchased was Montagu House, on the site of the present Museum, and the public was admitted to it for the first time on 15 January 1759. Eventually Montagu House, in spite of extensions added to it between 1804 and 1808, proved to be inadequate to house the ever-increasing collections and the last of it was demolished in 1845. It was replaced by the present building, designed by Robert Smirke and completed by his brother Sydney, and opened to the public in 1852. Between 1854 and 1857 the famous Reading Room was added, and further extensions followed as funds permitted.

It is in Sloane's collection that the British Museum's ethnographical holdings have their roots, for it included ethnographical objects from many different parts of the world, but not from Oceania, which until the explorations of the second half of the eighteenth century was only known in England from the early voyages of the Portuguese, Spanish and Dutch. This ethnographical material was included in the Department of Natural and Artificial Productions, one of the three early departments, the other two being Printed Books and Manuscripts. When in 1807 the Department of Antiquities was created, Ethnography was left with Natural History. In 1836 it was returned to the Department of Antiquities, and when this Department was split into three in 1860–1, Ethnography joined the Oriental (then Egyptian and Assyrian) Antiquities Department as the sub-department of British and Medieval Antiquities and Ethnography. In 1866 this sub-department became the separate Department of British and Medieval Antiquities and Ethnography, under the Keepership of Augustus Wollaston Franks, one of the greatest benefactors of the Museum with an interest in ethnography. It was thanks to Franks, in large measure, that in 1865 the Museum acquired the largest private ethnographical collection in existence at the time, formed by Henry Christy. Due to the lack of space in the main building, the Christy Collection remained in its own building at 103 Victoria Street until the mid 1880s, when the British Museum's natural history collections were transferred from Bloomsbury to a purpose-built museum in South Kensington, the present Natural History Museum. To help with the collections, Franks employed Thomas Gay, whom Christy had intended to engage as a curator to his collection (BM central archives: Original Papers, 10 January 1866). He was replaced in 1874 by Charles Hercules Read, whom Franks initially paid privately; but in 1880 Read was officially appointed to the British Museum and became the Museum's de facto first ethnographer, joined in 1895 by another assistant, Ormond Maddock Dalton. On Franks's retirement in 1896 Read became Keeper, and in 1902 the first specialist ethnographer, Thomas Athol Joyce, joined the Department, followed in 1913 by Hermann Justus Braunholtz. In 1910 the first edition of the British Museum's *Handbook to the Ethnographical Collections* was published, prepared by Dalton and Joyce; the second edition, prepared by Joyce and Braunholtz, appeared in 1925.

In 1921, during yet another departmental reorganization, a short-lived Department of Ceramics and Ethnography was created, with Joyce as Deputy Keeper responsible for Ethnography (Read retired the same year, and Dalton was appointed Keeper). From 1933 until 1946 Ethnography was part of the Department of Oriental Antiquities (now the Department of Asia) and Ethnography, Ethnography leading a semi-autonomous existence as the sub-department, with Joyce as its Deputy Keeper until his retirement in 1938, when he was succeeded by Braunholtz. When the Museum reopened after the war in 1946, Ethnography came of age as a fully fledged Department of Ethnography under Braunholtz's Keepership. Braunholtz was followed successively by Adrian Digby, William Fagg, Malcolm McLeod, John Mack and Jonathan King. The first curator in the Department with a special interest in, and

responsibilities for, the Oceanic material was Bryan Cranstone, appointed in 1947. When he left in 1976 to take over the post of Curator of the Pitt Rivers Museum in Oxford, Dorota Starzecka became responsible for the Oceanic collections, followed on her retirement in 1999 by Lissant Bolton.

In the late 1960s, lack of space being the permanent problem at the Museum, it was decided to move the Department temporarily to two outstations: exhibitions and offices to a building in Burlington Gardens near Piccadilly that was given the name of the Museum of Mankind, and the reserve collections to a specially acquired building at Orsman Road in East London. The Museum of Mankind existed as a physically separate entity until space became available at the main building in Bloomsbury, when the collections of books, manuscripts and maps, combined in 1973 as a new separate institution, the British Library, moved to a new building in St Pancras in the 1990s. Ethnography returned to its mother site in the early 2000s – although the reserve collections are still at Orsman Road and some material, mainly textiles, at another outstation at Blythe Road in West London (the reserve collections can be viewed by appointment, applying at the Museum's Centre for Anthropology, which also houses the Department's Library).

In 2004 the latest reorganization at the Museum took place, when the departmental structure, grown out of Britain's intellectual tradition and colonial past, gave way to a geographically and culturally based division; thus Ethnography's collections from Asia, the Middle East and Europe joined the other relevant Departments, and the remainder became the Department of Africa, Oceania and the Americas.

The registration system and documentation
As is the case with many old museums, documentation for the early period, throughout the nineteenth century and even well into the twentieth, is poor and patchy, and scattered among various departments of the Museum. The problem is especially complicated in the case of Ethnography; its convoluted history within the Museum, described above, is essential to understanding where one should look for additional information about objects.

The basic information is to be found in Registers, as the British Museum catalogues are known, and the system according to which they are organized is not entirely straightforward. Gifts and bequests were entered first in the central 'Book of Presents', after which they, as well as purchases, were catalogued within departments in bound ledgers, with a number and a drawing. The material acquired was catalogued as separate collections according to its source, i.e. donor or vendor. Each collection was given its own number consisting of the year of acquisition and the month and date within this year when it was formally entered in the Museum's records; thus the Grey Collection acquired in 1854 was given the number 1854.12[December]-29[date]; within the collection individual items were listed in numerical sequence: 1854.12-29.1, 1854.12-29.2 etc. Ethnography had its own separate Registers since 1903 (although in its first volume there is also included a section for the period 1861–8). For the early period not covered by the separate Ethnography Registers, ethnographical acquisitions are to be found in the Registers of the department to which Ethnography

belonged at the time, and also in the bound volumes of the British Museum Extracts and on Slips (see below), where ethnographical entries were copied.

A printed catalogue compiled by Steinhauer of a selection of items from the Christy Collection, including some Maori ones, was published in 1862. Some time after Christy's death an attempt was made to extend this catalogue. Existing entries were cut out and pasted on Slips, and similar material from the Christy Collection was added, together with additions from other sources, including Franks. These objects have St numbers.

At the same time, other material in the Christy Collection, and additions to it, were registered in numerical sequence without separation into collections, within the range 1–9999 (so-called 'four-figure numbers', e.g. 7362). This was followed by a similar sequence, but with numbers preceded by the plus sign (so-called 'plus numbers', e.g. +2354). When this sequence was exhausted in 1893, a different system was adopted – the year of acquisition followed by the number of the object within this year (e.g. 1895-349), again without separation into collections – which continued until 1938, after which all acquisitions were catalogued according to the British Museum system described above, i.e. year, month, date, individual object.

From 1921 Ethnography also had its own 'Donation Book', in which all acquisitions were recorded briefly before full registration in the ledgers. Registration numbers were also painted on the objects.

At some stage in the early years of the second half of the nineteenth century a decision was made to duplicate the ledger entries on paper Slips (some parts of bound Registers are annotated 'Slips done, Drawn, Described'), a practice continued for some collections in the Department until the 1930s. In 1878 Franks, then Keeper of the Department of British and Medieval Antiquities and Ethnography, submitted to the Trustees a paper explaining the registration system within his Department, which also clarifies the reason for the creation of the Slip registration. He writes:

> In addition to the Registers Class Catalogues have been commenced of separate sections: for instance 'Matrices of Seals', where they are fully described, with any historical information, and 'Personal Ornaments', chiefly in the precious metals, which are elaborately described with a careful drawing of each, so as to be able to identify the specimen if stolen. These catalogues are written in slips of paper 10½ inches broad and 4 inches high, one slip to each object, and are finally classed according to the nature of the object, and preserved in boxes or in movable covers. In the Christy Collection, a dependency of the Ethnographical Department, but held by the Museum on special conditions, the registration is entirely done on catalogue slips of the size just described …
> (BM central archives: Original Papers, 5 September 1878)

It is clear that the Slips were to have fuller information about the objects, and that they were to make it easier for the curators to arrange, or re-arrange, them into different categories, be it geographical or typological. Despite Franks's statement that the Christy Collection registration was done 'entirely' on Slips, bound Christy registers exist, the earliest one covering the period July 1869 to July 1877, with some entries having four-figure numbers annotated in pencil in the margin. It seems therefore that the bound Christy registers were created in parallel with the Slips; thus, for example, the Meinertzhagen Collection of 1895 is entered both in the bound Register, where it is annotated 'Drawn, Described', and on the Slips.

The Slips also include other sequences of numbers, apparently for objects which had never been catalogued previously or perhaps had lost their registration numbers and which were later catalogued in a numerical sequence with prefixes indicating geographical provenance (e.g. NZ 156 for a Maori object) or collection name (e.g. LMS 153 for an object in the London Missionary Society Collection). Much of this work was done by James Edge-Partington, Pacific scholar and collector, who was employed by the Museum as a supernumerary from 1891 until the early 1900s. For the Oceanic collections the Slip registration was discontinued in the early years of the 1900s.

From 1939 one uniform system of numbering was adopted, consisting of the year of acquisition, continental abbreviation (e.g. OC. for Oceania), collection number within the year, and the object number within the collection (e.g. 1944 OC.2.169). At the same time each continental area was assigned its own separate ledger, with some large collections, such as Beasley's, registered in separate volumes.

Finally, as a result of the inventory of the collections begun in 1972, yet another sequence of numbers was created with a Q prefix followed by the year, continental abbreviation and the number of the piece recorded within that year (e.g. Q1981 OC.1354), all entered in separate ledgers. This series consists of the objects which at the time of the inventory did not have any registration numbers, the assumption being that in time they could be matched with Register entries for which objects could not be found, as indeed it has been possible to do in many instances.

In 1979 the project to computerize the collections was started in Ethnography, in 1982 Oceanic bound ledgers were abandoned and since then all new acquisitions have been registered directly on computer, the registration numbers appearing there in a slightly modified form but always preceded by the continental prefix (OC. for Oceania; see preface to catalogue section, p. 25).

Loans constitute a special category of objects. They were entered in a separate Loan Register and their numbers consist of the year, L abbreviation, collection number within the year, and the object number in the collection. The exception to this rule among the Maori material was the Royal Loan of 1902 from the Prince and Princess of Wales which was registered at the time as a numerical sequence with the prefix TRH (Their Royal Highnesses) and as a result has two sets of numbers (beyond the Royal Collection number).

Strictly speaking, a Register entry should include all the available information about an object or, if this is too extensive, it should refer to the relevant numbered Ethnographic Document which contains it (e.g. Eth. Doc.836), housed in the Archives of the Department of Africa, Oceania and the Americas. However, more information may be contained in the Museum's central archives (Book of Presents, Miscellaneous Papers, including Reports to the Trustees, Committee Minutes, etc.) and often in departmental correspondence, held in several departments, depending on the departmental affiliation of Ethnography at the time (the overwhelming majority of this material is to be found in the Department of Prehistory and Europe, formerly Department of Medieval and Later Antiquities). Also in the AOA Departmental Archives are Donations Books, Temporary Registers, Miscellaneous Papers and volumes concerning specific collections (e.g. Beasley's collection is accompanied by four volumes of his own catalogue and two binders of correspondence), and personal archives and notebooks of previous curators, the most significant among them being the ethnographic notebooks compiled by Franks and his assistants (King 1997: 347–51). Some of this material is still in the process of organization and cataloguing.

Information about the Museum, its history and its departments is available on the Museum website, and the continuing work on the database aims to make all the available information about the objects in the Museum's holdings accessible to the public. All the Department's records, including the Maori ones, are available to the general public on the Museum's database. They are being constantly updated, but they record the history of the Museum's understanding of the objects, which may include mistakes. When the collections were computerized, basic information was copied from the Museum Registers. Additional information about the objects continues to be added and mistakes continue to be corrected. This book contains all the corrected and updated information about the Maori collections as it is known at the time of writing.

Acquisition of collections

The British Museum's Maori collections are probably the finest and largest outside New Zealand, although they only number just over 2,300 objects and are thus small by comparison with the New Zealand holdings. As with other ethnographical collections at the Museum, they reflect the British colonial past and the status of ethnography within the Museum. Collections were made by colonial administrators, missionaries, travellers, military and naval men, and they were presented or sold by them or their relations or descendants. They vary considerably, for they reflect the collectors' personal tastes and interests and the perceived desirability of objects, and probably also their portability or circumstances – for instance, objects received as gifts from the Maori or the limitations of what was available as a souvenir at a given time and place. Consequently, the collection is strong in smaller objects – ornaments, treasure boxes, musical instruments, fish-hooks – but it does not include either full-size houses or storehouses, or canoes.

Information about the history of objects acquired in the nineteenth and early twentieth centuries is scant. At that time the Museum curators were interested primarily in completing series of objects of a type, and the information about the provenance of an object, although sometimes asked about (albeit it seems not very often), did not seem to be of paramount importance. When in 1912 Read was negotiating for the purchase of the Robertson/White Collection and made a selection of objects wanted, he stated clearly that he chose the 'pieces representing small variation of type' (BM PE correspondence: C.H. Read, 25 March 1912).

It was quite late that documented collections were made by trained anthropologists; in the case of Oceanic holdings the first such collection was made by A.C. Haddon in the Torres Straits in 1888–9, and the first planned field collection of Maori material was made only in 1993.

At an early stage, when Ethnography was considered by the Museum authorities as not much more than a collection of miscellaneous curios, the great majority was acquired as

gifts: before 1865, 207 objects were presented and only 32 purchased; but subsequently the balance is more or less equal. Undoubtedly this change in policy was due to Franks's interest in, and support for, ethnography, and the huge and significant injection of ethnographical material into the Museum's holdings in the form of the Christy Collection, which came to the Museum with its own fund for expansion of the collection, thus making more purchases possible. At the same time ethnography, although still closely linked to prehistory as a source of comparisons with European prehistoric finds, was gradually achieving its status as a legitimate field of study in its own right.

Although during this period ethnographic acquisitions were mainly through gifts (a great deal of them made by Franks himself) and the purchase of objects offered for sale, the Museum also made efforts to extend the collections and fill in the gaps. In 1888 Franks wrote to Augustus Hamilton in Napier:

> There are but few things that are not represented in our series here: we want, however, a wholly good Maori spade (heko), the parts of which are old and belonging to each other. This you might possibly be able to secure for us. Another desideratum and I fear more difficult to procure, is a large bowl & cover (kumete) on four legs – about two feet or a little less in length. Sir Julius von Haast found here a good many desirable specimens among our duplicates and we might fill some of your gaps if you can find us anything we want.
>
> (BM PE correspondence: A.W. Franks, 12 January 1888)

Franks must have also explored a possibility of obtaining a full-size Maori canoe with Sir George Grey, for in 1895 Grey wrote to him:

> I think it would be too great an undertaking on considering the matter; it involves the moving of a canoe which would carry a hundred men and their provisions, for a voyage of good many days. In New Zealand, we have such a canoe, but we had to build a building specially to contain it, because, from its length, it was found impossible to move it into any building but one expressly made for it. It is more than a white elephant which you compare to a treasure of the kind proposed. I therefore relinquish all thought of such an undertaking.
>
> (BM PE correspondence: G. Grey, 10 July 1895).

Exchanges made with other museums were unfortunately not well documented, but it is clear that the objects exchanged came from the main British Museum collections, from the Christy Collection, from Duplicates, and also from the private possessions of Franks and Read. In 1893 Franks wrote to Robley: 'The British Museum rarely troubles about exchanges – but as a Trustee of the Christy Collection, I have a good many things to deal with in that way, as well as a great number of things of my own.' (BM PE correspondence: A.W. Franks, 28 November 1893). At the same time the importance of the objects considered 'duplicates' was clearly understood, as Read wrote to A.B. Meyer in Dresden:

> I was very glad to make Dr Heller's acquaintance … he spoke of you wanting a New Zealand box and I therefore showed him a duplicate one we have – but also told him that these things were much sought after here now, and that we ought to get something very good in exchange. … I shall be glad to oblige you if I can – but the fact is that these old Pacific duplicates are better than money to us & we must not squander them.
>
> (BM PE correspondence: C. H. Read, 22 July 1890)

It should be pointed out here that although the Museum engaged in exchanges in the past, it is prevented by law (the British Museum Act of 1963) from disposing of the objects in its collections unless the object is an exact duplicate or it is unsuitable to be held in the Museum and of no interest to students, or it is in such a bad state of preservation that it is beyond salvation.

Franks's and Read's wide professional and social contacts made it possible for them to hear about interesting objects and collections and acquire them for the Museum. Lady Sudeley's collection, which the Museum purchased in 1894, was spotted by Read eighteen years earlier: 'My friend and colleague Mr Read has returned and we have consulted over the New Zealand carvings, of which he took notes in 1876.' (BM PE correspondence: A.W. Franks, 7 July 1894). In 1890 Franks brought the Turvey Abbey Collection to the Museum's attention. He knew about it from Thomas Burgon, an amateur collector and also an employee of the Museum between 1844 and 1858: '… Mrs Higgins of Turvey Abbey, Bedfordshire, a daughter of my old colleague Thomas Burgon, & sister to Dean Burgon, has a collection of ethnographical objects likely to be interesting as collected a long time ago.' (BM PE correspondence: A.W. Franks, 31 May 1890). The collection was eventually bought in 1904 when it was through Read's contact that the interest in it was revived:

> May I introduce to you Mr Longuet Higgins the owner of the Turvey Abbey Collection of Ethnographical specimens – Mr Higgins is I believe not wishful to retain his collection & is anxious to know what is the best course to adopt in the circumstances – May I ask you to be good enough to do what you can to assist him in the matter?
>
> (BM PE correspondence: C. Heape, 31 March 1904)

Edge-Partington always had the interests of the Museum in mind. H.G. Jackson wrote to Read from Auckland in 1892: 'As requested by Mr Partington & yourself I have literally scoured the country round for Maori curios but they are not to be had at any price being now in the hands of squatters & private collectors who wont part, its only when a death takes place that a stray club comes into a sale room.' (BM PE correspondence: H.G. Jackson, 26 December 1892). Jackson sent two cases of miscellaneous Pacific material (BM AOA Christy correspondence: H.G. Jackson, 26 December 1892 and 20 April 1893) from which Read selected some (the rest purchased by Edge-Partington and Oxford and Cambridge, and the remainder returned to Jackson's family). Although Jackson's name does not appear in the Museum Registers as a vendor and there is no list of the objects selected, on 17 November 1893 Franks presented to the Museum fourteen Oceanic objects, including two Maori ones – **1779** (*pihepihe* cape, +6883) and **838** (wood axe, +6882) – for which the source is given as 'Jackson'; these objects also appear on the list of the consignment sent by H.G. Jackson, and the dates of the acquisition and of the correspondence confirm the provenance. This is one of many instances in which Franks used his own money for purchases that he gave to the Museum. In this case, the cooperation between the Museum and Jackson did not progress any further, although Jackson persisted, as Edge-Partington wrote from Dunedin during his 1897 journey to the Pacific:

> I have been immensely amused by hearing of Mr Jackson's exploits out here he attended sales & with a big cigar in his mouth when a lot was knocked down to him he called out "British Museum" … This staggered the folk as they cd not understand such a duffer being sent out. They are immensely pleased at the result & he has not been heard of since…
>
> (BM PE correspondence: J. Edge-Partington, 5 July 1897)

To Edge-Partington's good offices the Museum also owes the only model house in its collections (**105**, 1904.12-6.1): 'You may perhaps remember that you asked me, when you were here, whether I could get carved a similar model Maori house to that you saw in my collection. Well, after all this time, it is at last finished…' (BM PE correspondence: A.H. Turnbull, 10 May 1901). Similarly, Joyce was told about Beasley's collection by Fuller quite early: 'Beasley is an ardent collector of South Sea specimens & has a really fine collection, especially of N.Z. objects, & as he takes very great interest in the B.M. & is most friendlily [sic] disposed to it, he is a man worth taking a little trouble over. I know one day, the Museum won't regret it.' (BM PE correspondence: A.W. Fuller, 29 May 1913); after Beasley's death this collection came to the Museum in 1944.

At the same time many objects and collections were rejected, considered to be either 'duplicates' or of 'inferior quality', or simply for the lack of space and/or funds. Space was a consideration quite early, for in 1864 Samuel Birch (Keeper of Oriental Antiquities, which included Ethnography at the time) explains patiently in a rejection letter to an indignant potential vendor of two Maori cloaks, Mary E. Lloyd:

> This [rejection] arises from the want of adequate space to display Ethnographical objects in general and from the circumstances that the Museum has only purchased from time to time such objects of this class as have been deemed necessary to give greater completeness to the existing collections or specimens which were of the nature of antiquities or illustrative of the ancient remains of other nations. The Ethnographical collection here is compressed into one room and consists chiefly of donations from H.M. Government, public bodies, & private individuals, & comparatively small portion only having been purchased for reasons cited above.
>
> (BM PE correspondence: S. Birch, 27 April 1864)

In 1898 the Wallace Collection was rejected in a letter to the owner's daughter: 'I have just found a letter from your father in which he offers his museum for sale to the British Museum – as a whole. This proposal not unnaturally came to nothing…' (BM PE correspondence: C.H. Read, 24 March 1898). In 1894 John White, barrister and private collector of Dunedin, wrote to the Museum offering his large collection for sale: 'I am about to dispose of my collection of Maori Weapons, Implements, mats, carvings etc. and shall be glad to know if you can become a purchaser. My collection of greenstone ornaments, implements etc. is I believe the best in Existence, it is certainly far the best in New Zealand either in or out of a Museum.' (BM PE correspondence: J. White, 20 August 1894). There is no reply in the correspondence, but the collection was obviously not purchased (probably the asking price of £1,000 was too high). However, many stone implements from it did eventually find their way into the Museum through the two collections of 1912: Miss Robertson's 1912.5–24. and Mrs Erskine's 1912.5–25. (sisters of J. Struan Robertson, who bought part of the White Collection). Similarly, Robley's collection was rejected for lack of funds (BM PE correspondence: C.H. Read, 22 October 1901). Cloaks were not considered to be desirable in particular, and were often rejected, especially after the Royal Loan of 1902: '… it is unlikely that the Maori cloak in your possession is either of any considerable value or that it would be wanted here. We have scores of flax cloaks of probably the same kind, from the time of Capt. Cook up to the last journey of the Prince of Wales.' (BM PE correspondence: C.H. Read, 1 January 1907);

another rejection letter stated bluntly: 'I am afraid objects of this sort are not easy to dispose of, as collectors do not as a rule care for garments.' (BM PE correspondence: C.H. Read, 18 September 1904).

An early published record of the Oceanic, including Maori, collections at the British Museum is contained in the second volume of James Pellar Malcolm's *Londinium Redivivum; or, an Antient History and Modern Description of London*, issued in 1803. In it Malcolm devotes 10 pages to the description of 'The Otaheite and South Sea Rooms', the objects in which, judging by the date of the publication, must have come from Captain Cook's voyages. As Malcolm himself writes:

> The researches of Captain Cook are well known to the publick… The visitor will find in this room the result of years of labour and danger; a fund of information, supported by undoubted authenticity…
>
> (1803: 520)

He continues in a somewhat didactic tone:

> The visitor of the Museum should make himself acquainted with the wants and habits of the natives of the South Sea Islands before he ventures to view their productions; many of which are so far removed from our ideas, that their use cannot be imagined by an European, without referring to Captain Cook's narrative…
>
> (ibid.: 520)

About the Maori objects he writes:

> The natives of New Zealand make their threads from a plant resembling our flags [flax] … They have a process that produces fibres white and shining as silk. It also affords them lines, and cordage for nets, and to tie their canoes together.
>
> (ibid.: 522)

He continues:

> The New Zealanders wear combs, made of bone and wood, set upright in the hair as an ornament. They fasten their dresses with bone bodkins… Other ornaments are, chisels or bodkins, made of green talc [nephrite], for ear-drops; and shells strung upon thread. The men wear, as a valuable ornament, pieces of green talc, or whalebone, in the shape of a tongue, round the neck. They place carved planks near their doors, as we do pictures on our walls.
>
> (ibid.: 522–3)

In the case containing bailers one finds:

> A most elegantly-carved scoop, from New Zealand. The handle and rim of this is particularly rich. Weapons. One exacts in the shape of a violin, and all calculated for the most murderous effect.
>
> (ibid.: 528)

At the conclusion of this section he gives vent to his irritation with the Museum officialdom:

> I cannot conclude this article without expressing my regret, that the opposition of *one* individual only prevented my seeing the Catalogues, from which I wished to name several articles. Unfortunately, that individual has the care of those manuscripts. A man must have a brain suited to a Brobdignag to contain, correctly, the terms by which the articles in the Museum are designated.
>
> (ibid.: 531)

A few years later the Cook collections are mentioned in the *Synopsis of the Contents of the British Museum* published in 1808:

> To this list [of benefactors] must be added the name of the Right Hon. Sir Joseph Banks, Bart. K.B., who after his return from his circumnavigation, deposited at different times in the Museum numerous collections of natural and artificial curiosities from the newly discovered islands in the South Seas, which, with considerable additions since made by the Admiralty, Capt. Cook,

and other officers who have since performed similar distant and perilous voyages, forms one of the most conspicuous parts of the Museum.

(1808: xxiv)

The *Synopsis* further enumerates exhibition cases, including those devoted to New Zealand, located in the First Room on the Upper Floor, where 'miscellaneous collections of modern works of art, from all parts of the world' (ibid.: 4) are displayed, but it disappointingly concludes: 'This collection, the greatest part of which consists of donations, not being strictly of a scientific nature, no further detail is here given of its contents.' (ibid.: 5). The 1817 edition is much more specific: 'Various specimens of matting and cordage, mostly made of the New Zealand hemp. Sundry woven articles: belts, etc. – Fishing nets: hooks: cordage, etc. – From New Zealand'; and in another case: 'Articles of ornament: combs: necklaces, etc. Specimens of carving in wood and bone: pipes and other musical instruments. – Warlike instruments; conches used in war: clubs: saws made of sharks' teeth… Various wooden boxes ornamented with carvings…' (1817: 6).

Thereafter ethnographic collections, with their Maori component, were continually on display, although exhibition space was a perennial problem in the Museum and Ethnography was especially afflicted by it. When the Christy Collection was acquired it had to remain at Christy's house in Victoria Street until 1883, when it transferred to Bloomsbury after the last part of the natural history collection had been removed to South Kensington and new ethnographic displays were opened to the public in 1886 in the long gallery over the King's Library, once occupied by the bird and shell collections. There they stayed, with an interruption during the Second World War, when the collections were evacuated to safe sites in the country, until the end of the 1960s and Ethnography's move to the Museum of Mankind. Here a new exhibition policy was put into practice, of temporary exhibitions devoted to one culture or a particular theme. During that time individual Maori objects were exhibited, and in 1990 a small display was put together to commemorate the 150th anniversary of the signing of the Treaty of Waitangi, but it was only after the Department's return to Bloomsbury that 'Maori', the first large exhibition devoted entirely to Maori culture and art ever mounted at the British Museum, opened to the public in 1998.

The earliest Maori material in the Museum's collections comes from Captain Cook's three voyages of exploration of 1768–71, 1772–5 and 1779–80. There are several entries in the Registers for it, but they are very general and there is no list or catalogue specifying what was given or when. The objects were catalogued much later by Edge-Partington in the NZ number sequence, with a few later ones coming from other sources. The Museum has relatively few Maori objects from between the time of the Cook collections and 1854, some of which are mentioned in the synopses. The 47th edition mentions the kite (**587**, 1843.7-10.1) as presented by Mr Reed (or Read) and 'brought by Capt. Manning from Plenty Bay' (British Museum *Synopsis* 1844: 10), and the 59th edition points out two objects deserving attention: the cloak *pihepihe* (**1780**, 1847.11-28.1) and the war canoe stern *taurapa* (**18**, 1847.8-27.24): 'Coat of Eh Puni [Honiana Te Puni, Te Ati Awa chief], a chief of Pa of Ki Warra [Kaiwharawhara], entirely made of flax … Above this case is the prow of the canoe of

the celebrated New Zealand chief, Heki [Hone Heke Pokai, Ngapuhi chief]. Presented by Captain Sir Everard Home, Bart. RN.' (British Museum *Synopsis* 1852: 242).

In 1854 the Museum acquired one of its most important Maori collections (1854.12-29.), presented by Sir George Grey and including gifts presented to him as Governor of New Zealand between 1845 and 1854. In 1855 more Maori objects were added as part of the large ethnographical collection from Haslar Hospital Museum in Portsmouth, presented by the Lords of the Admiralty and consisting of the objects collected by men serving in the Royal Navy. The Royal United Services Institution Museum in Whitehall was also a source of Maori material acquired in the second half of the nineteenth century and incorporated into the Christy Collection, as was the collection of Revd William Sparrow Simpson, from whom objects were purchased in 1875 and others acquired as gifts prior to that and in 1895 via Franks. Also in the second half of the nineteenth century the Museum acquired the Meyrick Collection (1878.11-1.); Alfred Fowler's carved boards from a Rotorua storehouse *pataka* (1892.12-11.); Lady Sudeley's house carvings (1894.7-6.); and the largest Maori collection in the Museum's holdings, the Meinertzhagen Collection, formed by Frederick Huth Meinertzhagen and sold to the Museum in 1895 by his daughter Gertrude. In 1896 two small but interesting collections were added, one (1896.11-19.) presented by William Strutt, and another, consisting of the objects presented by the Ngapuhi chief Titore to Captain Sadler of HMS *Buffalo*. In 1898 the Museum's largest Chatham Islands collection (1891.10-21.) was bought from J.W. Williams.

In 1904 the Turvey Abbey Collection was purchased, followed later by the Budden/Angas Collection (1908.5-13.) of the objects collected by George French Angas. In 1911 the Museum acquired a very large Polynesian collection, including Maori material (LMS series) from the London Missionary Society, originally deposited on loan in 1890. Other important acquisitions of this period are the Yorkshire Philosophical Society Museum Collection (1921.10-14.), the Reid/Luce Collection (1927.11-19. and 1950 OC.6.1) made in the 1860s by Captain John Proctor Luce.

In 1933 there came an important addition to the collections: a large model storehouse *pataka* (**95**, 1933.7-8.1) from Maggie Papakura's Maori village erected in London for the coronation celebrations of 1911. In 1944 one of the largest and most important private ethnographic collections in Britain in the twentieth century (1944 OC.2), formed by Harry Geoffrey Beasley, was presented to the Museum by his widow. A decade later some Maori material came to the Museum with the Wellcome Historical Medical Museum Collection (1954 OC.6) and in 1960 the transfer from the Royal Botanic Gardens, Kew, also included a small number of Maori objects.

In the 1990s, partly in preparation for the planned Maori exhibition and partly carrying out the Departmental policy of collecting contemporary material, two field collections in New Zealand (1993 OC.3. and 1994 OC.4.) were made by the Museum staff (Eth. Doc. 1051).

Apart from these general collections, the Museum has also acquired at various times more specialized collections of stone implements and archaeological material. These include the 1876 gift of specimens from the Chatham Islands (CHAT numbers) and New Zealand (NZ numbers) presented on behalf of the Colonial Museum of New Zealand (present-day Te Papa

Tongarewa in Wellington) by Dr James Hector; a large number of the Chatham stone implements obtained from H.O. Forbes and presented by Franks in 1892–3; two collections of stone implements (1912.5-24. and 1912.5-25.) of J. Struan Robertson, originally from the John White Collection; the collection of stone tools (1928.1-10.) bequeathed by Prof. A. Liversidge; and an archaeological series, mainly fish-hooks (1937.7-3) presented by Dr H.D. Skinner of the University Museum, Dunedin.

In the Departmental Pictorial Collection there are also 15 pigmented ink drawings and colour lithographs by the Maori artist John Bevan Ford acquired in the 1990s from the artist, among them one picture commissioned specifically to celebrate the exhibition 'Maori' mounted at the Museum in 1998.

Among the Royal Loans, the largest one is that of 1902, presented by the Prince and Princess of Wales (later King George V and Queen Mary) and obtained on their 1901 visit to New Zealand as Duke and Duchess of Cornwall and York, consisting of gifts presented to the Royal couple, and catalogued by the Museum as the numerical series with the prefix TRH (Their Royal Highnesses). This loan included a large number of cloaks which, however, were not catalogued at the time in the TRH sequence and are probably now those included in the Q1995 sequence. Other Maori Royal Loans consist of the following: **460** (puppet, 1905 L.1.1), deposited by the Prince of Wales (later King George V); **705** (club, *taiaha*, 1938 L.1.5), brought to Britain by Maori chiefs in 1884 and deposited by King George VI; **10** (model canoe, 1954 L.1.45), deposited by Queen Elizabeth II; and three items presented to the Monarch during Her visit to New Zealand in 1990 (**175**, wood carving, 1990 L.1.1, by Rangi Hetet; **309**, nephrite pendant in carved box, 1990 L.1.2, by Arthur Morten; and **589**, flax-and-feather wall hanging, 1990 L.1.3, by Diggeress Te Kanawa), all deposited by Queen Elizabeth II.

Some of the collections mentioned above are discussed in greater detail below.

Notable collections

Beasley Collection, 1944 Oc.2.

Harry Beasley was born in 1881 and was a wealthy man, having inherited the North Kent Brewery. His collecting interests began during his school years and continued throughout his lifetime, and after his marriage were shared with his wife Irene.

His passion was ethnography: he was a member of the Royal Anthropological Institute, and he was particularly interested in the Pacific. He never collected in the field, but travelled widely in Britain and Europe: visiting museums and establishing contacts with museum curators, collectors and dealers, with a view to possible exchanges of objects.

His collection was such that when he moved to Chislehurst in Kent in 1928, he opened there the Cranmore Ethnographical Museum, with an extensive library and its own publication, *Ethnologia Cranmorensis*, of which four issues appeared between 1937 and 1939. He also published short communications in the *Journal of the Royal Anthropological Institute* and the *Journal of the Polynesian Society*, and in 1928 his major work was published – *Pacific Island Records: Fish Hooks*, with an introduction by T.A. Joyce. This was to be followed by a similar volume on combs, for which Beasley collected material, but this was never completed.

Beasley died in February 1939. His museum was bombed during the Second World War, but the collection survived and was housed for safekeeping at the British Museum. After the war his widow kept some of the collection, but the majority was offered to museums in Britain, with the British Museum having the first choice and the remainder going to museums in Liverpool, Edinburgh, Cambridge and Oxford. The Beasley Collection contains 2,123 Oceanic objects, of which over 170 are Maori or from the Chatham Islands. On Mrs Beasley's death in 1947 the residue of the collection was sold at an auction in Hove. In 1975 Beasley's daughters presented to the Department of Ethnography four volumes of Beasley's original catalogue and two folders (one marked 'Home', the other 'Foreign') of his letters and notes on the museums and collections he visited, together with a folder of the material collected for the planned publication on combs; all these are kept in the departmental archives.

The catalogues are an important source of information about Beasley's collecting in general, as well as about specific objects. When the Beasley Collection was registered at the Museum his catalogues were not yet in the possession of the Department and consequently the information from the catalogues could not be incorporated in the Registers; Register information was copied from Beasley's own labels. Thus the information about the Beasley objects contained in the Museum Register is not complete and must be augmented by searching the Beasley catalogues.

Budden/Angas Collection, 1908.5-13.

This collection, a mixed one that includes Maori objects, was purchased by the Museum from Miss E.S. Budden, who wrote 'I have some South Australian Weapons I am wishing to dispose of – They were collected by George Fife? [French] Angas I think, and given to my father some years ago.' (BM PE correspondence: E.S. Budden, 8 March 1908). George French Angas was a well-known naturalist, artist and writer, the author of several published volumes of illustrations of life in South Africa, Australia and New Zealand. The name 'Budden' appears in Angas's letter to William Hogarth, his London publisher, in which he asks Hogarth to send him some drawings 'through Messrs Bell, Budden & Co., 2 Jeffrey Square, St Mary Axe' (Tregenza 1980: 21). Bell, Budden & Co. were his father's London agents and handled all the Angas wool sales (Tregenza 1980: 22; Angas senior was one of the founders of the South Australia colony, where he had an estate in Barossa Valley).

Although known primarily as an artist, Angas was also a collector. The 1846 London exhibition of his paintings in the Egyptian Hall in Piccadilly also included some Australian and Maori objects (Tregenza 1980: 13), and between 1870 and 1886 he gave a large collection of shells and entomological specimens to the British Museum (now in the Natural History Museum, London). There is also a sizeable collection of molluscan material in the Hancock Museum in Newcastle upon Tyne donated by Angas's wife, Alicia Mary Angas (Kathie Way, Natural History Museum, pers. comm. 21 December 2007). It was probably through the British Museum connection that in 1848 he was appointed naturalist to a Commission which was to establish the frontier between Turkey and Persia and in which the Museum had a special interest (BM central archives: Trustees Minutes, 22 July 1848), but ill health prevented him from participating.

Between 1853 and 1860 he was Secretary of the Australian Museum in Sydney, became an acknowledged expert on Australian conchology, and was a Fellow of the Linnean Society, the Zoological Society of London and the Royal Geographical Society.

In 1911 some Zulu and Maori objects were offered to the Museum by Angas's daughter, Mrs Ada Bruce (BM PE correspondence: A. Bruce, 2 July 1911), but although this collection was purchased and a cheque sent by Read (C.H. Read, 8 August 1911), her name does not appear as vendor on any Museum records and the objects were most likely bought privately by Read.

Christy Collection

Henry Christy was born in 1810 into a banking and textile-manufacturing family, and in the course of business he travelled abroad. It is not clear when his interest in collecting began, but it was probably during his travels, initially on business and later pursuing his own objectives, that he

became interested in ethnography and archaeology. He travelled to the Middle East, where he made a collection of textiles; to Scandinavia, where his friendship with C.L. Steinhauer of the Ethnographical Museum of Copenhagen began; and to America, where he met E.B. Tylor, the father of British anthropology, with whom he travelled to Mexico. He also participated in excavations in France, contributing significantly to the study of European prehistory. In 1861 it was Steinhauer who was engaged to catalogue the Christy Collection, which was published a year later as *Catalogue of a Collection of Ancient and Modern Stone Implements and other Weapons, Tools, and Utensils of the Aborigines of Various Countries, in the possession of Henry Christy*.

When Christy died in 1865 his will instructed his trustees to offer his collection, and a sum of money to maintain it, to an existing institution or to create a new one to house it. One of these trustees was Augustus Wollaston Franks (see below), and there is no doubt that it is thanks to Franks's good offices that the collection was offered to the British Museum. However, due to the lack of space in the Museum in Bloomsbury, the collection remained in Christy's house at 103 Victoria Street, where the public was admitted one day a week, until the early 1880s. In 1868 the *Guide to the Christy Collection of Prehistoric Antiquities and Ethnography*, prepared by A.W. Franks, was issued by the British Museum, fulfilling the terms of the agreement of the 1865 transfer.

At the time of Christy's death the ethnographical component of the collection probably numbered more than 1,000 objects (King 1997: 139), but the sum of £5,000 left by Christy for the development of the collection allowed Franks to expand it enormously. During those years most of British Museum's ethnographical acquisitions were allotted to the Christy Collection and given Christy registration numbers, for reasons of space and no doubt because the Christy Fund allowed for greater freedom in purchases. Consequently, it is often impossible to say which objects were part of the original Christy Collection and which were acquired later.

Cook Collection

The earliest Maori material in the British Museum's collections comes from Captain James Cook's three voyages of exploration of 1768–71, 1772–5 and 1776–80.

In the Museum's Book of Presents of 1756–1823 (BM central archives: Book of Presents vol. I) there are seven entries relating to Captain Cook's voyages. The earliest is dated 18 October 1771: 'A curious Collection of Weapons, Utensils & Manufactures of various sorts, sent from the Hota Hita, and other newly discovered Islands in the South Seas & from New Zealand, made by Captain Cook: from The Lords of the Admiralty.' Two more entries, of 6 October 1775 and of 7 June 1776, are also 'from Captain Cook' (6 October 1775 mentions two collections, one 'of artificial Curiosities from South Sea Islands' from Cook, the other of 'Natural Productions' is from John Reinhold Forster; and the 7 June 1776 collection of 'Natural and Artificial Curiosities' is from 'Captains James Cook and Charles Clerke, and Mr Anderson'). 'A Collection from New Zealand and Amsterdam in the South Seas, consisting of 18 Articles, Domestic & Military, brought by Captain Furneaux: from the Lords of the Admiralty' is recorded on 3 February 1775. Three more collections of 'artificial curiosities' come from various officers and

expedition members: 23 October 1778 from Joseph Banks; 10 November 1780 has two collections, one from Joseph Banks, the other of 'Several natural & artificial Curiosities' is from John Gore, James King, James Burney, Lieuts Philips and Roberts, Gunners William Peckover and Robert Anderson, and Thomas Waling; and 24 November 1780, 'Several artificial Curiosities' from Captain Williamson, John Webber, Clevely, William Collett, Joseph Collett and Alexander Hogg.

All these entries are very general, no number of objects is specified (except for Captain Furneaux's gift of 3 February 1775) and there are no lists stating precisely what was given at what time. The objects thought to have come from Cook's voyages were catalogued much later, by Edge-Partington, in a numerical sequence with geographical prefixes (NZ for Maori material). A.L. Kaeppler has done a great deal of exhaustive research on various collections originating from Cook's voyages and a thorough and concise result of her work can be found in her *Artificial Curiosities* (Kaeppler 1978).

The British Museum has 28 Maori objects for which there is circumstantial or documentary (including pictorial records from or of the voyages) evidence supporting their Cook voyages provenance: 24 objects are eighteenth-century acquisitions and have NZ numbers, 4 objects (**714**, *patu paraoa* St.827; **758**, *patu onewa* 9006; **63**, paddle 1947 Oc.4.1; **478**, *nguru* 5369) came later (of which the last two have been identified only on pictorial evidence). Kaeppler lists 26 Maori items in her *Artificial Curiosities*; missing from her list are the two objects which were identified later on the basis of pictorial evidence.

It is likely that among the NZ-numbered objects there may be others, apart from those 24 mentioned above, which could have been collected on Cook's voyages. These may include two donations of 1777: 'Several Utensils, Manufactures, etc. from Otaheite and New Zealand: from Thomas Pell Esq. of Wellclose Square', of 12 September, and 'Two Oars from New Zealand, and a Flint formed like a Pear: from Mr Charles Smith of Woolwich', of 24 October, as well as 'A large Collection of natural and artificial Curiosities' presented by the Royal Society on 15 June 1781 (Banks was its President, so the collection could have included Cook pieces) and 'An Ornament used by the Chiefs in New Zealand: from Governor King [Philip Gidley King, Lieutenant-Governor of Norfolk Island and between 1800 and 1806 Governor of New South Wales; the object was probably collected during his ten-day visit to New Zealand in November 1793]' presented on 8 July 1797. Unfortunately, no objects from these collections can be identified at present, although some of the eighteenth-century pieces in this catalogue may have Cook provenance. There is still a great deal of work to be done on the British Museum's Cook Collection, similar to that done by J.C.H. King for the British Museum's Cook material from the Northwest Coast of America collected on the third voyage (King 1981).

Four objects which are not of Maori craftsmanship, but which have Maori and Cook voyages associations are **836**, **2335–2337** (axe *patiti* 1854.12-29.20, bronze *patu* 1936.2-6.1, and two iron *patu*, 1944 Oc.2.821 and 822).

Edge-Partington Collections, 1913.5-24. and 1915.2-17.

James Edge-Partington was a leading private collector of, and an authority on, Oceanic material culture. He was born in 1854 into a prosperous Manchester family and qualified as a solicitor, though he never practised. In 1879 he embarked on a

three-year voyage in the Pacific which resulted in the private publication of an account of his travels as *Random Rot* in 1883.

Soon after, he began his next work, a collection of drawings of Pacific objects from museums and private collections, which he eventually published with his friend Charles Heape as *An Album of the Weapons, Tools, Ornaments, Articles of Dress etc. of the Natives of the Pacific Islands*: the first two volumes in 1890, the third in 1895.

Two years later he went on another voyage to the Pacific, and after return published the final volume of his *Album* in 1898. The *Album*, his *magnum opus*, has become the bible of Pacific material culture for generations of museum curators and Pacific scholars, and is still used widely today. He started his own collecting while on his Pacific voyages, but continued throughout his life, buying at sales and from other private collectors.

It was during the preparation of the *Album*, after his first Pacific travel, that he became closely involved with the British Museum. Franks wrote in 1891 that in return for help with his work on the *Album*: '… Mr Partington … for some months past devoted the two students days in the Department (the only days on which such work can be done) to labelling the South Sea specimens.' (BM central archives: Report to the Trustees, 6 October 1891). Three years later Franks asked the Trustees for money 'for occasional assistance in the Ethnographical section', some of which was expressly meant for Edge-Partington: 'For some years… Mr J. Edge Partington has been constantly helping the Department in superintending the arrangements of the Ethnographical specimens, especially those of the Pacific races, with which he is so well acquainted … he has made a practice, for some years past, of coming to the Museum on the two students days, and giving any assistance he can in the Ethnographical Section; and he has even, on occasion, been good enough to go into the country to examine collections offered to the Museum, a great saving of the time of the officers. Mr Partington would have made a most excellent Assistant in the Department, but though not rich, he is a man of independent means, and prefers to live in the country, and the constant official attendance would not have suited him.' (BM central archives: Report to the Trustees, 5 October 1894). After this glowing introduction, he asks for £1 per day, with the annual total of Edge-Partington's working days being envisaged as 70 or 80. He adds that this proposition is entirely his own and that 'Mr Partington has no knowledge that any such plan is in contemplation.'

Edge-Partington's work at the Museum was indeed of considerable importance. His duties, apart from those mentioned by Franks, included the creation of registration Slips for objects which were at the Museum at the time, but had lost their provenance, and were thus catalogued with a geographical letter prefix, e.g. the NZ number sequence for Maori objects from New Zealand: 'Partington is cataloguing our New Zealand collection' (BM PE correspondence: C.H. Read to E.H. Giglioli, 20 April 1896). His relationship with the Museum senior employees, especially with Read, was a close one, as his letters written to Read from his second Pacific journey testify. He occasionally gave objects to the Museum and when around 1912 he decided to sell part of his collection, the Museum was given first refusal, as is clear from an unsigned letter, presumably written by Read to F. Kenyon, the Museum's Director and Principal Librarian:

Mr J.E. Partington who has worked here for many years past, has a large ethnographical collection, the nucleus of which was formed during his travels in the Pacific. He is now removing from his house and is in the process of packing up such portions of the collection as he proposes to keep. The rest he proposes to sell and offers to let us have a selection, to be made by ourselves, at a reasonable price. It seems to me that we would do well to take advantage of this opportunity, and I am therefore proposing, if you approve, that Joyce should go down to Winchfield and make the selection as Museum business on the usual official lines.
(BM PE correspondence: C.H. Read?, 11 January 1912)

Joyce's selection resulted in two collections purchased by the Museum in 1913 and 1915, which included 13 Maori items.

It is not clear when Edge-Partington stopped working at the Museum, but he was still selecting objects for the Museum in 1914 (BM PE correspondence: J.S.Udal, 6 May 1914). In 1924 he finally sold his collection to the Leys family in New Zealand, who purchased it for the Auckland Museum. He died in his home in Beaconsfield in 1930.

A full account of Edge-Partington's life and his collecting activities is given in Neich's 'James Edge-Partington (1854–1930): an ethnologist of independent means', *Records of the Auckland Museum 46*.

Franks Collection

Augustus Wollaston Franks was born in 1826 into a prosperous and well-connected family with traditions of collecting. He was educated at Eton and Cambridge, after which he worked for the Archaeological Institute, where he was involved in the organization of the Medieval Exhibition of 1850. A year later he was appointed to the British Museum as an Assistant responsible for the British and medieval collections within the Department of Oriental Antiquities. When in 1866 these collections became a separate department, Franks became its Keeper, the post which he held until his retirement in 1896.

He was a passionate collector, and although initially his interests were primarily those of a prehistorian and medievalist, some years after joining the British Museum they began to extend to ethnography, spurred perhaps by the 1855 Admiralty's gift of the Haslar Royal Naval Hospital Collection, which consisted mainly of ethnographical objects (Wilson 1984: 31). He collected widely and, being a well-off man of independent means, used his own money to buy objects to present to the Museum. It was also thanks to his foresight, influence and connections that in 1865 the Museum acquired the Christy Collection (see above) – the largest ethnographical collection in existence at the time. The acquisition of such a large collection was probably not unconnected with the creation, a year later, of a separate department, and as its Keeper Franks could indulge fully his ethnographic interests.

During his life he was member of various learned societies, including the Ethnological Society and later its successor, the Anthropological Institute, and was author of numerous publications, although very few of them were on non-European subjects. He maintained close contacts with museums, scholars and collectors in the country and abroad, and through these professional and social contacts he could influence potential donors and vendors to offer objects to the Museum on favourable terms. He also actively encouraged collecting for the Museum, aiming for a comprehensive range of objects. In 1891 he wrote to Sir C. Euan Smith:

We are rapidly forming an important ethnographical collection here, as a necessary adjunct to the productions of more civilized

races … Our Morocco section is very poor indeed, and I am writing to ask if you would be willing to help us in this direction in that country, if an opportunity should occur. Specimens such as we most care for are but seldom brought home by ordinary travellers, as they are but rarely of any beauty, and are in general the commonest things of the country.

(BM PE correspondence: A.W.F. Franks, 26 May 1891)

He travelled widely, although only in Europe, and made meticulous notes, with accomplished sketches, about collections he visited, and Franks's notebooks, and those of his assistants, are still a source of valuable information (Caygill and Cherry 1997: 347–51). At the same time, he was a hard-working museum curator engaged in arranging displays and registration of objects. It was Franks who introduced the Slip registration system, as he reminisced in 'The Apology of my Life' (Caygill and Cherry 1997: 318–24) written in 1893: 'I instituted the slip catalogue of the collection with a sketch of each specimen, which is still continued at my own expense as for some years I have provided a draughtsman.' (Caygill and Cherry 1997: 320).

Franks's whole life was dedicated to the Museum and his importance to its growth and to the expansion of the collections cannot be overemphasized: it would be no exaggeration to consider him as one of the founders of the British Museum. Ethnography is especially indebted to him. At the time when the ethnographic collections were not particularly highly regarded among the Museum's curators, he was their champion.

When Franks joined the Museum in 1851 the ethnographic collections probably consisted of about 3,700 objects; when he retired in 1896 their number was over 38,000 (King 1997: 136), including about 7,000 objects presented by him personally.

Grey Collection, 1854.12-29.

The Grey Collection consists of over a hundred Maori objects and includes many important pieces presented to Sir George Grey in his role as the Governor of New Zealand in the years 1845–53, some of them named pieces of historical importance.

It seems Grey was uncertain about the legal status of these objects and that he wrote to the Colonial Office to have it clarified. The reply, dated 12 June 1854, gave him a full legal right to the collection:

I am directed by the Duke of Newcastle to acquaint you that His Grace received your Despatches written from New Zealand … transmitting Addresses from Native Chiefs together with a description of their Heir Looms which had at the same time been presented to you, and requesting instructions as to the manner in which those presents should be disposed of. In reply I am directed to acquaint you that considering the peculiar nature of these presents His Grace feels no difficulty in authorizing you to retain them.

(National Archives, PRO: CO 406/14f. 67v).

A few months later the collection was presented by Grey to the Museum and was soon on display. The *Synopsis of the Contents of the British Museum* (1856: 267) described them with respect:

A case containing hereditary relics of the New Zealanders. These objects have all proper names of their own by which they are individually distinguished, derived from their former possessors, and were preserved with great care by the warrior tribes to which they belonged. An account of them is appended to each article. Presented by his Excellency Sir George Grey K.C.B., late Governor of New Zealand.

In 1870 Grey made several visits to view the Christy Collection at Victoria Street (BM AOA Archives: Visitors Christy Collection, 1866 – Sept. 1880) and his comments on Maori objects are recorded in Franks's notebooks (BM AOA archives: Franks Ethnographic Notebook SS2).

Some objects from this collection, and their history, are described in Charles Oliver B. Davis, *Maori Mementos: Being a Series of Addresses, Presented by the Native People, to His Excellency Sir George Grey*: **274** (*hei tiki*, 1854.12-29.12), **324** (pendant *kuru*, 1854.12-29.18), **325** (pendant *kuru*, 1854.12-29.19), **355** (pebble pendant, 1854.12-29.17), and possibly **609** (dart, 1854.12-29.117), although this last one is questionable; four cloaks, **1781**, **1806**, **1831** and **1832** (1854.12-29.132 –5) may also have come from the same context.

In 1855 Grey added to the collection a pendant *kuru* (**329**, 1855.5-14.1) that had been left behind when the collection was being packed, and in 1868 four flake knives (**1647** to **1650**, 5074–7) were also added.

Higgins/Turvey Abbey Collection of 1904

This collection was formed originally by John Higgins, and included some Cook pieces. John's wife, Theresa Higgins, nee Longuet, whom he married in 1804, was one of the purchasers at the 1806 sale of the collection of Sir Ashton Lever, which included a great number of objects collected on Cooks' s voyages (Kaeppler 1979: 180). John Higgins's collection was inherited by his son, Charles Longuet Higgins, who was interested in natural history and museums, but he died without issue in 1885 and his relations decided to dispose of it in 1904.

The first evidence of the Museum's interest in this collection appears in 1890, when Franks wrote to Thompson (Principal Librarian and head of the British Museum at the time):

I mentioned to you a short time ago that Mrs Higgins [Gertrude M. Longuet Higgins, not to be confused with Theresa Longuet Higgins mentioned above] of Turvey Abbey, Bedfordshire, a daughter of my old colleague Thomas Burgon, & sister to Dean Burgon, has a collection of ethnographical objects likely to be interesting as collected a long time ago. Mr Partington, who has been working for some time on our ethnographical collections, has arranged to go to Turvey Abbey on Tuesday next, & I have suggested that Read should go with him. Read would have been willing to take this time as vacation, but as I think he will be doing good work for the Museum I think his absence should count as Museum business.

(BM PE correspondence: A.W. Franks, 31 May 1890).

Thomas Burgon was a merchant and an enthusiastic amateur collector who, after his business failed, was employed as supernumerary assistant in the Department of Antiquities of the British Museum between 1844 and 1858, and it was undoubtedly through him that the collection was brought to Franks's attention. However, it seems nothing happened at the time – there are no more letters about it in the Museum's correspondence – until fourteen years later the collection is mentioned again, this time by Charles Heape, Edge-Partington's collaborator on his *Album*, in a letter to Read, introducing Mr Longuet Higgins of Turvey Abbey, who wished to dispose of his collection of ethnographical specimens (BM PE correspondence: C. Heape, 31 March 1904). Edge-Partington was again involved, this time in the arrangements for the purchase of the collection, for it was he who discussed things with Mrs Longuet Higgins when she came to the Museum while Read was away, and he made a valuation of the objects selected by Read, in addition to that made by Read himself; as it happened, the two valuations were 'very nearly the same' (BM PE correspondence: C.H. Read, 19 April 1904 and 23 November

1904). There are only seven Maori objects in this collection, but one is of special interest: **582**, figure container 1904-245, an unusual eighteenth-century piece carved with stone tools.

Three years later the rest of the collection at Turvey Abbey was sold, as Mrs Gertrude M. Longuet Higgins informed Read:

> It has just occurred to me that you may be interested in the sale that is taking place tomorrow morning at 12.30 at Mr Stevens' Auction Rooms… as they are going to sell for us then the bulk of the South Sea Island implements & weapons that you saw… I wonder if the 'Nation' would not like to buy some more of these interesting things…
>
> (BM PE correspondence: G.M. Longuet Higgins, 4 June 1907)

It seems that in this case the 'Nation' was either not interested or could not afford to buy.

Lady Sudeley Collection, 1894.7-16.

This small collection of architectural carvings was made in New Zealand, probably between 1850 and 1873, by the Hon. Algernon Tollemache, Lady Sudeley's uncle (AOA correspondence: Sir Lyonel Tollemache, 18 April 1996). In the Museum's list of 'Purchases Recommended' the Sudeley purchase is annotated: 'from a pah in the Bay of Plenty'.

Both Franks and Read were aware of the existence of this collection well before it was offered for sale. Edward Hussey of Scotney Castle wrote to Franks:

> You some time ago expressed an interest in the fate of the wooden images which Mr Algernon Tollemache brought from New Zealand to Ham House where you saw them. At his death they passed into the possession of Lord Sudeley and I now hear that he wishes to sell them so if you have any desire to acquire them for the British Museum I can get you further particulars from a relative of his.
>
> (BM PE correspondence: E. Hussey, 11 June 1894)

And a month later, Franks to Lady Sudeley: 'My friend and colleague Mr Read has returned and we have consulted over the New Zealand carvings, of which he took notes in 1876.' (BM PE correspondence: A.W. Franks, 7 July 1894). In her letters Lady Sudeley says: 'I part with them reluctantly because they were collected by my uncle…' and 'I should like to keep the carving of which you say there is a duplicate…' (BM PE correspondence: Lady Sudeley, 9 July 1894 and 14 July 1894). This 'duplicate' which Lady Sudeley retained was a lintel, as Franks explained: 'The specimen will probably be one of the horizontal pieces, either the one with two figures and scrolls between, which I valued at £10 or the other [schematic sketch of a lintel with two large spirals]. All the others were upright pieces, and therefore more easy to accommodate.' (BM PE correspondence: A.W. Franks, 16 July 1894).

Liversidge Collection, 1928.1-10. (Eth.Doc.921)

This collection was formed by Archibald Liversidge FRS, Professor of Chemistry and Mineralogy at the University of Sydney. After his death it was bequeathed to the British Museum by his executor, Rear-Admiral E.W. Liversidge; the minerals part of it went to the British Museum of Natural History in Kensington (now the Natural History Museum), and worked implements were passed to Braunholtz at the British Museum for the ethnographical collections.

In New Zealand, Liversidge stayed with the local and rather eccentric collector of Maori lore and artefacts, John Webster, at his large Hokianga Harbour establishment, where he collected some of the stone tools.

Many of these implements were published in 1894 by Liversidge himself as 'Notes on some Australasian and other stone implements' in the *Journal of the Royal Society of New South Wales* 28.

London Missionary Society (LMS) Collection

This Protestant Missionary Society was formally established in 1795 and adopted the name of the London Missionary Society in 1818. During the initial period of missionary activity in the Pacific many native religious and ceremonial objects were destroyed under the missionaries' influence. Later, such objects and other specimens of native crafts were collected by the missionaries as proof of the successful conversion of the local people to the new faith and their rejection of the old ways, and were sent back to London, where a museum was established to house them. A catalogue of this collection was published in 1826.

The British Museum began to be interested in the LMS Collection in the early 1880s, during Franks's Keepership. In 1883 Franks wrote to Ralph Wardlow Thompson, the Foreign Secretary of the LMS, suggesting that the collection be transferred to the British Museum (BM PE correspondence: A.W. Franks, 21 August 1883). The Society, however, did not wish to dispose of the collection outright and an agreement was reached to place the collection on permanent loan, in spite of Museum policy not to accept loans: obviously an exception was made in view of the importance of this collection. Soon after, some objects from the collection went on display in the ethnographic gallery and in 1911 the collection was purchased by the Museum, paid for partly from the Christy Fund, partly from the Museum's own funds, the negotiations concluded by Read, Franks' successor.

The loan collection of 1890 consisted of about 230 artefacts from various parts of Polynesia (some material was acquired later from the Society, e.g. a collection from New Guinea in 1894). As New Zealand (where the Church Missionary Society from 1814, and the Wesleyan Missionary Society from 1822, were both active) was outside the London Missionary Society's sphere of influence, Maori objects form a small part of this collection, comprising fewer than 30 artefacts. Some of these were probably collected during the tour of the Pacific mission stations by a deputation consisting of Daniel Tyerman and George Bennet in 1821–4; others may have been added later. In July 1824 the deputation stopped for a few days in Whangaroa Bay and the *Journal* of the deputation's travels records: 'The commerce in various articles, on both sides, went pretty well for some time … Up to this time we had been in friendly intercourse with the chiefs, rubbing noses, and purchasing their personal ornaments and other curiosities…' (Montgomery 1831: 132). One object which can be definitely attributed to this visit is **828** (short club *patu rakau*, LMS 153) which is inscribed in black: 'New Zealand club. Marihurue. July 1824. Geo Bennet'.

Maggie Papakura's storehouse, 1933.7-8.1

This storehouse was presented to the Museum without any documentation in 1933 by Mrs Todd. At some stage it was disassembled, and during the 1970s inventory its individual parts were given Q numbers. In 1990 these were eventually identified by Roger Neich as forming a complete storehouse, carved by Tene Waitere, with a known history.

It was carved in 1910 for a model Maori village erected in Clontarf, Sydney, under the leadership of Maggie Papakura, the well-known Rotorua guide (she was the Duchess's guide during the 1901 visit of the Duke and Duchess of Cornwall and York to New Zealand) and Maori scholar. The village was later shipped to London for the Coronation of George V in 1911 (Dennan 1968: 51–3), where it was included in the Coronation Exhibition in White City and the Festival of Empire in Crystal Palace, both exhibitions concurrent from May until October (C. Ross, Museum of London, pers.comm. 19 June 2007). At the time Fuller wrote to Joyce:

> I do not know whether you have met the Maoris who were at White City, & are now at the Crystal Palace, but they are very well worth seeing. Yesterday we had one or two to see the collection & the leader of the company – Maggie Papakura – was very interested. She is returning to N.Z. in about a month, but is coming back to this country for good. She told me she has a very fine collection of Maori specimens in N.Z., & that as she was leaving, she thought of giving them to a Museum. I, of course, strongly pressed the claims of the British Museum, & I think you may get something. One thing she is thinking of giving, is a unique jade fishhook, – completely of jade. Another is a Patika [sic] (food house) which is at present at White City. It is a very nice one & valuable, & would make a nice addition, if you could secure it. I think she would much like to meet you, & I should say that, if she has a good collection, she may prove a valuable friend to the Museum. I believe she is leaving this neighbourhood at the end of the week, so no time ought to be lost. Would you care to come down to dinner one evening – say Thursday or Friday, – & I could then introduce you & we could see the performance, which is quite different from that at the White City.
> (BM PE correspondence: A.W.F. Fuller, 8 October 1911)

Maggie Papakura's visit is mentioned again in another letter to Joyce:

> As you said you had not heard, or seen anything, of Miss Maggie Papakura, I thought it about time to give her a reminder as to the Pataka, & I accordingly asked her for this afternoon. She came with two other people, & said she has not had time to go to the Museum but was certainly coming up soon to see you.
> (BM PE correspondence. A.W.F. Fuller, 29 October 1911)

Whether Maggie Papakura did come to the Museum is not known; there are no more letters referring to her.

The gift of the storehouse was recorded by the Museum in June 1933 (BM central archives: Book of Presents, 1933, item 1631) as coming from 'Mrs Todd, Lessness Park, Abbey Wood SE2'. Coincidentally Mrs Todd, this time recorded as 'Mrs George Todd', also of Lessness Park, appears as the donor of a Maori fish-hook (1032, 1944 OC.2.176) in the Beasley Collection, registered by him in June 1933. Consequently, it would seem that the two donors are one and the same person. However, a search in the local archives of the area where Mrs George Todd had lived revealed that according to the 1901 census George Todd, Actuary Life Assurance, and Beatrice Todd lived not in Lessness Park but at Preston Lea, Woolwich Road (they were still there during the 1911 census; later census data are not available). Lessness Park was a large Victorian house in Woolwich Road belonging to a wealthy Gray family, of which the last owner, Miss Bethia Aitken Gray, died in April 1933 (Bexley Local Studies & Archive Centre, pers.comm. 20 February 2009). After her death the contents of the house, Lessness Park, were sold at a local auction on 4–5 July of the same year; there is no mention of the storehouse in the auction catalogue, although a few exotic objects are included. According to the Register of Electors 1932 (in force 15 October

1932 to 14 October 1933) for this area there is no George Todd living there, but the name Todd appears in Miss Gray's will: Captain Alfred John Kennett Todd is one of the executors, and his wife, Edith Mary Todd, is one of the beneficiaries and Miss Gray's niece. A.J.K. Todd was a Member of Parliament in the 1930s, and his grandson, Mr Mark Todd, also an MP, has been able to provide the conclusive evidence that the storehouse indeed came from Lessness Park:

> … he [A.J.K. Todd's son and Mr Mark Todd's father, Mr Matthew Todd] remembers the storehouse. He describes it as about 4 ft tall and maroon… It was kept in a relatively neglected part of the huge garden… The Mrs Todd who made the donation would have been my grandmother, Edith Mary Todd, the wife of AJK Todd. She would have been dealing with the house contents as the wife of one of the executors, my grandfather and the closest relative of Bethia.
> (Mark Todd, pers.comm. 29 July 2009)

What happened to the storehouse between the 1911 Coronation Exhibition and its presence at Lessness Park in 1933 is still a mystery. Mr Mark Todd speculates that it might have been acquired by the Gray family through their business connections, spread over many countries, which probably included New Zealand; and Mr Matthew Todd confirms this. And what about 'Mrs George Todd, Lessness Park' recorded in Beasley's catalogue? It seems pretty obvious that Beasley's Mrs Todd and the Museum's Mrs Todd must be one and the same: the same surname, the same address, the nature of donations (the Beasley one consists of five Oceanic objects, three of them Maori ones). However, Mrs George Todd recorded as living at Preston Lea in 1911 must be discounted, because although her husband, the actuary George Todd, was related to Alfred John Kennett Todd, both she and her husband were dead by 1920 (Mark Todd, pers.comm. 11 August 2009; Matthew Todd, pers. comm. 16 September 2009); in fact Mr Matthew Todd is quite firm that 'No Mrs George Todd related to me was involved in the disposal of Lessness Park in 1933' (Matthew Todd, pers. comm. 16 September 2009). The conclusion therefore must be that Beasley simply made a mistake in writing down the name, and that it was Mrs Edith Mary Todd, on Miss Gray's death on 13 April 1933, who decided to dispose of ethnographic objects before the sale of the contents of Lessness Park in July 1933.

Meinertzhagen Collection of 1895 (Eth.Doc.836)

Frederick Huth Meinertzhagen was born in 1845 into a prosperous and well-connected banking family. His German father, Daniel, came to London in 1826 from Bremen, to seek his fortune, and joined the banking house of Frederick Huth, eventually marrying his daughter Amelia (the Huth family were collectors of books, manuscripts and pictures – J.C.H. King, pers.com. 19 November 2007). After private schooling, Fritz, as he was known among his family and friends, emigrated to New Zealand in 1866, where he took a lease on land in Waimarama, Hawke's Bay, in partnership with his school friend, Walter Lorne Campbell, and married Ellen Moore, daughter of a Christchurch doctor. Campbell died suddenly in 1874 and was succeeded as Fritz's partner by Fritz's brother-in-law, Thomas Richard Moore. In 1881 Fritz took his entire family to England – his wife, five daughters and an adopted Maori son, Tame Turoa Te Rangihauturu. But on arrival at Liverpool a disaster struck – his wife, two of his daughters and the Maori son died of scarlet fever. Fritz never recovered from this tragedy, and it is not clear whether he ever returned to New Zealand, where eventually his daughter

Gertrude continued to farm. Meinertzhagen died at Tunbridge Wells in 1895 and in the same year his collection, the largest single Maori collection at the Museum, consisting of over 600 items and including other Pacific material, was sold by Gertrude to the British Museum.

These scant facts about Meinertzagen's life are given in Richard Meinertzhagen's (1964) *Diary of a Black Sheep* and Sydney Grant's (1977) *Waimarama*, both of which mention Fritz's collecting only very briefly, although Grant gives a detailed history of his farming activities in Waimarama and later those of Gertrude. It is Walter Lorne Campbell's unpublished journals (volumes 1–3 and 6–12, covering the period 1 January 1862 – 31 January 1863 and 1 March 1866 – 10 July 1874; volumes 4 and 5 are missing) which flesh out this elusive figure and throw some light on Fritz's collecting passion (his collection came to the Museum without any accompanying documentation). Apart from Campbell's journal, the only other documentation about Meinertzhagen that could be traced consists of his incomplete laconic diaries for 1867 and 1874 in the Canterbury Museum, Christchurch[I] and a few letters to von Haast, dated 1875–9, in the Alexander Turnbull Library in Wellington (MS-papers-0037-119).

Meinertzhagen and Campbell were friends since their early days in a private school, the Mr Thomas James Scale Academy, Wellesley House, in Twickenham near London, in which they spent five years, leaving in December 1862. It is obvious from Campbell's journal that it was a close friendship, the families knew each other, the boys visited each other's houses and spent a lot of time together, and wrote letters when they were in their respective family homes, Fritz in London, Walter in Carmyle near Glasgow. It was during those school years that Fritz's collecting began, although at that stage it was mainly natural-history specimens. Walter writes about a lunch with Fritz's mother and sister 'and then Fritz showed me his curiosities' (Campbell: 15 March 1862), and two days later they go 'to town to buy sand and a bath for Fritz's birds' (Campbell: 17 March 1862). In the same year there are several mentions of their collecting expeditions, for example: 'Went to Richmond with Fritz in the afternoon, and to Langley Park in the evening, where we got some moths, 2 of which are rather rare; I had the pleasure of seeing them first, which is rather difficult as Fritz has eyes like a weasel.' (Campbell: 10 May 1862).

What prompted the two young men to try their luck in New Zealand remains a mystery because the part of Walter's journal which would probably provide the answer is missing, but in March 1866 their plans are well under way: 'Got a letter from Fritz saying that his Father consents to the New Zealand plan.'; 'Got a letter from Fritz saying that <u>both</u> his parents consent to our plan. Wrote to him. Our plan looks very <u>real</u> now – I think it will be charming if it succeeds.' (Campbell: 12 March 1866; 13 March 1866). After preparations, shopping in London and family farewells, they left aboard *Sir Ralph Abercrombie* from Gravesend on 31 May and landed in Lyttleton on 5 September. They spent the next two years getting to know the country and sheep-breeding business, staying with friends and travelling, sometimes together, sometimes separately, and prospecting for land, during which time Fritz did not neglect his collecting. 'Fritz found a lot of veritable <u>Moa</u> bones amongst the limestone – not fossil, but real bones.' (Campbell: 1 October 1866); 'Fritz has got a good lot of moths & butterflies while in Nelson,

also a greenstone hatchet.' (Campbell: 15 January 1867). And Fritz himself: 'Found a piece of greenstone this morning, just begun to be worked for an axe.' (Canterbury Museum. Manuscripts Collection. ARC 1998.4. 1: 13 April 1867). After getting to Rangiora he 'instantly commenced bargaining with the proprietor of the Accom. Ho. for two Fijian clubs he had. He wanted £2.10 for them but I beat him down to 30 shillings very soon.' (ibid.: 14 April 1867). In Christchurch: 'I walked about this evening with little Dapper (who gave me a Maori cartridge box) [perhaps **840**, cartridge box 1895-415, although the date of 1869 given on the label pasted on the box seems to contradict it]…' (ibid.: 20 April 1867). At Lake Forsyth he came across an abandoned *pa* (fortified village): 'There were lots of nets made out of flax, which I felt very inclined to pocket, but didn't, I am happy to say. I found some spears also, made out of some very hard wood but they were too large to carry away.' (Canterbury Museum. Manuscripts Collection. ARC 1998.4.2:17 May 1867).

Finally in 1868 Meinertzhagen and Campbell took possession of Waimarama: '…having landed in Napier on the 27th July 1868 – I am now a full blown squatter & am going to take possession of the Waimarama station – The firm is to be Messrs Campbell & Meinertzhagen. Fritz had got married in the meantime…' (Campbell: note after 8 May 1867; there is a gap in the journal between 8 May 1867 and 30 July 1868), and Fritz and his wife arrived in Waimarama in October. While getting things organized on their station, Fritz did not neglect collecting: 'Fritz, his wife & I walked up to Monaghan's … On our way back we looked for curiosities at a place where there had been a great massacre & cannibal feast. I picked up rather a good jaw-bone & Fritz found an ear-ring of black jade [probably **365**, nephrite pendant 1895-656].'; 'Fritz & his wife went out for a walk, Fritz got some specimens of obsidian & shot a brace of grey ducks.' (Campbell: 31 January 1869; 11 February 1869). Fritz and Walter ran the station together, but one gets the impression from Walter's journal that it was he who carried the heavier burden (Fritz was frequently away), although there is not a trace of resentment on his part. Fritz continued his collecting and took interest in the local Maori, and they were both learning the language: 'Fritz & I worked at Maori grammar for a bit in the evening & then overhauled Station Accounts.' (Campbell: 9 August 1869); 'Fritz has taken to skinning birds & does them very well. …Arapiu came over to see Fritz about some Maori Axes that he has been making handles for.' [probably **1255** to **1260**, hafted adzes 1895-438 and 1895-864 to 868] (Campbell: 3 October 1869); 'Fritz unpacked his celebrated box of Auckland curiosities. His Mere "poenammoo" is lovely.' [probably collected when Fritz took his wife for confinement in Auckland in July where their daughter Gertrude was born but the present Meinertzhagen Collection at the Museum does not include any nephrite club]. (Campbell: 13 October 1869). They also got themselves tattooed: 'Both my tattoo & Fritz's are healing rapidly, I have had our crest & arms done on my chest … Fritz has had a Maori device put on his shoulder – The Natives did it, & very well, too.' (Campbell: 1 July 1870).

In July 1870 Fritz, with his wife and young daughter Gertrude, left for England, to raise funds for their farming venture, and there they stayed until late 1871. Fritz's mission was accomplished successfully, but their return was delayed by the arrival of another daughter. While in London

Meinertzhagen came to the British Museum, met Franks, looked at the Museum's Maori collections and made some general comments about various types of objects. These are recorded in Franks's notebooks under the name 'Mr Meinenhausen' (*sic*) under the dates 7 December 1870 and 9 December 1870 (BM AOA Archives: Franks Ethnographic Notebook SS2). He also visited the Christy Collection at Victoria Street on 9 December 1870 and 9 January 1871 (BM AOA Archives: Visitors Christy Collection, 1866 – Sept. 1880) and on 31 December 1870 presented to the Museum a pair of sandals, samples of flax and kauri gum and a collection of obsidian flakes (respectively, **1953**, 7012; **2032**, 7013; **2033**, 7014 and **1691**, 7015, where his initials are recorded in the Register incorrectly as 'J.H.'). At the same time he must have shown Franks and others some of his own 'curiosities', for Campbell writes after Fritz's return: 'Showed Fritz all the changes & improvements that have taken place since he left. Went down to the beach & he at once began to pick up chips of obsidian. He says his collection of stone adzes was very much prized at home – All the big wigs were in raptures about that big Okai Hau axe [perhaps **1531**, Hawke's Bay-type adze blade 1895-832].' (Campbell: 24 February 1872).

After Fritz's return in January 1872, it was Walter's turn to take a break at home. He left in May 1872 and returned in February 1874. We can tell Walter also acquired the collecting bug: there are several mentions of it in the journal and he brought home some items: 'We unpacked all my curiosities which were very much admired by all the dear people…' (Campbell: 12 September 1872). He also gave some objects to museums: 'I went to Edinburgh by 10.35 train … Went to the Antiquarian Museum & saw my Maori axe in a very good position among the stone weapons.' (Campbell: 27 June 1873). 'Went to Edinburgh by 10.35 train. Took my carved Maori image to the Antiquarian Museum. Mr Anderson, the Curator, was very much pleased with it.' (Campbell: 11 July 1873). This image is illustrated on the cover of Dale Idiens's (1982) *Pacific Art*. During his stay in Britain he frequently visited the Meinertzhagen family, of whom he writes very warmly in his journal, and kept in constant touch with Fritz. On his return he writes: 'Fritz has changed a good deal in the last two years. He looks very healthy & sun-burnt & his beard has grown enormously. It is very jolly seeing him again & makes the return to this miserable place much more bearable.' (Campbell: 17 February 1874). At Waimarama a new house had been finished and Fritz's family had increased by a third daughter.

In 1874 Fritz went away again (and this period, from 27 March to 27 May 1874, is recorded in his own diary), first sightseeing around Taupo and Rotorua, and never forgetting his collecting: 'Mooned about Ohinemutu & bought Maori curiosities.' (Canterbury Museums. Manuscripts Collection. ARC 1998.4.4: 5 April 1869? [1874]), then embarking on a trip to Fiji – where he also collected whenever there was an opportunity. At Navuso on the river Rewa on Viti Levu: 'Stayed at a house 80 feet long 50 feet wide and about 50 feet high.'; the following day: 'The other gentlemen all started this morning to go further up the river, but I, seeing signs of very good implements etc. about the place, thought I would stay on & see what I could get … I have been well repaid & have got more than ever I expected & than our boat will carry, I am afraid.' (ibid.: 4 and 5 May 1869? [1874]). On his return to Waimarama, Walter writes: 'Fritz looking very well – he says

he has enjoyed his trip immensely. He and Agnew Brown [a farmer near Gisborne, well thought of by the local Maori and depicted in a carving in the meeting house Te Mana o Turanga at Manutuke for helping them with a supply of timber for the building] were about 5 weeks at Fiji & saw a good deal of the Islands.' (Campbell: 29 May 1874). Life in Waimarama continued as usual, and the last entry in Campbell's journal is on 10 July 1874, where he writes about fishing with Fritz, letters from home and the work going on at the station; seven days later, on 17 July, Walter died suddenly while floating rafts of timber down the Tukituki River. His death was recorded as due to natural causes, and he was buried in the Napier cemetery (Grant 1977: 46).

Without Campbell's diaries, the information about Meinertzhagen's later life largely dries up. Soon after Walter's death, Meinertzhagen took on a new partner in Waimarama, his brother–in–law Thomas Richard Moore, who eventually became the de facto manager of the farm and Meinertzhagen gradually less active in its affairs (Grant 1977: 47). It is very likely that he concentrated more on his intellectual pursuits and collecting. He was a member of the Hawke's Bay Philosophical Society, the Hawke's Bay Agricultural and Pastoral Association and the Acclimatization Society (Grant 1977: 102), and in 1879 he had a paper published in the *Transactions and Proceedings of the New Zealand Institute*. He corresponded with Sir Julius von Haast, Director of the Canterbury Museum in Christchurch, with whom he exchanged specimens (BM AOA: Eth.Doc.836, R. Fyfe letter, 7 May 1996) and to whom he reported on his searches: 'I found nothing with the skeletons with one exception. With that one I found a large Mesodesma shell which had evidently been used to hold red ochre – the color still remaining in the shell [probably **194**, shell for mixing ochre, 1895-751] & fragments of the conventional "Tiki", carved on a piece of whalebone.' (Alexander Turnbull Library. MS-Papers-0037-119: 19 May 1876). In his searches he was accompanied by his wife: 'I think I can get you one more perfect human skeleton but, as my wife is the discoverer, I will not guarantee it till I see myself, though almost all the others were also discovered by her.' (ibid.). He also knew Augustus Hamilton, who mentions him in his diaries and in 1886 visited Waimarama – Meinertzhagen was not there, but Moore told him that he had given permission for Hamilton to take whatever he wanted from his room – mainly natural history specimens are mentioned (BM AOA: Eth. Doc.836, E. Pishief letter, 21 October 1997). Edge-Partington, while on his travels, wrote to Read from Auckland in 1897, two years after the Museum bought Meinertzhagen's collection:

> I am… in the thick of it here & have come across Mr Hamilton who knew Meinertzhagen well & has sketches of most of his things so we shall be able to get I think right descriptions for all specimens. The two fish hooks with the moa bone backs [probably **1193** and **1194**, composite trolling hooks, variant *pa kahawai* form, 1895-408 and 1895-409] are genuine & there is only one other pair known & those in the coll[ection] of Mr Colenso of Napier.
> (BM PE correspondence: J. Edge- Partington, 5 July 1897)

According to Skinner (1974: 24), at some stage Meinertzhagen visited the Chatham Islands, and there are indeed some objects from the islands in his collection.

Meinertzhagen's relationship with his Maori workers and neighbours was good. There were occasional frustrations and quarrels, but these were quickly patched up. He took interest in the people and visited them when they were sick,

and Campbell writes when in Scotland: 'Got New Zealand letters on 28th Nov. – two from Fritz … Matutaera is very ill & they fear he will die – Fritz has been vaccinating all the Maori children.' (Campbell: summary after 12 September 1872). That he had the trust of the Maori is perhaps best evinced by the fact that he was allowed to adopt a Maori child and take him to England, and his name was known and respected, for Hamilton mentions in his diaries, while on one of his expeditions to a *pah*, that 'Meinertzhagen's name acted like a charm' (BM AOA: Eth.Doc.836, E. Pishief letter, 21 October 1997).

Meinertzhagen died in 1895 in Tunbridge Wells. The last years of his life were sad. His health, never robust, declined, and his nephew writes: 'I scarcely remember my uncle. He never recovered from his triple bereavement and my recollection of him is of a thin, gaunt, bearded man with sad eyes.' (Meinertzhagen 1964: 35) – a poignant contrast to the humorous, enthusiastic, inquisitive and energetic young man who comes alive on the pages of Walter Campbell's journal.

When his collection was offered to the British Museum, Read wrote to Gertrude: 'If the collection comes here, it may be a satisfaction to you to know that every label will be marked "Meinertzhagen Coll." so that the objects will be always associated with your father.' (BM PE correspondence: C.H. Read, 10 October 1895). Read kept his word and the collection does have such labels. Franks was very happy with this purchase. He wrote to Hooker (one of the Trustees of the Christy Collection): 'I have recently made a wonderful acquisition for the Christy Collection in the form of a very good series collected by the late Mr Meinertzhagen in New Zealand and filling up a number of our gaps. It was necessary to buy the whole, so the purchase could not conveniently be made by the Museum, as there are many duplicates.' (BM PE correspondence: A.W. Franks [unsigned], 8 November 1895). The payment for the collection had to be made quickly as Gertrude Meinertzhagen was going abroad, so Franks paid for it himself and was reimbursed later from the Christy fund. The collection was duly registered, but some objects, considered 'duplicates', were not entered in the Register but were relegated to the Duplicate Collection and were incorporated into the main collection only in the 1980s, identified as Meinertzhagen's pieces thanks only to those labels promised by Read almost a century earlier. Meinertzhagen's is the Museum's largest single Maori collection, consisting of well over 500 objects.

Meyrick Collection, 1878.11-1.
Formed by Samuel Rush Meyrick (1783–1848), an antiquary, historian of arms and armour, and collector, this collection was displayed by him at Goodrich Court near Ross, Herefordshire, where there was a 'South Seas Room' (King 1997: 150). On Samuel Meyrick's death it was inherited by his second cousin, William Henry Meyrick, to whose son, Augustus Meyrick, it then passed. The collection was offered in its entirety to the government, but when the offer was turned down the collection was broken up: the European part was sold and the rest was presented to the British Museum in 1878. The entry for the collection in the Museum's Register reads:

> The objects given to the British Museum from the residue of the Meyrick-Douce collections. The bulk, after being exhibited at the S. Kensington [South Kensington Museum as the Victoria and Albert Museum was then known] about 1872, were sold by Pratt of Bond St. about 1876. Many objects were bought by Spitzer. Objects from the coll. had previously been exhibited at the Loan Exhibition of the Society of Arts in 1850, and at the Manchester Exhibition, 1857.

However, a later source gives the dates for the collection being exhibited at the South Kensington Museum as 1868–71 and part of it as sold in 1871 (Caygill and Cherry 1997: 330.84). Francis Douce was an antiquary and collector, at one time employed by the British Museum, who, on his death in 1834, left his antiquities to Meyrick; Francis Spitzer was a Parisian dealer and collector.

The importance of the collection lies in the early date of its acquisition, and the Maori component of it, consisting of 13 objects, can indeed be dated stylistically to the late eighteenth and the early nineteenth centuries. The Meyrick Collection was published in 1830 as a two-volume album of illustrations by Joseph Skelton: *Engraved Illustrations of Antient Arms and Armour, from the Collection of Llewelyn Meyrick at Goodrich Court, Herefordshire, after the Drawings and with the Descriptions of Dr Meyrick.* (Llewelyn Meyrick was Samuel's only child, and then legal owner of the family property, as Samuel's father had arranged for it to bypass him and devolve to his children; when Llewelyn died without issue in 1837 the property passed to Samuel.)

In volume 2 of the album, plate CXLIX consists of illustrations of 'Weapons from the isles and shores of the Pacific' and plate CL of 'Weapons from the isles and coasts of the Pacific'. These illustrate 11 Maori objects (one, a paddle, is misattributed to New Caledonia). Of these, two can be clearly identified as being now at the Museum: a whipsling, *kotaha*, **615**, 1878.11-1.606 and a basalt club, *patu onewa*, **768**, 1878.11-1.610.

Reid/Luce Collection, 1927.11-19. and 1950 Oc.6.1
This small collection was formed by Captain John Proctor Luce, RN, whose ship, HMS *Esk*, was involved in the New Zealand wars of the 1860s on the East Coast. His collection was presented to the Museum by Captain Luce's daughter, Mrs M. Reid, the last piece added to it by his grandson, Mr J.A. Reid in 1950.

The Royal Anthropological Institute has Captain Luce's private journal (MS 280), presented by Mr John Reid, his great-grandson in 1970, and covering the period 1852–67, in which there are several entries referring to his collecting.

In November 1865 Captain Luce wrote:

> Our friends the Waiapu natives came forward & gave us a war dance. Then some speechifying took place – the chiefs welcoming the Superintendent & delivering their prisoners over to him. My old friend Wekiuopi came out strong making a vigorous speech with much energy & having a Flax cloak over his shoulders all covered with feathers & holding in his hand a handsome Taiaha, a war club, which on finishing his speech he gave to McLean who afterwards kindly handed it over to me.
> (Royal Anthropological Institute Archives. MS 280.5).

This *taiaha* may be **690**, 1927.11-19.7. On 9 November in Poverty Bay, he continues: 'Finding the fleas still troublesome I thought it best to exchange my old coat & trousers that I had worn ashore for two greenstone Eardrops & a whalebone mere-mere… [none of which is included in the collection]', and the next day: 'Capt Fairchild gave me four specimens of native carving, he has a large quantity on board which was taken at Opotiki. Some of the Wanganui natives are fighting on our side in the Bay of Plenty. These carvings are their loot

& they are sending them to Wanganui to their tribe.' This last statement illustrates clearly one of the ways in which objects travelled from one part of the country to another. Then he mentions the carvings again on the 11th, with obvious satisfaction: 'Had the Maori carvings cleaned up & they promise to look well.'

Robertson/White Collection, 1912.5-24. and 192.5-25. (Eth.Doc.1106)

These two collections of stone implements were originally in the large Maori collection formed by a New Zealand barrister, John White of Dunedin. In 1894 White wrote to the Museum offering his collection for sale (BM PE correspondence: J. White, 20 August 1894), but it was not bought, presumably because the asking price of £1,000 was too high.

When White died in 1904 his collection was sold and part of it was bought by J. Struan Robertson (Leach 1972: 5, where the name given is that of 'Robinson', but undoubtedly 'Robertson' is meant). After Robertson's death, his sister, Miss Florence Robertson, placed his collection on loan at the Bristol Museum (L. Graves, Bristol Museum, pers. comm. 19 April 2007) and in 1912 she wrote to the British Museum:

> As you kindly said you would advise me as to the best way of selling my late brother's (Mr Struan Robertson's) collection of greenstone, I am sending you the list which he had with same. We hold the receipt from White for £500 & it was packed & brought over to England some years ago. It is now (on loan) at the Bristol Museum… It is not all, I think, on view in cases. So far as I know, the collection remains intact but as I don't understand the subject myself & was not living at home when my brother died, it is possible that he had disposed of some of the duplicates.
> (BM PE correspondence: F. Robertson, 11 January 1912).

Later, she added: 'We are giving you the first refusal of that greenstone collection or rather for such specimens as may be suitable for the British Museum.' (BM PE correspondence: F. Robertson, 18 March 1912). Read went to Bristol, made a selection, for the British Museum and for Bristol, and sent a list of his chosen pieces to Miss Robertson, writing at the same time that he did not want the 'finest things', for the Museum had plenty of similar ones, but that he had instead chosen the 'pieces representing small variations of type' (BM PE correspondence: C.H. Read, 25 March 1912). The Museum purchased the collection in two parts: 1912.5-24. from Miss Florence Robertson, and 1912.5-25. from her sister, Mrs Naomi Erskine. In her last letter to Read, Miss Robertson emphasized the White origins of the collection again, saying that her brother 'bought the Maori implements as a complete collection, made by White.' (BM PE correspondence: F. Robertson, 30 March 1912).

While the British Museum bought stone implements, the Bristol Museum bought 61 objects, mostly nephrite ones, but much of the material which was on loan in Bristol from 1911 until 1920 was purchased by T.E. Donne in November 1920 (L. Graves, Bristol Museum, pers. comm. 19 April 2007).

Sparrow Simpson Collection

William Sparrow Simpson, born in 1828 and educated at Queens' College, Cambridge, was ordained in 1851 and spent all his life in the service of the Church: from 1851 in London, where in 1861 he was appointed Minor Canon and Librarian of St Paul's Cathedral, about which he published several works. His interest in antiquities began during his student

days and continued until his death in 1897. His son wrote about him:

> Among the subjects to which he devoted most careful study was that of primitive man. He formed … a large collection of stone implements, which he afterwards presented to the British Museum. He was a recognized authority upon the subjects, often referred to by students, and very acute at detecting forgeries, recent clever but worthless counterfeits of the earliest weapons of man.
> (Simpson 1899: 36)

Between 1866 and 1890 he presented many objects to the Museum, including some ethnographical ones, and he seems to have had a discerning eye for good quality; many objects from his collection also came to the Museum as Franks's gifts. He was a frequent visitor to the Christy Collection at Victoria Street (BM AOA archives: Visitors Christy Collection, 1866 – Sept. 1880) thanks to Franks:

> My dear Sir, I have been intending, day after day, to call upon you at the Museum, and to thank you for your kindness in sending me a ticket of admission to the Christy Collection … I can scarcely expect that you would care to see my small collection and yet I feel it only right to say that I should have great pleasure in showing you the few trifles that have gradually accumulated around me.
> (BM AOA: Christy correspondence: W. Sparrow Simpson to Franks, 16 January 1867)

Consequently, in 1875 the Christy Trustees purchased for the Museum 'a selection from the prehistoric and ethnographical collections of the Rev. Dr W.S. Simpson…' (BM central archives: Trustees' Minutes, 8 January 1876); in 1895 more objects from the Sparrow Simpson Collection were presented by Franks.

The collection has no documentation. Although the Museum has five notebooks in which Sparrow Simpson listed his stone implements, mainly European but also some Oceanic and North American ones, they do not provide much help, as almost all the entries consist only of minimal description and measurements, and it is only sometimes that a source is given, one of which was Franks. The only Maori object in the notebooks which could be identified is **550**, the ceremonial adze 9338, purchased from Bryce Wright. Copies of the Sparrow Simpson note books are in the Department of Africa, Oceania and the Americas, in the Eth. Doc. 1989.

Titore/Sadler Collection of 1896

In 1896 Miss Belle S.M. Sadler wrote to the Museum: 'I have in my possession a fine specimen of a New Zealand Club and several other curios in Green Stone … They were the property of my late grandfather Commander F.W. Sadler R.N., K.T.S. & were presented to him by "Tetore" [Titore] the then King of the Island about 1833 or 4.' (BM PE correspondence: B.S.M. Sadler, 8 July 1896).

HMS *Buffalo* was a naval stores ship which visited New Zealand in 1833–4 and 1836–40, and Titore was an important Ngapuhi chief in the Bay of Islands. He was so well-disposed towards the British that he offered to place a tapu on some forests from which spars could be cut for British ships, in case of any future conflict with France (Orange 1987: 10). In 1834 he sent, through Captain Sadler, a letter and gifts to King William IV; in the letter he describes himself as 'the friend of Captain Sadler' and he concludes: 'I have put on board the Buffalo a mere pounamu and two garments: these are all the things which New Zealanders possess. If I had any thing better, I would give it to Captain Sadler for you.' (Yate 1835:

271). He was rewarded for his loyalty with the Royal gift of a suit of armour that is now in the Museum of New Zealand Te Papa Tongarewa in Wellington (Hamilton 1909: 40–6). The objects in Miss Sadler's possession, however, must have been private gifts from Titore to his 'friend', Captain Sadler.

The collection was small, consisting of some nine objects, and after the ensuing correspondence with Read (slightly acrimonious due to a misunderstanding about prices) four objects were bought: **271**, pendant *hei-tiki*, 1896-925; **498**, human bone flute *koauau*, 1896-930 and **383**, whale-tooth cloak pin *aurei*, 1896-931 by Franks; and **739**, nephrite *mere*, 1896-929 by Read. These were all presented by the two men to the Museum.

In the same year the Museum missed an opportunity to acquire more pieces with the same associations with Titore and HMS *Buffalo*. This time the collection was offered for sale by Joseph Chegwyn, son of Commander Chegwyn, RN, and the objects had been 'presented to him by a native chief named Titouri in 1837 … [they] were brought to England when my father was serving in H.M.S. Buffalo 1837–38.' (BM PE correspondence: J. Chegwyn, 7 February 1896). However, no agreement could be reached about the price, and Read withdrew from the negotiations.

TRH Collection, 1902 L.1. – Royal Loan of 1902, Prince and Princess of Wales (Eth.Doc.1947)

This is the largest Royal Loan of Maori objects deposited in the Museum by the Royal family. Royal Loans are not part of the Museum's own collections, they can be withdrawn at any time and are not given the Museum's own numbers, but are recorded with the infix L. In this particular case, however, the objects were also registered with the prefix TRH (Their Royal Highnesses) and thus they have two sets of numbers.

The loan consists of the objects presented to the Duke and Duchess of Cornwall and York (later Prince and Princess of Wales) during their visit to New Zealand in 1901. Unfortunately, at the time when the objects were registered with the TRH prefix, not all the pieces in this loan were given these numbers. Only 27 Maori objects were so numbered, and only 14 are today in the Museum's collection. Although there is clear evidence that more items were deposited, no list of items lent could be found either at the Museum or in the Royal Archives (BM AOA correspondence: Royal Archives, 7 February 1996). However, those objects that could be identified as coming from the loan of 1902 were subsequently given both TRH and L numbers. For three of them the evidence is incontrovertible: **2**, model canoe, TRH 82; **94**, model storehouse, TRH 83; and **1825**, *korowai* cloak, TRH 84.

The model canoe TRH 82 (**2**) was identified as originating from the Royal visit of 1901 by Roger Neich in 1990; it is mentioned in Loughnan's official record of the visit (1902: 124), it is listed in the *Catalogue of the Gifts and Addresses* (Imperial Institute 1902: 56, 334) and the circumstances surrounding its presentation were recorded by the Duke himself in his diary:

> June 15. Grand Hotel. Rotorua. N.Z. … at 9.30. We all went to the race course, where all the Maoris were assembled, over 4000. On our arrival they placed cloaks on May's & my shoulders & Huia feathers in our hats, which we wore all the time. Then the war dances, songs of welcome & poi dances (women) began, each tribe at a time. As each dance was finished the tribe presented us with beautiful presents, which were piled up in a heap in front of us, they consisted of greenstone Meres, whale bone Meres, whale

> bone paddles, carved sticks, feather cloaks innumerable, mats & other cloaks, also reed kilts. May and I then walked round, passing through the lines of Maoris, we were photographed with them. Major Fox the old Chief [Te Pokiha Taranui, the paramount chief of Ngati Pikiao] gave us a model canoe.
>
> (Royal Archives GV/PRIV/GVD/1901: 15 June. Quoted by the permission of Her Majesty Queen Elizabeth II)

The model storehouse TRH 83 (**94**) has an inscribed plaque stating that it is a gift of the women of Wellington to the Duchess on the occasion of her visit to Wellington; it is also mentioned in Loughnan and the *Catalogue of Gifts* (Loughnan 1902: 183–5; Imperial Institute 1902: 71, 439). The *korowai* cloak TRH 84 (**1825**) has a pinned-on label saying it is the gift of the Rangitane tribe to the Duke and Duchess of Cornwall.

A few other items which were probably part of the loan are annotated accordingly in the catalogue entries. There is, however, the problem of these 'feather cloaks innumerable, mats & other cloaks', which the Duke mentions in his diary and which undoubtedly were included in the loan – several letters in the Museum correspondence mention the abundance of cloaks in the collections that were presented by the Prince of Wales – but were deemed not worthy of recording. Nevertheless, it is almost certain that if not all, then most, of the cloaks and fibre items with numbers Q1995 are part of this loan – stylistically these objects are congruent with the date of the visit – although the supporting evidence is missing, and there may also be others among the Q-numbered objects that are now impossible to identify.

All the objects presented during the visit were exhibited in the Imperial Institute (later Commonwealth Institute) in London in May 1902, and were published in a formal catalogue the same year (Imperial Institute 1902). Subsequently, some remained in the Institute and some were offered to the British Museum:

> Many thanks for your letter and telegram with reference to the Maori and North American collections offered to the British Museum by the Prince of Wales. His Royal Highness seemed so pleased the Museum should be interested to have these objects – it is really a remarkable collection, but as you may imagine one that is rather a white elephant in a residence. I showed the Prince your letter – he thought he could hardly give the collection as it might offend those who gave it to him, but it should be placed on permanent loan.
>
> (BM PE correspondence: G.F. Laking to C.H. Read, 15 August 1902)

Thirty-seven objects 'from the collection lent by H.R.H. the Prince of Wales' were transferred to the Imperial Institute (BM AOA: Eth.Doc.1947) in 1907. They included 16 cloaks and 13 numbered TRH objects, the latter precisely those that are missing from the Museum's TRH collection. In 1997 only five of these TRH objects were in the Commonwealth Institute, for in 1926 there was a re-assignment of the Royal presents lodged with the Institute, 'prompted by instructions given by the Queen [Mary, consort of George V] after a visit to the Institute' (BM AOA: Eth.Doc.1947; Brigit Dohrendorf letter, 22 July 1997) which resulted in some items being retained at the Institute, some sent to other museums, and some returned to Buckingham Palace.

When the Commonwealth Institute closed in the late 1990s the material which the member countries of the Commonwealth wished to have back was returned to them and the remaining artefacts were gifted by deed of trust to the British Empire and Commonwealth Museum in Bristol, including some Maori objects from the 1901 visit (Ellie Davis, British Empire and Commonwealth Museum, pers. comm. 29 September 2006).

Wellcome Collection, 1954 Oc.6.

Henry Solomon Wellcome was born in 1853 into the family of a poor and unsuccessful farmer in Wisconsin, USA. He left school at fourteen, but was determined to continue his education, finally qualifying from the Philadelphia College of Pharmacy. Subsequently, he became a traveller for two American drug companies, and in 1880 he came to London to join Silas Mainville Burroughs, as a partner in the newly created pharmaceutical firm of Burroughs, Wellcome and Co. Eventually the partnership turned sour, resulting in legal disputes, but after Burroughs's death in 1895, Wellcome came into full control of the firm, which was by then widely known and respected. His main interest was in research rather than the commercial aspect of the company, and after Burroughs's death he was free to pursue it, establishing several research laboratories. It was also at that time that his early passion for collecting and archaeology was given free rein, and C.J.S. Thompson, a chemist by training, was employed as his agent. Thompson, and later also his assistants, bought widely at sales in Britain and abroad. Purchases included books and artefacts, and were not only of medical nature (Wellcome's interest in Native Americans began in his childhood), though in the process an invaluable and huge medical library was amassed. In 1913 Wellcome's collection was put on display in an especially established museum in London's Wigmore Street, to be known as the Wellcome Historical Medical Museum. Wellcome himself spent several seasons between 1910 and 1914 excavating in Sudan. Wellcome's agents continued buying, adhering to Wellcome's obsession with secrecy by making purchases in their own names, and having at their disposal practically unlimited funds. Unfortunately, the purchases they made were not always discriminating. Wellcome was an obsessive collector, with a magpie-like compulsion to collect books, pictures, artefacts, armour, in fact anything which caught his fancy, and among these all-encompassing purchases a fair amount of material was of questionable quality. With the growth of the collections and the expanded staff employed to look after them, it was soon apparent that his museum, and the numerous sites where the collections were stored, were becoming inadequate, and in 1932 the museum moved to a new building in Euston Road, the Wellcome Research Institution (later known as the Wellcome Building), intended as the headquarters for all Wellcome's research enterprises. In the same year Wellcome was knighted (he became a British citizen in 1910), and was elected a Fellow of the Royal Society and an Honorary Fellow of the Royal College of Surgeons. Thereafter, until his death in 1935, Wellcome spent most of his time in America and the work on the reopening of the museum stagnated.

On Wellcome's death the ownership of his enterprises was vested in a board of trustees who had to deal with the legal implications of Wellcome's charitable and commercial ventures. The varied and complicated fortunes of the museum since Wellcome's death are described in detail in Symons 1987. Eventually a decision was reached that the museum was to concentrate on the history of medicine, and the surplus material, including ethnography, was to be disposed of. This was done in a series of dispersals, between 1936 and 1983 (see Russell 1987), of which the period 1943–60 is most significant for Maori objects. In 1954 the British Museum received the bulk of its Wellcome ethnographical material, including over 400 Oceanic objects, with another small transfer in 1982.

William Strutt Collection, 1896.11-19.

Another collection acquired in 1896 consists of 13 Maori objects presented by William Strutt, an English artist, who spent several years in Australia and a year, 1855–6, in New Zealand. In his journal he writes that he 'fell in love with the romantic beauty of the country, and resolved to acquire a bush section…' (Mitchell Library, Sydney: William Strutt Autobiography, ML MSS 867/3:218), which he did, buying land at Mangorei, New Plymouth. It was during the hard work of clearing the land that he came across the most interesting object in the collection: **585**, ceremonial flax beater or weapon, 1896.11-19.5:

> It was in returning to my clearing from one of my monthly visits to New Plymouth, with a party of settlers, that I stumbled on the remarkable stone club now in the British Museum … suddenly I stepped against a hard substance, which appeared to be stone; picking it up, its long and peculiar shape struck me, as there was not a stone or even a pebble anywhere about on this road; my curiosity was at once aroused, and scraping off a little of the dirt with which it was covered, I found some apparent carving. Arrived at our whorry [hut], near which flowed a clear little rivulet, I unloaded myself of my kit of provisions, went down to the creek and there washed the interesting find. I quickly discovered, to my great delight, that it was an object of more than ordinary interest on account of the curious carving upon its surface. When, later on, I was residing in New Plymouth, I showed it to a Maori, wishing to know if he had seen anything of the kind before. He affirmed he had not, nor could he give me any information concerning it. The Club was very heavy and carved in stone or scoriae of Mount Egmont, probably an idol and of great antiquity.
>
> (Mitchell Library, Sydney: William Strutt Autobiography, ML MSS 867/3: 222–3)[2]

Mangorei is a small locality about 3 km directly south of New Plymouth township, so this account locates the discovery of this artefact to within that distance.

Williams Collection, 1898.10-21.

The Museum acquired Williams's collection of 82 objects from the Chatham Islands in 1898, but Williams – who signed himself as Joseph Walter Williams, Schoolmaster, Waitangi West – had approached the Museum for the first time in a letter dated 23 May 1896, advising the Museum that he had dispatched to it a case containing some Moriori skeletal material and asking whether, apart from more skeletal remains, 'some Moriori clubs formed of micaceous clay slate and some tomahawks of a harder stone' would be wanted (BM PE correspondence: J.W. Williams, 23 May 1896). After this, more letters followed until the correspondence was terminated in 1899, when Williams's employment in the Chathams ended and he left the Islands.

In reply to his first letter, Read encouraged him to collect and also wrote: '… and if at the same time you will send me a brief account of the discovery of what you may send I would have this published and send you copies of the paper, which would appear in one of our scientific journals.' (BM PE correspondence: C.H. Read, 2 October 1896). Williams followed these instructions, sending him his notes on the Moriori (which were published in 1898 in the *Journal of the Anthropological Institute*) and more consignments to the Museum.

Williams was a persistent and rather unscrupulous fossicker. He was well aware of breaking the law, as the

Government considered the removal of human remains an offence, and of risking Maori wrath by breaking the tapu placed on such searches. He did his searches secretively at dawn, and justifies his illegal activities thus: 'However having gone to considerable expense and spent a good deal of time to obtain what I have, I must run the risk.' (BM PE correspondence: J.W. Williams, 4 February 1897). The artefacts he collected were retained at the Museum, but the human remains were passed on to the Natural History Museum. At Manukau he collected

> …two bone fish hooks and two ornaments called Reis… The Moriori from whom I obtained them was very loth to part with them, there being no other bone articles in the Pah. It was only by a substantial present and an assurance that they would be sent to the "Great man in England who will cause the name of the Moriori to be remembered" that he became willing to let me have them. … At Operau the Morioris seemed to have occupied their spare time, when waiting for a favourable wind, in making axes and chisels. We procured some at Tuapanga and a few at Ngatikitiki.
> (BM PE correspondence: J.W. Williams, 20 January 1897)

Included in Williams's correspondence is a list of the objects he sent, arranged in a numerical sequence, with the places where they were found recorded; this information is given in the catalogue entries where it was possible to identify the objects.

In April 1897 another box was sent to the Museum and Williams writes:

> The chief object of importance is the inscription from the Kopi tree [one of the four dendroglyphs 2061–2064, 1898.10-21.79 to 82] near the boat harbour of Te Raki… the relic is genuine enough; in fact it was only as a favour that Mr Hay allowed me to remove it. … The bone clubs and spear heads and fish hooks belong to Mr Rowland Hay of Te Raki. His father bought the Te Raki property from the Maoris and he has a small collection of curios.
> (BM PE correspondence: J.W. Williams, 3 April 1897)

And in June:

> By the steamer leaving on Monday the 7th inst I will forward three slabs of Kopi or Karaka [three of the four dendroglyphs 2061–2064, 1898.10-21.79 to 82] upon which are some old Moriori carvings of rude execution. They were taken from a clump of bush at Te Raki and formed part of a circle of trees all similarly marked.
> (BM PE correspondence: J.W. Williams, 5 June 1897)

In the same letter he writes that he has employed a Moriori, whom he calls 'Rewi' and later 'Riwai', to help him in his searches, and who 'is faint hearted and would have nothing to do with the bones' (BM PE correspondence: J.W. Williams, 1 August 1897). His correct name was Riwai Te Ropiha (Rhys Richards, pers. comm. 30 April 2007). In a later letter he says: 'We were many weeks in the bush looking for the carvings on the Kopi trees. I do not believe there were any more to be obtained.' (BM PE correspondence: J.W. Williams, 29 January 1898).

Correspondence between London and the Chatham Islands in those times was difficult; letters took months to arrive, and there is obvious strain and impatience emerging in the exchanges. Williams repeatedly explains in great detail the difficulties he encounters in his collecting and his pressing need for money. After Read's first reply, Williams sent six more letters to Read, and then a seventh, addressed to the Secretary of the British Museum, complaining about the lack of response from Read. This produced an indignant missive from Read:

> I was on the point of writing to you about your things when your extraordinary letter of 1 October to our secretary was sent to me that I might answer it. I cannot understand what benefit you

expect by writing letters in such doubtful taste. It is possible that I may not have acknowledged the receipt of a consignment at once, and your mails being far apart some months probably passed before you heard from me that I explained to you before that this year has been a very busy one for me.
> (BM PE correspondence: C.H. Read, 9 December 1897)

Read was also irritated by Williams's request to send him '20 sovereigns in a tin box, so packed that they will not rattle, seal it well address to me and Register the package' (BM PE correspondence: J.W. Williams, 29 January 1898). He was also not very pleased with some material sent by Williams: 'I cannot say that I am much impressed by your last consignment – the two bone clubs are very modern. If they had been offered to me in London I should have thought them forgeries, especially the dentate one [here follows a sketch of 2078, 1898.10-21.63].' (BM PE correspondence: C.H. Read 22 March 1898). Williams replied:

> Mr Hay of Te Raki is very indignant at the suggestion that the club [sketch of 2078, 1898.10-21.63] is a forgery and has impressed upon me the necessity of demanding its return to him. Kindly make it up in a small parcel and oblige. There are a few Morioris in existence and no doubt it is the work of one of them. Anyway I do not want to be bothered about it.
> (BM PE correspondence: J.W. Williams, 4 August 1898).

Williams's request was ignored and the club remained in the Museum's collections, even though Mr Hay was not prepared to leave it at that. He wrote directly to the Museum: 'Sir, Will you kindly inform me what is the sum total paid by you for "Moriori" specimens & curios shipped to you by Mr J.W. Williams of Chatham Islands. Some of these curios belonged to my brother.' (BM PE correspondence: R.W. Hay, 4 October 1898). Read's reply directed him to Williams's brother in London, to whom the payment had been made at Williams's request.

It has proved impossible to discover anything further about Williams, beyond what is contained in his letters. In one of these he says: 'I have been in New Zealand twenty years… Being well acquainted with New Zealand and having travelled nearly all over it, is there any information regarding the country that you would like to obtain & which I might be likely to supply?' (BM PE correspondence: J.W. Williams, 5 June 1897). His intention on leaving the Chathams was presumably to go to New South Wales, for complaining about the lack of letters from Read, he writes: 'I do not suppose I should ever have heard anything about the cases as your letter would have been opened and returned and I should have been in N.S.W.' (BM PE correspondence: J.W. Williams, 19 January 1898). To what extent Williams was genuinely interested in Moriori culture and collecting, and to what extent he saw it as a financial enterprise, is difficult so say, but certainly money matters are frequently mentioned in all his letters.

Notes

1 Diary of Frederick Huth Meinertzhagen, Canterbury Museum Manuscripts Collection ARC 1998.4. 1. 2 April 1867 – 11 May 1867; 2. 12 May 1867 - 30 June 1867; 3. 2 July 1867 – 5 September 1867. 4. 27 March 1869? [1874] – 27 May 1869? [1874]).

2 The Mitchell Library does not have copyright to William Strutt's Autobiography; it present owners are unknown and could not be traced.

Colour plates

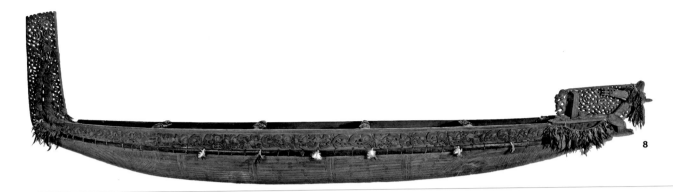

8

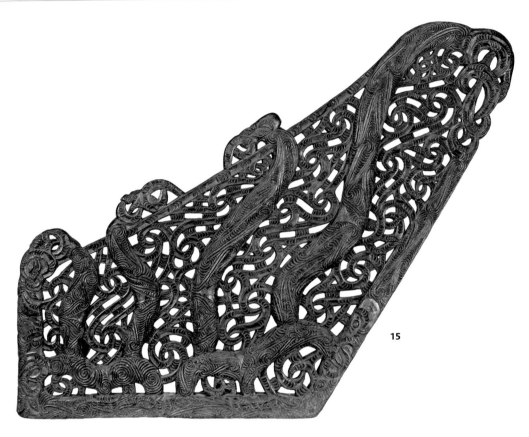

15

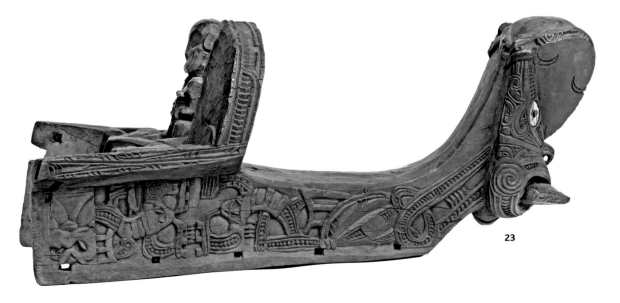

23

Colour plate 1 Model war canoe, *waka taua* (**8**), war canoe prow, *tauihu* (*tuere*) (**15**) and fishing canoe prow, *tauihu* (**23**).

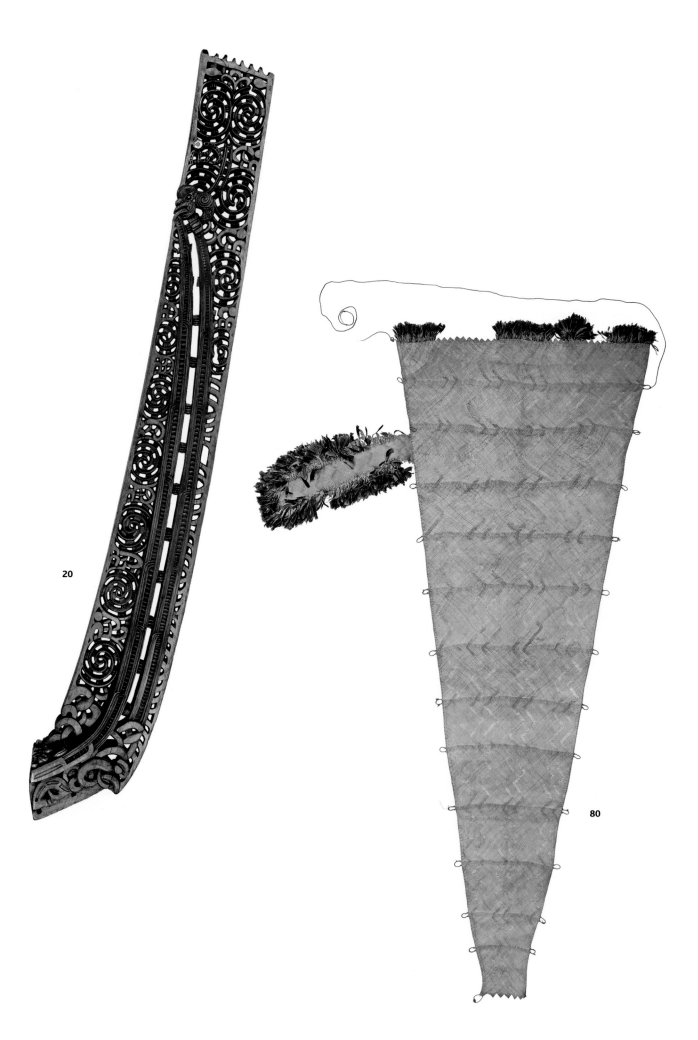

Colour plate 2 War canoe stern, *taurapa* (**20**) and sail, *ra* (**80**).

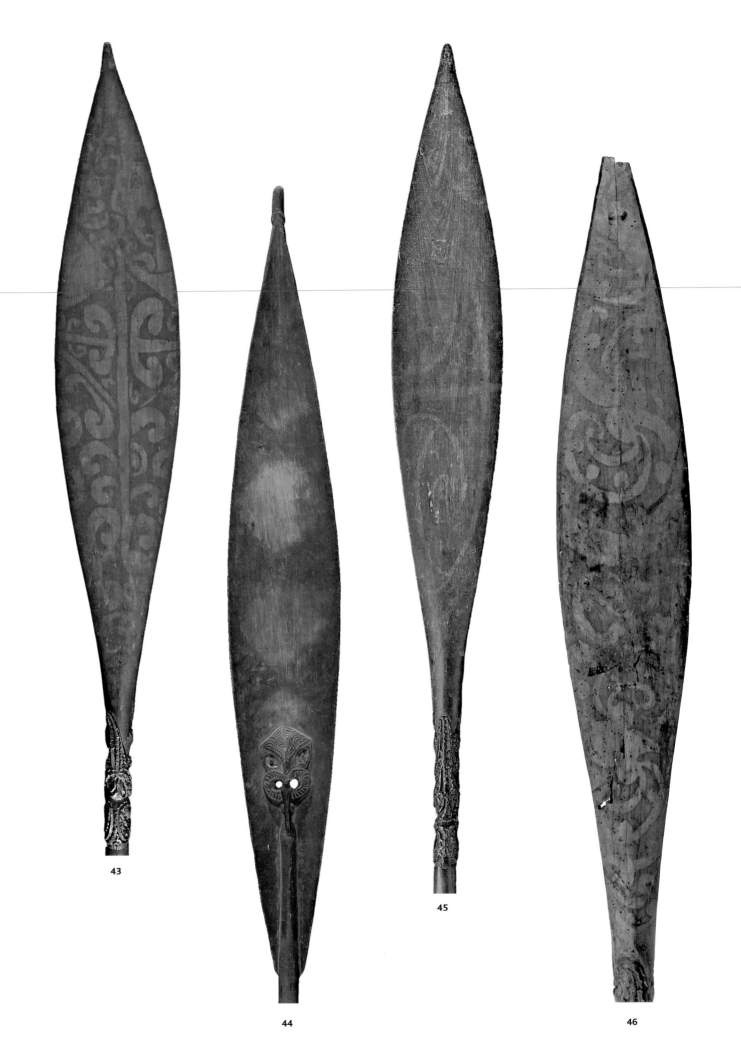

43

44

45

46

Colour plate 3 Painted paddle, *hoe*, blades (**43–46**).

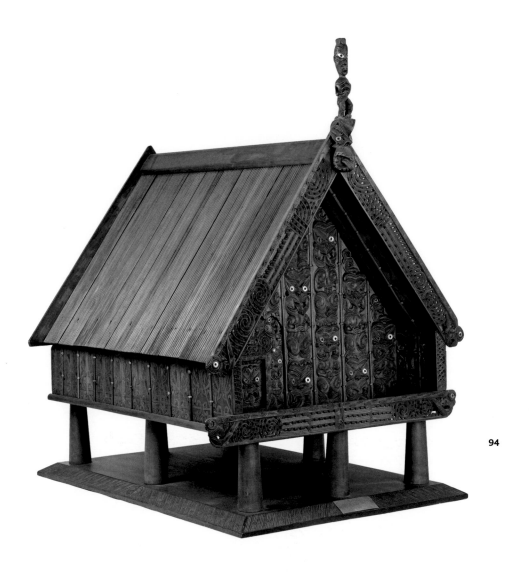

94

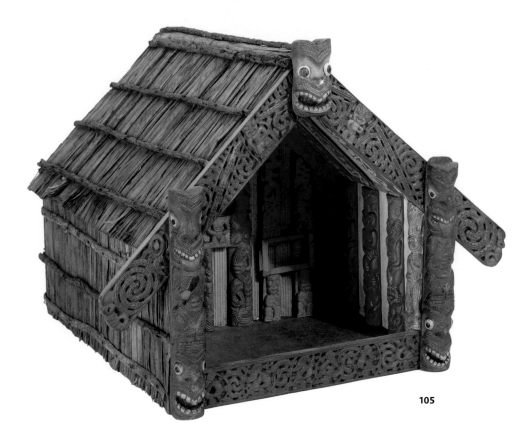

105

Colour plate 4 Model storehouse, *pataka* (**94**) and model house, *whare whakairo* (**105**).
94: The Royal Collection © 2009 Her Majesty Queen Elizabeth II.

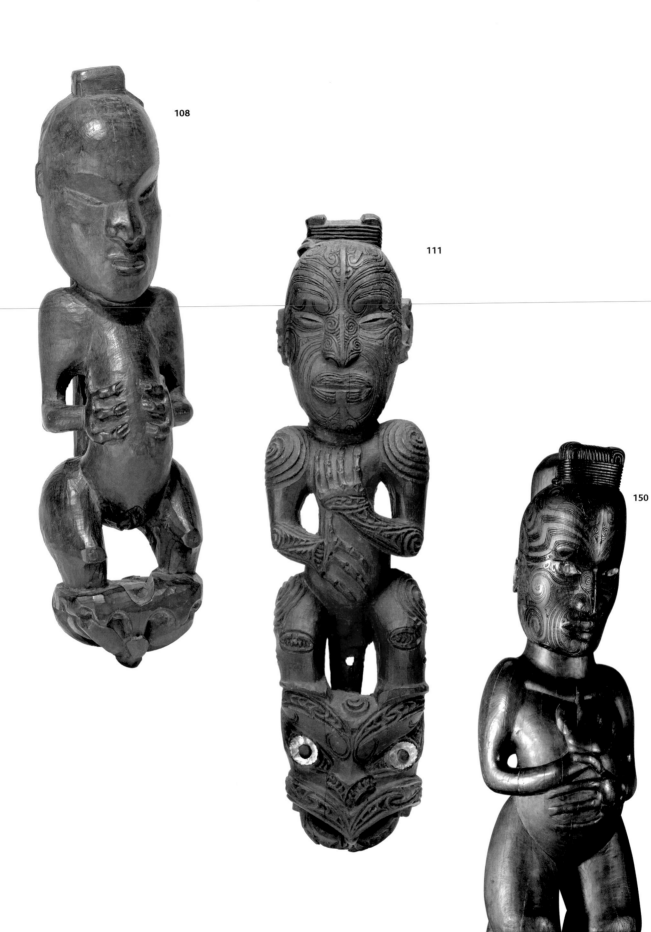

Colour plate 5 Gable figures, *tekoteko* (**108** and **111**) and an interior central-post figure, *poutokomanawa* (**150**).

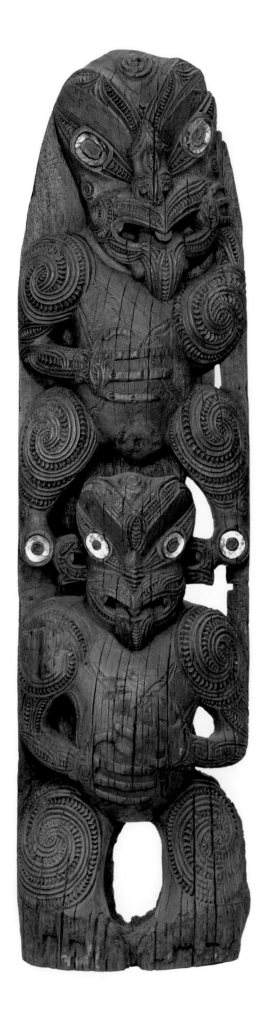 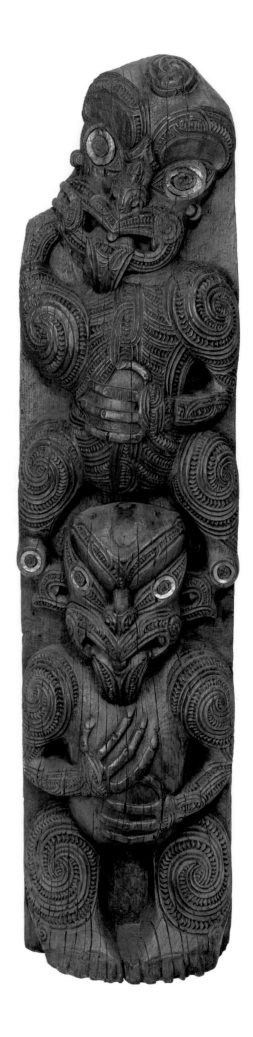

Colour plate 6 A pair of front side posts/bargeboard supports, *amo* (**126**).

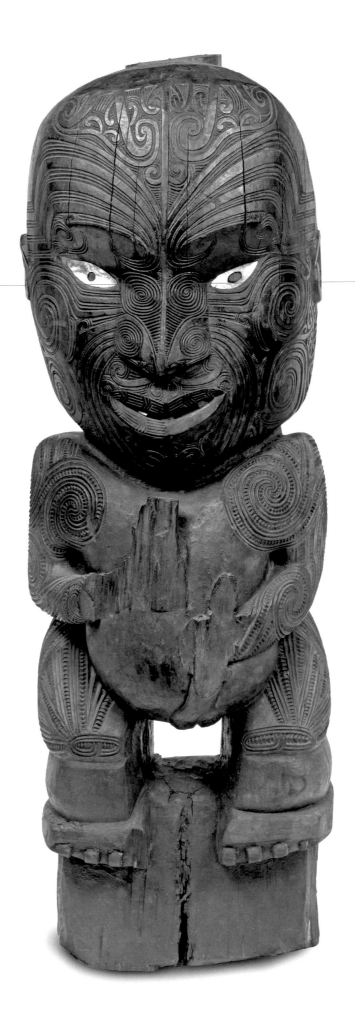

Colour plate 7 Interior central-post figure, *poutokomanawa* (**146**).

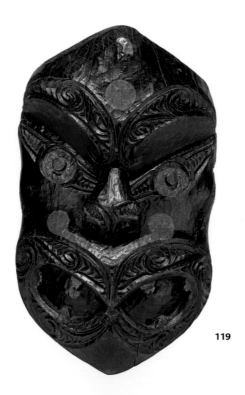

119

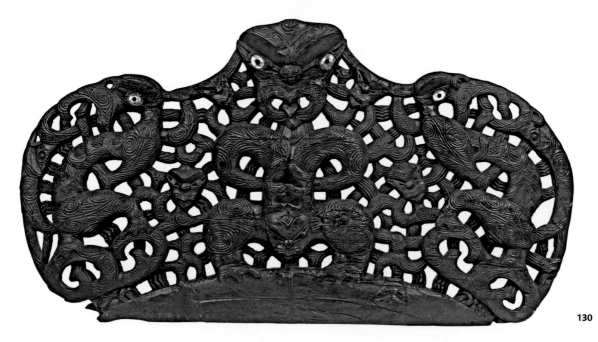

130

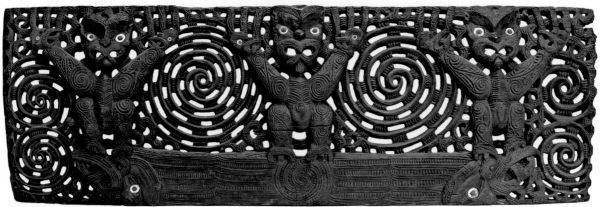

131

Colour plate 8 Gable mask, *koruru* (**119**) and lintels, *pare* (**130** and **131**).

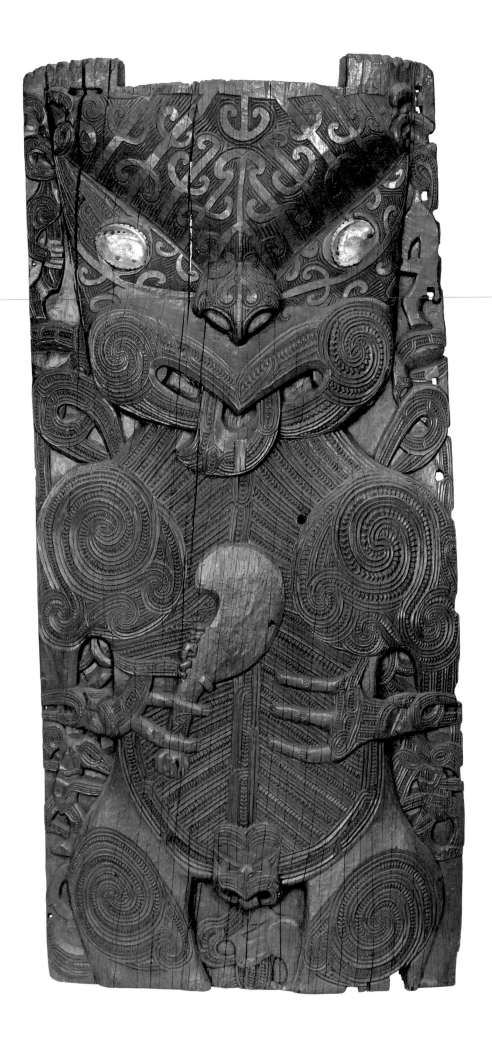

Colour plate 9 Side-wall panel, *poupou* (**152**).

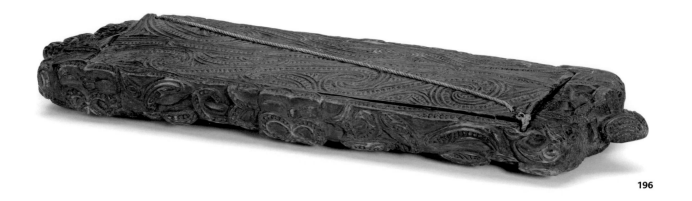

196

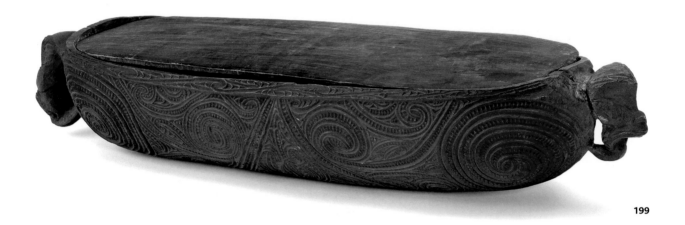

199

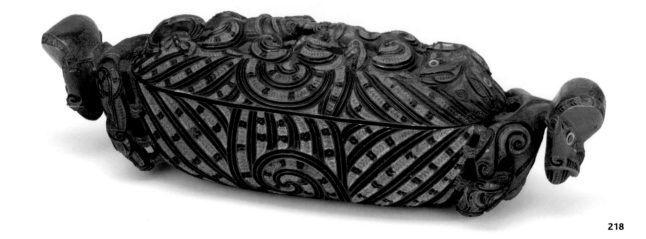

218

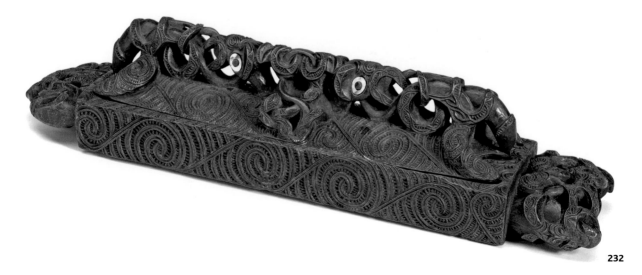

232

Colour plate 10 Treasure boxes: *papahou* (**196** and **232**) and *wakahuia* (**199** and **218**).

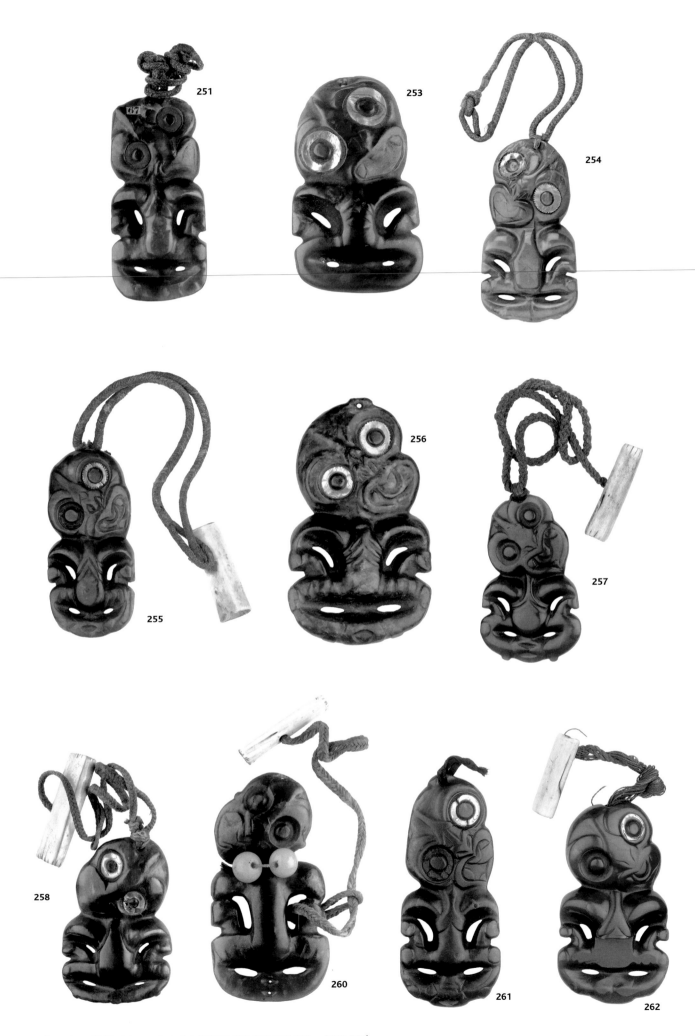

Colour plate 11 Nephrite pendants, *hei-tiki* (**251**, **253**, **254**, **255–258** and **260–262**).

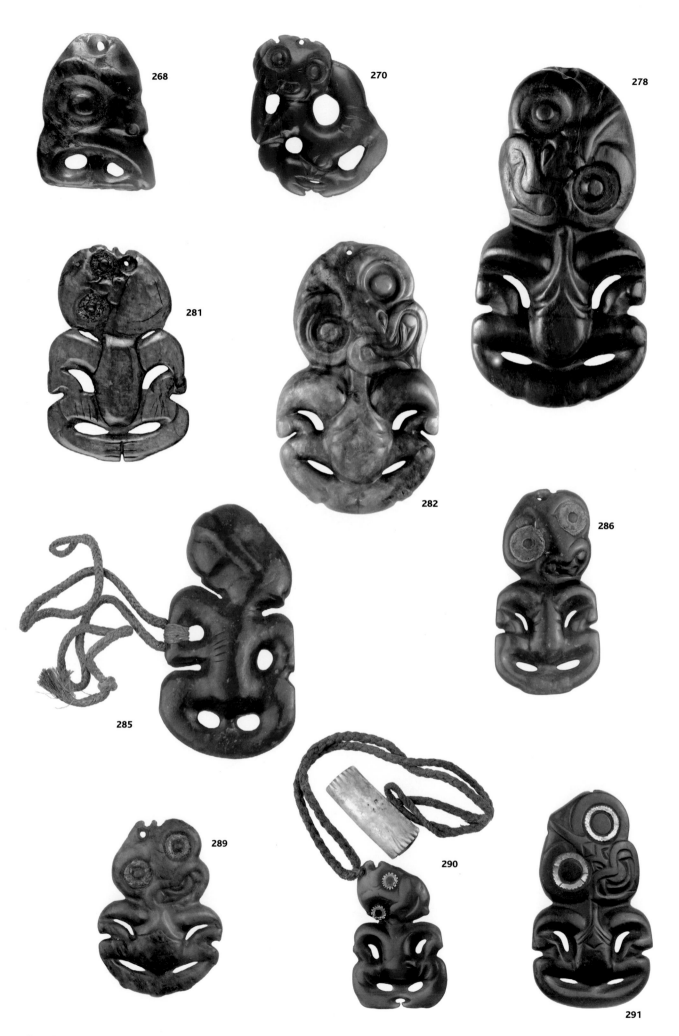

Colour plate 12 Nephrite pendants: *hei-tiki* (**268**, **270**, **278**, **281**, **282**, **285**, **286** and **289–291**).

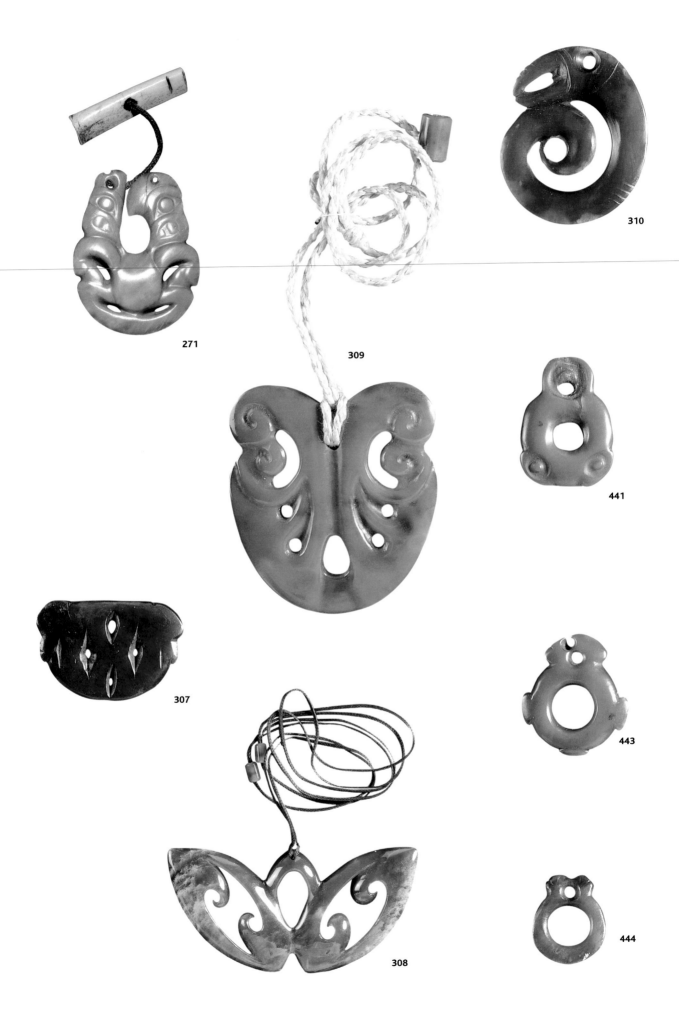

Colour plate 13 Nephrite pendants: *hei-tiki* (**271**), *pekapeka* (**307–309**) and *koropepe* (**310**); and parrot rings, *kaka poria* (**441**, **443** and **444**).
309: The Royal Collection © 2009 Her Majesty Queen Elizabeth II.

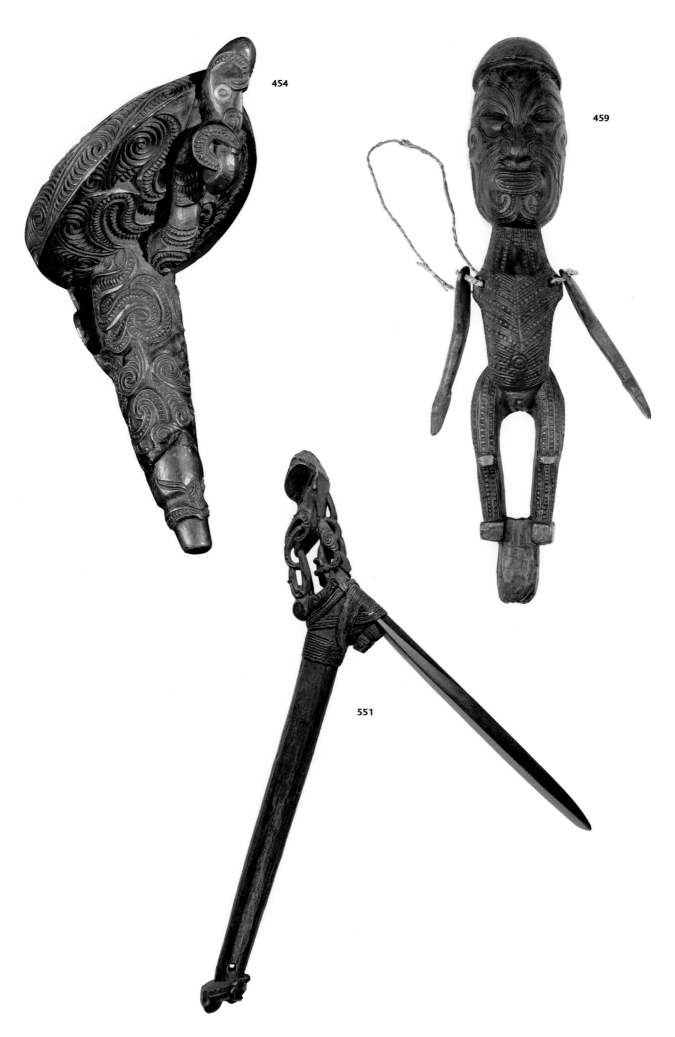

Colour plate 14 Feeding funnel, *korere* (**454**), puppet, *karetao* (**459**) and ceremonial adze, *toki poutangata* (**551**).

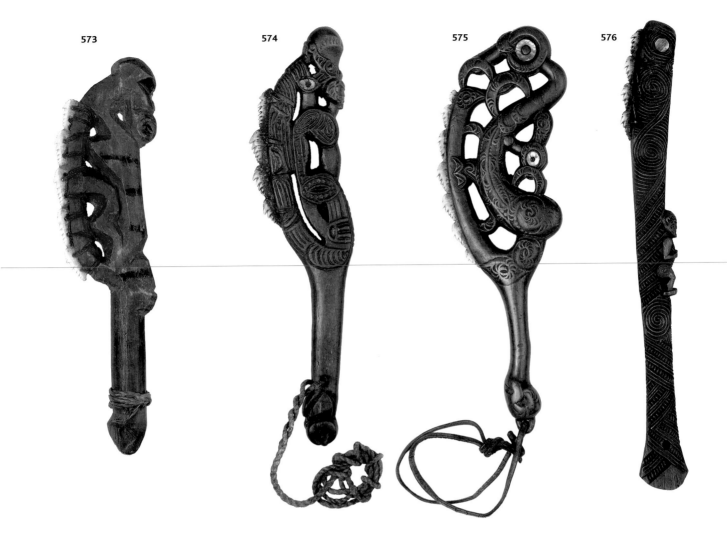

573 574 575 576

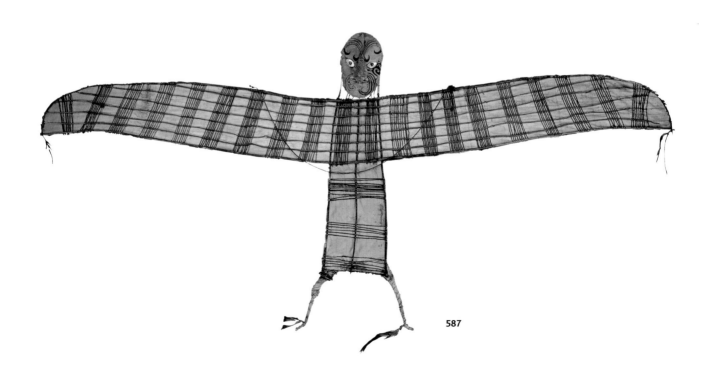

587

Colour plate 15 Shark-tooth knives, *maripi* (**573–576**) and kite, *manu tukutuku* (**587**).

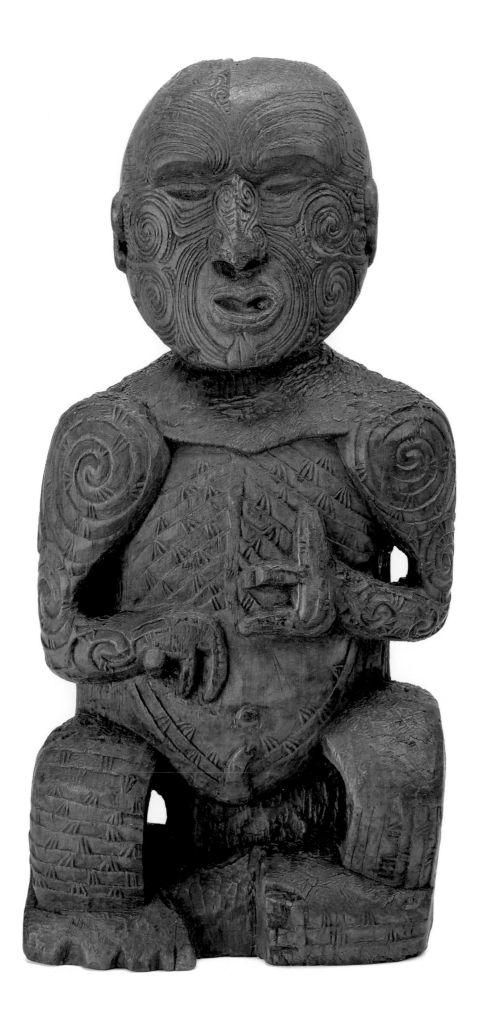

Colour plate 16 Figure container (**582**).

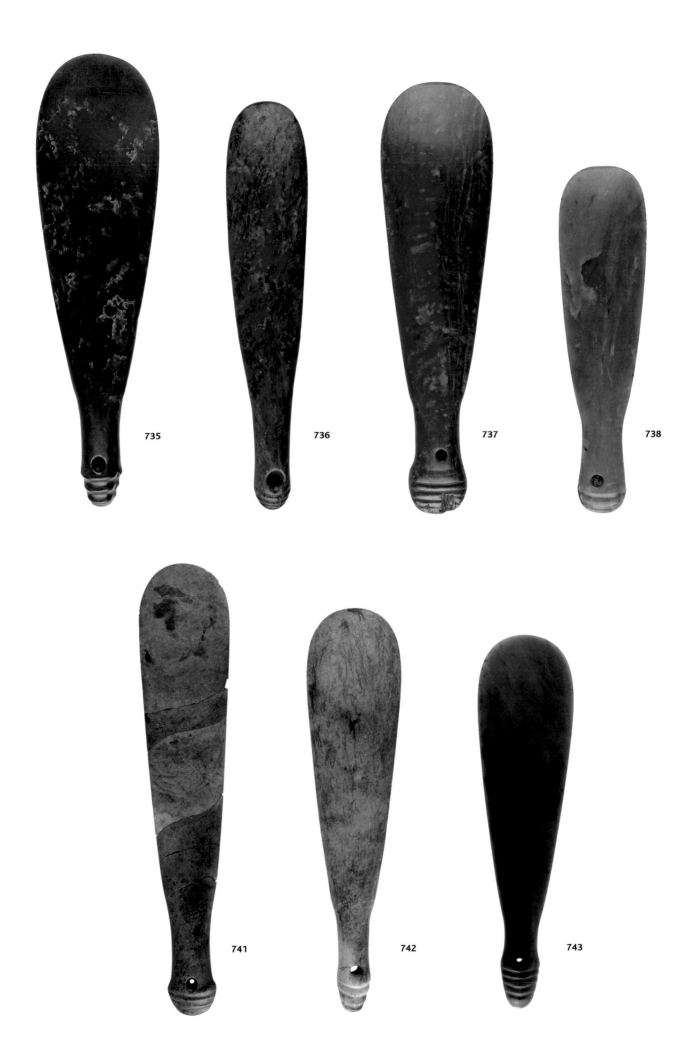

Colour plate 17 Short nephrite clubs, *mere pounamu* (**735–738** and **741–743**).

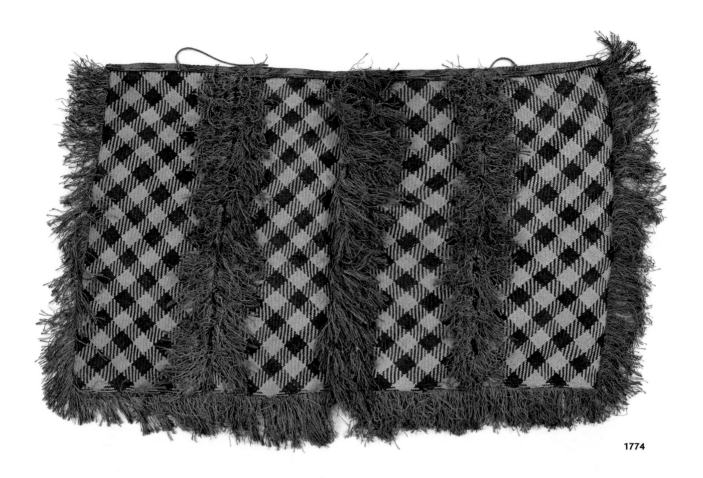

1774

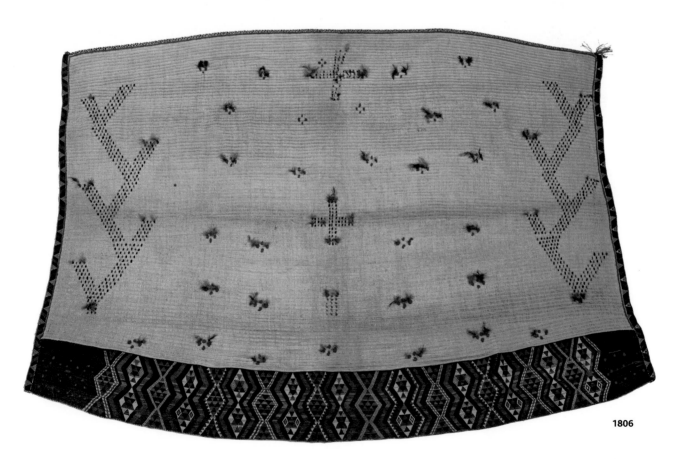

1806

Colour plate 18 Plaited cloak with fringes, *kakahu raranga* (**1774**) and cloak, *kaitaka* (**1806**).

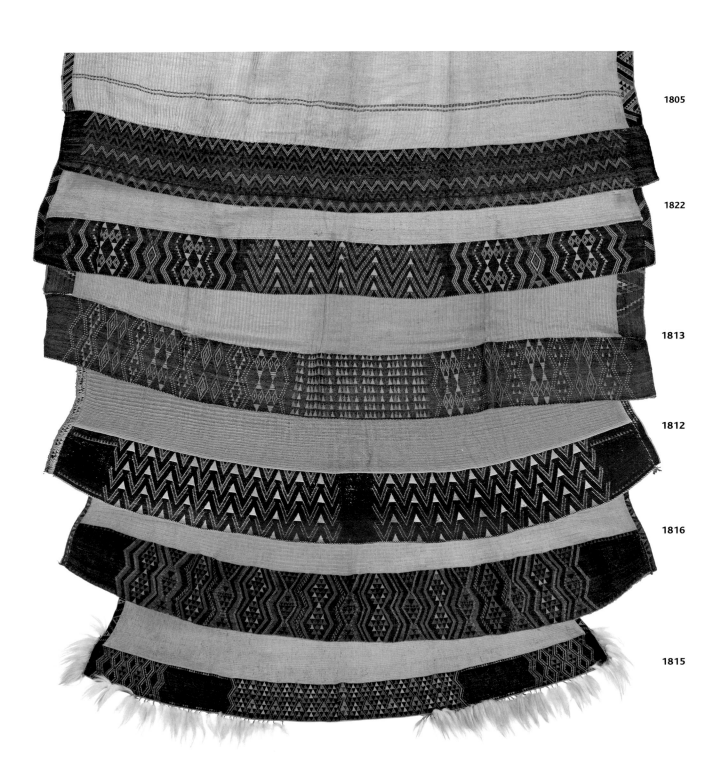

1805

1822

1813

1812

1816

1815

Colour plate 19 *Taniko* borders of cloaks, *kaitaka* (**1805**, **1822**, **1813**, **1812**, **1816** and **1815**).

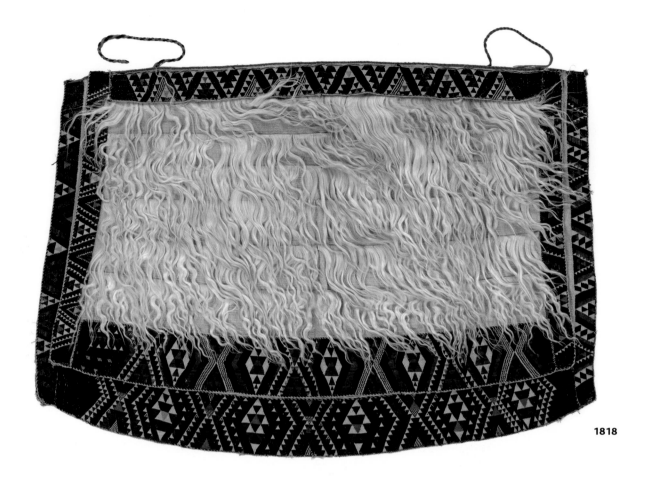

1818

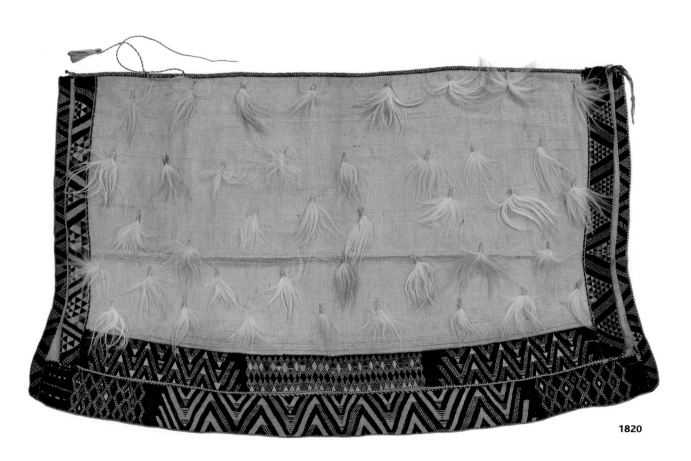

1820

Colour plate 20 Cloaks, *kaitaka* (*huaki*) (**1818** and **1820**).

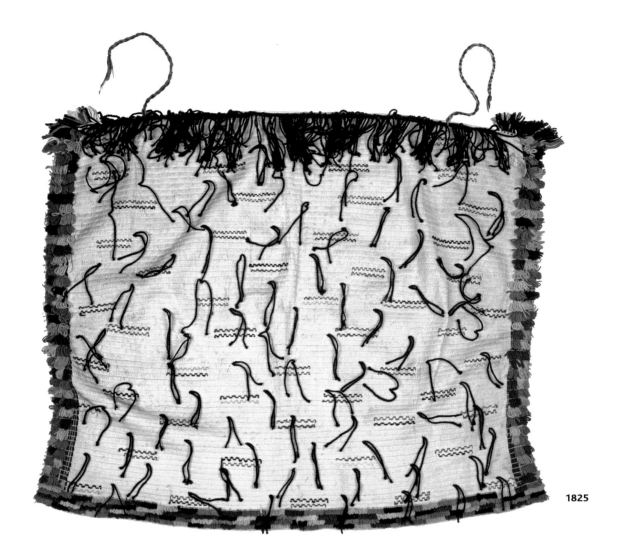

1825

1886

Colour plate 21 Cloak, *korowai* (**1825**) and feather cloak, *kahu huruhuru* (**1886**).
1825: The Royal Collection © 2009 Her Majesty Queen Elizabeth II.

1833

1866

Colour plate 22 Cloaks, *ngore* (**1833**) and *korowai ngore* (**1866**).

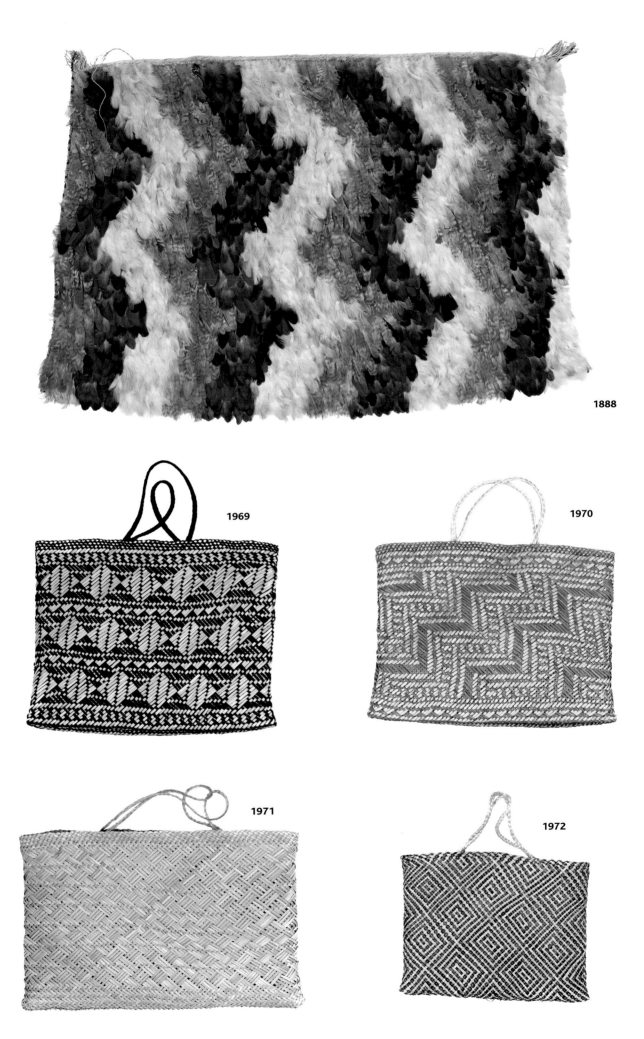

1888

1969

1970

1971

1972

Colour plate 23 Feather cape, *kahu huruhuru* (**1888**) and patterned plaited baskets, *kete whakairo* (**1969–1972**).

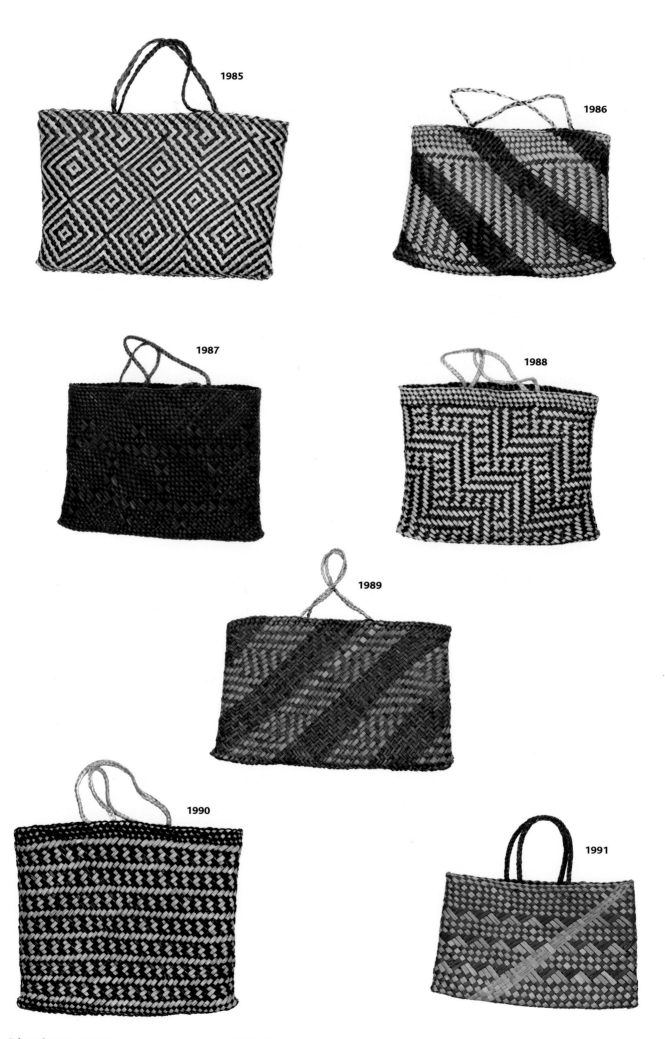

1985

1986

1987

1988

1989

1990

1991

Colour plate 24 Patterned plaited baskets, *kete whakairo* (**1985–1991**).

Catalogue

Arrangement of catalogue sections and of information within individual entries

Catalogue sections

The catalogue is divided according to the type of object, e.g. canoes, houses etc., with subsections grouping objects more specifically, e.g. model canoes, bailers etc. Within each subsection objects are grouped according to material in the following order: wood, bone, nephrite, other stone and shell.

In each material group, the entries appear in order of registration numbers. This order is not chronological, but is imposed for ease of reference. On the Museum's computer database these registration numbers appear in a slightly different form, always preceded by the prefix oc for Oceania, and an example of this form is given below for each type of number:

1 geographical or collection letter prefix numbers are listed in alphabetical order, e.g. LMS 157, NZ 140, TRH 83 (computerized form: oc,LMS.157; oc,NZ.140; oc,TRH.83 or oc1902,Loan01.83 – see 8 below);

2 early Christy numerical sequence, sometimes called 'four-figure' numbers, e.g. 1699 – not necessarily four-figure but within the range 1 to 9999 (computerized form: oc.1699);

3 subsequent Christy numerical sequence of 'four-figure' numbers preceded by a + sign, often called 'plus numbers', e.g. +7926, within the range +1 to +9999 (computerized form: oc,+.7926);

4 Christy numbers including the year of acquisition and object number within the year, e.g. 1895-918 (computerized form: oc1895,-.918);

5 British Museum numbers consisting of the year, month and day of registration of the collection followed by the number of the object within this collection, e.g. 1854.12-29.126, continued until the year 1939 (computerized form: oc1854,1229.126);

6 subsequent British Museum numbers consisting of the year of acquisition, geographical infix (in this case oc. for Oceania), collection number and the number of the object within this collection, e.g. 1944 oc.2.802 (computerized form: oc1944,02.802);

7 British Museum Q numbers (for objects identified during inventories as having no registration numbers) consisting of the year of the numbering, geographical infix (oc. for Oceania) and object number within the year, e.g. Q1981 oc.1354 (computerized form: oc1981,Q.1354);

8 loan collections numbers consisting of the year of the acquisition of the loan, L infix (for Loan), collection number, the number of the object within this collection, e.g. 1954 L.1.45 (computerized form: oc1954,Loan01.45). In this category the exception is made for the Royal Loan collection of 1902, which was at the time given the letter prefix TRH (Their Royal Highnesses) and thus appears within the geographical/collection letter sequence, e.g. TRH 83/1902 L.1.83 (computerized form: oc1902,Loan01.83).

Information within individual catalogue entries

Each entry contains the following information in the sequence as follows:

1 the catalogue number of the object, and plate reference, where appropriate;

2 name of the object, in English and Maori;

3 British Museum registration number;

4 measurements in centimetres;

5 brief basic description of the object;

6 provenance: how acquired (collection/donor/vendor/collector);

7 any additional information from Registers and labels if such exists: Register information is quoted from Donation Books, Bound Registers and Slips, or compiled from these sources to avoid duplication; Register notes of references to published sources not applying to specific objects but for comparison only are not included;

8 comments: stylistic and period attributions by Roger Neich and David R. Simmons, the latter's taken from his Draft Catalogue, 1996 (see References). If these differ, the author's initials follow his attribution, if in agreement, no initials are given; attributions of fibre objects are by Mick Pendergrast. Also any additional information extracted from the Museum archives, correspondence or any other sources, including Eth.Doc. number (Ethnographical Document accompanying the collection in the Archives of the Department of Africa, Oceania and the Americas) where such exists and there is a specific reference to this particular object; if Eth.Doc. is of a general nature, it is given in the introduction where the collection to which it refers is discussed.

9 references: scholarly publications in which the object is illustrated and/or discussed.

Canoes

Maori canoes varied considerably in size and design, depending on their uses. Small outrigger canoes and larger double canoes were still in use when Europeans first arrived but soon became obsolete. Thereafter, three basic canoe types, all constructed on dugout hulls from kauri or totara trees, answered to Maori needs. For transport of people and freight on rivers and lakes, plain single-tree dugouts (*waka tiwai*) were used. Ranging in size from one-person canoes to large 15-metre vessels, these were paddled or poled. Totally lacking in ornamentation, these were rarely collected.

Of a more complex design, with several component parts, the next main type was the fishing canoe (*waka tete*), used on lakes, rivers and open coast. For these, the dugout hull was deepened by single or double rows of plain side-strakes, and by raised prow and stern carvings of simplified design, all lashed together with flax cordage. Fishing canoe prows featured a stylized carved head projecting forward on a long neck and the stern was usually a solid vane of timber, sometimes with a reduced carving at the base. They were usually paddled and occasionally sailed.

Largest and most prestigious of the canoes was the war canoe (*waka taua*), which was built to the same pattern as a fishing canoe but up to 24-metres long, with fully carved side-strakes, prow and high raised stern. Serving as paddled and sailed transports for warriors on their way to war, *waka taua* were considered tapu and could carry neither women nor common freight such as food. Their high sternposts of strictly prescribed delicate openwork carving composition were decorated with long streamers of hawk feathers. Earlier prows, *tuere*, especially in the north, were a composite of separate carvings fitted together, with a delicate central openwork vane such as the finest surviving example (**15**, canoe prow 1900.7-21.1), now held in this collection. Later, more common war-canoe prows were carved from one solid timber featuring a thrusting figure with trailing arms. Especially important here in the British Museum is the world's largest range of carved paddles with painted red ochre designs (**43–46**, paddles NZ 150, NZ 152, 5370, 1896-1147), seen by the earliest European visitors but very soon becoming obsolete. Large model war canoes in this collection from the early nineteenth century are extremely rare, and were possibly paddled by one or two persons for ritual purposes, and also perhaps for the final deposition of ancestors' bones in burial caves.

Model canoes

War canoes

1 Plate 2
Model war (?) canoe, *waka taua* (?)
NZ 144. Length 204 cm.

Wooden canoe, red stain; prow and stern missing. Two *taumanu* (middle one missing), side-strakes and hull carved with *whakarare*; *pakura* along gunwales. On each side of the hull, three human figures at intervals: naturalistic frontal-view heads placed horizontally on stylized profile figures.

 Provenance: Unknown.
 Comments: East Coast/Bay of Plenty, 1840s (RN).

2 Plate 2
Model war canoe, *waka taua*
TRH 82 / 1902 L.I.82 / Royal Coll. no. 74079. Length 311 cm.

Wooden canoe, haliotis-shell inlay, red stain. Upright stern, *koruru*-type face on each end of all ten *taumanu*. *Pakura* along gunwales; alternating *manaia* and *koruru* figures along side-strakes. Flooring of grid of sticks. Naturalistic tattooed male face on *tuere*-type prow. Long-mouthed *manaia* in low- relief carving on hull under prow. Large *koruru*-type face looking upward inside hull behind prow crosspiece. Haliotis-shell inlay on prow, stern and side-strakes.

 Provenance: Royal Loan 1902, Prince and Princess of Wales.
 Comments: Carved by Anaha Te Rahui, Neke Kapua and Tene Waitere, Ngati Tarawhai (RN).

Official gift of Te Arawa to the Duke and Duchess of Cornwall and York during their visit to New Zealand in 1901, presented by Te Pokiha Taranui.

> The presentation of the Arawa, including the sub-tribes entitled to be considered *tangata whenua*, followed. Pohika Taranui rose to his feet as four of his powerful *rangatira* lifted the canoe, and together they advanced to the grand-stand, where the canoe was deposited, with its load of rich Maori garments and rare weapons … The model was very complete, with bow and stern carving, sideboards, and all appliances. The carvers were all Arawa: Tene Waitere, Anaha Te Rahui, and Neke Kapua, and there are none better in New Zealand.
>
> (Loughnan 1902: 124)

 References: Imperial Institute 1902: 56.334; Loughnan 1902: 124; Neich 1996b: 103; Neich 2001: 250–1 and 360, no.124; and Neich 2004: 59, 67 and 75.

3 Plate 2
Model war canoe, *waka taua*
321. Length 225 cm.

Wooden canoe, feather decoration, haliotis-shell inlay, black stain. Prow figure's arms broken, large feet. Hull plain. Angled *pakura* over whole of side-strakes and three *taumanu*. Traces of feathers along sides, haliotis-shell eyes in figures on prow and stern.

 Provenance: Unknown.
 Register: The entry reads '321 New Zealand Model of canoe sent to the Blackmore Museum', an intention obviously not carried out.
 Comments: East Coast, 1840s–50s, stern poor (RN).

4 Plate 2
Model war canoe, *waka taua*
1635. Length 394 cm.

Wooden canoe, red and black pigment. Black prow, stern and inside of hull; red hull extrerior and side-strakes. Four plain *taumanu*. Side-strakes with *pakura* along gunwales, two panels of *whakarare* and three sets of figures: each set a full *wheku* figure flanked on both sides by *manaia*. Haliotis-shell inlay in eyes of figures. Prow of usual war type but simplified, with no surface decoration.

 Provenance: Unknown.
 Register: Slip annotated 'New Zealand. Auckland … it was sent to the International Exhibition of … by the Rev. C. Volckner.'
 Comments: East Coast, 1840s–50s, standard item (RN).

5 Plate 3
Model war canoe, *waka taua*
1896-1241. Length 128 cm.

Wooden canoe, outside stained black. Slightly upturned prow, *takarangi* spirals, *rauponga* on body continuous with hull. Side-strakes and upper hull carved, with unusual varieties of *pakura*, haliotis-shell inlay mostly missing. Three *taumanu* carved with diagonal *rauponga*. Openwork carved stern with two ribs and *takarangi* spirals.

 Provenance: Presented by A.W. Franks, 24 December 1896.
 Comments: East Coast, 1860s, poorly proportioned (RN).

6 Plate 3
Model war canoe, *waka taua*
1846.8-26.1. Length 217 cm.

Wooden canoe, feather decoration, haliotis-shell inlay. Seven *taumanu* carved with

rauponga, one plain with *wheku* head at one end, other end broken. *Whakarare* all over hull and side-strakes. *Pakura* along gunwales. War-canoe prow. Feathers of grey gull (hawk?) around prow and stern, white gull feathers along side-strakes. White feathers at neck of prow figure, whose left arm is broken off; haliotis-shell inlay in eyes of stern figures. Flooring of strips of wood.

Provenance: Presented by Mr Chapman.

Comments: Whanganui/East Coast, about 1820–40 (RN).

According to description in Register, originally with a mat sail, which is now lost. It has also been numbered NZ 121.

References: Edge-Partington 1969 I: 382.2.

7 — Plate 3
Model war canoe, *waka taua*
1910.12-1.1. Length 400 cm.

Wooden canoe, haliotis-shell inlay, metal. Standard type prow, its large spiral damaged, rough carving; female *wheku*-faced *huaki* figure. Old metal repairs nailed on for use in sea. Side-strakes have carving of alternating male and female *wheku* figures and *manaia* in copulation, *rauponga* on bodies. Two end *taumanu* with two lizards tail to tail on each, central *taumanu* with two *wheku* figures head to head, all figures carved in the round. Stern with large stylized figure. Haliotis-shell inlay on prow figure.

Provenance: Purchased from H.J. Bedows, the Museum, Shrewsbury.

Comments: East Coast, 1840s (RN).

8 — Colour plate 1
Model war canoe, *waka taua*
1926.11-12.1. Length 423 cm.

Wooden canoe, feather decoration, metal nails, red pigment. Standard stern. Four *taumanu*, all carved with high-relief, two figures feet inwards, all *wheku* except two on front *taumanu* which are *koruru* type. *Whakarare* along gunwales. Alternating *manaia* and *wheku* figures along side-strakes, some male with penis, others indeterminate sex. Entire outer surface of hull carved in bands of *whakarare*. Standard prow: *rauponga*, *whakarare* and some *pakura*, haliotis-shell eyes on figure, its left arm broken off. *Wheku* heads on prow and *huaki* figure and on flat figure on baseboard; *rauponga* on faces and straight *ritorito* on flat figure. All stained red except *taumanu*. Grey feathers around neck of prow and across side of prow. White feathers at intervals along side join and grey feathers across side of stern.

Provenance: Presented by Lord Stanley of Alderley with two paddles: **70** (1926.11-12.1a) and **71** (1926.11-12.1b).

Comments: Arawa style, 1840s (RN).

Brought home by Captain Owen Stanley and collected probably between 1837 and 1843, when he was in command of HMS *Britomart* surveying various harbours in New Zealand.

> I believe that the canoe was brought to Alderley early in the 19th century by Capt. Owen Stanley RN who explored Papua … There is no written information at Alderley regarding this canoe and the information I send you in this letter is derived from what I was told by my Father.
>
> (BM AOA correspondence: Lord Stanley of Alderley to Joyce, 11 August 1926)

9 — Plate 3
Model war canoe, *waka taua*
Q1981 Oc.1919. Length 205.5 cm.

Wooden canoe, stained red. Naturalistic face on figurehead with upper portion of face tattooed; *rauponga* on trunk and upper legs. Stiff, rolling spirals along gunwales. Four plain *taumanu*. *Rauponga* on stern.

Provenance: Unknown.

Comments: Whanganui, mid to late nineteenth century (RN).

10
Model war canoe, *waka taua*
1954 L.1.45 / Royal Coll. no. 74010. Length 88 cm (canoe), 130 cm (case).

Wooden canoe: rigged, with mat sail, painted pinky ochre outside, black inside, with black and white *puhoro*, in wood and perspex display case. Standard prow and stern: side-strakes carved with *whakarare*, fourteen plain *taumanu*, each – except the front one – with a pair of painted paddles with white patterns on blades. Inside, flooring of four sections of reed on which rest six bailers. Prow decorated with vegetable-fibre *hihi*, white feathers at intervals along side-strakes, grey feathers along stern. Naturalistic male kilt-clad figure with steering paddle at stern.

Provenance: Royal Loan 1954, Her Majesty Queen Elizabeth II.

Comments: A modern presentation carving.

Fishing canoes

11 — Plate 4
Model fishing canoe, *waka tete*
1854.12-29.81. Length 157 cm.

Wooden canoe, missing prow. Carved all over, inside and out: diagonal *rauponga* on outside of hull, inside *whakarare* and *rauponga*. Five pairs of matching relief carvings spaced inside the hull: three pairs of double figures and two pairs (rear two) of *wheku* faces. Simple fishing-canoe stern carved in *rauponga*.

Provenance: Grey Collection.

Comments: East Coast, 1850s, very crude carving (RN).

12 — Plate 4
Model fishing canoe, *waka tete*
1913.3-12.1. Length 130 cm.

Wooden canoe: stained red, fishing-canoe stern, strange prow with loop and naturalistic face on end. Plain hull and side-strakes. Traces of feathers at intervals along the side-strakes.

Provenance: Presented by Miss Godley and obtained between 1849 and 1853.

Comments: Whanganui, mid nineteenth century (RN).

> The curios came directly from her father, John Robert Godley who was a leader of the Canterbury Settlement in the South Island of New Zealand, and was a close friend of Sir George Grey. Many of the curios came directly from tribes as presents to Mrs Godley, and as they have never been out of the hands of the family their provenance is entirely authenticated.
>
> (BM AOA correspondence: A.P. Newton to Joyce, 18 September 1935)

They were brought from New Zealand by her father in 1853.

(BM PE correspondence: F.G. Kenyon, 14 February 1913)

13
Model canoe, *waka*
1908.5-13.22. Length 64.5 cm.

Wooden hull only: plain, stained red outside.

Provenance: Budden/Angas Collection.

Canoe parts

War canoe parts

14 — Plate 5
War canoe prow, *tauihu* (*pitau*)
1895-353. Length 97 cm.

Wooden prow: unpainted, standard type. Arms and left leg broken off, *wheku* face at front, plain, no surface decoration, *rauponga* on body. Very simple *huaki* figure. Along right side of base, two figures, one male other probably female, on left side, two male figures; all with *pakura* and some *rauponga*. *Wheku* figure horizontal on top of base under *takarangi* spirals, with *pakura* on limbs.

Provenance: Meinertzhagen Collection.

Comments: East Coast; 1860s–70s, not well carved (RN); 1840–60 (DRS).

References: Neich 1996b: 99.

15 — Colour plate 1
War canoe prow, *tauihu* (*tuere*)
1900.7-21.1. Length 112 cm.

Wooden prow: brown, carved on both sides. Elongated *manaia* with rolling spirals on bodies and triangular clear patches. Interstitial openwork of loops and spirals including hands of *manaia* figures, all in *unaunahi* over v-shaped groove. Heads of *manaia* in *unaunahi*. *Rauponga* along upper margin interspersed with *unaunahi*. Line of *taratara-a-kai* on nose of rear *manaia*.

Provenance: Purchased from Rollin & Feuardent, originally acquired from Passmore.

Comments: Hokianga, eighteenth century.

Arthur D. Passmore, Imperial Yeomanry, offered the prow for sale to the Museum: 'I have lately purchased from the Bennett collection at Farringdon a beautifully carved piece of a New Zealand work made for the stern of a canoe.' (BM PE correspondence: Passmore, 18 December 1899). Read sent Passmore a cheque on 15 January 1900: 'Dear Sir, Herewith the cheque for the New Zealand carving…' (BM PE correspondence: Read to Passmore, 15 January 1900), but according to the Register the prow was bought from Rollin & Feuardent.

References: Archey 1933: 180, pl. 11a; Archey 1956: 372, pl. 66.1; and 1977: 60, pl. 114; Edge-Partington 1899b: 305, pl. XXX; Edge-Partington 1900a: 42; and 1900c: 40; Hooper 2006: 128.64; Neich 1996b: 100–1; Simmons 1985: 67, fig. 60.

16 — Plate 5
War canoe prow, *tauihu*
1927.11-12.1. Length 180 cm.

Wooden prow, Waikato type. Front spiral broken. Large *takarangi* spirals painted black, sinuous rib left plain. Rudimentary *manaia* head on top.

Provenance: Purchased from Lt Col. H.C. Parsons.

Register: Formerly belonged 'to a Waikato chief named Tauwhio [Tawhiao], obtained 1903'.

Comments: Waikato; 1870s–80s (RN); 1850–60 (DRS).

'The Canoe Head belonged to Tauphio a Waikato Chief and was given to me in 1903.' (BM AOA correspondence: H.C. Parsons, 6 September 1927).

References: Gathercole, Kaeppler and Newton 1979: 198; Joyce 1928: 103–4, pl. LXIXb; Phillipps 1955: 177, fig. 63.

17 Plate 6
War canoe stern, *taurapa*
1895-354. Height 99 cm.

Wooden stern: broken at top, *wheku* figure at top of ribs. Front rib with deep carved hatching pattern. Rear rib plain with spaced bands of *whakarare*, painted black. Female *wheku* figure at front of base. Left side of stern carved as described, right side all plain.

Provenance: Meinertzhagen Collection.

Comments: East Coast; 1850s (RN); nineteenth century (DRS).

18 Plate 6
War canoe stern, *taurapa*
1847.8-27.24. Height 144 cm.

Wooden stern: traces of black paint on ribs and lower rear *manaia* face. *Manaia* figure at top and base of ribs. No surface decoration.

Provenance: Presented by Captain E. Holme, RN (later Sir Everard Home?)

Register: 'Stern of a canoe of John Heke, chief of the New Zealanders. From the Bay of Islands, New Zealand.'

Comments: Bay of Islands; not much earlier than 1847, poorly carved (RN); c.1820–30 (DRS).

References: Archey 1938: 175, pl. 41.6.

19 Plate 7
War canoe stern, *taurapa*
1908.5-13.15. Height 64 cm.

Wooden stern: stained red, broken into two pieces. Naturalistic plain figure, no tattoo. Plain *manaia* behind front rib at base.

Provenance: Budden/Angas Collection
Comments: Arawa, 1830s–40s (RN).

20 Colour plate 2
War canoe stern, *taurapa*
1922.1-10.1. Height 211 cm.

Wooden stern: stained red, but ochre mostly worn off. Forward-facing *wheku* figure with *pakura* and *rauponga* on face, spiral shoulder joint and *pakura* on arm, its elongated body formed by the two central ribs of stern, decorated with *whakarare*. *Takarangi* spirals interspersed with *manaia* figures with *pakura* or *whakarare*, many of them unfinished, especially on left side. *Manaia*-headed frontal figure with *whakarare* at inner base, its left side unfinished. Another *manaia* with *whakarare* at outer base, also unfinished on left side.

Provenance: Presented by the National Art Collection Fund; purchased from Captain Daubeny via A.D. Passmore.

Comments: Bay of Plenty, mid nineteenth century (RN).

You will remember when down here seeing a large canoe prow from New Zealand. I have now heard from my friend Capt. Daubeny, he is willing to sell it …
(BM PE correspondence: A.D. Passmore, 31 October 1921)

As far as I am concerned the carving can wait till next April, I think my friend will agree to this, should much like you to have it as it is a nice specimen. I well remember the last one I sold you [see **15**, 1900.7-21.1], was only a boy at the time and as my father insisted that I should confine myself to Wiltshire things only, you were given the opportunity to have that glorious piece … am at the same time very glad it is with you. My friend the owner is in India, will write him what you say.
(BM AOA correspondence: A.D. Passmore, 11 November 1921)

References: Neich 1996b: 98.

Fishing canoe parts

21 Plate 7
Fishing canoe prow, *tauihu*
1895-355. Length 34 cm.

Wooden prow head: very weathered and broken. *Pakura* around mouth.

Provenance: Meinertzhagen Collection.

Comments: East Coast, mid to later nineteenth century (RN); West Coast (DRS).

22
Fishing canoe prow, *tauihu*
1898-4. Length 63 cm.

Wooden prow: unpainted, worn, grey. Rudimentary blocked-out face with raised eyes. No surface decoration.

Provenance: received in exchange from the Canterbury Museum, Christchurch.

Label: 'Waikato Riv. Figure head of a fishing canoe. Recd in exchange, Canterbury Mu, Ch:ch NZ 1898.'

Comments: Waikato River, North Island. A small box of stone implements was sent to Captain Hutton of the Canterbury Museum in exchange 'for Maori objects for my department' (BM PE correspondence: C.H. Read, 2 March 1898).

23 Colour plate 1
Fishing canoe prow, *tauihu*
1908.5-13.14. Length 71 cm.

Wooden prow: stained red, haliotis-shell eyes, no signs of wear. Face with tattoo pattern in *pitau*, plain spirals and *rauponga*. On each side of base: full-frontal *wheku* figure and *manaia* with jaws reaching up behind frontal face, both figures with some *rauponga*. *Whakarare* across edge of transverse board, *pakura* on its edges. *Huaki* figure with three-fingered hands on chest, jaws on flat space below it, no surface decoration. Large square-cut lashing holes.

Provenance: Budden/Angas Collection.

Comments: Arawa, mid nineteenth century (RN).

24
Fishing canoe stern, *taurapa*
1908.5-13.17. Height 61 cm.

Wooden stern. Plain vane. *Manaia* head at upper rear. Broken away at base.

Provenance: Budden/Angas Collection.

Comments: Arawa, 1840s (RN); Bay of Plenty, eighteenth century (DRS).

Thwarts

25 Plate 4
War canoe thwart, *taumanu*
1640. Length 51 cm.

Wooden lizard figure cut from a thwart. Head as *manaia* with large tooth. Notched ridge along back, *rauponga* on body. Plain spirals on front and rear joints.

Provenance: United Service Institution Museum.

Register: 'A tuatera [*tuatara*] … U.S.M. No.9 U.S.M. C.P.'

Comments: East Coast, 1820s–40s, coarse carving (RN); Bay of Plenty, c.1860, *pataka* ridge (DRS).

References: Neich 1996b: 83; Simmons 1986a: 26, pl. xa.

26
Canoe thwart, *taumanu*
1908.5-13.18. Length 48.3 cm.

Wooden, plain, with central vertical kink.
Provenance: Budden/Angas Collection.

27
Canoe thwart, *taumanu*
1908.5-13.19. Length 51.7 cm.

Wooden, plain, with central vertical kink.
Provenance: Budden/Angas Collection.

Model canoe parts

28 Plate 8
Model war canoe prow, *tauihu*
1908.5-13.21. Length 34.5 cm.

Wooden prow: stained black. Arms broken off; surface decoration of *rauponga* and *pakura*. Three crude *wheku* (?) faces on each side of base.

Provenance: Budden/Angas Collection.

Comments: Whanganui, mid/late nineteenth century, crude carving (RN).

29 Plate 8
Model war canoe prow, *tauihu*
1921.6-16.1. Length 37 cm.

Wooden prow: brown, traces of red ochre. Arms and legs broken off. *Rauponga* with wide *pakati*, and *pakura*, some surface ornamentation worn.

Provenance: Presented by Miss Hirst.

Comments: Taranaki style, early nineteenth century, well carved (RN).

30 Plate 8
Model war canoe prow, *tauihu*
Q2002 Oc.1. Length 24 cm.

Wooden prow: stained red, very weathered. Arms and left foot broken off, *rauponga* on body. Horizontal male (?) *wheku*-faced figure with *rauponga* on base under *takarangi* spirals; very weathered inverted *huaki* figure with *rauponga* at back, another face above it. *Manaia* with *rauponga* on each side of base. Haliotis-shell eyes (three remaining).
Provenance: Unknown.

Comments: North Auckland, 1830s–40s (RN).

31 Plate 9
Model war canoe stern, *taurapa*
1908.5-13.20. Height 26.5 cm.

Wooden stern: traces of red ochre. Continuous scroll pattern on central rib with interstitial *rauponga*, plain spirals

forward of rib, *rauponga* spirals with diamond-shaped *pakati* behind rib.

Provenance: Budden/Angas Collection.

32 **Plate 9**
Model fishing canoe prow, *tauihu*
1855.12-20.61. Length 32 cm.

Wooden prow: male, naturalistic tattooed face; haliotis-shell eyes. *Rauponga* and some *pakura*. Simple, naturalistic *huaki* face.

Provenance: Haslar Hospital Collection.

Register: 'Wood model of a canoe carved externally, ornaments at top and bottom. It has three crossbars. Length about 7 feet. From one of the Mallicotta Islands where La Perouse was wrecked [obviously incorrect]'; photocopy of this in Slips annotated: 'Prow only.'

Comments: Whanganui (?), mid nineteenth century (RN).

33 **Plate 9**
Model fishing canoe stern, *taurapa*
Q1981 Oc.1390. Height 43 cm.

Wooden stern: traces of red ochre, carved on both sides with *whakarare*.

Provenance: Unknown.

34
Model canoe thwart, *taumanu*
1285. Length 21.8 cm.

Wooden thwart, stained red. Figure with male tattoo, *rauponga* and *rauponga* spirals. Face looking outward at each end.

Provenance: Unknown.

Comments: Whanganui; early mid nineteenth century, well carved (RN).

35
Model canoe thwart, *taumanu*
1286. Length 21.8 cm.

Wooden thwart, stained red. Male tattooed face looking inward at each end, *rauponga* and rolling spirals.

Provenance: Unknown.

Comments: Whanganui; early mid nineteenth century (RN).

36–41
These six thwarts, registrations 1648–1653, probably come from the same model canoe; all are marked in pencil 'Dup', i.e. Duplicate Collection.

36
Model canoe thwart, *taumanu*
1648. Length 28.3 cm.

Wooden thwart: stained red, decorated with concentric rounded oblongs of *rauponga* on one side.

Provenance: Unknown.

Comments: Whanganui, *c*.1860 (DRS).

37
Model canoe thwart, *taumanu*
1649. Length 27.9 cm.

Wooden thwart: stained red, decorated with oblongs of *rauponga* on one side.

Provenance: Unknown.

Comments: Whanganui, *c*.1860 (DRS).

38
Model canoe thwart, *taumanu*
1650. Length 24.7 cm.

Wooden thwart: stained red, decorated with oblongs of *rauponga* on one side.

Provenance: Unknown.

Comments: Whanganui, *c*.1860 (DRS).

39
Model canoe thwart, *taumanu*
1651. Length 25.7 cm.

Wooden thwart: stained red, decorated with oblongs of *rauponga* on one side.

Provenance: Unknown.

Comments: Whanganui, *c*.1860 (DRS).

40
Model canoe thwart, *taumanu*
1652. Length 18.4 cm.

Wooden thwart: stained red, decorated with oblongs of *rauponga* on one side.

Provenance: Unknown.

Comments: Whanganui, *c*.1860 (DRS).

41
Model canoe thwart, *taumanu*
1653. Length 15.9 cm.

Wooden thwart: stained red, decorated with oblongs of *rauponga* on one side.

Provenance: Unknown.

Comments: Whanganui, *c*.1860 (DRS).

42
Model canoe thwart, *taumanu*
Q1981 Oc.1385. Length 25.7 cm.

Wooden thwart with central kink, one side decorated with *whakarare*.
Provenance: Unknown.

Paddles and sail

Painted paddles

43 **Colour plate 3; Plates 10, 13 and 15**
Paddle, *hoe*
NZ 150. Length 179 cm.

Wooden paddle: blade painted on both sides with *kowhaiwhai*, simple white *pitau* series on red. Three-dimensional face with coarse *taratara-a-kai*, even over eyes, at loom; simple *manaia* (unfinished on one side) at butt.

Provenance: Cook Collection.

Register: 'Add.MSS. 15,508 pl.29.1. A Paddle, perhaps the one drawn by JF Miller 1771.'

Fragments of stuck-on label, no visible writing.

Comments: Poverty Bay (RN); East Coast (DRS); eighteenth century.

References: Joppien and Smith 1985: 1.169, no. 1; Kaeppler 1978: 203; Neich 1993: 64, fig. 27 and Neich 1996b: 101; Simmons 1985: 57, fig. 48; Starzecka 1979: fig. 70.

44 **Colour plate 3; Plate 10**
Paddle, *hoe*
NZ 152. Length 204 cm.

Wooden paddle: blade painted on both sides with white diamonds on red. On concave side of blade, at base, a *wheku* face in relief with notched haliotis-shell eye (one missing), *unaunahi* around mouth. Flat, round butt, split and repaired with fibre; adze marks on upper part of shaft.

Provenance: Cook Collection (?)

Comments: South Island (RN); Queen Charlotte Sound (DRS); eighteenth century.

References: Neich 1993: 65–6, fig. 29; Simmons 1981: 58, fig. 14.

45 **Colour plate 3; Plates 10 and 15**
Paddle, *hoe*
5370. Length 181.5 cm.

Wooden paddle: blade painted on both sides with *kowhaiwhai*, simple white *pitau* series on red. Three-dimensional face with coarse *taratara-a-kai*, also over eyes and tongue, at loom; butt broken off but showing remnants of small *manaia*, also with *taratara-a-kai*.

Provenance: Presented by W. Bragge, 21 April 1869.

Comments: Poverty Bay (RN); Cook Strait (DRS); eighteenth century.

References: Neich 1993: 64, fig. 30.

46 **Colour plate 3; Plates 10 and 15**
Paddle, *hoe*
1896-1147. Length 172 cm.

Wooden paddle: blade painted on both sides with *kowhaiwhai*, complex white *kape* series on red. Three-dimensional face with *taratara-a-kai* over eyes at loom, upper jaw curved to one side, simple plain *manaia* at butt; tip of blade broken off, blade itself damaged by woodworm.

Provenance: United Service Institution Museum.

Comments: Poverty Bay (RN); Cook Strait (DRS); eighteenth century.

References: Neich 1993: 63, fig. 28.

Carved paddles

47 **Plate 15**
Paddle, *hoe*
NZ 149. Length 195 cm.

Wooden paddle: one side of blade carved with three groups of spirals, three-dimensional face with *pakura* at loom, plain simple *manaia* at butt. Tip of blade has two small holes for lashing (lost) to repair longitudinal split in blade.

Provenance: Unknown.

Comments: Poverty Bay, 1820s.

48 **Plate 11**
Paddle, *hoe*
NZ 151. Length 203 cm.

Wood paddle, stained red. On concave side of blade female figure in relief, *ritorito* on face, haliotis-shell eyes, plain spirals on shoulders, *rauponga* on right side of trunk, feet pointing towards enlarged tip of blade carved as rudimentary plain *manaia*. Rounded, convexo-concave butt, partly broken off.

Provenance: Cook Collection (?)

Comments: Cook Strait (RN); Queen Charlotte Sound (DRS); eighteenth century.

References: Simmons 1981: 58, fig. 15.

49 **Plates 11 and 13**
Paddle, *hoe*
5371. Length 198.5 cm.

Wooden paddle: long narrow blade, very long shaft with gentle natural curve. One side of blade plain, other side with relief carving of frontal figure with sinuous body, one hand in mouth, domed head, body plain, arms and legs in *rauponga* twisted around body; below it, a band of *rauponga* with two *rauponga* spirals leading to *manaia* figure with sinuous body and arms and legs intertwined; body plain, limbs in *rauponga*. Very large butt figure, female, with pointed head and bulbous eyes: S-curved body with hands passing under legs to rest on body below chin, feet raised on to both

sides of body; large vulva with small face mask behind; body plain, arms and legs in *rauponga* with large diamond-shaped *pakati*.

Provenance: Presented by W. Bragge, 21 April 1869.

Comments: Taranaki; 1800s–10s or late eighteenth century (RN); eighteenth century (DRS).

50 **Plate 11**
Paddle, *hoe*
5372. Length 229 cm.

Wooden paddle: long straight shaft, plain knob at butt, partly broken off. One side of blade plain. On other side, relief squatting figure displaying large vulva, hands around legs, body plain, arms, legs and vulva in *rauponga*. Bands of *rauponga* leading to *manaia* figure with sinuous plain body, and intertwined arms and legs in *rauponga* and *ritorito*. Another curved band in *rauponga* leads to lower pair of *manaia* figures with plain borders and intertwined limbs in *rauponga* and *ritorito*. Sharp, pointed heads, haliotis-shell eyes (some missing), diamond-shaped *pakati*.

Provenance: Presented by W. Bragge, 21 April 1869.

Comments: Taranaki, eighteenth century.

References: Barrow 1969: fig. 179; Neich 1996b: 101.

51 **Plate 13**
Paddle, *hoe*
+3460. Length 193 cm.

Wooden paddle: plain blade; shaft with natural double curve; butt as squatting male figure carved in the round, *rauponga* on face, *pakura* and some *rauponga* on body and limbs.

Provenance: Presented by A.W. Franks, 1 June 1887 (Alex Nesbitt sale, Christie's).

Comments: Southern North Island (RN); Horowhenua (DRS); eighteenth century.

52 **Plate 13**
Paddle, *hoe*
+5579. Length 145.5 cm.

Wooden paddle: plain blade; butt carved as knob with concentric ridges and grooves, below it a small Janus face in relief, with *rauponga*.

Provenance: Presented by A.W. Franks, 26 May 1892 (Cutter).

Comments: East Coast; early nineteenth century (RN); eighteenth to nineteenth century (DRS).

53 **Plates 11 and 14**
Paddle, *hoe*
1903.11-16.6. Length 185.6 cm.

Wooden paddle: one side of blade with non-traditional design of spirals and curves, haliotis-shell inlay. Butt carved as female with feet raised up under chin and hands down at back: body plain, spirals on arms, sparse *rauponga* on face and legs. Marked in pencil on blade: 'EG'.

Provenance: Bequest of Francis Brent, 16 November 1903.

Labels: 'Lent by Francis Brent Sept. 1898', '546 Paddle New Zealand'.

Comments: Whanganui; 1830 (RN); c.1820 (DRS).

Registered mistakenly on Slip as no. 7 in this collection.

54
Paddle, *hoe*
1908.5-13.7. Length 146 cm.

Wooden paddle: plain narrow blade, shaft curved near the blade, butt as plain *manaia*.

Provenance: Budden/Angas Collection.

Comments: East Coast; early nineteenth century (RN); eighteenth century (DRS).

55 **Plate 12**
Paddle, *hoe*
1915.2-17.5. Length 183 cm.

Wooden paddle: one side of blade with frontal low-relief figure, *koruru* face and small body; other side of blade with full-frontal *koruru* face with double tongue linked by rolling spirals to frontal face turned sideways with peaked head and looped body. Plain spirals and *pakura* on figures, notched haliotis-shell eyes. Gently curved shaft, butt as large Janus head with rounded tongue.

Provenance: Edge-Partington Collection.

Register: 'Collected in NZ at least 100 years ago.'

Comments: Taranaki, 1800s (RN); South Taranaki, eighteenth century (DRS).

56
Paddle, *hoe*
1927.3-7.55. Length 141.5 cm.

Wooden paddle: blade carved on both sides (one unfinished) with longitudinal *rauponga* bands with peaked *pakati* and six transverse *whakarare*. Face with *rauponga* at loom. Shaft carved all around with six longitudinal sections of oblongs of *rauponga*, each section consisting of three parallel oblongs; plain knob at butt. Haliotis circle in centre of blade and haliotis eye in the loom face (one missing).

Provenance: Presented by Mrs J.E. Birch, collected by Alfred Clay 1867–77.

Comments: Poverty Bay, 1880s.

57 **Plate 14**
Paddle, *hoe*
1927.11-19.5. Length 178.5 cm.

Wooden paddle: plain blade; butt carved as Janus face in high relief, with *rauponga* and *whakarare* and notched haliotis-shell eyes, now blackened.

Provenance: Reid/Capt. Luce Collection.

Comments: Poverty Bay, 1860s.

58
Paddle, *hoe*
1927.11-19.6. Length 168 cm.

Wooden paddle: plain blade; rudimentary plain Janus faces on middle of gently curved shaft and on butt.

Provenance: Reid/Capt. Luce Collection.

Comments: Bay of Plenty, 1840s.

59
Paddle, *hoe*
1944 Oc.2.795. Length 173 cm.

Wooden paddle: blade carved on one side with two transverse opposing pairs of face-to-face *manaia* with *rauponga* and plain spirals, longitudinal double band of *unaunahi* between them and running towards small *rauponga manaia* and plain rolling spirals near loom; cylindrical butt.

Provenance: Beasley Collection. Beasley no. 2710.

Comments: Northland, eighteenth century.

Beasley catalogue: 2710, registered 1 February 1931, 'Blackmore Museum'.

60 **Plate 15**
Paddle, *hoe*
1944 Oc.2.796. Length 166 cm.

Wooden paddle: plain blade; low-relief face with *taratara-a-kai*, painted black, at loom (both carving and paint worn); butt as simple openwork *manaia* with *taratara-a-kai*. Marked on blade 'New Zealand'.

Provenance: Beasley Collection. Beasley no. 2711.

Comments: East Coast; mid nineteenth century (RN).

Beasley catalogue: 2711, registered 1 February 1931, 'Blackmore Museum'.

61
Paddle, *hoe*
1944 Oc.2.797. Length 206.5 cm.

Wooden paddle: one side of blade carved in relief near loom with coarse plain squatting profile figure above frontal, equally coarse, face. Flat, circular projection on tip of blade, one side broken off. Flat, oval butt, one side broken off.

Provenance: Beasley Collection.

Label: 'Carved Paddle, Maori, New Zealand, 20-1-1930.'

Comments: South Island; early nineteenth century (RN); eighteenth century (DRS).

62 **Plates 12 and 14**
Paddle, *hoe*
1944 Oc.2.798. Length 169.5 cm.

Wooden paddle: one side of blade plain, other side slightly concave with low-relief carving of *manaia* face near loom linked by double line of *unaunahi* to large female figure with frontal face, profile body, plain spirals on limbs, large vulva, two *unaunahi* lines continued below. Gently S-curved shaft with plain raised section in middle, butt carved in the round as free-standing *wheku*-faced figure, hands behind chin, body curved, plain spirals.

Provenance: Beasley Collection. Beasley no. 992.

Comments: Hokianga; 1810s–20s (RN); 1820 (DRS).

Beasley no. 992 recorded in Register is incorrect, it should be 993. Beasley catalogue: 993, registered 10 November 1915, 'Bt Mr Webster'.

63 **Plate 12**
Paddle, *hoe*
1947 Oc.4.1. Length 217.5 cm.

Wooden paddle stained red. Blade carved on both sides: one with longitudinal, full human figure (female) near tip with *wheku* face, long body with spirals on limbs and parallel grooves on trunk; other side with transverse frontal face at end of central rib. Tip of blade as triangular pointed knob. Straight shaft with flat, circular butt (one side broken off) with two square holes. Similar holes – three on each side – on blade, for lashing repairs, as blade has a longitudinal split.

Provenance: Cook Collection. Purchased from Sidney Burney, ex Leverian Museum.

Comments: Queen Charlotte Sound, eighteenth century.

References: Force and Force 1968: 128; Simmons 1981: 56, figs 12 and 13.

64

Paddle, *hoe*

1994 oc.4.76. Length 161 cm.

Wooden paddle: unstained, made up of three pieces – shaft and central part of blade carved from one piece, and two sides added and glued on. Blade with rounded end and flattened edge, carved one side in shallow low relief with longitudinal female figure with naturalistic face and chin tattoo, *pungawerewere* spirals on limbs and small, plain figure between legs, standing above *wheku*-faced figure with *rauponga* spirals on limbs and small, plain figure between legs; small, plain face at tip of blade; two main figures with small haliotis eyes, space on sides and above filled with *manaia* figures with some *rauponga* ornamentation. Shaft with slight curve near blade and rectangular cross section at butt end. 'Matahi 94' carved on plain side of blade.

 Provenance: Collected in the field.

 Comments: Carved by Matahi Brightwell of Gisborne in 1994. Contemporary art.

Plain paddles

65

Paddle, *hoe*

169. Length 171.5 cm.

Wooden paddle: plain, lanceolate blade, shaft with small knob butt, pronounced angle at loom.

 Provenance: Unknown.

 Comments: Central North Island, *c.*1850 (DRS).

66

Paddle, *hoe*

1854.12-29.88. Length 145.8 cm.

Wooden paddle: plain blade, shaft in undulating natural curves with knob butt.

 Provenance: Grey Collection.

 Comments: Northland, eighteenth century, river paddle (DRS).

67

Paddle, *hoe*

1908.5-13.8. Length 170 cm.

Wooden paddle: plain, large wide blade, shaft with large knob butt.

 Provenance: Budden/Angas Collection.

 Comments: North Island (DRS).

68

Paddle, *hoe*

1908.5-13.9. Length 165.7 cm.

Wooden paddle: plain, shaft with oblong knob. Carved on blade: 'HI/T [?]'.

 Provenance: Budden/Angas Collection.

 Comments: Northland (DRS).

69

Paddle, *hoe*

1908.5-13.10. Length 159.3 cm.

Wooden paddle: plain; blade incised with 'Hate Ko Ho', slight bulge at butt.

 Provenance: Budden/Angas Collection.

 Comments: Northland, eighteenth century (DRS).

70

Paddle, *hoe*

1926.11-12.1a. Length 123 cm.

Wooden paddle: plain, lanceolate blade, shaft with slight knob butt.

 Provenance: Presented by Lord Stanley of Alderley, with model canoe **8** (1926.11-12.1).

71

Paddle, *hoe*

1926.11-12.1b. Length 123 cm.

Wooden paddle: plain, lanceolate blade, top of shaft slightly widened.

 Provenance: Presented by Lord Stanley of Alderley, with model canoe **8** (1926.11-12.1).

72

Paddle, *hoe*

Q1980 oc.1286. Length 171.5 cm.

Wooden paddle: plain, lanceolate blade, shaft with slight curve near blade and mushroom-like knob butt.

 Provenance: Unknown.

 Comments: Northland, 1850–60 (DRS).

73

Paddle, *hoe*

Q1981 oc.1699 (wrongly numbered as 1854.12-29.88). Length 148.5 cm.

Wooden paddle: plain, shaft with slight curve in plane with blade on which letters 'J.H.W.' are carved.

 Provenance: Unknown.

 Comments: River paddle (DRS).

Steering paddle

74 **Plate 14**

Steering paddle, *hoe*

1980 oc.2.1. Length 255.3 cm.

Wooden paddle: large, plain blade; thick shaft with slight curve at loom and terminating at butt end in carved hand with five straight fingers and surface decoration of long *pakati* on back of hand and transverse band of *pakati* across knuckles of fingers.

 Provenance: Purchased from Anthony Jack.

 Comments: Whanganui, mid nineteenth century (RN); Taranaki (DRS).

Model paddles

75 **Plate 16**

Model paddle, *hoe*

7981. Length 83.3 cm.

Wooden paddle: blade carved on both sides with *pitau* series *kowhaiwhai* pattern, one side entirely, other upper half only. Plain naturalistic figure at loom, another, with spirals on buttocks, at butt.

 Provenance: Presented by A.W. Franks, 12 September 1871; bought from Wareham.

 Comments: Whanganui; 1840s–50s (RN); 1840 (DRS).

76

Model paddle, *hoe*

1895-157. Length 39.5 cm.

Wooden paddle: stained red; blade with painted *pitau*-series pattern on both sides: red background with pattern of plain yellowish wood outlined in black; rough *manaia* at butt.

 Provenance: Presented by A.W. Franks, 3 June 1895; ex Sparrow Simpson Collection.

 Comments: East Coast, early nineteenth century (RN).

77

Model paddle, *hoe*

1895-158. Length 49 cm.

Wooden paddle: stained red; blade with painted *pitau*-series pattern on both sides: red background with pattern of plain yellowish wood outlined in black; rough *manaia* at butt.

 Provenance: Presented by A.W. Franks, 3 June 1895; ex Sparrow Simpson Collection.

 Comments: East Coast, early nineteenth century (RN).

78 **Plate 16**

Model paddle, *hoe*

1848.3-13.1. Length 83 cm.

Wooden paddle: blade carved on one side with *pitau*-series *kowhaiwhai* and infilling of parallel grooves; shaft with butt as naturalistic standing female figure carved in the round, full face male tattoo, spirals on buttocks. Wrapped around shaft is grooved eel/snake in low relief, its head between feet of butt figure.

 Provenance: Purchased from Mr Clark.

 Comments: Whanganui, 1840s.

79 **Plate 16**

Model paddle, *hoe*

1848.3-13.2. Length 83.5 cm.

Wooden paddle: blade carved on one side with *pitau*-series *kowhaiwhai* and infilling of parallel grooves; shaft with butt as naturalistic standing male figure carved in the round holding *taiaha*, full-face tattoo, spirals on buttocks. Wrapped around shaft is grooved eel/snake in low relief, its head between feet of butt figure.

 Provenance: Purchased from Mr Clark.

 Comments: Whanganui, 1840s.

Sail

80 **Colour plate 2**

Canoe sail, *ra*

NZ 147. Height 435 cm.

Plaited in check from strips of flax leaf, in thirteen panels joined together with mat joins, with zigzag bands of hexagonal openwork three-directional plaiting; along top edge and around 'tail' fringes of dark-coloured feathers. Loops made of four two-ply, soft, flax-fibre strings wrapped with fine rolled cords; some loops still have kaka feathers attached; two have small remnants of dog hair.

 Provenance: Unknown.

 Comments: Late eighteenth century, probably Cook Collection (MP).

 References: Best 1924, vol I: 441; Best 1925b: 263–4; Edge-Partington 1969 II.2: 162; Firth 1931: 129–35; Haddon and Hornell 1936 [1975]: 208–10; Pendergrast 1998: 123–4; Te Rangihiroa 1931: 136–40; 1950 [1974]: 205–6.

Bailers

81
Bailer, *tiheru*

NZ 122. Length 25 cm.

Wooden bailer: small, plain, light yellow wood.

Provenance: Unknown.

Comments: Nineteenth century (RN); Northland, eighteenth century, possibly Cook Collection (DRS).

82
Plate 17

Bailer, *tiheru*

NZ 123. Length 49 cm.

Wooden bailer with traces of red ochre. Bold openwork *manaia* head on handle, re-curved to large nose. Openwork mouth with *manaia* eye and brow to sides on posterior rim. *Pakura* along two-thirds of rim and over carved features, end of bowl rounded. No ridge across bowl, nor underneath as in so many later bailers. Smooth rounded curve to all of bowl; wear and patina.

Provenance: Cook Collection.

Register: 'Drawn by JF Miller 1771. Add MSS 15,508 28/1.'

Comments: East Coast, eighteenth century; fine quality carving (RN).

References: Barrow 1969: figs 73 and 74; Joppien and Smith 1985: 1.167, no. 1; Kaeppler 1978: 203; Neich 1996b: 81; Starzecka 1979: pl. VIII.

83
Plate 17

Bailer, *tiheru*

1895-375. Length 46 cm.

Wooden bailer, one side broken off. *Manaia* face at end of high curved handle; nose above plain openwork carving on posterior rim. No surface decoration.

Provenance: Meinertzhagen Collection.

Comments: East Coast; mid to late nineteenth century (RN).

84
Plate 17

Bailer, *tiheru*

1854.12-29.79. Length 38.5 cm.

Wooden bailer: large, crude *whakarare* all over base; *manaia* head on handle, *pakura* on nose and jaws.

Provenance: Grey Collection.

Comments: East Coast; mid nineteenth century (RN); nineteenth century (DRS).

85
Plate 18

Bailer, *tiheru*

1854.12-29-80 (also numbered NZ 124). Length 42.5 cm.

Wooden scoop bailer: *whakarare* all over scoop and handle, carved as two parallel bars terminating with *wheku* head.

Provenance: Grey Collection.

Comments: East Coast, 1850s; a crude carving with sharp fresh cuts that has never been used; perhaps made for the Governor? (RN); nineteenth century (DRS).

86
Plate 18

Bailer, *tiheru*

1855.12-20.70. Length 42 cm.

Wooden bailer: *manaia* on handle with *pakura*. Different composition from usual, with handle coming from lower lip of full *koruru*-type face on posterior rim, which is in openwork, with *pakura* and *rauponga*.

Provenance: Haslar Hospital Collection.

Comments: Early nineteenth century, good quality and worn (RN); Canterbury (DRS). Presented to the hospital by Surgeon Thos Kay in 1855.

87
Plate 18

Bailer, *tiheru*

1913.5-24.81. Length 42 cm.

Wooden bailer with traces of red ochre: *manaia* on handle, *pakura* ornamentation on all carving.

Provenance: Edge-Partington Collection.

Register: 'E.P. Album 382'.

Handwritten label: 'New Zealand canoe bailer No J51 Pl.382 No. 3' [The reference to Edge-Partington's *Album* is probably for comparison, the bailer illustrated there is not 1913.5-24.81.]

Comments: Poverty Bay; 1830s, small, fine, well shaped (RN); eighteenth century (DRS).

88
Bailer, *tiheru*

1913.5-24.82. Length 51.2 cm.

Wooden scoop bailer: very worn, plain except for *pakura* around rim. *Wheku* face at end of handle carved as two parallel bars. Haliotis-shell eyes in handle face and on each side of rim (one missing). 'Maringi' or 'Marongo' carved inside scoop.

Provenance: Edge-Partington Collection.

Labels: 'New Zealand, Wanganui River, canoe bailer No J.185' and 'Made by Katene, chief of Tapuackura [Tapuaekura]'.

Comments: Whanganui, nineteenth century.

89
Bailer, *tiheru*

1913.5-24.83. Length 43.5 cm.

Wooden scoop bailer: quite plain, 'P A' carved inside scoop.

Provenance: Edge-Partington Collection.

Label: 'New Zealand, Wanganui River, canoe bailer No J 184'.

Comments: Whanganui; late nineteenth century (RN); nineteenth century (DRS).

90
Plate 19

Bailer, *tiheru*

1934.12-5.9. Length 41.5 cm.

Wooden bailer: plain; *manaia* head with haliotis-shell eyes at end of handle; small nose above plain openwork posterior rim of *manaia*-form jaws with haliotis-shell eyes. No surface decoration.

Provenance: Bequeathed by T.B. Clarke Thornhill.

Comments: East Coast; 1840s–50s (RN); *c*.1840 (DRS).

91
Plate 19

Bailer, *tiheru*

1944 oc.2.802. Length 39 cm.

Wooden bailer: high curved handle, *manaia* face at end, nose at lower handle end. Openwork carving on posterior rim with *rauponga* and plain spirals; *pakura* halfway along rim.

Provenance: Beasley Collection. Beasley no. 2300.

Comments: Poverty Bay; early nineteenth century (RN); eighteenth century (DRS).

Beasley catalogue: 2300, registered 22 March 1929, 'Bought: Junk shop, Bournemouth'.

92
Bailer, *tiheru*

1944 oc.4.2. Length 49 cm.

Wooden scoop bailer: plain, rough, large triangular terminal on handle.

Provenance: Purchased from Glendinning & Co. Ltd.

Comments: Later nineteenth century (RN).

93
Plate 19

Bailer, *tiheru*

1959 oc.2.1. Length 46 cm.

Wooden bailer: deep, sharp *rauponga* and *whakarare* on openwork carving on posterior rim; *pakura* halfway along side rim. Handle with figure at end: plain head, hands on to chest, with *rauponga* started on one side. Braided vegetable-fibre (flax?) cord loop threaded through openwork of posterior rim.

Provenance: Purchased from Prof. L.S. Palmer, the Wells Museum.

Handwritten label: 'Baler [sic] from a Maori war canoe. These canoes, made out of a single tree, hollowed out with stone axes, would accommodate [sic] 50–100 warriors, who squatting down & singing a weird song, would send the canoe with lightning strokes of their paddles at a swift rate through the water. The prow was ornamented in war time with a grotesque head resembling a demon. This particular canoe was a short time ago on the Beach nr "Wainoui" [Wainui] (East Coast N.Z.) but being "Tapu" (i.e. placed under a Ban) no native would touch it. A Pakeha (white man) not caring for Tapu "annexed" the Baler, but the canoe was to [sic] big to carry away! 1881.'

Comments: East Coast, mid nineteenth century (RN); eighteenth century (DRS).

Storehouses, houses, miscellaneous carvings

Maori raised storehouses, dwelling houses and meeting houses were built to a regular structural plan with standard wooden building components, readily identifiable as to their location in the structure. At the front, the ridgepole, roof and sides projected to create an open porch. Bargeboards supported on frontal side posts met the ridgepole at the apex. Side posts supported the rafters reaching up to the ridgepole. For dwelling and meeting houses, the ridgepole was supported at front and rear by solid posts set into the ground. Raised storehouses followed the regular plan, except that they stood on horizontal beams across the piles.

In lesser houses, the building components were often left plain and uncarved. In superior houses and storehouses, most of the components on the front and in the porch were carved with ancestral figures. For meeting houses, often the internal components were also carved; the exterior was left plain. For raised storehouses, carving was concentrated on the front and porch, and occasionally on the external sides and rear, leaving the interior plain. Another type of storehouse, especially designed for kumara winter storage, was excavated into sloping ground and built to a simpler plan. Rarely, these have carving, just at the entrance, as seen in the collection here (**104**, 1630).

There has been much debate about the antiquity of the fully carved meeting house. Archaeological remains and early European reports confirm their rare early presence, but these may have been superior chief's houses. Historical records of the mid nineteenth century document the increasing size and elaboration of the village meeting houses, which reach their full development in the 1880s, when large fully carved houses served the roles of community meeting houses and religious venues. The British Museum holds the most comprehensive collection of carved door lintels (*pare*) in the world. Removed for trade from meeting houses and dwelling houses throughout the North Island, these represent all the major regional and tribal carving styles.

Carved storehouses reach further back into antiquity, and in many cases were the most prominent building in a village. Before the development of the meeting house, storehouses and their war canoe were the main focus of tribal group pride. Many carved storehouse components carved with stone tools have been recovered from the swamps of the western areas, where they were hidden from northern musket-armed raiders.

Model carved houses and storehouses became popular gifts to regal and viceregal visitors in the late nineteenth and early twentieth centuries, and were commissioned from famous carvers, especially in the Rotorua and Wellington regions, by those tribal groups eager to assure their visitors of their loyalty to the British crown. Later, war canoe models also served the same purpose.

Model storehouses

94 Colour plate 4

Model storehouse, *pataka*

TRH 83/1902 L.I.83/ Royal Collection no. 74078. Length 92.5 cm, width 79.5 cm, height 88 cm.

Carved wooden model of raised storehouse. Rectangular base with *whakarare* around edge; nine plain legs; roof and back wall of fluted planks; side walls carved with low-relief *kowhaiwhai* pattern. *Tekoteko* figure standing on *wheku* head; openwork *maihi* with *takarangi* spirals, *whakarare*, and *manaia* head each end; *paepae* also in openwork: *takarangi* spirals, *whakarare* with spaced grouped *pakati*, and *manaia* head each end; front wall with multiple *wheku*-faced frontal figures, hands on stomach, surface ornamentation of *rauponga* and *rauponga* spirals; door with similar *wheku* face, lintel with similar central figure flanked by *takarangi* spirals and *manaia*. All figures and faces with haliotis-shell eyes.

Provenance: Royal Loan 1902, Prince and Princess of Wales.

Inscribed brass plaque: 'Presented by The Women of the City & Suburbs of Wellington NZ to HRH The Duchess of Cornwall & York on the Occasion of the Visit of HRH to Wellington.'

Paper label: 'Presented by the women of the City and Suburbs of Wellington to HRH The Duchess of Cornwall and York on the occasion of the visit of HRH to Wellington.'

Carved by JW [i.e. Jacob William] Heberley of Petone.'

Comments:

A little later in the forenoon [19 June 1901] a deputation of the women of Wellington waited upon the Duchess. Its members … were presented by the Countess of Ranfurly in the ball-room of Government House, the Duchess standing by the model of the Maori House. Mrs Bell made the presentation, asking Her Royal Highness's acceptance, as a gift of the women of Wellington, of this model of a food-house used by the Maoris in ancient times. She explained that, as the work was unfinished, the Countess of Ranfurly had kindly allowed the deputation to use her model, which was exactly like theirs, for the presentation and she promised that when complete, the gift of the women would be forwarded to Her Royal Highness.

'I thank you very muc''', the Duchess said, adding that 'it was very nice and kind' of the ladies to have thought of this; then she looked with great interest on the model, examined its fine carvings closely and asked, 'Will it be like this?' and on being told that it would, expressed her pleasure in the most cordial terms.

(Loughnan 1902: 183–5)

References: Imperial Institute 1902: 71.439; Loughnan 1902: 183–5; Neich 1991: 93–5, figs 22–4; Neich 2004: 56.

95 Plate 20

Model storehouse, *pataka*

1933.7-8.1; parts: Q1972 oc.117a (*paepae*); Q1972 oc.117b (*maihi*); Q1972 oc.117c (*maihi*); Q1981 oc.1432 (back wall); Q1981 oc.1433 (front wall); Q1981 oc.1434 (side wall); Q1981 oc.1435 (side wall); Q1981 oc.1440 (*amo*); Q1981 oc.1441 (*amo*); Q1981 oc.1442 (*tekoteko*); Q1981 oc.1917a–d (legs); Q1981 oc.1918a–h (planks); Q1982 oc.742-3 (thatching). Lengths 190, 150 and 146 cm (*paepae, maihi, maihi*); heights 125 and 120 cm (back wall, front wall); lengths 213 and 214 cm (side wall, side wall); heights 56, 55, 63 and 65 cm (*amo, amo, tekoteko*, legs); lengths 90 cm (planks).

Large carved wooden model of a raised storehouse. Front wall with frontal *koruru* figure and all flanking *manaia* ornamented with *taratara-a-kai*, narrow strips of *unaunahi* each side of door opening; *maihi* with *takarangi* spiral, whale body and four *manaia*, surface in *taratara-a-kai*; *amo* with *manaia* in *taratara-a-kai*; *paepae* with central *wheku* face flanked by *manaia*, all with *rauponga*, *unaunahi* strip above; *tekoteko* as standing *wheku* figure above *koruru* head; side walls with *manaia* and spirals, all in *rauponga*; back wall with two frontal *wheku* figures above two smaller *koruru* figures, flanked by *manaia*, with two *manaia* above, all with *rauponga*, with some *taratara-a-kai*. Major figures with haliotis-shell eyes, many missing, except for back wall where eyes are painted white. Badly preserved straw/raupo reed? roof thatching.

Provenance: Presented by Mrs Todd.

Comments: Carved by Tene Waitere, probably between 1905 and 1910, for Maggie Papakura's model Maori village in Clontarf, Sydney, then shipped to London for George V's coronation celebrations in 1911.

References: Dennan 1968: 51–3; Neich 2001: 316, no. 13; Neich 2004: 76; Starzecka 1996: 154–6.

Storehouse parts

96 **Plate 21**
Storehouse, *pataka*, front parts
1892.12-11.1 (*paepae*); 1892.12-11.2 (*maihi*); 1892.12-11.3 (*maihi*); 1892.12-11.4 (*epa*); 1892.12-11.5 (*epa*). Lengths 237, 196, 197, 103 and 96 cm.

Five carved wooden boards, some damaged, black (as result of burning or swamp immersion or both?), with sharp metal cuts. *Maihi*: *taratara-a-kai* with zigzag ridge raised above plain sunken ridge all over body of whale or sea monster; some straight *ritorito* on interstitial parts of whale's head; plain bodies on *manaia* and central *wheku* figure; *takarangi* spirals along sides of whale. *Epa*: figures with some *taratara-a-kai* and forked penes. *Paepae*: central *wheku* figure flanked by *takarangi* spirals and smaller figures.

Provenance: Presented by A. Fowler.

Register: 'Carved wooden panels from a Maori house at Rotorua.'

Comments: Bay of Plenty, 'It appears to be a swamp piece … Arawa variant of Te Kaha style' (DRS); 1870s–80s (RN).

'The boards you have I bought from a Maori's whare about 20 miles from Rotorua but the name of the place I cannot recollect. I saw them in situ & the owner only sold them because he had fallen on evil days.' (BM PE correspondence: A. Fowler, 3 December 1892).

References: Roth 1901: fig. 24.

97 **Plate 22**
Gable figure, *tekoteko pataka*
1634. Height 120.5 cm.

Wooden openwork standing *wheku* figure with topknot, three-fingered hands, right hand to face, left on stomach, standing on column of two similar smaller lower figures carved in solid wood. Genitals altered or removed (plug inserted in top figure). Plain spirals, except one with *raupona*, on all shoulders; *raupona* on limbs and faces.

Provenance: Unknown.

Comments: Poverty Bay, 1840s, metalwork (RN).

98 **Plate 22**
Gable figure, *tekoteko pataka*
1895-346. Height 112 cm.

Wooden, naturalistic standing figure, stained red, with deeply carved face tattoo, topknot with holes and traces of feather decoration; hands on protruding stomach. Series of rudimentary *manaia* loops on post below, down to *wheku* face at bottom.

Provenance: Meinertzhagen Collection.

Comments: Arawa, 1860s (RN); Bay of Plenty, c.1860 (DRS).

99 **Plate 22**
Gable figure, *tekoteko pataka*
1895-347. Height 108 cm.

Wooden standing figure, stained red, hands on stomach; deeply carved face tattoo, holes for decoration at top of head. Stylized *manaia* loops on post below, down to *wheku* face. Longitudinal split from top to feet of figure.

Provenance: Meinertzhagen Collection.

Comments: Arawa, 1860s (RN); Bay of Plenty, 1860–80 (DRS).

100 **Plate 23**
Gable figure, *tekoteko pataka*
1954 Oc.6.308. Height 55.5 cm.

Wooden, standing male figure, plain, stained red, no surface decoration, *wheku* face, left hand with two fingers in mouth, right on stomach above erect penis. Small *wheku* head below. Marked in white ink on back: 'SL 111/88'.

Provenance: Wellcome Collection. Wellcome Museum no. 61845.

Comments: Arawa, 1870s–80s, lower figure of *tekoteko*, upper figure sawn off (RN); Bay of Plenty, nineteenth century (DRS).

101 **Plate 24**
Side post, *pataka amo*
1947 Oc.3.1. Height 105 cm.

Wooden, standing male figure, stylized naturalistic face with slanting eyebrows and large mouth (lower left face damaged), remains of topknot, three-fingered hands on stomach, arms broken off, with small relief figure on chest between hands, remnants of *piupiu* of flax *pokinikini* at hips; standing atop another, similar but female, figure with naturalistic face. No surface ornamentation, much weathered.

Provenance: Presented by Mrs Roper.

Register: 'From the side posts of a hut on Mokoia Island, Lake Rotorua… collected in 1888 by donor's husband'; Eth.Doc.1143.

Comments: Arawa, possibly *tekoteko* reused as *amo* (RN); *tekoteko* (DRS).

My mother has 2 Maori carvings which she would like to present to you if you would care to accept them. They were brought here from New Zealand by my father in 1888 and the enclosed account of them was copied from the catalogue he compiled of his curios.
(BM AOA correspondence: Mrs Helen Marchant Smith, 27 November 1946)

These two specimen were taken from a derelict hut – the only one left – on Mokoia Island, Lake Rotorua, North Island N.Z. (in 1888). The island was Tapu & in consequence we had the greatest difficulty in obtaining natives to take me to it. Eventually we persuaded a crew & in a native canoe proceeded on condition that the natives had not to touch the shore of the island … We soon found the solitary hut in a small palm grove not far from the shore, it was a very broken down condition … We took the carvings from side posts … Inside the hut we fortunately found some native matting in which we carefully concealed our finds.
(Eth.Doc. 1143)

102 **Plate 23**
Side post, *pataka amo*
1947 Oc.3.2. Height 69 cm.

Wooden standing figure, naturalistic, male face tattoo, wearing *piupiu* of flax *pokinikini* and red wool, flax-fibre cord around neck; *koruru* below, with *raupona* painted black and red.

Provenance: Presented by Mrs Roper.

Register: 'From the side post of a hut on Mokoia Island, Lake Rotorua … collected in 1888 by donor's husband' Eth.Doc.1143.

Comments: Arawa, possibly *tekoteko* reused as *amo* (RN).

See side post **101**, 1947 Oc.3.1, for additional information.

103 **Plate 24**
Door jamb, *whakawae*
1944 Oc.2.804. Height 69.5 cm.

Two wooden figures, one atop another, varnished; lower figure female, both *wheku*-faced with notched haliotis eyes and large teeth, three-fingered hands on stomach, plain spirals on shoulders, hips and knees, *raupona* on faces and limbs. Flange of *takarangi* spiral sawn off on right-hand side of figures.

Provenance: Beasley Collection. Beasley no. 1727.

Register: '"Old carving with deified ancestors from interior of council house', 'Post for doorway of a Pataka, from Hokianga, 1883", "From S(?) Hokianga, N. Isd in 1838" – old labels.'

Comments: East Coast; 1870s (RN); nineteenth century (DRS).

Beasley catalogue: 1727, registered 22 February 1926, 'The Lieut. Colonel Gaskell collection. The left Hand door Post of a Pataka or storehouse… Bt Glendinnings Rooms. Lot 176.'

104 **Plate 25**
Entrance of semi-subterranean storehouse, *rua tahuhu*
1630. Height 66 cm.

Wooden figure, with tilted head, naturalistic face with male tattoo and slit eyes; legs and wedge-shaped feet hooked over arms, hands on chest, genitals with bulging shape; body plain, *raupona* spirals on buttocks, *raupona* on legs. Large square-cut lashing holes on both edges.

Provenance: United Service Institution Museum.

Register: 'From Capt. E. Stanley RN. U.S.M. Cat.145. C.P. 5881'.

Comments: Taranaki, 1850s; 'A *tekoteko* from a *pataka* …. The legs belong to a second figure not shown, the whole represents copulation' (DRS).

References: Edge-Partington 1969 I: 369.2; Neich 1996a: 98–9, fig. 19; Simmons 1985: 89, fig. 82; Simmons 1986b: 143, fig. 201.

Model house

105 **Colour plate 4**
Model house, *whare whakairo*
1904.12-6.1. Length 52 cm.

Wooden house: sides, back and roof of vertical strips of bark held in place by horizontal twigs. Front and porch carved and stained red. *Koruru* with teeth painted white and painted black-and-white eyes; *maihi* with plain *wheku* figure near *koruru*, *taratara-a-kai* spirals and *manaia* at ends. Each *amo* with standing figure: face similar to *koruru*, *raupona* on bodies, three-fingered hands on chest, one figure holding black *mere*; another face, below, similar to *koruru*. *Paepae* with alternating plain *takarangi* spirals and plain *manaia*. Inside porch carved *poupou*, *epa*, *pare*, *pane* and *whakawae*, window frame plain; rafters with white-on-red *kowhaiwhai*.

Provenance: Purchased from Elder & Co.

Register: 'Made to scale by a native named Piwiki' (i.e. Piwiki Horohau of Ngati Raukawa; Neich 1991: 79).

Comments: Ngati Raukawa, early 1900s (RN).

The model Maori House commissioned for the Museum is begun but that is about all. Piwiki the carver has been away for a long time at various 'tangis' & native meetings. He has all the material together & has I believe done some of the carving but it will be many months before the complete House is done.

(BM PE correspondence:
A.H. Turnbull, 26 May 1898)

You may perhaps remember that you asked me, when you were here, whether I could get carved a similar model Maori house to that you saw in my collection. Well, after all this time, it is at last finished and herewith you will find a photo of it.

(BM PE correspondence:
A.H. Turnbull, 10 May 1901)

Dear Mr Edge-Partington, at last I have got the little Maori House completed and packed, and I am despatching it on the 11th inst. by the S.S. 'Athenic'.

(BM PE correspondence:
A.H. Turnbull, 11 December 1902)

References: Neich 2004: 58.

House parts

Gable figures, *tekoteko*

106 Plate 26
Gable figure, *tekoteko*
NZ 146. Height 62 cm.

Wooden standing figure: plain, three-fingered hands on stomach, *ritorito* and spirals on face.

Provenance: See Register.

Register: 'Tapu Maori figure from Lake Rotu iti, N. Zealand Oct.18, 1877, taken by E.A. Bothamley.'

Comments: Lake Rotoiti, Rotorua; 1850s (RN); nineteenth century (DRS).

References: Archey 1967: pl. 50.6.

107 Plate 26
Gable figure, *tekoteko*
1638. Height 113 cm.

Wooden standing figure: naturalistic, male, with facial tattoo and topknot, plain body, right hand to mouth, left on stomach, penis long, to left thigh. *Wheku* face below, with *pakura*, *rauponga* on nose, haliotis-shell eyes (one missing, as are both in top figure).

Provenance: United Service Institution Museum.

Register: 'U.S.M. Cat. 145. C.P.5880. From Capt. E. Stanley, RN.'

Comments: Rotorua, 1880s–90s (RN); Bay of Plenty, c.1850, *poutokomanawa* (DRS).

108 Colour plate 5
Gable figure, *tekoteko*
1642. Height 35 cm.

Wooden, naturalistic standing female figure with topknot, eyes as raised curved ridges, ears, hands with fingernails on chest, sex shown large. *Koruru* face below in deep relief looking horizontally down to earth; *wheku* face with large nose extending to central button on head. Attachment flange at back. Brown stain/patina, no surface ornamentation.

Provenance: United Service Institution Museum.

Register: 'U.S.M. No. 3'.

Comments: Northern Hawke's Bay, 1850s, very fine, well proportioned (RN); Hawke's Bay style (DRS).

References: Archey 1958: pl. 20.1; Archey 1967: pl. 40.5; Archey 1977: 14, fig. 3; Simmons 1985: 161, fig. 131; Te Awekotuku 1996: 33.

109 Plate 27
Gable figure, *tekoteko*
1895-345. Height 64 cm.

Wooden standing male figure with 'top hat', hole for feather decoration on right side of head, facial tattoo; three-fingered hands on chest, right lower arm broken, large penis. *Rauponga* on right stomach and leg, left side plain, plain spiral on each buttock. Plain *wheku* face below.

Provenance: Meinertzhagen Collection.

Comments: Arawa, 1850s–60s (RN); Bay of Plenty, 1850–60, the style is that of the Ngati Pikiao tribe of Arawa (DRS).

110 Plate 27
Gable figure, *tekoteko*
1895-348. Height 56 cm.

Wooden figure, upper half only: naturalistic face with male tattoo, topknot with 'badge' at front; plain body, naturalistic hands on chest. Stained red, eyes painted black and white; hollowed out at back.

Provenance: Meinertzhagen Collection.

Comments: Arawa; 1870s–80s (RN); nineteenth century (DRS).

111 Colour plate 5
Gable figure, *tekoteko*
1904-244. Height 65 cm.

Wooden, naturalistic, standing male figure stained red, with topknot, deeply incised facial tattoo in black and slit eyes; left hand on chest, right on stomach; plain spirals on shoulders and hips, *pakura* on hands and lower arms; no genitals. *Wheku* face below with haliotis-shell eyes, *pakura* on nose, *rauponga* on nose. Names, mostly illegible, written on back of head and front of legs.

Provenance: Higgins/Turvey Abbey Collection.

Comments: Poverty Bay/East Coast, 1830s–40s, well proportioned (RN); East Coast, nineteenth century (DRS).

References: Barrow 1969: fig. 161; Te Riria and Simmons 1989: 22.14; Te Riria and Simmons 1999: E.

112 Plate 28
Gable figure, *tekoteko*
1904-246. Height 112 cm.

Wooden figures, one above another. Upper figure with naturalistic face with tattoo, hands on stomach (arms are later replacement), standing atop of lower solid figure, hands on hips, genitals removed, *wheku* face with *pakura*, *rauponga* spirals on shoulders. Oyster-shell eyes in both figures, lower figure with red sealing-wax pupils.

Provenance: Higgins/Turvey Abbey Collection.

Comments: Poverty Bay, 1850–60; *poutokomanawa* (DRS).

References: Te Riria and Simmons 1989: 22.15; Te Riria and Simmons 1999: F.

113 Plate 28
Gable figure, *tekoteko*
1894.7-16.6. Height 123 cm.

Wooden standing figure: plain, male facial tattoo, no eyes or mouth, hands on stomach. Below, two small plain figures; under them, a *koruru* face with *wheku* eyes with

haliotis-shell inlay (one missing) and large open mouth. Feathers (hawk?) over top and rear of top figure's head and down both rear sides of lower figures, held in place by clumps by wooden pegs driven into drilled holes.

Provenance: Lady Sudeley Collection.

Comments: East Coast; 1850s–60s, careless carving but good proportions (RN).

References: Te Riria and Simmons 1989: 22.18; Te Riria and Simmons 1999: G.

114 Plate 29
Gable figure, *tekoteko*
1921.10-14.8. Height 33.2 cm.

Wooden standing figure, sawn off below feet, with partial male facial tattoo, small topknot, chin poorly cut underneath, plain body, crude hands on stomach. Scratched on back of head: 'X.C. [?] 1837'.

Provenance: Yorkshire Philosophical Society Museum.

Comments: Bay of Plenty, 1837(?) (RN); probably Waikato, 1850–60 (DRS).

Perhaps 'a New Zealand Grave God, from Dr Gibson's sale' purchased in 1880 (Eth. Doc.1912).

References: Te Riria and Simmons 1989: 40.21; Te Riria and Simmons 1999: H.

115 Plate 29
Gable figure, *tekoteko*
1927.11-19.4. Height 88 cm.

Wooden standing figure: plain, naturalistic, square topknot, notched haliotis-shell eyes, three-fingered hands on chest. Below, a *wheku*-faced figure with plain body and *whakarare* on face and notched haliotis-shell eyes above plain face *wheku*. Paint or varnish stripped.

Provenance: Reid/Capt. Luce Collection.

Comments: East Coast; 1860s (RN); nineteenth century (DRS).

116 Plate 30
Gable figure, *tekoteko*
1944 oc.2.805. Height 57.5 cm.

Wooden standing male figure: *wheku* face, *whakarare* on face and lower arms, *rauponga* spirals on shoulders and hips, hands on stomach; line of *taowaru* (openwork arcades) down centre of body. Below, *koruru* with *taratara-a-kai* on nose and mouth and *whakarare* on forehead. Notched haliotis-shell eyes in both figures. Stained black.

Provenance: Beasley Collection. Beasley no. 2648.

Comments: Poverty Bay, 1860s–70s (RN); East Coast (DRS).

Beasley catalogue: 2648, registered 1 February 1931, 'Blackmore Museum'.

117 Plate 30
Gable figure, *tekoteko*
1944 oc.2.806. Height 65 cm.

Wooden standing figure: topknot, head hollowed out at rear, deeply carved *wheku* face, two holes each side of face for feather (?) decoration, three-fingered hands on stomach; remnants of *wheku* face below. Dark brown, no surface ornamentation, weathered.

Provenance: Beasley Collection. Beasley no. 4558.

Comments: Bay of Plenty(?), 1860s–70s (RN); Whanganui, nineteenth century (DRS).

Beasley catalogue: 4558, registered 10 September 1937, 'Bt. L. Casimir, [London]'.

Gable masks, *koruru*

118 Plate 31
Gable mask, *koruru*
1895-349. Length 41 cm

Wooden gable mask: flattish, stained red. *Wheku* face: *whakarare* around brows, mouth and on double tongue, haliotis-shell eyes (one missing), notched teeth. Remains of feather 'beard' attached to holes around lower face.

Provenance: Meinertzhagen Collection.
Comments: Tuhoe/Ngati Awa, 1880s–90s, heavy, coarse carving (RN); East Coast/Whanganui, c.1860 (DRS).

119 Colour plate 8
Gable mask, *koruru*
1952 oc.5.1. Length 41 cm.

Wooden gable mask: *wheku* face, painted red, dark brown and yellow, varnished; *pakura* on brows and mouth, attachment flange at rear.

Provenance: Purchased from P. Pelosi.
Register: '"Parata", from a house gable.'
Comments: East Coast, 1860s–70s (RN); Poverty Bay, 1840–60 (DRS).

120 Plate 32
Gable mask, *koruru*
1954 oc.6.307. Length 75.5 cm.

Wooden gable mask, stained red: rectangular face, large bulbous eyes, *whakarare* on brows (plain spiral between them) and nose, *pitau* on upper lip, *pakura* on double tongue, large teeth. Badly weathered, damaged under nose and through mouth; two holes on each side.

Provenance: Wellcome Collection. Wellcome Museum no. 23684.
Comments: Bay of Plenty; 1880s (RN), c.1860 (DRS).

121
Gable mask, *koruru*
1994 oc.4.118. Length 47.5 cm.

Wooden gable mask: stylized openwork carving, with minimal black incised decoration on nose.

Provenance: Collected in the field.
Comments: Carved by Roi Toia of Nga Puhi in 1999; surface design on the nose refers to the practice of *hongi* (pressing noses). Contemporary art.

122 Plate 32
Gable mask, *koruru*
Q1972 oc.113. Length 85.5 cm.

Wooden gable mask painted white with black tattoo and carving details. Stylized face with large round eyes, *pitau*-series *kowhaiwhai* on cheeks, rauponga on brows; below it another, naturalistic, face with male tattoo; attachment flange at rear. Marked on back: 'R.6800/1936 C.Ay'.

Provenance: Wellcome Collection.
Register: 'Wellcome R 6800/1936 Ex Armitage'. Wellcome label: 'Carving from canoe-house … From the Meeting House, Lake Rotoiti. Accession No. 98414/47748'.
Comments: Mataatua style, 1860s–70s (RN); Lake Rotoiti, Bay of Plenty (DRS).

Various house parts: *raparapa, tahuhu, amo*

123 Plate 31
Bargeboard end, *raparapa*
1633. Length 164 cm.

Wooden bargeboard end from very large meeting house. Unusual *manaia* face composition, with large teeth, *rauponga* and *rauponga* spirals, and *ritorito* around eyes; *whakarare* on fingers.

Provenance: United Service Institution Museum.
Register: 'See U.S.M. Cat. 145. C.P.'
Comments: Whanganui, 1880s (RN).

124 Plate 33
Ridgepole, *tahuhu*
1927.11-19.1. Length 181 cm.

Wooden ridgepole: male *wheku* figure with eyes almost parallel, large wide nose, crude *pitau*-series *kowhaiwhai* incised on cheeks, hands on chest, penis; *wheku* face below. Haliotis-shell eyes, spirals and *rauponga* on both figures. *Takarangi* spirals and *manaia* along sides, flat back.

Provenance: Reid/Capt. Luce Collection.
Comments: East Coast, 1860s. Strange, crude carving, not by well-trained carver: rough, poor spirals, very irregular *pakati* (RN).
References: Joyce 1928: 103-4, pl. LXIX:a.

125 Plate 33
Front side post/bargeboard support, *amo*
1632. Height 173 cm.

Wooden post bearing traces of red pigment. Large, heavy deep-relief female *wheku* figure: hands on stomach, *rauponga* spirals, *rauponga*, *whakarare* on upper-left jaw and upper-left leg; *whakatara* around vulva; *whakarare* down body in centre. Diagonal rabbet at rear indicates this is a right *amo* (looking at house).

Provenance: United Service Institution Museum.
Register: 'See U.S.M. Cat.145.C.P.'
Comments: Arawa/Ngati Tarawhai, 1880s–90s, possibly carved by Tene Waitere; typical Tarawhai deep cut above nose, but poor example; coarse, irregular carving (RN); Bay of Plenty, Mataatua style (DRS).

126 Colour plate 6
Pair of front side posts/bargeboard supports, *amo*
1894.7-16.1 and 1894.7-16.3. Heights 154 and 153 cm.

Wooden posts, both with two figures above each other, genitalia removed. Upper figures with outer hand passing through mouth and fingers on lips, inner hands on stomach, both lower figures with hands on stomach. All figures *wheku*-faced, spiral on heads of upper figures. Three bodies plain, one (upper figure of 1894.7-16.3) with *rauponga*, *rauponga* spirals on all shoulders and hips. Feet of upper figures as *manaia* heads with haliotis-shell eyes. *Ritorito* and *rauponga* on faces of upper figures, *rauponga* or *whakarare* on lower. All figures with haliotis-shell eyes. Deep, bold relief of body sculptural forms.

Provenance: Lady Sudeley Collection.
Comments: Rongowhakaata/Poverty Bay, 1830s–40s (RN); Poverty Bay, 1840–50 (DRS).
References: Neich 1996b: 104.

Lintels, *pare*

127 Plate 34
Lintel, *pare*
NZ 87. Width 81 cm.

Wooden lintel: solid, only pierced occasionally, stained red. Central female *wheku* figure with large vulva, three-fingered hands, left on chest, right on stomach. Terminal *manaia* not sexed. Surface decoration in some *rauponga*, but mostly *ritorito* on plain spirals, i.e. *pungawerewere*.

Provenance: Presented by H. Cuming.
Comments: East Coast/Poverty Bay/North Auckland, eighteenth century to 1820s (RN); Bay of Islands, c.1820 (DRS).
References: Archey 1933: 176, pl. 10c; Archey 1977: 27, fig. 34; Simmons 2001: 71.

128 Plate 34
Lintel, *pare*
1639. Width 68 cm.

Wooden lintel: openwork spirals, rest solid. Central *wheku* face with small, plain spiral each side, *pakura* on forehead, *rauponga* on lips. At each end: large *manaia* face with bulbous eye, its jaw taking appearance of *takarangi* spiral with *pakura*; *rauponga* with chevroned form on face.

Provenance: United Service Institution Museum?
Register: 'U.S.M.? C.P. No. 8.'
Comments: Ngati Whatua, 1870s (RN); Ngati Whatua style; possibly from the only Ngati Whatua house of the era, Aotearoa, which stood at Shelly Beach, South Kaipara Head – about 1870 the carvings were removed at the request of a missionary and sold (DRS).
References: Simmons 1997: 43, colour p. 7; Simmons 2001: 123.

129 Plate 34
Lintel, *pare*
1895-352. Width 97 cm.

Wooden openwork lintel, stained red. Central *wheku* figure with plain trunk, spirals on shoulders and hips; *pakura* on face and all over openwork, *rauponga* on solid base. Openwork damaged in a few places.

Provenance: Meinertzhagen Collection.
Comments: Ngati Porou, 1870s (RN); East Coast, c.1860 (DRS).
References: Simmons 2001: 61.

130 Colour plate 8
Lintel, *pare*
1854.12-29.89. Width 98 cm.

Wooden openwork lintel with central *wheku* figure, pearl-shell eyes, hands on chest, mask replacing genitals. Both terminal *manaia* with definite female sex organs and standing on large *manaia* faces. Surface decoration all plain spirals with angular *unaunahi* rather than *ritorito*, although giving effect of *pungawerewere*. Some minor restoration.

Provenance: Grey Collection.
Comments: Poverty Bay: 1800–20s. Very fine controlled surface decoration on deep sculptured forms; masterful carving (RN). 1820–40 (DRS).
References: Archey 1960: 207, pl. 38B; Archey 1962: 275, fig. 6; Barrow 1969: fig. 126; Hooper 2006: 127.63; Neich 1996b: 107; Simmons 1985: 42, fig. 33; Simmons

1986a: 18, pl. 1b; Simmons 1997: colour p.7; Simmons 2001: 97.

131 Colour plate 8
Lintel,*pare*
1854.12-29.90. Width 131.5 cm.

Wooden openwork lintel, stained black. Three *wheku* figures, unsexed, with haliotis-shell eyes, raised arms, surface decoration of spirals and *pakura*, separated and flanked by *takarangi* spirals. Solid base with bands of *rauponga*, central *rauponga* spiral and two terminal *manaia* with haliotis-shell eyes under feet of outer *wheku* figures.

 Provenance: Grey Collection.
 Comments: Bay of Plenty (Mataatua/ Whakatane), 1830s–40s, average carving (RN).
 References: Archey 1962: pl. 53A; British Museum 1925: fig. 166; Neich 1996b: 107.

132 Plate 35
Lintel,*pare*
1894.7-16.7. Width 87.5 cm.

Wooden openwork lintel. Central figure of Ngati Porou *ruru* type: haliotis-shell eyes, spirals on shoulders and hips, cat's-eye shell inset to right of head. *Takarangi* spirals, *manaia* faces with haliotis-shell eyes and jaws upward at each end.

 Provenance: Lady Sudeley Collection.
 Comments: East Coast, crude, disjointed carving (RN); Hawke's Bay, c.1850 (DRS).
 References: Archey 1962: pl. 57A; Simmons 2001: 127.

133 Plate 35
Lintel,*pare*
1904.7-16.1. Width 81 cm.

Wooden openwork lintel. Three *wheku* figures with double tongues, raised arms, plain faces and trunks, plain spirals on shoulders and knees, split penes. *Takarangi* spirals. Solid base with bands of *rauponga* and *rauponga manaia* head at each end.

 Provenance: Purchased from A.S. Drey.
 Comments: Bay of Plenty: (Whakatane?), c.1870s (RN); (Mataatua), 1860 (DRS).
 'Dear Sir, In possession of your most favoured of 15th inst. I take notice of your order for lot 573 at the Leidz sale to be bought for you …' (BM PE correspondence: A.S. Drey, 16 June 1904).
 References: Simmons 2001: 215.

134 Plate 35
Lintel,*pare*
1908.5-13.13a and b, 1908.5-13.16. Width 109 cm.

Wooden openwork lintel: stained red, broken into three pieces, part of openwork missing. Plain base with ledge at back, central female *wheku* figure, large terminal *manaia* unsexed; elongated interstitial *manaia* biting head of central figure. Surface decoration of *rauponga* and plain spirals.

 Provenance: Budden/Angas Collection.
 Comments: East Coast, 1880s–90s, this is later version of item **127**, lintel NZ 87 (RN); Poverty Bay, c.1880 (DRS).
 References: Simmons 2001: 69.

135 Plate 36
Lintel,*pare*
1927.11-19.2. Width 94 cm.

Wooden openwork lintel: thick, flat carving. Central figure with double tongue, hands on hips, unsexed, flanked by small *manaia* figures; large terminal *manaia*. All figures with notched haliotis-shell eyes. Surface decoration of spirals, *rauponga*, *whakarare*, *pakura* and *taratara-a-kai*. Bands of *rauponga* on solid base with *manaia* head at each end.

 Provenance: Reid/Capt. Luce Collection.
 Comments: Hawke's Bay, 1860s (RN).
 References: Barrow 1969: fig. 70; Barrow 1984: 38; Joyce 1928: 103–4, pl. LXVIIIb; Simmons 1985: 161, fig. 132; Simmons 1997: 42; Simmons 2001: 93.

136 Plate 36
Lintel,*pare*
1927.11-19.3. Width 106 cm.

Wooden openwork lintel, paint stripped. Three *wheku* figures, arms raised, unsexed, *takarangi* spirals, plain base. *Rauponga* spirals on shoulders and hips of central figure and on shoulders of one to its left, *pakura* on arms and legs of central figure and on arms of one to its left; figure to right of central figure plain. All figures with haliotis-shell eyes (one missing).

 Provenance: Reid/Capt. Luce Collection.
 Comments: Mataatua style, 1860s (RN); Bay of Plenty, 1860–80 (DRS).
 References: Archey 1962: pl. 54A; Joyce 1928: 103–4, pl. LXVIIIa; Simmons 2001: 171.

137
Lintel,*pare*
1994 Oc.4.96. Width 71 cm.

Wooden openwork lintel: thin, varnished. Central male figure flanked on each side by pair of *manaia* in coitus. Haliotis-shell eyes in central figure and two near *manaia*. Surface ornamentation of spirals, *pakura* and *unaunahi*. Engraved on back: 'G. Moana 92'.

 Provenance: Collected in the field.
 Comments: Purchased from Te Warena Taua, Auckland; carved by Guy Moana in 1992. Contemporary art.

138
Lintel,*pare*
1994 Oc.4.97. Width 66 cm.

Wooden openwork lintel, painted black, with some features picked in red. Central female figure with domed head, flanked on each side by very large *manaia* with solid body. Haliotis-shell eyes in all figures; surface ornamentation of *pakura* and *unaunahi*.

 Provenance: Collected in the field.
 Comments: Purchased from Mataeo Art Gallery, Auckland; carved by Harry Wikaira of Nga Puhi - Ngati Whatua. Contemporary art.

139
Lintel,*pare* (fragment)
Q1981 Oc.1384. Width 31 cm.

Wooden lintel fragment, openwork, with three-fingered limb; plain, no surface decoration.

 Provenance: Wellcome Collection.
 Labels: 'Lot 396'; '222102 Fragment of carving. Made N. Zealand'; BM label annotated '[ex Wellcome Collection]'.
 Comments: Bay of Plenty, 1840s (RN); Taranaki, eighteenth century, part of the body of a *manaia* and part of spiral (DRS).

Door jambs, *whakawae*

140 Plate 37
Door jamb,*whakawae*
1901-40. Height 96 cm.

Two wooden, solid figures, one above another, with naturalistic plain bodies and legs, *wheku* faces with spirals and *whakarare*; three-fingered hands, upper figure on hips, lower on stomach. Circular haliotis-shell inlay in eyes, and knees. *Manaia* and *takarangi* spirals in openwork on one side.

 Provenance: Purchased from Mrs Howie (Te Rangi Pai).
 Register: 'Doorjamb (*waewae*) of a meeting house. TT Barrow.'
 Comments: East Coast, 1880s. Most likely by the same carver as **141** (1901-41), **142** (1901-42) and **149** (1901-39), and from the same house. Lower part of figure **142** (1901-42) and possibly a pair with **141** (1901-41) (RN).

141 Plate 37
Door jamb,*whakawae*
1901-41. Height 38.5 cm.

Wooden standing figure, blackened. *Wheku* face with spirals and *whakarare*, plain body, three-fingered hands on lower stomach, legs cut off below knees; circular haliotis-shell inlay in eyes and knees. Marked in black ink on back of head and legs: 'Claude Sheriff Gisborne'.

 Provenance: Purchased from Mrs Howie (Te Rangi Pai).
 Comments: East Coast; 1880s, most likely by the same carver as **140** (1901-40), **142** (1901-42) and **149** (1901-39), and from the same house (RN); nineteenth century (DRS). Either middle figure of *whakawae* which is pair with **140** (1901-40) and **142** (1901-42) or part of window frame (RN).

142 Plate 37
Door jamb,*whakawae*
1901-42. Height 54.5 cm.

Wooden, solid figure: naturalistic plain body and legs, three-fingered hands on stomach, naturalistic face with male tattoo. Oval haliotis-shell eyes and haliotis-shell circles on knees. Sawn off below feet. Marked in black ink on back: 'Louis Sheriff Gisborne'.

 Provenance: Purchased from Mrs Howie (Te Rangi Pai).
 Comments: East Coast; 1880s, most likely by the same carver as **140** (1901-40), **141** (1901-41) and **149** (1901-39), and from the same house (RN); nineteenth century (DRS). Upper part of figure **140** (1901- 40) and possibly pair with **141** (1901-41) (RN).

143 Plate 38
Door jamb,*whakawae*
1894.7-16.4. Height 99 cm.

Three solid wooden figures, arranged vertically, stripped of paint/varnish. Two upper figures are *wheku*-faced, lower is *ruru* with ear plugs; *whakarare*, *rauponga* and spirals on faces with haliotis-shell eyes; *pungawerewere* spirals on shoulders and hips; hands on trunk.

 Provenance: Lady Sudeley Collection.
 Comments: Poverty Bay/ Rongowhakaata, 1820s–40s (RN); East Coast, nineteenth century (DRS). Pair with

figure **144** (1894.7-16.5); close but not exact match, probably by different carvers (RN).

144 **Plate 38**
Door jamb, *whakawae*
1894.7-16.5. Height 103 cm.

Three solid wooden figures, arranged vertically, varnished. Two upper figures are *wheku*-faced, lower is *ruru* with ear plugs; *whakarare*, *rauponga* and spirals on faces with haliotis-shell eyes; *pungawerewere* spirals on shoulders and hips; hands on trunk, except for lowest figure with hands on hips.

 Provenance: Lady Sudeley Collection.

 Comments: Poverty Bay/ Rongowhakaata, 1820s–40s (RN); East Coast, nineteenth century (DRS).

 Pair with figure **143** (1894.7-16.4); close but not exact match, probably by different carvers (RN).

145 **Plate 39**
Pair of door jambs, *whakawae*
1944 oc.2.803a and b. Height 79 cm.

Pair of solid wooden carvings with three *wheku*-face figures on each, both top figures with heads cut off or broken away; all figures with large three-fingered hands on chests; sex not indicated. On one side of each set of figures: spirals and *manaia*. No surface ornamentation.

 Provenance: Beasley Collection. Beasley no. 652.

 Comments: East Coast (RN); nineteenth century (DRS).

 Beasley catalogue: 652, registered 5 July [19]12, 'A pair of carved wood door jams "Whaka-wae" belonging to a carved store house "Pakata" [*pataka*?]. From a Sale at Regents Park near Southampton. Bought Henry F. Hope. Castle St Christchurch.'

Interior central-post figures, *poutokomanawa*

146 **Colour plate 7**
Interior central-post figure,
poutokomanawa
1631. Height 111 cm.

Wooden, standing, thickset male figure. Large naturalistic head with facial tattoo and haliotis-shell eyes. *Rauponga* spirals on shoulders and arms, hands on chest broken off; *rauponga* on thighs, *whakarare* on knees; erect penis broken off. Large squared post base roughly cut off.

 Provenance: United Service Institution Museum

 Register: "'… it was taken from the house of a New Zealand Chief". U.S.M. Cat. 145.'

 Comments: Ngati Tarawhai, 1840s–50s (RN); 1860 (DRS).

 References: British Museum 1925: fig. 163.

147 **Plate 40**
Interior central-post figure,
poutokomanawa
1641. Height 39.5 cm.

Wooden standing male figure: asymmetrical, left shoulder lower, trunk curved slightly to left, left hand to chin, right on stomach (three fingers). Naturalistic face with male tattoo, hole for decoration attachment at top rear edge of head; large penis. *Moko kuri* on chest, *rauponga* spirals on stomach, shoulders and buttocks; rest

of body, including back, covered with *whakarare* and *rauponga*, with *pakati* in red ochre, *raumoa* and *haehae* in black; indication of *puhoro* on thighs. *Raumoa* varies between two and four parallel ridges.

 Provenance: United Service Institution Museum

 Register: 'U.S.M. No.4. C.P.'

 Comments: East Coast; 1820s–30s; fairly crude carving, but finely detailed, maybe earlier type of *poutokomanawa* (RN); c.1820 (DRS).

 References: Roth 1901: fig. 21; Te Riria and Simmons 1989: 70.60; Te Riria and Simmons 1999: 59.

148 **Plate 40**
Interior central-post figure,
poutokomanawa
7228. Height 54 cm.

Wooden standing female figure: naturalistic face and body; female tattoo on lips only as black painted *haehae*, notched haliotis-shell eyes, ornaments of strips of dog skin with hair, flax fibre and red wool tied through holes in ears, hands on stomach, breasts, vulva. Right shoulder with single-spiral *rauponga* with single *raumoa*, left shoulder plain in front and with plain double spiral on side, *rauponga* and *pakura* on arms. Right thigh plain, left with large single-spiral *rauponga* with one *raumoa* and smaller plain spirals and *rauponga*.

 Provenance: Presented by A.W. Franks, 21 April 1871; ex Sparrow Simpson Collection.

 Comments: Whanganui; 1830s, stone-tool work (RN); 1840–50 (DRS).

 References: Te Riria and Simmons 1989: 78.67; Te Riria and Simmons 1999: 67.

149 **Plate 41**
Interior central-post figure,
poutokomanawa
1901-39. Height 103 cm.

Wooden standing male figure: facial tattoo in black, haliotis-shell eyes, topknot; naturalistic hands on stomach, right one holding black *patu*. Large double spiral on hips, indication of *puhoro* on thighs, *rape* in black, flat circular knees, rest of body plain.

 Provenance: Purchased from Mrs Howie (Te Rangi Pai).

 Comments: East Coast; 1880s (RN); 1860–80 (DRS).

 Most likely by same carver as door jambs **140** (1901-40), **141** (1901-41) and **142** (1901-42), and from same house (RN).

150 **Colour plate 5**
Interior central-post figure,
poutokomanawa
1892.4-9.1. Height 85 cm.

Wooden standing male figure: naturalistic face with black tattoo, haliotis-shell eyes, carved topknot, collarbone; left ear nailed on. Body and limbs plain, hands with large four fingers on chest, no genitals. Post remnant rounded off; polished patina.

 Provenance: Purchased from Clinton Engleheart, obtained by vendor in New Zealand.

 Comments: Poverty Bay/ Northern Hawke's Bay, c.1820s–40s (RN); East Coast, 1840–50 (DRS).

 References: Ford n.d.: fig. 8, top right, and cover; Neich 1996b: 85.

Side-wall panels, *poupou*

151 **Plate 42**
Side-wall panel, *poupou*
1894-637. Height 133 cm.

Wooden panel, roughly triangular, carved as human figure: *wheku* face in openwork, eyes of haliotis shell (one missing), surface decoration in *whakatara* and *taratara-a-kai*; *taratara-a-kai* spirals on shoulders, three-fingered hands on chest and lower body. Below, small *wheku*-faced figure, also in *taratara-a-kai*. Three longitudinal splits repaired on back with nine metal plates.

 Provenance: Presented by A.W. Franks (Mrs Adelaide Ralls).

 Register: 'Maori god obtained in Auckland NZ.'

 Comments; Ngati Pikiao, 1860s–70s (RN); Bay of Plenty (DRS).

 Probably collected by Captain George Tolman Ralls between 1873 and 1877.

152 **Colour plate 9**
Side-wall panel, *poupou*
1894.7-16.2. Height 145 cm.

Wooden panel with frontal figure, *wheku* face with *pitau*-series *kowhaiwhai* on forehead and around haliotis-shell eyes, *rauponga* spirals on cheeks. *Rauponga* spirals on shoulders and hips; arms as *manaia*, three-fingered hands with thumbs on stomach, right one holding *wahaika*; trunk in *rauponga*; small *wheku* figure between legs. Line of *whakarare* around lower-body margin and up to body midline. On both sides of main figure: small *manaia* with *rauponga* and *whakarare*.

 Provenance: Lady Sudeley Collection.

 Comments: Arawa, Ngati Pikiao, mid nineteenth century (RN); Poverty Bay, 1850–60 (DRS).

 References: Neich 1996b: 71; Neich 2001: 96, fig. 7.17, 385.

153 **Plate 42**
Side-wall panel, *poupou*
1922.5-12.1. Height 262 cm.

Wooden panel with two frontal figures, one above another. Upper figure *wheku*-faced with plain spirals and *whakarare* on mouth (with teeth) and tongue, four-fingered hands through mouth; *rauponga* spirals on right shoulder and hip, simplified *pungawerewe* on left shoulder, plain double spiral on hip; *whakarare* and *rauponga* on body and limbs; *manaia* with *taratara-a-kai* on each side between arm and hip, plain lizard beside left eye, dog in crook of left arm; lizard and dog (?) between legs, on sides of mask covering genitalia. Lower figure similar, all *rauponga* spirals, *rauponga* and *whakarare* on trunk and limbs, hands on stomach; on each side of eyes *manaia*, left with *whakarare*, right with *taratara-a-kai*, similar *manaia* above each shoulder; mask over genitals and two plain figures in coitus (?) below. Haliotis-shell eyes in all figures.

 Provenance: Presented by Sir C. Hercules Read.

 Register: 'Carved house-board (1 of a pair; the other at Camb. Mus.).'

 Comments: East Coast, Ngati Porou, 1870s; produced by Ngati Porou carvers for a large meeting house intended for the chief Karaitiana Takamoana of Pakowhai,

Hawke's Bay, but never erected; this panel may be later addition to original carvings as shown by unorthodox naturalistic animal figures. This house was dismantled and many of the carvings sold to Augustus Hamilton, who took them to Dunedin where they were used in the Dunedin South Sea Exhibition of 1889. At the close of the exhibition most of the carvings were purchased from Augustus Hamilton for the Otago Museum through a subscription organized by Dr Hocken. Hamilton brought his remaining carvings to the Wellington Museum when he became the Director there. Later, Dr Skinner of the Otago Museum traded many of these carvings to overseas museums in exchange for foreign items. (RN).

Please, accept my sincere thanks for the flint and bone implements which reached the museum by the last Home mail… We would be delighted to send something in return, but doubt whether we have anything to send that you would desire. Our duplicates are either finely carved slabs (7 ft x 18 inches), on which freight would be heavy, or rough stone tools…
(BM AOA correspondence: H.D. Skinner, 12 November 1920)

We are sending off by the next freighter a pair of carved slabs addressed to your department. Will you please open them and keep the one you prefer, sending on the other to the Museum of Archaeology and Ethnology, Cambridge, who will pay half of the total freight from New Zealand. The slabs were carved in the seventies by skilled carvers of Ngati Porou and show no trace of European influence, apart from the steel tools used and the absence of indecency in one of them.
(BM AOA correspondence: H.D. Skinner, 22 June 1921)

I think there can be no doubt that Skinner's consignment is in return for a gift of mine.
(BM AOA correspondence: C.H. Read, 10 April 1922)

References: Anson 2004: 73–90; Neich 1996b: 108–9; Phillipps 1944: 118.

154 Plate 41
Side-wall panel, *poupou*
1950 Oc.6.1. Height 105 cm.

Wooden panel with frontal figure: *wheku* face with haliotis-shell eyes, plain spiral and *whakarare*; three-fingered hands with nails on stomach; *rauponga* spirals with chevron *pakati* on shoulders and hips, small plain spirals and *whakarare* on legs; between them small female figure with *wheku* face over genitalia of large figure. On each side of panel: *takarangi* spirals and small figure, their faces over elbows of large figure.
Provenance: Reid/Capt. Luce Collection.
Comments: East Coast/Bay of Plenty, 1840s (RN); Poverty Bay (DRS).

155
Side-wall panel, *poupou*
1993 Oc.3.79. Height 63.5 cm.

Wooden panel with frontal figure: *wheku*-faced, with teeth; *rauponga* spirals on face, shoulders and hips, *rauponga* and *whakarare* on rest of body; plain three-fingered hands on stomach. Between legs: small plain naturalistic male figure with penis. On both sides of head of main figure: small *manaia* and spirals. All figures with haliotis-shell eyes. Stained yellowish light

brown. Engraved on back: 'Tuhoe Huata 20th Intake'.
Provenance: Collected in the field.
Comments: Purchased from New Zealand Maori Arts and Crafts Institute, Rotorua; exercise piece in Ngati Tarawhai style carved by Tuhoe Huata of Hawke's Bay, graduate student at Institute's Carving School. Contemporary art.

156
Side-wall panel, *poupou*
1993 Oc.3.80. Height 86.5 cm.

Wooden panel with female figure in high relief: peaked head with round haliotis-shell eyes, sinuous plain body with vulva, right hand through mouth, left arm and leg intertwined; all limbs decorated with *pungawerewere* and *ritorito*. Figure stained light brown, base panel dark brown.
Provenance: Collected in the field.
Comments: Purchased from New Zealand Maori Arts and Crafts Institute, Rotorua; exercise piece in North Taranaki style carved by Darren Palmer of Lake Taupo, student at Institute's Carving School. Contemporary art.

Plaited side-wall panels, *tukutuku*

157 Plate 43
Plaited side-wall panel, *tukutuku*
1898-2. Height 138 cm.

Black and undyed strips of kiekie leaf and yellow *pingao* leaves on split-wood slats stained black and red/brown and arranged in horizontal groups of six of each colour. Coloured leaf strips form repeating diamond patterns on each side of central dividing line; behind, stalks of *toetoe* plant arranged vertically. Colours faded.
Provenance: Presented by A. Hamilton.
Register: 'These panels were placed along the inner wall of a Maori house alternating with carved wooden panels. Called "Tukutuku".'
Comments: Pair with **158** (1898-3).

158 Plate 43
Plaited side-wall panel, *tukutuku*
1898-3. Height 138 cm.

Black and undyed strips of kiekie leaf and yellow *pingao* leaves on split-wood slats stained black and red/brown and arranged in horizontal groups of six of each colour. Coloured leaf strips form repeating diamond patterns on each side of central dividing line; behind, stalks of *toetoe* plant arranged vertically. Colours good.
Provenance: Presented by A. Hamilton.
Register: 'These panels were placed along the inner wall of a Maori house alternating with carved wooden panels. Called "Tukutuku".'
Comments: Pair with **157** (1898-2).
References: Ford n.d.: back cover.

159
Plaited side-wall panel, *tukutuku*
1994 Oc.4.105. Height 183.5 cm.

Black and undyed strips of kiekie leaf and yellow *pingao* leaves on horizontal split-wood slats attached to pegboard. Board and slats painted ochre red, leaf strips arranged in vertical repeating diamond pattern on each side of central dividing line.
Provenance: Collected in the field.

Comments: Commissioned from and made by Emily Schuster and her team in New Zealand Maori Arts and Crafts Institute, Rotorua, in 1994/5. Contemporary art.

160
Plaited side-wall panel, *tukutuku*
1994 Oc.4.106. Height 185.5 cm.

Black and undyed strips of kiekie leaf and yellow *pingao* leaves on horizontal split-wood slats attached to pegboard. Board and slats painted ochre red, leaf strips arranged in vertical repeating diamond pattern on each side of central dividing line.
Provenance: Collected in the field.
Comments: Commissioned from and made by Emily Schuster and her team in New Zealand Maori Arts and Crafts Institute, Rotorua, in 1994/5. Contemporary art.

161
Plaited side-wall panel, *tukutuku*
1994 Oc.4.115. Height 138 cm.

Black and undyed strips of kiekie leaf and yellow *pingao* leaves on horizontal split-wood slats attached to pegboard. Board and slats painted ochre red, coloured leaf strips arranged in vertical repeating diamond pattern on each side of central dividing line. Behind pegboard, stalks of *toetoe* plant arranged vertically.
Provenance: Collected in the field.
Comments: Commissioned from and made by Emily Schuster and completed by Jim and Cathy Schuster in New Zealand Maori Arts and Crafts Institute, Rotorua, in 1996/7 (Natasha McKinney, pers.comm. 5 March 2009). Contemporary art.

162
Plaited side-wall panel, *tukutuku*
1994 Oc.4.116. Height 138 cm.

Black and undyed strips of kiekie leaf and yellow *pingao* leaves on horizontal split-wood slats attached to pegboard. Board and slats painted ochre red, coloured leaf strips arranged in rectangular design patterns, four each side of central dividing line, each pattern different. Behind pegboard, stalks of *toetoe* plant arranged vertically.
Provenance: Collected in the field.
Comments: Commissioned from Emily Schuster and made by Jim and Cathy Schuster in New Zealand Maori Arts and Crafts Institute, Rotorua, in 1997 (Natasha McKinney, pers.comm. 5 March 2009). Contemporary art

Miscellaneous carvings

Palisade posts, *pou whakarae/himu*

163 Plate 44
Palisade post, *pou whakarae/himu*
1896-1232. Height 168 cm.

Wooden post in form of standing narrow human figure with hands on chest, right hand with fingers upright; body and limbs plain; face with weathered male tattoo; topknot. Back of body partially hollowed out; right leg broken at mid-calf; traces of varnish.
Provenance: Presented by A.W. Franks (Cohen, 2 December 1895).
Comments: Wairoa/East Coast, 1860s (RN); East Coast (DRS).

Undated letter from L. Cohen, offering for sale two Maori gods 'which I brought from Napier; they belong to Miss Cavendish.' (BM PE correspondence: L. Cohen, 1895).

164 Plate 44
Palisade post, *pou whakarae/himu*
1883.8-4.I. Height 121 cm.

Wooden post in form of standing angular human figure: long face with male tattoo, traces of haliotis-shell eyes, thick long neck with spirals and collar with v-shaped *pakati*; spirals on sides, arms with squared, blocked *rauponga*, left hand to neck, right on stomach; diagonal v-shaped *pakati* over lower body; traces of red ochre.

Provenance: Presented by Captain James Drysdale.

Register: 'Given to the donor by Na Paora Taki, chief of the Ngati-hou [Ngati Hau] tribe, who stated it to have been brought by his ancestors from Hawaiki.'

Comments: West Coast/Whanganui, 1880s, very crude, completely untrained carver but probably Maori (RN); Northland, *c*.1860, *tekoteko* (DRS).

Dear Sir, Our mutual friend, Mr King, having forwarded to me your letter to him, I have Captain Drysdale's consent to send to you the idol referred to in the correspondence, & it will probably reach you on Monday next. I think you have the letter from the New Zealand chief, and the translation of it. It may interest you to know that when Captain Drysdale, as arranged with the Chief, sent his boat ashore for the idol, the New Zealanders would not allow it to be taken away, & the boat had to return without it. The Chief subsequently sent it on board in his own canoe.

(BM AOA Christy correspondence: H. Edmorestone-Montgomerie F.S.A., 21 July 1883)

Rapahi Native Reserve, February 9th 1883. To Captain James Drysdale, Ship City of Delhi. From His Sincere Friend. Na Paora Taki, Chief of the Ngatihou Tribe. This image was brought originally by a very old Ancestor of mine from Hawaiki to New Zealand & has been ever since in the possession of our family at Kaiapoi, Arahura, & lastly at Rapaki. I now present the same to you as a mark of esteem for your Gentlemanly Conduct & respect towards the Natives here. Na Paora Taki.

(BM AOA Christy correspondence: Na Paora Taki, 9 February 1883)

Kaainga Maori Rapaki Puapure 9th 1883. Kia Kapene Heme Drysdale Kaipuke (City of Delhi) O Toona ahoa Na Paora Taki Rangatiru o Te Ngatihou iwi Tenei ritanga ote iwi Maori o Mua o toohu tepuna tawhito o Hawaiki ki Nue Tirand Ki la malou iwi Kia Kaiapoi, ki Arahura ki Rapaki. Ka hoatu ohau Ki a Koe Tenei Ritanga Katoa, o te iwi Maori. Na Paora Taki.

(BM AOA Christy correspondence: Na Paora Taki, 9 February 1883)

References: Edge-Partington 1969 I: 369.1; Ford n.d.: fig. 8, bottom right; Te Riria and Simmons 1989: 64.50; Te Riria and Simmons 1999: 54.

165 Plate 45
Palisade post, *pou whakarae/himu*
1972 oc.3.I. Height III cm.

Wooden post in form of standing human figure: very weathered, no surface decoration; rounded, deeply moulded face, right hand on stomach, left under chin;

small topknot or comb; remnants of penis; pale brown wood.

Provenance: Purchased from Mrs P. Withofs.

Comments: East Coast/Wairoa, 1870s (RN); Waikato, *c*.1850 (DRS).

References: Ford n.d.: fig. 8, top left.

166 Plate 45
Palisade post, *pou whakarae/himu*
1968 oc + I. Height 95 cm.

Wooden post in form of human figure: deeply carved face, topknot, three-fingered hands with thumbs on chest, no legs, no surface ornamentation; remnants of black paint all over.

Provenance: A.W. Franks. Ex Duplicate Collection.

Register: 'Found in duplicate room. A 19th century acquisition bearing a red-rimmed Franks duplicate label AF.'

Comments: 1890s (RN); Waikato (DRS).

Other carvings

167 Plate 46
Figure
1895-343. Height 145.5 cm.

Wooden, elongated, attenuated male figure: long head with topknot and narrow, long tongue; face, body and legs covered with deep ridged notching; arms with v-shaped *pakati*, hands on stomach; right foot broken off. Pair with **168** (1895-344).

Provenance: Meinertzhagen Collection.

Comments: West Coast/Whanganui, 1890s (RN); S. Waikato, post; elongated post figures similar to the external posts illustrated by G.F. Angas in 1844 at Otawhao (Te Awamutu) (DRS).

Probably by untrained Maori carver; for same carver's work, see Christie's sale, London, 3 December 1991, lot 47 (RN).

References: Ford n.d.: fig. 8, bottom, first left.

168 Plate 46
Figure
1895-344. Height 82.5 cm.

Wooden, elongated, attenuated female figure: long head with topknot and narrow, long tongue; face and body covered with deep ridged notching; upper arms with v-shaped *pakati*, hands on stomach; legs broken off at trunk. Pair with **167** (1895-343).

Provenance: Meinertzhagen Collection.

Comments: West Coast/Whanganui, 1890s (RN); S. Waikato, post; elongated post figures similar to the external pots illustrated by G.F. Angas in 1844 at Otawhao (Te Awamutu)(DRS).

Probably by untrained Maori carver; for same carver's work, see Christie's sale, London, 3 December 1991, lot 47 (RN).

References: Ford n.d.: fig. 8, bottom, second left.

169 Plate 46
Figure
1895-351. Height 25 cm.

Wooden standing female figure: squat, dumpy. *Wheku*-faced but semi-naturalistic, large round crater at back of head, angled hole in top of head, row of nail holes across brows. Neck in deep groove; large buttocks; vulva; three-fingered hands on chest, right shoulder and arm broken off. Red stain, no

surface decoration. Unusual shaped nose; original rough cuts under feet.

Provenance: Meinertzhagen Collection.

Comments: Bay of Plenty/East Coast, 1820s–40s, could be net float (RN); Poverty Bay, early nineteenth century, *poutokomanawa* (DRS).

References: Barrow 1969: fig. 201-3.

170 Plate 47
Figure
1844.7-25.I. Height 87 cm.

Wooden standing male figure: feet cut separate with no attachment to post or stand, but unable to stand on its own. No other attachment devices. Unusual stance with one leg forward. Naturalistic face with full male facial tattoo; plain spirals on front of shoulders, curving *haehae* and deeply carved spirals on lower arms and stomach. Five fingers on hands; one hand up under chest ridge, other on stomach. *Puhoro* and *rape* carved on thighs. Knees and lower legs left plain, penis on lower belly, back incurved and plain. Dark brown and reddish stained, badly damaged by insects. Marked in white on back: 'M.703'.

Provenance: Purchased from Mr Isaacson.

Register: 'From Museum at Chatham.'

Comments: Style uncertain, early nineteenth century (RN); Waikato/Taranaki (DRS).

171 Plate 47
Figure
1903.10-15.I. Height 49.2 cm.

Wooden standing male (emasculated?) figure on top of cut off pole. Head has mushroom-like projection, *wheku* face, mouth carved in openwork, *pitau*-series *kowhaiwhai* pattern on cheeks, haliotis-shell eyes; plain spirals on shoulders, buttocks and knees, *pakura* on arms. Large hands: right naturalistic, left stylized. Dark brown stain, varnished.

Provenance: Purchased from Samuel Vesty.

Comments: Poverty Bay; 1820s–30s, too small for *tekoteko*, with pole below possibly godstick, but head projection suggests weaving peg (RN); early nineteenth century (DRS).

172 Plate 48
Figure
1926.II-12.3. Height 33 cm.

Wooden standing figure: large naturalistic head with full male facial tattoo, haliotis-shell eyes, topknot. Hands on chest, plain spirals on shoulders, *whakarare*, *rauponga* and some *pakura* on body, including back; bow legs. Brown, traces of red ochre.

Provenance: Presented by Lord Stanley of Alderley.

Comments: East Coast, 1820s–40s, maybe early *poutokomanawa* (RN); Poverty Bay, *c*.1840, *poutokomanawa* (DRS).

Probably collected by Captain Owen Stanley, RN while in command of *Britomart* 1837–43.

173
Figure
1994 oc.4.88. Height 56 cm.

Wooden standing male figure on cube stand. Full facial tattoo, closed eyes, figure-of-eight mouth. Spirals on shoulders and

buttocks, *pakura* on arms, *puhoro* on thighs. Small projections on elbows, hands with long tapering three fingers, left on chest, right on stomach with tips of fingers to spiral navel. Large plain penis; plain incurved back. Horizontal adze marks on cube base.

　　Provenance: Collected in the field.

　　Comments: Carved by Lyonel Grant of Te Arawa, Ngati Pikiao. Contemporary art.

　　References: Starzecka 1996: 156.

174　　　　　　　　　　　　　　　　Plate 48
Figure

1994 Oc.4.117. Height 264 cm.

Wooden standing male figure: large oblong face with *rauponga* and spirals, haliotis-shell eyes. Small projections on elbows, hands with *rauponga* at circular haliotis-shell navel, heavy legs with feet merging into thick semicircular base on which figure stands; long penis widening towards end and also merging into base. Back of figure flat, slightly concave, with adze marks and 'Ihenga' across shoulder blades. Fluted adze marks on lower penis, calves and top of base. Surface ornamentation on body and limbs in *taratara-a-kai* of miscellaneous traditional and non-Maori motifs and inscriptions: chain and crucifix on neck; 'Kotahitanga' to right of chest; 'Waitangi' and New Zealand flag on left shoulder; '65185' and 'Ake ake kia kaha e' [be strong] below left elbow; 'L. Grant March 97', 'MoM', stylized human figure and human face on right hip; outline of two New Zealand islands, '1642' and '1769' on left hip.

　　Provenance: Collected in the field. Eth. Doc.1051.

　　Comments: Carved by Lyonel Grant of Te Arawa, Ngati Pikiao for the British Museum's 1998 exhibition, 'Maori'; It…

　　will symbolically link the work to be displayed and the work being produced today. It also is a statement of the Maori affinity to the land (depicted in this case by the umbilicus link to the land/base… Although the general shape of the figure is classically orientated the surface embellishment will reflect more modernistic symbols and events affecting Maori today and some European contact i.e. Treaty of Waitangi, perhaps passages of text incised into the surface etc.

　　(L. Grant letter, 19 February 1997, in Eth.Doc.1051).

Contemporary art.

References: Starzecka 1998: 156.

175　　　　　　　　　　　　　　　　Plate 49
Figure

1990 L.1.1/Royal Collection no.74069. Height 92 cm.

Wooden openwork figure: sinuous, flattish, carved on both sides, on low rectangular stand. Domed head, haliotis-shell eyes, plain body, *pakura* on limbs. On one side of body hands holding hafted axe; on the other, hands holding quill pen and scroll.

　　Provenance: Royal Loan 1990, Her Majesty Queen Elizabeth II.

　　Comments: Carving named 'Te Tiriti'. Carved by Rangi Hetet of Tuwharetoa, Maniapoto, in commemoration of the Treaty of Waitangi and presented to the Queen during visit to New Zealand in 1990.

　　Two figures back to back represent the partnership of the Treaty of Waitangi. The figure holding the quill represents the European, the opposite side features a figure holding a toki symbolising the Maori people. Both figures are part of each other providing the balance of the piece. Master Carver Rangi Hetet has carved the figure in the Northland style acknowledging the tribal area in which the Treaty was signed.

　　(Information provided with the object)

Contemporary art.

References: Nicholas and Kaa 1986: pl. 20.

176　　　　　　　　　　　　　　　　Plate 49
Mask

NZ 145. Height 11.5 cm.

Wooden mask: *wheku* face, *unaunahi* around mouth, haliotis-shell eyes, one notched, stained red; flat back with rectangular projection and square recess for attachment.

　　Provenance: Unknown.

　　Comments: East Coast; eighteenth or early nineteenth century, very small model (?) or cut-off *paepae tapu* (?), but probably not right shape for this; small masks such as this one were collected on Cook's first visit to New Zealand – see Parkinson 1773: pl. 26 (RN); possibly Cook, small mask for attachment to end of *paepae*(?) (DRS).

　　References: Edge-Partington 1969 II.1: 231.7.

177
Carving fragment

1897-6. Length 30 cm.

Wooden fragment: deeply carved on one side with *rauponga*.

　　Provenance: Presented by A.W. Franks, 1 January 1897.

　　Comments: East Coast, nineteenth century.

178
Pumice carving

1895-380. Length 34 cm.

Sub-cylindrical (with flat sides) pumice slab: face with pointed top carved on upper half of one side.

　　Provenance: Meinertzhagen Collection.

　　Comments: Possibly European carver (RN); European (DRS).

Domestic equipment

Much domestic equipment was plain and uncarved, though often displaying a fine, elegant, functional form. However, European collectors of the nineteenth century concentrated on the carved and decorated items, leading to some misleading bias in the surviving collections (some tribes were more famous for their carving skills, while other groups made functional but less-spectacular artefacts).

　　Plain gourds were used as water containers. Large gourds set in plaited-flax covers and supported on carved stands, fitted with a carved mouthpiece and sealed with a stopper, held various meats preserved in their own fats. Attached feathers were used to signal the contents of the gourd. These large decorated gourds of preserved food were prestige valuables, and were often exchanged or presented at important tribal gatherings.

　　In a culture that did not practise pottery manufacture, wooden bowls took on a variety of forms for many cooking and domestic purposes. Food and other materials could be heated in bowls by dropping hot stones into them. Pounded fern root was soaked with water in a bowl to separate the starchy food from the rhizome fibres, which were thrown away. The water was then poured off to leave the starch in the bowl. Techniques for preserving birds and other meat in their own fat in gourds required wooden bowls for separating and decanting, before pouring the fat into the storage gourd. Dyeing techniques for textile fibres and house linings also needed special bowls for mixing and decanting the dyes, and for soaking the working fibres in the colour.

　　Food was served ceremonially to important guests in large, carved bowls. In later times, innovative carvers adapted the form of these bowls with supporting figures so that they could stand on flat tables and mantelpieces, with the ornate bowl itself becoming the prestige gift. Maori families exchanged these ornate bowls among themselves and used them for special occasions, as well as presenting them to honoured European guests and officials.

Bowls and gourds

179 Plate 50
Spouted bowl, *kumete/ipu*
LMS 150. Length 22.5 cm.

Wooden bowl: oval, shallow, flat-bottomed, with large projecting spout; upper rim with *pakura*, underside with low-relief carving of female figure, with *rauponga* and plain spirals. Faint traces of red ochre.

Provenance: London Missionary Society Collection.

Labels: 'No 544 L.M.Socy'; 'L.M.S. Loan 1890 No 150'.

Comments: Hokianga, 1820s (RN).

References: Edge-Partington 1969 I: 384.5.

180 Plate 50
Bowl, *kumete*
LMS 152. Length 66.5 cm.

Wooden bowl: large, with protruding straight, thick tongue of face serving as handle at one end and protruding *wheku* figure at other. Each quarter of underside with large *rauponga* double spiral; *rauponga* in interstices and *pakura* around raised rim. Traces of red ochre.

Provenance: London Missionary Society Collection.

Labels: 'No 400 L.M.Socy'; 'LMS. Loan 1890 No'.

Comments: East Coast, 1840s–50s (RN); Poverty Bay, c.1850 (DRS).

References: Edge-Partington 1969 I: 384.4.

181 Plate 50
Bowl/casket, *kumete*
1854.12-29.82. Length 77.5 cm.

Wooden, large, deep and pointed-oval bowl in form of treasure box with *wakahuia*, on four legs. Black and red stain. Slightly raised lid divided by *whakarare* into quarters, each with large *rauponga* spiral; peg at each end to fit into notch on bowl; *raumoa* and *haehae* in black; carved plain loop for string in centre of lid. Bowl with projecting *wheku* head at each end on carved low-relief unsexed figure: haliotis-shell eyes, hands on chest, plain body, plain spirals on shoulders and hips. Bowl surface divided by *whakarare* into quarters, each filled with large *rauponga* spiral. Legs carved from solid, covered with *rauponga*. *Raumoa* and *haehae* black, *pakati* red; red ochre on figures.

Provenance: Grey Collection.

Register: 'Bowl for preserved birds. Wooden box "papa" in which to keep feathers & other valuables.'

Comments: Poverty Bay; 1840s–50s (RN); 1860, casket (DRS).

References: Neich 2005: 64.

182 Plate 51
Bowl, *kumete*
1913.3-12.2. Length 64.5 cm.

Wooden, rounded rectangular deep bowl: flat-bottomed, with figure supports facing outwards at each end. Both figures with *wheku* faces, unsexed; haliotis-shell eyes and three circles of other type of shell on each side of rim and one on each foot of figures; plain bodies, three-fingered hands, with knuckles and nails, on stomach; plain spirals with straight *ritorito* on thighs,

pakura on feet. Band of *pakura* around rim. Sides of bowl in horizontal *whakarare*. Very sharp metal cuts.

Provenance: Presented by Miss F.E. Godley, obtained 1849–53.

Comments: Poverty Bay, 1840s.

> They were brought from New Zealand by her father in 1853.
>
> (BM PE correspondence:
> F.G. Kenyon, 14 February 1913)

> The curios came directly from her father, John Robert Godley who was a leader of the Canterbury Settlement in the South Island of New Zealand, and was a close friend of Sir George Grey. Many of the curios came directly from tribes as presents to Mrs Godley, and as they have never been out of the hands of the family their provenance is entirely authenticated.
>
> (BM AOA correspondence:
> A.P. Newton, 18 September 1935)

183 Plate 51
Bowl, *kumete*
1944 Oc.2.799. Length 100 cm.

Wooden, large, deep oval bowl with one end pointed. Large raised *koruru*-type head (lower mouth and nose damaged) on high-relief female figure under bowl at pointed end; plain spirals on shoulders, *pakura* on arms and legs, *ritorito* around vulva, three-fingered hands on hips. Similar relief figure at broad end of bowl, but here hands pass under legs and head is replaced by protruding rounded knob with *rauponga* which serves as handle. Outer surface of bowl divided longitudinally by line of *whakarare*, large *rauponga* spiral on each side in centre, *rauponga* on sides of it. *Pakura* around rim. Dark brown stain.

Provenance: Beasley Collection. Beasley no. 532.

Comments: Poverty Bay, 1820s–30s, beautiful old bowl (RN).

Beasley catalogue: 532, registered 8 December 1910, 'Bt W. Oldman'.

References: Beasley 1919: 36; Beasley 1938: 15, pls X, XI.

184
Bowl, *kumete*
1944 Oc.4.1. Length 60 cm.

Wooden bowl: plain, roughly carved, circular, narrowing down to flat bottom; slight shoulder below rim, two large crude lugs, one each side; weathered.

Provenance: Purchased from Glendinning and Co.

Comments: Damaged, and therefore illegible, old label.

185 Plate 52
Container, *ipu*
NZ 118. Height 9 cm.

Small gourd container: internal lid held by suspension cord of two-ply twisted string; design of spirals and *pitau* pricked in and coloured black.

Provenance: Unknown.

Comments: Nineteenth century (RN).

References: Edge-Partington 1969 I: 386.6.

186 Plate 51
Container, *taha huahua*
+3483. Height 35 cm.

Gourd container: plain, with carved wooden mouthpiece decorated with *rauponga* spirals and toothed upper edge.

Provenance: Presented by Sir Julius von Haast, Director of Canterbury Museum, Christchurch, NZ, 12 July 1887.

Register: 'Pigeon preserving pot… Wanganui River. For this a number of Christy duplicates were given in advance.' Originally 'contained in a coarsely plaited basket' now lost.

Comments: Whanganui River.

> My dear Franks, if you wish it, I shall write by this mail to my [illegible] to send you at once the big Gourd with carved wooden mouthpiece, ornamented with feathers for the preservation of pigeons in their own fat. There are only 2 in New Zealand (in my Museum) & I shall be only too delighted to let you have one of these.
>
> (BM PE correspondence:
> J. von Haast, 13 October 1886)

> As arranged with Sir Julius I shall consider it a present to the Christy collection from him, though in reality an exchange with me…
>
> (BM PE correspondence:
> A.W. Franks, 1 July 1887)

References: Edge-Partington 1969 I: 382.1.

187 Plate 52
Container, *hue*
1977 Oc.8.5. Length 32 cm.

Oval gourd container with lateral stalk spout, decorated with fine incised *pitau*-series pattern using upper rim, central equator line and base as *manawa* lines for pattern; interstitial spaces filled with hatching; bottom plain.

Provenance: Purchased from Christie's, Hooper Collection sale of 21 June 1977, lot 115.

Comments: East Coast (?), early nineteenth century (RN).

Ex Penzance Natural History and Antiquarian Society, 1947; probably collected by William Colenso between 1834 and 1899.

References: Hooper 2006: 136.78; Phelps 1976: pl. 8.36, 411.36; Starzecka 1979: fig. 64.

188 Plate 52
Gourd mouthpiece, *tuki taha*
1913.5-24.80. Diameter 15 cm.

Wooden carved mouthpiece, with *rauponga wheku* figure with raised arms in low relief on either side; *whakarare* below upper rim and each side of figures; in between irregular pattern of *raumoa* and *haehae*.

Provenance: Edge-Partington Collection.

Comments: Whanganui (?), late nineteenth century (RN).

References: Edge-Partington 1969 I: 381.5.

189 Plate 52
Gourd mouthpiece, *tuki taha*
1921.10-14.6. Diameter 12.9 cm.

Wooden mouthpiece, with scalloped upper edge and ornamented with *whakarare*.

Provenance: Yorkshire Philosophical Society Museum.

Register: 'Mouthpiece for gourd vessel for preserving pigeons.'

Comments: Rotorua/East Coast, mid nineteenth century (RN).

Beaters and other implements

190
Fern-root beater, *patu aruhe*
NZ 85. Length 32.5 cm.

Wooden beater: split in half lengthwise, plain oval rounded head, narrow handle.
Provenance: Unknown.
Comments: Eighteenth century, mallet possibly made from a broken fern beater(DRS).

191
Fern-root beater, *patu aruhe*
1954 oc.6.303. Length 36 cm.

Wooden beater: plain oval rounded head, circular cross section, narrow slim handle with expanded flat-bottomed butt; weathered.

Provenance: Wellcome Collection. Wellcome Museum no. 222263.
Comments: Northland, eighteenth century (DRS).

192 Plate 52
Stopper/peg, *puru*
1903.11-16.5. Length 9 cm.

Whale-tooth stopper: wide upper part carved in openwork with two faces back to back, surface decoration of *rauponga* and small spirals.
Provenance: Bequest of Francis Brent.
Register: 'stopper for gourd'.
Labels: 'New Zealand'; '14 22/5 7B'.

193
Fire plough, *kaunoti/hika*
1934.12-5.5. Length 26.5 cm.

Wooden fire plough with fibre wrapping.
Provenance: Bequeathed by T.B. Clarke Thornhill.

194
Shell for mixing ochre
1895-751. Length 9.8 cm.

Bivalve shell, interior covered with red ochre.
Provenance: Meinertzhagen Collection.
Comments: '… I found a large Mesodesma shall which had evidently been used to hold red ochre – the colour still remaining in the shell…' (Alexander Turnbull Library. MS-papers-0037-119: 19 May 1876).

Treasure boxes, ornaments, tattooing equipment

Exceeded in number only by the collections of the Auckland and Wellington museums, the British Museum collection of treasure boxes for holding personal valuables is by far the largest outside New Zealand. By virtue of its geographical coverage and the age range, from boxes collected on Cook's voyages to modern examples, the British Museum collection provides an invaluable record of the main tribal carving styles and their development under European influence. Originally, treasure boxes were designed to be suspended on flax cords from the rafters of a dwelling house, and therefore had as much carving on the underside as on the top lid. Probably many boxes had plain uncarved surfaces, but these were rarely collected.

An ancient regional type concentrated in the northern and western areas was usually called a *papahou* in reference to its flattened rectangular form. Most *papahou* have been carved with stone tools and feature the sinuous intertwined figures of Northland and Taranaki carvings from these areas. *Papahou* did not make the transition into the metal age, perhaps because the carvers from those areas suffered in the early epidemics or were involved in the destructive musket raids of the 1820s. A later regional type of treasure box, called *wakahuia,* from the central and eastern areas, spread across the country and continued as a metal-tool carved form throughout the nineteenth century. The name *wakahuia* refers to their oval, rounded cross-sectional, canoe-shaped form. With the adoption of flat tables and other European furniture, innovative carvers with an eye to the tourist market began to experiment on *wakahuia* with flat bottoms, or enlarged the terminal figures as supports to stand on a flat surface.

In addition to *papahou* and *wakahuia*, there is a third, previously unrecognized, form of treasure or trinket box, *powaka whakairo*, of which much smaller numbers are to be found in museum collections. This form is of squared-box shape with sharp edges and flat bottom. All its surfaces, including the bottom, are covered with decoration. Usually it has figures or faces at the ends and sometimes on the sides and on the lid.

Papahou, wakahuia and *powaka whakairo* held the treasured feathers and ornaments owned individually by high-ranking persons. Being worn in close contact with the tapu heads of chiefly individuals, these ornaments and their treasure-box containers took on the tapu power of their owners. A very wide range of ear, neck and breast ornaments rendered in stone, bone, shell, teeth, ivory and precious jade nephrite were worn by both men and women, becoming treasured family and tribal heirlooms as they passed down through the generations.

An indelible aspect of personal adornment was the facial and bodily tattoo of chiefly men and women, applied with simple tools of small bone chisels and mallets by highly trained *tohunga ta moko* specialists. Men displayed deeply carved facial moko and body tattoo on buttocks and thighs, as represented on many of the woodcarvings. Women's tattoo was mostly restricted to the lips and chin, with some occasional limited body markings. Women also deeply scarified their arms and breasts with shells and obsidian flakes during mourning, leaving permanent markings of their grief.

Treasure boxes

195 Plate 53
Treasure box, *wakahuia*
LMS 151. Length 77 cm.

Wooden box: very dark brown, long, oval-shaped with flat lid, rim rabbeted for lid. Projecting *wheku* head on short neck with low-relief body at each end: plain spirals on shoulders and knees, *pakura* on arms, hands and feet, *whakarare* on lower body of one figure. Surface between figures divided by low-relief *rauponga* and *whakarare* into quarters filled with irregular *rauponga*. Part of rim on one side in *pakura*, but most left plain. Lid with two separated high-relief male figures, feet towards ends, hands on chest, plain spirals on shoulders and hips; lid surface divided by *whakarare* into eight sections, each carved in *rauponga*. Several cracks in base of box, multiple insect marks, especially on lid, with slight damage to face of one figure. Base marked in black ink: 'Piha New Zealand'.

 Provenance: London Missionary Society Collection.

 Comments: Poverty Bay, 1810s–30s, unusually long box of considerable age and distinctive carving technique (RN); East Coast (DRS).

196 Colour plate 10
Treasure box, *papahou*
NZ 109. Length 65 cm.

Wooden box: brown, rectangular, shallow, flat, recessed all around for flat lid. Rounded tongue of low-relief *wheku* face projecting at each end, larger one with *rauponga*. Sides and bottom of box with heavy, coarse relief carving of, alternating, three *wheku* and two *manaia* figures: central *wheku* figure, female, transverse, with head on one side of box and body extending to other, second, *wheku* figure, parallel to central one, at one end of box, and third, in reverse position, at other end, *manaia* in between. Figures with *rauponga* and *whakarare*; background surface left plain. Lid with longitudinal reversing *rauponga* spirals separated by central line of *whakarare*. Twisted-flax string threaded diagonally through holes in two corners of lid and corresponding holes in rim of box. Traces of red ochre.

 Provenance: Cook Collection.

 Register: 'See Add. M.S. 15,508, page 22.'

 Comments: Bay of Islands, eighteenth century; this box is remarkable for the boldness of its composition and execution, producing powerful directional flow of linked figures, with little attention to fussy detail (RN).

 References: Archey 1977: 72, fig. 144; British Museum 1925: fig. 165; Joppien and Smith 1985: 1.163, 1.164; Kaeppler 1978: 181; Neich 1996b: 96; Newell 2003: 248, fig. 232; Simmons 1981: 58; Simmons 1985: 50, fig. 41; Starzecka 1979: pl. VII.

197 Plate 53
Treasure box, *papahou*
NZ 110. Length 64 cm.

Wooden box: brown, rectangular, rabbeted at each end for flat lid. High-relief *wheku* heads at ends (upper lip of one damaged) connecting to large female and male bodies joined in sexual union across base of box.

Each side of box with two elongated fish-like *manaia* figures, face to face. All figures, in strong relief, decorated in *pakura* and plain spirals against plain background. Lid with two blocked-out figures, head to head, left hand to mouth, no surface decoration, perhaps unfinished. Dark stain on lid and end heads; two natural (?) holes in bottom of box, four holes in lid, two plugged with coarse fibre.

 Provenance: Unknown.

 Comments: Early, bold Rongowhakaata style, 1830s, making full use of new metal tools, *manaia* figures are outstanding examples of range of Poverty Bay carving expression (RN); Poverty Bay, 1830s–40s (DRS).

 References: Capistrano 1989: fig. 5.

198 Plate 53
Treasure box, *wakahuia*
NZ 111. Length 46.5 cm.

Wooden box: brown, oval-shaped, with flat lid fitting into notch at each end. Projecting smallish plain *wheku* head at each end. Surface of box divided by central *rauponga* spiral and longitudinal *whakarare* into quarters filled with diagonal curved *rauponga*. Same arrangement of surface ornamentation on lid. *Pakati* notches in sets of three separated by extended notch, except for those in two quarters on one side of box and in three quarters on lid. *Pakati* coloured red; *raumoa* and *haehae*, black.

 Provenance: Presented by H. Cuming.

 Label: '29 Box, N. Zealand, H. Cuming'.

 Comments: East Coast; 1810s–30s, pattern of *pakati* notches in sets gives this carving unusual appearance (RN); 1860 (DRS).

199 Colour plate 10
Treasure box, *wakahuia*
NZ 113. Length 59.5 cm.

Wooden box: brown, deep, rounded-oblong shape, recessed around rim for flat uncarved lid. Projecting *wheku* head at each end, grooved tongue joined to box. Surface ornamentation divided by narrow bands of *whakarare* into quarters, each quarter in turn divided by diagonally curved band of *rauponga* into two parts, each filled with major and minor *rauponga* spirals. Band of *pakura* around rim. All surface carving coloured with red ochre, residue of same ochre inside. Lid decorated with *kowhaiwhai* pattern of pale natural-wood colour and dark stain, divided by straight transverse line into fields of curved *pitau* patterns.

 Provenance: Cook Collection.

 Comments: Eighteenth century; probably Poverty-Bay-style *kowhaiwhai*, carving related to Whanganui style, pattern on lid is the oldest surviving example of *kowhaiwhai*, apart from blades of early contemporaneous painted paddles, carving is stone-tool work, notable for its comfortable successful variation and lack of strict bilateral symmetry (RN); Whanganui/Cook Strait (DRS).

 References: Archey 1977: 72, fig. 143; Kaeppler 1978: 181; Neich 1993: 59, fig. 22; Neich 1996b: 97; Simmons 1981: 58.

200 Plate 54
Treasure box, *papahou*
NZ 114. Length 47.5 cm.

Wooden box: brown, rectangular, sharp-edged, deep, recessed all around to fit lid with two scallops at each end. No terminal projections on box; square ends and upper surface with curved *rauponga* and indication of *manaia* eyes. Sides, bottom and lid all covered with longitudinal, rolling, plain spirals; dark-brown stain on top and lid.

 Provenance: Unknown.

 Comments: Hokianga, 1850s; restrained surface decoration of one pattern and sharp-edged flat sides with no projections give this box very distinctive appearance (RN).

201 Plate 54
Treasure box, *wakahuia*
553. Length 42.5 cm.

Wooden box: brown, boat-shaped, recessed all around rim for slightly raised lid. Rudimentary large stylized head projecting at one end, small projection (head with features worn off?) at other; box plain. Lid with scallop at one end, squared at other, covered in rolling *rauponga* and plain spirals; two small haliotis-shell eyes in centre, two at scalloped end (one of each set missing), recess for eyes at other end but inlay missing. Part of edge on one side of lid broken off and replaced with new piece, lashed in position in two places; incipient carving on replacement piece.

 Provenance: Unknown.

 Comments: Northland, 1840s, unusual form of box with fairly cursory carving on lid only (RN); South Taranaki (DRS).

202 Plate 54
Treasure box, *wakahuia*
1905. Length 41.5 cm.

Wooden box: dark brown, elongated-oval shaped, recessed all around for flat lid. Large projecting *wheku* head at each end, with *rauponga* and haliotis-shell eyes (only one extant). Surface of box covered with longitudinal *rauponga*, separated into bands by kinks at regular intervals; *pakati* strongly chevroned. Lid with *rauponga* in similar bands, plain raised loop at one end of lid, remnants of loop at other.

 Provenance: Unknown.

 Comments: East Coast or Ngati Kahungunu, 1860s–70s, pattern of kinked *rauponga* in bands, with chevroned *pakati*, lends this box distinctive appearance (RN); East Coast, 1860 (DRS).

203 Plate 55
Treasure box, *wakahuia*
1907. Length 41 cm.

Wooden box: dark brown, rounded-oblong shape, with flat lid fitting into notch at each end. Projecting *wheku* head with *rauponga* and notched haliotis-shell eyes (one missing) and body in relief, with plain spirals and *rauponga*, *manaia* face on trunk, at each end; one body mostly plain (unfinished?), but with notched haliotis-shell ring between right arm and trunk, surface between covered with *whakarare*. Lid divided into quarters by *whakarare*, each filled with *rauponga* spiral and diagonal *rauponga*.

 Provenance: Unknown.

Comments: Poverty Bay, 1870s–80s; classical standard form of Poverty-Bay-type treasure box, but smaller than most (RN).

204 **Plate 55**

Treasure box, *papahou*

1908. Length 38 cm.

Wooden box: yellowish brown, narrow oblong with flat lid fitting into notch at each end. Projecting *wheku* head with low-relief female body at each end; one head with *rauponga*, other with *pakura*, bodies with plain spirals. Surface between divided by *whakarare* into quarters, each filled with diagonal *whakarare*, horizontal *whakarare* at ends; band of *pakura* around upper edge of box. Lid with high-relief figure at each end, feet inward, one with *wheku* face with *rauponga*, other with naturalistic male facial tattoo, both with upraised naturalistic hands; *rauponga* and *whakarare* on rest of lid surface. Notched haliotis-shell eyes in heads and figures (one only extant in heads); *haehae* stained black, *pakati* red. End heads and bodies stained with red ochre.

Provenance: Unknown.

Register: '543 1034'.

Label: '…516'.

Comments: Poverty Bay/East Coast, 1860s–70s, raised figures with naturalistic hands on lid are unusual, otherwise this is fairly standard Poverty Bay/East Coast type of box, distinguished by careful colour patterning of surface decoration (RN); Poverty Bay, 1880 (DRS).

References: Simmons 1985: 155, fig. 127.

205 **Plate 55**

Treasure box, *wakahuia*

1909. Length 60 cm.

Wooden box: light brown, elliptical, rabbeted all around rim for flat lid. Projecting *wheku* head and high-relief female body at each end. Rest of surface divided into quarters by lines of *whakarare*, each quarter filled with *rauponga* spiral with S-form centre; one spiral with four *raumoa* ridges, all others with three *raumoa*; strongly chevroned *pakati* notches, some with nick out of apex; *raumoa* and *haehae* stained dark brown, *pakati* more reddish. Bodies and interstitial area decorated with *rauponga*, one head with haliotis-shell eyes, eyes in other unfinished. Lid with two frontal low-relief *wheku* figures, feet to feet, bodies left plain with plain spirals at shoulders and knees, faces with *rauponga* and notched haliotis-shell eyes (one plain, replacement?); background of lid in *whakarare*. One end of lid damaged.

Provenance: Unknown.

Comments: Poverty Bay, 1850s–60s; very fine, detailed carving with sharp cuts (RN).

206 **Plate 56**

Treasure box, *wakahuia*

1910. Length 56 cm

Wooden box: brown, rounded-oblong shape, with slightly raised lid to fit notch at each end. Projecting *wheku* head and body at each end, raised above surface of box on openwork chocks. Both figures with hands replaced by *manaia* heads, *manaia* on stomach, plain spirals on shoulders and knees, *pakura* on legs and on *manaia*, notched haliotis-shell eyes in all heads,

but most missing (only four remaining); one figure's lower legs damaged. Surface between figures divided by *whakarare* into quarters, each filled with diagonal *whakarare* and *rauponga*, band of *pakura* around outer rim. Lid surface divided by *rauponga* with limited *ritorito* into quarters, each filled with diagonal *whakarare*. Red ochre rubbed into all surfaces.

Provenance: Revd John Whiteley, via Royal Botanic Gardens, Kew.

Label: 'Royal Commissioners. P.267 No 35. No.I. Native Box (Papa ruakuara) [*papa raukura*] is generally used to keep their head dresses in – a feather called To wia [Te huia?] much prized by the Maories. Presented by the Reverend John Whiteley – Wesleyan Mission Kawia [Kawhia] – New Zealand. In case A.41 No.4. [Reverse] from Kew 1910'.

Comments: Poverty Bay, 1830s, fine early Poverty Bay Rongowhakaata type of *wakahuia* with added refinement of raising terminal figures above surface of box, which must have been transported across North Island to Kawhia at some stage in its history (RN); East Coast style (DRS).

207 **Plate 56**

Treasure box, *wakahuia*

1911. Length 35.4 cm.

Wooden box: dark brown, narrow elongated-oval shape, with flat lid fitting into notch at each end. Projecting *wheku* head with *pakura* and wide, vertically grooved tongue on relief body at each end; bodies with some plain spirals and *pakura*, but mostly left plain (unfinished?). Surface between figures divided by line of two *raumoa* into quarters, each filled with diagonally curved *rauponga*. Lid with same pattern, with addition of *ritorito* on central longitudinal line. Small, rectangular hole in centre of lid. Traces of red stain.

Provenance: Unknown.

Comments: East Coast; 1850, rendering of tongue with grooved lines and shaping of nose on terminal figures is unusual, carving technique fairly heavy and coarse (RN); probably made in Whanganui *c*.1860 (DRS).

208 **Plate 56**

Treasure box, *papahou*

7215 (also numbered, incorrectly, 2715). Length 59 cm.

Wooden box: yellowish brown, rectangular, recessed all around to fit flat lid with two scallops at each end. Large, sinuous-bodied, three-dimensional openwork female figure at each end, decorated with plain spirals and *rauponga* on bodies, and *unaunahi* around mouth and brows. All surfaces of box and lid carved with fairly high-relief complex pattern of full-frontal figures, three female, and intertwined scrolls. Bodies decorated with *rauponga*, plain spirals and limited *unaunahi* on faces. Haliotis-shell eyes in some figures and between their bodies.

Provenance: Presented by A.W. Franks, 1 June 1871 (bought from Wright 1870).

Comments: Bay of Islands, 1820s–30s; perfect demonstration of intricacy and detail of North Auckland figural composition (RN).

References: Barrow 1969: figs 72, 219 (mistakenly attributed to Cook); British

Museum 1925: fig. 164; Edge-Partington 1969 I: 368.2; Hamilton 1901: 430, pl. LXIV, fig. 2; Roth 1901: fig. 43.

209 **Plate 57**

Treasure box, *wakahuia*

7366. Length 50.5 cm.

Wooden box: brown, pointed-oval shape, with high, rounded lid. Large semi-naturalistic head with male tattoo at each end, narrow haliotis-shell eyes. Division between base and lid passes horizontally through each head. Base and lid with two large *rauponga* single spirals. Pronounced split at bottom and two hairline cracks in lid. Remnants of red fabric tape through mouth of one head.

Provenance: Presented by A.W. Franks, 12 September 1871 (Wareham).

Comments: Whanganui, 1860s–70s, noteworthy on this box are single rather than usual double spirals, and division of terminal heads by base/lid join (RN); East Coast, 1860 (DRS).

210 **Plate 57**

Treasure box, *wakahuia*

+3447. Length 39 cm.

Wooden box: brown, pointed-oval shape, with flat lid. Projecting *wheku* head facing upwards at each end. Surface of base divided longitudinally by line of *whakarare*, and both sides filled with series of three reversing *rauponga* spirals. Lid with longitudinal *rauponga* and *whakarare*, some with double rows of *pakati* notching. *Haehae* coloured black, traces of red colour elsewhere. Hole in centre of lid, partially plugged, small hole drilled through lid and box at each end next to projecting heads.

Provenance: Presented by A.W. Franks, 2 May 1887 (Miss Leigh).

Comments: East Coast, 1840s, arrangement of terminal heads facing upwards and double rows of *pakati* are unusual (RN); Bay of Plenty (DRS).

211 **Plate 57**

Treasure box, *wakahuia*

1894-272. Length 49 cm.

Wooden box: oblong, with flat lid. Plain projecting *wheku* head at each end (one head damaged and devoid of its upper half), surface divided longitudinally by line of *whakarare* (sections of *pakati* missing) with four sections of *rauponga* loops on each side. Lid with longitudinal central line of *whakarare* and four sections of curved *rauponga* on each side, rectangular hole in centre. *Haehae* and *raumoa* coloured red, *pakati* black.

Provenance: Presented by Mrs Charles H. Read.

Register: 'Bought at Hastings, New Z… Given to Dr Sonnie by Mr Stack 1832.' Labels: 'A New Zealand carved box called by the natives E'papa wakairo', 'A New Zealanders' casket accompanied with Mr Stacks grateful rememberances of Dr Sonnie's attention to him …t Hastings. London Augt 1, 1832'.

Comments: East Coast or Ngati Kahungunu, 1800s–20s, well-proportioned, restrained box distinguished by its consistent colouring pattern and unusual *rauponga* loops (RN); East Coast (DRS).

References: Capistrano 1989: fig. 1.

212 Plate 58

Treasure box, *wakahuia*

1895-358. Length 43.5 cm.

Wooden box: brown, dark stain, narrow
elongated-oval shape, with flat plain lid
fitting into notch at each end. Projecting
wheku heads and low-relief plain bodies
(one female, slightly abraded) at ends;
surface of box plain.

Provenance: Meinertzhagen Collection.

Comments: East Coast or Ngati
Kahungunu, 1830s–40s, old box with
minimal surface decoration (RN); East
Coast (DRS).

213 Plate 58

Treasure box, *wakahuia*

1895-1224. Length 38.5 cm.

Wooden box: brown, rounded-oblong
shape, rabbeted all around rim for lid.
Projecting *wheku* faces on short neck to
high-relief bodies, one male one female,
at each end: plain spirals on shoulders and
thighs, *rauponga* and some *ritorito* on trunk
and limbs; male figure with hands on hips,
female with right hand on hip, left on chest.
High-relief *wheku* face mid sides of box,
with *raupona* spiral in quarters separated
by *whakarare*. Very slightly hollowed-out
lid, high-relief *manaia* face with finely
notched haliotis-shell eyes and surface
decoration of *raupona* towards each end;
surface of lid divided by *whakarare* into
quarters, each filled with *raupona* spiral.
Traces of red and black stain.

Provenance: Presented by A.W. Franks,
10 December 1895; ex Sparrow Simpson
Collection.

Register: 'Exhibited at Fine Art
Exhibition, Derby 1877.'

Comments: Poverty Bay; 1850s (RN);
c.1860 (DRS).

214 Plate 58

Trinket box, *powaka whakairo*

1896-806. Length 20 cm.

Wooden box: small, faded light brown,
rectangular, deep, rabbeted at each end for
lid (missing). Projecting *wheku* head at each
end: *raupona* on brows, eyes, mouth and
projecting tongue, nose of *pakati*, red ochre
in eyes, plain spiral on top of head. All sides
with *whakarare*: long sides and bottom,
horizontal; short end sides, vertical. Top of
rim with *pakati* on long sides, and *raupona*
on short.

Provenance: Presented by F.LL. Griffith,
MA, FSA, 19 June 1896.

Comments: East Coast, 1880s (RN).

215 Plate 59

Treasure box, *wakahuia*

1896-1127. Length 41 cm.

Wooden box: reddish brown, flattish
pointed-oval shape with very thick rounded
lid fitting into notch at each end. Small
projecting *wheku* head without mouth at
each end. Surface of box and lid covered in
symmetrical, diagonal and transverse, with
central kink, *raupona*. Six haliotis-shell
eyes among *raupona*, only two (on box)
extant.

Provenance: Presented by A.W. Franks,
22 October 1896.

Comments: Taranaki, 1850s, carving
style of heads is unusual but overall form of
box and its surface decoration are typical

of West Coast of North Island (RN); West
Coast (DRS).

216 Plate 59

Treasure box, *wakahuia*

1904-248. Length 35.5 cm.

Wooden box: brown, canoe-shaped, lid
missing. Large naturalistic face with male
tattoo projecting at each end, only one
pearl-shell (?) eye extant. Surface divided
longitudinally by *whakarare*, and sides
covered in vertical *whakarare*.

Provenance: Higgins/Turvey Abbey
Collection.

Comments: Whanganui; mid nineteenth
century, standard Whanganui form of
wakahuia, carved in fairly coarse technique
(RN); 1860 (DRS).

217 Plate 59

Treasure box, *papahou*

1925-44. Length 70 cm.

Wooden box: painted red, large, rectangular,
rabbeted for lid (missing). Projecting *wheku*
head on neck at each end to male body
on underside of box. Deep relief carving
over total outer surface. On each side of
box, two horizontally placed figures, one
male, one female, with one frontal figure
between them; frontal figures' bodies, one
male, one female, meeting in sexual union
on underside of box. Bodies decorated in
pakura and plain spirals; raised rim around
top in *pakura*. Projecting heads with notched
haliotis-shell eyes (one missing), on surface
figures only one eye extant; top of one head
missing, small chunk missing next to right
eye in other; rim damaged at one end, four
small holes in bottom.

Provenance: Purchased from Devizes
Museum 1922.

Comments: Poverty Bay, 1840s;
unusually deep, clear relief carving against
plain background displaying new virtuosity
available with metal tools (RN); work of
Rukupo of Gisborne (DRS).

Lid to box stolen, by J.E. Little, while
in Devizes Museum. Box was part of 1869
bequest to Devizes Museum by executors of
T.B. Merriman (Eth.Doc.588).

References: Capistrano 1989: fig. 2.

218 Colour plate 10

Treasure box, *wakahuia*

1854.12-29.21. Length 58 cm.

Wooden box: yellowish brown, black and
red stain, rounded-oblong shape with
raised lid, both rim and lid rabbeted to
fit. Projecting *wheku* head and body, one
male one female, at each end, raised above
surface of box on openwork chocks. Female
figure with *raupona* spirals, male with
plain spirals, *raupona* on faces. Surface
between divided by longitudinal line of
whakarare and transverse *raupona* spirals
into quarters, each filled with diagonal
raupona. Lid with high-relief male and
female figures, feet to feet, in sexual union,
haliotis-shell eyes, bodies with *raupona*
spirals and *raupona*. Rest of lid surface
with diagonal *raupona* on each side and
raupona spiral in centre. All figures with
notched haliotis-shell eyes. Entire surface
of box coloured: *raumoa* and *haehae* black,
pakati red with two black *pakati* at regular
intervals, flat areas of design red.

Provenance: Grey Collection.

Register and silver presentation
plaque: 'Te Matumotu-o-te-ahi-o-te-
okoro. Presented to Sir George Grey by Te
Rangihaiata [Rangihaeata] at Waikanae
March 21, 1851.'

Comments: Poverty Bay, 1840s; striking
wakahuia, distinguished by raised terminal
figures and brightness and regularity of
its painted decoration; another *wakahuia*
given to Sir George Grey by Te Rangihaeata
is now in Auckland Museum, see Edge-
Partington 1907: 23 and 1915: 66 (RN).

References: Archey 1977: 68, fig. 136;
Ford n.d.: fig. 4a.

219 Plate 60

Treasure box, *wakahuia*

1854.12-29.83. Length 72 cm.

Wooden box: light brown, black and red
stain, shallow elongated-oval shape, on
two pairs of legs, with large raised lid fitting
into notch at each end. Projecting *wheku*
head and relief body with projecting legs
supporting box at each end, one figure
female, one male (feet of male figure
broken off); figures with plain spirals
and *pakura*. Surface between figures
with central plain spiral and divided into
quarters by longitudinal and transverse
lines of *whakarare*, each quarter with coarse
raupona, plain spiral each side of figures.
Lid with two raised high-relief *wheku*
figures, one female, feet to feet; surface
of lid with longitudinal *whakarare* and
diagonal *raupona*. All carving coloured
in somewhat irregular pattern of red and
black, haliotis-shell eyes in figures.

Provenance: Grey Collection.

Comments: East Coast, 1850s; apparently
early unsuccessful attempt to produce
wakahuia designed to stand on flat surface
on its own feet, also marked by crude, rough
carving technique (RN).

References: Neich 2005: 64.

220 Plate 60

Treasure box, *wakahuia*

1854.12-29.84. Length 67.5 cm.

Wooden box: brown, large rounded-oblong
shape with heavy raised lid fitting into
notch at each end. Projecting *wheku* head
with low-relief female body, hands on hips,
at each end; bodies with plain spirals and
pakura, with limited *ritorito* around vulva.
Surface between divided longitudinally by
whakarare and transversely by *raupona*
spirals into quarters filled with diagonal
raupona. Lid with central longitudinal
raupona, central *raupona* spiral each side,
diagonal *raupona* in each quarter. Traces of
red ochre on rim.

Provenance: Grey Collection.

Comments: Poverty Bay, early 1850s;
large, standard Rongowhakaata type of
wakahuia with very regular, sharp, metal-
cut detailed carving (RN).

221 Plate 60

Treasure box, *wakahuia*

1854.12-29.85. Length 58 cm.

Wooden box: light brown, black and
red stain, oval shape with flat lid. Plain
openwork figure with large *wheku* head
projects above level of lid at each end,
notched haliotis-shell eyes extant only in
one figure. Surface between figures divided
by longitudinal *raupona* and transverse

whakarare into quarters, each filled with diagonal *rauponga*. Lid surface decorated to same arrangement except for longitudinal *whakarare* and transverse *rauponga*. *Raumoa* and *haehae* coloured black, *pakati* notches red. Small round hole drilled at one end of lid.

Provenance: Grey Collection.

Comments: East Coast, late 1840s, raised terminal figures are unusual and idiosyncratic (RN); Poverty Bay (DRS).

222 — Plate 61
Treasure box, *wakahuia*
1854.12-29.86. Length 37.5 cm.

Wooden box: brown, polished, small, deep oval shape with flat, plain lid. Projecting *wheku* head on neck with long tongue joining box at each end. Carving unfinished. Surface divided longitudinally by line of *rauponga*, finished side of box with three *rauponga* spirals, unfinished side with central *rauponga* spiral and some diagonal *rauponga*. Signs of incipient design on lid, three small holes with string threaded through them.

Provenance: Grey Collection.

Comments: Poverty Bay, 1840s–50s, not very accomplished carving, with unusual hooked noses on terminal figures (RN); East Coast (DRS).

223 — Plate 61
Treasure box, *papahou*
1854.12-29.87. Length 48 cm.

Wooden box: dark brown, very shallow, flat, rectangular, recessed all around for flat, plain lid with scallop shape at each end. Sinuous-bodied three-dimensional openwork figure at each end, with *pakura* spirals and *unaunahi* on hands and faces, only one notched haliotis-shell eye extant. Sides and bottom of box covered with longitudinal repeating pattern of plain rolling spirals, small haliotis-shell piece on bottom of box at one end.

Provenance: Grey Collection.

Comments: Hokianga, eighteenth century; very old, stone-tooled classic North Auckland form of treasure box (RN).

224 — Plate 61
Treasure box, *wakahuia*
1855.12-20.62. Length 42.5 cm.

Wooden box: brown, black and red stain, narrow pointed-oval shape, with raised lid. Large naturalistic face with male tattoo and haliotis-shell eyes (one missing) projecting at each end. Surface of box and lid divided by *whakarare* into eight sections on each, all filled with low-relief diagonal *rauponga*. *Raumoa* and *haehae* mostly coloured black, *pakati* mostly red. Two-ply twisted-flax string wrapped around one end of box.

Provenance: Haslar Hospital Collection.

Register: 'Marked no. 6131.'

Comments: Whanganui; 1820s–30s, small, well-proportioned box with close-fitting lid (RN); 1860–80 (DRS).

225 — Plate 62
Treasure box, *wakahuia*
1855.12-20.63. Length 39 cm.

Wooden box: brown, elongated-oval shape with slightly raised lid, rabbeted all around edge and fitting into notch at each end. *Wheku* head on extended neck and raised-relief body at each end; bodies with plain

spirals on limbs. Surface between divided by *whakarare* into quarters, each with *rauponga* spiral. Lid divided longitudinally by line of *haehae* with large, plain rolling spirals on either side. All carving in low subdued relief. Traces of red ochre inside box.

Provenance: Haslar Hospital Collection.

Comments: Poverty Bay/East Coast, 1830s (RN); East Coast (DRS).

226 — Plate 62
Treasure box, *papahou*
1878.11-1.605. Length 36.5 cm.

Wooden box: brown, rectangular, recessed all around rim for lid (missing). Projecting *wheku* head at each end linked to low-relief male bodies on base. Between these terminal figures is transverse female figure with another face below. *Wheku* figure with profile body (one male) in each of four side corners, with head towards end. All figures with plain or *rauponga* spirals on bodies, all heads and figures with notched haliotis-shell eyes (some missing). Rim at ends with *pakura*.

Provenance: Meyrick Collection.

Comments: South Taranaki, 1820s; this box features complex, basically symmetrical arrangement of figures skilfully fitted into small surface area (RN).

227 — Plate 62
Treasure box, *papahou*
1896.11-19.3. Length 52 cm.

Wooden box: brown, black and red stain, flat, rectangular, rabbeted at ends for flat lid. Flat, naturalistic tattooed head projects above box at each end, one head broken off and top re-carved on break with *rauponga* and small naturalistic face. Box and lid decorated with generally symmetrical, free-flowing pattern of *rauponga* spirals and series of loops. Lid in dark stain, but on box *raumoa* and *haehae* coloured black, *pakati* red. Loop of twisted-flax string through hole in centre of lid. Cracks at each end of box, two larger ones on each side of undamaged projecting head strengthened with flax lashing passing through holes drilled for this purpose. Rim damaged on one side, near damaged head.

Provenance: William Strutt Collection.

Register: 'Presented to me by Mr Mortimer of Melbourne, whose vessel, the barque "Favourite", traded with the Islands.'

Comments: East Coast, 1840s–50s, this box has composition very different from that of most East Coast *wakahuia*, marked by its rectangular shape, naturalistic terminal faces and flowing freedom of its surface decoration, all of which are combined in most successful manner (RN); Poverty Bay, 1860 (DRS).

References: Capistrano 1989: fig. 3.

228 — Plate 63
Trinket box, *powaka whakairo*
1896.11-19.4. Length 12.2 cm.

Wooden box: small, deep, rectangular. Lid, recessed all around to fit plain opening at top of box, with high-relief, prone *wheku*-faced male figure, plain body, three-fingered hands on chest, face with *whakarare* brows, *pakura* mouth, *pakati* nose and notched haliotis-shell eyes. Lid around figure, all sides and bottom covered with diagonal

slightly curved *rauponga*. Sides and lid stained dark brown.

Provenance: William Strutt Collection.

Comments: East Coast, 1890s (RN).

Inside box: dried fern leaf on cotton wool and small pieces of scoria wrapped in paper with hand-written inscription: 'Scoria from peak of Mt Egmont New Zealand. This piece of scoria or lava was broken from the highest of the peaks, of Mount Egmont 9000 feet above the level of the ocean by Mr Adams a fellow settler who with a party ascended Mount Egmont in March 1856.'

References: Neich 2005: 59, fig. 12.

229 — Plate 63
Treasure box, *wakahuia*
1905.1-20.2. Length 47.5 cm.

Wooden box: brown, shallow oblong shape, with one notch to fit raised lid. *Koruru*-type head with large, notched haliotis-shell eyes facing upwards, projecting on long neck at each end from contorted relief body on upper end. Elongated relief *manaia* with haliotis-shell eyes on lower surface around projecting neck. Surface of box divided by *whakarare* into quarters, each filled with two *rauponga* spirals; *whakarare* below rim on each side. Lid with high-relief prone *wheku* figure, hands on chest, *pakura* decoration; surface of lid covered with *rauponga*.

Provenance: Purchased from H. Hollman.

Comments: Taranaki, 1820s–30s, very complex figural composition successfully fitted to shape of box, with *manaia* figure adding delicate touch below terminal figures (RN); Bay of Plenty, 1850 (DRS).

230 — Plate 63
Treasure box, *wakahuia*
1920.3-15.1. Length 40 cm.

Wooden box: reddish brown, oblong, with notch at each end to fit slightly raised lid. Projecting *wheku* head and low-relief female body with large plain spirals on shoulders and thighs at each end. Surface of box covered with regular bands of *rauponga*, divided into sections by kink, *pakura* around rim. Lid divided into eight sections by one longitudinal and three transverse *whakarare*, each section filled with diagonal *rauponga* and one end section also with low-relief *wheku* mask. Native repair with fibre on one corner of box. Edge of lid slightly chipped in some places; huia feather inside box. Box marked in pencil: '35'; lid – 'Feather Box 40'.

Provenance: Purchased from J.A. Ritchie.

Comments: Poverty Bay, 1800s–30s, softness of carving detail and irregularity against grain suggest that this box may have been carved with stone tools or early soft metal tools, kink in *rauponga* is feature carried over into later Rongowhakaata work (RN); East Coast (DRS).

231 — Plate 64
Treasure box, *papahou*
1921.10-14.5. Length 43.5 cm.

Wooden box: brown, dark stain, very shallow, flat, rectangular, recessed all around for plain flat lid. Pair of blocked-out projecting *wheku* heads at each end; unfinished blocked-out carving along

sides. Bottom with three deep-relief *wheku* figures: female at each end and male between, all joined in sexual union. Figures decorated with plain spirals on shoulders and hips, *rauponga* on faces, trunk and limbs. Traces of red ochre inside box.

Provenance: Yorkshire Philosophical Society Museum.

Comments: Taranaki, 1820s; deep detailed carving on base illustrates variation and inventiveness of skilled carver who is able to form new figural compositions within established tradition (RN).

232 **Colour plate 10**
Treasure box, *papahou*
1926.3-13.30. Length 46 cm.

Wooden box: light brown, shallow, flat, rectangular, recessed for lid scalloped at ends. Sinuous-bodied, three-dimensional openwork composition of double figures projecting at each end. Bottom with central row of four *wheku* figures: middle pair male and female in sexual union; haliotis-shell eyes in outer figures and one such eye in female figure. Lid with high raised central ridge of openwork sinuous-bodied figures, head to head, with transverse median band of two smaller figures; three haliotis-shell eyes in this composition. All figures decorated with *rauponga* and *whakarare*. Remainder of lid and box surface with *rauponga* spirals.

Provenance: Presented by Sir F. Sydney Parry.

Register: 'Probably collected 1830–40, while Parry was governor of Australia' (this probably refers to Arctic explorer Sir William Edward Parry, 1790–1855, who was not Governor but Commissioner for Australian Agricultural Company 1829–34 and Superintendent of Haslar Hospital 1846–52, whereas this specimen was presented by Sir F[rederick] Sydney Parry, 1861–1941, his grandson).

Comments: Taranaki, 1810s–20s, typically complex classical Taranaki composition of linked and interstitial figures, executed with minute attention to fine detail (RN); South Taranaki, 1830 (DRS).

References: Archey 1977: 80, fig. 158; Neich 1996b: 96; Simmons 1985: 94, fig. 87.

233 **Plate 64**
Treasure box, *wakahuia*
1928.1-11.1. Length 51.5 cm.

Wooden box: dark brown, oval shape, with notches for lid (missing) at each end. Projecting *wheku* head, with haliotis-shell eyes, to low-relief figure decorated with plain spirals and *rauponga*, at each end. Surface between figures divided by one longitudinal and three transverse bands of *whakarare* into eight sections, each filled with diagonal *rauponga*.

Provenance: Purchased from S.O. Woodhead.

Comments: Poverty Bay, 1870s, low-relief standard carving (RN); East Coast, 1860 (DRS).

234 **Plate 64**
Treasure box, *papahou*
1931.10-9.1. Length 36 cm.

Wooden box: brown, flat, narrow, rectangular, rabbeted for lid. Projecting small *wheku* head at each end, suspension

hole formed by head's tongue joining box. Sides and base covered with scrolled reversing *rauponga* spirals, some with sets of four *raumoa*. Lid has central transverse raised *wheku* figure with plain body, except for simple spiral on shoulders and *rauponga* on brows, surrounded by *rauponga* spirals and curved bands of *rauponga*. Lid chipped at one corner, dark blue/black (ink?) stains inside box (used as pencil case?).

Provenance: Purchased from Kenneth Peck.

Label: 'Annie Stocks, 7 Hereford Rd, Southport'.

Comments: Poverty Bay/East Coast, 1840s, this box is carved in very accomplished but unusual style, not represented among any other boxes in British Museum's collection (RN); South Taranaki (DRS).

This box was offered for sale to the Museum by Miss A. Stocks in 1907, but the offer was rejected as the price was too high (BM PE correspondence: O.M. Dalton, 18 October 1907).

235 **Plate 65**
Treasure box, *wakahuia*
1944 Oc.2.800. Length 57.5 cm.

Wooden box: dark brown, long, deep, oblong shape, rabbeted all around for flat lid. Small projecting *wheku* head at one end, much larger projecting *wheku* head, with notched haliotis-shell eyes (one missing), on two supports at other. Surface divided by one longitudinal and three transverse *whakarare* into eight sections, each filled with diagonal *rauponga*; strongly chevroned *pakati* notches. Lid plain except for set of four carved raised loops with *whakarare* towards each end. Longitudinal crack on one side of box.

Provenance: Beasley Collection. Beasley no. 594.

Comments: East Coast, 1840s, different size and style of heads at each end are most unusual feature (RN); Bay of Plenty, decoration in East Coast style (DRS).

Beasley catalogue: 594, registered 22 September 1911, 'Bt W Oldman'.

236 **Plate 65**
Treasure box, *wakahuia*
1944 Oc.2.801. Length 53 cm.

Wooden box: reddish brown, pointed-oval shape, with slightly raised lid, ridged all around rim to fit notch at each end of box. Projecting elongated *wheku* head with prominent brows and tongue and haliotis-shell eyes at each end. Lid and box covered in finely detailed curving *rauponga*, often with flat semicircular scales across *haehae*, arranged in sections, with twelve low-relief small *wheku* faces, some with brows prolonged into 'horns', among design: one in centre and one each end of base, three smaller ones on each side of box below rim, and three on lid, one in centre flanked by two smaller ones. Perforation through each extreme end of lid and corresponding perforations through rabbeted step at each end of box.

Provenance: Beasley collection. Beasley no. 4706.

Comments: North Taranaki; 1820s–30s, this box is distinguished by fine precision of its carving technique and striking small

face masks distributed among surface decoration (RN).

Beasley catalogue: 4706, registered 1 November 1938, 'Bt Montague Marcussen'.

237 **Plate 65**
Treasure box, *wakahuia*
1953 Oc.17.1. Length 67 cm.

Wooden box: brown, black and red stain, long oval shape, with slightly raised lid fitting into notch at each end. Projecting *wheku* head on short neck to relief body at each end: haliotis-shell eyes, one body left plain, other with *rauponga* spirals on shoulders and *ritorito* across chest. Surface between figures divided by *whakarare*, three longitudinal and seven transverse (three on one side and four on other), into fifteen sections, each filled with diagonal *whakarare*. Lid with large central *rauponga* spiral and longitudinal *whakarare* each side of it creating quarters filled with diagonal *whakarare*. *Haehae* and *raumoa* often coloured black, *pakati* in red. Round holes in lid (two each end) and box (three in base); remnants of linen cloth glued inside box. Split in one end of box, down decorated figure, repaired with flax lashing and later glued.

Provenance: Presented by E.F. Storey.

Register: 'Sent to donor's father from New Zealand about 1896'.

Label: 'AF 1873'.

Comments: Poverty Bay; 1820s–30s, figures carved in distinctive style with ridged facets on body and squared stance, arrangement of surface pattern is unusual (RN); 1840 (DRS).

238 **Plate 66**
Treasure box, *papahou*
1964 Oc.5.1. Length 43 cm.

Wooden box: reddish brown, narrow, deep, rectangular, recessed all around for flat lid with two scallops at each end. All surfaces of box and lid carved with fourteen relief *wheku*-faced figures, of these six clearly female and four male, linked in various types of sexual union. Arched projecting bodies of one figure at each end form suspension lugs. All figures decorated with *rauponga* and plain spirals, background left plain. Two small insets on lid: one haliotis shell, and one nephrite in vulva of female figure; one nephrite inset in base of box.

Provenance: Presented by Mrs Geoffrey W. Russell.

Register: 'Believed to have been in England since at least 1900. Formerly in the possession of a Mrs Mary Pye, whose family had military connections.'

Comments: Bay of Islands; late eighteenth century, very complex composition of figures in unusually explicit variety of sexual connections (RN); eighteenth century (DRS).

239 **Plate 66**
Treasure box, *wakahuia*
1993 Oc.3.81. Length 36 cm.

Wooden box: light brown, gourd-shaped, with one flat side as base, long curved stalk, rabbeted all around for raised lid. Spare, low-relief spiral and curving decoration of *taratara-a-kai* on sides and lid, with one small inset of haliotis shell on lid. Pronounced fluted adze marks on

curved stalk and one longitudinal curved indentation on one side of box. Inside box in centre, plain nose shape carved in high relief.

Provenance: Collected in the field.

Comments: Carved by Lyonel Grant of Te Arawa, Ngati Pikiao, for British Museum's 1998 exhibition 'Maori'.

240 Plate 66
Treasure box, *wakahuia*
Q1981 Oc.1393. Length 46.5 cm.

Wooden box: light brown, black and red stain, shallow oval shape, with raised lid fitting into notch at each end. Projecting *wheku* head with *rauponga* at each end. Surface decoration of central *rauponga* spiral surrounded by curving *rauponga*, separated by central longitudinal line of *rauponga*. Surface decoration of lid repeats this pattern. *Raumoa* and *haehae* coloured black; *pakati* red with regularly spaced sets of two or three notches coloured black.

Box and lid deeply stamped: 'MA 3563'; exterior marked in white paint: '1626 527'.

Provenance: Unknown – but see Comments.

Comments: East Coast; 1830, this matching carving pattern on box and lid is unusual, and made more striking by regular colour pattern (RN).

Possibly from Royal Artillery Museum, Woolwich, London: '…the Maori box may once have been our "… box in the form of a tortoise curiously carved", mentioned in the catalogue of 1873, updated in 1889.' (BM AOA correspondence: P.G.W. Annis, 7 February 1994).

241 Plate 67
Treasure box, *papahou*
Q1981 Oc.1394. Length 52.5 cm.

Wooden box: yellowish brown, large, deep, rectangular, with flat rectangular inset lid. High-relief *wheku* figure with large head and small body at each end and mid side, with heads projecting above lid. All figures with haliotis-shell eyes (one missing) and *rauponga* and *whakarare* covering bodies. Similar high-relief prone figure with notched haliotis-shell eyes in centre of lid. Surface of box and lid covered in longitudinal *rauponga* divided into sections by transverse bands of *whakarare* (four on lid and sides, five on base). Strongly chevroned *pakati*.

Provenance: Ex Wellcome Collection.

Label: 'K 15409 [reverse] MA T'.

Comments: East Coast, 1850s–60s, deep rectangular shape differs from usual *wakahuia* form (RN); Poverty Bay, 1860, jewel casket (DRS).

242 Plate 67
Treasure box, *wakahuia*
Q1987 Oc.29. Length 50 cm.

Wooden box: light brown, deep, very rounded oval shape, with high bulbous lid not rabbeted, but originally with peg to insert into each end. *Wheku* head projecting on neck at each end, linked to female body. Surface carving unfinished, with *rauponga* and *whakarare* on heads and bodies, rest left plain but figures linked across base by single row of *pakati* notches and beginnings of *whakarare*. Lid has relief *koruru*-type face with bulbous eyes at each end; one side

of lid left plain, other side with *rauponga* and incipient spiral. All ornamentation deeply carved; polished slightly reddish close-grained wood.

Provenance: Unknown.

Comments: Ngati Kaipoho/ Rongowhakaata, 1840s, carved in style of Raharuhi Rukupo, possibly even by Rukupo himself; carving displays his characteristic deep *rauponga* with three *raumoa* and kink running across bands of *rauponga* (RN).

243
Lid of treasure box, *papahou*
1910-288. Length 28 cm.

Wooden lid: dark brown, flat, with scalloped ends; relief carving of two figures, *wheku* faces, bodies entwined, surface decoration of plain spirals with some *rauponga*.

Provenance: London Missionary Society Collection.

Comments: North Auckland, 1840s–50s (RN).

Ornaments

Pendants, *rei puta*

244 Plate 68
Pendant, *rei puta*
LMS 154. Length 17 cm.

Whale-tooth pendant: raised tip with black pigment in eyes and T-shaped nose, flat back with three holes and flax lashing.

Provenance: London Missionary Society Collection.

Label: 'No 486'.

Comments: eighteenth century (RN).

245 Plate 68
Pendant, *rei puta*
LMS 155. Length 17 cm.

Whale-tooth pendant: raised tip with some black pigment in eyes, deeply carved T-shaped nose; flat back with four holes.

Provenance: London Missionary Society Collection.

Comments: Eighteenth century (RN).

246 Plate 68
Pendant, *rei puta*
NZ 159. Length 14 cm.

Whale-tooth pendant: raised tip with some black pigment in eyes, no nose, flat back with three holes and suspension cord of fine black flax braided into thick round cord; toggle of albatross bone, one end stuffed with reddish clay.

Provenance: Cook Collection.

Register: 'See Add. MS 15 508, Plate 21.'

Comments: Eighteenth century.

References: Davidson 1996: 20; Edge-Partington 1969 I: 370.1; Jessop 2003: 107; Joppien and Smith 1985: 1.126, 1.127; Kaeppler 1978: 177; Starzecka 1979: fig. 61.

247 Plate 68
Pendant, *rei puta*
1962 Oc.4.1. Length 13.2 cm.

Whale-tooth pendant: tongue-shaped, curved to one side and pointed, sharp cut above raised tip with large, almost parallel eyes with notched haliotis-shell inlay and black grooves in each corner; no nose but small perforation at tip; flat back with three holes; dark patina.

Provenance: Purchased from D. Crownover, University Museum, Philadelphia, PA.

Comments: Early nineteenth century, possibly Fijian *tabua* later shaped for *rei puta* and eyes added at this stage (RN).

Bought originally at Epstein sale at Christie's, 15 December 1961, lot 158; exhibited at the Arts Council of Great Britain, 1960, cat. no. 198 (H. Waterfield, pers. comm., 1 May 2008).

Pendants, *hei-tiki*

248 Plate 69
Pendant, *hei-tiki*
NZ 156. Length 12.5 cm.

Anthropomorphic bone pendant carved from human skull. Eyes of concentric rings with notched haliotis-shell inlay in centre; plain spirals on buttocks, *rauponga* and *rauponga* spirals with long *pakati* on back; right hand as *manaia* touching right leg. Metal (?) ring covered with fine reddish flax braid in mouth for suspension.

Provenance: Unknown.

Comments: Taranaki style, early nineteenth century.

References: British Museum 1925: fig. 162; Edge-Partington 1969 I: 371.2; Skinner 1933: 201, fig. 62; Skinner 1974: 65.4.79.

249 Plate 69
Pendant, *hei-tiki*
NZ 157. Length 10.3 cm.

Anthropomorphic bone pendant carved from human skull. Plain, except for indented circle on each leg, right hand raised to mouth of horizontally placed head, high patina.

Provenance: Unknown.

Comments: Nineteenth century, very crude work, looks quite old but could be deliberate fake (RN); Northland, eighteenth century (DRS).

250 Plate 69
Pendant, *hei-tiki*
1922.6-7.1. Length 9.6 cm.

Anthropomorphic pendant of human bone: head to right, haliotis-shell eyes; female with large vulva, right hand to mouth, left on chest; carved all over with *rauponga* and plain spirals on legs; flat sawn back with 'F.O. Fisher to T.E.L.' marked in black ink.

Provenance: Presented by F.O. Fisher via T.E. Lawrence.

Comments: Rotorua, nineteenth century.

I enclose the 'hei-tiki' which came from the so-called 'Rebel' or 'King Country' many years ago, where I was friendly with King Tawhio [Tawhiao], who in '83 made me a Maori chief…

(BM AOA correspondence: F.O. Fisher to T.E. Lawrence, 10 March 1922)

To the best of my recollection this was the one that belonged to an aged Tohunga or Wizard named Te Ao Katoa, who dwelt at Ao-Te-A-Roa in the King's Country.

(BM AOA correspondence: F.O. Fisher, 24 May 1922).

251 Colour plate 11
Pendant, *hei-tiki*
LMS 138. Length 11 cm.

Anthropomorphic nephrite pendant: mottled light and dark green, head to right, hands on hips, red sealing-wax eyes, old hole; finely braided thick flax cord.

Provenance: London Missionary Society Collection.

Labels: '67', 'No 497 LM Socy'.

Comments: Taranaki, nineteenth century; deep relief but poorly shaped, from disused adze blade (RN).

252

Pendant, *hei-tiki*

LMS 139. Length 7.3 cm.

Anthropomorphic nephrite pendant: homogenous dark green, head to right, hands on hips, red sealing-wax eyes; old, braided-flax cord.

Provenance: London Missionary Society Collection.

Label: 'No 500 LM Socy'.

Comments: Mid nineteenth century, badly shaped, flat, machine-sawn back, cord older (RN); early nineteenth century (DRS).

253 **Colour plate 11**

Pendant, *hei-tiki*

LMS 140. Length 7 cm.

Anthropomorphic nephrite pendant: dark green, head to right, hands on hips, haliotis-shell eyes, small, thick, angled hole, convex back.

Provenance: London Missionary Society Collection.

Comments: Mid nineteenth century, body and face details not very well done (RN); eighteenth century? (DRS).

254 **Colour plate 11**

Pendant, *hei-tiki*

LMS 141. Length 12.3 cm.

Anthropomorphic nephrite pendant: slightly mottled medium green, highly polished, head to left, hands on hips, finely notched haliotis-shell eyes, old hole, concave back, worn; thick finely braided flax cord.

Provenance: London Missionary Society Collection.

Label: 'No 498 LM Socy'.

Comments: Late eighteenth century (RN); Northland, eighteenth century (DRS).

References: Hooper 2006: 133.73.

255 **Colour plate 11**

Pendant, *hei-tiki*

NZ 154. Length 12 cm.

Anthropomorphic nephrite pendant: homogenous medium green, head to right, hands on hips, notched haliotis-shell eye (one missing), deep moulding, flat back; thick, fine, braided-flax cord with albatross-bone toggle.

Provenance: Unknown.

Comments: Early nineteenth century (RN); eighteenth century? (DRS).

References: British Museum 1925: pl. x, top right.

256 **Colour plate 11**

Pendant, *hei-tiki*

NZ 155. Length 16.8 cm.

Anthropomorphic nephrite pendant: mottled medium green, head to right, hands on hips, hole in lug, haliotis-shell eyes, one finely notched.

Provenance: Unknown.

Comments: Late/mid nineteenth century; very poor modelling, especially face (RN); Otago (?), early nineteenth century (DRS).

According to description in Register originally with flat fibre suspension cord and bone toggle, now lost, through right arm.

257 **Colour plate 11**

Pendant, *hei-tiki*

NZ 158. Length 10.5 cm.

Anthropomorphic nephrite pendant: homogenous bright green, head to right, hands on hips, well shaped, slightly concave back; coarse flax cord and albatross-bone toggle with both ends notched on one side. Marked in black ink on toggle: 'July 1849'.

Provenance: Unknown.

Comments: Late eighteenth century/ early nineteenth century (RN).

Originally **339** (*kapeu*, NZ 158B) and **441** (*kaka poria*, NZ 158A) were tied to suspension cord of this tiki.

258 **Colour plate 11**

Pendant, *hei-tiki*

st. 824. Length 10 cm.

Anthropomorphic nephrite pendant: variegated dark green, head to left, hands on hips, haliotis-shell eyes, thick stomach, convex back; braided-flax cord, albatross-bone toggle, both ends notched. Marked on toggle: 'CH.O.10'.

Provenance: Christy Collection. Acquired before 1862.

Comments: Late eighteenth/early nineteenth century (RN); Canterbury (DRS).

References: Christy 1862: 65.10.

259 **Plate 70**

Pendant, *hei-tiki*

st. 825. Length 13.8 cm.

Anthropomorphic nephrite pendant: homogenous dark green, head to right, hands on hips, clearly marked vulva, large old-type hole, slightly concave back.

Provenance: Christy Collection. Acquired before 1862.

Comments: eighteenth or early nineteenth century, surface details well done, probably shaped from disused adze blade, perfect example (RN); Taranaki, eighteenth century (DRS).

References: British Museum 1925: pl. x, bottom left; Christy 1862: 65.11; Te Awekotuku 1996: 45.

260 **Colour plate 11**

Pendant, *hei-tiki*

st. 826. Length 13.5 cm.

Anthropomorphic nephrite pendant: medium green, head to left, hands on hips; flat back, deep moulding, body and limb details poorly shaped; flat braided-flax cord, albatross-bone toggle notched at both ends; small hole in top of head but cord threaded through left arm so that when worn pendant would be suspended horizontally; round neck two globular yellow glass beads on string. Marked on toggle: 'CH. O. 12'.

Provenance: Christy Collection. Acquired before 1862.

Comments: Nineteenth century (RN); South Island, *c.* 1850 (DRS).

References: Christy 1862: 65.12.

261 **Colour plate 11**

Pendant, *hei-tiki*

1719. Length 14.5 cm.

Anthropomorphic nephrite pendant: homogenous dark green, head to right, hands on hips, hole in lug on top, one haliotis-shell eye, other red sealing wax; flawed along concave back; remnants of black tape through hole.

Provenance: A.W. Franks.

Label: '3262 AWF [A.W. Franks] 25/–'.

Comments: Early nineteenth century (RN); Northland, eighteenth century (DRS).

262 **Colour plate 11**

Pendant, *hei-tiki*

1720. Length 12.5 cm.

Anthropomorphic nephrite pendant: homogenous medium green, head to right, hands on hips, haliotis-shell eye (one missing); thick, deep modelling, slightly concave back, lower stomach sawn off, large old hole; many-stranded cord of fine twisted-flax threads, albatross-bone toggle.

Provenance: Unknown.

Comments: Eighteenth century, magnificent old tiki with beautiful facial detail (RN); South Island, nineteenth century (DRS).

'Deliberately mutilated by someone with sophisticated technical skill & resources. Not an accidental break. Why?' (Ngahuia Te Awekotuku's comments, August 1994).

263 **Plate 70**

Pendant, *hei-tiki*

1721. Length 10.3 cm.

Anthropomorphic nephrite pendant: homogenous medium to dark green, head to right, right hand on chest, left on hip, well-modelled facial details, old hole, flat back.

Provenance: Unknown.

Comments: Eighteenth century, well proportioned, perfect example of this style (RN); Bay of Plenty, nineteenth century (DRS).

264 **Plate 70**

Pendant, *hei-tiki*

1722. Length 9 cm.

Anthropomorphic nephrite pendant: homogenous medium green, head to right, hands on hips, two holes, some moulding on back; good clear facial details.

Provenance; Unknown.

Comments: Late eighteenth/early nineteenth century, well proportioned, standard type, very good (RN); East Coast, eighteenth century (DRS).

265 **Plate 70**

Pendant, *hei-tiki*

1723. Length 7.5 cm.

Anthropomorphic nephrite pendant: light green, head to right, hands on hips, good facial details; old, worn, thin; one hole worn out, large newer hole with thin silk cord loop.

Provenance: Unknown.

Label: 'New Zealand. Child's toy. Lt W.P. Cowting [?] RN.'

Comments: Late eighteenth century (RN); East Coast (DRS).

266 **Plate 70**

Pendant, *hei-tiki*

1724. Length 9 cm.

Anthropomorphic nephrite pendant: homogenous dark to medium green,

unusual upright head with red sealing-wax eyes, right hand to head, left on hip, separated legs, indication of vulva; one hole worn out, second later hole; well moulded, face details worn.

Provenance: Unknown.

Comments: Eighteenth century; Northland (DRS).

References: British Museum 1925: pl. X, middle left; Edge-Partington 1969 II.2: 183.2; Skinner 1932: 207, 210, fig. 1; Skinner 1966: 12, fig. 7; Skinner 1974: 50.4.2.

267 **Plate 70**

Pendant, *hei-tiki*

1725. Length 7.7 cm.

Anthropomorphic nephrite pendant: medium green, head to right, right hand on chest, left on hip; right leg broken, flat back.

Provenance: Unknown.

Comments: Early mid-nineteenth century, standard type, average quality (RN); nineteenth century (DRS).

268 **Colour plate 12**

Pendant, *hei-tiki*

1726. Length 4.3 cm.

Manaia-face-shaped nephrite pendant: homogenous light green, modelling on both sides.

Provenance: Unknown.

Comments: Early nineteenth century, unique example (RN); Northland, eighteenth century, *tiki-manaia* (DRS).

References: Edge-Partington 1969 II.2: 183.3; Skinner 1932: 209–10, fig. 6; Skinner 1974: 59 4.47.

269 **Plate 71**

Pendant, *hei-tiki*

1727. Length 18 cm.

Anthropomorphic nephrite pendant: dark green, head to right, hands on hips, haliotis-shell eyes, average-detail modelling, flat back; thick braided-flax cord and albatross-bone toggle.

Provenance: Unknown.

Comments: Mid nineteenth century (RN); Northland, early nineteenth century (DRS).

270 **Colour plate 12**

Pendant, *hei-tiki*

6742. Length 6.5 cm.

Anthropomorphic nephrite pendant: homogenous medium green, head to left, hands to face, contorted body, one hole and two old ones broken off on forehead of round, slightly flattened face, flat back.

Provenance: Presented by A.W. Franks, 7 July 1870.

Comments: Early mid-nineteenth century, unique form (RN); Northland, contorted *hei-tiki/pekapeka* (DRS).

References: Edge-Partington 1969 II.2: 183.1; Skinner 1932: 209–10, fig. 5; Skinner 1974: 59.4.46.

271 **Colour plate 13**

Pendant, *hei-tiki*

1896-925. Length 8.5 cm.

Anthropomorphic nephrite pendant: bluish light green (*inanga*), cross between *hei-tiki* and *hei-matau*: two *manaia* heads on wide single tiki body; rear moulded in shape of *hei-matau* but with tiki body modelling; suspension holes in both heads, old hole worn out of smaller head; fine braided-flax

cord (now detached) and albatross-bone toggle; very old, worn.

Provenance: Presented by A.W. Franks, 20 July 1896.

Comments: Eighteenth century; Northland, *hei matau*/tiki (DRS).

Given by Ngapuhi chief Titore to Captain F.W. Sadler of HMS *Buffalo* in 1833–4; Franks obtained it from Captain Sadler's daughter.

Register: Letter dated 30 July 1965 from Mr D.R. Simmons, Otago Museum. 'Tetoro, otherwise spelt Titore, was a powerful Ngapuhi chieftain from the Bay of Islands. In 1835 he wrote a letter to the King in which he calls himself a 'special friend of Capt. Saddler' (Sadler), so it is more than likely this friendship was sealed or marked by gifts. Titore died in 1837. Sadler was Captain of H.M.S. Buffalo, the stores ship which sailed regularly from Sydney to the Bay of Islands in 1833–4–5.'

References: Barrow 1961b: 353, fig. 2; Barrow 1972: 43, fig. 65; Beasley 1928: pl. CLX; British Museum 1925: pl. X, middle right; Edge-Partington 1969 II. 2: 184.8; Hamilton 1901: 342, pl. XLVI, fig. 2; Hooper 2006: 134.75; Skinner 1932: 209–10, fig. 4; Skinner 1966: 14, fig. 11; Skinner 1974: 51.4.9; Starzecka 1996; Starzecka 1998: 152.

272 **Plate 71**

Pendant, *hei-tiki*

1854.12-29.10. Length 22 cm.

Anthropomorphic nephrite pendant: light green, head to right, hands on hips, red sealing-wax eyes, flat back, old-type hole; straight sides.

Provenance: Grey Collection.

Register: 'Hei-tiki or neck ornament known by the name "Ko Wakatere Kohukohu, presented to Sir George Grey by Hone-heke at Te-Waimate, April 1848" (with silver plate inscribed)' [silver plate no longer with tiki].

Comments: Nineteenth century, probably from disused adze blade, huge size, made especially for Governor (?) (RN).

References: Edge-Partington 1969 I: 371.1; British Museum 1925: pl. X, bottom centre.

273 **Plate 71**

Pendant, *hei-tiki*

1854.12-29.11. Length 17 cm.

Anthropomorphic nephrite pendant: light green, head to right, hands on hips, old hole worn through and replaced with another; curved convex back; lower legs damaged by fire and discoloured, vertical crack across left arm and leg.

Provenance: Grey Collection.

Register: 'Belonged to Te-Puni, a chief of the Ngati-Awa tribe. The jade has been injured by the fire at Government House, Auckland.'

Comments: Early nineteenth century, shaped from disused adze blade (?) (RN); Taranaki, eighteenth century (DRS).

274 **Plate 71**

Pendant, *hei-tiki*

1854.12-29.12. Length 14 cm.

Anthropomorphic nephrite pendant: bluish light green (*inanga*), head to right, hands on hips, red sealing-wax eyes; folded and stitched linen cord with albatross-bone toggle; nephrite *kuru* pendant tied on to linen cord with back ribbon.

Provenance: Grey Collection.

Register: 'Te Pirau Kaukaumatua. Belonged to Hone Te Paki the high priest of Waikato.'

Comments: Eighteenth century, beautiful old tiki (RN); Northland (?), early nineteenth century (DRS).

On Thursday, the 22nd of December, 1853, about twenty Chiefs of note, from the District of Waikato, waited on Sir George Grey, for the purpose of presenting a valedictory Address to his Excellency on his approaching departure… It was not only novel, but deeply gratifying to see each Chief, as he concluded his song, presenting to the Governor some venerated heir-loom of his family… Hone Te Paki, eldest son of Watere Te Paki, stood up and said: … As a token of my affectionate regard I send Governor Grey a Heitiki named Te Pirau. This was left us by our fathers as a remembrance of them…

(Davis 1855: 13, 19)

References: Davis 1855: 13–19; Pole 1988: 129.

275 **Plate 71**

Pendant, *hei-tiki*

1854.12-29.13. Length 12 cm.

Anthropomorphic nephrite pendant: medium green, head to right, hands on hips, haliotis-shell eye set in red sealing wax (one missing), old hole, concave back.

Provenance: Grey Collection.

Comments: Nineteenth century, not so well shaped (RN); Taranaki, eighteenth century (DRS).

276 **Plate 71**

Pendant, *hei-tiki*

1854.12-29.14. Length 10.8 cm.

Anthropomorphic nephrite pendant: bluish light green (*inanga*), head to right, hands on hips, old hole in lug, slightly hollowed back; thin.

Provenance: Grey Collection.

Register: 'Belonged to Topeora, sister of Te Rangihaeata.'

Comments: Taranaki; nineteenth century (RN); eighteenth century (DRS).

277

Pendant, *hei-tiki*

1854.12-29.27. Length 9 cm.

Anthropomorphic nephrite pendant: mottled dark green, in process of manufacture from poor adze form; lower body started on both sides.

Provenance: Grey Collection.

Comments: Nineteenth century (RN); eighteenth century (DRS).

278 **Colour plate 12**

Pendant, *hei-tiki*

1855.12-20.73. Length 14.5 cm.

Anthropomorphic nephrite pendant: dark green, head to left, hands on hips, large hole through top of head, flat back.

Provenance: Haslar Hospital Collection; J.W. Hamilton.

Comments: Early mid-nineteenth century, well moulded, but average, standard type (RN); Hauraki, early nineteenth century (DRS).

References: British Museum 1925: pl. X, bottom right.

279 **Plate 72**

Pendant, *hei-tiki*

1855.12-20.74. Length 10.7 cm.

Anthropomorphic nephrite pendant: dark–medium green, head to left, hands on hips, old hole, almost flat back; face details good but very worn; very fine old cord, several-stranded, twisted, partly unravelled.

Provenance: Haslar Hospital Collection; J.W. Hamilton.

Comments: Late eighteenth century, beautiful, old, very worn (RN); eighteenth century (DRS).

280 **Plate 72**

Pendant, *hei-tiki*

1878.11-1.613. Length 14 cm.

Anthropomorphic nephrite pendant: speckled, light bright green, head to right, hands on hips, haliotis-shell eyes, one finely notched; good moulding.

Provenance: Meyrick Collection.

Illegible hand-written label.

Comments: Early mid-nineteenth century, shaped from disused adze blade (RN); this tiki looks much too good to be genuine (DRS).

References: British Museum 1925: pl. x, top left.

281 **Colour plate 12**

Pendant, *hei-tiki*

1878.11-1.614. Length 7.3 cm.

Anthropomorphic nephrite pendant: light green, highly polished by wear, head to right, hands on hips, face and body details muted, simplified; two old holes broken off and replaced with third. Flat, old, worn.

Provenance: Meyrick Collection.

Comments: Late eighteenth century (RN); nineteenth century (DRS).

282 **Colour plate 12**

Pendant, *hei-tiki*

1896.2-11.1. Length 18.3 cm.

Anthropomorphic nephrite pendant: bluish light green (*inanga*), head to right, hands on hips, very flat back, good modelling.

Provenance: Purchased from S.F. Purday.

Register: 'Was for many years in the possession of the Oxley family, to whom it came through the wife of a clergyman who doubtless obtained it through Samuel Marsden.'

Comments: Early nineteenth century; Hauraki (?) (DRS).

References: British Museum 1925: pl. x, top centre.

283 **Plates 69 and 70**

Pendant, *hei-tiki*

1906.4-16.1. Length 11 cm.

Anthropomorphic nephrite pendant: homogenous medium green, carved and completed on both sides; red sealing-wax eyes and vulva indicated on one side which is old, and lug for hole offset makes it original front. Rear modelling done much later.

Provenance: Purchased from Fenton and Son.

Register: 'Tiki called Kaupwina (= 2 stomachs). It belonged to the Wiari family, who have a song about its loss to the family. It is the only one known (Information supplied by Sir C.H. Read from Rotorua N.Z. 1925). (It was recognised by Bella Wiari in the BM).'

Comments: Original side early nineteenth century, facial modelling on later

rear is poor and not by skilled artist (RN); Taranaki (?), eighteenth century (DRS).

'Tuhourangi, Te Arawa, Rotorua' (Ngahuia Te Awekotuku); 'Bella was elder sister of Makereti Papakura and a renowned guide and resident at Whakarewarewa' (Paul Tapsell).

References: Joyce 1906: 53.

284 **Plate 71**

Pendant, *hei-tiki*

1919.5-2.1. Length 8.6 cm.

Anthropomorphic nephrite pendant: dark green, head to right, hands on hips, good facial details, old hole; thick, deep relief; remnants of twisted-fibre string.

Provenance: Presented by Dowager Viscountess Wolseley.

Comments: Early nineteenth century (RN); Northland (DRS).

285 **Colour plate 12**

Pendant, *hei-tiki*

1922.6-6.1. Length 14 cm.

Anthropomorphic nephrite pendant: homogenous medium green, head to right shoulder, which is higher than left, right hand with rudimentary finger grooves on chest, left on hip; very worn, facial details gone or, more likely, never finished; flat back. Square braided-flax cord attached by binding to right arm to wear tiki sideways.

Provenance: Presented by Revd R.L. Martyn-Linnington.

Register: '"Tiki", said to have been originally obtained by a sailor who accompanied Capt. Cook.'

Donor's note: 'The jade figurine was given to my grandmother early in the last century, I have always been given to understand, by a man who sailed with Captain Cook.'

Comments: Eighteenth century (RN); Rotorua, nineteenth century (DRS).

286 **Colour plate 12**

Pendant, *hei-tiki*

1934.12-5.20. Length 9.3 cm.

Anthropomorphic nephrite pendant: light green, head slightly to right, hands on hips, red sealing-wax eyes, very worn facial and body details; old hole worn out and another added; concave back.

Provenance: Bequeathed by T.B. Clarke Thornhill.

Comments: Early nineteenth century (RN).

287 **Plate 69**

Pendant, *hei-tiki*

1945 oc.5.1 (also numbered 1945.11-7.14). Length 13 cm.

Anthropomorphic nephrite pendant: homogenous dark green, head to left, hands on hips, deeply carved details, haliotis-shell eye (one missing); back with two old sawing grooves with traces of red ochre; old hole worn out, another in lug; fine braided-flax cord and albatross-bone toggle with notched ends.

Provenance: Bequeathed by Oscar Raphael.

Label: '30'.

Comments: Early nineteenth century (RN); fake (DRS).

288 **Plate 69**

Pendant, *hei-tiki*

1982 oc.1.9. Length 14.8 cm.

Anthropomorphic nephrite pendant: mottled medium green, head to right, hands on hips, notched haliotis-shell eyes, poorly carved; braided-flax cord, albatross-bone toggle (now detached). Marked 'R 773/1939'.

Provenance: Transferred from Wellcome Museum of Medical Science.

Register: 'From collection of Sir John Evans' (Eth.Doc.960).

Comments: Mid nineteenth century, thick, poorly shaped, out of proportion, shaped from disused adze blade (RN).

289 **Colour plate 12**

Pendant, *hei-tiki*

1982 oc.1.11. Length 8.7 cm.

Anthropomorphic nephrite pendant: black-veined green, head to right, hands on hips, squat, red sealing-wax eyes, concave back, two old holes worn out, third *in situ*; poor modelling. Marked: 'R 6080/1936'.

Provenance: Transferred from Wellcome Museum of Medical Science.

Register: 'Obtained by Sir Rider Haggard 1914–18'. 'Presented 16.7.1929 by Lady Rider Haggard' (Eth.Doc.960).

Comments: Early nineteenth century (RN).

290 **Colour plate 12**

Pendant, *hei-tiki*

Q1981 oc.1367. Length 6.5 cm.

Anthropomorphic nephrite pendant: light green, head to right, hands on hips, notched haliotis-shell eyes with red sealing-wax pupils; one hole worn out, braided-flax cord through another, albatross-bone toggle with notched ends. Marked in black ink: '584'.

Provenance: Unknown.

Comments: Late eighteenth century, worn but beautifully modelled (RN); nineteenth century (DRS).

291 **Colour plate 12**

Pendant, *hei-tiki*

Q1987 oc.30. Length 13 cm.

Anthropomorphic nephrite pendant: homogenous dark green, head to right, hand on hips, fine notched haliotis-shell eyes, old hole worn out, new one started, fine detailed modelling and some modelling on back.

Provenance: Unknown.

Label: '556'.

Comments: Early nineteenth century (RN).

292

Pendant, *hei-tiki*

Q1999 oc.31. Length 4.2 cm.

Anthropomorphic nephrite pendant: medium green, head to right, hands on hips, red sealing-wax eyes, metal ring through suspension hole; thin, crude.

Provenance: Ex Duplicate Collection.

Label: 'Given by Mrs Hilda Patterson July 1959'.

Comments: Tourist piece (RN).

293

Pendant, *hei-tiki*

Q1999 oc.32. Length 6.5 cm.

Anthropomorphic nephrite pendant: medium green, head to left, hands on hips,

no detail, hole drilled through right cheek, thin, rudimentary.

Provenance: Unknown.

Comments: Early twentieth century (RN).

294 Plate 72

Pendant, *hei-tiki*

1854.12-29.28. Length 8.5 cm.

Anthropomorphic bowenite pendant: greyish medium green, head to right, hands on hips, no hole, very poor modelling.

Provenance: Grey Collection.

Comments: Nineteenth century; nephrite, reproduction tiki (DRS).

295 Plate 72

Pendant, *hei-tiki*

1933.2-9.1. Length 10.2 cm.

Anthropomorphic bowenite pendant: translucent mottled medium green, head slightly to right, right hand on stomach, left on hip, red sealing-wax eyes, black wool cord. Flat, very poorly shaped.

Provenance: Presented by Major General B.R. Mitford.

Label: 'Jade "tiki" from New Zealand worn as a pendant & handed down as a heirloom. Probably … cut unusually translucent jade. A genuine early piece.'

Comments: Early twentieth century (RN); fake (DRS).

296 Plate 72

Pendant, *hei-tiki*

1966 Oc.1.1. Length 6.2 cm.

Anthropomorphic bowenite pendant: light green and completely translucent, head to right, hands on hips, metal ring through hole.

Provenance: Presented by Miss E. Mills.

Register: 'Collected by donor's uncle, William Long, in New Zealand and sent to donor's mother about 1920; said to have belonged to Maori chief.'

Comments: Early twentieth century, poor modelling (RN); reproduction (DRS).

297 Plate 72

Pendant, *hei-tiki*

1968 Oc.2.1. Length 4.2 cm.

Anthropomorphic bowenite pendant: mottled light green, upright head, hands on hips, traces of red sealing wax in eyes, hole; modern.

Provenance: Presented by Miss Rosa Rayner.

Register: 'Given to donor by Mr Daniel Reeve of the New Zealand Expeditionary Force in 1916 or 1917 before he was invalided back to New Zealand after being seriously wounded. It had been given to him by a Maori chief in Taranaki, who told him always to wear it as good-luck talisman.'

Comments: Early twentieth century, very poor modelling (RN); late nineteenth century (DRS).

Pendants, *hei-matau*

298 Plate 73

Pendant, *hei-matau*

1895-733. Length 7 cm.

Partial hook-shaped nephrite pendant: light greyish cloudy nephrite, thin, polished; small old hole.

Provenance: Meinertzhagen Collection.

Register: 'For cutting priest's hair. N. Island.'

Comments: Late eighteenth century (RN); Otago, eighteenth century, anthropomorphic pendant (DRS).

References: Phillipps 1955: 159, fig. 42, right.

299

Pendant, *hei-matau*

1895-735. Length 2.5 cm.

Fish-hook-shaped nephrite pendant: medium green, one barb on each side, notched head, no hole, polished.

Provenance: Meinertzhagen Collection.

Comments: Mid nineteenth century (RN); East Coast, double-barb fish-hook (DRS).

300 Plate 73

Pendant, *hei-matau*

1869.12-5.1. Length 7.8 cm.

Hook-shaped nephrite pendant: deep green (*kawakawa*), hole worn right through, one deep groove cut with old method across base, another on one side; very thick, well shaped.

Provenance: Unknown.

Comments: Late eighteenth/early nineteenth century (RN); eighteenth century (DRS).

This registration number is a mistake. 1869.12-5.1 in bound Register in Department of Prehistory and Europe is a Roman 'leaden seal', as are three other objects in this small collection presented by C. Roach Smith and transferred from Department of Coins; annotation in Register adds: 'Found at Felixstowe Suffolk and given to donor by Mr W.S. Fitch.' It is impossible to establish whether the pendant was part of this collection; if it was, it might have been passed to the ethnographical collections and registered on a Slip with an incorrect object number.

References: Beasley 1928: pl. CLXIV, right; Edge-Partington 1969 I: 375.3.

301 Plate 73

Pendant, *hei-matau*

1944 Oc.2.829. Length 9 cm.

Hook-shaped nephrite pendant: silvery variegated light green, one barb, head with large old hole and well-shaped 'eye' partially drilled. Marked in red near hole: '763'.

Provenance: Beasley Collection.

Comments: Late eighteenth century (RN); Northland, eighteenth century (DRS).

Perhaps it is no. 263 in Beasley catalogue, registered 23 January 1907, 'Hook shaped ornament. 3 ½ × 3 2/8 [inch] of light coloured jade, bored 1 hole, called "Hei-Matau". Bt W. Oldman.'

References: Pole 1998: 129.

302 Plate 73

Pendant, *hei-matau*

1993 Oc.3.82. Length 5.2 cm.

Hook-shaped nephrite pendant: homogenous bluish green (*inanga?*), two barbs, hole, high polish.

Provenance: Collected in the field.

Comments: Purchased at Auckland Museum shop. Contemporary art.

303 Plate 73

Pendant, *hei-matau*

1994 Oc.4.92. Length 7.5 cm.

Hook-shaped nephrite pendant: slightly variegated bluish green (*inanga?*), no barb, hole, thin flat braided black synthetic (?) cord, small nephrite toggle; highly polished.

Provenance: Collected in the field.

Comments: Carved by Clem Mellish of Havelock, Marlborough, for his wife Pimia, and presented by them to the British Museum. Contemporary art.

References: Starzecka 1998: 158.

304

Pendant, *hei-matau*

Q1999 Oc.33. Length 3.3 cm.

Fish-hook-shaped nephrite pendant: medium green, one barb on each side, notched head, no hole, polished.

Provenance: Unknown.

Comments: Mid nineteenth century (RN).

305 Plate 73

Pendant, *hei-matau*

7406. Length 6.3 cm.

Hook-shaped bowenite pendant: mottled medium green, poorly shaped, old hole, low polish.

Provenance: Presented by A.W. Franks, 5 May 1871 (Wright).

Comments: Mid nineteenth century (RN); eighteenth century, nephrite (DRS).

References: Beasley 1928: pl. CLXIV, left.

Pendants, *pekapeka* and *koropepe*

306 Plate 78

Pendant, *pekapeka*

1944 Oc.2.830. Width 5.6 cm.

Horizontal bone pendant of two *manaia* figures back to back in openwork: carved on both sides, rounded, moulded, polished; haliotis-shell eyes on both sides.

Provenance: Beasley Collection.

Comments: Late nineteenth century, probably carved by Jacob Heberley (RN).

Perhaps it is no. 150 in Beasley catalogue, registered 12 September 1905: 'Pendant. Ivory 2 ¼ inch long shaped as a double god having a ball in each mouth & inlaid with four pieces of haliotis shell. From Major Robley's coll. Bt S.Fenton. Cranbourne St. "Peke-Peke".'

307 Colour plate 13

Pendant, *pekapeka*

1934.5-5.7. Width 4.7 cm.

Horizontal nephrite pendant: dark green (*kawakawa*), carved on one side in spare openwork, flat, indication of *manaia* face at each end, perforation by sawing deep; worn, unfinished.

Provenance: Presented by Miss Marion Darby.

Register: 'Collected by donor's father between 1880 and 1882.'

Comments: Mid nineteenth century (RN).

308 Colour plate 13

Pendant, *pekapeka*

1994 Oc.4.102. Width 10.2 cm.

Horizontal nephrite pendant: bright emerald green, slightly mottled on outer sides, openwork butterfly-shaped, very highly polished, convex front, very well-

shaped concave back; very thin braided black synthetic (?) cord, two small nephrite toggles. Plain, wooden, shaped box in two parts to contain it.

Provenance: Collected in the field.

Comments: Carved by Clem Mellish of Havelock, Marlborough. Contemporary art.

References: Starzecka 1996: 153.

309 **Colour plate 13**

Pendant, *pekapeka*

1990 L.1.2/Royal Collection no. 74070. Length 7.3 cm (pendant), 16.5 cm (box)

Nephrite pendant: homogenous medium green, openwork, with symmetrical stylized *koru* motifs, carved and moulded on both sides; white, flax, braided cord and small nephrite toggle. Dark-brown-stained wooden box in two parts to contain it: lid carved as stylized human figure in low-relief with haliotis-shell inlay and brass plaque: 'Presented by Kahungunu Ki Te Wairoa Te Kohanga Reo'; lower half carved inside to receive shaped lid and pendant; on underside in corner carved: 'AEM'.

Provenance: Royal Loan 1990, Her Majesty Queen Elizabeth II.

Comments: Pendant and box carved by Arthur Morten of Christchurch in January 1990 as gift to the Queen from Kohanga Reo Whanau and people of Kahungunu Ki Te Wairoa and presented to Her at Wairoa College on 7 February 1990 by children from local Kohanga Reo, Matiu Manuel and Lady Taumata, both aged 4 (BM AOA correspondence: New Zealand High Commission, 3 April 1990). Contemporary art.

310 **Colour plate 13**

Pendant, *koropepe*

1934.12-5.29. Length 5.6 cm.

Spiral bowenite pendant: medium green, carved on both sides, *manaia* head with perforation for suspension cord as its eye, gills marked, ridged body.

Provenance: Bequeathed by T.B. Clarke Thornhill.

Comments: Late 1890s (RN); nineteenth century, nephrite (DRS).

Pendants, *kuru*

311 **Plate 74**

Pendants, *kuru*

LMS 158 (a-c, e). Lengths: a – 10.5 cm, b – 10.2 cm, c – 6.2 cm, e – 8 cm.

Four straight nephrite pendants with perforations: a – homogenous light medium green, pointed end; b – homogenous medium green, pointed end; c – homogenous medium green, flat, straight end bevelled on both sides; e – mottled bluish green, pointed end.

Provenance: London Missionary Society Collection.

Register: 'Jade stone Ear drops from New Zealand'. Label: '146'.

Comments: Registered under same number as **338** (*kapeu*, LMS 158 (d)).

312

Pendants, *kuru*

LMS 159 (a and b). Lengths: a – 4.5 cm; b – 4.2 cm.

Two straight nephrite pendants with perforations: medium green, chunky, pointed ends.

Provenance: London Missionary Society Collection.

Comments: Tied together with two white shell imitation human-teeth ear ornaments **406**, LMS 159 (c and d).

313 **Plate 74**

Pendant, *kuru*

NZ 162. Length 9 cm.

Straight nephrite pendant: light medium green, slim, pointed end, with two human molars, worn flat, on sinew loop at perforation.

Provenance: Cook Collection.

Register: 'Add. MS 15 508 Pl.23'.

Comments: Eighteenth century.

References: Edge-Partington 1969 I: 370.3; Joppien and Smith 1985: 1.126, 1.127; Kaeppler 1978: 179; Starzecka 1979: fig. 60; Te Awekotuku 1996: 44.

314

Pendant, *kuru*

1733. Length 8.5 cm.

Straight nephrite pendant: mottled bluish green (*inanga*), old worn hole, tapering blunt end.

Provenance: Unknown.

Label: 'Ear ornaments worn by the females of New Zealand.'

315

Pendant, *kuru*

1734. Length 8.5 cm.

Straight nephrite pendant: homogenous dark green, flat, thin, straight end, old hole.

Provenance: Unknown.

Comments: Nineteenth century (DRS).

316 **Plate 74**

Pendant, *kuru*

1735. Length 5.1 cm.

Straight nephrite pendant: mottled light medium green, thick, chunky, pointed end, old hole.

Provenance: Unknown.

Comments: Eighteenth century (DRS).

317

Pendant, *kuru*

1736. Length 8.7 cm.

Straight nephrite pendant: homogenous dark green (*kawakawa*), flat, pointed end, old worn hole, high polish.

Provenance: Unknown.

Comments: Eighteenth century (DRS).

318 **Plate 74**

Pendant, *kuru*

1737. Length 6.6 cm.

Straight nephrite pendant: mottled medium green, chunky, pointed end.

Provenance: Unknown.

Comments: Eighteenth century (DRS).

319

Pendant, *kuru*

1895-705. Length 19 cm.

Straight nephrite pendant: mottled dark green, flattish top with hole, widening and markedly thickening towards blunt end bevelled on one side.

Provenance: Meinertzhagen Collection.

320

Pendant, *kuru*

1895-706. Length 11.8 cm.

Straight nephrite pendant: mottled dark green, flat rectangular cross section, damaged end, old hole.

Provenance: Meinertzhagen Collection.

Comments: Nineteenth century (DRS).

321

Pendant, *kuru*

1895-709. Length 5.5 cm.

Straight nephrite pendant: slightly mottled dark green, rectangular cross section, squared end, hole; chunky, polished.

Provenance: Meinertzhagen Collection.

Comments: Nineteenth century (DRS).

322

Pendant, *kuru*

1895-715. Length 5.3 cm.

Straight nephrite pendant: mottled medium green, flat, thin, one end straight, other slightly rounded with notch on each side; poor quality stone, uneven surface; no hole.

Provenance: Meinertzhagen Collection.

Comments: 'chisel pendant' (DRS).

323

Pendant, *kuru*

1853.2-4.2. Length 32.4 cm.

Straight nephrite pendant: mottled dark green, thick, faceted sides, tapering towards damaged narrow end, old hole.

Provenance: Presented by Captain Stokes, RN, of HMS *Acheron*.

Register: '…to be used as a mat pin & sometimes as a spear point'.

Comments: Nineteenth century (DRS).

324

Pendant, *kuru*.

1854.12-29.18. Length 6.1 cm.

Straight nephrite pendant: homogenous light green, flat, rounded end; green fabric tape through hole.

Provenance: Grey Collection.

Register: 'Kaitangata-No-Wiremu-Poukawa [Kaitangata belonging to Wiremu Poukawa]'.

Comments: Eighteenth century (DRS).

On Thursday, the 22nd of December, 1853, about twenty Chiefs of note, from the District of Waikato, waited on Sir George Grey, for the purpose of presenting a valedictory Address to his Excellency on his approaching departure… It was not only novel, but deeply gratifying to see each Chief, as he concluded his song, presenting to the Governor some venerated heir loom of his family… 'Kai tangata' – An ear-drop, presented by the Chief Reihana Poukawa of the Ngatihaua tribe.

(Davis 1855: 13, 15)

References: Davis 1855: 13–15.

325 **Plate 74**

Pendant, *kuru*

1854.12-29.19. Length 3 cm.

Straight nephrite pendant: light green, slightly chunky, pointed end; black ribbon through hole.

Provenance: Grey Collection.

Register: 'Whatiteri-No-Te-Mokorou [Whatitiri belonging to Te Mokorou]'.

Comments: Eighteenth century (DRS).

Presented to Sir George Grey on the same occasion as **324** (*kuru*, 1854.12-29.18). '"Whatitiri" – An ear-drop, presented by Riwai Te Mokorou, the aged Chief of the Ngatiruru tribe.' (Davis 1855: 15).

References: Davis 1855: 13–15.

326

Pendant, *kuru*

1854.12-29.29. Length 4.5 cm.

Straight nephrite pendant: mottled light green, flat, blunt end, old hole.

Provenance: Grey Collection.

Comments: Nineteenth century (DRS).

327

Pendant, *kuru*

1854.12-29.33. Length 5.2 cm.

Straight nephrite pendant, homogenous light green, pointed end; no hole but on one side trace of incipient drilling.

Provenance: Grey Collection.

328

Pendant, *kuru*

1854.12-29.46. Length 34.8 cm.

Straight nephrite pendant: mottled dark green, faceted side. Tapering towards slightly pointed end; old hole.

Provenance: Grey Collection.

Register: '…used for fastening the cloak & sometimes as a spear point called a "tara"'.

Comments: Nineteenth century (DRS).

References: Edge-Partington 1969 I: 379.2.

329 **Plate 74**

Pendant, *kuru*

1855.5-14.1. Length 5.3 cm.

Straight nephrite pendant: light emerald green, flattish, rounded end; narrow green silk ribbon through hole.

Provenance: Presented by Sir George Grey.

Label: 'A Greenstone called "Kaitangata" or "Man-eater", a very old heir-loom indeed. It was first the property of Te Ngahue a chief who came from Hawaiki, one of the Polynesian Islands, in his canoe, and having discovered the New Zealand Islands, visited Te Waipounamu or Middle Island, where he procured this Jasper stone, which he called Kaitangata. Te Ngahue then disembarked in Cook's Strait, and having sent on his canoe with his people, he walked overland to Tauranga where he met them. At Tauranga he met with a very large Moa which he killed near to a rivulet called Wairere. The Moa bones he took back in his canoe to Hawaiki as also the piece of Jasper called Kaitangata. Te Ngahue never returned to New Zealand, but his people hearing of the fame thereof embarked in two canoes called Tainui and Te Arawa, and brought back with them here the Greenstone. From them as the ancestors of the Ngatitoa tribe, it has descended through several generation'.

Comments: Early nineteenth century (RN); eighteenth century (DRS).

Gentlemen, When I transmitted, for the purpose of being deposited in the National Collections, a number of Heir-looms, which had been presented to me by various Chiefs in New Zealand, a part of my baggage was not unpacked. I have now found the enclosed jasper ear-ring drop, which is one of the oldest heirlooms of New Zealand, and which was presented to me by the Chief of Njateraukawn [Ngati Raukawa], and Ujabiton [Ngati Toa?] tribes. I should therefore feel much obliged to you if you would allow it to be added to the collection which I have already placed in the British Museum. The history of this ear drop is attached to it [see label above].

(BM AOA Christy correspondence: G. Grey, 28 March 1855).

References: Fletcher 1913: 228–9; Smith 1913: 167.

330

Pendant, *kuru*

1930.12-13.2. Length 10.3 cm.

Straight nephrite pendant: mottled dark green, circular cross section, slightly tapering towards blunt end, hole.

Provenance: Presented by James Bertram (executor James Hilton bequest).

Comments: Nineteenth century (DRS).

331

Pendant, *kuru*

1930.12-13.3. Length 12.6 cm.

Straight nephrite pendant: homogenous dark green, narrow, slightly flattened, widening towards straight-cut end, hole.

Provenance: Presented by James Bertram (executor James Hilton bequest).

Comments: Nineteenth century (DRS).

332

Pendant, *kuru*

1930.12-13.4. Length 5.2 cm.

Straight nephrite pendant: homogenous medium green, flat, broad, thin, widening slightly towards rounded wide end, worn hole.

Provenance: Presented by James Bertram (executor James Hilton bequest).

Comments: Bowenite (DRS).

333

Pendant, *kuru*

1934.12-5.18. Length 5.6 cm.

Straight nephrite pendant: black-speckled medium green, thick, flat, widening slightly towards rounded end, hole.

Provenance: Bequeathed by T.B. Clarke Thornhill.

Comments: Nineteenth century (DRS).

334

Pendant, *kuru*

1945 OC.5.3. Length 4.3 cm.

Straight nephrite pendant: homogenous dark green, flat oblong, widening towards blunt end; no hole.

Provenance: Bequeathed by Oscar Raphael.

Comments: Watch fob (DRS).

335 **Plate 74**

Pendant, *kuru*

TRH 3/1902 L.I.3/Royal Collection no. 69963. Length 8.5 cm.

Straight bowenite pendant: mottled medium green, rounded, pointed end; large old hole.

Provenance: Royal Loan 1902, Prince and Princess of Wales.

Register: 'Old work'.

References: Imperial Institute 1902: 46.274.

336

Pendant, *kuru*

1895-703. Length 5.4 cm.

Straight bowenite pendant: mottled medium green, flat, thin, widening towards wide rounded end; hole.

Provenance: Meinertzhagen Collection.

Comments: Nineteenth century (DRS).

337

Pendant, *kuru*

1895-651. Length 8.1 cm.

Straight slate pendant: flat on one side, convex and rough on other, hole, straight-cut end.

Provenance: Meinertzhagen Collection.

Comments: Minnow shank, unfinished (DRS).

Pendants, *kapeu*

338 **Plate 75**

Pendant, *kapeu*

LMS 158 (d). Length 11 cm.

Curved nephrite pendant: variegated silvery light green, old hole.

Provenance: London Missionary Society Collection.

Comments: Registered under same number as **311** (*kuru*, LMS 158 a–c, e).

339 **Plate 75**

Pendant, *kapeu*

NZ 158B. Length 8.7 cm.

Curved nephrite pendant: homogenous light green, with bead of lighter emerald-green nephrite on twisted-flax string through large old hole.

Provenance: Unknown.

Register: 'This specimen & the parrot ring NZ 158A [**441**], were originally attached to the tiki NZ 158 [**257**]. July 1849.'

Comments: Eighteenth century (DRS).

340 **Plate 75**

Pendant, *kapeu*

TRH 1/1902 L.I.1/Royal Collection no. 69961. Length 13.7 cm.

Curved nephrite pendant: mottled light green, hole almost worn through.

Provenance: Royal Loan, Prince and Princess of Wales 1902.

Register: 'Old work.'

References: Imperial Institute 1902: 46.274; Te Awekotuku 1996: 44.

341 **Plate 75**

Pendant, *kapeu*

1728. Length 9 cm.

Curved nephrite pendant: mottled dark and medium green, convex on both sides, old hole.

Provenance: Unknown.

Comments: Nineteenth century (DRS).

342

Pendant, *kapeu*

1729. Length 7.1 cm.

Curved nephrite pendant: homogenous medium green, old hole, worn.

Provenance: Unknown.

Comments: Eighteenth century (DRS).

343

Pendant, *kapeu*

+3489. Length 15.4 cm.

Curved nephrite pendant: mottled dark green with black specks, hole.

Provenance: Presented by A.W. Franks 21 July 1887 (W.T. Ready).

Comments: Nineteenth century (DRS).

References: Edge-Partington 1969 I: 370.2.

344

Pendant, *kapeu*

1896-1018. Length 6.4 cm.

Curved nephrite pendant: mottled dark green, hole.

Provenance: Presented by A.W. Franks, 18 August 1896.

Comments: Nineteenth century (DRS).

345

Pendant, *kapeu*

1878.11-1.615. Length 5 cm.

Curved nephrite pendant: translucent mottled silvery light green, old hole at top broken off, another drilled below.

Provenance: Meyrick Collection.

Comments: Eighteenth century (DRS).

346

Pendant, *kapeu*

1934.12-5.19. Length 5.1 cm.

Curved nephrite pendant: translucent homogenous medium green, old hole at top broken off, another drilled below.

Provenance: Bequeathed by T.B. Clarke Thornhill.

Comments: Eighteenth century (DRS).

347 Plate 75

Pendant, *kapeu*

1951 oc.8.1. Length 15.5 cm.

Curved nephrite pendant: mottled dark green, old hole.

Provenance: Purchased from Town Clerk, Bideford, Devon.

Register: 'Ear pendant, called Tau Tau, of unusual length. (Oldman Collection longest was 7 3/4in).'

Other nephrite and bowenite pendants

348

Pendant

TRH 18/1902 L.I.18/Royal Collection no. 69978p.

Length 9.7 cm.

Roughly rectangular nephrite pendant: poor quality stone, flat, ground, hole for suspension.

Provenance: Royal Loan 1902, Prince and Princess of Wales.

349 Plate 76

Pendant

1895-710. Length 6.8 cm.

Nephrite pendant: translucent light green, in form of bird spear-point with one barb and notched on opposite side at proximal edge; old hole in point for suspension.

Provenance: Meinertzhagen Collection.

Comments: Early nineteenth century (RN); eighteenth century, fish-hook pendant (DRS).

350 Plate 76

Pendant/cloak pin, *aurei*

1854.12-29.47. Length 10.5 cm.

Nephrite pendant: light bluish green (*inanga*), curved, sharply pointed.

Provenance: Grey Collection.

Comments: Eighteenth century.

351 Plate 76

Pendant

1920.3-17.2. Length 14.1 cm.

Nephrite sculptural form pendant: bluish green (almost *inanga*), oblong upper part, wider bifurcated lower end with notching

on outer edge at top and bottom, grooved and polished to shape; braided loop of flax through hole at narrow top.

Provenance: Bequeathed by Thomas Boynton (Honorary Curator of Yorkshire Philosophical Society Museum).

Register: 'worn as a charm'.

Comments: Late eighteenth century, very old and beautiful (RN); eighteenth century, anthropomorphic pendant (DRS).

References: Hooper 2006: 135.76; Phillipps 1955: 159, fig. 42, left.

352 Plate 76

Pendant/flax scraper, *haro muka*

1944 oc.2.828. Width 6 cm.

Semicircular nephrite pendant: translucent light green, thin, polished, sharp edges, small hole with fine braided-flax loop for suspension.

Provenance: Beasley Collection.

Comments: Early nineteenth century (RN); pendant, bowenite (DRS).

Perhaps it is no. 592 in Beasley catalogue, registered 22 September 1911, 'Greenstone knife, having a plaited loop & used for cutting the hair of distinguished persons, taken from a Mokoed Head in the Robley Collection. Bt W. Oldman.'

353 Plate 76

Pendant

Q1981 oc.1378. Length 15 cm (including cord).

Shaped nephrite pendant: dark green (*kawakawa*), four irregular projecting corners, polished; old hole in smaller fifth projection with brown-and-white braided-flax cord with five human teeth, drilled and strung on fine braided loop over main cord.

Provenance: Unknown.

Comments: Eighteenth century; anthropomorphic pendant (DRS).

References: Phillipps 1955: 159, fig. 42, centre.

354

Pendant

1895-704. Length 6.8 cm.

Nephrite pebble pendant: mottled medium green, roughly elliptical with wider lower end, flat, thin, hole at other end.

Provenance: Meinertzhagen Collection.

Comments: Late nineteenth century (RN).

355

Pendant

1854.12-29.17. Length 5.3 cm.

Nephrite pebble pendant: emerald green, flattish, rounded oblong, longitudinal groove on one side, old hole with black-ribbon suspension cord.

Provenance: Grey Collection.

Register: 'Tuohu No-Ta-Kerei [Tuohu belonging to Te Kerei]'.

Comments: Nineteenth century, *kuru* (DRS).

Presented to Sir George Grey on the same occasion as **324** (*kuru* 1854.12-29-18). '"Tuohungia" – An ear-drop presented by Ta Kerei Te Rau, a Chief of great rank and influence.' (Davis 1855: 15).

References: Davis 1855: 13–15.

356

Pendant

1854.12-29.30. Length 3.4 cm.

Nephrite pebble pendant: medium green, rounded-triangular shape, flat on one side, convex at wider end on other; hole at narrow end.

Provenance: Grey Collection.

Comments: Nineteenth century, *kuru* (DRS).

357

Pendant

1854.12-29.31. Length 4.7 cm.

Nephrite pebble pendant: bluish green, shaped flat, wider lower end, hole at narrow end.

Provenance: Grey Collection.

References: Edge-Partington 1969 I: 370.4.

358

Pendant

1854.12-29.32. Length 5 cm.

Nephrite pebble pendant: mottled medium green, wide-ended oval, very thin, flat.

Provenance: Grey Collection.

Comments: *Kuru* (bowenite) (DRS).

359

Pendant

1854.12-29.34. Length 3.2 cm.

Nephrite pebble pendant: homogenous medium green, flat, rounded end, old hole.

Provenance: Grey Collection.

Comments: Nineteenth century, *kuru* (DRS).

360

Pendant

1854.12-29.35. Length 3.5 cm.

Nephrite pebble pendant: homogenous medium green, flat, rounded oblong, old hole.

Provenance: Grey Collection.

Comments: Nineteenth century, *kuru* (DRS).

361

Pendant

1854.12-29.36. Length 2.8 cm.

Nephrite pebble pendant: mottled light green, roughly triangular, flat. Old hole at narrow end.

Provenance: Grey Collection.

Comments: *Kuru* (DRS).

362

Pendant

1854.12-29.39. Length 5 cm.

Nephrite pebble pendant: homogenous beige grey, smooth, irregularly shaped, elongated, with beginning of hole drilled at one end.

Provenance: Grey Collection.

363

Pendant

1854.12-29.41. Length 4.6 cm.

Nephrite pebble: mottled medium green, flattened, ovoid, no hole.

Provenance: Grey Collection.

Register: '...probably an ear ornament in process of manufacture'.

364

Pendant, *hei-pounamu*

1895-649. Length 6.5 cm.

Adze-form nephrite pendant: mottled medium green, thin, poor quality stone,

roughly shaped; suspension hole broken out and new one started.

Provenance: Meinertzhagen Collection.
Comments: Later nineteenth century (RN).

365 Plate 76

Pendant, *hei-pounamu*
1895-656. Length 7 cm.

Adze-form nephrite pendant: black, thin, polished, old hole; diagonal crack or fault in stone.

Provenance: Meinertzhagen Collection.
Comments: Early nineteenth century (RN); eighteenth-century nephrite, burnt black (DRS).

Probably collected in Hawke's Bay area in January 1869:

> Fritz, his wife & I walked up to Monaghan's …
> On our way back we looked for curiosities at a
> place where there had been a great massacre
> & cannibal feast. I picked up rather a good jaw-
> bone & Fritz found an ear-ring of black jade.
> (Campbell: 31 January 1869).

References: Edge-Partington 1969 II.2: 199.6.

366

Pendant, *hei-pounamu*
1895-707. Length 8.1 cm.

Adze-form nephrite pendant, homogenous medium green, rectangular cross section, thick, slightly widening towards straight cut end very slightly bevelled on both sides; hole at narrower end.

Provenance: Meinertzhagen Collection.
Comments: Northland, late nineteenth century (RN).

367 Plate 76

Pendant, *hei-pounamu*
1895-708. Length 7.5 cm.

Adze-form nephrite pendant: mottled dark and medium green, rectangular cross section, flat, thin, widening towards straight end bevelled on both sides; hole at narrower end.

Provenance: Meinertzhagen Collection.
Comments: Northland (RN).

368

Pendant, *hei-pounamu*
1895-770. Length 5.2 cm.

Adze-form nephrite pendant: mottled medium green, poor quality stone. Very rough on one side; small hole.

Provenance: Meinertzhagen Collection.

369

Pendant
1854.12-29.42. Length 6.7 cm.

Bowenite pebble: mottled medium green, flat, ovoid; no hole.

Provenance: Grey Collection.
Register: '…to form an earring'.

370 Plate 76

Pendant, *whakakaipiko*
1912.5-24.21. Length 8.3 cm.

Bowenite kinked pendant: mottled medium green, flat, polished, poorly shaped, faults in stone; small hole. Marked in red ink: 'M.B.'

Provenance: Robertson/White Collection.
Comments: Late nineteenth century (RN).

Cloak pins, *aurei*

371

Cloak pin, *aurei*
NZ 160. Length 14 cm.

Whale-tooth pin: narrow, hole with remains of thick two-ply twisted-fibre string.

Provenance: Unknown.
Comments: Early, good (RN).

372

Cloak pin, *aurei*
1730. Length 13 cm.

Whale-tooth pin: curved, hole; writing on object illegible.

Provenance: Unknown.
Label: 'New Zealand. Curved pin for fastening a cloak called "Aurei" BM.'
Comments: Early, good (RN).

373

Cloak pin, *aurei*
1731. Length 11.5 cm.

Whale-tooth curved pin: hole with loop of thin silk cord.

Provenance: Unknown.
Comments: Early, good (RN).

374

Cloak pin, *aurei*
1732. Length 11.5 cm.

Whale-tooth pin: curved, hole.

Provenance: Unknown.
Register: '"Ear ornament worn by the female of New Zealand" tied up along with 1733–4–5' (*kuru* pendants **314–16**).
Comments: Early, good (RN).

375

Cloak pin, *aurei*
1738. Length 10.5 cm.

Whale-tooth pin: slim, sharply pointed, hole with remnants of twisted-flax string, now mostly unravelled.

Provenance: Unknown.
Comments: Early, good (RN).

376

Cloak pin, *aurei*
6869. Length 8.7 cm.

Whale-tooth pin: very thin, strongly curved, hole.

Provenance: Purchased from Wareham, 31 January 1870.
Comments: Early, good (RN).

377 Plate 77

Cloak pins, *aurei*
7987. Length 9.5 cm.

Four pig-tusk pins: narrow, curved, on twisted, brown-fibre string.

Provenance: Presented by A.W. Franks.
References: Edge-Partington 1969 I: 370.5; Te Awekotuku 1996: 44.

378

Cloak pin, *aurei*
9073c. Length 13 cm.

Whale-tooth pin: thick, slightly curved, hole, blunt point.

Provenance: Presented by John Davidson, 27 June 1872.
Comments: Early, good (RN).

379 Plate 77

Cloak pin, *aurei*
+1417. Length 13.5 cm.

Whale-tooth pin: thick, slightly curved, blunt end, hole, above which traces of

another, older, broken off. Marked in ink: 'Maori ear-ornament'.

Provenance: Presented by A.W. Franks, January 1881 (Geo. S. Perceval).
Comments: Early, good (RN).

380

Cloak pin, *aurei*
1895-529. Length 11.3 cm.

Three bone pins: two very thin, one thicker, holes, on twisted, grey-fibre string; poorly shaped.

Provenance: Meinertzhagen Collection.

381

Cloak pin, *aurei*
1895-530. Length 10.8 cm.

Pig-tusk pin: thin, strongly curved, modern hole.

Provenance: Meinertzhagen Collection.

382

Cloak pin, *aurei*
1895-536. Length 9 cm.

Pig-tusk pin or needle, very thin, curved, hole.

Provenance: Meinertzhagen Collection.

383 Plate 77

Cloak pin, *aurei*
1896-931. Length 12.5 cm.

Whale-tooth pin: slightly curved, enlarged flat area around hole, leather thong.

Provenance: Presented by A.W. Franks, 14 August 1896.
Comments: Unique, old worn patina (RN).
Given by Ngapuhi chief Titore to Captain F W Sadler of HMS *Buffalo* in 1833-4; Franks obtained it from Captain Sadler's daughter. See Register entry for **271** (*hei-tiki* 1896-925).

384

Cloak pin, *aurei*
1854.12-29.48. Length 18.5 cm.

Whale-tooth pin: very thick, heavy, slightly curved.

Provenance: Grey Collection.
Comments: Early, good (RN).
References: Edge-Partington 1969 I: 370.6?

385 Plate 77

Cloak pin, *aurei*
1854.12-29.49. Length 18 cm.

Whale-tooth pin: thick, slim point, hole.
Provenance: Grey Collection.
Comments: Early, good (RN).

386

Cloak pin, *aurei*
1854.12-29.50. Length 14.2 cm.

Whale-tooth pin: thick, slightly curved, hole.
Provenance: Grey Collection.
Comments: Early, good (RN).

387

Cloak pin, *aurei*
1954 oc.6.298. Length 15.4 cm.

Bone pin or needle: very slightly curved, sharp point, hole broken off.
Provenance: Wellcome Collection.
Wellcome Museum no. 48958.

388

Cloak pin, *aurei*
1954 oc.6.299. Length 14.7 cm.

Bone pin or needle: flat, very slightly curved, sharp point, hole.
Provenance: Wellcome Collection.
Wellcome Museum no. 48959.

389 Plate 77

Cloak pin, *aurei*

Q1981 Oc.1354. Length 8.3 cm.

Whale-tooth pin: thick, strongly curved, wider and thicker at blunt point, hole.

 Provenance: Ex Sparrow Simpson Collection via A.W. Franks.

 Label: 'C.C. 9366A. 3.3.1875.; [reverse] New Zealand. Pendant of boar's tusk. W.S. Simpson Colln. A.W. Franks 3.3.75.'

 Comments: Early, good (RN).

 There is no number 9366A in Registers.

390

Cloak pin, *aurei*

Q1981 Oc.1355. Length 9.5 cm.

Whale-tooth/pig tusk (?) pin: curved, point broken off, hole.

 Provenance: Ex Duplicate Collection; Sparrow Simpson Collection via A.W. Franks.

 Register: 'NZ Dup[licates] AF.WSS. 9366B.'

 Comments: Initials stand for Augustus Franks and William Sparrow Simpson; there is no number 9366B in Registers.

391

Cloak pin, *aurei*

Q1981 Oc.1356. Length 5.8 cm.

Whale-tooth pin: thick, chunky, slightly curved, hole.

 Provenance: Ex Duplicate Collection; Sparrow Simpson Collection via A.W. Franks.

 Label: 'Dup[licates]. 9366C AF WSS.'

 Comments: Early, good (RN).

 Initials stand for Augustus Franks and William Sparrow Simpson; there is no number 9366C in Registers.

392 Plate 77

Cloak pin, *aurei*

Q1981 Oc.1357. Length 6 cm.

Whale-tooth pin: very thick, chunky, curved, hole; longitudinal split all along concave side.

 Provenance: Ex Duplicate Collection; A.W. Franks.

 Label: 'Dup AF [Augustus Franks] ?local Bateman'.

393

Cloak pin, *aurei*

Q1981 Oc.1358. Length 11 cm.

Whale-tooth pin: very thin, slim, curved, sharp point, hole.

 Provenance: Unknown.

 Comments: Early, good (RN).

Miscellaneous pendants

394 Plate 78

Whale-tooth pendant

+4761. Length 6 cm.

In form of squatting human figure, naturalistic, polished; hands on chest, suspension lug in back of shoulders, slightly concave back, opening between legs.

 Provenance: Presented by Charles H. Read, 17 October 1890 (R. H. Soden Smith).

 Comments: Maori proportions and figure stance, perhaps inspired by whaler's work – not typical type of Maori work, old, early (RN).

 References: Edge-Partington 1969 I: 378.5.

395 Plate 78

Whalebone pendant

1994 Oc.4.82. Length 11.5 cm.

In form of whale, highly stylized, openwork carving, flattish; fine white string lashing around whale's tail.

 Provenance: Collected in the field.

 Comments: Carved by Jonathan Mohi Moke of Ruatoria, East Coast, and named by him 'Paikea [whale]'. Contemporary art.

 References: Starzecka 1996: 153.

396 Plate 78

Cow-bone pendant

1994 Oc.4.83. Length 10.5 cm.

In form of *manaia* figure in profile, openwork, narrow, highly polished; three-fingered hand on stomach, smaller *manaia* at feet; haliotis-shell eyes.

 Provenance: Collected in the field.

 Comments: Carved by Jonathan Mohi Moke of Ruatoria, East Coast. Contemporary art.

397

Steatite pendant

1854.12-29.37. Length 4.2 cm.

Elongated oval, slightly flattened, polished; large hole at one end broken.

 Provenance: Grey Collection.

 Comments: Ear pendant (soapstone) (DRS).

398

Steatite pendant

1854.12-29.38. Length 4.8 cm.

Bullet-shaped; polished; old-style hole.

 Provenance: Grey Collection.

 Comments: Ear pendant (agate) (DRS).

399

Stone pendant

1954.Oc.6.304. Length 7 cm.

Reddish brown, flat, rounded oblong, two holes at narrower end; several transverse straight and curved lines incised on one side.

 Provenance: Wellcome Collection. Wellcome Museum no. 2490.

 Label: 'R-AZ'.

 Comments: Pebble (DRS).

400

Archaic pendant fragment

1895-621. Length 3 cm.

Broken top and bottom, old drill holes on either side at top, edges notched. Black argillite with light fawn rind (decomposition zone) on old external surfaces. Front keel with curve at top, notched.

 Provenance: Meinertzhagen Collection.

401

Archaic pendant fragment

1895-749. Length 5 cm.

Dark grey (Nelson argillite?) flattish stone fragment, notched along one side, small notched projection on opposite side; flattish sides rough and irregular.

 Provenance: Meinertzhagen Collection.

402

Archaic reel unit/neck ornament

1944 Oc.2.868. Length 9 cm.

Unfinished. Black stone (argillite?) cylindrical pendant with three ridges and corresponding grooves; conical hole about quarter of length of pendant drilled at one end, other end flat.

 Provenance: Beasley Collection. Beasley no. 2947.

 Label: 'Greenstone paddle ornament. Unfinished & hurt by fire. Ancient Maori [illegible initials]'.

 Comments: Beasley catalogue: 2947, registered 12 November 1931, annotated 'Watu-tuara, Vertibrae stones.'

403

Haliotis-shell pendant

NZ 161. Length 4.8 cm.

Rough, irregular oval; hole at one narrow end with traces of thin two-ply twisted-fibre suspension string.

 Provenance: Unknown.

Ear pendants, *mau taringa*

404 Plate 79

Ear pendant, *niho*

4294. Length 4.5 cm.

Nine human teeth: drilled at root end, highly polished, strung on wrapped-fibre ring (broken) with half hitching.

 Provenance: Presented by A.W. Franks 1867.

 Register: 'New Hebrides? Similar in Louvre brought by Cpt. Dillon from Vanikolo.'

 References: Edge-Partington 1969 II.1: 238.9; Skinner 1916: 80, top left.

405 Plate 79

Ear pendant, *niho*

4295. Length 3.5 cm.

Eight human teeth: drilled at root end, crowns ground down, strung on wrapped-fibre ring with half hitching.

 Provenance: Presented by A.W. Franks, 1867.

 Register: 'New Hebrides'.

 References: Skinner 1916: 80, top right.

406

Ear pendant, *niho kakere?*

LMS 159 (c and d).

Lengths: c – 3.4 cm, d – 3.1 cm

Two white shell imitation human teeth (?): conical, perforation at narrow end.

 Provenance: London Missionary Society Collection.

 Comments: Tied together with **312** (two nephrite *kuru* pendants, LMS 159 (a and b)).

407 Plate 79

Ear pendant, *niho kakere*

4296. Length 6 cm.

Four flat white shell imitation human teeth: drilled at narrow ends, strung on wrapped-fibre ring with half hitching.

 Provenance: Presented by A.W. Franks 1867.

 References: Edge-Partington 1969 II.1: 238.10; Skinner 1916: 80, bottom left.

408

Ear pendant, *niho kakere?*

1895-572. Length 5 cm.

White shell imitation human tooth (?): conical, narrow end broken off.

 Provenance: Meinertzhagen Collection.

409

Ear pendant, *niho kakere?*

1895-573. Length 4.5 cm.

White shell imitation human tooth (?): conical, hole at narrow end broken off.

 Provenance: Meinertzhagen Collection.

410 Plate 79

Ear pendant, *niho kakere*

Q1981 Oc.1361. Length 4.3 cm.

Four flat white shell imitation human teeth: drilled at narrow ends, strung on wrapped-fibre ring with half hitching.

 Provenance: Unknown.

 References: Skinner 1916: 80, bottom right.

411 Plate 79

Ear pendant, *mako*

5052. Length 3.2 cm.

Shark tooth: root end covered with red sealing wax, hole.

 Provenance: Ex Haslar Hospital.

 Register: 'Haslar; J.M. Hamilton, Surg. RN'.

 Comments: Good (RN).

 References: Edge-Partington 1969 I: 370.7.

412

Ear pendant, *mako*

1934.12-5.21. Length 3.4 cm.

Shark tooth: root end covered with red sealing wax (one projection broken and repaired), hole.

 Provenance: Bequeathed by T.B. Clarke Thornhill.

413 Plate 79

Ear pendant, *mako*

1944 Oc.2.831. Length 5.3 cm.

Bone imitation shark tooth: hole.

 Provenance: Beasley Collection. Beasley no. 2443.

 Comments: Beasley catalogue: 2443, registered 1 October 1929: 'An imitation shark's tooth pendant carved from whalebone. Mako Mango. Bought Stevens Rooms. Lot 148.'

414 Plate 79

Ear pendant, *mako*

1854.12-29.40. Length 4 cm.

Steatite imitation shark tooth: hole.

 Provenance: Grey Collection.

 Comments: Soapstone *mako* tooth (DRS).

 References: Edge-Partington 1969 I:378.6?

415

Ear pendant

1895-615. Length 4 cm.

Perforated dog tooth.

 Provenance: Meinertzhagen Collection.

416

Pair of earrings

1994 Oc.4.80. Length 8 cm.

Made in *taniko* style of black-and-white acrylic yarn; cylindrical, with terminal tassels and wire hooks for suspension.

 Provenance: Collected in the field.

 Comments: Made by Mrs Wahine Mackey of Ruatoria, East Coast. Contemporary art.

Necklaces

417 Plate 80

Necklace

Q1981 Oc.1359. Length 26.8 cm.

Made of 25 human teeth, drilled at root ends and strung on thick five-strand braid of flax-fibre; molars not ground flat.

 Provenance: Unknown.

 References: Edge-Partington 1969 II.I: 238.8; Skinner 1916: 80, centre.

418 Plate 80

Necklace

1895-156. Length 37 cm.

Made of ten (probably fossil) shark teeth, each tooth drilled twice, strung on commercial string not original (RN); tightly rolled three-ply string of (probably) flax fibre (MP); one tooth with drill holes worn through and replaced by new pair.

 Provenance: Presented by A.W. Franks, 3 June 1895 (Sparrow Simpson).

419

Necklace segment

1895-610. Length 3 cm.

Shark tooth: drilled twice.

 Provenance: Meinertzhagen Collection.

420

Necklace segment

1895-611. Length 3.5 cm.

Shark tooth: three drill holes broken off.

 Provenance: Meinertzhagen Collection.

421

Necklace segment

1895-612. Length 3.3 cm.

Shark tooth: indication of drill holes at broken-off wide end.

 Provenance: Meinertzhagen Collection.

422

Necklace segment?

1895-613. Length 3.1 cm.

Shark tooth, its wide end broken off.

 Provenance: Meinertzhagen Collection.

423 Plate 80

Necklace

Q1981 Oc.1362. Length 84 cm.

Three haliotis-shell discs with notched edges, each with two drill holes, attached to flax-fibre braided cord.

 Provenance: Unknown.

 Label: 'New Zealand? No history or particulars. See Sydney Parkinson's Journal, 1773, p. 129, pl. 26, fig. 1.'

 Comments: Very good and interesting, similar object is illustrated in Parkinson's Journal (RN); total length too long and spacing incorrect for necklace, perhaps a waist ornament (MP).

 References: Edge-Partington 1969 II.I: 223.3.

Toggles, *poro toroa*; brooch

424

Toggle, *poro toroa*

1895-566. Length 6.1 cm.

Albatross bone: plain, one hole in centre of one side.

 Provenance: Meinertzhagen Collection.

425

Toggle, *poro toroa*

1854.12-29.44. Length 6 cm.

Albatross bone: plain, one hole in centre of one side.

 Provenance: Grey Collection.

 Register: 'Toggle of bird's bone; "Button" of pigs bone.'

426

Toggle, *poro toroa*

1854.12-29.45. Length 6.4 cm.

Albatross bone: incised with cross-hatched decoration; one large and one small hole in one flat side.

 Provenance: Grey Collection.

427

Brooch

1994 Oc.4.81. Length 5 cm.

Three miniature flax-leaf plaited baskets on flax-leaf strip, attached to metal safety pin.

 Provenance: Collected in the field

 Comments: Made by Mrs Wahine Mackey of Ruatoria, West Coast. Contemporary art.

Combs, *heru*

428 Plate 81

Comb, *heru*

+3448. Length 13 cm.

Wooden comb: rectangular, of 18 separate tines, two external ones wider, with vegetable-fibre decorative-patterned lashing on its upper half.

 Provenance: Presented by A.W. Franks, 2 May 1887 (Miss Leigh).

 Register: 'Combs are made of Kaikatoa & Roweto wood. Heru ngapara.'

 References: Edge-Partington 1969 I: 390.2.

429 Plate 81

Comb, *heru*

1895-426. Length 9 cm.

Wooden comb: rectangular, of 10 separate tines, two external ones with projections at upper end carved as stylized human heads in profile, with coarse vegetable-fibre lashing on its upper one-third.

 Provenance: Meinertzhagen Collection.

430 Plate 81

Comb, *heru*

1895-427. Length 12.3 cm.

Wooden comb: rectangular, of 12 separate tines, two external ones wider, with fine vegetable-fibre decorative-patterned lashing on its upper half, stained with red ochre.

 Provenance: Meinertzhagen Collection.

 Register: '[On a piece of paper in which this comb was wrapped is written: "Native comb, heru, made by the Schief Te Kanni Te Kirau of Uwama or Tologoa Bay in 1839 and presented to me. F.W.C. Sturm"].'

 Comments: Very fine, early (RN).

 Register information has been misattributed and refers in fact to **434** (whalebone comb, +6159). Name is Te Kani-a-Takirau of Uawa or Tolaga Bay.

431 Plate 81

Comb, *heru*

1944 Oc.2.812. Length 14 cm.

Wooden comb: roughly rectangular, but widening in centre, of 19 separate tines, two external ones wider and with incurving projections at upper end, with vegetable-fibre decorative-patterned lashing on its upper half.

 Provenance: Beasley Collection. Beasley no. 791.

 Comments: Ruatahuna (DRS).

 Beasley catalogue: 791, registered 22 September 1913, 'Native name "Heru". Bt. W. Oldman, Hamilton House, Brixton.'

432 Plate 81

Comb, *heru*

1944 Oc.2.813. Length 17.5 cm.

Wooden comb: very narrow fan shape, of 12 separate tines, two external ones much thicker and wider, all tines projecting irregularly above vegetable-fibre

decorative-patterned lashing. Marked in white ink: 'D.26.264 Ruatahunga [Ruatahuna], Urewera Country'.

Provenance: Beasley Collection. Beasley no. 2000.

Comments: Beasley catalogue: 2000, registered 21 April 1927, 'Heru. Unfinished & rough work. Locality: Ruatahunga, Urewera Country. Exchanged with the Otago Museum.'

433 Plate 81
Comb, *heru iwi/paraoa*
NZ 163. Length 33 cm.

Whalebone comb: 11 tines, rounded top and one rounded lower lobe, plain, very slightly convexo-concave.

Provenance: Cook Collection.

Torn stuck-on label, handwritten: '... ornaments w... of New Zeala...'.

Register: 'Cook Coll. See Add. MS 15,508. Plate 21 [incorrect: comb depicted there is not NZ 163].'

Comments: Eighteenth century; North Island (DRS).

References: Edge-Partington 1969 I: 390.1; Kaeppler 1978:180; Starzecka 1979: fig. 59.

434 Plate 81
Comb, *heru iwi/paraoa*
+6159. Length 22.6 cm.

Whalebone comb: 8 tines, rounded top, flat, one side-edge with openwork *rauponga manaia* in centre. Inscribed in pencil: 'Made by Te Kanni Te Kirau [Te Kani-a-Takirau] of Uwama [Uawa], or Tologoa [Tolaga] Bay in 1893 & presented to F.W.C. Sturm.'

Provenance: Presented by A.W. Franks, 29 June 1893 (Bateman Coll.).

References: Edge-Partington 1969 II.1: 223.1.

435 Plate 81
Comb, *heru iwi/paraoa*
1933.11-25.2. Length 15.3 cm.

Whalebone comb: 4 tines of original 6 remaining, upper half deeply carved as stylized human face on slightly convex front; back flat.

Provenance: Purchased from V. Salt.
Comments: Whanganui? (RN).

He [Mr V. Salt] vouches for its having been collected (as well as that comb) about the middle of the 19th century & I feel pretty sure it is all right, and worth getting as an unusual type. It was formerly in the collection of Lady Palmer, of Wanlip Hall, Leicester.
(BM AOA correspondence: T.A. Joyce, 27 January 1934).

436
Comb, *heru iwi/paraoa*
1944 OC.2.857. Length 17.5 cm.

Whalebone comb: slightly convexo-concave, rounded top, with small *manaia* head on one side; multiple tines all broken off but preserved; extremely fragile. Convex side entirely covered with peeling layer of black substance. Back marked in black ink: 'D.26.265'.

Provenance: Beasley Collection. Beasley no. 1999.

Comments: Beasley catalogue: 1999, registered 21 April 1927, 'A whalebone comb "Heru" from a grave and fragmentary in parts. Locality: Waikonati [Waikouaiti],

Otago, S. Island. Exchanged with the Otago Museum.'

437
Comb, *heru*
NZ 164. Length 16.5 cm.

Horn comb: 5 tines, thin, flat, transparent, rounded top with rounded lower lobe on one side.

Provenance: Unknown.

438 Plate 81
Comb, *heru*
NZ 165. Length 16.9 cm.

Horn comb: 7 tines, thin, flat, transparent, rounded top with rounded lower lobe on one side.

Provenance: Unknown.

Parrot rings, *kaka poria*, and feather ornaments

439 Plate 78
Parrot ring, *kaka poria*
1934.12-5.15. Length 4.5 cm.

Bone ring with two three-pronged projections on one side and larger projection with hole and serrated edge on other.

Provenance: Bequeathed by T.B. Clarke Thornhill.

Comments: Poorly shaped (RN).

440 Plate 78
Parrot ring, *kaka poria*
1950 OC.4.11. Length 3.2 cm.

Bone ring with four equidistant three-pronged projections, one slightly larger with hole; old patina.

Provenance: Purchased from Mrs D.K. Oldman.

Label: 'Poria for leg of taki kaka or Decoy bird (Parrot)'; reverse: '85'.

Comments: Standard type but well shaped, 1870s (?) (RN).

441 Colour plate 13
Parrot ring, *kaka poria*
NZ 158A. Length 4 cm.

Nephrite ring: homogenous dark green (*kawakawa*); perforated lug with 'eye' shape on one side, and two similar 'eye' shapes on opposite side; 'eye' ornamentation on one surface of ring only. Thick, deep moulding; polished.

Provenance: Unknown.

Register: 'This specimen & the jade pendant NZ 158B [339], were originally attached to the tiki NZ 158 [257]. July 1849.'

Comments: Early nineteenth century (RN); fake (DRS).

References: Edge-Partington 1969 I: 371.4.

442
Parrot ring, *kaka poria*
1895-734. Length 4 cm.

Nephrite ring: mottled medium green, flat, thin (part broken off), elongated on one side to accommodate hole.

Provenance: Meinertzhagen Collection.

Comments: Poorly shaped, modern (RN); bowenite (DRS).

443 Colour plate 13
Parrot ring, *kaka poria*
1878.11-1.616. Length 3.8 cm.

Nephrite ring: translucent medium green, with four small equidistant outer lobes, one,

much enlarged, with hole; another hole at edge worn out and broken. Polished, worn.

Provenance: Meyrick Collection.

Comments: Standard shape, eighteenth century (RN).

References: Hooper 2006: 135.77.

444 Colour plate 13
Parrot ring, *kaka poria*
1926.3-13.29. Length 2.8 cm.

Nephrite ring: light green, thin; suspension lug on one side with large hole.

Provenance: Presented by Sir F. Sidney Parry.

Register: 'Probably collected 1830–34, while Parry was governor of Australia.' This probably refers to Arctic explorer Sir William Edward Parry, 1790–1855, who was not Governor but Commissioner for Australian Agricultural Company 1829–34 and Superintendent of Haslar Hospital 1846–52, whereas this specimen was presented by Sir (Frederick) Sidney Parry, 1861–1941, his grandson.

Comments: Poorly shaped, irregular form, late nineteenth century (RN).

445
Two feather ornaments
1854.12-29.125 (eight feather bundles) and 1854.12-29.126 (nine feather bundles). Widths: 38 and 39 cm (respectively).

Double braid of narrow flax-leaf strips, curved, forming loop at one end, with black/brown hawk (?) and smaller white feathers tied into bundles with narrow strips of flax and/or flax-fibre strings before assembling on braids. Dark feathers have been split in half and typical bundle is made up of 18 half feathers and 3 smaller white ones; when assembled, white feathers are at convex top of each bundle.

Provenance: Grey Collection.

Register: 'Headdress of black cock's feathers.'

Comments: Braid is bent, so that it appears that at one time one end was threaded through other, perhaps tied in place with two-ply rolled-fibre cord; this forms braid into small circle. If this is indeed a headdress, it appears that it would have been secured around a topknot; alternatively it could be decoration around a spear – there are traces of red pigment on rolled cord which suggest some age. (MP)

Tattooing equipment

Pigment containers, funnels

446 Plate 82
Pigment container, *oko*
6858. Length 21.5 cm.

Wooden bowl: oval, with slightly flattened bottom and large Taranaki *wheku* figure carved in the round projecting as handle at one end, hands on knees and feet facing backward. Surface decoration of *rauponga*, with traces of red ochre. Inside of bowl stained dark black–blue, with some of same on rim.

Provenance: Presented by A.W. Franks, 18 August 1870 (Wright).

Register: 'Taranaki. T.T. Barrow.'
Comments: Taranaki, 1820s–30s (RN).
References: Barrow 1969: fig. 168; Edge-Partington 1969 I: 388.1; Neich 1996b: 82.

447 Plate 82

Pigment container, *oko*

1944 Oc.2.809. Height 8 cm.

Wooden cylindrical container: carved all over with four full-frontal *koruru*-type figures, alternately head up and head down, all with large, plain spirals on shoulders and hips, some hands as *manaia*. One figure male with penis, one probably male, one probably female, one indeterminate.

Provenance: Beasley Collection. Beasley no. 3071.

Loose label inside: 'Drinking cup taken from Heke's Pah in New Zealand warfare. Presented by Col Somerset.'

Comments: Bay of Islands, early nineteenth century (RN).

Beasley catalogue: 3071, registered 27 July 1932, 'Bought Gloucester Museum per M. Russell… An old label inside states that this was looted from Heke's pa "Okihau" [Okaihau] which was captured on May 8th 1845. This pot has evidently been used for oil.'

References: Te Awekotuku 1996: 40.

448 Plate 82

Feeding funnel, *korere*

LMS 148. Length 19.5 cm.

Wooden funnel with projecting *wheku* face and plain female body, with vulva, forming openwork handle; interlocking *rauponga* with three *raumoa* over body of bowl and spout; small free-cut head at rear top of plain rim. Janus face at bottom of spout, with large tooth each side. Marked in black ink: 'LMS 542'.

Provenance: London Missionary Society Collection.

Comments: Northern, probably Hokianga, early nineteenth century (RN); Northland, 1830 (DRS).

449 Plate 82

Feeding funnel, *korere*

LMS 149. Length 16 cm.

Wooden funnel with head projecting slightly from plain rim: plain body, no sex indicated, opening for suspension cord through chest; another face at rear; Janus face at bottom of spout, with teeth. Surface decoration of *unaunahi* in three registers, *rauponga* and plain spirals; *pakura* below rim and above Janus face on spout. Section of rim near front head broken off.

Provenance: London Missionary Society Collection.

Label: 'No. 541. LM Socy'.

Comments: Hokianga, eighteenth century (RN); Hokianga/Bay of Islands (DRS).

450 Plate 83

Feeding funnel, *korere*

LMS 160. Length 25.5 cm.

Wooden funnel with projecting openwork figure as handle, with vulva, high domed head and notched haliotis-shell eyes, surface with interlocking loops of *pakura*.

Small *wheku* face at top of spout, which ends in Janus face. Surface decoration of plain spirals, *pakura* and *unaunahi* between single *raumoa*; *pakura* around rim. Patches of black deposit in bowl.

Provenance: London Missionary Society Collection.

Comments: Hokianga; early nineteenth century (RN); eighteenth century (DRS).

References: Barrow 1969: fig. 97; Barrow 1984: 84; Ford n.d.: fig. 4b.

451 Plate 83

Feeding funnel, *korere*

1913. Length 21 cm.

Wooden funnel without projecting head at front, but may have had one broken off, connecting to female body with vulva and large claw-like hands: decorated with plain spirals and *unaunahi*. *Wheku* head and body extending down at rear spout in backward embrace with reversed figure on other side of spout. Janus face at end of spout, figures on spout plain, plain rim.

Provenance: Unknown.

Comments: Hokianga, early nineteenth century (RN); Northland, eighteenth century (DRS).

References: Edge-Partington 1969 I: 383.1.

452 Plate 83

Feeding funnel, *korere*

7229. Length 16.5 cm.

Wooden funnel with large head projecting over female figure with large vulva; similar head at rear top of spout, also female with large vulva. Janus face with teeth at lower end of spout. Surface in *rauponga* and curving eye forms. Rim with spaced eye forms; one side of rim slightly damaged.

Provenance: Presented by A.W. Franks, 21 April 1871. (Sparrow Simpson Collection).

Label: 'Feeding funnel used in New Zealand during tattooing process. (Purchased 22 June 1869.CJ).'

Comments: Aupouri, eighteenth century (RN); Far north? (DRS).

453 Plate 83

Feeding funnel, *korere*

9358. Length 16.5 cm.

Wooden funnel with female figure with projecting bird-like head and bulbous body and large vulva, *manaia* at sides. Smaller figure at rear top of spout with small open space behind it for suspension cord, facing down spout, Janus face at bottom of spout. Plain spirals and *rauponga* all over, plain rim.

Provenance: Sparrow Simpson Collection.

Label: 'From the South Sea Islands. Presented by Edw. Harwood.'

Comments: Bay of Islands; early nineteenth century (RN); eighteenth century (DRS).

References: Hamilton 1901: 352, pl. LI, fig. 2, centre.

454 Colour plate 14

Feeding funnel, *korere*

1915.2-17.4. Length 20.5 cm.

Wooden funnel with projecting *wheku* head with curved female body with vulva. Another small head at top of spout, which is separate piece attached to funnel bowl, and ends in Janus face with teeth. Surface covered in plain spirals and *rauponga*. *Pakura* around top and sides of thick squared rim.

Provenance: Edge-Partington Collection.

Register: 'Collected in N.Z. at least 100 years ago.'

Comments: Hokianga; early nineteenth century (RN); c.1820 (DRS).

References: Te Awekotuku 1996: 41.

Tattooing implements

455

Hafted tattoo chisel, *uhi*

1895-390. Length 17.2 cm.

Wooden haft, serrated bone blade.

Provenance: Meinertzhagen Collection.

Comments: Mock-up, never used, but correct (RN).

456

Fifteen tattoo chisel blades of bone, *uhi*

1895-574 to 1895-588. Lengths 3.1–6.3 cm.

Provenance: Meinertzhagen Collection.

Comments: Good range of surface-collected archaeological tattoo chisels, some only fragments, all authentic (RN).

457

Twelve hafted tattoo chisels, *uhi* (2 hafts only)

1854.12-29.96. Lengths 8.5–12.8 cm.

Wooden hafts with three or four paired groups of three notches, sharply pointed proximal ends; bone blades of different width with notches on side and plain bevels, except for three with very fine serration.

Provenance: Grey Collection.

Comments: Never used, possibly made for Governor (RN).

References: Edge-Partington 1969 I: 386.5; Roth 1901: fig. 1.

458

Three tattoo chisel blades of bone, *uhi*

1944 Oc.2.846 to 1944 Oc.2.848. Lengths 6, 5 and 4.6 cm (respectively).

All serrated, one (848) with small hole near proximal end.

Objects marked: 846 – 'D.25.1765 Warrington'; 847 – 'D.25.1763 Warrington'; 848 – 'D.25.1764 Warrington'.

Provenance: Beasley Collection. Beasley no. 2004.

Comments: Beasley catalogue: 2004, registered 21 April 1927, 'Three bone tattooing needles, one with pierced hole. All from middens at Warrington, South Island. Exchanged with Otago Museum.'

Amusements, musical instruments

Many of the Maori games for children encouraged manual dexterity and taught young boys to handle projectile spears and passing sticks, important early training for a warrior society. Young girls enjoyed cat's-cradle string figures and the twirling of poi balls on string in time to the dance. Boys and girls played with whipping tops and humming tops of wood, stone and gourd. Older people passed the time with carved puppets with moveable arms, manipulating them in time with special chants to represent a haka posture dance. With the European introduction of tobacco, older men and women took to smoking clay and wooden pipes, many of the latter being carved by their owners with figures and faces, for their own use and later for the tourist trade.

The range of percussion instruments was very limited. A simple example was the pair of tapping sticks, *pakuru*, one of which was held between the teeth of the operator. Wooden gongs for signalling in warfare were hollowed out of a standing tree-trunk or a length of timber shaped to be suspended, for striking with a short beater. These were very rarely collected. The skin drum of Polynesia and Melanesia was not known among the Maori. Bullroarers consisting of a thin, flat piece of pointed oval wood were twirled above the head on a cord, and were said by some to bring rain for the crops.

In contrast, wind instruments were varied and sophisticated, and frequently decorated with detailed carving. This explains their large numbers in older museum collections, with the British Museum's containing the greatest range of types and periods, dating from those collected on Cook's voyages to the most modern examples. Trumpets called *pukaea* (shaped out of wooden sections) or *putatara* (utilizing a large gastropod seashell with an attached wooden carved mouthpiece) were formerly used as signalling devices in warfare, or were sounded periodically by a watchman at night. In modern times, the *putatara* often announces the arrival of a visiting group or the start of a ceremony. An instrument unique to Maori culture was the *putorino*, sometimes regarded as a trumpet and sometimes as a flute. The playing method is in doubt, partly because *putorino* became obsolete very soon after European contact. Despite their apparent limitations as an instrument, they were very highly valued, if we are to judge by the amount of refined carving often invested in their decoration. *Putorino* were shaped out of a piece of solid matai wood that was then split lengthwise, hollowed out and tightly lashed back together with bindings of flax cord in northern and western areas, or with the fine aerial roots of the kiekie plant in central and eastern areas, of North Island.

Outnumbering all other musical instruments are the flutes: the straight open-tube type called a *koauau* and those with an upturned closed distal end called a *nguru*. Ancient flutes of the *koauau* type, made of albatross wing and leg bones, are found on archaeological sites in southern South Island. Most *koauau* and *nguru* are elaborately carved from wood, but stone and whale-tooth ivory examples are also found. *Koauau* of human arm and leg bones are fairly frequent, and were made from the bones of slain enemies. Maori flutes were blown obliquely across the open end and, despite some claims that the *nguru* was blown as a nose flute, most modern academic opinion agrees that *nguru* were played in the same way. Both *koauau* and *nguru* produce the same range of notes. A modern version of an extra-long *koauau* was made to resemble the European flute and was called a *porutu* in a transliteration of English 'flute'.

Amusements

Puppets, pipes etc.

459 Colour plate 14
Puppet, *karetao*
1921.10-14.2. Height 47 cm.

Wooden puppet with moveable arms, naturalistic male face with full facial tattoo and cap dome over head; apparently female genitalia. Arms plain, each with six fingers and thumb, on twisted-flax string. Body: front, back and legs covered with *rauponga* with square *pakati*; flat, plain spirals incised on buttocks; *pitau* on back of head. Short shaft below feet.

 Provenance: Yorkshire Philosophical Society Museum.

 Register: '"Jumping Jack" ("Karetao") acquired from Capt. F. Vernon, RN' (Eth. Doc.1912).

 Comments: Whanganui; 1840s–50s (RN); c.1840 (DRS).

 References: Te Awekotuku 1996: 47.

460 Plate 84
Puppet, *karetao*
1905 L.1.1/ Royal Collection no. 69997. Height 53.5. cm.

Wooden puppet: long head with naturalistic face with black male facial tattoo, haliotis-shell eyes, carved and blackened hairstyle. Plain body: legs together, with *rauponga* and *pakura*; back slightly hollowed out. Arms with large hands and four fingers, of lighter wood, on twisted flax string. Substantial shaft below feet.

 Provenance: Royal Loan 1905, HRH The Prince of Wales.

 Label: 'Deposited by H.R.H. the Prince of Wales 13.3.05.'

 Comments: Bay of Plenty, early twentieth century, possibly made for Royal visit of 1901 (RN).

461 Plate 85
Tobacco pipe, *paipa*
NZ 148. Length 11.5 cm.

Wooden pipe bowl: squared, with *whakarare*; *wheku* head projecting at distal end. Rim of bowl marked in black ink: 'New Zealand 1830', 'Mr Wheeler' written around stem.

 Provenance: Bragge Collection.

 Register: 'Bragge Coll. Ea.10'.

 Comments: East Coast, early nineteenth century, not used, unlike all other pipes (RN); Poverty Bay (DRS).

 References: Bragge 1880: 165.10; Neich 2005: 65, fig. 17.

462 Plate 84
Tobacco pipe, *paipa*
1646. Length 43 cm.

Wooden pipe with two very finely carved Arawa-style figures back to back on shaft. Figures with naturalistic faces and partial male facial tattoo, one with haliotis-shell eyes, three-fingered hands on stomach, limbs with *rauponga* spirals. *Whakarare* on upper shaft, *wheku* face below figures. Tobacco bowl with *rauponga* on upper half, over head of one figure, slight charring inside and hole at bottom, its channel continued through top of shaft and terminating in open mouth of other figure.

 Provenance: Arley Castle.

 Register: 'From Arley Castle.'

 Comments: Bay of Plenty, early nineteenth century (RN).

 References: Edge-Partington 1969 I: 389.8; Hamilton 1901: 254, pl. XXXV, fig. 2, centre.

463 **Plate 85**

Tobacco pipe, *paipa*

1896-530. Length 15 cm.

Wooden pipe: slightly oval bowl charred inside, *rauponga* outside. On outer/distal end of bowl: *wheku*-faced figure carved free of bowl, its body bent under bowl, arms extended backwards with three-fingered hands grasping raised legs. On opposite side of bowl: *wheku* face with carved stem emerging from its open mouth and terminating in small Janus face, from which it is extended with metal and then amber piece (latter broken and repaired). Surface decoration of *rauponga*, spirals on shoulders and hips of figure; all faces with haliotis-shell eyes (one missing).

Provenance: Presented by A.W. Franks, 25 March 1896 (Giglioli).

Register: 'Carved Maori pipe once the property of Tawhiao – the Maori King. Rcd from Sir Julius von Haast 1884. E.H. Giglioli'; '… given to Giglioli by Von Haast.'

Comments: Carved by Patoromu Tamatea of Ngati Tamateatutahi hapu of Ngati Pikiao, 1870s (?) (RN); Poverty Bay (DRS).

464 **Plate 85**

Tobacco pipe, *paipa*

1944 Oc.1.1. Length 13.5 cm.

Wooden pipe: bowl with thick metal rim on back of *ruru*-faced figure, arms extended backwards around bowl and then brought back to mouth, legs and buttocks behind bowl at rear. Eyes of *ruru* face of small pinkish bivalve shells (one missing). Surface decoration of fine *rauponga*, *whakatara* on feet and forehead. Stem of metal, extended into plainly carved bone.

Provenance: Presented by O.I. Thomas.

Donation Book: 'Given to donor by the late Mrs Firth, curator of the Wanganui Nat. Hist. Museum, who described it as a good example of this work.'

Comments: Carved by Neke Kapua of Ngati Tarawhai, 1890s–1900s (RN); Poverty Bay (DRS).

465 **Plate 86**

Cigarette holder

1944 Oc.2.808. Length 9.7 cm.

Wooden cigarette holder: bowl with *ruru* faces back to back, circular haliotis-shell inlay in eyes, mouth, forehead and chin; nostrils filled with red sealing wax. Surface ornamentation of *rauponga*.

Provenance: Beasley Collection. Beasley no. 338.

Comments: Carved by Ihakara Te Aukaha of Ngati Pikiao, c.1890 (RN).

Beasley catalogue: 338, registered 29 May 1908, 'Mouthpiece of carved wood from a shell trumpet… Bt Mrs E. White, per G.O. Hughes.'

466

Spinning top, *potaka*

1895-388. Length 7.5 cm.

Made of wood, with pearl-shell button inserted in flat top.

Provenance: Meinertzhagen Collection.

467

Spinning top, *potaka***, of pumice**

1895-389. Length 5.5 cm.

Provenance: Meinertzhagen Collection.

Comments: Pumice stopper (DRS).

References: Edge-Partington 1969 II.2: 192.3. Best 1925a: fig. 40.3.

Poi balls

468 **Plate 86**

Poi ball

5870. Diameter 11.5 cm.

Round ball: *raupo* down contained in looped netting of rolled-flax fibre, ornamented with five haliotis-shell discs, held in place with single knot at central perforation, and six short wrapped-fibre cords (half hitching) which have held bundles of dog hair, now missing.

Provenance: Presented by A.W. Franks, 2 November 1869 (Wareham).

Comments: Nineteenth century (MP).

References: Andersen 1934: fig. 85B; Best 1925a: fig.22B; Edge-Partington 1969 I: 380.5; Te Awekotuku 1996: 46.

469

Poi ball

1895-398. Length 15 cm.

Oval ball made of *raupo*, no cord.

Provenance: Meinertzhagen Collection.

Comments: Nineteenth century (MP).

470 **Plate 86**

Poi ball

1926.1-5.4. Diameter 7.5 cm.

Round ball: corn-husk covering with outer decorative bands of strips of *raupo* and kiekie leaf dyed purple and black; flax-fibre fringe around top; rolled white and purple cord.

Provenance: Presented by O. Raphael.

Comments: Twentieth century (MP).

471

Poi ball

1926.1-5.5. Diameter 5.5 cm.

Round ball: *raupo* down, with *raupo* on outer surface; two-ply flax string.

Provenance: Presented by O. Raphael.

Comments: Twentieth century, probably pair with **472** (1926.1-5.6) (MP).

472

Poi ball

1926.1-5.6. Diameter 5.5 cm.

Round ball: *raupo* down, with *raupo* on outer surface; two-ply flax string.

Provenance: Presented by O. Raphael.

Comments: Twentieth century, probably pair with **471** (1926.1-5.5) (MP).

473

Pair of poi balls

1954 Oc.6.309. Length 10 cm.

Oval-shaped balls, made from *raupo*, with two strips of dyed yellowish-green kiekie on each; no cords.

Provenance: Wellcome Collection. Wellcome Museum no. 166763.

Comments: Twentieth century (MP).

474

Pair of poi balls

1954 Oc.6.310. Length 12 cm.

Oval-shaped balls, made from *raupo*, with two strips of kiekie (?) on each; no cords.

Provenance: Wellcome Collection.

Comments: Twentieth century, non functional (?) (MP).

475

Pair of poi balls

1995 Oc.5.3. Diameter 8 cm.

Round balls, filled with plastic foam, covered with corn husk; braided black-and-white wool cords terminating in black-and-white pompoms.

Provenance: Presented by D.C. Starzecka.

Comments: Made by Erenora Puketapu Hetet. Contemporary art.

476

Pair of poi balls

Q1982 Oc.860. Lengths 13 and 11.5 cm.

Two oval balls, probably not a pair as one is larger than other; larger covered with red-dyed tree bast (probably *Hoheria* sp.), smaller has *raupo* with only bands of dyed bast. Both have three tassels of flax fibre and rolled pink-dyed bast cord.

Provenance: Wellcome Collection.

Label: 'Poi Balls (2) New Zealand'; reverse: '221963'.

Comments: Twentieth century, probably non-functional (MP).

Musical instruments

Curved flutes, *nguru*

477 **Plate 87**

End-blown curved flute, *nguru*

LMS 146. Length 13.2 cm.

Wooden flute: dark brown; Janus face with *pakura* at blowing end; three finger holes – two on body, one on outer curve below upturned end. Surface plain except for openwork high-relief two figures in line on lower side incorporating lug; their surface decoration of plain spirals and *rauponga*.

Provenance: London Missionary Society Collection.

Label: 'LM Socy 569'.

Comments: Bay of Islands; eighteenth century, fine detail, well carved (RN); early nineteenth century (DRS).

478 **Plate 87**

End-blown curved flute, *nguru*

5369. Length 8 cm.

Wooden flute: light brown; four finger holes, with signs of wear; small lug on outer curve. Low-relief rudimentary Janus face with tooth at blowing end; surface covered in *rauponga*: concentric elongated circles with large square *pakati* and single *raumoa* interspersed with single spirals.

Provenance: Presented by W. Bragge, 21 April 1869. Cook Collection.

Comments: Whanganui/Cook Strait, eighteenth century.

References: Joppien and Smith 1985: 1.160. no. 2; Starzecka 1979: fig. 67.

479 **Plate 87**

End-blown curved flute, *nguru*

7986. Length 16 cm.

Wooden flute: light brown; recessed suspension lug; Janus face with eyes and four low-relief rounded teeth at blowing end. Three finger holes: two on body, one on outer curve below upturned end. Surface decoration of rolling plain spirals, but only one side completely finished.

Provenance: Presented by A.W. Franks, 28 April 1873.

Comments: Hokianga; late eighteenth / early nineteenth century, very good quality (RN); early nineteenth century (DRS).

References: Andersen 1934: figs 50B (where it is mistakenly described as 'stone pipe or whistle') and 52; Best 1925a: 135, fig. 67, right; Edge-Partington 1969 I: 387.1; Hamilton 1901: 225.

480 Plate 87
End-blown curved flute, *nguru*
+5094. Length 7 cm.

Wooden flute: brown, plain; two finger holes on body and one below upturned end.

Provenance: Purchased 24 April 1891 (Noldwritt).

Comments: Eighteenth century.

481 Plate 87
End-blown curved flute, *nguru*
+7926. Length 11 cm.

Wooden flute: light brown, worn Janus face with four teeth and haliotis-shell eyes at blowing end. Two finger holes in body, another, with haliotis-shell ring round it, below upturned end which also has a haliotis-shell ring around its hole. Surface carved with three sinuous-bodied figures, suspension lug passing under body of figure with blind eye, haliotis-shell inserts between bodies. Plain spirals, *pakura* and some *rauponga* on figures, but sinuous trunks left plain.

Provenance: Sparrow Simpson Collection.

Comments: Bay of Islands; eighteenth century, very old, beautiful work (RN); early nineteenth century (DRS).

References: Hooper 2006: 123.56; Te Awekotuku 1996: 49.

482 Plate 87
End-blown curved flute, *nguru*
1896-31. Length 11.3 cm.

Wooden flute: light brown; Janus face at blowing end; lug as carved face below it on outer curve, rest plain; three finger holes – two on body, one on outer curve below upturned end. Highly polished and worn.

Provenance: Presented by A.W. Franks, 8 January 1896.

Comments: Bay of Islands, eighteenth century (RN); South of Bay of Islands (DRS).

483 Plate 87
End-blown curved flute, *nguru*
1915.2-17.3. Length 9.5 cm.

Whale-tooth flute: plain; three finger holes: two on body with haliotis-shell rings (one finely notched), one plain on outer curve below upturned end. Recessed lug on outer curve.

Provenance: Edge-Partington Collection.

Register: 'Collected in NZ at least 100 years ago.'

Comments: Nineteenth century.

References: Best 1925a: 135, fig. 67, bottom.

484 Plate 87
End-blown curved flute, *nguru*
1994 0c.4.103. Length: flute 105 cm; bag 16 cm.

Nephrite flute: mottled light and dark green, plain. Three finger holes: two on body and one below upturned end. Suspension lug on small ridge on outer curve, with two-ply twisted-flax string with nephrite bead at end. Oblong, plaited flax-leaf bag to contain it.

Provenance: Collected in the field.

Comments: Carved by Clem Mellish of Havelock, Marlborough. Contemporary art.

Straight flutes, *koauau*

485 Plate 88
End-blown straight flute, *koauau*
NZ 108. Length 11.5 cm.

Wooden flute: light brown; three finger holes, covered in carving of spirals and *haehae* with *unaunahi* and *ritorito*; Janus face at both ends. Tiny lug at blowing end broken off, distal end broken and re-carved in fine notches.

Provenance: Unknown.

Comments: Northern, late eighteenth century (RN); Hauraki, eighteenth century (DRS).

486 Plate 89
End-blown straight flute, *koauau*
1711. Length 19 cm.

Wooden flute: brown, three finger holes, lug broken out, covered with intertwined faces and bodies, Janus face at each end. Surface decoration of *rauponga* and *pakura*, and some spirals. Remains of flax fibre through new recessed lug.

Provenance: Unknown.

Comments: Bay of Islands; late eighteenth century (RN); eighteenth century (DRS).

487 Plate 88
End-blown straight flute, *koauau*
1712. Length 12 cm.

Wooden flute: brown, three finger holes. Janus face at ends, rest covered in fine low-relief carving of faces and bodies with *rauponga*, with projecting suspension lug through mouth of largest face.

Provenance: Unknown.

Comments: Bay of Islands; late eighteenth century (RN); eighteenth century (DRS).

References: Andersen 1934: fig. 43, right; Best 1925a: 135, fig. 67, centre.

488 Plate 88
End-blown straight flute, *koauau*
1713. Length 12.3 cm.

Wooden flute: brown; three finger holes, one with rabbet for haliotis-shell inlay; two oblong recesses between finger holes, possibly also for shell inlay; protruding lug. Janus face at ends, most of surface plain except for *pakura* at ends and some *rauponga pitau* shapes.

Provenance: Unknown.

Comments: Whanganui style, early nineteenth century (RN); Whanganui, eighteenth century (DRS).

489 Plate 88
End-blown straight flute, *koauau*
1714. Length 13.2 cm.

Wooden flute: brown, three finger holes, small lug. Covered in plain rolling spirals; Janus face at ends.

Provenance: Unknown.

Comments: Hokianga, early nineteenth century.

490 Plate 89
End-blown straight flute, *koauau*
9359. Length 12.7 cm.

Wooden flute: brown; three finger holes, two stopped and re-drilled further down. Carved all over with faces and bodies, some plain, some with *rauponga*; Janus faces at ends, with teeth indicated. Recessed lug with flat braided-flax cord and albatross-bone toggle.

Provenance: Sparrow Simpson Collection.

Comments: Bay of Islands; late eighteenth century (RN); early nineteenth century (DRS).

References: Andersen 1934: fig. 43, left; Best 1925a: 135, fig. 67, left.

491 Plate 89
End-blown straight flute, *koauau*
+7927. Length 13.2 cm.

Wooden flute: brown; protruding lug; three finger holes and one old one plugged. Plain, except for *pakura* and implied Janus face at both ends.

Provenance: Sparrow Simpson Collection.

Label: 'Tu-i-au, or flute, New Zealand. Purchased 25 May 1868. CJ.'

Comments: Whanganui, mid nineteenth century (RN); Northland, eighteenth century (DRS).

492 Plate 89
End-blown straight flute, *koauau*
1896-32. Length 17 cm.

Wooden flute: brown, three finger holes, lug in middle. Plain, except for Janus face at ends and middle, in deep carving and *pakura*.

Provenance: Presented by A.W. Franks, 8 January 1896.

Comments: Northern, late eighteenth century (RN); Northland, early nineteenth century (DRS).

References: Andersen 1933: fig. 43, top; Best 1925a: 135, fig. 67, second right.

493 Plate 89
End-blown straight flute, *koauau*
1854.12-29.16. Length 14.8 cm.

Wooden flute: brown; three finger holes, two with haliotis-shell insets; protruding lug below with thin leather loop with hair at end. Covered with low-relief *rauponga*, no heads at ends except for indication of a tooth.

Provenance: Grey Collection.

Register: 'It belonged to the Ngati-awa tribe; made from knot of the kauri tree.'

Comments: Taranaki; early nineteenth century (RN); c.1820 (DRS).

References: Andersen 1934: fig. 43, centre; Best 1925a: 135, fig. 67, second left; Edge-Partington 1969 I: 387.2.

494 Plate 89
End-blown straight flute, *koauau*
1915.2-17.2. Length 17.5 cm.

Wooden flute: light brown; three finger holes; recessed lug. Rolling plain spirals over whole surface, rudimentary Janus face at ends.

Provenance: Edge-Partington Collection.

Register: 'Collected in NZ at least 100 years ago.'

Comments: Hokianga; early nineteenth century (RN); eighteenth century (DRS).

References: Barrow 1969: fig. 205; Barrow 1984: 48.

495 **Plate 89**
End-blown straight flute, *koauau*
9360. Length 28.3 cm.

Bamboo flute: three finger holes; small protruding lug for cord underneath. Incised *pitau*-series *kowhaiwhai* all over; one haliotis-shell eye in Janus face at blowing end. Incised: 'R.W. Parnell Hofaneur Wicatto'.
 Provenance: Sparrow Simpson Collection.
 Comments: Waikato; strange, non-traditional, but quite old (RN); nineteenth century (DRS).

496 **Plate 90**
End-blown straight flute, *koauau*
LMS 145. Length 14.2 cm.

Human-bone flute: three finger holes in side; Janus face at both ends. Lug through projecting, prone, human figure with convoluted asymmetrical body in *rauponga* and plain spirals; very low-relief naturalistic lizard on opposite side.
 Provenance: London Missionary Society Collection.
 Label: 'LM Socy 568'.
 Comments: Taranaki; early nineteenth century (RN); nineteenth century (DRS).
 References: Barrow 1972: 33, fig. 41; Te Awekotuku 1996: 48.

497 **Plate 90**
End-blown straight flute, *koauau*
1716. Length 17 cm.

Human-bone flute: three finger holes on same side as slightly protruding lug. Janus face at both ends with *pakura* and red sealing wax in eyes, rest plain.
 Provenance: Unknown.
 Comments: Northern, early nineteenth century (RN); Northland, *c.*1830 (DRS).
 References: Edge-Partington 1969 I: 387.3.

498 **Plate 90**
End-blown straight flute, *koauau*
1896-930. Length 16.5 cm.

Human-bone flute: Janus face at both ends; side with three finger holes plain; rest carved with figures and faces with no surface decoration; lug built into one of faces.
 Provenance: Presented by A.W. Franks, 14 August 1896.
 Comments: Bay of Islands, early nineteenth century.
 Given by Ngapuhi chief Titore to Captain Sadler of HMS *Buffalo* in 1833–4; Franks obtained it from Captain Sadler's daughter. See Register entry for **271** (*hei-tiki*, 1896-925).

499 **Plate 90**
End-blown straight flute, *koauau*
1850.2-6.1. Length 16 cm.

Human-bone flute: dark; recessed lug. Five finger holes and two more plugged; Janus face at both ends, one very rudimentary, other with *pakura*.
 Provenance: Purchased from P. Whelan.
 Register: 'Found at Chalk Road, Islington (New Zealand).'
 Comments: Northern, mid nineteenth century (RN).

Slip for this objects is annotated 'Meyrick Coll.' but no information about such Meyrick provenance could be found.

500 **Plate 90**
End-blown straight flute, *koauau*
1715. Length 17 cm.

Albatross-bone flute: plain, polished, three finger holes and small hole beside end for suspension.
 Provenance: Unknown.
 Comments: Otago, nineteenth century.

501
Three bone flute fragments, *koauau*
1944 Oc.2.837, 838, 839. Lengths 15, 10.5 and 9.2 cm.

Albatross bone flutes: 387 – plain, longitudinal cracks; 388 – traces of cross-hatched decoration; 389 – two finger holes.
 Provenance: Beasley Collection. Beasley nos 2002B, 2002A, 2002C.
 Beasley label for each reads: 'NZ Otago, part of flute. From middens.'
 Beasley catalogue: 2002A–C, registered 21 April 1927: 'Exchanged with the Otago Museum.'

Long flutes, *porutu and rehu*

502 **Plate 91**
End-blown long flute, *porutu*
1895-387. Length 38.5 cm.

Wooden flute: light, plain, polished, three finger holes.
 Provenance: Meinertzhagen Collection.
 Comments: Nineteenth century (DRS).

503 **Plate 91**
End-blown long flute, *porutu*
1921.10-14.7. Length 23.5 cm.

Wooden flute: light, plain, three finger holes. Marked in ink, mostly illegible: 'Waikato … Wellington … Taranaki … Auckland flute made by Manuka 1855.'
 Provenance: Yorkshire Philosophical Society Museum.
 Register: 'Flute made by Manuka, 1855. Mr H.B. Johnstone (donor).'
 Comments: Waikato, 1855 (DRS).

504 **Plate 91**
Transverse flute, *rehu*
1986 Oc.2.52. Length 57.5 cm.

Wooden flute: end near blowing hole plugged; three finger holes near open end. Carved all over with bands of *rauponga* and some *whakarare*; Janus face at both ends and in middle, all with notched haliotis-shell eyes. Face at closed end and central face with unorthodox looped teeth. Intensive insect damage.
 Provenance: Purchased from Royal Institution of Cornwall; ex County Museum, Truro.
 Comments: Rotorua, 1870s–80s (RN).

Trumpets/flutes, *putorino*

505 **Plate 92**
Trumpet/flute *putorino*
LMS 142. Length 46.9 cm.

Wooden trumpet: polished; brown; kiekie bindings, one of flax. *Wheku* face at blowing end with *manaia* biting its tongue, both with haliotis-shell eyes. Low-relief female figure around central hole: *wheku*-faced with haliotis-shell eyes, vulva. *Wheku* face at distal end.

Provenance: London Missionary Society Collection.
 Comments: East Coast, early nineteenth century (RN); Bay of Plenty, eighteenth century (DRS).
 References: Hooper 2006: 122.55.

506
Trumpet/flute, *putorino*
LMS 143. Length 34.9 cm.

Wooden trumpet: brown, plain, all bindings missing.
 Provenance: London Missionary Society Collection.
 Label: '350'.
 Comments: Nineteenth century.

507 **Plate 92**
Trumpet/flute, *putorino*
LMS 144. Length 46.6 cm.

Wooden trumpet: fine braided-flax bindings; plain, except for face carved around central hole.
 Provenance: London Missionary Society Collection.
 Register: '802'.
 Comments: Northland, early nineteenth century (RN); South Taranaki (DRS).

508 **Plate 92**
Trumpet/flute, *putorino*
NZ 102. Length 54.2 cm.

Wooden trumpet: kiekie and fine flax bindings. *Wheku* face with one haliotis-shell eye at blowing end, *rauponga* around central hole, *wheku* face on opposite side at distal end; red ochre on faces.
 Provenance: Unknown.
 Comments: Whanganui, late eighteenth century, worn, old (RN); Taranaki, eighteenth century (DRS).

509 **Plate 92**
Trumpet/flute, *putorino*
NZ 103. Length 49.8 cm.

Wooden trumpet: light brown, string bindings linked by connecting strings at back. *Wheku* face with notched haliotis-shell eyes at blowing end; small *wheku* face on opposite side at distal end; plain, round central hole.
 Provenance: Unknown.
 Comments: East Coast, mid nineteenth century.

510 **Plate 93**
Trumpet/flute, *putorino*
NZ 104. Length 53.9 cm.

Wooden trumpet: crude kiekie bindings. *Wheku* face at blowing end: notched haliotis-shell eyes, long nose. Janus face at distal end with high rounded eyebrows, same nose as above, teeth formed around both sides, notched haliotis-shell eye on one side. Plain, oblong central hole. Over-cleaned.
 Provenance: Unknown.
 Comments: Taranaki style, early nineteenth century, well carved (RN).

511
Trumpet/flute, *putorino*
NZ 107. Length 22.6 cm.

Wooden trumpet: brown, plain, bindings of fine-braided flax. Mouth-shaped central hole and small round hole opposite it in underside of trumpet.
 Provenance: Unknown.

Comments: North Island, nineteenth century (RN).

References: Andersen 1934: fig. 58A; Best 1925a: 132, fig. 60, left.

512

Trumpet/flute,*putorino*

NZ 120. Length 31 cm.

Wooden trumpet: light brown; plain; kiekie bindings; plain, round central hole.

Provenance: Unknown.

Comments: Nineteenth century (RN).

513 **Plate 93**

Trumpet/flute,*putorino*

NZ 168. Length 56.2 cm.

Wooden trumpet: dark brown; kiekie bindings – many missing; *wheku* face at both ends; plain, round central hole.

Provenance: Unknown.

Comments: East Coast; early nineteenth century (RN).

514 **Plate 93**

Trumpet/flute,*putorino*

VAN 397. Length 65.4 cm.

Wooden trumpet: exceptionally long; kiekie bindings. *Wheku* face at blowing end: notched haliotis-shell eyes. Plain, round central hole.

Provenance: Vancouver Collection. Presented by A.W. Franks, 16 March 1891 (Hewett).

Label: 'Not in [Hewett's] Catalogue.'

Comments: East Coast, late eighteenth century (RN); Taranaki (DRS).

This objects is not listed in the manuscript catalogue (Eth.Doc.1126) accompanying this collection made by G.G. Hewett during Vancouver's voyage of 1791–95 and acquired for the Museum from Hewett's descendants; there is also no record of artefact collecting while in Dusky Bay in November 1791 in Vancouver's account of the voyage (published in 1798, edited version 1984), although the manuscript catalogue has several entries for shells from Dusky Bay.

515 **Plate 93**

Trumpet/flute,*putorino*

1692. Length 55 cm.

Wooden trumpet: dark brown; braided-flax bindings, three of them linked by string at back. Plain, except for carving of female figure above mouth-shaped central hole linked to profusion of interlocking loops and eyes around hole; *unaunahi* in all loops.

Provenance: Unknown.

Comments: North Auckland (RN); Taranaki (DRS).

References: British Museum 1925: fig. 173, right; Edge-Partington 1969 I: 388.3; Te Awekotuku 1996: 48–9.

516 **Plate 93**

Trumpet/flute,*putorino*

1693. Length 57.5 cm.

Wooden trumpet: exceptionally long, kiekie bindings. Projecting *wheku* face at blowing end with haliotis-shell eyes (one missing) and strongly tapered face. Male figure sideways around round, central hole with mouth as hole: notched haliotis-shell eyes, plain spirals on shoulders and hips, long penis, and body going around back of flute. Face at distal end on same side as upper

face looking back: haliotis-shell eyes (one missing).

Provenance: Unknown.

Comments: Probably East Coast, but note different face on upper end with Taranaki look and *pakati*, nineteenth century (RN); East Coast, eighteenth century (DRS).

517 **Plate 94**

Trumpet/flute,*putorino*

1694. Length 45 cm.

Wooden trumpet: dark brown, kiekie bindings. *Wheku* face at blowing end with looped tongue; Janus face at distal end; notched haliotis-shell eyes on all faces. Rounded oblong central hole, rest of surface carved with *rauponga* spirals and *rauponga* in short ovals with very wide *pakati*.

Provenance: Unknown.

Comments: Taranaki, early nineteenth century, very well carved (RN); South Taranaki (DRS).

References: Andersen 1934: fig. 58D; Barrow 1969: fig. 206; Barrow 1984: 96; Best 1925a: 132, fig. 60, third right; British Museum 1925: fig. 173, left.

518 **Plate 94**

Trumpet/flute,*putorino*

1695. Length 64.6 cm.

Wooden trumpet: dark brown; fine flax bindings. At blowing end: *manaia* face on one side, *wheku* face on other, notched haliotis-shell eyes (one missing). Face around central hole, on same side as upper *manaia*: looking upwards, large mouth as hole (broken at lower lip), haliotis-shell eyes. *Wheku* face at distal end on same side as upper *wheku* face: looking upwards.

Provenance: Unknown.

Comments: East Coast; later eighteenth century (RN); nineteenth century (DRS).

519 **Plate 94**

Trumpet/flute,*putorino*

4991. Length 45.3 cm.

Wooden double trumpet: very fine kiekie bindings. Projecting *wheku* face at blowing end, low-relief face around each central hole, *manaia* at distal end. All faces with *pakura* and notched haliotis-shell eyes.

Provenance: Received in exchange from Salford Museum, Manchester, 16 September 1868.

Comments: East Coast, early nineteenth century (RN); Taranaki (DRS).

References: Andersen 1934: fig. 60B; Best 1925a: 132, fig. 61E; British Museum 1925: fig. 173, second right; Edge-Partington 1969 I: 388.2; Hamilton 1901: 418, pl. LVIII, fig. 1.

520 **Plate 94**

Trumpet/flute,*putorino*

+5030. Length 34.7 cm.

Wooden trumpet: kiekie bindings, carved all over in very shallow low-relief *rauponga* and *pakura*. Low-relief face on both sides at blowing end and inward facing face above and below rounded-oblong central hole; haliotis-shell eyes (some missing). Marked in black ink: '21'.

Provenance: Purchased from Noldwritt, 24 April 1891.

Comments: Whanganui; eighteenth to early nineteenth century, extremely old and worn. (RN); eighteenth century (DRS).

References: Andersen 1934: fig. 58C; Best 1925a: 132, fig. 60, third left.

521

Trumpet/flute,*putorino*

+5921. Length 34.6 cm.

Wooden trumpet: kiekie bindings. *Wheku* face around central hole with upper lip and tongue dividing hole; incised circle near broken blowing end.

Provenance: Presented by A.W. Franks, 3 November 1892 (J.W. Luff).

Comments: East Coast, nineteenth century.

522 **Plate 95**

Trumpet/flute,*putorino*

1895-1225. Length 36.5 cm.

Wooden trumpet: flax string bindings linked by string at back. Low-relief *wheku* face around figure-of-eight central hole; very small hole in centre of back, opposite main central hole.

Provenance: Presented by A.W. Franks, 10 December 1895 (Sparrow Simpson).

Comments: Taranaki, early nineteenth century (RN); South Taranaki, eighteenth century (DRS).

523

Trumpet/flute,*putorino*

1904-247. Length 47.4 cm.

Wooden trumpet: kiekie bindings; plain, no surface ornamentation; rounded oblong central hole.

Provenance: Higgins/Turvey Abbey Collection.

Comments: North Island; early nineteenth century (RN).

524 **Plate 95**

Trumpet/flute,*putorino*

1854.12-29.72. Length 42.2 cm.

Wooden trumpet: flat braided-flax bindings, linked together at back. Low-relief *wheku* face around horizontal-B-shaped central hole, with *pakura* and notched haliotis-shell eyes. Blowing end broken, remains of *pakura* around it. Marked in black ink on back: '102'.

Provenance: Grey Collection.

Comments: South Taranaki; 1830s–40s (RN); nineteenth century (DRS).

525 **Plate 95**

Trumpet/flute,*putorino*

1854.12-29.73. Length 38.4 cm.

Wooden trumpet: kiekie bindings. All surface carved in *rauponga* bands; *rauponga* spirals in central area; figure-of-eight central hole.

Provenance: Grey Collection.

Comments: Taranaki; mid nineteenth century (RN).

526 **Plate 95**

Trumpet/flute,*putorino*

1855.12-20.64. Length 28 cm.

Wooden trumpet: kiekie and coarser *mangemange* (?) bindings. *Wheku* face at both ends on same side, both facing inwards; rest of surface covered in *rauponga* with square *pakati*; oblong central hole.

Provenance: Haslar Hospital Collection.

Register: 'Presented by Sir George Grey to Haslar Hospital 1855.'

Comments: Whanganui; 1830s–40s (RN).

References: Andersen 1934: fig. 58B; Best 1925a: 132, fig. 60, second left.

527 **Plate 95**

Trumpet/flute, *putorino*

1905.1-20.1. Length 64 cm.

Wooden trumpet: dark brown; very long; kiekie bindings. Large projecting *wheku* face at blowing end with notched haliotis-shell eyes, joined around back from ears by *manaia* figure. Similar *wheku*-face composition at distal end, looking towards centre, with no provision for shell eye-inlay. Large *manaia* with mouth around central hole: its full female body with large vulva sideways all around trumpet, with feet meeting end of jaws. Plain spirals and *pakura* on central figure.

Provenance: Purchased from H. Hollman, 20 January 1905.

Comments: East Coast, late eighteenth or early nineteenth century, very worn, old (RN); Whanganui, *c*.1860 (DRS).

References: British Museum 1925: fig. 173, second left.

528 **Plate 96**

Trumpet/flute, *putorino*

1915.2-17.1. Length 42.4 cm.

Wooden trumpet: fine braided-flax bindings, linked together by string at back, with three tassels of dog fur attached. Low-relief *wheku* face around B-shaped central hole with haliotis-shell eyes (one missing); simple *manaia* faces above (only one haliotis eye *in situ*), and face at centre rear. All faces with *rauponga*.

Provenance: Edge-Partington Collection.

Register: 'Collected in N.Z. at least 100 years ago.'

Comments: Taranaki, eighteenth century.

References: Andersen 1934: fig. 58E; Best 1925a: 132, fig. 60, second right.

529 **Plate 96**

Trumpet/flute, *putorino*

Q1981 Oc.1629. Length 59.4 cm.

Wooden trumpet: dark, almost black; black braided-fibre binding over much of trumpet. Low-relief face around B-shaped central hole, and in band above and below centre; Janus faces with nose at sides of bands. Carved on back: 'R. R.'; and marked in white ink: '327-1882'.

Provenance: From Victoria and Albert Museum, June 1925; V&A no. 327-1882.

Comments: Taranaki, eighteenth century (RN).

From a large collection of musical instruments formed by Carl Engel, lent and in 1882 sold to the Victoria and Albert Museum (Eth.Doc.1161).

530 **Plate 96**

Trumpet/flute, *putorino*

Q1981 Oc.1630. Length 52.5 cm.

Wooden trumpet: twisted flax-cord bindings. Openwork *wheku* face carved around central hole, not suitable for fingering, with notched haliotis-shell eyes and *pakura*. Marked in white ink: '326-1882'.

Provenance: From Victoria and Albert Museum, June 1925; V&A no. 326-1882.

Comments: East Coast, early nineteenth century (RN).

From a large collection of musical instruments formed by Carl Engel, lent and in 1882 sold to the Victoria and Albert Museum (Eth.Doc.1161).

Trumpets, *pukaea*, *putatara*; bullroarers

531 **Plate 97**

Long trumpet, *pukaea*

LMS 147. Length 58.5 cm.

Wooden trumpet made from two longitudinal pieces, bound all its length with vine (supplejack?), with three turns of braided-flax cord at distal end, which is carved as *manaia* mouth with tooth each side, throat with longitudinal ridge with 7–8 grooves on each side and *pakati* notching around lips. Plain mouthpiece. Marked: '809'.

Provenance: London Missionary Society Collection.

Labels: '162'; 'No.325 LM Socy'.

Comments: Early nineteenth century, good, old (RN); Taranaki, eighteenth century (DRS).

References: Andersen 1934: fig. 69B; Best 1925a: 156, fig. 93B; British Museum 1925: fig. 172; Edge-Partington 1969 I: 384.2; Te Awekotuku 1996: 48–9.

532 **Plate 97**

Long trumpet, *pukaea*

+2354. Length 200 cm.

Wooden trumpet made from two longitudinal pieces: very long, narrow, bound all its length with fine twisted-flax (?) string. Six plain uncarved wooden lobes at distal end with straight divergence and no flare. Mouthpiece, showing construction of two pieces of longitudinal timber, carved with *wheku* face with haliotis-shell eyes and protruding tongue on one side, and low-relief face on other. More binding around mouthpiece.

Provenance: Presented by A.W. Franks, 25 March 1885 (Stevens' sale, Covent Garden, lot 116).

Register: 'War horn unique. Angas copied this one for his folio work (where it is said to come from Owtea on the Thames) see Angas's, New Zealanders pl. 58. fig. XV.'

Label: 'Owtea, Thames, N. Zealand. A.W.F. 25.3.85. Stevens sale. Angas 58.15.'

Comments: Thames, eighteenth century.

References: Angas 1847: pl. 58, fig. XV; Best 1925a: fig. 93C; Edge-Partington 1969 I: 385.1; Hamilton 1901: 416, pl. LVII, fig. 3, right.

533 **Plate 97**

Long trumpet, *pukaea*

1895-356. Length 144 cm.

Wooden trumpet made from two longitudinal pieces, with four lobes at distal end: plain, bound all its length up to mouthpiece with cane/vine? string, under which is another layer of fine twisted-flax string; section next to lobes bound with twisted-flax string.

Provenance: Meinertzhagen Collection.

Comments: North Island; nineteenth century, rough, poor workmanship (RN); eighteenth century (DRS).

534 **Plate 97**

Long trumpet, *pukaea*

1902.8-3.1. Length 68 cm.

Wooden trumpet made from two longitudinal pieces: dark brown, no binding. Body and mouthpiece plain; distal end carved all over outer surface: faces and

interlocking loops in *rauponga* and plain spirals on both sides around raised plain body. Throat with three longitudinal, evenly spaced ridges on each side. Sides of lips mostly plain, except for plain spirals on half of one side, with tooth in curve.

Provenance: Presented by Max Rosenheim.

Comments: Taranaki/Hokianga, beautiful, old, unique (RN); Taranaki (DRS); eighteenth century.

535

Shell trumpet, *putatara*

1895-412. Length 36 cm.

White shell (*Charonia lampas capax*?): long, tapering, plain wooden mouthpiece covered with leaf wrapping and binding of vine, now loose and unravelling.

Provenance: Meinertzhagen Collection.

Comments: Late nineteenth century (RN).

References: Andersen 1934: fig. 66; Best 1925a: 132, fig. 60, right.

536 **Plate 98**

Shell trumpet, *putatara*

1854.12-29.74. Length 25 cm.

White shell (*Charonia lampas capax*?) with some black markings: flat braided-flax binding around wooden mouthpiece carved with Janus face, its top at blowing end. Small, old hole with flax-leaf loop beside shell opening.

Provenance: Grey Collection.

Register: 'Buccinum […] with wooden mouth piece used as a horn by watchmen by night called "pu–kaea–moana".'

Comments: North Auckland, late eighteenth century, old, worn (RN).

References: Edge-Partington 1969 I: 387.4.

537 **Plate 98**

Shell trumpet, *putatara*

1921.10-14.3. Length 26 cm.

White shell (*Charonia lampas capax*?): flat braided-flax binding covered with dark brown resin, around dark-brown wooden mouthpiece carved with Janus head: lower jaw at blowing end, blank eyes, tooth each side. Thick ring of coarse string in hole at upper lip and then four cords depend, of which one ends in large knot and one in three fillets of dog fur on thin skin strips. Small elliptical hole at narrow end of shell opening.

Provenance: Yorkshire Philosophical Society Museum.

Comments: North Auckland, late eighteenth century, old, not much wear (RN).

538

Shell trumpet, *putara*

1933.3-15.24. Length 32.5 cm.

Pacific triton shell: plain, blowing hole near cone end of shell.

Provenance: Bequeathed by William Leonard Loat per Mrs Loat.

Label: 'No. 8.K. Shell trumpet. New Zealand. 1908.'

Bullroarer, *purorohu / purerehua*

4878. Length 34.3 cm.

Wooden bullroarer: oval-shaped, with pointed ends, decorated on both sides with *pitau*-series *kowhaiwhai* outlined in red on natural wood colour.

 Provenance: Purchased from B.M. Wright, June 1868.

 Comments: Nineteenth century.

 References: Te Awekotuku 1996: 48–9.

Bullroarer, *purorohu/purerehua*

4879. Length 29.2 cm.

Wooden bullroarer: oval-shaped, with pointed ends, decorated on both side with *pitau*-series *kowhaiwhai* in natural-wood colour on black background.

 Provenance: Purchased from B.M. Wright, June 1868.

 Comments: Nineteenth century.

 References: Best 1925a: fig. 102A. Edge-Partington 1969 I: 388.4.

Whistle/weka call

1912.5-24.40. Length 6 cm.

Steatite weka call: cone-shaped, with large blowing hole and one small hole at closed, narrow end terminating in shaped knob.

 Provenance: Robertson/White Collection.

 Label: 'Purakanui'.

Whistle/weka call

1994 Oc.4.104. Length 7.5 cm.

Argillite whistle: grey, of flattened-ovoid shape, with gentle in-curve on one side, with round hole below it; pair of low-relief arms around hole, right with hand grasping hole, left extended downwards. Larger round blowing hole at top of wider end.

 Provenance: Collected in the field.

 Comments: Carved by Clem Mellish of Havelock, Marlborough, as contemporary version of weka call **541** (1912.5-24.40). Contemporary art.

Ceremonial, memorial and mortuary objects

In some cases, 'ceremonial' is simply used to describe more elaborate examples of everyday practical objects, such as the stone flax beater carved with a figure, or oversized carved fish-hooks, presumably employed by the *tohunga* ritual expert while blessing a new project. But, as in most cultures, a wide and diverse range of objects can be described as 'ceremonial' or 'ritual', indicating that they were used in activities regarded as religious or non-practical by outside observers. Genealogical staves with their series of projecting knobs served as mnemonic aids to a speaker on a marae reciting his tribal genealogy. Since their obsolescence in the later nineteenth century, this function has to some extent been taken over by carved walking sticks that are a combination of the traditional orators' staves, *tokotoko*, with forms derived from European-style walking sticks, also called *tokotoko*. For direct communication with specific gods, the *tohunga* activated the relevant godstick by applying flax binding and red feathers. The godstick was set up in the ground to be addressed with prayers by the *tohunga*, who received the responses back from the god. Large kites with a human figure were flown to divine the future by their behaviour, most often to indicate the outcome of military activity. Unusually shaped stones or other objects, such as a preserved human head, might be placed in gardens as a *mauri* to protect and nurture the crops. Large ceremonial nephrite adze blades (classified here according to the typology proposed by Roger Duff, 1956) in finely-carved hafts, called *toki poutangata* ('the adze that establishes the man'), were tribal heirlooms carried in oratory by the highest-ranking chiefs. Notches along the edges of a

blade may be genealogical markers of the generations that have held that tribal treasure. Wooden 'knives' set with a row of shark teeth are sometimes said to have been used for butchering meat, or else by women for scarring their chest and shoulders during mourning ceremonies, instead of the usual obsidian flakes or sharp seashells. The function of so-called latrine bars collected by the earliest visitors to New Zealand is still uncertain, with suggestions ranging from the ends of latrine beams (which had important ritual uses), to prows of small canoes, to fishnet handles.

 The Maori honoured their dead by marking their graves with carved figures or by erecting carvings and upright half-canoes as memorials. Large elaborate mausolea painted with curvilinear *kowhaiwhai* patterns commemorated exceptionally important or beloved persons. In some areas, the bones of the dead were recovered after a period, then cleaned and painted with red ochre before being deposited in secluded *tapu* burial caves. Family heirlooms were often buried with the dead but, especially in the case of nephrite treasures, were sometimes recovered later. In northern districts the recovered bones of important deceased persons were placed in wooden burial chests carved with a human or supernatural figure and set upright in the burial cave. Occasionally, the head of an important family member was preserved through a smoking process and kept in the house for periodic mourning ceremonies. Such heads might also be placed among the crops as a protective *mauri*. When Europeans began to collect these preserved heads, some were prepared specifically for sale or in exchange for muskets.

Ceremonial objects

Genealogical staves, *rakau whakapapa*

543
Genealogical staff, *rakau whakapapa*
1895-465. Length 55.5 cm.

Wooden staff: blackened, flat, one edge with twenty-one evenly spaced triangular projections; one end broken and covered with red ochre.

 Provenance: Meinertzhagen Collection.

 Comments: 1880s (RN); nineteenth century (DRS).

544 Plate 99
Genealogical staff, *rakau whakapapa*
1854.12-29.22. Length 103.5 cm.

Wooden staff: brown, flattish, upright figure at top with naturalistic face with male tattoo, three-fingered hands on stomach, body covered in *rauponga*. Scalloped knobs along the length of the staff on one side: top fifteen in *rauponga*, remaining three plain. *Whakarare* along each side of *rauponga* knobs. Upper surfaces of knobs are flat and plain, except for the lowest *rauponga* knob, which has polished piece of nephrite set into it. Barb shape at lower end.

 Provenance: Grey Collection.

 Register: 'This staff records the history of the Ngati-Rangi [Ngaiterangi? Ngati Rangitihi?] tribe. It belonged last to a chief named Te Korokai [of Ngati Whakaue, Ohinemutu, Rotorua?] and was used to aid the memory when a chief was recounting the history of his tribe.'

 Comments: Arawa, 1800s–1820s (RN); Taupo, nineteenth century, Te Heuheu's *whakapapa* stick (DRS).

 References: British Museum 1925: fig. 171; Edge-Partington 1969 I: 375.1; Hamilton 1901: 416, pl. LVII, fig. 4; Te Awekotuku 1996: 31.

Godsticks, *whakapakoko atua*

545 Plate 100
Godstick, *whakapakoko atua*
1854.12-29.15. Length 42.5 cm.

Wooden staff: short, brown, stained with red ochre, with human head carved at top with *wheku* face, large projecting brows, long nose, haliotis-shell eyes, *pakura* on top of brows and around mouth, protruding tongue, teeth at each side of mouth. Lower half of shaft with larger diameter. *Rauponga* around eyes with long curved *pakati*.

 Provenance: Grey Collection.

 Register: 'Wood, the image of the God of War, "Maru". It was decorated with feathers and stuck into the ground when prayed to. The top is painted red and the eyes filled with mother of pearl.'

 Comments: Whanganui (RN); South Taranaki (DRS); early nineteenth century.

 References: Barrow 1961a: 214–5, pl. 8, left; Edge-Partington 1969 I: 389.9; Hamilton 1901: 416, pl. LVII, fig. 2, centre; Simmons and Te Riria 1983: 132, fig. 23.

546 Plate 100
Godstick, *whakapakoko atua*
1863.2-9.6. Length 35 cm.

Wooden staff: short, brown, stained with red ochre, human head carved at top with *wheku* face with large bulbous head, haliotis-shell eyes, *pakura* spirals on brows and around mouth, short tongue across mouth, tooth in upper jaw. Lower half of shaft expanded, with low-relief reversing spirals on one side of its upper section.

 Provenance: Presented by Revd R. Taylor.

 Register: 'This is said to be an image of Maru the god of war it was originally decorated with feathers and stuck in the ground.'

 Comments: Whanganui, early nineteenth century, attributions to particular gods are problematic (RN).

 References: Barrow 1959: 193, pl. 7, left; Edge-Partington 1969 I: 389.10; Hamilton 1901: 416, pl. LVII, fig. 2, right; Neich 1996b: 84; Simmons and Te Riria 1983: 132, fig. 24.

547 Plate 100
Godstick, *whakapakoko atua*
1863.2-9.7. Length 37 cm.

Wooden staff: short, light, brown, stained with red ochre, human head carved at top with abraded *wheku* face with large brows, eyes with deep inset and peg but no haliotis-shell inlay, plain, flat nose, *whakarare* around mouth. Plain shaft with expanded section near base.

 Provenance: Presented by Revd R. Taylor.

 Register: 'Said to be an image of Maru god of war – it was decorated with feathers and stuck in the ground.'

 Comments: Whanganui, early nineteenth century, attributions to particular gods are problematic (RN).

 References: Barrow 1959: 193, pl. 7, right; Hamilton 1901: 416, pl. LVII, fig. 2, left; Simmons and Te Riria 1983: 132, fig. 25.

Ceremonial adzes, *toki poutangata*

548 Plate 101
Ceremonial adze, *toki poutangata*
LMS 156. Length 42 cm.

Hafted adze: brown wooden shaft of circular cross section, heel carved as squatting human figure stained with red ochre, with *wheku* face, ears perforated for additional ornamentation, long tongue joined to *manaia* head carved below, end of which terminates at genital area of figure. Both figures with notched haliotis-shell eyes and surface decoration of plain spirals and *rauponga*. Proximal end of shaft with pattern of criss-crossed bands of *rauponga* and beginnings of drilling for suspension-cord hole above. Blade (Type II B) of vivid mottled dark green nephrite with transverse lashing of thick, braided-flax cord.

 Provenance: London Missionary Society Collection.

 Label: 'No 378 [?]'.

 Comments: Taranaki; 1800s–20s (RN); *c*.1830 (DRS).

549 Plate 101
Ceremonial adze, *toki poutangata*
TRH 20 / 1902 L.1.20 / Royal Collection no. 69980. Length 39 cm.

Hafted adze: dark brown, almost black, wooden shaft of circular cross section, heel carved as sitting male figure with *wheku* face, three-fingered hands grasping erect penis/lizard reaching to figure's mouth. *Koruru* face with haliotis-shell eyes at toe of shaft, *wheku* face at proximal end of shaft. Figure, faces and upper part of shaft all with bands of *rauponga*. Mottled medium green nephrite blade (Type II B), transverse lashing of twisted flax and cotton (?) fibre, decorated with reddish feathers and white goat (?) hair; three tassels of similar hair on twisted-flax string through hole above proximal end of shaft.

 Provenance: Royal Loan 1902, Prince and Princess of Wales.

 Register: 'Modern manufacture.'

 Comments: Arawa, 1880s (RN).

Presented to the Duke by Te Pokiha Taranui.

> He [Te Pokiha Taranui], too, made his present to the Duke, an ancient elaborately carved *toki* (adze) with greenstone blade, handing it to the Royal visitor with stately grace. … He accepted the *toki* with cordial thanks, and kept it in his hand, not putting it with the heap of presents made by the tribe. The Duke … carried the *toki* throughout the Rotorua celebrations, the Maoris greatly appreciating this respect for the badge of chieftainship and for the weapon of many traditions.
>
> (Loughnan 1902: 87).

> The Duke was carrying at the same time the *toki-hohoupu* (greenstone adze) given him by Pokiha Taranui at Ohinemutu the day before [i.e. 14 June 1901]. His doing so was the subject of many pleased remarks among the Maori…'
>
> (Loughnan 1902: 124).

 References: Imperial Institute 1902: 53.308; Loughnan 1902: 87, 124.

550 Plate 102
Ceremonial adze, *toki poutangata*
9338. Length 52 cm.

Hafted adze: brown wooden shaft, circular cross section, heel carved as openwork sitting figure with large head and small, plain body; face with *rauponga* on forehead and notched haliotis-shell eyes; right hand to mouth, left to wrist of right. Entire shaft carved with coarse *rauponga* and plain spirals. Blade (Type II B) of dark green nephrite, transverse lashing of thick twisted flax string.

 Provenance: Sparrow Simpson Collection.

 Comments: Whanganui; 1870s (RN); 1860, a tourist *toki* carved by Wanganui carvers with square block *pakati* – a carved version of a common adze (DRS).

 'New Zealand. Jade axe 7.5 × 3.3 with richly carved wooden handle, eyes of figure set with haliotis shell. Purchased Bryce-Wright Aug. 1869.' (Eth.Doc.1989: W. Sparrow Simpson Notebook 2, no. 257).

551 Colour plate 14
Ceremonial adze, *toki poutangata*
1900.5-19.1. Length 51 cm.

Hafted adze: brown wooden shaft of oval cross section, heel carved as openwork human figure with large head and small body with *wheku* face, hands on chest; *manaia* below, its feet back to body and head reaching up to tongue of *wheku* face, surface decoration of plain spirals and *ritorito*; toe of shaft as simplified face, another *wheku* face at proximal end of shaft, with hole above it. Long, slightly mottled dark green nephrite blade (Type II B) with bevel to front, yet triangular lashing of thin braided-flax cord looks original.

 Provenance: Purchased 19 May 1900 (Rollin and Feuardent, from Wallace Collection, Whitehaven).

Comments: Poverty Bay, 1850s–60s.

'I have also bought the <u>finest</u> Maori adze ever seen, blade 30cm long, of beautifully polished green jade, in its original handle and binding. For this adze I had to pay heavily, but I do not regret it.' (BM PE correspondence: C.H. Read, 22 May 1900).

References: Edge-Partington 1899c: 305–6, pl. xxxv, bottom; Edge-Partington 1900a: 42; Te Awekotuku 1996: 28.

552 Plate 102

Ceremonial adze, *toki poutangata*

1921.10-14.4. Length 40 cm.

Hafted adze: brown wooden shaft of circular cross section, heel of shaft carved as human figure with *wheku* face, looped tongue linking to *manaia* below, its feet back to body; both faces with haliotis-shell eyes, haliotis-shell ring inlay on tongue of figure, surface ornamentation of spirals and *rauponga*. Human face on toe of shaft, small delicate *wheku* head at proximal end of shaft. Remains of thin, narrow twisted-flax string lashing. Long narrow blade (Type II B) of highly polished homogenous dark green (*kawakawa*) nephrite.

Provenance: Yorkshire Philosophical Society Museum.

Register: '"Toki". ("Revd J. Blackburn" on label).'

Comments: 1830s–40s (RN); East Coast, eighteenth century (DRS).

Acquired in 1845 from Revd John Blackburn (Eth.Doc.1912).

References: Hooper 2006: 126.61.

553 Plate 103

Ceremonial adze, *toki poutangata*

1708. Length 53 cm.

Haft only: brown wood of rectangular cross section with definite ridges, heel carved as openwork human figure with high domed head and *wheku* face with openwork looped tongue linked to *manaia* head below, three-fingered hands on chest, lower body grasped by three-fingered *manaia* hands; large *wheku* face at toe of shaft. *Wheku* face at proximal end of shaft, with hole behind it. All faces with notched haliotis-shell eyes, surface ornamentation of plain spirals and *rauponga*. High polish and patina.

Provenance: Unknown.

Comments: Taranaki/North Auckland, 1810s–20s (RN); South Taranaki, c.1840 (DRS).

References: Edge-Partington 1969 I: 379.1; Hamilton 1901: 254, pl. xxxv, fig. 2, right.

554 Plate 103

Ceremonial adze, *toki poutangata*

+251. Length 47 cm.

Haft only: brown wood of circular cross section, heel carved as openwork *wheku*-faced figure, *manaia* head below reaching to and connected with figure's tongue, toe of shaft with *wheku* face; all faces with haliotis-shell eyes and surface decoration of *rauponga*. Proximal end of shaft with simple *wheku* face with some worn *rauponga* around mouth.

Provenance: Presented by A.W. Franks, 1 September 1877 (J.G. Wood's collection).

Register: 'See Wood's Nat. Hist. of Man (America etc) p. 201.'

Comments: Northland; 1800s–20s (RN); c.1830 (DRS).

References: Wood 1870: 201, figure on right.

555 Plate 103

Ceremonial adze, *toki poutangata*

1895-372. Length 59 cm.

Haft only: brown wood of circular cross section, heel carved as recumbent plain human figure with haliotis-shell eyes, hands on chest. Upper half of *koruru* face at toe of shaft with *whakarare* eyebrows, haliotis-shell eyes (one missing); below it plain lizard figure with haliotis-shell eyes, divided tail surrounding *koruru* face. Butt with parallel ridges, remnants of lashing of thick twisted-flax string.

Provenance: Meinertzhagen Collection.

Comments: Hawke's Bay, late 1880s, unorthodox, non-traditional carving composition (RN); reproduction adze haft (DRS).

According to description in Register, originally with 'thin greenstone blade' now lost.

556

Ceremonial adze, *toki poutangata*

4905. Length 23.5 cm.

Blade (Type II B) only: nephrite, pale, mostly homogenous cloudy greyish/brownish green, brown butt, large hole. Strange shovel shape with reduced butt. Water-worn?

Provenance: Presented by A.W. Franks, 18 July 1868.

Register: 'Labelled as having been "found in a Tomb in Greece within a "Cyclopean" enclosure".'

557

Ceremonial adze, *toki poutangata*

9038. Length 29 cm.

Blade (Type II B) only: nephrite, dark green merging into light green at proximal end. Narrow blade, old hole, butt above it broken off; sawing grooves on sides of blade.

Provenance: Presented by A.W. Franks, July 1874.

558

Ceremonial adze, *toki poutangata*

9348. Length 9.4 cm.

Blade (Type II B) only: nephrite, grayish medium green, slightly mottled (inferior *pipiwharauroa?*), old hole.

Provenance: Sparrow Simpson Collection.

559

Ceremonial adze, *toki poutangata*

9350. Length 12.3 cm.

Blade (Type II B) only: nephrite, medium green, mottled, very small hole.

Provenance: Sparrow Simpson Collection.

560 Plate 104

Ceremonial adze, *toki poutangata*

9351. Length 23.7 cm.

Blade (Type II B) only: nephrite, light silvery green, chatoyant, with fish-scale-like pattern (*pipiwharauroa*), very old hole, polished.

Provenance: Sparrow Simpson Collection.

561 Plate 104

Ceremonial adze, *toki poutangata*

+5969. Length 21.5 cm.

Blade (Type II B) only: nephrite, mottled dark and lighter green. Poll rough, grooved on one side.

Provenance: Presented by A.W. Franks, 25 January 1893 (W. Sparrow Simpson Collection).

Register: '"From the grave of a great chief Tomati Walker [Tamati Waka Nene], Onehunga, New Zealand", "This adze belonged to a renowned New Zealand chief Tomati Walker, was found about eight feet from the surface at Onehunga on the River Manakau, having been buried with him", from papers obtained with the specimen by Dr W.S. Simpson. Apr.24 1869.'

562 Plate 104

Ceremonial adze, *toki poutangata*

1854.12-29.61. Length 16.2 cm.

Blade (Type II B) only: nephrite, pale silvery green, with fish-scale-like pattern (*pipiwharauroa?*), thin, flat, small hole in top, another started and abandoned; polished.

Provenance: Grey Collection.

563

Ceremonial adze, *toki poutangata*

1903.11-16.33. Length 20 cm.

Blade (Type II B) only: nephrite, mottled dark and medium green, large cratered hole, notching down both edges.

Provenance: Bequeathed by Francis Brent.

564

Ceremonial adze, *toki poutangata*

1944 Oc.2.827. Length 21.3 cm.

Blade (Type II B) only: nephrite, mottled dark and medium green, cratered hole, notched edges.

Provenance: Beasley Collection. Beasley no. 1457.

Comments: Beasley catalogue: 1457, registered 16 July 1924, 'The Northesk Collection. Sold at Christies. For many years at the Winchester Corporation Museum and later at the Tudor House Museum, Southampton.'

Staves, *tokotoko*

565 Plate 105

Staff, *tokotoko*

5400. Length 140.5 cm.

Wooden, slim staff/walking stick: projecting angled solid figure at top with *wheku* face, hands on back and smaller face at rear; surface ornamentation of *rauponga* and plain spirals. Straight shaft with vertical *rauponga* separated into thirteen bands by lines of zigzag ridge; Janus face below this, above plain lower section. Stained with red ochre, *haehae* black.

Provenance: Presented by A.W. Franks, 21 April 1869 (Cutter).

Comments: East Coast, 1840s, unusual earlier stage of walking stick (RN); Poverty Bay, c.1850 (DRS).

566 Plate 105

Staff, *tokotoko*

7003. Length 93 cm.

Wooden staff/walking stick: thick, spirally (naturally?) twisted, brown. Naturalistic

human face with male tattoo near top, rest with deeply carved spiralling bands of *rauponga*, with small projecting knobs at turning points and some pieces of haliotis-shell inlay. Wide, closely spaced *pakati*.

Provenance: Sparrow Simpson Collection (presented 14 November 1870).

Comments: Taranaki, 1860s (RN).

567 Plate 105
Staff, *tokotoko*
7221. Length 117.5 cm.

Wooden staff/walking stick: brown, lower part of square cross section, its sides decorated with rolling spirals, zigzag *haehae* patterns and diamond shapes filled with *pakati* and *koru* patterns; upper part slimmer, of circular cross section terminating in sinuous squatting male figure in openwork with *wheku* face, S-shaped body with arms around legs; face and legs with *rauponga*, body left plain with ridged facets.

Provenance: Sparrow Simpson Collection (presented 21 April 1871).

Comments: Taranaki; 1810s–30s (RN).

568 Plate 105
Staff, *tokotoko*
7222. Length 146 cm.

Wooden staff/walking stick: brown, of rectangular cross section, with tapering pointed lower and upper ends, each side decorated with sharply metal-cut rolling spirals, except for middle section which is plain and of oval cross section.

Provenance: Presented by A.W. Franks, 25 May 1871 (Davis).

Comments: Probably Northland, 1850s (RN).

References: Edge-Partington 1969 I: 385.4.

569
Staff, *tokotoko*
7992. Length 113 cm.

Wooden staff/walking stick: brown, of diamond cross section, slightly widened and flattened towards lower end, small plain lobed terminal at top.

Provenance: Presented by R.G. Whitfield, 31 July 1872.

Comments: Mid nineteenth century (RN).
References: Edge-Partington 1969 II.1: 233.9.

570 Plate 106
Staff, *tokotoko*
+6194. Length 50.5 cm.

Wooden staff/walking stick, upper part only: brown, with well-modelled three-dimensional head at top *wheku* face with plain knob or topknot, *rauponga* on face, plain circular eyes, small *manaia* faces at top of eyebrows carved to rear; smaller similar *wheku* face further down shaft, which is sawn off.

Provenance: Presented by A.W. Franks, 25 July 1893 (E. Cutter).

Comments: Rongowhakaata, 1840s, *toko wananga* (RN).

571 Plate 106
Staff, *tokotoko*
1895-69. Length 83 cm.

Wooden staff/walking stick: brown, top with stylized face in gently curving plain high-domed pointy head, haliotis-shell eyes;

rest of shaft with surface ornamentation in eight sections, separated by horizontal bands of *rauponga* (five sections of diagonal *rauponga*, two sections of *whakarare*, one section of *taratara-a-kai*); below two upper *rauponga* sections and above *whakarare* sections is Janus face with haliotis-shell eyes.

Provenance: Presented by A.W. Franks, 23 April 1895.

Register: 'Maori Toko-Toko formerly property of a chief who was killed at the eruption of Mt Tarawera. Procured from a native interpreter on a visit to the celebrated terraces just before they were destroyed.'

Comments: Te Arawa/Ngati Tarawhai, early 1880s (RN).

572 Plate 106
Staff, *tokotoko*
1895-374. Length 60 cm.

Wooden staff/walking stick: light brown, diamond cross section, lower end broken off, top end curved and terminating in naturalistic head with carved hair, female tattoo and red sealing-wax eyes; below it on opposite side, human figure in low relief with spirals and *haehae*, hands on stomach, tongue extended to form narrow edge of shaft. Surface ornamentation of zigzag *haehae* with central line of chevron *pakati*.

Provenance: Meinertzhagen Collection.

Comments: Hawke's Bay (RN); East Coast (DRS); late nineteenth century.

Other ceremonial objects

573 Colour plate 15
Shark-tooth knife, *maripi*
NZ 166. Length 23.5 cm.

Wooden knife with five shark teeth: upper half crudely carved as openwork simplified human figure, with teeth inserted into groove in figure's back and lashed with twisted vegetable-fibre string; stained with red ochre, with horizontal black bands on body and black in eyes and mouth; twisted-flax string around proximal end of handle.

Provenance: Cook Collection.

Comments: Eighteenth century; East Coast style (DRS).

References: Hamilton 1901: 252, pl. XXXIV, fig. 1, second left; Kaeppler 1978: 198.

574 Colour plate 15
Shark-tooth knife, *maripi*
NZ 167. Length 24.5 cm.

Wooden knife with four shark teeth: upper half carved as openwork human figure, face with *pakura*, body with various permutations of parallel grooves; finely notched haliotis-shell inlay on each side behind face, and one small piece on left hand. Teeth are inserted into groove in figure's back, lashed with string and caulked with resin (?); length of thinner string was attached to knife below teeth – now separated. Handle terminates in plain *manaia* head, above it hole with thick twisted-flax string. Traces of red ochre.

Provenance: Unknown.

Comments: Whanganui, 1800s–20s (RN); Whanganui/Cook Strait, possibly Cook (DRS).

References: Hamilton 1901: 252, pl. XXXIV, fig. 1, second right.

575 Colour plate 15
Shark-tooth knife, *maripi*
1854.12-29.9. Length 24 cm.

Wooden knife with seven shark teeth: upper half carved as openwork *manaia* figure with haliotis-shell eyes, similar eyes in secondary *manaia* head in in-curved back of main figure; surface decoration of *unaunahi* and *pungawerewere*. End of handle as simplified, very worn face with terminal loop through which leather suspension cord is threaded. Surface ornamentation very worn. Teeth are inserted into groove in front of main *manaia* and fixed with resin (?); no lashing.

Provenance: Grey Collection.

Register: 'An ancient sacrificial knife used by the high priest Totaki to take out the human heart as an offering to the gods.'

Comments: Hokianga; 1800s–20s (RN); eighteenth century (DRS).

References: Archey 1977: 85, fig. 180; Barrow 1969: fig. 166 (incorrectly attributed to Hunterian Museum, correct text with fig. 164); British Museum 1925: fig. 170; Edge-Partington 1969 I: 383.2; Hamilton 1901: 252, pl. XXXIV, fig. 1, first right; Neich 1996b: 80.

576 Colour plate 15
Shark-tooth knife, *maripi*
1854.12-29.71. Length 27.5 cm.

Wooden knife with four shark teeth: long, narrow, solid. Top as simplified face with haliotis-shell eyes, halfway down small finely detailed human figure, modern hole in proximal end of handle. Entire surface ornamented with plain spirals and *rauponga*, teeth inserted into groove and lashed with flax string and caulked with resin (?).

Provenance: Grey Collection.

Comments: Whanganui, 1830s–40s (RN); Poverty Bay (DRS).

References: Edge-Partington 1969 I: 383.3; Hamilton 1901: 252, pl. XXXIV, fig. 1, first left.

577 Plate 109
Bone fork
+6160. Length 20.5 cm.

Tubular bone fork with four (possibly more) teeth, only one of which is complete. Upper half carved in openwork as female body, decorated with spirals and *rauponga*, its head missing. Below, body surface ornamentation of *pakati* in *raumoa* ovals.

Provenance: Presented by A.W. Franks, 29 June 1893 (Bateman Collection).

Comments: East Coast, 1840s (RN).

References: Edge-Partington 1969 II.1: 223.2; Hamilton 1901: 414, pl. LVI, fig. 2; Keyes 1976: fig. 8; Keyes 1980: 41–2, fig. 3; Phillipps 1955: 125, fig. 3.

578 Plate 107
Latrine bar?, *paepae tapu?*
NZ 66. Length 23.5 cm.

Wooden object: brown, roughly oblong. Large *wheku* face with haliotis-shell eyes (right one missing) at one end, *pakura* on brows, around mouth and on tongue, lower part of mouth broken off; small plain *wheku* face at other end, *manaia* face extending into one limb, with *rauponga*, on upper surface of shaft; lower surface left plain. Deep slots on each side of shaft, each with two rectangular perforations cut through.

Provenance: Unknown.

Register: 'Probably portion of some household implement or utensil. Possibly appendage to a fishing rod…'

Comments: East Coast, possibly Cook (DRS).

References: Anon. 1926: 351; Phillipps 1955: 149, fig. 30, upper.

Latrine bar?, *paepae tapu*?

7361. Length 25.5 cm.

Wooden object: dark brown, roughly oblong. Large *wheku* face with female body behind at one end: large shoulders, hands to chest, webbed feet up to chin, *pakura* on shoulders, arms and hands, plain spirals on buttocks. Small *wheku* face at other end. Elongated bodies with hands and feet on both upper and lower surfaces of shaft. Deep slots on both sides of shaft with two rectangular perforations cut through.

Provenance: Presented by A.W. Franks, 5 September 1871 (Wareham).

Comments: Poverty Bay; 1800s–20s (RN); eighteenth century (DRS).

References: Anon. 1926: 351; Edge-Partington 1969 II 1: 230.3; Hooper 2006: 125.59; Phillipps 1955: 149, fig. 30, lower.

580 **Plate 108**

Carved head, *whakapakoko rahui*

1854.12-29.91. Length 34 cm.

Wooden human head: stained dark brown, modelled on form of preserved human head, *mokomokai*. Full male tattoo, haliotis-shell eyes with fake furry eyelashes; mouth stretched open with three shell teeth in upper jaw and sockets for three in lower. Square-cut hole in each ear. Upside-down plain *wheku* face with haliotis-shell eyes (one missing) projecting from upper rear. Countersunk lashing hole at rear, above vertical round socket through chin.

Provenance: Grey Collection.

Register: '…it has been placed over the door of a house.', 'In Auckland Museum a similar specimen is labelled "Whaka-pakoko-rahui" a warning against trespassing on tapu lands.'

Comments: East Coast, 1820–40s (RN); Taranaki (?), canoe mask (DRS).

References: Barrow 1969: fig. 32; Barrow 1984: 24.

581 **Plate 108**

Carved head

1944 oc.2.807. Length 29 cm.

Wooden human head: dark varnish, copy of preserved human head *mokomokai* with deeply carved full male tattoo, haliotis-shell eyes, five bone teeth extant, presumably some missing. Slightly hollowed out at back but no attachment devices; old cutting facets on back (stone tools?).

Provenance: Beasley Collection. Beasley no. 1934.

Label: 'Native name: Mokaikai rakau (an effigy head of a dead chief reproducing the original dried head).'

Comments: East Coast, 1830s (RN); mask for under a trapezoid prow, this looks like the work of Captain Little of Bath (DRS).

Beasley catalogue: 1934, registered 15 November 1926, 'The Peek collection. Collected between 1850–80 of Rousden, Devon. Purchased of the Grandson. Sir

Wilfrid Peek Bart. … Recorded in Journal of the Polynesian Society. P.291 Vol.38 1929.'

References: Beasley and editors 1929: 291–2, fig. 1.

582 **Colour plate 16**

Figure container

1904-245. Height 64 cm

Wooden container: brown, traces of red ochre, in form of human figure. Full male tattoo, square-cut hole in each ear for decoration, three-fingered hands on chest, penis; spirals with straight *pungawerewere* on shoulders, plain area below shoulders, diagonal *whakatara*-type *ritorito* on chest, lines of it around lower stomach and on legs and feet; legs carved as flat loops of wood with perforation behind; sawn off across bottom below feet. Shallow rectangular cavity in back; whole back of head and body sawn off flat, new sharply rabbeted section cut out of back for lid (missing) to be nailed in – nail holes still show. Remnants of clay pipe still in mouth.

Provenance: Higgins/Turvey Abbey Collection.

Comments: Eighteenth century; Arawa (?), old stone-tool work (RN); East Coast, a repository for a tapu object, in this case a sacred adze named Iriperi ko Tama (DRS).

References: Archey 1967: pl. 46.2; Te Riria and Simmons 1989: 19; Te Riria and Simmons 1999: 13.

583 **Plate 107**

Relic box?

6262. Length 52 cm.

Wooden oblong box: *papahou*-shaped, but with lid at narrow side and long projecting handle at one end; at opposite end projecting *manaia* in openwork and *wheku* head below projecting upwards, both heads sharing one body. Lid with projecting *wheku* head at one end and projecting *ruru* face and small *manaia* at other. Flat, large sides of box with *manaia* face at each corner, except one missing. Surface covered in longitudinal *whakarare* dividing areas of *rauponga* spirals and *rauponga*. Handle with Janus face broken off. All *manaia* faces with haliotis-shell eyes.

Provenance: Presented by A.W. Franks, 26 March 1870 (Mrs Lamb).

Comments: East Coast, 1850s (RN); this would seem to be a Christian cult object for holding the scriptures (DRS).

References: Edge-Partington 1969 I: 368.1; Hamilton 1901: 430, pl. LXIV. fig. 1.

584 **Plate 109**

Bowl with lid, *kumete whakairo*

1895-357. Length 34.5 cm.

Wooden bowl supported by dog figure at each end, two *ruru* faces underneath, all carved from one piece. Lid with lizard in high relief on top, fluted inside. Surface decoration of *rauponga* with some *whakarare* on box, *pakura* on lid rim and *taratara-a-kai* on dogs' faces and lizard. Bowl wobbly, will not stand straight.

Provenance: Meinertzhagen Collection.

Comments: Tarawhai, 1900–10, definitely by Ngati Tarawhai carver, probably Neke Kapua (RN); Rotorua, c.1885, the work of Tene Waitere (DRS).

References: Neich 2001: 368, no. 196, fig. 15.23.

585 **Plate 110**

Ceremonial flax beater?, *patu muka*?; or weapon?

1896.11-19.5. Length 29.5 cm.

Stone beater/club of light-grey coarse vesicular andesite: on one side, carved in low relief, a stylized human figure (only face, arms and legs indicated) with face at wide end of beater, on other lizard (?) body in reversed position with its human-form face on butt; wide groove at distal end of beater.

Provenance: William Strutt Collection.

Register: 'Maori club found by Mr William Strutt in the forest land of the Mangarei? [Mangorei, 3 km south of New Plymouth] District, Taranaki, New Zealand, near Mount Egmont. This specimen is unique, the Maoris were unacquainted with any similar weapon. Found in 1855.'

Comments: Taranaki, Eighteenth century.

References: Davidson 1996: 17.

586

Stone ring, *mauri*

1927.7-6.1. Diameter 16 cm.

Brown, dense concretion, natural stone.

Provenance: Presented by G.G. Harrop.

Register: '"Mauri" used as charm.'

References: Best 1924, vol. 1: 305.

587 **Colour plate 15**

Kite, *manu tukutuku*

1843.7-10.11. Width 207 cm.

Composite kite in form of human figure. Framework is of sticks, body and horizontals on wings of peeled saplings, probably manuka or kanuka, other sticks used are much thinner and some show notching that may be leaf scars if plant used is climbing fern *mangemange*, all covered with commercial fabric, legs wrapped with same. Head is of wooden framework also covered with fabric attached with stitches of thread, with finely painted male tattoo and haliotis-shell eyes secured by large knots of flax fibre which form pupils. Small bunches of brown split feathers are attached to ends of wings and legs.

Provenance: Presented by Mr Reid/Reed/Read.

Register: 'Brought by Capt. Manning from Plenty Bay.'

Comments: Bay of Plenty; c.1840 (DRS).

References: Barrow 1984: 103; Best 1925a: fig. 28; Chadwick 1931: pl. IV.2; Edge-Partington 1969 I: 369.3; Maysmor 1990: 23–4, 29–30, 79; Newell 2006: 36–43; Starzecka 1996: 150.

588 **Plate 109**

Pennant

Q1982 oc.705. Length 254 cm.

Triangular flax pennant: warps not rolled or beaten, alternating double and single pair wefts at wide end, double pair at narrow end. Bunch of kaka feathers sewn to tip, across wider end band of feathers sewn into place. Along both side edges feathers have also been sewn, but most now missing. Profile of man's head embroidered at wide end with red and maroon thread, bunch of kaka feathers sewn on as hair, pieces of bird skin with white feathers at ear. Attempt to depict cloak by attaching maroon cord to represent *hukahuka* tags. Behind top

of head: representation of lizard. All decoration applied to both sides of pennant.

Provenance: Unknown.

Comments: Nineteenth century (MP). Probably Ringatu banner (DRS); for comparison see Binney 1995: pl. 4 (DCS).

589
Wall hanging
OC.1990 L.I.3 / Royal Collection no. 74071. Length 64.5 cm.

Rectangular woven flax wall hanging: fringe of warp ends left at commencement at bottom edge; woven in double-pair twining with four horizontal bands of weka and kereru feathers. Between these, and above and below, are horizontal bands of openwork formed by diverting selected warps, and five wefts carrying decorative brown-dyed (with *tanekaha* bark) flax-fibre cords; near bottom another band of openwork, separated from fringe by bands of braiding (flat six-strand braids). Hanging bar of wood threaded through braided loops at top, with eight-strand square braid attached to its ends.

Provenance: Royal Loan 1990, Her Majesty Queen Elizabeth II.

Comments: Made by Diggeress Rangitamira Te Kanawa. Presented to the Queen by Maori Women's Welfare League at reception ('Hui Mana Wahine') held at Government House in Wellington on 8 February 1990, and accompanied by following text:

> "Aotearoa". The wall hanging is symbolic of Aotearoa, with muka flax fibre a motive of growth, interweaving of peoples, the pattern of cream a myriad of stars, Nga Purapura Whetu the sky itself, brown feathers of the weka denote Papatuanuku mother earth, white – green of the kereru (pigeon) the Moana Nuiakiwa the ocean caressing our islands and those of the Polynesian peoples.
> (BM AOA correspondence: Jacqui Dean, New Zealand High Commission, 4 May 1990)

Contemporary art.

Memorials and mortuary objects

590
Plate 111
Tomb figure
1850.7-3.1. Height 110 cm.

Wooden standing male figure: black, plain, hands on stomach, erect penis, naturalistic face with weathered traces of painted tattoo; square-cut holes near ears and around head for decoration, nails in head to hold feathers. Flange at back, support post cut off below feet.

Provenance: Presented by E. Hodgson.
Comments: Te Ati Awa, 1848 (RN).

> It is from the grave of Warepori [Wharepouri], a chief of the Nga-te-awa [Te Ati Awa], a tribe inhabiting the shores of Cooks' Straits and the neighbourhood of Port Nicholson. Dr Dieffenbach in describing similar images remarks 'they are intended as portraits of the deceased'. Mr Brees in describing the spot from which the image was taken speaks of it as the 'effigy' of Warepori, from which I should assume that it is a rude attempt to represent the features of the chief and has so far a more strict ethnological value.
> (BM ME correspondence: E. Hodgson, 11 March 1850)

Te Wharepouri lived at Ngauranga on the western side of Wellington Harbour between Petone and Wellington. He died on 22 November 1842 and was buried at Petone. A cenotaph memorial for him was erected in 1848 at Ngauranga by Rawiri Te Motutere, grandfather of Mere Ngamai, who lived there (RN).

> A large canoe was first sawn into three pieces transversely, the middle part was then supported on six posts, and the two extremities placed together and raised up on their ends, a bunch of feathers terminating the top. A small effigy of Warepori [Wharepouri] was also set up by the side. The monument was finished by painting with red ochre, ornamented with scrollwork, and tapued, or rendered sacred.
> (Brees 1850:23).

References: Best 1918: 168; Brees 1847: 8; Brees 1850: frontispiece, 23; Neich 2004: 63.

591
Burial chest, *waka koiwi*
1944 OC.2.810. Length 96 cm.

Wooden container: light brown, rough, plain, triangular cross-section base with cavity cut into it, flat lid; three lashing holes in each side of cavity, no lashing holes on lid; left rough at one end (base?), other end shaped into rounded point (top?), slight rabbet for lid at top end.

Provenance: Beasley Collection. Beasley no. 3847.

Comments: Probably bone chest designed to stand in cave (RN).

Beasley no. 3847 is incorrect; no. 3847 in Beasley's catalogue is 'jade mere'; perhaps it is no. 3843, registered 11 July 1935, 'Bt Sothebys. New Zealand. Plain wooden bone box and cover. 36 in long (ex lot 86), from the coll. of Lt Col. Sir F. Mac Clean…'.

592
Plate 111
Burial chest, *waka koiwi*
1950 OC.11.1. Height 93 cm.

Wooden container in form of human figure: very eroded, back hollowed out in rectangle, probably male judging by testicles (?) shown. Face carved in low relief: tattoo around mouth, large oval eyes and brows, elongated nose, *rauponga* across brow, ears with square holes for attaching decoration, two small plain spirals under chin. Left side of body damaged, right side preserved: flat shoulder and arm, spiral with *unaunahi* on shoulder, *unaunahi* down arm and on fingers which extend over stomach; three fingers on hand, each with *unaunahi*, space between them in *rauponga* with large squared raised *pakati*. Spiral with *unaunahi* on chest (side) and stomach (central), plain spiral on side of hip, feet with toes. Traces of red ochre in grooves.

Provenance: Purchased from Town Clerk, Bideford, Devon.

Register: '"Papa kowi" – burial chest. Probably collected by Capt. A.J. Higginson, in whose daughter's possession it was until a few years ago. She bequeathed it to a Miss Venables, who gave it to Bideford Museum. Capt. Higginson is said to have visited New Zealand in the mid-19th century in a clipper. He probably obtained the chest at the Bay of Islands, where the majority of the other known specimens were found in caves near the coast.'

Comments: Eighteenth century.

References: Barrow 1969: figs 131–2; Barrow 1984: 101; Cranstone 1952: 58–9, pl. XXV; Fox 1983: 48–9, pl. 69; Hooper 2006: 121.53; Neich 1996b: 102.

593
Preserved human head, *mokomokai*
NZ 69.

Male, black hair, tattoo not complete, no cheek spirals, eyes stitched in part; skin cut/torn and stitched in four places: from right upper lip to cheekbone, from right earlobe to cheek, from hairline along right cheekbone, on left bottom of skull; traces of woodworm on face. No post-mortem work. Label inside lower jaw: '302. Mr Home'.

Provenance: Unknown..

Comments: West Coast of North Island, c.1820–30 (DRS).

One of 593 (NZ 69), 594 (NZ 70) or 595 (NZ 71) may be the head given to the Museum by John Lubbock: 'My dear Franks, I have sent the Museum a New Zealand head which I believe rather a good specimen of tattooing. If however you do not care to keep it perhaps you will advice me next time I see you where I had better send it.' (BM PE correspondence: J. Lubbock, 6 April, no year, but filed in Pre-1896 Box). The letter is annotated: 'Kept'

References: Robley 1896: 192.

594
Preserved human head, *mokomokai*
NZ 70.

Male, dark-brown hair, traces of moustache and beard, tattoo not complete, right side left clear, left side sketched in with incised line, left rough underneath. Slight post-mortem work. Gash on back of skull with skin stitched together, damaged skin around eyes and over nose bridge.

Provenance: Unknown, but see 593, Comments.

Register: 'Post-mortem work. TT Barrow.'

Comments: West Coast of North Island, c.1820–30 (DRS).

References: Robley 1896: 191.

595
Preserved human head, *mokomokai*
NZ 71.

Male, black hair, moustache, complete tattoo, no post-mortem work; nose plugged and padded; finished underneath with cane ring stitched to skin.

Provenance: Unknown, but see 593, Comments.

Comments: West Coast of North Island, c.1820–30 (DRS).

References: Robley 1896: 190.

596
Preserved human head, *mokomokai*
+1998.

Male, black hair, complete tattoo, some post-mortem work, eyes stitched; small neat aperture underneath, but no finishing.

Provenance: Presented by A.W. Franks, 1882 (exchange with Sheffield Museum).

Comments: West coast of North Island, 1820–30 (DRS).

From Bragge Collection given to Sheffield Museum in 1881 (Gill Woolrich, Sheffield Museum: pers. comm. 4 May 2007).

References: Robley 1896: 193.

597
Preserved human head, *mokomokai*
1925-46.

Male, reddish hair, tattoo not complete, eyes with red sealing wax, yellow skin, rough cut underneath, no finishing. Skin cut/broken and stitched on right chin and lower jaw; piece of skin missing on left lower cheek (must have been stitched originally, as there are puncture marks along the edge of remaining skin).

Provenance: Purchased from Devizes Museum.

Comments: West coast of North Island, 1820–30 (DRS).

From T.B. Merriman Collection, acquired by Devizes Museum in 1869 (Eth.Doc.588).

598
Preserved human head, *mokomokai*
1913.5-19.1.

Male, sparse black hair, beard, complete tattoo, much post-mortem work. Rough cut underneath. Gash on top rear skull, skin stitched together. Badly damaged skin around eyes.

Provenance: Presented by Miss Bacot.

Register: 'Tatued head of a Maori, given by Lord Erskine to donor's great-grandfather (Dr Rickward of Horsham).'

Comments: West coast of North Island (DRS).

599
Preserved human head, *mokomokai*
1921.10-14.1.

Male, black hair, complete tattoo faint, slight post-mortem work but most original, teeth, cut away rough underneath – no band or stitching. Hole in top of skull, slightly right of centre, damage to skin in inner corner of left eye.

Provenance: Yorkshire Philosophical Society Museum.

Comments: West coast of North Island, c.1820–30 (DRS).

Weapons

As a proud, warlike people, the Maori were quick to protect their personal reputation and mana, preferring hand-held close-combat weapons rather than long-distance projectiles. Men became famous for their prowess with particular weapons. Even most spears were used as thrusting weapons at close quarters, sometimes through the palisades of a fortified village or downwards from a fighting stage or earthwork embankment. The only true projectile weapon was the whipsling, or *kotaha*, a short stick with an elaborately carved finial and a cord at the other end wound around a light dart, *teka*, which was jerked over a man's shoulder to launch the dart from its upright position standing in the soil. But *kotaha* were seldom used and soon became obsolete.

An extensive range of very specific close-combat clubs was standard throughout the country. Two-handed long clubs, or rather staves, were of three types, all modelled on the same basic pattern. Te Rangi Hiroa (1950:276) argued for their local evolution from the *pouwhenua*, representing the ancestral Polynesian type, to the *tewhatewha*, to the *taiaha*. In the *pouwhenua*, a simplified carved head was introduced into the original Polynesian spear-pointed club to separate the blade from the point. In the *tewhatewha*, the blade above the head has one edge extended into a wide vane giving weight and direction to the other striking edge. In the *taiaha*, the Maori carver has elaborated the simplified head into a fully carved Janus face with the long point shortened and transformed into its tongue. The *taiaha*, often called a *hani* in earlier times, became the most favoured and most common Maori two-handed weapon. Almost all of the two-handed clubs were made of wood, but there are rare examples cut from whalebone, although some of these are clearly only ceremonial items. One type of long weapon always made from whalebone is the *hoeroa*, but its actual use is problematic between a two-handed club, a throwing stick or a staff of office.

Single-handed clubs, usually known by the general term of *patu*, included a wider range of types and materials. But again, each specific type followed a general pattern of a short handle, usually with an enlarged proximal butt often carved in various forms, and a spatulate blade with various modifications to its edges, especially in the case of the bone and wood items. Nephrite and other stone clubs preserved the simple spatulate form, while the *kotiate* type had a sinus introduced into both edges and the *wahaika* type had a projecting figure carved into an enlarged sinus on one edge of the blade. All these weapons were used with a thrusting and cleaving stroke rather than as a bludgeon. Another variant and rarer type of true club was the wooden or occasional bone *patuki*, with four flat or slightly concave sides often carved with repeating surface patterns.

When steel axe blades became available from European traders and missionaries, Maori very quickly adapted them as weapons. Axe blades were mounted on a short wooden or whalebone handle to produce a single-handed weapon called a *patiti* that became a favourite in New Zealand combat. Steel axes mounted on a long handle called a *kakauroa* became the counterpart of the two-handed traditional weapons, but were never as popular as the *patiti*.

Spears, darts, whipslings

Spears, *tao*, and darts, *teka*

600 Plate 112
Spear, *tao*
NZ 72. Length 288.5 cm.

Wooden spear carved from one single piece: reddish brown, single point with six barbs (one damaged) on each side and flat, projecting flange on one side at proximal end. Full figure carved at junction of shaft and point: feet towards point, male, erect penis, *wheku* face, large mouth, right hand behind mouth, left on chest, rudimentary spiral on left shoulder, otherwise plain; coarse, blocked-out carving.

Provenance: Cook Collection.

Register: 'Cook: Coll. See Add. MS. 23, 920, p. 70.'

Comments: East Coast, eighteenth century. None of the weapons depicted in Register reference is NZ 72.

References: Kaeppler 1978:194.

601 Plate 112
Spear, *tao*
NZ 73. Length 267 cm.

Wooden spear carved from one single piece: dark brown, two parallel points with seven pairs of very shallow barbs, plain shaft, carved at junction of points with shaft with Janus faces with deeply cut eyes and circular mouth with square tongue; squared sides, very rough carving, rudimentary spiral on one side of faces, ear on other.

Provenance: Cook Collection.

Comments: Whanganui, eighteenth century.

References: Edge-Partington 1969 I: 386.1; Hamilton 1901: 242, pl. XXIX, fig. I, right; Kaeppler 1978: 194.

602
Spear, *tao*
6021. Length 190 cm.

Wooden spear: dark brown, circular cross section, tapering at both ends, plain.

Provenance: Purchased 31 January 1870 (Wareham).

Comments: eighteenth/nineteenth century (RN); eighteenth century (DRS).

603 Plate 112
Spear, *tao*
8345. Length 193 cm.

Wooden spear: brown, circular cross section, shaft tapered to proximal end; sharp point, painted black, with enlarged section below on which are carved two opposing pairs of faces (each face different), alternately facing in opposite directions, with surface ornamentation of *rauponga*.

Provenance: Presented by Arthur Bridge, 26 June 1872.

Comments: Whanganui, eighteenth century.

References: Edge-Partington 1969 I: 385.2; Hamilton 1901: 242, pl. XXIX, fig. I, centre.

604
Spear, *tao*
+4647. Length 187.7 cm.

Wooden spear: light brown, shaft of oval cross section expanding into flattened blade at proximal end; point with six sets of opposing barbs – four internal, each with two barbs, distal set with four barbs, and proximal set with three. Point separated from shaft by short section of vertical elongated *rauponga* spirals.

Provenance: Received in exchange from Salford Museum, Manchester, 4 March 1890.

Comments: Northland; late eighteenth / early nineteenth century (RN); 1860 (DRS).

References: Edge-Partington 1969 I: 384.1; Hamilton 1901: 242, pl.XXIX, fig. I, left.

605
Spear, *tao*
1895-424. Length 110 + 78.5 cm.

Wooden spear: brown, circular cross section, tapering at both ends, plain; cut in two pieces.

Provenance: Meinertzhagen Collection.
Comments: nineteenth century (RN).

606
Spear, *tao.*
1895-425. Length 65.5 cm.

Wooden spear: brown, proximal portion of circular cross section, butt end pointed and of rectangular cross section.

Provenance: Meinertzhagen Collection.
Comments: Nineteenth century (RN).

607
Spear, *tao*
1944 Oc.2.794. Length 218.2 cm.

Wooden spear: brown, circular cross section, tapering at both ends with very slim, sharp point. Wide band of ornamentation of *rauponga* and *pakura* on shaft towards proximal end.

Provenance: Beasley Collection. Beasley no. 2709.

Comments: East Coast (RN); Poverty Bay (DRS); eighteenth century.

Beasley catalogue: 2709, registered 1 February 1931, 'Blackmore Museum. Long slender spear … name koi koi.'

608
Spear, *tao* / **dart,** *teka,* **for whipsling**
NZ 74. Length 170 cm.

Wooden spear/dart: light brown, circular cross section, tapering towards pointed distal and rather blunt proximal ends. Wide band of deeply carved vertical *whakarare* ornamentation near distal end.

Provenance: Unknown.
Comments: Whanganui; eighteenth century (RN).

References: Edge-Partington 1969 I: 385.3.

609
Dart, *teka,* **for whipsling**
1854.12-29.117. Length 129 cm.

Wooden dart: light brown, very slender, plain, circular cross section, tapering towards sharp point; proximal end broken off and lost.

Provenance: Grey Collection.

Comments: According to description in Register originally the broken-off proximal end had 'two bands of leaf like design, wrapping of fine twine' and the original total length was 162 cm.

Perhaps it is 'spear', named 'Hauhakiriwai', presented to Grey by Ngati Awa chiefs in 1853, although it is too short for a spear, is not 'ornamental' and does not have red feathers:

> A large concourse of Natives of the Ngatiawa Tribe met at Hoewaka on the 28th of December, 1853, for the purpose of preparing and signing a valedictory Address to his Excellency Governor Grey on the occasion of his leaving New Zealand; and on the 11th of January, 1854, the document in question was delivered to G.S. Cooper, Esq., together with an ornamental spear, which were to be forwarded to Sir George Grey at the convenient opportunity. … These men stood up to bid adieu to the Governor; and the token of their affection is a spear ornamented with red feathers, the name of which is 'Hauhakiriwai'.
> (Davis 1855: 86, 91)

Whipslings, *kotaha*

610 Plate 113
Whipsling, *kotaha*
NZ 75. Length 150 cm.

Wooden whipsling: dark brown, top carved as female *wheku* figure with splayed vulva, hands on chest, feet to chin; *whakarare* on brows, mouth and tongue, plain spirals on shoulders and buttocks. Plain shaft with band of lashing of twisted-flax string at end.

Provenance: Cook Collection.

Register: 'In the United Service Instn's Museum are similar objects labelled "Tabu wands". Now in BM.'

Comments: Poverty Bay (RN); Cook Strait (DRS); eighteenth century.

References: Edge-Partington 1899a: 304–5, pl. XXIV.4; Edge-Partington 1969 I: 380.2; Kaeppler 1978: 194; Starzecka 1979: figs 55, 56; Te Awekotuku 1996: 37.

611 Plate 113
Whipsling, *kotaha*
NZ 76. Length 146 cm.

Wooden whipsling: reddish brown, top carved as simple rudimentary figure with plain spirals on limbs and *rauponga* on brow and mouth; plain shaft with slight groove around end.

Provenance: Cook Collection.

Register: 'In United Service Museum similar objects are labelled "tabu wands". Now in the BM.'

Comments: East Coast, eighteenth century.

References: Edge-Partington 1899a: 304–5, pl. XXXIV.3; Kaeppler 1978: 194.

612 Plates 113, 115 and 116
Whipsling, *kotaha*
1896-1169. Length 150.5 cm.

Wooden whipsling: dark brown, top carved as female *wheku* figure with splayed vulva with small aperture, legs to chin, hands on sides of body, *pakura* on brow and mouth, plain spirals on shoulders and buttocks, *pakura* on limbs, haliotis-shell eyes. Prone figure at mid-shaft facing towards finial: *wheku* face, hands on stomach, legs doubled under, no sex, haliotis-shell eyes, *pakura* on brow and mouth, plain spirals on shoulders and hips. Small Janus *wheku* face with *rauponga* mouth at end. Thin shaft.

Provenance: United Service Institution Museum.

Register: 'Tabu stick of the chief Utatee, Marquesas Islands. Presd by Capt. Duckett, 91st Regt.'

Comments: Poverty Bay; 1800s–20s (RN); eighteenth century (DRS).

References: Edge-Partington 1899a: 304–5, pl. XXXIV.1.

613 Plates 113 and 116
Whipsling, *kotaha*
1896-1170. Length 142 cm.

Wooden whipsling: dark brown, top carved as small female figure with splayed vulva, *wheku* face with underslung mouth, haliotis-shell eyes (one missing), feet to chin, hands on thighs, surface ornamentation of plain spirals and *rauponga*. On shaft near end prone male *wheku* figure facing shaft end, with legs doubled under, *pakura* on arms and legs, *rauponga* on face. Band of lashing of twisted-flax string at end of thick shaft.

Provenance: United Service Institution Museum.

Register: 'Taboo stick. New Zealand.'

Comments: Poverty Bay; 1810s–30s (RN); eighteenth century (DRS).

References: Edge-Partington 1899a: 304–5, pl. XXXIV.2.

614 Plates 114, 115 and 116
Whipsling, *kotaha*
1926-60. Length 204 cm.

Wooden whipsling: dark brown, top carved as large openwork composition – large *wheku* figure with plain spirals and *pakura*, looped tongue, body curved to front, with smaller figure, also with spirals and *pakura*, and large vulva, on back. Prone figure at mid-shaft: *wheku* face, arched belly and large vulva, plain spirals on arms and legs. Raised knob at end of shaft.

Provenance: Purchased from Sir Wilfrid Peek; Peek Collection.

Comments: Poverty Bay; 1840s, sharp, metal-tool carving (RN); 1820s (DRS).

615 Plates 114 and 116

Whipsling, *kotaha*

1878.11-1.606. Length 77.5 cm.

Wooden whipsling: brown, shaft with oblong cross section, top carved as sexless figure with round, domed head, looped tongue, hands to chin, haliotis-shell eyes; body as openwork loop with *rauponga* and plain spirals. Janus face in lower quarter of shaft, square-cut hole above it.

Provenance: Meyrick Collection.

Register: 'Skelton Pl. cxlix. fig. 9.'

Comments: Taranaki, early nineteenth century.

References: Edge-Partington 1969 I: 385.5; Skelton 1830: pl. CXLIX, fig. 9.

616 Plates 114, 115 and 116

Whipsling, *kotaha*

1921.6-16.3. Length 131 cm.

Wooden whipsling: reddish light brown, top carved as *manaia* head with large jaws in *rauponga*. At quarter down shaft: *wheku* face with *rauponga* cut into shaft with *rauponga* surround. Raised openwork *manaia* figure with *pakura* at lower quarter of shaft. Small band of lashing of twisted-flax string at end above enlarged knob.

Provenance: Presented by Miss Hirst.

Comments: East Coast, 1870s (RN); East Cape, c.1850, a replica whipsling (DRS).

Long clubs

Pouwhenua

617

Long club, *pouwhenua*

4877. Length 158.8 cm.

Wooden club: brown, shaft with circular cross section, tapering towards point and flattening towards wide flared blade, separated from point by Janus face with *pakura*.

Provenance: Purchased from B.M. Wright, June 1868.

Label: 'Paddle very rare New Zealand.'

Comments: South Taranaki, eighteenth century (DRS).

References: Te Awekotuku 1996: 37.

618 Plate 117

Long club, *pouwhenua*

5511. Length 160 cm.

Wooden club: dark brown, shaft separated from thick point by Janus face with *rauponga* with square *pakati*, small hole drilled through point.

Provenance: Transferred from Victoria and Albert Museum, 22 July 1869.

Register: 'From S. Kensington Museum [Victoria and Albert Museum] 22.7.1869 (Mann coll.). 407/65.'

Comments: Whanganui; early nineteenth century (RN); eighteenth century (DRS).

From the collection of 61 objects presented to Victoria and Albert Museum in 1865 by L.F. Mann (Eth.Doc.1161).

References: Edge-Partington 1969 I: 386.2.

619

Long club, *pouwhenua*

7363. Length 210.6 cm.

Wooden club: brown, extremely long narrow blade, shaft separated from very thin point by Janus face by *rauponga*, worn.

Provenance: Presented by A.W. Franks, 12 September 1871 (Wareham).

Comments: Northland (RN); Taranaki (DRS); eighteenth century.

620

Long club, *pouwhenua*

1903.11-16.7. Length 167 cm.

Wooden club: dark brown, slightly flared blade, shaft separated from point by Janus face with *pakura*. Small hole drilled through point.

Provenance: Bequeathed by Francis Brent.

Label: 'Lent by … Sept. 1898.'

Comments: Northland, eighteenth century.

Registered mistakenly on Slip as no. 6 in this collection.

621

Long club, *pouwhenua*

1944 Oc.2.792. Length 167.7 cm.

Wooden club: dark brown, roughly finished blade, shaft separated from long thick point by Janus face with *pakura* and *rauponga*.

Provenance: Beasley Collection.

Comments: Whanganui; nineteenth century (RN); 1830–40 (DRS).

622

Long club, *pouwhenua*

1944 Oc.2.793. Length 150.5 cm.

Wooden club: brown, shaft separated from point by enlarged cylindrical section.

Provenance: Beasley Collection. Beasley no. 378.

Comments: Beasley catalogue: 378, registered 10 April 1909, 'Bt. Biddell … Brighton'.

Tewhatewha

623

Long club, *tewhatewha*

6724. Length 157.2 cm.

Wooden club: dark brown, wide asymmetrical blade with curved outer edge extending on one side of shaft, tapered point separated from shaft by Janus-faced carving with *pakura* on brows and jaw, perforation for feather attachment at bottom of blade next to shaft.

Provenance: Presented by A.W. Franks, 12 July 1870 (Wareham).

Comments: Northland, eighteenth century (DRS).

624

Long club, *tewhatewha*

7364. Length 129.2 cm.

Wooden club: brown, perforation for feathers, Janus face with *pakura*.

Provenance: Presented by A.W. Franks, 12 September 1871 (Wareham).

Comments: Northland, 1860 (DRS).

625

Long club, *tewhatewha*

7365. Length 177 cm.

Wooden club: brown, perforation for feathers, Janus face with *pakura*.

Provenance: Presented by A.W. Franks, 30 September 1871 (Wyatt).

Comments: Northland, eighteenth century (DRS).

626

Long club, *tewhatewha*

7985. Length 174 cm.

Wooden club: brown, piece cut out of distal edge of blade, leaving vertical projection on outer edge; no perforation for feathers; Janus face replaced by plain boss; plain *manaia* figure behind blunt point with *rauponga* spirals.

Provenance: Presented by R.G. Whitfield, 31 July 1872.

Comments: Whanganui, tourist piece (DRS).

627

Long club, *tewhatewha*

1895-381. Length 123 cm.

Wooden club: brown, perforation with remnants of feathers attached, Janus face with *rauponga*.

Provenance: Meinertzhagen Collection.

Comments: Whanganui, eighteenth century (DRS).

628

Long club, *tewhatewha*

1895-382. Length 98 cm.

Wooden club: brown, perforation with remnants of feathers attached, point separated from shaft by shoulders.

Provenance: Meinertzhagen Collection.

Comments: 1860, model *tewhatewha* (DRS).

629

Long club, *tewhatewha*

1925-200. Length 172 cm.

Wooden club: very dark brown, perforation for feathers, Janus face with *pakura*; curved edge of blade chipped.

Provenance: Purchased from Royal Asiatic Society.

Comments: Northland, eighteenth century (DRS).

630 Plate 117

Long club, *tewhatewha*

1854.12-29.78. Length 155 cm.

Wooden club: light brown, with diagonally spiraling band of darker brown, perforation with bunches of feathers attached, Janus face with *pakura*.

Provenance: Grey Collection.

Comments: South Taranaki, c.1850 (DRS).

References: Te Awekotuku 1996: 37.

631

Long club, *tewhatewha*

1855.11-16.7. Length 129 cm.

Wooden club: light brown, perforation with feathers attached, rudimentary Janus face with haliotis-shell eye (one missing) set in red sealing wax and *raumoa*. Blade and distal part of shaft with darker brown ripple effect.

Provenance: Presented by Henry Latham.

Comments: Whanganui, 1860–70 (DRS).

632

Long club, *tewhatewha*

1896.11-19.2. Length 117 cm.

Wooden club: brown, perforation with remnants of feathers attached, no Janus face.

 Provenance: William Strutt Collection.
 Comments: South Island, 1860 (DRS).

633

Long club, *tewhatewha*

1908.5-13.11. Length 120.5 cm.

Wooden club: brown, diagonal darker bands on blade, perforation for feathers, slight enlargement in place of Janus face.

 Provenance: Budden/Angas Collection.
 Comments: 1860, model *tewhatewha* (DRS).

634

Long club, *tewhatewha*

1908.5-13.12. Length 143 cm.

Wooden club: brown, perforation for feathers, Janus face with *pakura*.

 Provenance: Budden/Angas Collection.
 Comments: South Taranaki, 1850 (DRS).

635

Long club, *tewhatewha*

1929.11-8.10. Length 100 cm.

Wooden club: dark brown, perforation with feathers attached, Janus face with *pakura*; metal screw inserted in tip of point.

 Provenance: Transferred from United Services Institution, Whitehall.
 Comments: Whanganui, eighteenth century (DRS).

636

Long club, *tewhatewha*

1936.5-12.1. Length 103 cm.

Wooden club: dark brown, blade with large *raupanga* spiral on each side, distal part of shaft with pattern of zigzag *raumoa*, Janus face replaced by set of four curved ridges, perforation for feathers. Proximal end of shaft repaired with two wooden dowel pins.

 Provenance: Presented by H.M. Leveson.
 Register: 'Collected by donor's brother 30 years ago.'
 Comments: Whanganui, 1870, carved tourist piece (DRS).

637

Long club, *tewhatewha*

1944 oc.2.788. Length 157.3 cm.

Wooden club: brown, unusually wide expanded blade, no perforation for feathers, Janus face with prominent brows and teeth, *raupanga* surface decoration.

 Provenance: Beasley Collection.
 Label: 'On loan from Col. Carr-Ellison Dunston Hill 1907.'
 Comments: South Taranaki, eighteenth century (DRS).

638

Long club, *tewhatewha*

1944 oc.2.789. Length 144.5 cm.

Wooden club: dark brown, perforation for feathers, *manaia* face with haliotis-shell eye (one missing) and large *raumoa* surface decoration at junction of shaft and expanded blade; Janus face with *raumoa*.

 Provenance: Beasley Collection. Beasley no. 4435.
 Comments: Whanganui, tourist *tewhatewha* (DRS).

Beasley catalogue: 4435, registered 3 June 1937, 'Bt The Corporation of Reading (Museum)'.

639

Long club, *tewhatewha*

1944 oc.2.790. Length 154.4 cm.

Wooden club: brown, expanded portion of blade cut off at distal end to produce curved edge ending in point; distal section of shaft decorated on one side with one section of diagonal *whakarare* and one section of diagonal *raupanga*, separated by transverse bands of *whakarare*, and extending on to blade as longitudinal *whakarare*; Janus face without surface decoration.

 Provenance: Beasley Collection. Beasley no. 1051 (?).
 Comments: Rotorua, eighteenth century (DRS).

Beasley no. 1051 given in Register is incorrect; no. 1051 in Beasley's catalogue is *kaukauroa*.

640

Long club, *tewhatewha*

1944 oc.2.791. Length 171.5 cm.

Wooden club: brown, large blade, perforation with feathers attached, Janus face with *pakura*.

 Provenance: Beasley Collection. Beasley no. 2715.
 Comments: Northland, eighteenth century (DRS).

Beasley catalogue: 2715, registered 1 February 1931, 'Blackmore Museum'.

641

Long club, *tewhatewha*

Q1980 oc.1279. Length 117.5 cm.

Wooden club: dark brown, perforation for feathers, no Janus face, expanded cylindrical blunt point; curved edge of blade chipped.

 Provenance: Unknown.
 Comments: Eighteenth century (DRS).

642

Long club, *tewhatewha*

Q1980 oc.1280. Length 157.3 cm.

Wooden club: dark brown, perforation for feathers, Janus face with *pakura*.

 Provenance: United Service Institution Museum.
 Label: 'C. Fund 4 Nov.1896 U.S.M.'
 Comments: Northland, eighteenth century (DRS).

643

Long club, *tewhatewha*

Q1980 oc.1281. Length 142.3 cm.

Wooden club: brown, perforation for feathers, Janus face with no surface decoration.

 Provenance: United Service Institution Museum.
 Label: 'C. Fund 4 Nov.1896 U.S.M.'
 Comments: Northland, Eighteenth century (DRS).

Taiaha

644

Long club, *taiaha*

st. 831. Length 172 cm.

Wooden club: brown, shaft of oval cross section flattening towards wider blade; point carved on both sides as face with long tongue with *raupanga*, oval haliotis-shell

eyes (one replaced with red sealing wax). Below point collar of vegetable fibre and black cloth, much decayed, with remnants of feathers, fringed with well-preserved multiple tassels of dog hair.

 Provenance: Christy Collection. Acquired before 1862.
 Register: 'Pickering, "Races of Man" p.78 says its use (speaking of the tuft of hair) is to protect the hand from the roughness of the fern when travelling.'
 Comments: Taranaki, 1830–40 (DRS).
 References: Christy 1862: 66.17.

645 Plate 118

Long club, *taiaha*

TRH 24/1902 L.I.24/Royal Collection no. 69984. Length 159.5 cm.

Wooden club: dark brown, shaft becoming of diamond cross section towards point. Collar of cream-coloured wool textile with woven pattern, fringed with layers of multiple dog/goat-hair tassels. Small rectangular silver (?)] plate embedded in blade.

 Provenance: Royal Loan 1902, Prince and Princess of Wales.
 Comments: Arawa, 1880 (DRS).
 References: Imperial Institute 1902: 56.328; Te Awekotuku 1996: 37.

646

Long club, *taiaha*

135. Length 142.5 cm.

Wooden club: dark brown, oval cross section, no collar, faces with finely notched haliotis-shell eyes (one missing) with pupils of red sealing wax.

 Provenance: Unknown.
 Comments: South Taranaki, eighteenth century (DRS).

647

Long club, *taiaha*

139. Length 148.7 cm.

Wooden club: brown, oval cross section, prominent transverse grain ripples on shaft and blade on both sides all its length; collar of flat braided-flax cord.

 Provenance: Unknown.
 Comments: Taranaki, 1860 (DRS).

648

Long club, *taiaha*

202. Length 193 cm.

Wooden club: dark brown, oval cross section, large faces on point, worn blade.

 Provenance: Unknown.
 Comments: South Taranaki, 1830 (DRS).

649

Long club, *taiaha*

204. Length 165.2 cm.

Wooden club: brown, almost circular cross section, unusual composition of linked spirals on tongue.

 Provenance: Unknown.
 Comments: Taranaki, 1860 (DRS).

650

Long club, *taiaha*

206. Length 174.3 cm.

Wooden club: dark brown, oval cross section.

 Provenance: Unknown.
 Comments: South Taranaki, eighteenth century (DRS).

651

Long club, *taiaha*

931. Length 179.7 cm.

Wooden club: yellowish brown, oval cross section, narrow blade, face with notched haliotis-shell eye (one missing).
 Provenance: Arley Castle.
 Register: 'Arley Castle.'
 Comments: Poverty Bay, 1860 (DRS).

652

Long club, *taiaha*

932. Length 133 cm.

Wooden club: brown, oval cross section, surface decoration on both sides of *whakarare* with three intervening spirals (spirals and one section of *whakarare* on one side unfinished) from mid shaft to blade; notched haliotis-shell eyes.
 Provenance: Arley Castle.
 Register: 'From Arley Castle.'
 Comments: Poverty Bay, 1860 (DRS).

653

Long club, *taiaha*

933. Length 171 cm.

Wooden club: brown, oval cross section, notched haliotis-shell eyes (two missing, one on each side).
 Provenance: Arley Castle.
 Register: 'From the Arley Castle Collection. Lot 277.'
 Comments: South-west North Island (DRS).

654

Long club, *taiaha*

1903. Length 149.7 cm.

Wooden club: brown, oval cross section, blade chipped on one side.
 Provenance: Unknown.
 Comments: Poverty Bay, 1860s (DRS).

655

Long club, *taiaha*

5512. Length 211.4 cm.

Wooden club: brown, oval cross section, unusually long, carving worn, notched haliotis-shell eyes.
 Provenance: Transferred from Victoria and Albert Museum, 22 July 1869.
 Register: 'From S. Kensington Mus. [Victoria and Albert Museum] 22.7.1869 (Mann Coll) 406/65.'
 Comments: Whanganui, eighteenth century (DRS).
 From the collection of 61 objects presented to Victoria and Albert Museum in 1865 by L.F. Mann (Eth.Doc.1161).

656 **Plate 118**

Long club, *taiaha*.

5846. Length 211.4 cm.

Wooden club: brown, oval cross section, unusually long, varnished; large heavy point as separate piece fitted on to shaft: bold deep carving, *rauponga* spirals on tongue with *pakati* deeply recessed, prominent teeth, eyes with double rings of finely notched haliotis shell; flared blade.
 Provenance: Presented by A.W. Franks, 7 September 1869 (Cutter).
 Comments: South Taranaki, eighteenth century, new head on old blade (DRS).

657

Long club, *taiaha*

6020. Length 157 cm.

Wooden club: brown, oval cross section, entire shaft and blade with longitudinal *rauponga* divided into seven sections by six transverse narrow *rauponga*, three alternate ones with notched circular haliotis-shell inlay on both sides.
 Provenance: Purchased from Wareham, 31 January 1870.
 Comments: Taranaki (DRS).

658 **Plate 117**

Long club, *taiaha*

7362. Length 170.6 cm.

Wooden club: brown, oval cross section, narrow blade, haliotis-shell eyes; collar of vegetable fibre with yellowish red faded kaka (?) feathers and band of black cloth just behind point; fringed with multiple tassels of dog/goat hair.
 Provenance: Presented by A.W. Franks, 12 September 1871 (Wareham).

659

Long club, *taiaha*

7984. Length 140 cm.

Wooden club: dark brown, oval cross section, plain spirals on brows, haliotis-shell eyes; shaft and blade covered with linked *rauponga* spirals with *rauponga* infilling.
 Provenance: Presented by R.G. Whitfield, 31 July 1872.
 Comments: South Taranaki, 1860 (DRS).

660

Long club, *taiaha*

+2004. Length 191 cm.

Wooden club: very dark brown, almost black, oval cross section, worn carving.
 Provenance: Presented by A.W. Franks, February 1884 (R.H. Soden Smith).
 Comments: South Taranaki, eighteenth century (DRS).

661

Long club, *taiaha*

+3561. Length 140.5 cm.

Wooden club: dark brown, circular cross section, steep, prominent brows and jaws, *rauponga* spirals on tongue with deeply recessed *pakati*.
 Provenance: Presented by A.W. Franks, 7 October 1887 (Fenton).
 Comments: Taranaki, nineteenth century, unfinished, tourist (DRS).

662

Long club, *taiaha*

+5920. Length 196 cm.

Wooden club: brown, oval cross section of shaft with marked side edges, notched haliotis-shell eyes; collar of linen cloth, vegetable-fibre string, remnants of reddish kaka (?) feathers; fringed with multiple tassels of dog/goat hair.
 Provenance: Presented by A.W. Franks, 3 November 1892 (J.W. Luff).
 Comments: South Taranaki, eighteenth century (DRS).

663

Long club, *taiaha*

+6193. Length 151.5 cm.

Wooden club: dark brown, almost black; oval cross section, unusual elongated tongue and head, no surface decoration.

 Provenance: Presented by A.W. Franks, 25 July 1893.
 Comments: Taranaki, eighteenth century (DRS).

664

Long club, *taiaha*

1895-383. Length 151.5 cm.

Wooden club: dark brown, oval cross section, no surface decoration.
 Provenance: Meinertzhagen Collection.

665

Long club, *taiaha*

1895-384. Length 144.5 cm.

Wooden club: dark brown, diamond cross section, haliotis-shell eyes set in red sealing wax with red wax pupils.
 Provenance: Meinertzhagen Collection.
 Comments: South Taranaki, eighteenth century (DRS).

666

Long club, *taiaha*

1896-1143. Length 180.7 cm.

Wooden club: brown, oval cross section, notched haliotis-shell eyes; collar of flax and lace bark with remnants of feathers (mostly quills only) and dog/goat-hair tassels, much decayed.
 Provenance: Purchased from United Service Institution Museum.
 Comments: Taranaki, eighteenth century (DRS).

667

Long club, *taiaha*

1896-1144. Length 163 cm.

Wooden club: brown, diamond cross section, haliotis-shell eyes, narrow blade; collar of green and reddish brown cloth, vegetable-fibre string, remnants of feathers (mostly quills only), very sparse remnants of dog/goat-hair tassels, badly decayed.
 Provenance: Purchased from United Service Institution Museum.
 Comments: Taranaki, 1860 (DRS).

668

Long club, *taiaha*

1896-1145. Length 200.5 cm.

Wooden club: brown, oval cross section, notched haliotis-shell eyes (one missing); short longitudinal row of *pakati* mid shaft on one side.
 Provenance: Purchased from United Service Institution Museum.
 Comments: Poverty Bay, eighteenth century (DRS).

669

Long club, *taiaha*

1896-1146. Length 138 cm.

Wooden club: brown, flat oval cross section, standard, conventional type.
 Provenance: Purchased from United Service Institution Museum.
 Comments: Taranaki, 1850 (DRS).

670

Long club, *taiaha*

1896-1171. Length 138.4 cm.

Wooden club: brown, oval cross section, short tongue with *rauponga* (unfinished on one side), prominent eyes and brows, no surface decoration.
 Provenance: Purchased from United Service Institution Museum.
 Comments: Taranaki, 1880 (DRS).

671

Long club, *taiaha*

1925-45. Length 137.2 cm.

Wooden club: brown, oval cross section, *raupongo* on tongue with square flat *pakati*, notched haliotis-shell eyes (only one remaining); narrow blade, blade marked in black ink: 'Wm. Cunnington'.

Provenance: Purchased from Devizes Museum 1922.

Comments: Whanganui, eighteenth century (DRS).

672

Long club, *taiaha*

1926-61. Length 193.5 cm.

Wooden club: dark brown, oval cross section, *raupongo* on tongue with deeply recessed *pakati*, eyes projecting at sides with haliotis-shell inlay on one side only; two spaced bands of *raupongo* (one transverse, one diagonal) mid shaft on one side, and three on other (two transverse and one diagonal); blade decorated with incised modified *kowhaiwhai* pattern on one side, and on other, in addition to similar *kowhaiwhai*, with depiction of war canoe with sail and two-legged animal with long thin body and head crest.

Provenance: Purchased from Sir Wilfrid Peek.

Comments: Whanganui, 1850 (DRS).

673

Long club, *taiaha*

1928-111. Length 150 cm.

Wooden club: brown, oval cross section, notched haliotis-shell eyes (one missing).

Provenance: Presented by E.P. Allen.

Comments: Taranaki, eighteenth century (DRS).

674 Plate 118

Long club, *taiaha*

1848.4-11.1. Length 150.4 cm.

Wooden club: light brown, oval cross section, tip of tongue slightly damaged on one side, narrow blade.

Provenance: Presented by Captain Sir Everard Home, BT., RN.

675

Long club, *taiaha*

1854.12-29.23. Length 152.7 cm.

Wooden club: dark brown, oval cross section, notched haliotis-shell eyes; collar of remnants of red cloth, feathers, vegetable-fibre string and dog/goat-hair tassels, badly decayed; blade with T-shaped motif with long chevroned *pakati* on stem of T on one side, with similar but longer bands of longitudinal *pakati* on other side from mid shaft to blade, separated by three *raupongo* spirals; tip of blade plain.

Provenance: Grey Collection.

Comments: Poverty Bay, *c*.1850 (DRS).

676

Long club, *taiaha*

1854.12-29.75. Length 166.4 cm.

Wooden club: brown, oval cross section, plain tongue with traces of *pakati*, lightly incised decoration on head.

Provenance: Grey Collection.

677 Plate 118

Long club, *taiaha*

1854.12-29.76. Length 168.6 cm.

Wooden club: light brown, oval cross section, tongue with red and black *whakarare*, head carved as *manaia* with *whakarare* on brows and notched haliotis-shell eyes; red ochre on blade.

Provenance: Grey Collection.

Comments: East Coast (DRS).

678 Plate 118

Long club, *taiaha*

1854.12-29.77. Length 179 cm.

Wooden club: brown, oval cross section, haliotis-shell eyes; collar of cloth, remnants of red kaka (?) feathers and multiple dog/goat-hair tassels; at top of collar a ring of plaited vegetable fibre with brown feathers attached to outer surface.

Provenance: Grey Collection.

Comments: Taranaki (DRS).

679

Long club, *taiaha*

1896.11-19.1. Length 166 cm.

Wooden club: brown, flattened oval cross section, standard, conventional type.

Provenance: William Strutt Collection.

Register: 'Maori spear, purchased at New Plymouth from a Maori.'

Comments: New Plymouth (DRS).

680 Plate 118

Long club, *taiaha*

1903.11-16.4. Length 213 cm.

Wooden club: brown, oval cross section, unusually long, large heavy deeply carved point, tongue with deeply recessed *pakati*, notched haliotis-shell eyes on one side only, circular projecting top of head; flared blade.

Provenance: Bequest of Francis Brent.

Label: 'Lent by Francis Brent Sept. 1898.'

Comments: Taranaki, 1860 (DRS).

681

Long club, *taiaha*

1908.5-13.1. Length 157.3 cm.

Wooden club: dark brown, oval cross section, haliotis-shell eyes (only one remaining), collar of two kinds of brown cloth and remnants of feathers; slim shaft, narrow blade.

Provenance: Budden/Angas Collection.

Comments: Taranaki, 1860 (DRS).

682

Long club, *taiaha*

1908.5-13.2. Length 158 cm.

Wooden club: brown, oval cross section, collar of two kinds of discoloured cloth, vegetable-fibre string and traces of dog/goat-hair tassels; slim shaft, narrow blade.

Provenance: Budden/Angas Collection.

Comments: South Taranaki, 1860 (DRS).

683

Long club, *taiaha*

1908.5-13.3. Length 154 cm.

Wooden club: brown, oval cross section, slightly recessed *pakati* on tongue, notched haliotis-shell eyes; slightly damaged blade.

Provenance: Budden/Angas Collection.

Comments: Taranaki, 1860 (DRS).

684

Long club, *taiaha*

1908.5-13.4. Length 167.5 cm.

Wooden club: dark brown, oval cross section, square *pakati* on tongue *raupongo*, diamond-shaped haliotis-shell eyes (two missing, one on each side).

Provenance: Budden/Angas Collection.

Comments: Taranaki, 1880 (DRS).

685

Long club, *taiaha*

1908.5-13.5. Length 175 cm.

Wooden club: dark brown, almost circular cross section, standard, conventional type.

Provenance: Budden/Angas Collection.

Comments: South Taranaki, eighteenth century (DRS).

686

Long club, *taiaha*

1908.5-13.6. Length 141.6 cm.

Wooden club: dark brown, oval cross section, haliotis-shell eyes (one missing, remnants of shell in another), tip of tongue chipped; collar of dark-green spotted textile, with vegetable-fibre string, remnants of feathers and traces of dog/goat-hair tassels.

Provenance: Budden/Angas Collection.

Comments: Poverty Bay, 1860–70 (DRS).

687

Long club, *taiaha*

1921.6-16.2. Length 165 cm.

Wooden club: dark brown, oval cross section, haliotis-shell eyes set in red sealing wax (one missing). Engraved near head 'NA', marked in white ink '30'.

Provenance: Presented by Miss Hirst.

Comments: Taranaki, *c*.1860 (DRS).

688

Long club, *taiaha*

1921.10-14.21. Length 150.8 cm.

Wooden club: brown, rounded oblong cross section, narrow blade, standard, conventional type.

Provenance: Yorkshire Philosophical Society Museum.

Comments: Taranaki, 1860 (DRS).

689

Long club, *taiaha*

1927.3-7.54. Length 178 cm.

Wooden club: dark brown, oval cross section, carving worn, standard, conventional type.

Provenance: Presented by Mrs J.E. Birch, collected by Alfred Clay 1867–77.

690

Long club, *taiaha*

1927.11-19.7. Length 189.2 cm.

Wooden club: dark brown, oval cross section, notched haliotis-shell eyes; collar of vegetable-fibre string, ring of brown feathers near top with remnants of other feathers, fringed with strips of dog skin with hair attached.

Provenance: Reid/Capt. Luce Collection.

Comments: Poverty Bay, eighteenth century (DRS).

Probably the *taiaha* mentioned in Captain Luce's Journal in November 1865:

> Our friends the Waiapu natives came forward & gave us a war dance … My old friend Wekiuopi came out strong making a vigorous speech with much energy & having a Flax cloak

over his shoulders all covered with feathers &
holding in his hand a handsome Taiaha, a war
club, which on finishing his speech he gave to
McLean who afterwards kindly handed it over
to me.

(RAI MS 280:5).

691

Long club, *taiaha*

1931.11-18.8. Length 168.5 cm.

Wooden club: dark brown, flattened
diamond cross section, red sealing-wax
eyes.

Provenance: Bequeathed by Alban Head.
Comments: South Taranaki, 1860 (DRS).

692

Long club, *taiaha*

1949 oc.9.9. Length 118.6 cm.

Wooden club: dark brown, oval cross
section, very slender point and blade, small
head and tongue. Marked in white ink on
lower blade '104'.

Provenance: Presented by E. Cave.
Comments: Taranaki, eighteenth century
(DRS).

693

Long club, *taiaha*

1949 oc.9.10. Length 136.5 cm.

Wooden club: brown, rounded oblong cross
section, slender point and blade, bulbous
eyes, tongue plain on one side, with plain
spirals on other, otherwise no surface
decoration. Marked in white ink on lower
blade '103'.

Provenance: Presented by E. Cave.
Comments: Whanganui, nineteenth
century (DRS).

694

Long club, *taiaha*

Q1980 oc.1270. Length 145.6 cm.

Wooden club: brown, oval cross section,
standard, conventional type.

Provenance: Meinertzhagen Collection
(ex Duplicate Collection).

695

Long club, *taiaha*

Q1980 oc.1271. Length 158.5 cm.

Wooden club: brown, diamond cross
section, haliotis-shell eyes set in red sealing
wax (two missing, one on each side),
transverse ripple effect on shaft and blade.

Provenance: Miss Leigh via A.W.F. Franks
(ex Duplicate Collection).

Comments: Poverty Bay, eighteenth
century (DRS).

696

Long club, *taiaha*

Q1980 oc.1272. Length 158.2 cm.

Wooden club: dark brown, oval cross
section, haliotis-shell eyes (one missing);
collar of flat braided-flax cord, cloth
padding, remnants of feathers and dog/
goat-hair tassels.

Provenance: Meinertzhagen Collection
(ex Duplicate Collection).

Comments: Central North Island, 1850–
60 (DRS).

697

Long club, *taiaha*

Q1980 oc.1273. Length 124.4 cm.

Wooden club: brown, oval cross section,
red sealing-wax eyes, slender point and
blade, shaft ornamentation divided into ten
sections: eight of *rauponga*, one – near point

– of *haehae*, and one – near plain blade – of
rauponga spirals. Marked in black ink on
blade: 'No.13/7'.

Provenance: Unknown.
Comments: 1860, ceremonial *taiaha*
(DRS).

698

Long club, *taiaha*

Q1980 oc.1275. Length 147.6 cm.

Wooden club: brown, oval cross section,
slender shaft and point, standard,
conventional type.

Provenance: Unknown.
Comments: Taranaki, 1860 (DRS).

699

Long club, *taiaha*

Q1980 oc.1276. Length 217 cm.

Wooden club: brown, oval cross section,
unusually long, notched haliotis-shell eyes
(one missing).

Provenance: Purchased from United
Service Institution Museum.

Labels: 'C. Fund. 4 Nov. 1896. U.S.M.';
'War Paddle New Zealand 11 125'.

Comments: Poverty Bay, 1850 (DRS).

700

Long club, *taiaha*

Q1980 oc.1277. Length 176.4 cm.

Wooden club: very dark brown, oblong
cross section, transverse ripple effect on
shaft.

Provenance: Meinertzhagen Collection
(ex Duplicate Collection).

Comments: Taranaki, 1860 (DRS).

701

Long club, *taiaha*

Q1980 oc.1278. Length 170.5 cm.

Wooden club: dark brown, oval cross
section, red sealing-wax eyes, standard,
conventional type.

Provenance: Purchased from United
Service Institution Museum.

Labels: 'C. Fund. 4 Nov. 1896. U.S.M.';
'War Paddle New Zealand 11 136'.

Comments: Taranaki, eighteenth century
(DRS).

702

Long club, *taiaha*

Q1980 oc.1282. Length 159 cm.

Wooden club: brown, diamond cross
section, haliotis-shell eyes, prominent teeth;
collar of reddish and some green feathers,
flat braided-flax cord, cloth, fringed with
dog/goat-hair tassels.

Provenance: Unknown.
Comments: Rotorua, 1860, copied from
an old one (DRS).

Museum label is annotated 'TRH', i.e.
Royal Loan 1902, Prince and Princess of
Wales, although there is no other evidence
for it, but see Imperial Institute 1902: 45.267
where description seems to match **702**
(Q1980 oc.1282).

703

Long club, *taiaha*

Q1980 oc.1283. Length 138.2 cm.

Wooden club: brown, oval cross section,
very slender, elongated head, no surface
decoration except for beginning of spiral on
one half of tongue on one side.

Provenance: Unknown.
Comments: Whanganui, nineteenth
century (DRS).

704

Long club, *taiaha*

Q1980 oc.1284. Length 152 cm

Wooden club: dark brown, oblong cross
section, standard, conventional type.

Provenance: Ex A.W. Franks Collection.
Label: 'AF [A.W. Franks] 8 – 12 [?]'.
Comments: Northland (?), 1820–30
(DRS).

705

Long club, *taiaha*

1938 L.I.5/ Royal Collection no. 74002.
Length 170 cm.

Wooden club: brown, oblong cross section,
haliotis-shell eyes (two missing, one on each
side), slightly recessed *pakati* on tongue;
collar (only lower half remaining) of black
cloth, braided-flax cords and multiple
strands of dog/goat-hair tassels. Metal disc
with '1849' engraved attached.

Provenance: Royal Loan 1938, King
George VI.

Comments: South Taranaki, 1860 (DRS).
Eth.Doc.1915: 'Brought by the Maori Chiefs,
28th July 1884.'

706

Long club, *taiaha*

9075. Length 124.5 cm.

Whalebone club: plain tongue and head
except for *rauponga* on jaw, flat shaft.

Provenance: Presented by Captain J.
Storey July 1874.

Label: 'Holy stick or execution sword –
New Zealand. J. Storey.'

Comments: Waikato (DRS).

Hoeroa

707

Long club, *hoeroa*

TRH 21/1902 L.I.21/Royal Collection no.
69981. Length 146.3 cm.

Whalebone club: slightly curved, proximal
end with plain spirals and two perforations,
simple plain spirals on each edge at mid
blade.

Provenance: Royal Loan 1902, Prince and
Princess of Wales.

Comments: Northland, 1860 (DRS).

Either this or **708** (TRH 22) may be the one
described by Loughnan on 15 June 1901:

> During the presentation an ancient Chief, with
> orthodox and plentiful tattoo … advanced
> bearing a priceless polished two-handed
> whalebone sword (hoeroa), gave the Duke the
> magnificent bow of hospitality, together with
> the broad smile of kindness, and deposited
> the weapon with great reverence in his hands.
> His Royal Highness having reciprocated the
> courtesy, the old man retired backwards,
> smiling broadly and repeatedly bowing.
>
> (Loughnan 1902:122)

References: Imperial Institute 1902:
61.364; Loughnan 1902: 122.

708

Long club, *hoeroa*

TRH 22/1902 L.I.22/Royal Collection
no. 69982. Length 127 cm.

Whalebone club: proximal end with
plain spirals and two perforations, pair
of elongated grooves on each edge and
semicircular copper-plate repair at mid
blade on both sides.

Provenance: Royal Loan 1902, Prince and
Princess of Wales.

Comments: 1860s (DRS).
See also Comments **707** (TRH 21).
References: Imperial Institute 1902:
60.363; Loughnan 1902: 122.

709 Plate 117
Long club, *hoeroa*
1903.11-16.3. Length 128.5 cm.

Whalebone club: proximal end with variant carving of *pakura* and two perforations, rudimentary *manaia* (?) on each edge at mid blade.
Provenance: Bequeathed by Francis Brent.
Comments: Northland, 1860 (DRS).
References: Te Awekotuku 1996: 37.

710
Long club, *hoeroa*
1944 Oc.2.786. Length 171.3 cm.

Whalebone club: proximal end with variant carving of *pakura* and two perforations, slight shoulders with single groove at mid blade.
Provenance: Beasley Collection. Beasley no. 2714.
Comments: Northland, eighteenth century (DRS).
Beasley catalogue: 2714, registered 1 February 1931, 'Blackmore Museum'.

711
Long club, *hoeroa*
1944 Oc.2.787. Length 136.4 cm.

Whalebone club: proximal end with variant carving of *pakura* and two perforations, slight shoulders with double grooves on each edge at mid blade. Faded inscription on blade: 'Mr W.C. Hill … Edward Queen St Auckland'. Also marked: 'Beasley collection New Zealand 3357'.
Provenance: Beasley Collection. Beasley no. 3337 (incorrect; should be 3357).
Comments: Hokianga, eighteenth century (DRS).
Beasley catalogue: 3357, registered 3 December 1933, 'A whalebone hoeroa having the handle carved with a conventional face, and with two raised stops in the middle of the blade. Written in ink upon the blade is: Mr W.C. Hill c/o M. Edwards. Queen Street, Auckland. Length 53 ½ in. Bought H. Andrade, 20 Portland Square, Plymouth.'

Short clubs

Patu paraoa

712 Plate 119
Short club, *patu paraoa*
NZ 81. Length 41.3 cm.

Whalebone club: thick blade, no shoulders, old round hole, flat butt with five low curved ridges.
Provenance: Unknown.
Comments: 1870s–80s (RN); North Island, eighteenth century (DRS).

713
Short club, *patu paraoa*
NZ 82. Length 46.5 cm.

Whalebone club: thick blade, definite shoulders, large traditional hole, six raised ridges on butt; thick flat braided-flax cord, now separated from club and in two pieces, badly preserved.
Provenance: Unknown.

Comments: 1830s–40s (RN); South Island, eighteenth century (DRS).

714 Plate 119
Short club, *patu paraoa*
St. 827. Length 32.5 cm.

Whalebone club: very heavy, dense, crystalline jawbone, highly polished; extremely thick blade, shoulders, old hole, three low ridges on butt. Marked in ink: 'Brought by Captain Cook. W. H. Pepys F.R.S.'
Provenance: Cook Collection.
Register: '13… An inscription explains that it was presented by Capt. Cook to the late Mr Pepys, F.R.S.'; 'Bought at sale of W.H. Pepys Esq. F.R.S. to whom it was given by Cook.' Handwritten label: '… New Zealand… chiefs to… presented by Captain Cook to the… Wm H Pepys F.R.S. purchased at his sale.'
Comments: eighteenth century; South Island (?) (DRS).
References: Christy 1862: 65.13; Kaeppler 1978: 190; Starzecka 1979: fig. 53; Te Awekotuku 1996: 39.

715
Short club, *patu paraoa*
TRH 11/1902 L.I.11/Royal Collection no. 69971. Length 40.8 cm.

Whalebone club: thickish blade, no shoulders, round hole, butt carved as *manaia* face, decorated with *rauponga* with large pointed *pakati*, haliotis-shell eyes. One side of club of darker colour, presumably result of exposure to light. Marked in pencil: '671'.
Provenance: Royal Loan 1902, Prince and Princess of Wales.
Comments: Ngati Pikiao, 1890s (RN).

716 Plate 119
Short club, *patu paraoa*
1700. Length 46 cm.

Whalebone club: long thin curved/warped blade, slight shoulders, round hole, flat butt with seven very low ridges on one side and three – seemingly unfinished – on other.
Provenance: Unknown.
Labels: 'Bone "Meri". New Zealand', 'Lot 291'.
Comments: South Island, eighteenth century (DRS).

717
Short club, *patu paraoa*
9333. Length 51.7 cm.

Whalebone club: very large wide flat blade, shoulders, square hole; flat butt with three, very worn, barely perceptible, ridges.
Provenance: Sparrow Simpson Collection.
Comments: North Island, eighteenth century.

718
Short club, *patu paraoa*
+4764. Length 37.8 cm.

Whalebone club: flat thin blade, no shoulders, round hole, plain, crudely carved butt. Large part of butt, handle and blade broken off on one side.
Provenance: Presented by A.W. Franks, 12 May 1890.
Handwritten label: 'Maori Marri or Mirri dug up at Waikanae it is over 100 yrs old and is only used by the Chiefs it has killed many

maoris it is whale bone it was dug up by Mr Wakelin of Wellington New Zealand they are very rare, and valuable Maoris wont [*sic*] touch it they never touch old things they are sacred with them you can see the Skulls and Bones lying about of Maoris now in that district.'
Comments: Wellington district, eighteenth century.

719
Short club, *patu paraoa*
1895-159. Length 41.5 cm.

Whalebone club: thick blade, slight shoulders, old hole, four large low ridges on butt. Thin two-ply twisted flax string loop through hole.
Provenance: Presented by A.W. Franks, 3 June 1895 (Sparrow Simpson).
Handwritten label: 'Meri, or club, of whale's bone, New Zealand. Purchased 25 May 1868 JC.'
Comments: 1820s (RN); North Island, eighteenth century (DRS).

720
Short club, *patu paraoa*
1895-363. Length 38.8 cm.

Whalebone club: medium-thick blade with *kotiate*-form inner curve on one side edge of blade, no shoulders, squarish hole with loop of dog-skin strap through it, flat butt with three low ridges.
Provenance: Meinertzhagen Collection.
Comments: Early nineteenth century (RN); North Island, nineteenth century (DRS).

721
Short club, *patu paraoa*
1906-169. Length 40.3 cm.

Whalebone club: convexo-concave blade with longitudinal groove on concave side extending to handle, well-defined shoulders, round hole, butt carved as plain *wheku* face; old, weathered bone. Round braided-flax cord, now separated from club and in two pieces.
Provenance: Presented by C.H. Read.
Comments: East Coast; mid nineteenth century (RN); nineteenth century, a whalebone reproduction club with *kotiate*-type handle (DRS).

722 Plate 119
Short club, *patu paraoa*
1854.12-29.8. Length 30.5 cm.

Whalebone club: thick short blade, squared strongly defined shoulders, metal-drilled round hole, butt with four low, perfunctorily carved, ridges.
Provenance: Grey Collection.
Register: 'Bone battle axe or mere-parawa which belonged to Moka a chief of Nga-puhi [Ngapuhi] tribe.'
Comments: South Island style, 1840s (RN); northern South Island, nineteenth-century reproduction *patu paraoa* (DRS).

723
Short club, *patu paraoa*
1854.12-29.54. Length 45.6 cm.
Whalebone club: long narrow blade, slightly marked shoulders, round hole with thick two-ply twisted-flax string, plain flat butt. 'This … [illegible] 1846' scratched on blade.
Provenance: Grey Collection.

Comments: Early nineteenth century (RN); northern South Island, nineteenth century (DRS).

724 Plate 119
Short club, *patu paraoa*
1878.11-1.609. Length 33 cm.

Whalebone club: thick, small, narrow blade, no shoulders, very large round hole below plain butt. Very dark bone.
Provenance: Meyrick Collection.
Comments: South-west North Island, eighteenth century (DRS).

725
Short club, *patu paraoa*
1910.11-6.3. Length 47.9 cm.

Whalebone club: thin, worn blade with one side edge broken off, slight shoulders, round hole, flattish butt with four ridges; very dark bone, with some areas black. Marked in pencil: '619'.
Provenance: Presented by Library Committee of City of London (from Guildhall Museum).
Comments: Late nineteenth century (RN); South Island (DRS).

726
Short club, *patu paraoa*
1921.10-14.9. Length 41.7 cm.

Whalebone club: wide convexo-concave blade, shoulders, short handle, hole square on convex side, round on concave, butt with three incised grooves on convex side which has been varnished (?). Finely braided flax cord loop through hole.
Provenance: Yorkshire Philosophical Society Museum.
Label: 'Robinson Coll. 1852'.
Comments: Early nineteenth century (RN); South Island, eighteenth century (DRS).

727
Short club, *patu paraoa*
1921.10-14.10. Length 33.9 cm.

Whalebone club: thick, narrow blade, no shoulders, old round hole, simple straight grooves across butt, one edge chipped. Very thin twisted-string loop through hole.
Provenance: Yorkshire Philosophical Society Museum.
Comments: 1820s–40s (RN); Taranaki (?), eighteenth century (DRS).

728
Short club, *patu paraoa*
Q1987 Oc.31. Length 29.4 cm.

Whalebone club: rather thick, wide blade, shoulders, butt with five pronounced ridges, small round hole just above ridges on short handle.
Provenance: Meinertzhagen Collection (Ex Duplicate Collection).
Comments: East Coast, late nineteenth century (RN).

729
Short club, *patu paraoa*
Q1987 Oc.32. Length 46 cm.

Whalebone club: convexo-concave blade with two transverse bands of rectangular *pakati* above handle, no shoulders, round hole, butt carved as *manaia* head with *rauponga* and red sealing-wax eyes. Thin, flat, braided vegetable-fibre wrist cord. Bone much darker and weathered on convex side.

Label: 'E.R. 248'.
Provenance: Unknown.
Comments: Whanganui, late nineteenth century.

Mere pounamu

730 Plate 120
Short club, *mere pounamu*.
NZ 79. Length 35.5 cm.

Nephrite club: dark green, thick, wide, slightly curved blade, polished but rough flaws left. Woven flax butt pad with flat braided wrist cord, slightly frayed in places.
Provenance: Unknown.
Comments: Eighteenth century.
References: Edge-Partington 1969 I: 375.2; Hamilton 1901: 246, pl. XXXI, fig. 4.

731 Plate 120
Short club, *mere pounamu*
St. 830. Length 33 cm.

Nephrite club: mottled dark and lighter green, rather thick blade, old, worn round hole, plain butt of irregular shape resulting from natural fault in stone.
Provenance: Christy Collection. Acquired before 1862.
Register: '...it has a leather strap', 'Leather strap removed'.
Comments: Eighteenth century (RN).
References: Christy 1862: 66.16.

732
Short club, *mere pounamu*
TRH 5 / 1902 L.I.5 / Royal Collection no. 69965. Length 33.3 cm.

Nephrite club: mottled medium green with brown patches, slightly marked shoulders, old round hole placed slightly off centre, short plain butt. Marked in pencil: '665[?]'.
Provenance: Royal Loan 1902, Prince and Princess of Wales.
Comments: Late eighteenth century (RN).

733
Short club, *mere pounamu*
TRH 6 / 1902 L.I.6 / Royal Collection no. 69966. Length 32.5 cm.

Nephrite club: mottled medium green with black flecks, round hole, plain butt. Marked in pencil: '664'.
Provenance: Royal Loan 1902, Prince and Princess of Wales.
Comments: Mid nineteenth century (RN).

734
Short club, *mere pounamu*
TRH 8 / 1902 L.I.8 / Royal Collection no. 69968. Length 39.7 cm.

Nephrite club: mottled dark green, wide blade, round hole, butt with four shallow grooves and low ridges; machine-cut hole and ridges, and machine polish. Marked in pencil: '661'.
Provenance: Royal Loan 1902, Prince and Princess of Wales.
Comments: Late nineteenth century (RN).

735 Colour plate 17
Short club, *mere pounamu*
1500. Length 41 cm.

Nephrite club: very dark mottled green, wide blade, slight shoulders, old round hole, butt narrowed towards end with three very pronounced high ridges and wide deep grooves; polished.

Provenance: Unknown.
Register: '7.C.6'.
Comments: Eighteenth century? (DRS).

736 Colour plate 17
Short club, *mere pounamu*
1701. Length 36.6 cm.

Nephrite club: mottled light green with black flecks, long narrow blade, no shoulders, large old hole, butt with three ridges and deep grooves; polished.
Provenance: Unknown.
Comments: Eighteenth century; far North (DRS).

737 Colour plate 17
Short club, *mere pounamu*
1702. Length 39.1 cm.

Nephrite club, mottled dark green, well-defined shoulders, large old hole, wide butt with four uneven ridges; polished. Fault in stone on one side of butt.
Provenance: Unknown.
Comments: South Island, eighteenth century (DRS).

738 Colour plate 17
Short club, *mere pounamu*
9644. Length 31.2 cm.

Nephrite club: mottled light-bluish green *inanga*, slight shoulders, old round hole with remnants of flax cord, three low ridges on butt; polished.
Provenance: Presented by A.W. Franks, 20 January 1876.
Register: 'Rare colour of jade.'
Comments: Eighteenth century; very well proportioned (RN); South Island (DRS).

739 Plate 120
Short club, *mere pounamu*
1896-929. Length 43.3 cm.

Nephrite club: medium and light green, veined, fractured stone with grinding marks, shoulders, short handle, old angled hole, butt with four wide ridges.
Provenance: Presented by C.H. Read.
Comments: Eighteenth century; very old and good (RN); South Island (DRS).
Given by Ngapuhi chief Titore to Captain F.W. Sadler of HMS *Buffalo* in 1833–4; Read obtained it from Captain Sadler's daughter. See Register entry for **271** (*hei-tiki* 1896-925).

740 Plate 122
Short club, *mere pounamu*
1853.2-4.1. Length 42.1 cm.

Nephrite club: mottled medium green with black flecks, fractured stone, no shoulders, no hole, barely indicated flat plain butt with chipped end. Illegible pencil writing on blade.
Provenance: Presented by Captain Stokes of HMS *Acheron*.
Comments: Mid nineteenth century (RN); eighteenth century? (DRS).

741 Colour plate 17
Short club, *mere pounamu*
1854.12-29.1. Length 49.5 cm.

Nephrite club: mottled light green, discoloured, blade with multiple transverse cracks and chipped edge on one side, old hole, four ridges on butt.
Provenance: Grey Collection.
Register: 'Jade, a "mere-pounami" or battle axe known in New Zealand by the name "Tuhi-wai". It belonged to Te-Hiko-

o-Te-Rangi of the Ngati-toa [Ngati Toa] tribe. This axe was much injured in a fire at Government House, Auckland by which the jade has been discoloured and made to look opaque. It is broken into 8 pieces [subsequently reassembled].'

Comments: Eighteenth century; Taranaki/Waikato (RN); Taranaki (DRS).

742 **Colour plate 17**
Short club, *mere pounamu*
1854.12-29.2. Length 43.5 cm.

Nephrite club: veined and mottled light green, discoloured in places, especially on butt; shoulders, large old hole, long narrow butt with three wide ridges.

Provenance: Grey Collection.

Register: '… known by the name "Papatahi"; it belonged to Te Rauparaka [Te Rauparaha] of the Ngati-toa [Ngati Toa] tribe, discoloured by the same fire as the last.'

Comments: Eighteenth century (RN); South Island (DRS).

743 **Colour plate 17**
Short club, *mere pounamu*
1854.12-29.3. Length 50.5 cm.

Nephrite club: mottled medium green with black flecks, no shoulders, short handle, recent round hole, longish butt with four irregularly cut ridges.

Provenance: Grey Collection.

Register: '… known by the name "Piwari", it belonged to Ripa a chief of the Bay of Islands, who lost his hand in fighting on the side of the British in 1846. Fine colour.'

Comments: Early nineteenth century (RN); South Island, nineteenth century (DRS).

744 **Plate 121**
Short club, *mere pounamu*
1854.12-29.4. Length 40.5 cm.

Nephrite club: mottled medium to light green, slight shoulders, plain butt with old large off-centre hole through it.

Provenance: Grey Collection.

Register: '… belonged to Te Ruinga-o-te-Rangi [Te Huinga o Te Rangi] a chief of Ngati Pava [Ngati Paoa].'

Comments: Eighteenth century; South Island (DRS).

745 **Plate 121**
Short club, *mere pounamu*
1854.12-29.5. Length 37.7 cm.

Nephrite club: very dark mottled green, slight shoulders, old large off-centre hole, short butt with three pronounced ridges.

Provenance: Grey Collection.

Register: '… belonged to Waikato chief of Te-Puna.'

Comments: Eighteenth century; Taranaki (DRS).

References: Jones 1990: 233.256a.

746 **Plate 121**
Short club, *mere pounamu*
1854.12-29.6. Length 28.7 cm.

Nephrite club: mottled medium green with black flecks, small recent hole, short pointed butt with three ridges.

Provenance: Grey Collection.

Register: '… belonged to the Ngati-Pava [Ngati Paoa] tribe.'

Comments: Nineteenth century.

747 **Plate 122**
Short club, *mere pounamu*
1907.12-23.1. Length 37 cm.

Nephrite club: veined light green, very thick blade, old hole, rudimentary *manaia* face on butt; grinding and high polish.

Provenance: Presented by C.H. Read.

Comments: 1830s (RN); European, nineteenth century (DRS).

References: Hooper 2006: 138.82; Te Awekotuku 1996: 38.

748 **Plate 122**
Short club, *mere pounamu*
1910.11-6.1. Length 33.5 cm.

Nephrite club: dark green, mostly homogenous but with some lighter flecks, thick broad blade with squared distal end, wide, old hole, thick handle, butt with three ridges; ground marks, then high polish.

Provenance: Presented by Library Committee of City of London (from Guildhall Museum).

Comments: 1800s–20s (RN); Taranaki, eighteenth century (DRS).

749
Short club, *mere pounamu*
1934.12-5.23. Length 34.8 cm.

Nephrite club: mottled medium green with black flecks, thin wide blade, hole, thin pointed butt with six low crescent-shaped ridges.

Provenance: Bequeathed by T.B. Clarke Thornhill.

Handwritten label: 'Mere of greenstone – formerly belonged to the chief Raika of the Ngatipara [Ngati Paoa?] tribe, Thames – got from him personaly [sic] by Mr John Findlay of Miranda on Oct. 26 1892 – from whom I bought on Nov. 4th 1892. [reverse] No - 441-.'

Comments: Mid nineteenth century (RN); Thames, nineteenth century (DRS).

750
Short club, *mere pounamu*
1953 Oc.5.1. Length 42.5 cm.

Nephrite club: dark green with mottled medium green, wide blade, old hole, pointed butt with four irregular curved ridges; high machine polish.

Provenance: Bequeathed by G.C. Nickels.

Comments: Mid nineteenth century (RN); European, a reproduction club made by a jeweller (DRS).

751
Short club, *mere pounamu*
Q1987 Oc.33. Length 37 cm.

Nephrite club: dark green with mottled light green, blade with very thin edge, recent hole, butt with three wide flat irregular ridges, slightly curved; high polish.

Provenance: Unknown.

Label: 'E.R. 93'.

Comments: Late nineteenth century (RN).

Patu onewa and *miti*

752
Short club, *patu onewa*
NZ 77. Length 40 cm.

Basalt club: very wide and thick blade, strongly marked shoulders; butt of sub-circular cross section with four wide ridges and a vertical groove on each side; edges of blade chipped, whole piece massive.

Provenance: Unknown.

Comments: nineteenth century (RN); fake (DRS).

753
Short club, *patu onewa*
NZ 78. Length 32 cm.

Basalt club: polished; butt with four very carefully finished concentric narrow sharp ridges and one in centre, wide grooves in between; old hole with braided-flax wrist cord through it.

Provenance: Unknown.

Comments: Nineteenth century (RN); North Island, eighteenth century (DRS).

754 **Plate 123**
Short club, *patu onewa*
NZ 80. Length 40 cm.

Greywacke club: coarse grained; very prominent sharp flared rim to flattened butt with three concentric ridges, old round hole; one side of blade chipped.

Provenance: Cook Collection.

Comments: Eighteenth century; particularly unusual shape to butt (RN); northern South Island (DRS).

References: Joppien and Smith 1985: I.154; Kaeppler 1978: 191; Starzecka 1979: fig. 54; Te Awekotuku 1996: 39.

755
Short club, *patu onewa*
St. 828. Length 42 cm.

Basalt club: butt with three low ridges and shallow grooves, old hole with twisted-flax wrist cord through it.

Provenance: Christy Collection, acquired before 1862.

Comments: Nineteenth century (RN).

References: Christy 1862: 66.14.

756
Short club, *patu onewa*
1698. Length 36 cm.

Basalt club: butt with four concentric ridges and one in centre, old hole with braided-flax wrist cord through it.

Provenance: Unknown.

Comments: Northland, eighteenth century (DRS).

757 **Plate 123**
Short club, *patu onewa*
1699. Length 36.5 cm.

Basalt club: butt with four prominent concentric ridges, old round hole; chip on one side of distal end of blade, other side also slightly chipped.

Provenance: Unknown.

Label: 'Patapatoo from New Zealand.'

Comments: Northland, eighteenth century (DRS).

758 **Plate 123**
Short club, *patu onewa*
9006. Length 30 cm.

Basalt club: butt with four flat low ridges, not perforated for suspension; distal end of blade chipped.

Provenance: Cook Collection. Presented by A.W. Franks, 6 May 1874, bought from Parkinson.

Handwritten label: 'Patapatoo presented by Captn Cooks widow to the Leverian Museum.'

Comments: Eighteenth century.

References: Kaeppler 1978: 191.

759

Short club, *patu onewa*

9330. Length 51.5 cm.

Basalt club: unusually long, definite shoulders, slight keel to blade; butt with five concentric sharp ridges and one in centre, old hole.

Provenance: Sparrow Simpson Collection.

Label: '"Meri", "Patiti" or "Patta-pattoo" of basalt from, New Zealand.'

Comments: Late eighteenth /early nineteenth century (RN); eighteenth century (DRS).

760

Short club, *patu onewa*

9331. Length 42.5 cm.

Basalt club: butt with four concentric ridges, old hole.

Provenance: Sparrow Simpson Collection.

Comments: Northland, eighteenth century (DRS).

761

Short club, *patu onewa*

+5977. Length 45 cm.

Greywacke club: shoulders, butt with three ridges, old hole.

Provenance: Presented by A.W. Franks, 16 July 1892.

Label: 'A.W.F. 16 July 182 (Nickinson).'

Comments: Nineteenth century (RN); northern South Island, eighteenth century (DRS).

762

Short club, *patu onewa*

1895-361. Length 38.3 cm.

Greywacke club: very fine-grained stone, no shoulders, butt with four concentric fine sharp ridges and one in centre, old hole.

Provenance: Meinertzhagen Collection.

Comments: Early nineteenth century, perfect example (RN); Northland (DRS).

763

Short club, *patu onewa*

1910-289. Length 34 cm.

Greywacke club: no shoulders, butt with three concentric ridges and one in centre.

Provenance: London Missionary Society Collection.

Labels: '149', '857'.

Comments: Nineteenth century (RN); eighteenth century (DRS).

764

Short club, *patu onewa*

1926-62. Length 26.5 cm.

Greywacke club: shoulders, very reduced flair to butt with three concentric ridges and one in centre, old hole.

Provenance: Purchased from Sir Wilfrid Peek.

Register: 'Peek collection. He onewa. Given by Te Pukuatua Chief of Ngati Whakaue on ceding land for the Rotorua railway. An ancestral mere used in the wars against Ngapuhi, and previously in those against Tuhaurangi [Tuhourangi tribe]. 1883.'

Label with identical text, concluding with: 'C.E.P. 1883.'

Comments: Nineteenth century (RN); Rotorua, eighteenth century (DRS).

765

Short club, *patu onewa*

1854.12-29. 52. Length 37 cm.

Basalt club: rather narrow blade, chipped distal end, short butt with four concentric ridges, old hole.

Provenance: Grey Collection.

Comments: Central North Island, eighteenth century (DRS).

766

Short club, *patu onewa*

1854.12-29.53. Length 36 cm.

Greywacke club: butt with four concentric sharp ridges and one in centre, old hole; flat braided vegetable-fibre cord now separated from club.

Provenance: Grey Collection.

Comments: Nineteenth century (RN); central North Island, eighteenth century (DRS).

767

Short club, *patu onewa*

1855.12-20.72. Length 42.5 cm.

Greywacke club: long blade, cracked transversely in middle, shoulders, butt with four concentric ridges and one in centre, old hole with thick wide stitched wrist thong of dog skin, dog-skin decorative tassels attached; hair in places still extant.

Provenance: Haslar Hospital Collection.

Register: 'A War instrument from New Zealand – Mr J.M. Hamilton ASRN.'

Comments: Late eighteenth /early nineteenth century (RN); south-west of North Island, eighteenth century (DRS).

768

Short club, *patu onewa*

1878.11-1.610. Length 32 cm.

Greywacke club: short butt with three ridges, old hole with very thick round braided-flax wrist cord through it.

Provenance: Meyrick Collection.

Register: 'Skelton Pl. cl. fig. 8. Skelton 250.'

Comments: Early nineteenth century (RN); eighteenth century (DRS).

References: Skelton 1830: pl. CL, fig. 8.

769

Short club, *patu onewa*

1878.11-1.611. Length 37 cm.

Basalt club: long narrow blade, butt with four concentric ridges, old hole; natural fault in stone on one side of blade.

Provenance: Meyrick Collection.

Comments: Eighteenth century? (DRS).

770

Short club, *patu onewa*

1903.11-16.1. Length 32.5 cm.

Greywacke club: butt with four concentric ridges and one in centre; hole started on both sides but not drilled through.

Provenance: Bequeathed by Francis Brent.

Comments: Nineteenth century (RN); eighteenth century (DRS).

771

Short club, *patu onewa*

1910.11-6.2. Length 30.5 cm.

Basalt club: butt with three concentric ridges and one in centre, old hole with dog-skin wrist thong through it, most of hair on skin extant.

Marked: 'New Zealand W.S.S. [William Sparrow Simpson?]'

Provenance: Presented by Library Committee of City of London (from Guildhall Museum).

Label: 'S.18'.

Comments: Nineteenth century (RN); central North Island (DRS).

772

Short club, *patu onewa*

1930.2-12.2. Length 35.5 cm.

Greywacke club: shoulders, butt with four concentric ridges and one in centre, old hole.

Provenance: Presented by E.W. Paine, through Miss E.H. Paine.

Comments: Nineteenth century (RN).

773

Short club, *patu onewa*

1944 OC.2.817. Length 26 cm.

Basalt club: very thick blade, short handle; very short, plain, straight-cut butt with two natural (?) circular indentations on its top.

Provenance: Beasley Collection. Beasley no. 4174.

Comments: Nineteenth century (RN); far North? (DRS).

Beasley catalogue: 4174, registered 3 June 1936: 'New Zealand. Basalt hand club "patu" … Bt Stevens Lot 167.'

774

Short club, *patu onewa*

1944 OC.2.818. Length 24.5 cm.

Greywacke club: halfway down blade, distal end is cut off straight across and bevelled on both sides; butt with three worn ridges, old hole.

Provenance: Beasley Collection. Beasley no. 43.

Comments: Nineteenth century (RN); butt reused as a hammer (DRS).

Beasley catalogue: 43, registered 9 April 1904: 'Basalt mere … Bt Jamrach. Cut down for use as an adze.'

775

Short club, *patu onewa*

1949 OC.7.1. Length 30.7 cm.

Greywacke club: very short butt with three ridges, hole started on both sides but not drilled through.

Provenance: Presented by Mrs M. Walton.

Register: '"Found on the old battle field of Matacana [Matakana], a small place on the coast below Auckland, more than 45 years ago" – old label later forwarded by donor and written in 1939.'

Comments: Late eighteenth /early nineteenth century (RN); northern South Island (DRS).

'My father, George Davey, was Superintendent of the Watikauri Mines about 1901–2–3. He took a great interest in the Maoris…' (BM AOA correspondence: M. Walton, 20 November 1949).

776

Short club, *patu onewa*

1977 OC.10.1. Length 33 cm.

Greywacke club: butt with three ridges, old hole with wrist cord of twisted blue commercial yarn cord.

Provenance: Purchased from Mrs J. M. Wallis.

Comments: Nineteenth century (RN).

777

Short club, *patu onewa*

Q1987 Oc.34. Length 42 cm.

Greywacke club: long blade, butt with four ridges, old hole with thick braided-flax wrist cord.

Provenance: Unknown. Ex Duplicate Collection.

Comments: Nineteenth century (RN).

778

Short club, *patu onewa*

Q1981 Oc.1379. Length 14 cm.

Greywacke club: handle and butt only; butt with three ridges, old hole. Marked in ink: 'New Zealand Capt… [illegible]'.

Provenance: Unknown.

Comments: Nineteenth century (RN).

779

Short club, *patu onewa*

Q1999 Oc.35. Length 28 cm.

Greywacke club: short blade, butt with two shallow concentric ridges, old hole; polished.

Provenance: Sparrow Simpson Collection. Ex Duplicate Collection.

Label: 'Purchased Simpson [i.e. W. Sparrow Simpson] … 75', overwritten 'Dup. AF'.

Comments: Late eighteenth century (RN).

780

Short club, *patu onewa*

Q1999 Oc.36. Length 34.5 cm.

Greywacke club: butt with three sharp concentric ridges, old hole with dog-skin wrist thong; polished.

Provenance: Unknown. Ex Duplicate Collection.

Comments: Nineteenth century (RN).

781 **Plate 123**

Short club, *patu miti*

1912.5-24.2. Length 45 cm.

Schistose rock club: long thick blade with notches all around edge, shoulders, perforation for wrist-thong hole started by pecking and bruising from both sides, after earlier attempts broke.

Provenance: Robertson/White Collection.

Register: 'Formerly in the White Collection, purchased by J. Struan Robertson Esq. Found in bed of Waiareka stream, Ta…[illegible], Otago, deep in the earth.'

Label: 'Mere or War Club … Maori Found in the bed of the Waiareka stream … Otago, deep in the earth exceedingly rare.'

Comments: Waiareka Stream, Otago; archaic/early (RN); eighteenth century or earlier (DRS).

References: Hamilton 1901: 246, pl. XXXI, fig. 3, left.

782 **Plate 123**

Short club, *patu miti*

1912.5-24.3. Length 27.5 cm.

Stone club: flat wide blade with squared distal end, definite shoulders, wide handle, butt barely indicated, with old hole squared, polished end. Broken across blade into two pieces.

Provenance: Robertson/White Collection.

Register: 'Formerly in the White Collection purchased by J. Struan Robertson Esq. Long beach.'

Labels: 'Long beach. Found perfect, broken before I got it', 'Very fine club. Exceedingly rare shape. Drilling of hole…'.

Comments: Eighteenth century; South Island (RN); Otago (DRS).

References: Hamilton 1901: 246, pl. XXXI, fig. 3, centre.

Kotiate

783 **Plate 124**

Short club, *kotiate*

NZ 90. Length 36 cm.

Wooden club: brown, thick blade, longitudinal handle ridge extending into it, old squarish hole with twisted-flax wrist cord through it. Butt carved as *wheku* head with *rauponga* on brows and *pakura* around mouth, split across face at eye level, extending to cord hole and length of handle. Distal edge of blade on one side damaged.

Provenance: Unknown.

Comments: Northland, eighteenth century.

784 **Plate 124**

Short club, *kotiate*

NZ 91. Length 39.2 cm.

Wooden club: light brown, large heavy spatulate blade without inner curve at side edges, which are sharp and finished all way around, grinding marks on blade. Long handle with square hole, butt carved as large head with round bulging eyes, pronounced nose and jaw; side of face with remnant of square-notched rudimentary *rauponga*, spirals around eyes and on forehead.

Provenance: Cook Collection.

Label: 'Wood Bludgeon Otaheite'.

Comments: Eighteenth century; worn, patina, very unusual form (RN); Whanganui (DRS).

References: Kaeppler 1978: 188; Hooper 2006: 138.83; Starzecka 1979: fig. 52.

785 **Plate 124**

Short club, *kotiate*

9336. Length 33.5 cm.

Wooden club: dark brown, thick heavy form, thick rounded edges to blade; long handle with small square hole, butt carved as plain *wheku* face. Small natural indentation on blade near handle.

Provenance: Sparrow Simpson Collection.

Label: 'Meri New Zealand'.

Comments: Bay of Plenty; 1810s–20s (RN); eighteenth century (DRS).

References: Edge-Partington 1969 I: 377.5.

786 **Plate 124**

Short club, *kotiate*

1895-368. Length 35 cm.

Wooden club: brown, longitudinal handle ridge extending into full length of blade. Round hole with wrist cord of black silk/cotton textile in bad state of preservation. Butt carved as solid head with projecting nose, notched haliotis-shell eyes and surface decoration of *rauponga*.

Provenance: Meinertzhagen Collection.

Comments: Bay of Plenty; early nineteenth century (RN); 1860 (DRS).

787 **Plate 124**

Short club, *kotiate*

1878.11-1.607. Length 34 cm.

Wooden club: brown, thick blade, long handle with square hole, butt with plain *wheku* face.

Provenance: Meyrick Collection.

Comments: Northland, eighteenth century (DRS).

788 **Plate 124**

Short club, *kotiate*

1878.11-1.608. Length 33.5 cm.

Wooden club: dark brown, thick heavy blade, edges moderately sharp, grinding marks prominent, longitudinal handle ridge extending length of blade, square hole. Butt carved as *wheku* face in deep relief, low-slung mouth with large teeth carved in.

Provenance: Meyrick Collection.

Comments: 1820s–30s (RN); Bay of Plenty, eighteenth century (DRS).

789

Short club, *kotiate*

1928.1-10.109. Length 28.5 cm.

Wooden club: light brown, inner curve at side edges of blade closed, indentations in sides, holes in blade; entire blade decorated on both sides with diagonal bands of *whakarare*; round hole with faded green-ribbon wrist cord through it. Butt carved as solid plain *wheku* head. Marked in black ink: 'Wairoa N.Z. Jan. 1885.'

Provenance: Liversidge Collection.

Comments: Hawke's Bay (RN); East Coast (DRS); 1880s.

790

Short club, *kotiate*

1934.12-1.27. Length 31.5 cm.

Wooden club: very dark brown, thick blade with deep inner curve at side edges, which are rounded; slight handle ridge on blade, round hole with twisted-flax wrist cord through it. Butt carved as plain *wheku* face. Polished. Marked with red paint: '39/09'.

Provenance: Presented by E.A.L. Martyn.

Label: 'Bucks. County Museum, Aylesbury. 39/09. Mr A. Oliver. Maori war club.'

Comments: East Coast, 1810s–20s (RN); Bay of Plenty (?), eighteenth century (DRS).

References: Te Awekotuku 1996: 39.

791

Short club, *kotiate*

Q1987 Oc.35. Length 39 cm.

Wooden club: light but stained dark brown, blade with deep wide inner curve at side edges, both sides decorated: distal half with *koruru* face and two *manaia* heads, proximal half only with *koruru* face, haliotis-shell eyes (some missing), surface decoration of *rauponga* on entire blade. No perforation on handle, red-and-brown twisted-wool cord around handle. Butt carved as solid Janus face with *rauponga* and haliotis-shell eyes.

Provenance: Presented by Mr and Mrs F. Stacey. Ex Duplicate Collection.

Labels: 'Dup. From Mr Stacey 24 Oct. 1946 [reverse] offered as a gift with other specimens which may be disposed of as requisite by us'; 'ER 241'.

Comments: Rotorua, early twentieth century, non-functional souvenir piece (RN).

792 **Plate 125**

Short club, *kotiate*

NZ 89. Length 30 cm.

Whalebone club: thick wide blade, very slightly convexo-concave, tight inner curve at side edges of blade, round hole with rough twisted-flax wrist cord through it. Butt carved as plain *wheku* head with large tongue.

 Provenance: Unknown.

 Comments: East Coast, late nineteenth / early twentieth century (RN); Bay of Plenty, nineteenth century, reproduction (DRS).

793 **Plate 125**

Short club, *kotiate*

TRH 14/1902 L.I.14/Royal Collection no. 69974. Length 34.9 cm.

Whalebone club: wide blade, handle ridge extending halfway down blade, big round hole. Butt carved as plain squat *manaia* face with large rabbeted eyes but no shell inlay. One side discoloured brown, presumably from exposure to light. Marked in pencil: '672'.

 Provenance: Royal Loan 1902, Prince and Princess of Wales.

 Comments: Rotorua, late nineteenth century (RN).

794

Short club, *kotiate*

1895-364. Length 33 cm.

Whalebone club: one side of blade cut away in smooth curve, round hole. Butt carved as plain *manaia* head.

 Provenance: Meinertzhagen Collection.

 Comments: East Coast, late nineteenth century (RN); East Cape, nineteenth century (DRS).

795 **Plate 125**

Short club, *kotiate*

1895-365. Length 34 cm.

Whalebone club: thin blade, very tight inner curve at side edges of blade, handle extended in V-shape into blade, square hole with dog-skin (some hair still attached) double-strip wrist thong through it. Butt carved as plain head.

 Provenance: Meinertzhagen Collection.

 Label: 'Whaka-ate'.

 Comments: East Coast, 1870s (RN); East Cape, nineteenth century (DRS).

796 **Plate 125**

Short club, *kotiate*

1895-366. Length 30 cm.

Whalebone club: thick wide handle with round drilled hole and leather wrist thong through it. Butt carved as plain *wheku* face.

 Provenance: Meinertzhagen Collection.

 Comments: East Coast; 1860s–70s (RN); nineteenth century (DRS).

797

Short club, *kotiate*

1895-367. Length 34.5 cm.

Whalebone club: flat handle extended in V-shape on to blade, round hole. Butt carved as plain *manaia* face.

 Provenance: Meinertzhagen Collection.

 Comments: East Coast, late nineteenth century (RN); East Cape, 1850 (DRS).

798

Short club, *kotiate*

1895-377. Length 37.2 cm.

Whalebone club: thick blade, inner curve at side edges of blade not cut through but two small round holes drilled on blade, very wide handle with no hole. Butt carved in low relief on both sides as wide face with long horizontal eyes and mouth with row of teeth and sideways-curved tongue; on one side of face small hole with fibre-string loop with peacock feathers attached.

 Provenance: Meinertzhagen Collection.

 Comments: East Coast; late nineteenth century (RN); nineteenth-century reproduction (DRS).

Wahaika

799 **Plate 126**

Short club, *wahaika*

NZ 84. Length 40.5 cm.

Wooden club: brown; concave recess on one edge of blade, below it solid figure with three-fingered hands on stomach, spirals on shoulders and hips, *pakura* on face; butt carved with simplified face with coarse *rauponga* and *pakura* around it; old round hole with thick braided-flax cord through it.

 Provenance: Unknown.

 Comments: Whanganui, early nineteenth century (RN); Northland, eighteenth century (DRS).

800 **Plate 126**

Short club, *wahaika*

1696. Length 36.6 cm.

Wooden club: dark brown; recess on one edge of blade, inner curve on other, oval hole in blade with notching around; below it *wheku* female figure with *rauponga* on face, three-fingered hands on stomach, spirals on shoulders and hips, disjointed legs; head on butt with circular large mouth with *rauponga* as suspension hole; another, modern drill hole through handle.

 Provenance: Unknown.

 Comments: Northland, 1830s, unusual piece, very neat (RN); Whanganui, 1860 (DRS).

 References: Edge-Partington 1969 I: 377.3

801

Short club, *wahaika*

4805. Length 35.5 cm.

Wooden club: brown, recess at one side edge of blade, plain, no figure, flat roughly cut round butt, round hole.

 Provenance: Haslar Hospital Collection.

 Comments: Late nineteenth century (RN); nineteenth century (DRS).

802 **Plate 126**

Short club, *wahaika*

9334. Length 39.5 cm.

Wooden club: brown, large curving recess at one side edge of blade; below it small figure in openwork with plain body, hands on stomach; *wheku* face on butt, long nose, low-slung mouth; thick handle, squared hole. Outer curve of blade slightly damaged on one side.

 Provenance: Sparrow Simpson Collection.

 Labels: 'Meri, or club, of wood. New Zealand. Purchased 26 Feb. 1868 JC.'

 Comments: Bay of Plenty/East Coast, late eighteenth/ early nineteenth century (RN); East Coast, eighteenth century (DRS).

803 **Plate 126**

Short club, *wahaika*

9335. Length 30.5 cm.

Wooden club: brown, thick *kotiate*-shaped blade with recess at one side edge of blade and small inner curve at other; fine, detailed plain openwork *wheku* figure with tongue curving loop on to chest, legs curled backward; plain *wheku* face on butt; proportionally long handle with squared hole and leather thong.

 Provenance: Sparrow Simpson Collection.

 Comments: Bay of Plenty/ East Coast, eighteenth century (RN); East Coast, nineteenth century (DRS).

 References: Te Awekotuku 1996: 39.

804 **Plate 126**

Short club, *wahaika*

9337. Length 31.5 cm.

Wooden club: light brown, recess at one side edge of blade, small curve at other, openwork male (?) *wheku* figure low down, almost on handle, with *rauponga* and spirals, long nose, hands under thighs with long legs reaching back to *manaia* foot on blade; *wheku* face with *rauponga* and same long nose on butt; square-cut hole with old braided-flax cord in chevron pattern of light and dark brown.

 Provenance: Sparrow Simpson Collection.

 Label: 'Meri, or club, of wood. New Zealand. Purchased 25 May 1868. JC.'

 Comments: East Coast; eighteenth century (RN).

805

Short club, *wahaika*

+1975. Length 43.3 cm.

Wooden club: very dark brown, very large heavy wide blade, recess, plain, no figure; butt as rudimentary Janus head with bulbous tongue; roughly cut rectangular hole in short handle.

 Provenance: Presented by A.W. Franks, February 1884 (R.H. Soden Smith).

 Comments: Early nineteenth century (RN); Whanganui, eighteenth century (DRS).

806 **Plate 127**

Short club, *wahaika*

1912-149 (also registered as 1913.2-4.1). Length 35.5 cm.

Wooden club: brown, recess, small plain figure with large head and surface decoration of deep *haehae*; plain butt with angled knob and square hole in butt centre.

 Provenance: Presented by Miss Bird.

 Label: 'Wooden "mere" (or "patoo patoo") waha-ika type (used in dances), from New Zealand.'

 Comments: Whanganui (?), early nineteenth century (RN).

807 **Plate 127**

Short club, *wahaika*

1854.12-29.55. Length 39.5 cm.

Wooden club: brown, tight recess, openwork figure with *wheku* face, haliotis-shell eyes, three-fingered hands on chest, surface decoration of *rauponga* and plain spirals; long handle, butt as plain *manaia* head, square hole with thick square leather thong.

 Provenance: Grey Collection.

Comments: East Coast, 1840s–50s (RN); Poverty Bay, 1840 (DRS).

808 Plate 127
Short club, *wahaika*
1854.12-29.56. Length 37.9 cm.

Wooden club: light brown, narrow blade, recess at one side edge of blade, small curve at other, plain figure with three-fingered hands on chest, one above other; long handle with hole round but square-cut on outer sides and thick twisted-flax cord loop; butt carved in openwork as two plain figures standing back-to-back, three-fingered hands on chest.

Provenance: Grey Collection.
Comments: Whanganui; 1840s (RN).

809
Short club, *wahaika*
1944 Oc.2.819. Length 37.2 cm.

Wooden club: brown, very shallow recess at one side edge of blade, inner curve at other, no figure but edge blade rough and irregular possibly indicating presence of figure in past; butt carved as two figures, back-to-back, with large naturalistic heads and very small conjoined body; no perforation on handle but space between butt figures' heads creates hole for suspension cord. Hole in blade natural or result of insect activity.

Provenance: Beasley Collection. Beasley no. 515.
Comments: Whanganui; early nineteenth century (RN); eighteenth century (DRS).
Beasley catalogue: 515, registered 1 September 1910, 'New Zealand. Wahaika of wood. A very old and plain piece having the usual figure missing… Bt privately of James Glaisher, Greenwich. Glaisher had had these pieces in his family for not less than 50 years.'

810
Short club, *wahaika*
1953 Oc.5.2. Length 35.5 cm.

Wooden club: dark brown, polished, recess at one side edge of blade, inner curve at other, male (?) figure, haliotis-shell eyes, spirals on shoulders and hips, arms with long plain *haehae*, hands with long fingers, one hand to mouth, other to thigh, feet with five and four long toes with nails; plain *wheku* head with haliotis-shell eyes on butt; large square-cut hole. Small natural (?) indentation with fine notches around it on one side of blade.

Provenance: Bequeathed by G.C. Nickels per Messrs Miller, Taylor & Holmes.
Comments: Whanganui; 1800s–20s (RN); eighteenth century (DRS).

811 Plate 128
Short club, *wahaika*
NZ 88. Length 40.2 cm.

Whalebone club: recess at one side edge of blade, inner curve at other, fairly thick blade, male figure with rounded brows, spirals on shoulders and hips, three-fingered hands on chest, large penis, legs bent backwards with large feet in low relief on handle; openwork male figure with penis and large three-fingered hands on butt; round hole with thick braided-flax cord.

Provenance: Unknown.

Comments: Eastern Bay of Plenty, 1840s (RN); South Taranaki, early nineteenth century (DRS).

812
Short club, *wahaika*
TRH 15 / 1902 L.I.15 / Royal Collection no. 69975. Length 28.2 cm.

Whalebone club: recess at one side edge of blade, inner curve at other, plain figure with three-fingered hands on stomach; butt carved as solid *manaia* head; both heads with notched haliotis-shell eyes; round hole. One side of club discoloured (brownish), presumably from prolonged exposure. Marked on both sides: '674'.

Provenance: Royal Loan 1902, Prince and Princess of Wales.
Comments: East Coast, late nineteenth century (RN).

813 Plate 128
Short club, *wahaika*
9332. Length 42 cm.

Whalebone club: recess at one side edge of blade, inner curve at other, very thin, flat blade; openwork *wheku* figure not completed (?), four-fingered hands on chest, spirals on shoulders and hips, *rauponga* on legs; openwork *manaia* head on butt; old round hole.

Provenance: Sparrow Simpson Collection.
Comments: Taranaki; late eighteenth / early nineteenth century (RN); eighteenth century (DRS).

814 Plate 128
Short club, *wahaika*
1853.2-4.3. Length 40.5 cm.

Whalebone club: shallow recess at one side edge of blade, inner curve at other, thick heavy blade; large figure with three-fingered left hand on chest, right arm on blade unfinished, legs bent backwards with three-toed feet on handle, surface decoration of *pakura*; large solid face on butt; rough old drilled hole and new hole drilled through butt face. Long longitudinal natural indentation on one side of blade. Marked on blade: '… [illegible] 1852 From Capt Stokes HMS Acheron'.

Provenance: Presented by Captain Stokes of HMS *Acheron*.
Comments: East Coast; 1820s–30s (RN); nineteenth century (DRS).
References: Edge-Partington 1969 I: 377.4.

815 Plate 129
Short club, *wahaika*
1854.12-29.7. Length 39 cm.

Whalebone club: very shallow recess at one side edge of blade, inner curve at other, flat blade; plain openwork figure with small face below body; openwork butt as two joined face in *pakura*, noses outward, jaws turned back; large square-cut hole. Drastically cleaned.

Provenance: Grey Collection.
Register: 'Bone battle axe or patu paraoa known by the name of Hine-te-ao [Hine Te Ao], the maternal ancestor of a section of the Ngati rau kawa [Ngati Raukawa] tribe. Hine-te-ao was born at Maungatautari. She had a brother named Te Maihi who was very nearly killed with this patu paraoa. It was in consequence seized and taken in payment for the offence by his sister who gave it

her own name, from her it has descended through six generations to the present time. It was presented to his Exc. by Taratoa in the name & on behalf of the chiefs & people belonging to his tribe called Ngati rau kawa.'

Label: '"Patu Paraoa" or Instrument of War called after Hine Te Ao, the maternal ancestor of a section of the Ngatiraukawa Tribe. The principal chiefs now living are Taratoa, Te Ahu Karamu, Te Matia, and Taraia the principal chief of the Thames. Hine Te Ao was born… [continues as above, with added at end] Sept. 1853.'
Comments: Waikato/Hauraki, early nineteenth century (RN); Hauraki style, eighteenth century (DRS).

816
Short club, *wahaika*
1934.2-12.1. Length 35.8 cm.

Whalebone club: recess, thin blade; stylized plain simple openwork figure; butt as coarse solid *manaia* head; round hole.

Provenance: Presented by V. Salt.
Register: 'From the collection of Lady Palmer, – 1870 or earlier.'
Comments: Late nineteenth/ early twentieth century (RN); Rotorua, bone tourist wahaika (DRS).

He [V. Salt] vouches for its having been collected (as well as that comb [435, 1933.11-25.2.]) about the middle of the 19th century & I feel pretty sure it is all right, and worth getting as an unusual type. It was formerly in the collection of Lady Palmer, of Wanlip Hall, Leicester.
(BM AOA correspondence: H.J. Braunholtz, 27 January 1934)

817 Plate 129
Short club, *wahaika*
1934.12-5.22. Length 34.5 cm.

Whalebone club: recess at one side edge of blade, inner curve at other; large, thick, heavy, plain figure with naturalistic body and face, hands on hips, red sealing wax in eyes; butt as solid *manaia* head with circular haliotis-shell eyes; round hole.

Provenance: Bequeathed by T.B. Clarke Thornhill.
Label: 'Maori bone Patu – Mere Wheua – from Morea [Mourea] Lake Rotoiti.'
Comments: Arawa, late nineteenth century (RN); Rotorua, tourist bone *wahaika* (DRS).

818 Plate 129
Short club, *wahaika*
1944 Oc.2.820. Length 37.7 cm.

Whalebone club: dark-brown colour, shallow recess at one side edge of blade, inner curve at other, thin flat blade; well-carved openwork figure with large hands, legs bent backward to blade, surface decoration of *pakura* on left side of body and on right leg; small butt with flat *manaia* face; round hole.

Provenance: Beasley Collection. Beasley no. 475.
Comments: Taranaki; 1810s–20s (RN); eighteenth century (DRS).
Beasley no. 475 is incorrect; no. 475 in Beasley's catalogue is a New Guinea bone lime spatula; perhaps it should be no. 473, registered 27 May 1910, 'Whale bone "Waha-ika" 14 6/8 [inch] long. Sold at Stevens Rooms. May 10th 1910. Lot 59. Bt W. Oldman.'
References: Te Awekotuku 1996: 39.

Patuki

819 **Plate 130**

Short club, *patuki*

NZ 86. Length 43.5 cm.

Wooden club: brown, plain, long blade of flattened diamond cross section, pointed distal end, shoulders, short narrow handle, bulbous roughly adzed butt.

 Provenance: Unknown.

 Register: 'Small hand club probably used as a flax or fern root beater.'

 Comments: Early nineteenth century (RN); eighteenth century (DRS).

820 **Plate 130**

Short club, *patuki*

1647. Length 45 cm.

Wooden club: brown, long, narrow, pointed blade of square cross section decorated on each side: proximal half with alternating sections of horizontal and vertical bands of *rauponga*, distal half with *pakura*, point plain. Plain handle of circular cross section, butt of square cross section with flat end, each side with alternating sections of horizontal and vertical *rauponga*; small round hole.

 Provenance: Unknown.

 Label: '15'.

 Comments: Whanganui, early nineteenth century (RN).

 References: Edge-Partington 1969 I: 389.2.

821 **Plate 130**

Short club, *patuki*

6726. Length 27 cm.

Wooden club: blade of rectangular cross section with rounded distal end, large central section decorated on each side: one with plain spirals, one with plain and *rauponga* spirals, two others with diamond shapes and *haehae,* traces of red and black pigment in grooves; uncarved proximal section of blade with painted black double spiral on each side. Narrow handle of circular cross section, pointed butt.

 Provenance: Presented by A.W. Franks, 12 July 1870 (Wareham).

 Register: 'A flax beater?', 'Patuki - hand club. T.T. Barrow.'

 Comments: Whanganui; 1800s–20s (RN); eighteenth century (DRS).

 References: Edge-Partington 1969 I: 389.3.

822 **Plate 130**

Short club, *patuki*

+436a. Length 35.5 cm.

Wooden club: dark brown, blade of flattened diamond cross section with rounded distal end, carved entirely with low-relief surface ornamentation of repeating triangles in *rauponga* with suggestion of faces on opposing edges. Narrow, plain handle flaring toward rectangular hole; rounded butt with four concentric low ridges. Worn.

 Provenance: Presented by A.W. Franks, 15 December 1877 (Whitfield Collection).

 Register: 'Patuki – T.T. Barrow.'

 Comments: Whanganui, 1820s–30s (RN); Taranaki, eighteenth century (DRS).

 References: Edge-Partington 1969 I: 389.4.

823 **Plate 131**

Short club, *patuki*

1895-413. Length 43.5 cm.

Wooden club: dark brown, plain, blade of rectangular cross section with pointed distal end; narrow, slim handle widening toward round flat-ended butt.

 Provenance: Meinertzhagen Collection.

 Label: 'Wooden beater for beating fern-root. New Zealand. 1870.'

 Comments: Nineteenth century (DRS).

824 **Plate 131**

Short club, *patuki*

1849.11-29.3. Length 40 cm.

Wooden club: brown, wide blade of diamond cross section with slightly concave facets, covered entirely with surface ornamentation of *puhoro* design rendered in *raupanga* spirals; in middle of each facet is a ring of haliotis shell (one missing). Narrow handle, its distal half with similar ornamentation, proximal half plain. Rounded butt with two low concentric ridges and oval haliotis-shell inlay in centre, round hole with thick twisted-flax wrist cord.

 Provenance: Purchased from J.S. Dowman.

 Comments: Whanganui, early to mid nineteenth century (RN).

 References: Edge-Partington 1969 I: 389.6.

825 **Plate 131**

Short club, *patuki*

1854.12-29.92. Length 44.5 cm.

Wooden club: brown, blade of irregular diamond cross section, pointed distal end. Short handle of circular cross section, flattened spherical butt. No surface decoration, worn, patina.

 Provenance: Grey Collection.

 Comments: Early nineteenth century (RN); eighteenth century (DRS).

826 **Plate 131**

Short club, *patuki*

1925.5-9.1. Length 29 cm.

Wooden club: brown; thick, heavy blade of square cross section, pointed distal end, each side decorated with deeply carved arrangements of *rauponga* with some *whakarare*. Plain constricted handle widening toward flared flat-ended butt with round hole.

 Provenance: Purchased from C.F. Spink.

 Comments: Taranaki, early nineteenth century (RN); a reproduction *patuki* (DRS).

827 **Plate 132**

Short club, *patuki*

1944 Oc.2.815. Length 33.5 cm.

Wooden club: brown, blade of diamond cross section with definite sharp edges, slightly concave burnished facets showing rippling effect of grain, definite shoulders, pointed distal end. Slim handle with large square chisel-cut hole and narrow leather-strip wrist thong through it. Small mushroom-shaped butt with very shallow grooves and low ridges on one side and groove across end of butt.

 Provenance: Beasley Collection. Beasley no. 533.

 Comments: Late eighteenth/early nineteenth century (RN); eighteenth century (DRS).

Beasley catalogue: 533, registered 18 January 1911, 'Bt W. Oldman, called "potuki".'

Patu rakau

828 **Plate 132**

Short club, *patu rakau*

LMS 153. Length 43 cm.

Wooden club: brown; thick, heavy, bulbous blade of circular cross section; narrower constricted handle flaring toward butt carved in openwork with face on one side, beginnings of surface ornamentation on mouth, unfinished. Marked in black ink: 'New Zealand club. Marihurue. July 1824. Geo Bennet.'

 Provenance: London Missionary Society Collection.

 Label: 'No 571. LM Socy.'

 Comments: North Auckland, 1800s (RN); Taranaki, eighteenth century (DRS).

 References: Edge-Partington 1969 I: 384.3.

829 **Plate 132**

Short club, *patu rakau*

+1989. Length 53.5 cm.

Wooden club: blackened, with traces of red ochre; long blade of circular cross section with rounded distal end, narrower handle, butt with Janus face, all covered entirely in ornamentation, mainly various combinations of *rauponga* with some *pakura*; near handle two *wheku* faces back to back, with linking upper limbs, both with hands in mouth. Faces with haliotis-shell eyes (most missing).

 Provenance: Presented by A.W. Franks, February 1884 (R.H. Soden Smith, FSA).

 Comments: Hokianga, 1830s (RN); 1860–80, a reproduction *patuki* (DRS).

 References: Edge-Partington 1969 I: 389.1.

830 **Plate 133**

Short club, *patu rakau*

+3290. Length 36 cm.

Wooden club: brown, blade of flattened diamond, almost oval cross section, covered with surface ornamentation separated into four facets by bands of *rauponga*: two *whakarare* sections on one side, two diagonal plain ridges sections, each with two plain spirals, on the other. Janus face with four square teeth between blade and thick, plain handle narrowing toward square hole with thick twisted-flax wrist cord. Butt carved as plain *wheku* face. Thick, flat distal end.

 Provenance: Presented by A.W. Franks, 6 October 1886 (Jamrach).

 Comments: Whanganui, 1840s–50s (RN); 1860–80, a reproduction *patuki* (DRS).

 References: Edge-Partington 1969 I: 389.5.

831 **Plate 133**

Short club, *patu rakau*

1895-362. Length 41.5 cm.

Wooden club: brown, blade of flattened diamond, almost oval, cross section with wide rounded distal end, with low-relief *pitau* patterns on both sides; narrower plain handle flaring toward round hole. Butt carved as plain face with rabbeted eyes, though no shell inlay; a band of *rauponga* is behind face.

Provenance: Meinertzhagen Collection.

Comments: Late nineteenth century (RN); 1860–80, a reproduction *patuki* (DRS).

832 Plate 133
Short club, *patu rakau*

1944 Oc.2.814. Length 37 cm.

Wooden club: dark brown; heavy, bulbous blade of circular cross section; plain, polished surface showing rippling effect of grain; short, constricted handle flaring toward butt carved in openwork as Janus figures with linking limbs, with surface ornamentation of *rauponga* and *rauponga* loops.

Provenance: Beasley Collection. Beasley no. 3442.

Comments: Northern, 1800s (RN); Taranaki, eighteenth century (?) (DRS).

Beasley catalogue: 3442, registered 10 April 1934, 'A fern root beater (?) … Native name paoi. From the collection of E. Towey Whyte. Bought Sotheby's Rooms Ex Lot 205.'

References: Beasley 1934: 294–5.

833
Bill-hook club, *patu rakau*

NZ 83. Length 39.5 cm.

Wooden club: brown, thick, solid, plain; butt as large rudimentary head with flat mouth, unfinished. Old round hole with twisted-flax string wrist cord.

Provenance: Unknown.

Comments: Early nineteenth century (RN); Taranaki, eighteenth century (DRS).

References: Edge-Partington 1969 I: 377.2; Hamilton 1901: 250, pl. XXXIII, fig. 3.

834 Plate 133
Bill-hook club, *patu rakau*

NZ 92. Length 54 cm.

Wooden club: dark brown, carved on both sides; large 'beaked' head at distal end with large round haliotis-shell eyes and teeth carved in 'beak'; below back of head two figures, one above other, with bulbous eyes. Surface ornamentation of notched *pakura* and *ritorito*, except for *rauponga* on figures' faces. Plain handle with wrist cord of multiple twisted strings through worn round hole. Butt carved as plain *wheku* face with bulbous eyes.

Provenance: Unknown.

Comments: Taranaki, 1840s (RN); eighteenth century (DRS).

References: British Museum 1925: fig. 169; Edge-Partington 1969 I: 377.6; Hamilton 1901: 254, pl. XXXV, fig. 2, right.

Non-traditional weapons

835 Plate 134
Axe, *patiti*

6474. Length 32.5 cm.

Composite axe: iron blade, whalebone shaft, butt carved as openwork *manaia* face, square hole with leather thong through it.

Provenance: Presented by J.L. Brenchley, 24 March 1870.

Comments: East Coast, early nineteenth century (RN); Central North Island, *c*.1860 (DRS).

References: Edge-Partington 1969 I: 380.4.

836 Plate 134
Axe, *patiti*

1854.12-29.20. Length 44 cm.

Composite axe: European style, wooden handle, iron blade with illegible stamp on one side; scratched on handle: 'TVMARV' (Tumaru); rectangular hole for suspension cord near proximal end.

Provenance: Grey Collection.

Register: 'Given to the New Zealanders by Capt. Cook & preserved as a relic.', 'Iron. An axe given by Captain Cook to the New Zealanders on it is a stamp of this form … now obliterated on the handle is scratched TVMARV.'

References: Newell 2003: 252, fig. 238

837 Plate 134
Long axe, *kakauroa*

+3289. Length 157 cm.

Composite axe: iron blade; brown, wooden shaft. Blade, made from whaling tool, broken and repaired, with cutting edge, curved at top, on one side and sharply pointed spike on opposite side. Shaft tapering to pointed proximal end; section of distal end decorated in low relief with three sections of *rauponga*, two diagonal and one zigzagged, separated by bands of transverse *rauponga*; on one edge of decorated section narrow band of vertical *whakarare* extending into plain area. Next to blade, Janus face with *pakura,* with blade in mouth; Janus face at lower quarter of shaft with brow, eyes and upper jaw in *pakura*.

Provenance: Presented by A.W. Franks, 6 October 1886 (Jamrach).

Register: 'Sir Julius von Haast confirms the opinion that this handle was made for the head.'

Comments: Taranaki; 1830s–40s (RN); 1860 (DRS).

838
Axe

+6882. Length 102.2 cm.

Wooden, light brown, plain, carved from one piece.

Provenance: Presented by A.W. Franks, 7 November 1893 (Jackson).

Comments: Nineteenth-century, wooden imitation of European axe (RN).

Collected for the Museum by H.G. Jackson in New Zealand at the request of C.H. Read (BM PE correspondence: H.G. Jackson, 26 December 1892).

References: Edge-Partington II.1: 226.2.

Military accoutrements

839 Plate 135
Cartridge box, *hamanu*

1710. Length 33 cm.

Wooden box: brown, curved shape to fit body on belt, hollowed out from narrow opening on top for cartridges, plain on concave inner side, decorated on convex outer side. *Wheku*-faced sitting figure with *pakura* projecting at one end, face on top of *rauponga* spiral at other; low-relief figure in center of convex side with *wheku* face, one eye with red glass trade bead (?) inset, plain spirals on shoulders and hips, *rauponga* on trunk; cut-out spaces between face and shoulders and between arms and trunk; diagonal *rauponga* on rest of outer surface

of box, each side of figure. On plain concave side, two perforations next to projecting figure, one through to side of box, other through to bottom; on opposite side also two perforations through to side of external spiral.

Provenance: Unknown.

Comments: East Coast, 1860s.

840 Plate 135
Cartridge box, *hamanu*

1895-415. Length 21 cm.

Wooden box: black, curved shape to fit body on belt, top with eighteen circular holes for cartridges, arranged in two rows. Two vertical strips of leather nailed to convex side, similar strip nailed to one narrow side of box, other narrow side with very shallow diagonal grooves.

Provenance: Meinertzhagen Collection. Label on box: 'Cartridge-box taken from a Maori during the war. New Zealand. 1869.'

Register: 'Cartridge box taken from a Maori during the war. New Zealand 1861.'

Comments: Mid nineteenth century (RN).

Meinertzhagen wrote in his diary while in Christchurch in 1867: 'I walked about this evening with little (Dapper who gave me a Maori cartridge box)…' (Canterbury Museum ARC 1988.4: 20.4.1867). This might be box 1895-415, although the date on the label pasted on it contradicts this.

841
Cartridge-loading pin, *teka*

1895-393. Length 17.5 cm.

Wooden, brown, slightly hollowed out at wide end for ball.

Provenance: Meinertzhagen Collection.

842
Cartridge-loading pin, *teka*

1895-416. Length 24.5 cm.

Wooden, brown, thick, heavy.

Provenance: Meinertzhagen Collection.

843
Cartridge-loading pin, *teka*

1895-417. Length 11.5 cm.

Wooden, light brown, roughly carved.

Provenance: Meinertzhagen Collection.

844
Cartridge-loading pin, *teka*

1895-394. Length 15 cm.

Bone, solid.

Provenance: Meinertzhagen Collection.

845 Plate 135
Rifle butt

1954 Oc.6.306. Length 47 cm.

Wooden, black, one side decorated in low-relief *pitau* pattern and *rauponga* infill, other with simple *rauponga* spirals and large inscription, 'Turi Turi Mokai'. Proximal end of narrow part with low-relief cross-hatching.

Provenance: Wellcome Collection. Wellcome Museum no. 222271.

Comments: Taranaki; late nineteenth century (RN); *c*.1863 (DRS).

Turuturu Mokai, 'impaled heads', is the name of a famous Maori *pa* in Taranaki and a site of battles during the wars of the 1860s.

Fishing, hunting, agriculture, tools

In the varied environments of New Zealand's lakes, rivers, estuaries, swamps and coastal waters, Maori developed a range of types of fishing gear from the basic Polynesian repertoire. In the Bay of Plenty lakes district around Rotorua, freshwater mussel dredges were manipulated on a long wooden handle from a canoe drifting across the mussel beds. Eels were taken in traps or by weirs of stakes driven into the river-bed to guide them into holding nets. Very large seine nets were made of green flax, while smaller nets such as hand-held scoop nets were made of dressed flax fibre twisted into cord. Floats of light wood or pumice were sometimes carved with figures. The lower edge of nets and fishing lines were held down by stone sinkers, some of which were carved with figures and geometric decoration. The British Museum collection of Maori fish-hooks is the best and most representative in the world, apart from its lack of archaic archaeological types.

Birds were caught with nooses set beside feeding places or along the sides of feeding troughs. Perch snares with running nooses hanging down each side were placed up trees on poles or hooked over branches. When a bird alighted on the perch, the fowler pulled on a cord that tightened the noose around the bird's feet. The main other technique for hunting larger birds, especially pigeons, was to use a long and light wooden spear tipped with a barbed bone point that was carefully pushed up through the tree until close enough to the bird for a final sudden thrust. Tame pet decoy parrots were kept to attract wild birds into the snares, and their home perches were often elaborately carved with a feeding bowl at one end. Albatrosses were taken with carved wooden and bone-barbed baited hooks trolled along the surface behind a canoe.

Maori agricultural tools were usually plain, utilitarian, wooden implements, but several digging sticks had a symbolic design on the upper end of the handle, often a crescent or an openwork *manaia* or figure form. Most footrests lashed on digging sticks were left plain, but on some early examples, especially from the North Auckland and Taranaki areas, a crouching human figure was carved into the structure. These detachable and elaborately carved footrests were usually the only agricultural tool that attracted the European collectors, accounting for their misleading frequency in museum collections.

A wide variety of manufacturing tools were produced for specific tasks, mostly from stone but also from wood, shell and bone. The first Polynesian settlers in New Zealand quickly learnt to take advantage of the new and extensive range of stone types available in the continental geology of these islands. Earlier archaic stone adzes of several different forms utilized favoured stone types from major quarry sites that were traded the length of the country, such as metasomatized argillites from Southland and Nelson or basalt from Tahanga on the Coromandel Peninsula. Later stone adzes were made from a wider variety of stone types available locally, while their form became more standardized throughout the country. Within a relatively short time, Maori had even begun to exploit the highly valued resource of jade nephrite from the inhospitable west coast of the South Island for tools, ornaments and weapons. For convenience of description, the adze blades have been grouped according to the typology proposed by Roger Duff (1956), although this has been modified by more recent studies.

Fishing implements

846 Plate 136
Freshwater mussel dredge, *rou kakahi*
1895-359. Length 108 cm.

Wooden D-shaped frame only (net missing): brown, lashings of flax leaves, flax-fibre cords and *mangemange*. Carved on one side only: simple *manaia* faces at apex, *manaia* figure at each end with surface decoration of plain spirals and some *rauponga* and *taratara-a-kai*.
 Provenance: Meinertzhagen Collection.
 Comments: Rotorua, mid nineteenth century (RN).
 References: Edge-Partington 1969 II.2: 169.1 (where it is attributed to 'Peabody Acd. of Science Salem Mass. U.S.A.', though the drawing is identical to dredge **846**, 1895-359).

847 Plate 136
Hand fishing net, *kupenga*
1913.5-24.84. Length 56 cm.

Wooden ring: brown, with large-mesh net of thin twisted string suspended from it; lashed to T-shaped wooden handle carved in form of *manaia* with long extended jaw and notched haliotis-shell eyes (one missing).
 Provenance: Edge-Partington Collection.

Labels: 'J.E.P. 24', 'New Zealand hand net No. J.19'.
 Register: 'Supplejack net with carved handle.'
 Comments: East Coast, 1850s–70s (RN).
 References: Edge-Partington 1969 II.1: 226.1.

848
Rectangular fishing net, *kupenga*
NZ 140. 148 × 19 cm, 166 × 17 cm.

Vegetable-fibre string, very small mesh; two pieces.
 Provenance: Presented by H. Cuming.

849
Rectangular fishing net, *kupenga*
1960 OC.11.4. 200 × 120 cm.

Strips of flax leaves, large mesh.
 Provenance: Transferred from Royal Botanic Gardens, Kew.
 Label: 'Fishing net made of the split leaves of New Zealand Hemp. Phormium tenax, Forst.'

850 Plate 137
Fishing float, *poito*
1895-350. Length 33 cm.

Wooden float in form of openwork face, painted with red ochre: large nose, plain

spiral each side of mouth, lower mouth broken off.
 Provenance: Meinertzhagen Collection.
 Comments: East Coast/Urewera, 1850s–60s, unusual form, coarse carving (RN); Taranaki, c.1860 (DRS).

851 Plate 137
Fishing float, *poito*
1944 OC.6.1. Length 38.2 cm.

Wooden float, light brown, in form of *wheku* figure with semi-naturalistic face, openwork eyes, attachment hole at top of head; two-fingered hands on chest, plain surface. Extreme right side, from shoulder to foot, broken off; feet sawn off underneath.
 Provenance: Anonymous acquisition.
 Register: 'bought over 35 years ago'.
 Comments: Bay of Plenty; 1840s–50s (RN); 1850–60 (DRS).

852
Float for fishing line, *poito*
NZ 30. Length 4.5 cm.

Circular, of pumice, with irregular grooves cut across it.
 Provenance: Hector/ Colonial Museum Collection.

Register: 'From old hunting camp. Wainongoro [Waingongoro River mouth, South Taranaki], N.Z.'

853
Fish stringer, *au ika*

1717. Length 27 cm.

Bone stringer: carved on one side with *manaia* face at each end, longitudinal *rauponga* and plain spiral in centre; three holes at one end, with thick braided-flax cord threaded through two.

Provenance: Unknown.

Comments: East Coast, late nineteenth century (RN).

References: Edge-Partington 1969 I: 379.5.

854
Fish stringer, *au ika*

1718. Length 30.8 cm.

Bone stringer, plain, slightly curved at one end, with thick braided and then twisted flax cord attached at other and wound around stringer three quarters of its length.

Provenance: Unknown.

855
Fish stringer, *au ika*

1895-391. Length 22 cm.

Bone stringer: narrow, slim, polished; two-ply vegetable-fibre string threaded through hole at one end and wound around stringer for one third of its length.

Provenance: Meinertzhagen Collection.

856
Fish-hook spreader

1898-304. Length 100 cm.

Vegetable fibre, cruciform.

Provenance: Presented by J. Edge-Partington.

Label: 'Piece of Maori fishing line made and used by the natives of Parihaka for deep sea fishing.'

857
Fishing line, *aho*

6061. Length 8 cm.

Vegetable fibre, rolled into coil; very fine cord, coated with black waxy substance.

Provenance: Received in exchange from Mr Lempriere, 21 February 1870.

Label: '119'.

Comments: Also numbered later by mistake NZ 119

858
Fishing line and sinker, *aho* **and** *mahe*

1895-399. Length 13 cm (bundle), 6 cm (sinker).

Vegetable-fibre twisted line rolled in bundle, to one end of which is tied light-brown, flattish, ovoid, grooved stone (quartz?) sinker.

Provenance: Meinertzhagen Collection.

859
Fishing line and sinker, *aho* **and** *mahe*

1895-400. Length 12 cm (bundle), 5.4 cm (sinker).

Vegetable-fibre twisted line rolled in bundle, to one end of which is tied greyish beige, flattish, ovoid, grooved stone sinker (calcite or fluorspar?).

Provenance: Meinertzhagen Collection.

Sinkers, *mahe*

860
NZ 14. Diameter 11 cm. Sandstone; globular, dark grey, rough, grooved.

Provenance: Hector/Colonial Museum Collection.

Register: 'Found at Brighton, West Coast N.Z.'

861
NZ 15. Length 10.5 cm. Andesite; dark greenish grey, coarse, ovoid, with longitudinal grove.

Provenance: Hector/Colonial Museum Collection.

Label: 'Col:Mus: N.Z. 186 No. N.Z. 15. Waikava [Waikawa] Harbour. Mahe. Sinker used by Maoris for fishing, Waikava [Waikawa] Harbour, Otago.'

Comments: Waikawa Harbour, Southland.

862
4903. Length 10.5 cm. Andesite; greenish white, two figures back to back, hands on chests, heads joined at top, hole between necks through which is threaded two-ply twisted vegetable-fibre string.

Provenance: Purchased from B.M. Wright, 14 July 1868.

References: Edge-Partington 1969 I: 391.11.

863
6854. Length 8.5 cm. Argillite; dark grey, smooth, oval cross section, flat bottom, narrowing towards rounded top carved with concentric grooves; cratered hole through narrow part.

Provenance: Presented by Sir Walter C. Trevelyan, 7 October 1870.

Meinertzhagen Collection (864–884)

864 1895-414. Length 19 cm. Vesicular basalt, black, rounded oblong, flattish, grooved all around edge, seven transverse grooves on one face.

865 1895-879. Length 9 cm. Calcite, white, pear-shaped, deep longitudinal groove.

866 1895-880. Diameter 7.5 cm. Mudstone, grey, globular, slightly flattened, equatorial groove.

867 1895-881. Length 9 cm. Sedimentary, grey, ovoid, equatorial groove.

868 1895-882. Length 8 cm. Sedimentary, grey, ovoid, longitudinal groove.

869 1895-883. Length 5 cm. Mudstone, grey, round, flattish, equatorial groove.

870 1895-883A. Length 5.5 cm. Argillite, grey, round, one side flat, other convex, notched edge, equatorial groove.

871 1895-884. Length 5.2 cm. Calcite, white, round, slightly flattened, equatorial groove.

872 1895-885. Length 6.5 cm. Mudstone, grey, narrow pointed oval, longitudinal groove.

873 1895-886. Length 5.8 cm. Calcite, white, oblong, irregular square cross section, bevelled ends, longitudinal groove.

874 1895-887. Length 6.5 cm. Mudstone, grey, triangular cross section, one side convex with short groove in centre, longitudinal groove on opposite edge.

875 1895-888. Length 4.8 cm. Mudstone, grey, ovoid, longitudinal groove.

876 1895-889. Length 4.5 cm. Mudstone, grey, globular, polished, equatorial groove.

877 1895-890. Length 5 cm. Mudstone, white, flattened, ovoid, longitudinal groove.

878 1895-891. Length 5.2 cm. Mudstone, grey, square cross section, slightly convex sides, pointed ends, notched edges, longitudinal groove.

879 1895-892. Length 3.5 cm. mudstone, dark grey, rectangular cross section, slightly convex sides, pointed ends, longitudinal groove.

880 1895-893. Length 4.5 cm. Mudstone, grey, rectangular cross section, two sides flat, two convex, slightly pointed ends, longitudinal groove.

881 1895-894. Length 5.5 cm. Calcite, grey, coarse, ovoid, longitudinal groove.

882 1895-895. Length 4 cm. Mudstone, grey, roughly triangular, one side more pronouncedly convex than others, longitudinal groove.

883 1895-896. Length 4 cm. Sandstone, dark grey, ovoid, rough, longitudinal groove; one end broken off.

884 1895-897. Diameter 3.2 cm. Argillite, dark grey, disc shaped, groove on one side only.

885
1912.5-24.39. Length 10 cm. Schist, grey, oblong, very thin, flat, longitudinal groove.

Provenance: Robertson/White Collection.

886 Plate 138
1912.5-24.41. Length 6 cm. Calcite, yellowish brown, three-lobed heart shape, parallel grooves on three lobes, rest plain, longitudinal groove, old hole at top.

Provenance: Robertson/White Collection.

887
1913.5-24.85. Length 15 cm. Basalt, grey, coarse, circular cross section, wide rounded bottom, narrowing towards other, pointed, end, two parallel, shallow, equatorial grooves.

Provenance: Edge-Partington Collection.

Comments: Kawhia (DRS).

888 Plate 138
1913.5-24.86. Length 10.5 cm. Iron-rich stone, greyish brown, irregular shape; one end with constricted groove, and domed extreme end with groove across it.

Provenance: Edge-Partington Collection.

Label: 'New Zealand Stone sinker for fishing net. No. J.10 Pl.391. No. 11.'

References: Edge-Partington 1969 II 1: 232.6.

889
1928.1-10.104. Length 9.5 cm. Basalt, dark grey, polished, globular, with perforated loop handle.

Provenance: Liversidge Collection.

Comments: Hokianga (DRS).

890 Plate 138
1928.1-10.105. Length 6.5 cm. Iron-rich sandstone, dark grey, globular, with constricted neck with hole and grooved mushroom-shaped top.

Provenance: Liversidge Collection.

Label: 'A. Liversidge. J. Webster. Nr Hokianga NZ.'

891
1928.1-10.106. Length 3 cm. Mudstone, brownish grey, ovoid, longitudinal groove.
Provenance: Liversidge Collection.
Label: 'A. Liversidge. Hokianga NZ. J. Webster.'

892
Q1981 Oc.1894. Length 6 cm. Calcite, grey-white, coarse, roughly ovoid, longitudinal groove.
Provenance: Unknown.

893
Q1987 Oc.95. Length 6.2 cm. Sandstone, grey, coarse, roughly ovoid, one side broken, longitudinal groove.
Provenance: Unknown.

Fish-hooks, *matau*

All measurements are for hooks only, excluding snood.

Archaic bone and stone shanks

Meinertzhagen Collection (894–901)

894 1895-524. Length 8 cm. Bone, broken in half.
895 1895-525. Length 4.2.cm. Bone, half only.
896 1895-526. Length 7.3 cm. Bone, broken in half.
897 **Plate 139**
 1895-527. Length 6.3 cm. Bone, end broken off.
898 1895-527a. Length 3–4.3 cm. Three stone shank fragments.
899 **Plate 139**
 1895-563. Length 8.1 cm. Bone.
900 1895-651a. Length 6 cm. Stone shank.
901 1895-622. Length 4.6 cm. Bone, half only, blackened.

Bone points, barbed and unbarbed

902
NZ 60. Length 3.5 cm. Middle section, with four notches on one edge.
Provenance: Hector/Colonial Museum Collection.
Register: 'From a Moa bone cave at Sumner near Christchurch, Canterbury NZ.'

Meinertzhagen Collection (903–926)

903 1895-528. Length 4 cm. One external barb, three notches on outer edge.
904 1895-546. Length 8 cm. Two barbs, one internal, one external; notches on outer edge and on inner down to barb.
905 1895-547. Length 8 cm. Two barbs, one internal, one external; notches on both edges down to barbs.
906 1895-548. Length 7.5 cm. Two barbs, one internal, one external; notches down to barbs on both edges, and on base of shank.
907 1895-549. Length 9 cm. Two barbs, one internal, one external; very weathered.
908 1895-550. Length 7.1 cm. Unbarbed; notches on outer edge, low knob at bend, perforation at shank head.
909 1895-551. Length 6.8 cm. Unbarbed; two perforations at shank head, one broken off.

910 1895-552. Length 7 cm. Unbarbed; perforation at shank head.
911 1895-553. Length 6.5 cm. Two barbs, one internal, one external.
912 1895-554. Length 7.5 cm. Unbarbed.
913 1895-555. Length 6 cm. Unbarbed; worn shallow notching on outer edge.
914 1895-556. Length 4.5 cm. One internal (?) barb.
915 1895-557. Length 4.3 cm. One internal (?) barb.
916 1895-558. Length 4.1 cm. One internal barb..
917 1895-559. Length 2.8 cm. One internal barb.
918 1895-560. Length 3.3 cm. Unbarbed.
919 1895-561. Length 2.8 cm. One internal barb, notches on outer edge and on inner down to barb..
920 1895-571. Length 3 cm. Two grooves and very small knob on point.
921 1895-594. Length 6.7 cm. One internal (?) barb, tip of point broken off, three notches on outer (?) lower shank.
922 1895-598. Length 4.5 cm. One barb, tip of point broken off; broken in half and glued together.
923 1895-601. Length 4.6 cm. One barb.
924 1895-602. Length 4.2 cm. One barb, tip of point broken off, notches on one edge down to barb, two grooves at shank head; blackened.
925 1895-618. Length 5.8 cm. Unbarbed, worn.
926 1895-619. Length 4.4 cm. Middle section, with one barb, partly blackened.

Bone points, unbarbed, plain

Skinner Collection (927–937)

927 1937.7-3.25. Length 4.5 cm. Marked 'D.27.1065. Shag River.'
928 1937.7-3.26. Length 5.2 cm. Register: 'D.31.641. Little Papanui.'
929 1937.7-3.27. Length 4 cm. Marked 'D.29.1071'.
 Register: 'Little Papanui'.
930 1937.7-3.28. Length 7.2 cm. Marked 'D.35.1208. Onepoto.'
931 1937.7-3.29. Length 7.3 cm. Marked 'D.27.1172. Shag River.'
932 1937.7-3.30. Length 10 cm. Marked 'D.27.1165. Shag River.'
933 1937-7-3.53. Length 4.9 cm.
934 1937-7-3.54. Length 5.1 cm. Marked 'D.31.585. Centre Island.'
935 1937-7-3.55. Length 4.8 cm. Marked 'D.24.1430. Long Beach.'
936 1937-7-3.56. Length 6.7 cm. Marked 'D.27.1399. Centre Island.'
937 1937-7-3.57. Length 5.7 cm. Marked 'Kaikai'.

Bone points, mostly unbarbed and notched on outer edge

Skinner Collection (938–948)

938 1937.7-3.31. Length 5.5 cm. Tip of point broken off. Marked 'Little Papanui'.
939 1937.7-3.32. Length 5.8 cm. Perforation in shank head. Marked 'D.28.22'.
 Register: 'Papanui Inlet'.
940 1937.7-3.33. Length 3.4 cm. Marked

'D.29.1109. Little Papanui.'
941 1937.7-3.34. Length 4 cm. Marked 'D.31.592. Centre Island.'
942 1937.7-3.35. Length 5.3 cm. Marked 'D.32.705. L[ong] B[each].'
943 1937.7-3.36. Length 4.2 cm. Tip of point broken off, perforation at shank head. Marked 'D.31.673. Murdering Beach.'
944 1937.7-3.37. Length 5 cm. Notched also on upper part of inner edge. Marked 'D.19.169'.
945 1937.7-3.38. Length 5.3 cm. One internal barb, perforation at shank head. Marked 'D.29.92'.
 Register: 'Shag River'.
946 1937.7-3.39. Length 3.5 cm. Marked 'D.31.658. Onepoto.'
947 1937.7-3.40. Length 3.2 cm. Marked 'D.34.168. Kaikais Beach.'
948 1937.7-3.41. Length 3.6 cm.

Bone points, some barbed and/or notched

Beasley Collection (949–981)

950–981 (1944 Oc.2.211 to 242) are all annotated in Register as 'Otago' or 'Otago Museum'; **950–955** (1944 Oc.2.211 to 216) have Beasley no. 1494/2, Beasley catalogue 1494/2, registered 10 November 1924, '…obtained from H.D. Skinner, Otago Museum, in exchange for No. 1475 [Rotuma club]'; **956–981** (1944 Oc.2. 217 to 242) have Beasley no. 1571, Beasley catalogue 1571, registered 29 January 1926, 'From sites in South Island. In exchange with the Otago Museum.'

949 1944 Oc.2.207. Length 3.9 cm. Two barbs, one internal, one external Label: 'Ex York Museum… Human bone barb from a Kahawai Hook.'
950 1944 Oc.2.211. Length 5.9 cm. Plain.
951 1944 Oc.2.212. Length 6.5 cm. Plain. Marked 'D.24.597. Shag River.'
952 1944 Oc.2.213. Length 5.6 cm. Plain. Marked 'D.24.594. Shag River.'
953 1944 Oc.2.214. Length 5.3 cm. Plain. Marked 'Shag River'.
954 1944 Oc.2.215. Length 5.5 cm. Plain. Marked 'Shag River'.
955 1944 Oc.2.216. Length 3.5 cm. Plain. Marked '… Shag River'.
956 1944 Oc.2.217. Length 4 cm. Notched outer edge, perforation at shank head. Marked 'D.18.433'. Beasley: 'Seal teeth.'
957 1944 Oc.2.218. Length 4 cm. Tip broken off, notched outer edge, perforation at shank head. Marked 'D.25.2222'. Beasley: 'Seal teeth.'
958 1944 Oc.2.219. Length 4.2 cm. Notched outer edge near tip, perforation at shank head broken off. Marked 'D.24.899'. Beasley: 'Seal teeth.'
959 1944 Oc.2.220. Length 4.7 cm. Notched outer edge, perforation at shank head broken off. Marked 'D.24.203'. Beasley: 'Seal teeth.'
960 1944 Oc.2.221. Length 4.9 cm. Plain, perforation at shank head broken off. Marked 'D.25.2220'. Beasley: 'Seal teeth.'
961 1944 Oc.2.222. Length 5.1 cm. Notched outer edge down to one external barb. Marked 'D.24.917'. Beasley: 'Dog jaw.'

962 1944 Oc.2.223. Length 5.2 cm. Plain. Marked 'D.24.2221'. Beasley: 'Dog jaw.'

963 1944 Oc.2.224. Length 6.3 cm. Plain, small external knob half way down. Marked 'D.24.907A'. Beasley: 'Otter bone [perhaps seal bone as otters do not occur in New Zealand]'.

964 1944 Oc.2.225. Length 4.8 cm. Notched outer edge down to one external barb, perforation at shank head. Marked 'D.18.335'. Beasley: 'Otter bone [perhaps seal bone as otters do not occur in New Zealand]'. Label: 'A. Moritzson'.

965 1944 Oc.2.226. Length 6.8 cm. Notched outer edge, perforation at shank head. Marked 'D.10.154'. Beasley: 'Otter bone [perhaps seal bone as otters do not occur in New Zealand]'. Label: 'Dr Hocken's'.

966 1944 Oc.2.227. Length 5 cm. Traces of notching on outer edge. Marked 'D.25.2223'. Beasley: 'Otter bone [perhaps seal bone as otters do not occur in New Zealand]'.

967 1944 Oc.2.228. Length 5.1 cm. One internal (?) barb. Marked 'D.25.2235'.

968 1944 Oc.2.229. Length 4.5 cm. One internal (?) barb. Marked 'D.25.2234'.

969 1944 Oc.2.230. Length 4.3 cm. One internal (?) barb. Marked 'D.25.2233'.

970 1944 Oc.2.231. Length 5 cm. One internal barb, notched outer edge and internal down to barb. Marked 'D.25.2236'.

971 1944 Oc.2.232. Length 4.4 cm. One internal barb, notched outer edge and inner down to barb. Marked 'D.25.2231'.

972 1944 Oc.2.233. Length 5.1 cm. Two barbs, one internal, one external. Marked 'D.25.2238 [?]'.

973 1944 Oc.2.234. Length 4.5 cm. One barb, opposite edge notched. Marked 'D.25.2232'.

974 1944 Oc.2.235. Length 2.8 cm. One barb. Marked 'D.25.2229'.

975 1944 Oc.2.236. Length 3.3 cm. One internal barb, notched outer edge and inner down to barb. Marked 'D.25.2229 [?]'.

976 1944 Oc.2.237. Length 4.4 cm. One external barb, notching below it. Marked 'D.25.2227'.

977 1944 Oc.2.238. Length 4 cm. Plain, worn. Marked 'D.25.2226'.

978 1944 Oc.2.239. Length 6.5 cm. Three very shallow barbs, two internal, one external. Marked 'D.25.2237'.

979 1944 Oc.2.240. Length 2.1 cm. Plain.

980 1944 Oc.2.241. Length 3.6 cm. Plain.

981 1944 Oc.2.242. Length 5.2 cm. Plain, tip broken off. Marked 'D.25.2225'.

Bone points, one barb

Skinner Collection (982–992)

982 1937.7-3.42. Length 3.5 cm. Marked 'D.32.659. L[ong] B[each].'

983 1937.7-3.43. Length 2.9 cm. Both edges notched down to barb. Marked 'D.31.573'. Register: 'Little Papanui'.

984 1937.7-3.44. Length 1.7 cm. Both edges notched. Marked 'D.29.5358'. Register: 'Little Papanui'.

985 1937.7-3.45. Length 3.3 cm. Marked 'D.31.532. Centre Island.'

986 1937.7-3.46. Length 5.5 cm. Marked 'D.22.91. Long B[each].'

987 1937.7-3.47. Length 4.9 cm. Traces of notching on one edge. Marked 'D.28.440. Long Beach.'

988 1937.7-3.48. Length 3.8 cm. Marked 'D.35.1192. Kaikais Beach.'

989 1937.7-3.49. Length 2.2 cm. Both edges notched, one only down to barb. Marked 'D.28.410. L[ong] B[each].'

990 1937.7-3.50. Length 3.3 cm. Marked 'D.28.417. L[ong] B[each].'

991 1937.7-3.51. Length 4.9 cm. Marked 'Long Beach'.

992 1937.7-3.52. Length 6.8 cm. Marked 'D.29.5401. Kaikai.'

One-piece bone hook manufacture

Varying in size from 2.8 to 11 cm.

Skinner Collection (993–1004)

993 1937.7-3.13. Blank. Marked 'D.27.1012. Shag River.'

994 1937.7-3.14. Blank. Register: 'D.35.1146. Shag River.'

995 1937.7-3.15. Blank. Marked 'D.27.1013. Shag River.'

996 1937.7-3.16. Preformed hook. Marked 'D.35.1149. Shag River.'

997 1937.7-3.17. Preformed hook. Marked 'D.22.94'. Register: 'Long Beach'.

998 1937.7-3.18. Preformed hook. Marked 'D.35.1147. Shag River.'

999 1937.7-3.19. Preformed hook. Marked 'D.36.522. Hamilton, Northern Trench, Shag River.'

1000 1937.7-3.20. Preformed hook. Marked 'D.29.1108'. Register: 'Shag River'.

1001 1937.7-3.21. Preformed hook. Marked 'D.29.2273'. Register: 'Shag River'.

1002 1937.7-3.22. Preformed hook. Marked 'D.27.1019. Shag River.'

1003 1937.7-3.23. Preformed hook. Marked 'D.27.1020. Shag River.'

1004 1937.7-3.24. Bone fragment/shank, hole at one end. Marked 'D.29.447. Little Papanui.'

One-piece bone hooks and fragments

Beasley Collection (1005–1010)

1005–**1010** (1944 Oc.2.204 to 210) are all annotated in Register as 'Otago' or 'Otago Museum'; **1005**–**1007** (1944 Oc.2.204 to 206) have Beasley no. 2005, Beasley catalogue 2005, registered 21 April 1927, 'All from middens in Otago. Exchanged with the Otago Museum.'; **1008**–**1010** (1944 Oc.2. 208 to 210) have Beasley no. 1494/2, Beasley catalogue 1494/2, registered 10 November 1924, '…obtained from H.D. Skinner, Otago Museum, in exchange for No. 1475 [Rotuma club].'

1005 1944 Oc.2.204. Length 3.7 cm. Point fragment, unbarbed. Marked 'D.26.1324'. Beasley label: 'Otago. [Beasley no.] 2005.'

1006 1944 Oc.2.205. Length 4.2 cm. Point fragment, unbarbed. Marked 'D26.1325'. Beasley label: 'Otago. [Beasley no.] 2005.'

1007 1944 Oc.2.206. Length 1.2 cm. Point fragment, unbarbed. Marked 'D.26.1323'. Beasley label: 'Otago. [Beasley no.] 2005.'

1008 1944 Oc.2.208. Length 4 cm. Hook, unbarbed, three-lobed shank head; very worn. Marked 'D.24.601. Shag River.'

1009 1944 Oc.2.209. Length 4.2 cm. Hook, tip of point broken off, three-lobed shank head. Marked 'D.24.600. Shag River.'

1010 1944 Oc.2.210. Length 4.5 cm. Hook, with large part of point broken off, three-lobed shank head. Marked 'D.24.602. Shag River.'

One-piece bone hooks, barbed, symmetrical

1011 **Plate 139**
NZ 192. Length 2.6 cm. Two barbs, one internal, one external, of human bone; snood.
Provenance: Unknown.

1012
NZ 193. Length 3.3 cm. One internal barb, notched outer edge, of human bone; snood.
Provenance: Unknown.
References: Edge-Partington 1969 I: 391.5.

1013
NZ 195. Length 3.3 cm. One internal barb, of human bone; remnants of snood.
Provenance: Unknown.

1014 **Plate 139**
4315. Length 2.5 cm. One notched external barb, two notched knobs on outer edge; snood.
Provenance: Unknown.

1015
4316. Length 2.7 cm. Three barbs, one internal, two external, notch in bend; snood.
Provenance: Unknown.

Meinertzhagen Collection (1016–1021)

1016 1895-500. Length 2.8 cm. One internal barb, notch in bend; snood. References: Beasley 1928: pl. XIIA, top row, third right. Trotter 1956: 246, 248, fig. 5.

1017 1895-501. Length 2.5 cm. One internal barb, notch in bend, shank head with point and two lobes. References: Beasley 1928: pl. XIIA, top row, third left.

1018 1895-502. Length 2.2 cm. One internal barb, notch in bend, shank head with point and notched lobe. References: Beasley 1928: pl. XIIA, top row, second right.

1019 1895-503. Length 2.1 cm. One internal barb, shank head with point and grooved lobe. References: Beasley 1928: pl. XIIA, top row, second left.

1020 1895-504. Length 1.9 cm. One internal barb, notch in bend, shank head with point and lobe. References: Beasley 1928: pl. XIIA, top row, first right.

1021 **Plate 139**
1895-505. Length 1.9 cm. One internal barb, notch in bend; remnants of snood.

References: Beasley 1928: pl. xiiA, top row, first left.

1022 **Plate 139**

Q1981 oc.1333. Length 2.5 cm. One internal barb, notched outer edge, grooved knob at bend; snood.
 Provenance: Unknown.

One-piece bone hooks, mostly unbarbed, asymmetrical

1023 **Plate 140**

1918. Length 3.1 cm. One notched external barb, two notched external barbs/knobs at base, one each side of bend; snood.
 Provenance: Unknown.

Meinertzhagen Collection (1024–1031)

1024 **Plate 140**

1895-494. Length 4.5 cm. Shank head with knob.
References: Beasley 1928: pl. xiiA, middle row, third left (where label with number 95-404 is incorrect).

1025 **Plate 140**

1895-495. Length 3.9 cm. Notched knob on point, notched outer edge, three-lobed knob at base, shank head with lobe.
References: Beasley 1928: pl. xiiA, middle row, third right.

1026 1895-496. Length 4 cm. Notched outer edge, three-lobed shank head.
References: Beasley 1928: pl. xiiA, middle row, second left.

1027 1895-497. Length 4.1 cm. Point limb with notched outer edge, three-lobed shank head.
References: Beasley 1928: pl. xiiA, middle row, second right.

1028 **Plate 140**

1895-498. Length 3.2 cm. Notched outer edge, including shallow barb, two-lobed shank head.
References: Beasley 1928: pl. xiiA, middle row, first right.

1029 1895-499. Length 3 cm. Notched outer edge, including shallow barb, two-lobed shank head.
References: Beasley 1928: pl. xiiA, middle row, first left.

1030 1895-506. Length 4.2 cm. Tips of point and shank broken off.

1031 1895-507. Length 3.1 cm. Three-lobed shank head, notch in bend.
References: Beasley 1928: pl. xiiA, bottom row, third right.

Beasley Collection (1032–1036)

1032 **Plate 140**

1944 oc.2.176. Length 4.2 cm. Knob at base; snood. Beasley no. 3223.
Label: 'Grey coll. 3223'.
Beasley catalogue 3223, registered 6 June 1933, 'Presented by Mrs George Todd.'

1033 1944 oc.2.200. Length 4.5 cm. Two-lobed shank head, notch in bend. Beasley no. 3069.
Beasley catalogue 3069, registered 18 July 1932, 'Bought H. Furze.'

1034–1036 (1944 oc.2.201 to 203) have Beasley no. 1253, Beasley catalogue: 1253, registered 7 November 1922, 'Chatham Islands. Moriori… Exchanged with the Otago Museum, Dunedin, per Skinner.'

1034 1944 oc.2.201. Length 3.8 cm. Tip of point broken off, three-lobed shank head, notch in base. Marked 'D.10.155'.
Label: 'Ex Otago Museum. No. 1253.'

1035 1944 oc.2.202. Length 4.8 cm. Two-lobed shank head. Marked 'D.19.336'.
Label: 'Ex Otago Museum. No. 1253.'

1036 1944 oc.2.203. Length 3.5 cm. Tip of shank broken off.
Labels: 'Ex Otago Museum. No. 1253'; 'Dr Hocken's'.

1037

Q1981 oc.1336. Length 3.5 cm. Notched outer edge, three-lobed shank head; snood (detached).
 Provenance: Unknown.
 References: Beasley 1928:8, fig. 1.

One-piece hooks of iridescent shell, unbarbed

1038

1895-163. Length 3 cm. Two hooks, originally attached by lines to snood of composite hook **1083** (1895-163) but now separated (lines broken); one with its snood still attached, other's snood broken off.
 Provenance: Presented by A.W. Frank, 3 June 1895 (ex Sparrow Simpson Collection).

Meinertzhagen Collection (1039–1046)

1039 1895-508. Length 3.3 cm.

1040 **Plate 140**

1895-509. Length 3.2 cm.
References: Beasley 1928: pl. xiiA, bottom row, third left.

1041 1895-510. Length 3 cm.
References: Beasley 1928: pl. xiiA, bottom row, second right.

1042 1895-511. Length 2.2 cm.

1043 1895-512. Length 2.5 cm.

1044 1895-513. Length 2.5 cm.
References: Beasley 1928: pl. xiiA, bottom row, second left.

1045 1895-514. Length 2.5 cm.
References: Beasley 1928: pl. xiiA, bottom row, first right.

1046 **Plate 140**

1895-515. Length 2 cm.
References: Beasley 1928: pl. xiiA, bottom row, first left.

One-piece wooden hooks, sub-circular, barbed

1047 **Plate 141**

NZ 179. Length 25.5 cm. Two external barbs; snood.
 Provenance: Unknown.
 References: Beasley 1928:13, pl. xxiii; Edge-Partington 1969 1: 391.1.

1048

250. Length 24.5 cm. One external barb; snood.
 Provenance: Unknown.

1049 **Plate 141**

1916. Length 12 cm. Three external barbs; snood.
Provenance: Unknown.

1050

1944 oc.2.149. Length 24.5 cm. Two external barbs; snood.
 Provenance: Beasley Collection. Beasley no. 2874.

Beasley catalogue 2874, registered 14 September 1931, 'Tahiti. Bought Andrade & Son.'

One-piece iron hooks, U-shaped

1051

1895-410. Length 16 cm. One internal barb; snood.
 Provenance: Meinertzhagen Collection.

1052 **Plate 141**

1944 oc.2.199. Length 13 cm. Unbarbed; snood.
 Provenance: Beasley Collection. Beasley no. 390.
Beasley catalogue 390, registered 6 August 1909, 'Bt W. Oldman'.

1053

Q1981 oc.1344. Length 5.8 cm. Unbarbed; corroded.
 Provenance: Meinertzhagen Collection.

Composite bone hooks with one-barbed point

All with snood.

Provenance unknown (1054–1057)

1054 NZ 188. Length 3.7 cm. One internal barb, notched outer edge of point, of human bone.

1055 NZ 189. Length 3.4 cm. One internal barb, of human bone.

1056 NZ 190. Length 3.8 cm. One internal barb, of human bone.

1057 **Plate 141**

NZ 191. Length 4.1 cm. One internal barb, notched outer edge of point and shank.

Composite hooks: curved, wooden shank, shell point, unbarbed

All with snood.

1058

2052 and 2053. Lengths 7 and 8.3 cm.
 Provenance: Unknown.

1059 **Plate 141**

2057. Length 14.5 cm. Slight notching on inner edge of point.
 Provenance: Unknown.

Beasley Collection (1060–1064)

1060 1944 oc.2.155. Length 16.5 cm. Beasley no. 2842.
Beasley catalogue 2842, registered 1 February 1931, 'Blackmore Museum.'

1061 1944 oc.2.172. Length 6 cm. Very small point. Beasley no. 2843.
Beasley catalogue 2843, registered 1 February 1931, 'Blackmore Museum.'

1062 **Plate 141**

1944 oc.2.173. Length 8 cm. Beasley no. 688.
Beasley catalogue 688, registered 1 January 1913, 'Bt W. Oldman ex Stevens. Lot 72. Dec.17,1912.'

1063 1944 oc.2.174. Length 6 cm. Remnants of snood. Beasley no. 1372.
Beasley catalogue 1372, registered 3 April 1924, 'Ex Sale F.H. Keeble, Manor House, Tatsfield, Surrey.'

1064 **Plate 141**

1944 oc.2.175. Length 6.5 cm. Beasley no. 2844.
Beasley catalogue 2844, registered 1 February 1931, 'Blackmore Museum.'

Composite hooks: U-shaped, wooden shank, bone point, usually barbed; includes also dog's jaw-bone points
All with snood.

Provenance unknown (1065–1079)

1065 NZ 171. Length 16.2 cm. Four barbs, three internal, one external, notched outer edge; lashing at point mostly gone.

1066 NZ 172. Length 14.5 cm. Two barbs, one internal, one external.

1067 NZ 173. Length 16 cm. Three barbs, two internal, one external, outer edge notched.

1068 NZ 175. Length 11 cm. Point notched on both edges down to barbs, one on each side.

1069 **Plate 142**
NZ 176. Length 17 cm. Point notched on both edges, five barbs, two internal, three external; point extends through lashing into another notched point. Shank head carved as stylized human face, with snood attachment passing through its open mouth.
References: Beasley 1928:15, pl. XXVI; Edge-Partington 1969 I: 391.3.

1070 NZ 178. Length 18 cm. Three barbs, one internal, two external; crude lashing.

1071 NZ 183. Length 11.5 cm. One barb each side; covered in red ochre.

1072 NZ 184. Length 6 cm. One external barb, gnarled/twisted shank.

1073 NZ 185. Length 6.5 cm. One internal barb, outer edge notched; bent shank.

1074 **Plate 142**
NZ 186. Length 4.7 cm. One shallow external barb, gnarled/twisted shank.

1075 NZ 187. Length 22 cm. One internal barb; very long, slightly worn shank.
References: Edge-Partington 1969 I: 391.2.

1076 251. Length 18 cm. Dog's jaw-bone point; five very shallow external barbs.

1077 252. Length 13.5 cm. Five very shallow barbs, two internal, three external, all finely notched.

1078 **Plate 142**
1914. Length 9 cm. One internal barb; two opposing stylized faces carved on outer edge (part of lower one broken off).

1079 1917. Length 10 cm. Two minute external barbs.

1080 **Plate 142**
9356. Length 13 cm. Three barbs, one internal, two external, outer edge notched; shank head carved as *wheku* face with surface ornamentation of *pakura*. Snood attachment behind face.
Provenance: Sparrow Simpson Collection.
References: Davidson 1996: 18; Edge-Partington 1969 I: 391.4; Hooper 2006: 130.67.

1081
+6047. Length 4.5 cm. One minute internal barb; gnarled/twisted shank.
Provenance: Presented by A.W. Franks, 22 April 1893 (Rusher Davies sale).

Presented by A.W. Franks, 3 June 1895 (ex Sparrow Simpson Collection) (1082–1084)

1082 **Plate 142**
1895-161. Length 5.1 cm. Three barbs, one internal, two external.

1083 1895-163. Length 10 cm. One external barb; two one-piece iridescent shell hooks **1038** (1895-163) attached to snood.

1084 **Plate 142**
1895-164. Lengths 3.7, 4.2 and 6.5 cm. Three hooks – one with one internal barb, second with three barbs, one internal and two external; and third with two barbs, one internal and one external.

1085
1895-411. Length 10.2 cm. One internal barb; outer edge and inner notched down to barb; shank head carved as stylized face with some surface ornamentation.
Provenance: Meinertzhagen Collection.

1086
1896.11-19.10. Length 16 cm. One internal barb; outer edge and inner notched down to barb; shank head carved as stylized face with open mouth and some surface ornamentation.
Provenance: William Strutt Collection.
References: Beasley 1928:15, pl. XXVII.

Beasley Collection (1087–1096)

1087 **Plate 142**
1944 oc.2.157. Length 15 cm. Dog's jaw-bone point, one internal, one external notched barb. Beasley no. 2959.
Beasley catalogue 2959, registered 28 January 1932, 'The gift of Thomas A. Joyce to commemorate the opening of the Cranmore Museum in 1928. [In the event of the dispersal of the Museum this hook is to be passed to the British Museum].'

1088 1944 oc.2.158. Length 12.5 cm. Dog's jaw-bone point, outer edge below tip with four deep notches, inner edge with one tooth *in situ*. Beasley no. 3256.
Beasley catalogue 3256, registered 26 July 1933, 'Bought Kelso Museum, Roxburghshire.'

1089 1944 oc.2.159. Length 13 cm. Four barbs, one internal, three external, all notched; snood missing. Beasley no. 1371.
Beasley catalogue 1371, registered 3 April 1924, 'Ex Sale F.H. Keeble. Manor House, Tatsfield, Surrey.'

1090 1944 oc.2.160. Length 11.5 cm. Six notched external barbs, notched external tip; trace of broken-off internal barb. Beasley no. 3153.
Label: 'D 3153. Donor: G. Parks.'
Beasley catalogue 3153, registered 20 October 1932, 'Dover Museum.'

1091 1944 oc.2.161. Length 12.5 cm. Two barbs, one internal, one external, traces of notching. Beasley no. 3154.
Label: 'D 3154. Donor: G. Parks.'
Beasley catalogue 3154, registered 20 October 1932, 'Dover Museum.'

1092 1944 oc.2.162. Length 11.5 cm. Five barbs, one internal, four notched external. Beasley no. 687.

Beasley catalogue 687, registered 1 January 1913, 'Bt W. Oldman ex Stevens. Lot 72. Dec.17, 1912.'
References: Beasley 1928:11, pl. XIX.II.

1093 1944 oc.2.163. Length 9.7 cm. Two barbs, one internal, one external, both notched. Beasley no. 448.
Beasley catalogue 448, registered 20 January 1910, 'Bt Cole & Son, Parade, Sherborne.'

1094 1944 oc.2.164. Length 7 cm. Five barbs, one internal, four external, all notched. Beasley no. 2685.
Label: 'Lb 2685'.
Beasley catalogue 2685, registered 1 February 1931, 'Blackmore Museum.'

1095 1944 oc.2.165. Length 7.5 cm. Four notched external barbs. Beasley no. 3155.
Label: 'D.3155. Donor: G. Parks.'
Beasley catalogue 3155, registered 20 October 1932, 'Dover Museum.'

1096 1944 oc.2.170. Length 4.8 cm. One very shallow external barb. Beasley no. 2051.
Label: 'Valentine Starbuck. Sea Whaler. Ship L'Aigle, prior to 1793.'
Beasley catalogue 2051, registered 7 December 1927, 'The second portion of the Valentine Starbuck Collection (for 1st portion cf Nos 2014–2018 [see fish-hook **1104**, 1944 oc.2.150, and fish-hook **1107**, 1944 oc.2.153]). Brought to England on the South Sea Whaler L'Aigle prior to 1793 and Bt the great grand daughter Miss Eva P. Starbuck, 8 Temple Square, Aylesbury.'

1097 **Plate 142**
1967 oc.4.1. Length 8 cm. One internal barb.
Provenance: Presented by Mrs G. Gough.
Register: 'Obtained in New Zealand by donor's husband about 40 years ago.'

1098
Q1981 oc.1320. Length 21 cm. Very small point, outer edge notched; very long gnarled/twisted shank.
Provenance: Unknown.

Composite hooks: circular, wooden shank, small bone point, usually barbed
All with snood.

1099
NZ 177. Length 12.5 cm. Unbarbed, outer edge notched.
Provenance: Unknown.

1100
6000. Length 10.5 cm. One external, one internal barb.
Provenance: Unknown.

1101
1895-162. Length 6.6 cm. Three barbs, one internal, two external.
Provenance: Presented by A.W. Franks, 3 June 1895 (ex Sparrow Simpson Collection).

1102 **Plate 143**
1895-165. Length 11 cm. Three barbs, one internal, two external.
Provenance: Presented by A.W. Franks, 3 June 1895 (ex Sparrow Simpson Collection).

1103

1926-38. Length 17 cm. One internal barb with two notches, three notches on outer edge near lashing.

Provenance: Presented by Mrs Kellner, 15 September 1926.

Beasley Collection (1104–1108)

1104　　　　　　　　　　　　　　**Plate 143**

1944 oc.2.150. Length 20 cm. Two barbs, one internal, one external, both with some notches. Beasley no. 2016.
Label: 'Collected by Capt. Starbuck Whaler L'Aigle prior to 1824'.
Beasley catalogue 2016, registered 15 July 1927, 'Belonged to Capt. Valentine Starbuck of the Whaler L'Aigle. Bt Miss Eva P. Starbuck.'

1105 1944 oc.2.151. Length 16 cm. Worn point, traces of notching near lashing; shank also worn. Beasley no. 4704c.
Label: 'Australasian Court. Fish hook from the Sandwich Islands. Lent by the Misses Minty'.
Beasley catalogue 4704c, registered 15 September 1938, 'Prs by the Misses Minty.'

1106 1944 oc.2.152. Length 14 cm. Two very shallow external barbs, loose lashing around point. Beasley no. 4704b.
Beasley catalogue 4704b, registered 15 September 1938, 'Pres by the Misses Minty.'

1107 1944 oc.2.153. Length 11.5 cm. Five groups of notching, three outer, two inner. Beasley no. 2017.
Label: 'Collected by Valentine Starbuck Capt. Whaler L'Aigle prior to 1824.'
Beasley catalogue 2017, registered 15 July 1927, 'Belonged to Capt. Valentine Starbuck of the South Sea Whaler L'Aigler. Bt Miss Eva P. Starbuck.'

1108 1944 oc.2.154. Length 13 cm. Irregular notches on outer and inner edges. Beasley no. 386.
Beasley catalogue 386, registered 18 May 1909, 'Bt W.C. Wells… Wembley.'
References: Beasley 1928:11, pl. XX.III.

Composite hooks: V-shaped, wooden shank, bone point, usually barbed; includes some iron points

1109

NZ 181. Length 12 cm. Two barbs, one internal, one external, edges notched down to barbs; snood remnants.

Provenance: Unknown.

1110

NZ 182. Length 9.2 cm. One internal barb; snood remnants.

Provenance: Unknown.

1111

1915. Length 10 cm. Three barbs, one internal, two external; snood.

Provenance: Unknown.

1112

6643. Length 17 cm. Iron point; snood.

Provenance: Presented by J.L. Brenchley, 24 March 1870.

1113　　　　　　　　　　　　　　**Plate 143**

1895-168. Length 9.5 cm. Three barbs, one internal, two external, notching on inner edge down to barb, and on outer edge above lower barb; snood.

Provenance: Presented by A.W. Franks, 3 June 1895 (ex Sparrow Simpson Collection).

1114

1935.4-11.13. Length 20.5 cm. Iron point, corroded wire lashing around point; snood.

Provenance: London Missionary Society Collection.

Beasley Collection (1115–1118)

1115 1944 oc.2.156. Length 17 cm. One external barb, outer edge notched down to barb; snood. Beasley no. 250.
Beasley catalogue 250, registered 15 November 1906, 'Bt E. Little, Kingston.Taunton.'

1116 1944 oc.2.166. Length 12 cm. Two barbs, one internal, one external, both edges notched down to barbs; snood. Beasley no. 2875.
Beasley catalogue 2875, registered 14 September 1931, 'Bt Andrade & Son, Old Sugar Refinery, Plymouth.'

1117　　　　　　　　　　　　　　**Plate 143**

1944 oc.2.167. Length 12.5. cm. One internal barb, shank head with knob. Beasley no. 2687.
Beasley catalogue 2687, registered 1 February 1931, 'Blackmore Museum.'

1118 1944 oc.2.168. Length 9 cm. Two barbs, one internal, one external; snood. Beasley no. 2686.
Beasley catalogue 2686, registered 1 February 1931, 'Blackmore Museum.'

Composite hooks: wooden shank, bone point, usually barbed; parallel limbs with strengthening lashing at bend

1119　　　　　　　　　　　　　　**Plate 143**

1944 oc.2.169. Length 12.5. cm. One external barb; snood.

Provenance: Beasley Collection. Beasley no. 3501.

Beasley catalogue 3501, registered 17 July 1934, 'Bought Stevens Rooms. Ex Lot 170.'

1120　　　　　　　　　　　　　　**Plate 143**

Q1981 oc.1329. Length 9.5 cm. Unbarbed; snood.

Provenance: Unknown.

References: Beasley 1928:10, pl. XVIIA, bottom; Edge-Partington 1969 I: 391.8.

1121　　　　　　　　　　　　　　**Plate 143**

Q1981 oc.1337. Length 11 cm. One external barb; snood.

Provenance: Unknown.

References: Beasley 1928: 10, pl. XVIIA, top.

Composite hooks: bone shank, shell or bone point

1122

2054. Length 18 cm. Point of pearly shell; snood.

Provenance: Unknown.

References: Edge-Partington 1969 I: 391.6.

1123

2057. Length 14.5 cm. Point of human bone, notching on inner edge, traces of notching on outer edge.

Provenance: Unknown.

Composite barracuda trolling hooks: wooden shank, bone point (usually unbarbed) inserted through shank

1124

NZ 197. Length 15 cm. Point with outer edge notched.

Provenance: Unknown.

References: Beasley 1928:7, pl. X.

Meinertzhagen Collection (1125–1128)

1125 1895-401. Length 17.5 cm. Plain point.

1126 1895-402. Length 17.5 cm. Point with outer edge notched.

1127　　　　　　　　　　　　　　**Plate 144**

1895-403. Length 17.5 cm. Point with outer edge notched; snood.

1128 1895-404. Length 18 cm. Iron point, slightly corroded; snood.

Beasley Collection (1129–1131)

1129 1944 oc.2.178. Length 16.8 cm. Point with worn-off outer edge notching; snood. Beasley no. D3151.
Label: 'D 3151. Donor: G. Parks.'
Beasley catalogue 3151, registered 20 October 1932, 'Dover Museum.'

1130 1944 oc.2.179. Length 16.5 cm. Traces of notching on outer edge of point. Beasley no. D3152.
Label: 'D 3152. Donor: G. Parks.'
Beasley catalogue 3152, registered 20 October 1932, 'Dover Museum.'

1131 1944 oc.2.180. Length 17.7 cm. Iron point. Beasley no. 1496.
Label: 'N. Zealand. Otago. S. Island. Barracouta Hook. No. 1496.'
Beasley catalogue 1496, registered 10 November 1924, 'Obtained from H.D. Skinner, Otago Museum, in exchange for No 1475 [Rotuma club].'

Composite trolling hooks: standard *pa kahawai* hooks, wooden shank with haliotis-shell inlay, bone point, barbed

All with snood or its remnants.

1132

TRH 19 / 1902 L.1.19 / Royal Coll. no. 69979. Length 10.8 cm. One internal barb.

Provenance: Royal Loan 1902, Prince and Princess of Wales.

References: Imperial Institute 1902: 48.285.

1133

4345. Length 9.5 cm. One internal barb.

Provenance: Unknown.

References: Edge-Partington 1969 I: 391.9.

1134　　　　　　　　　　　　　　**Plate 144**

4346. Length 10 cm. One internal barb.
Label: '107'.

Provenance: Unknown.

1135

+4762. Length 18 cm. One internal barb; feather hackle.

Provenance: Presented by C.H. Read, 17 October 1890.

1136

1923-5. Length 7 cm. One internal barb.
Provenance: Presented by T.W. Travis.
Register: 'From Napier, Hawke Bay'.

1137

1928-93. Length 10.6 cm. Two barbs, one internal, one external.

Provenance: Presented by Mrs Emily Baxter.

Register: 'Collected early 19th cent. (?c1811) by Gabriel Land, donor's grandfather, a gunner in British Navy.'

1138

1846.1-4.4 (also numbered NZ 200). Length 9.5 cm. One internal barb.

Provenance: Transferred from Natural History Department.

William Strutt Collection (1139–1141)

1139 1896.11-19.11. Length 11 cm. One internal barb.

1140 1896.11-19.12. Length 11.3 cm. One internal barb.

1141 1896.11-19.13. Length 10.5 cm. One internal barb.

1142

1921.10-14.25a. Length 9.5 cm. Two barbs, one internal, one external; feather hackle.

Provenance: Yorkshire Philosophical Society Museum.

1143

1934.12-5.10. Length 11 cm. One internal barb.

Provenance: Bequeathed by T.B. Clarke Thornhill.

1144 **Plate 144**

1934.12-5.11. Length 12 cm. One internal barb.

Provenance: Bequeathed by T.B. Clarke Thornhill.

Beasley Collection (1145–1151)

1145 1944 Oc.2.181. Length 16 cm. One internal barb; feather hackle. Beasley no. 501.
Beasley catalogue 501, registered 23 July 1910, 'Bt at Sale at Vesta Rd Brockley.'
References: Beasley 1928:16, pl. XXIX, lower row, second right.

1146 1944 Oc.2.182. Length 11 cm. One internal barb. Beasley no. 2684.
Beasley catalogue 2684, registered 1 February 1931, 'Blackmore Museum.'

1147 1944 Oc.2.183. Length 9.7 cm. One internal barb. Beasley no. 844.
Label: 'No. 844. Presented by Edmund Lucas'.
Beasley catalogue 844, registered 21 January 1914, 'Presented by Edmund Lucas who had it in 1858 from his Aunt Miss R. Lucas.'

1148 1944 Oc.2.184. Length 8.8 cm. One internal barb. Beasley no. 570.
Beasley catalogue 570, registered 24 June 1911, 'Bt Harris, Plymouth.'

1149 1944 Oc.2.185. Length 8.2 cm. One internal barb. Beasley no. 784.
Beasley catalogue 784, registered 16 August 1913, 'Bt Pickering, 94 Church St. Whitby.'
References: Beasley 1928:16, pl. XXIX, bottom.

1150 1944 Oc.2.186. Length 8.2 cm. One internal barb. Beasley no. 298.
Beasley catalogue 298, registered 19 September 1907, 'Bt E. Little.'

1151 1944 Oc.2.187. Length 7.5 cm. One internal barb. Beasley no. 249.
Beasley catalogue 249, registered 16 November 1906, 'Bt E. Little.'

1152

Q1981 Oc.1308. Length 9.2 cm. One internal barb.

Provenance: Unknown.

1153

Q1981 Oc.1311. Length 11 cm. One internal barb.

Label: 'TAJ'.

Provenance: Unknown.

1154

Q1981 Oc.1321. Length 9.4 cm. One internal barb; shell inlay cracked in half.

Label: 'Captain Philip Savage Alcock', annotated: 'Dup. Mrs Lem…'.

Provenance: Ex Duplicate Collection.

1155

Q1981 Oc.1342. Length 10 cm. One internal barb.

Provenance: Meinertzhagen Collection.

1156

Q1981 Oc.1345. Length 8 cm. Iron point.

Provenance: Ex Duplicate Collection; A.W. Franks, ex Sparrow Simpson Collection.

1157

Q1981 Oc.1346. Length 9 cm. One internal barb.

Provenance: Ex Duplicate Collection; A.W. Franks, ex Sparrow Simpson Collection.

1158

Q1981 Oc.1347. Length 11.3 cm. One internal barb; no haliotis-shell inlay, shank head broken off.

Provenance: Ex Duplicate Collection; A.W. Franks, ex Sparrow Simpson Collection.

Composite trolling hooks: standard *pa kahawai* hooks, haliotis-shell shank (usually made from rim of shell), point of bone, haliotis or other shell, bird beak, barbed or unbarbed

Provenance unknown (1159–1163)

1159 2058. Length 8 cm. Bird-beak point, shank with one edge notched.

1160 4338. Length 8.2 cm. Unbarbed haliotis-shell point, shank with notched edges; snood.

1161 4339. Length 6.5 cm. Unbarbed haliotis-shell point, shank with notched edges; snood.

1162 4341. Length 7.5 cm. Bone point with one internal barb; snood.
References: Edge-Partington 1969 I: 391.10.

1163 4343. Length 7.3 cm. Bone point with one small external barb or more pronounced notching and some notching on inner edge, fine binding in middle of point, shank with notched edges; snood.
References: British Museum 1925: fig. 168a.

1164

1895-160. Length 7 cm. Bone point with one internal barb; snood.

Provenance: Presented by A.W. Franks, 3 June 1895 (ex Sparrow Simpson Collection).

1165

1895-166a–c. Length 8.5 cm. Three hooks, haliotis-shell points: a) unbarbed, plain, remnants of snood; b) unbarbed, shank with one edge notched; c) point with one internal barb, shank with three groups of notching on one edge; snood.

Provenance: Presented by A.W. Franks, 3 June 1895 (ex Sparrow Simpson Collection).

1166

1878.11-1.599. Length 4.2 cm. Unbarbed shell point, shank with one edge notched; snood remnants.

Provenance: Meyrick Collection.

Beasley Collection (1167–1172)

1167 1944 Oc.2.190. Length 5 cm. Bone point with three barbs, one internal and two external; snood remnants. Beasley no. 2741.
Label: '2741. Portsmouth Philosophical Institution'.
Beasley catalogue 2741, registered 1 February 1931, 'Blackmore Museum. Portsmouth Philosophical Institution.'

1168 1944 Oc.2.191. Length 8 cm. Bone point with one notched internal barb, shank with notched edges; lashing coming half way up point, with some notching above; feather hackle, snood. Beasley no. 2052.
Label: '2052. Valentine Starbuck S.Sea Whaler. Ship L'Aigle prior to 1793.'
Beasley catalogue 2052, registered 7 December 1927: 'The Second portion of the Valentine Starbuck Collection (For 1st portion cf Nos 2014 – 2018 [see fish-hook **1104**, 1944 Oc.2.150, and fish-hook **1107**, 1944 Oc.2.153]). Brought to England on the South Sea Whaler L'Aigle prior to 1793 and Bt the great grand daughter Miss Eva P. Starbuck, 8 Temple Square, Ayelsbury.'

1169 **Plate 144**

1944 Oc.2.192. Length 6.5 cm. Bird-beak point, shank with notched edges; snood. Beasley no. 2747.
Beasley catalogue 2747, registered 1 February 1931, 'Blackmore Museum.'

1170 1944 Oc.2.193. Length 8.5 cm. Unbarbed haliotis-shell point, shank with notched edges; snood. Beasley no. 1192.
Label: 'No. 1192. Ex W.L. Nickels Coll.'
Beasley catalogue 1192, registered 9 December 1920, 'From the W.L. Nickels Coll. Birkenhead. Lot 841.'

1171 **Plate 144**

1944 Oc.2.194. Length 6.5 cm. Unbarbed haliotis-shell point; hair hackle, snood. Beasley no. 449.
Beasley catalogue 449, registered 20 January 1910, 'Bt Cole & Son, Parade, Sherbourne.'
References: Beasley 1928:16, pl. XXXI.I.

1172 1944 Oc.2.195. Length 7 cm. Haliotis-shell point with one external barb; feather hackle, snood. Beasley no. 2746.
Beasley catalogue 2746, registered 1 February 1931, 'Blackmore Museum.'

1173

Q1981 OC.1319. Length 8 cm. Haliotis-shell point with one internal barb, shank with six groups of notching on one edge; snood.

Provenance: Unknown.

1174 **Plate 144**

Q1981 OC.1334. Length 8.2 cm. Bone point with one internal barb, shank with one edge notched; snood.

Provenance: Unknown.

Composite trolling hooks: transitional *pa kahawai*, iron hook with haliotis-shell lure attached

1175

6856. Length 10.5 cm. Unbarbed; feather hackle, snood.

Provenance: Presented by Revd W. Greenwell, 7 October 1870.

1176

1846.1-4.5 (also numbered NZ 201). Length 9.7 cm. One internal barb, feather hackle, snood remnant; broken – middle part of haliotis lure missing.

Provenance: Transferred from Natural History Department.

1177

1944 OC.2.196. Length 9.3 cm. Unbarbed; crude lashing with feather hackle, snood.

Provenance: Beasley Collection. Beasley no. 491.

Beasley catalogue 491, registered 4 July 1910, 'Bt William Icke, King Charles Tower. Chester.'

1178 **Plate 145**

1944 OC.2.197. Length 8.8 cm. One internal barb; snood.

Provenance: Beasley Collection. Beasley no. 3202.

Beasley catalogue 3202, registered 1 May 1933, 'Bought Gresly [?] …. B …..'

1179–1182 (Q1981 OC.1349, 1351 to 1353) are tied together, possibly all Meinertzhagen pieces ex Duplicate Collection.

1179 Q1981 OC.1349. Length 11 cm. Unbarbed; snood.
Provenance: Unknown.

1180 Q1981 OC.1351. Length 11.5 cm. Unbarbed; feather hackle, snood.
Provenance: Unknown.

1181 Q1981 OC.1352. Length 12.4 cm. Unbarbed; snood.
Provenance: Unknown.

1182 Q1981 OC.1353. Length 11 cm. Unbarbed; snood.
Provenance: Meinertzhagen Collection.

Composite trolling hooks: transitional *pa kahawai*, iron point, haliotis-shell rim shank

1183 **Plate 145**

+8256. Length 7.7 cm. Point with one internal barb, shank with notches on both edges; feather hackle, snood.

Provenance: Unknown.

Register: 'This fish hook was picked out by Dr Hector as having possibly moa feathers upon it. The hook was submitted to Prof. Owen, who decided that the feathers were <u>not</u> moa. Nevertheless, curiously distorted accounts have since appeared

in the N.Z. and English papers e.g. that the hook was found when Dr Hector was present at the unpacking of some of Captain Cook's Collections at the British Museum – whereas the hook was seen first by Dr Hector at 103 Victoria Street where the Christy Collection then was.'

1184

1896-772. Length 7 cm. Point with one internal barb, shank with groups of notches on both edges; snood.

Provenance: Presented by A.W. Franks, 28 May 1896 (ex Sparrow Simpson Collection).

Composite trolling hooks: variant *pa kahawai* form, various materials

Provenance unknown (1185–1189)

1185 NZ 196. Length 9.2 cm. Bone point with one internal barb, bone shank; of human bone; feather hackle; point base carved to resemble stylized face?
References: Beasley 1928:7–8, pl. XI.I.

1186 NZ 198. Length 8.3 cm. Bone point with one internal barb, sub-fossil moa bone shank, feather hackle remnants.

1187 **Plate 145**
NZ 199. Length 8.2 cm. Bone point with one internal barb, sub-fossil moa bone shank; three-pointed base of point.

1188 **Plate 145**
1919.Length 9.2 cm. Bone point with one internal barb and two high-relief *manaia* heads with haliotis-shell eyes (two missing) on outer edge, bone shank, feather hackle.
References: Beasley 1928: 7–8, pl. XI.II; British Museum 1925: fig. 168c.

1189 **Plate 145**
4344. Length 6 cm. Bird-beak point, shell shank; snood. Feather hackle remnants?

Meinertzhagen Collection (1190–1194)

1190 1895-405. Length 11.5 cm. Iron hook, unbarbed, with lure of pearly shell attached, lure notched on both edges; snood.

1191 **Plate 146**
1895-406. Length 12.5 cm. Iron hook, unbarbed, with mussel-shell lure attached; snood.

1192 1895-407. Length 12 cm. Bone point with one internal barb, horn shank with haliotis-shell inlay; snood.

1193 1895-408. Length 9 cm. Bone point with one internal barb, *manaia* head carved at base, sub-fossil moa bone shank, its head carved with three small projections on each side, feather hackle remnants; snood.

1194 1895-409. Length 7.5 cm. Bone point with one internal barb, two *manaia* heads in high relief carved on outer edge, sub-fossil moa bone shank with circle each side of its head, feather hackle; snood.

Beasley Collection (1195–1197)

1195 1944 OC.2.188. Length 9 cm. Bone point with one internal barb and two high-relief *manaia* heads with haliotis-shell eyes on outer edge,

wooden shank with circle each side of its head; snood. Beasley no. 3156.
Beasley catalogue 3156, registered 20 October 1932, 'Dover Museum'.

1196 1944 OC.2.189. Length 11 cm. Bone point with one internal barb, bone shank with haliotis-shell inlay; snood. Beasley no. 569.
Beasley catalogue 569, registered 24 June 1911, 'Bt Harris. Ramsgate.'
References: Beasley 1928:16, pl. XXX.II.

1197 **Plate 146**
1944 OC.2.198. Length 9.5 cm. Curved iron point, unbarbed, boar-tusk shank; snood. Beasley no. 490.
Beasley catalogue 490, registered 4 July 1910, 'Bt William Icke. King Charles Tower. Chester.'
References: Beasley 1928: 18, fig. 6.

1198

Q1981 OC.1350. Length 11 cm. Iron hook, unbarbed, with lure of pearly shell attached; snood.

Provenance: Unknown.

Composite fish-hooks fragments

Meinertzhagen Collection (1199–1206)

1199 1895-504a. Length 5.5 cm. Haliotis-shell point, unbarbed.

1200 1895-516. Length 10 cm. Haliotis-shell shank inlay.

1201 1895-517. Length 10 cm. Haliotis-shell shank inlay.

1202 1895-518. Length 7.5 cm. Haliotis-shell shank inlay.

1203 1895-562. Length 5.8 cm. Haliotis-shell point, unbarbed.

1204 1895-564. Length 5.8 cm. Haliotis-shell rim shank with notched edges.

1205 1895-564a. Length 3 cm. Wooden shank, head with knob.

1206 1895-565. Length 5.6 cm. Haliotis-shell rim shank with notched edges.

1207

Q1981 OC.1343. Length 8.2 cm. Wooden shank, head with knob.

Provenance: Unknown.

1208

Q1981 OC.1348. Length 11 cm. Wooden shank, head with knob and groove.

Provenance: Meinertzhagen Collection.

Yorkshire Philosophical Society Museum (1209–1212)

1209 1921.10-14.22. Length 5.3 cm. Haliotis-shell rim shank, one edge notched.

1210 1921.10-14.23. Length 8.9 cm. Haliotis-shell inlay blank.

1211 1921.10-14.24. Length 12 cm. Haliotis-shell inlay blank.

1212 1921.10-14.25. Length 10 cm. Haliotis-shell inlay blank.

1213

Q1981 OC.1312. Length 5.5 cm. Half of double-layer haliotis-shell shank, with snood.

Provenance: Unknown.

1214

Q1981 OC.1327. Length 4 cm. Haliotis-shell rim shank, traces of notching on both edges; broken.

Provenance: Unknown.

Composite albatross hooks: carved wooden shank, various points, barbed

1215 **Plate 146**

NZ 202. Length 14.5 cm. Nephrite point with one internal and one very shallow external barb; shank carved with three high-relief faces, top and bottom ones (with some *rauponga*) facing in same direction, middle one (one eye with haliotis-shell inlay) in opposite; line tied to shank head.

Provenance: Unknown.

Comments: Aberrant form (RN).

References: Beasley 1928:114, pl. CLXIX.II.

1216 **Plate 146**

1944 Oc.2.171. Length 9.3 cm. Bone point with one internal barb and four notches on outer edge; shank at head and base carved with high-relief *wheku* face, remains of haliotis-shell in one eye of each head; shank limb with surface decoration of *rauponga*; traces of red ochre; remnants of snood.

Provenance: Beasley Collection. Beasley no. 1224.

Comments: East Coast, mid nineteenth century (RN).

Beasley catalogue: 1224, registered 3 September 1921, 'Bt Stevens Rooms, Lot 170.'

Hunting equipment

1217 **Plate 147**

Bird-snare perch, *mutu kaka*

+6005. Length 22.5 cm.

Wooden perch: brown, plain, shank pointed, head with hole at end through which is threaded length of two-ply twisted vegetable-fibre string. Another hole above slightly curved shaft with quills through it, fastened with fibre lashing at top of shaft; similar quills and lashing at bottom of shaft.

Provenance: Presented by Alfred Fowler, 31 January 1893.

Comments: Bay of Plenty, nineteenth century.

Obtained by donor in New Zealand.

References: Edge-Partington 1969 II.1: 227.3.

1218

Bird-snare perch, *mutu kaka*

1913.5-24.79. Length 28 cm.

Wooden perch: dark brown, shaft slightly curved down and terminating in plain openwork *manaia* face; head carved as high-relief human figure with plain face, three-fingered hands on chest, legs raised to meet slanting projection carved on shank; holes for cord in forehead and between arms and trunk. No surface decoration.

Provenance: Edge-Partington Collection.

Labels: 'Perch used lashed to long pole or branch for snaring birds with running noose. No J 206 CF. Whites Illustn'; 'Used chiefly for kaka (Nestor) native name Tumu'.

Comments: Bay of Plenty, nineteenth century.

Possibly the perch mentioned in Edge-Partington's letter to Read:

> Having nothing better to do today I ran up to attend Webster's sale at Stevens & hoped to see Joyce there more specially as things were going dirt cheap & there were one or two things the Museum ought to have bought. I bought a few nice things & swiped [?] Robley's eye over

a bird snare from NZ. I also got a dredge & a finely mounted jade axe (NZ)…

> (BM PE correspondence: J. Edge-Partington, 1904, no date)

1219

Bird-snare perch, *mutu kaka*

1934.12-5.7. Length 26 cm.

Wooden perch: dark brown, up-curved shaft with ridges and terminating in highly stylized human face, its upper curve decorated with five groups of notches; head carved as high-relief human figure, plain face, three-fingered hands on chest, legs raised to meet slanting projection carved on shank; holes for cord in forehead and between arms and trunk. No surface decoration.

Provenance: Bequeathed by T.B. Clarke Thornhill.

Label: 'Bird snares got at the Urewere [Urewera] Country N.I. N.Z. [reverse:] Maori carved wooden bird snare. It is set on the top of a pole among trees & a decoy bird tied near. As soon a bird settles, the string which is passed through the holes is pulled & the bird caught by the feet. Some of these snares are famous for their attraction of the birds.'

Comments: Bay of Plenty; late nineteenth century (RN).

1220

Bird-snare perch, *mutu kaka*

1934.12-5-8. Length 34 cm.

Wooden perch: brown, up-curved shaft, head carved as *wheku* face with large mouth with *pakura*; cylindrical projection on shank with concentric grooves on flat top; loop of commercial string, extended with length of same string, threaded through hole in top of head; cane pegs through holes in corners of mouth; similar pegs through holes in *wheku* face terminating shaft, fastened with flax lashing under face. Upper curve of shaft ridged and decorated with four groups of notching. Very weathered and worn.

Provenance: Bequeathed by T.B. Clarke Thornhill.

Label: 'Carved wooden Maori bird-snare from the Urewera country - The string is in readiness for snaring, except that it should go through the holes where the pegs are. The snare is placed on a pole on a high tree with a decoy bird near & the cord hangs down to the ground in front. [Reverse:] T.B.C. Thornhill Esq Star Hotel.'

Comments: Bay of Plenty; nineteenth century (RN).

1221 **Plate 147**

Bird-snare perch, *mutu kaka*

1944 Oc.2.811. Length 26 cm.

Wooden perch: light brown, up-curved shaft terminating in *wheku* face decorated with *pakura*, with quills threaded through mouth corners. Head carved as human figure: *wheku* face, three-fingered hands on chest, legs raised to meet vertical projection carved on shank; face, upper chest and arms decorated with *pakura*. Quills threaded through holes between arms and trunk and lashed in position with vegetable-fibre string.

Provenance: Beasley Collection. Beasley no. 299.

Comments: Bay of Plenty, nineteenth century.

Beasley catalogue: 299, registered 4 October 1907, 'Parrot Trap: called "mutu-kaka" carved with a full length tiki figure. Bt W. Oldman.'

1222 **Plate 147**

Bird-snare perch, *mutu kaka*

1960 Oc.+2. Length 26 cm.

Wooden perch: greyish brown, up-curved shaft terminating in plain openwork *manaia* head; traces of notching on upper curve of shaft. Head carved as *wheku* face with circular indentations for eyes, brows with *pakura*, mouth with *rauponga*; hole for cord in top of head, wooden pegs in holes in corners of mouth. Shank with small projection. Very weathered.

Provenance: Unknown. Ex Duplicate Collection.

Register: 'Found with duplicates'.

Comments: Bay of Plenty, nineteenth century.

1223

Bird-snare perch, *mutu kaka*

Q1987 Oc.94. Length 26 cm.

Wooden perch: dark brown, strongly up-curved shaft terminating in plain stylized head, cord holes through eyes. Head carved as long plain *wheku* face, holes for cord through top of face and corners of mouth. Shank with small, round, flat-topped projection.

Provenance: Unknown. Ex Duplicate Collection.

Comments: Bay of Plenty, nineteenth century (RN).

Bird-spear points, *tara/makoi*

Meinertzhagen Collection (1224–1232)

1224 1895-589. Length 7.6 cm. Thin bone point, three barbs.

1225 1895-590. Length 8.6 cm. Thin bone point, six barbs.

1226 1895-591. Length 6.1 cm. Thin bone point, four barbs.

1227 1895-592. Length 7.3 cm. Thin bone point, four barbs.

1228 1895-593. Length 5.2 cm. Thin bone point, two barbs.

1229 1895-594. Length 7 cm. Thin bone spear point, one barb, three notches on opposite side.

1230 1895-597. Length 4.9 cm. Thin bone point (fragment), one barb.

1231 1895-603. Length 4.2 cm. Thin bone point, one barb.

1232 1895-623. Length 3.9 cm. Thin bone point, one barb.

Skinner Collection (1233–1235)

1233 1937.7-3.1. Length 12.5 cm. Thin bone point, four barbs. Marked 'D.29. 1198. Onepoto.'

1234 1937.7-3.2. Length 9 cm. Thin bone point, six barbs. Marked 'Hoopers Inlet D.29. 5228.'

1235 1937.7-3.3. Length 5.5 cm. Thin bone point, three barbs. Marked 'D.28. 395. Long Bch.'

1236

1944 Oc.2.849. Length 6.8 cm. Thin bone point, three barbs. Marked 'D.25. 2219'.

Provenance: Beasley Collection.

Label: 'Bird spear points, Otago Museum.'

1237

1944 oc.2.850. Length 4.9 cm. Thin bone point, four barbs. Marked 'D.24.954'.

Provenance: Beasley Collection.

Label: 'Bird spear points, Otago Museum'.

1238

Bone dart head

1895-595. Length 7.1 cm.

Thin bone point, five bilateral barbs.

Provenance: Meinertzhagen Collection.

1239

Bone harpoon (?) point

1895-568. Length 5 cm.

Wider half broken off at drilled hole.

Provenance: Meinertzhagen Collection.

Agricultural implements

1240

Digging stick, *ko*

1895-418. Length 148 cm.

Wooden stick: brown, shaft of oval cross section with spatulate blade and constriction for grip near top; plain, slightly curved perforated step lashed to it with coarse flax cord.

Provenance: Meinertzhagen Collection.

Comments: Nineteenth century (RN).

1241

Digging stick, *ko*

1895-419. Length 181.5 cm.

Wooden stick: brown, shaft of rounded oblong cross section, spatulate blade, slight constriction for grip near top, cut in half, presumably to facilitate packing and transport; step with perforation, top square-cornered and slightly curved, notching on lower edge of long sides, now separated from shaft.

Provenance: Meinertzhagen Collection.

Comments: Nineteenth century (RN).

1242

Digging stick, *ko*

1895-420. Length 238 cm.

Wooden stick: brown, shaft of oval cross section, spatulate blade, top of shaft slightly wider with rectangular cross section, all its edges with notching; cut in half, presumably to facilitate packing and transport. Step missing.

Provenance: Meinertzhagen Collection.

Comments: Nineteenth century (RN).

1243 Plate 148

Digging stick, *ko*

1895-421. Length 203 cm.

Wooden stick: brown, shaft of flat oval cross section, spatulate blade, top with slight constriction with notching on both sides, cut in half, presumably to facilitate packing and transport, and re-assembled. Step, lashed to shaft with coarse braided-flax cord, carved as openwork standing human figure: three-fingered hands with thumbs on chest, *wheku* face with *rauponga* on forehead, around eyes and mouth, spirals on cheeks, *pakura* on arms.

Provenance: Meinertzhagen Collection.

Comments: Bay of Plenty, nineteenth century (RN).

1244

Digging stick, *ko*

1895-422. Length 148.6 cm.

Wooden stick: brown, shaft of circular cross section, spatulate blade with notches on each side (three on one, two on other), top of shaft slightly enlarged.

Provenance: Meinertzhagen Collection.

Register: '... suggests that it is the upright portion of ko. The end also is worn as if with digging.'

Comments: Nineteenth century (RN).

1245 Plate 148

Digging stick, *ko*

1886.12-11.1. Length 161 cm.

Wooden stick: brown, short shaft of rounded oblong cross section, large paddle-shaped blade, top flat and in different plane from that of blade. Step, lashed to shaft with braided-flax cord, blackened and carved as standing human figure: hands on hips, *wheku* face, *pakura* on mouth, otherwise plain.

Provenance: Presented by Sir Walter Lawry Buller KCMG.

Register: '?Do the two pieces belong together, the tie of cord is very new. Native name He Ko. Wereroo Pah, New Zealand, July 1865. Made of Maire (Eugenia maire)…'

Comments: Bay of Plenty (RN); Poverty Bay (DRS); eighteenth century.

> I have added a good specimen of the Maori Ko (spade) with foot-rest attached, one that was actually used during the late War, having been found by the troops among the earthworks of a vacated pa.
>
> (BM PE correspondence: Sir Walter Buller, 15 December 1886).

References: Edge-Partington 1969 I: 380.1.

1246 Plate 148

Digging-stick step, *teka*

1283. Length 19 cm.

Wooden step: brown, with worn low-relief carving representing stylized human figure: female, genitals clearly marked; surface ornamentation of plain rolling spirals and some *rauponga*.

Provenance: Unknown.

Comments: Whanganui; 1830s (RN); eighteenth century (DRS).

1247 Plate 148

Digging-stick step, *teka*

1284. Length 16 cm.

Wooden step: brown, carved as stylized human figure (only one eye carved), with asymmetrically arranged surface ornamentation of rolling spirals and some *rauponga*.

Provenance: Unknown.

Comments: Whanganui; 1830s (RN); 1820 (DRS).

1248 Plate 148

Digging-stick step, *teka*

1904-249. Length 24 cm.

Wooden step: dark brown, carved as large non-sexed human figure with domed bulbous head, notched haliotis-shell eyes, hands on chest, feet extend into another, *wheku*, head below; rolling spirals on one side of forehead and all over body, *unaunahi* around mouth and on hands. Old patina, dark polished varnish; back of head, at top, slightly damaged.

Provenance: Higgins/Turvey Abbey Collection.

Comments: Hokianga, 1800–20.

1249 Plate 148

Digging-stick step, *teka*

1929-1. Length 16.5 cm.

Wooden step: brown, carved as standing human figure with naturalistic face, female chin and forehead tattoo, female genitalia shown; three-fingered hands on chest, *rauponga* on body and limbs, *pakura* and *rauponga* on edge of step; polished over red ochre.

Provenance: Presented by J.H. Spottiswood (per Mrs Kinch).

Comments: Rotorua, c.1840s (RN); Whanganui, 1860 (DRS).

1250 Plate 149

Digging-stick step, *teka*

1934.12-5.6. Length 13.2 cm.

Wooden step: dark brown, top with rounded point shod with iron plate, *pakura* on side edges.

Provenance: Bequeathed by T.B. Clarke Thornhill.

Register: 'Shod with iron plate from a rifle butt.'

Label: 'Takahi mo te ko. [step for digging stick]'

Comments: East Coast (RN); probably Poverty Bay (DRS); nineteenth century.

1251

Spade, *kaheru*

1895-423. Length 194.5 cm.

Wooden spade: brown shaft terminating in mushroom-shaped knob, cut in half, presumably to facilitate packing and transport, and re-assembled; blade of lighter wood, spade-shaped with square lower corners.

Provenance: Meinertzhagen Collection.

Register: 'Rapa Maire'.

Comments: Nineteenth century (RN); Waikato, eighteenth century (DRS).

Replacement lashing of cane applied by Dante Bonica in 1996.

1252

Spade, *kaheru*

1904-250. Length 204.5 cm.

Wooden spade: brown, shaft terminating in mushroom-shaped knob; blade long, rectangular, with rounded lower corners, lashed to shaft with twisted-flax string.

Provenance: Higgins/Turvey Abbey Collection.

Label: '146'.

Comments: Nineteenth century (RN); eighteenth century (DRS).

References: Edge-Partington 1969 I: 36.1.

1253 Plate 149

Grubber, *timo*

6048. Length 30.5 cm.

Wooden grubber: dark brown, curved, wide blade carved as mouth of *wheku* face at bend, shaft narrows towards small plain *wheku* face at butt, old square-cut hole above it with flat braided-flax cord through it; haliotis-shell eyes (one missing) in main head, *pakura* on brows and mouth. Dark patina.

Provenance: Sparrow Simpson Collection. Presented 17 February 1870.

Comments: East Coast, 1810s–20s (RN).

References: Edge-Partington 1969 I: 377.1.

Tools

Hafted tools

1254 Plate 150
Hafted adze, *toki pounamu*
LMS 157. Length 55.5 cm.

Nephrite blade: mottled dark green, Type
II B. Wooden haft: brown, curved; transverse
lashing of twisted string covered with
blackish substance, and triangular lashing
of finer twisted-flax string on heel and top
of shaft.
> Provenance: London Missionary Society
Collection.
> Label: 'No 366. L.M. Socy'.
> References: Davidson 1996: 16.

1255 to **1260** (1895-438 and 1895-864 to 868)
were evidently reconstructed especially for
Meinertzhagen, for Campbell writes in his
Journal: 'Arapu came over to see Fritz about
some Maori Axes that he has been making
handles for.' (Campbell: 3 October 1869).

1255
Hafted adze, *toki*
1895-438. Length 34 cm.

Greywacke blade: dark grey, Type II B.
Wooden haft: light brown, blackened in
places, thick, crude; transverse lashing of
thick string of twisted vegetable fibre linked
to braided cord wrapped around shaft
below foot.
> Provenance: Meinertzhagen Collection.
> Comments: Late-nineteenth-century
reconstruction: old blade, new haft (RN);
*c.*1860 (DRS).

1256
Hafted adze, *toki*
1895-864. Length 55.5 cm.

Nelson argillite blade: dark grey, Type
II A. Wooden haft: light brown; transverse
lashing of thick braided-flax cord linked to
braided cord wrapped around shaft below
foot.
> Provenance: Meinertzhagen Collection.
> Comments: Late-nineteenth-century
reconstruction: archaic blade, old haft
(RN).

1257
Hafted adze, *toki*
1895-865. Length 56 cm.

Argillite blade: black, Type II A. Wooden haft:
pale brown; transverse lashing of braided-
flax cord strengthened with flax strips.
> Provenance: Meinertzhagen Collection.
> Comments: Late-nineteenth-century
reconstruction: old blade, old haft (RN).

1258
Hafted adze, *toki*
1895-866. Length 48.5 cm.

Argillite blade: black, Type II A. Wooden
haft: pale, crude, flimsy; transverse lashing
of twisted flax string.
> Provenance: Meinertzhagen Collection.
> Comments: Late-nineteenth-century
reconstruction: old blade, new haft (RN).

1259
Hafted adze, *toki*
1895-867. Length 54.5 cm.

Argillite blade: greenish grey, Type II A.
Wooden haft: brown; crude transverse
lashing of flax-leaf strips.

> Provenance: Meinertzhagen Collection.
> Comments: Late-nineteenth-century
reconstruction: old blade, old haft (RN);
eighteenth century (DRS).

1260
Hafted adze, *toki*
1895-868. Length 44.5 cm.

Argillite blade: greenish grey, Type II A.
Wooden haft: pale, curved; crude transverse
lashing of flax-leaf strips.
> Provenance: Meinertzhagen Collection.
> Comments: Late-nineteenth-century
reconstruction: old blade, new haft (RN).

1261
Hafted adze, *toki*
1841.2-11.33. Length 42 cm.

Nephrite blade: mottled dark green, Type
II B. Wooden haft: brown, slightly curved,
with knob at proximal end; remnants of
lashing of braided-flax cord. Blade and haft
separated.
> Provenance: Presented by Queen
Victoria.
> Comments: Good old blade and haft
(RN); eighteenth century (DRS).

1262 Plate 150
Hafted adze, *toki*
1854.12-29.66. Length 65 cm.

Brecciated argillite blade: mottled greyish
green, Type I A. Wooden haft in two parts:
brown, curved. Lashing of flat braided-flax
cord: transverse on blade and triangular
on heel and top of shaft. Unique composite
construction of wooden socket attached to
curved handle, blade lashed into socket and
socket lashed to handle.
> Provenance: Grey Collection.
> Comments: Early/mid-nineteenth-
century reconstruction: archaic blade, new
haft (RN); Waikato, eighteenth century
(DRS).
> References: Davidson 1996: 16; Edge-
Partington 1969 I: 380.3; Keyes 1973: 130–1.

1263 Plate 150
Hafted chisel, *whao*
NZ 101. Length 21 cm.

Nephrite blade: mottled dark green.
Wooden haft: brown; lashing of twisted-flax
string, another lashing of flax-leaf strips
near butt end (to strengthen haft which is
split?) flattened from mallet blows.
> Provenance: Cook Collection.
> Label: 'Probably obtd. By Capt. Cook
?figured in drawings from Sir Ashton Levers
Mus. p.123.'
> Comments: Eighteenth century.
> References: Barrow 1969: fig. 85; Edge-
Partington 1969 I: 379.4; Hamilton 1901:
235; Kaeppler 1978: 197.

1264
Hafted chisel, *whao*
1961 Oc.3.2. Length 24.3 cm.

Nephrite blade: mottled medium green.
Wooden haft: brown, with three tapered
sections, each separated by shoulder,
slightly conical butt with iron wire loop
inserted into it; lashing of old twisted-flax
string with two skin wrappers underneath.
> Provenance: Purchased from Miss Jean
Cook, Curator, Royal Museum, Canterbury,
Kent.
> Label: 'Property of Royal Museum No.
4494'.

Comments: Late eighteenth/early
nineteenth century, iron loop added later
(RN); eighteenth century (DRS).

1265
Hafted chisel, *whao*
1985 Oc.3.1. Length 18 cm.

Sandstone blade: dark grey. Wooden haft:
pale, carved near proximal end with band
of *whakarare*; lashing of twisted-flax string;
blade glued to haft under lashing.
> Provenance: Presented by The Duke of
Gloucester.
> Comments: Contemporary art.

Wooden tools

1266
Pointed implement
NZ 56. Length 6.7 cm.

Provenance: Hector/Colonial Museum
Collection.
> Register: 'From a Moa bone cave at
Sumner near Christchurch, Canterbury
N.Z.'

1267
Staff-like implement (fishing club?)
1895-461. Length 86 cm.

Reddish, oval cross section, widening
towards one end of circular cross section
and also towards other end with a very
broad rounded point.
> Provenance: Meinertzhagen Collection.

Bone tools

Hector/Colonial Museum Collection (1268–1270)
Register: 'From a Moa bone Cave at Sumner
near Christchurch. Canterbury NZ':
1268 NZ 57. Length 19.2 cm. Pointed bone
implement (threader?).
1269 NZ 58. Length 5.4 cm. Pointed bone
implement (threader?).
1270 NZ 59. Length 4.7 cm. Pointed bone
implement (threader?).

Meinertzhagen Collection (1271–1274)
1271 1895-395. Length 20 cm. Flat
weathered implement (chisel?).
1272 1895-530a to 1895-535, 537, 538, 541.
Lengths 5–13.5 cm. Needles.
1273 1895-539, 540, 542 to 545. Lengths
4.5–8 cm. Weathered slivers
(needles?).
1274 1895-567. Length 9.5 cm. Awl. Wider
upper end decorated with notched
top and one side edge.

Beasley Collection (1275–1277)
1275 1944 Oc.2.840-844. Lengths 4.8–6
cm. Needles, marked respectively:
'D.26.1329 Otago', 'D.26.1325 Otago',
'D.26.1327 Otago', 'D.25.1889'.
Beasley no. 2006.
Beasley catalogue 2006, registered
21 April 1927, '... all from middens in
Otago. Exchanged with the Otago
Museum.'
1276 1944 Oc.2.845. Length 8.8 cm. Pointed
implement, triangular cross section.
Marked: 'D.26.1326 Otago'. Beasley
no. 2003.
Beasley catalogue 2003, registered 21
April 1927, 'Obtained from middens
in Otago. Exchanged with the Otago
Museum.'

1277 1944 Oc.2.856. Length 16.5 cm. Awl. Wider upper end with notched edges. Marked: 'D.26.266'. Beasley no. 2001? Beasley catalogue 2001, registered 21.4.1927, 'A two pronged hair comb of bone the end notched and one prong missing, from a midden, Otago, S. Island. Exchanged with the Otago Museum.'

Skinner Collection (1278–1286)

1278 1937.7-3.4. Length 9.2 cm. Threader. Marked: 'D.35.1471. Papanui Inlet.'

1279 1937.7-3.5. Length 8.6 cm. Threader. Marked: 'D.30.472. Hooper's Inlet.'

1280 1937.7-3.6. Length 9.7 cm. Threader. Marked: 'D.36.545. South Side, Hooper's Inlet.'

1281 1937.7-3.7. Length 9.8 cm. Threader. Marked: 'D.35.1166. Onepoto.'

1282 1937.7-3.8. Length 12.8 cm. Threader. Marked: 'D.29.5283. Purakanui.'

1283 1937.7-3.9. Length 14.5 cm. Marlin. Marked: 'D.29.3111. Pipikaritu.'

1284 1937.7-4.10. Length 14.3 cm. Threader. Marked: 'D.29.3052. Pipikaritu.'

1285 1937.7-3.11. Length 14 cm. Threader. Marked: 'D.29.4974. Onepoto.'

1286 1937.7-3.12. Length 33.5 cm. Threader. Marked: 'D.31.404. Centre Island.'

Nephrite adze blades, *toki pounamu*

Type I A
Quadrangular, tanged. Thick, massive, sometimes with lugs on poll, 'horned'.

1287 **Plate 151**
NZ 98. Length 27.9 cm.
Provenance: Unknown.

1288
1912.5-25.1. Length 27.9 cm.
Provenance: Robertson/White Collection.

Type I B
Quadrangular, tanged. Thinner, spade-shouldered.

1289 **Plate 151**
1895-757. Length 21.8 cm.
Provenance: Meinertzhagen Collection.

Type II B
Quadrangular, without tang. Cross section between rectangular and lenticular.

1290
NZ 21. Length 9.5 cm.
Provenance: Hector/Colonial Museum Collection.
Register: 'From Camping places of the Maori when Moa hunting.'

Provenance unknown (1291–1297)

1291 NZ 94. Length 15.9 cm.
1292 NZ 95. Length 18.1 cm.
1293 NZ 96. Length 13.4 cm.
1294 NZ 99. Length 15.4 cm.
1295 NZ 100. Length 24.7 cm.
1296 **Plate 151**
1704. Length 26.9 cm.
1297 1706. Length 12.5 cm.

1298
9347. Length 8.4 cm.
Provenance: Sparrow Simpson Collection.

1299
9684. Length 14.7 cm.
Provenance: Presented by A. Abraham, 26 February 1876.

1300 Number not used.

Meinertzhagen Collection (1301–1316)

1301 1895-753. Length 30.1 cm.
1302 1895-754. Length 26.7 cm.
1303 1895-755. Length 19.4 cm.
1304 1895-756. Length 13.9 cm.
1305 1895-758. Length 15.6 cm.
Register: 'Otago'.
1306 1895-759. Length 14.5 cm.
1307 1895-760. Length 12.1 cm.
1308 1895-761. Length 11.5 cm.
1309 1895-763. Length 8.7 cm.
1310 1895-764. Length 8.3 cm.
Register: 'Wellington'.
1311 1895-765. Length 7 cm.
1312 1895-766. Length 8.3 cm.
1313 1895-767. Length 6.6 cm.
1314 1895-769. Length 5.3 cm.
1315 1895-771. Length 5 cm.
1316 1895-772. Length 4.2 cm.

Grey Collection (1317–1322)

1317 1854.12-29.57. Length 27.9 cm.
Register: 'For working canoes'.
1318 1854.12-29.58. Length 19.1 cm.
1319 **Plate 151**
1854.12-29.59. Length 16.9 cm.
1320 1854.12-29.60. Length 13.3 cm.
1321 1854.12-29.64. Length 7.8 cm.
1322 1854.12-29.65. Length 5 cm.

1323
1863.2-9.4. Length 11.9 cm.
Provenance: Presented by Revd R. Taylor.

1324
1876.11-10.1. Length 11.1 cm.
Provenance: Presented by Llewellyn Prichard.
Register: 'Stated to have been found in summer of 1873 in River [blank] Dolgelly.'

1325
1909.5-6.5. Length 11.8 cm.
Provenance: Presented by Council of Linnaean Society (ex S.W. Silver Collection).

1326
1910.11-6.4. Length 13.3 cm.
Provenance: Presented by City of London Library Committee (ex Guildhall Museum).

Robertson/White Collection (1327–1330)

1327 1912.5-24.4. Length 16.3 cm.
Register: 'Warrington'.
1328 1912.5-24.22. Length 11.9 cm.
Register: 'Murdering Beach'.
1329 1912.5-24.23. Length 12.9 cm.
Register: 'Otago'.
1330 1912.5-24.25. Length 8.8 cm.
Register: 'Murdering Beach'.

1331
1925.11-9.1. Length 12.4 cm.
Provenance: Presented by A.H. Smith.

1332
1928.1-10.36. Length 14.8 cm.
Provenance: Liversidge Collection.
Register: 'Tammatawiwi [Taumatawiwi]'.
References: Liverside 1894: 240, pl. XXVII, top.

1333
1928.1-10.37. Length 12.7 cm.
Provenance: Liversidge Collection.

Register: 'Kaiapoi, Gnahati [Ngahati] Pa N. of Christchurch'.
References: Liversidge 1894: 240.

1334
1934.12-5.14. Length 31.9 cm.
Provenance: Bequeathed by T.B. Clarke Thornhill.

1335
1944 Oc.2.825. Length 26.3 cm.
Provenance: Beasley Collection. Beasley no. 1339.
Beasley catalogue 1339, registered 16 November 1923: 'Bt James Mackie… Gloucester'.

1336
1944 Oc.2.826. Length 22.9 cm.
Provenance: Beasley Collection. Beasley no. 341.
Beasley catalogue 341, registered 7 July 1901, 'Robley Coll. ex Stevens': 'Bt S. Fenton'.

1337
1949 Oc.10.2. Length 25.4 cm.
Provenance: Purchased from Mrs D.K. Oldman (ex Oldman Collection).

1338
1949 Oc.10.3. Length 24.1 cm.
Provenance: Purchased from Mrs D.K. Oldman (ex Oldman Collection).

1339
1951 Oc.12.1. Length 27.8 cm.
Provenance: Presented by the Commandant of Royal Army Medical College.

1340
1955 Oc.7.1. Length 16.1 cm.
Provenance: Presented by T.F. Corley.

1341
1971 Oc.11.1. Length 26.4 cm.
Provenance: Transferred from British Museum's Department of Prehistoric and Romano-British Antiquities, found with MacAlpine-Woods Collection.

1342
Q1981 Oc.1883. Length 12.1 cm.
Provenance: Unknown.

Type IV A
Triangular, front apex, 'hog-backed'. Tanged, narrow cutting edge.

1343
1912.5-24.13. Length 13.4 cm.
Provenance: Robertson/White Collection.
Register: 'Moa Flat, Otago'.

Type V
Side-hafted.

1344
1912.5-24.24. Length 16.5 cm.
Provenance: Robertson/White Collection.
Register: 'Murdering Beach'.

Type VI
Circular cross section.

Robertson/White Collection (1345–1347)

1345 1912.5-24.5. Length 16.2 cm.
Register: 'Warrington'.
1346 1912.5-24.6. Length 15.5 cm.
Register: 'Warrington'.
1347 1912.5-24.7. Length 9 cm.
Register: 'Flag Swamp'.

Broken nephrite adze blades

1348
NZ 20. Length 9.4 cm.
Provenance: Hector/Colonial Museum Collection.
Register: 'From Camping places of the Maoris when Moa hunting.'

1349
NZ 153. Length 4.2 cm.
Provenance: Cook Collection.
Register: 'Cook Coll. No. 25. Engr[aving] tools of green stone from New Zealand'. Parchment label: ' No 25 En… [illegible] New Zealand'.
References: Kaeppler 1978: 197.

1350
+5970. Length 18.3 cm.
Provenance: Presented by A.W. Franks, 25 January 1893 (ex Sparrow Simpson Collection).

Stone adze blades, *toki*

Type I A
Quadrangular, tanged. Thick, massive, sometimes with lugs on poll, 'horned'.

Hector/Colonial Museum Collection (1351–1354)

1351 NZ 5. Length 25.5 cm. Argillite.
Register: 'Found at the root of a tree near Wellington.'

1352 NZ 7. Length 18.5 cm. Argillite.
Register: 'Found at Wellington, under the root of large rata tree.'

1353 NZ 7A. Length 29.5 cm. Argillite.
Register: 'Found at the root of a tree near Wellington, New Zealand.'

1354 NZ 11. Length 25 cm. Argillite.
Register: 'Found on the South bank of the Teramakau [Taramakau River]'.
Label: '17.7.72… Pres. by Judge Harvey.'
References: Davidson 1996: 15.

1355
+1201. Length 20.3 cm. Conglomerate.
Provenance: Unknown. Presented 1880.

1356
+4773. Length 40.5 cm. Argillite.
Provenance: Presented by A.W. Franks (F.H. Butler), 8 October 1890.

1357
+4776. Length 16.9 cm. Greywacke.
Provenance: Presented by A.W. Franks (F.H. Butler), 8 October 1890.

1358
+5623. Length 22 cm. Argillite.
Provenance: Presented by A.W. Franks (Victoria Government), 13 August 1891.
Register: 'Nelson, S. Island'.

1359
+5917. Length 10.5 cm. Argillite.
Provenance: Presented by H.O. Forbes, 7 November 1892.
Register: 'Monck's Cave, near Sumner'.

Meinertzhagen Collection (1360–1365)

1360 1895-831. Length 37 cm. Argillite.
1361 1895-838. Length 23 cm. Argillite.
1362 1895-841. Length 17 cm. Sandstone.
1363 1895-844. Length 14.5 cm. Argillite.
1364 1895-848. Length 14.7 cm. Sandstone.
1365 1895-850. Length 12.7 cm. Sandstone.

1366
1854.12-29.67. Length 26 cm. Argillite.
Provenance: Grey Collection.

Robertson/White Collection (1367–1372)

1367 1912.5-24.18. Length 9.5 cm. Argillite.
1368 1912.5-25.2. Length 33.5 cm. Argillite.
Register: 'Waikowaiti [Waikouaiti], Otago'.
1369 1912.5-25.3. Length 27.5 cm. Argillite.
Register: 'Warrington'.
1370 **Plate 153**
1912.5-25.4. Length 26 cm. Sandstone.
Register: 'Green Island, near Dunedin'.
1371 1912.5-25.5. Length 26.5 cm. Basalt.
Register: 'Riverton, Southland'.
1372 1912.5-25.7. Length 13.2 cm. Metamorphic rock.
Register: 'Hooper's Inlet, Otago'.

Liversidge Collection (1373–1375)

1373 1928.1-10.31. Length 19 cm. Argillite.
Register: 'Otepopo. Hokianga River'.
References: Liversidge 1894: 239, pl. XXV, top.
1374 1928.1-10.42. Length 8.5 cm. Sandstone.
Register: 'Ploughed up at Tammatawiwi [Taumatawiwi].'
References: Liversidge 1894: 241, pl. XXVIII, middle.
1375 1928.1-10.80. Length 18.8 cm. Volcanic. Liversidge no. 44.2.
Register: 'From Hokianga. J. Webster.'

1376
1977 Oc.11.1. Length 14.4 cm. Argillite.
Provenance: Presented by Miss B. Harrison.
Register: 'Found in a trout river in South Island by a friend of the donor, could not remember when.'

Type I B
Quadrangular, tanged. Thinner, spade-shouldered.

1377 **Plate 152**
NZ 9. Length 12.5 cm. Sandstone.
Provenance: Hector/Colonial Museum Collection.
Register: 'Found in Pelichet Bay, Dunedin.'

1378
1895-789. Length 7 cm. Argillite.
Provenance: Meinertzhagen Collection.

1379
1895-859. Length 8 cm. Argillite.
Provenance: Meinertzhagen Collection.

1380
1863.2-9.5. Length 9.5 cm. Argillite.
Provenance: Presented by Revd R. Taylor.

1381
1928.1-10.100. Length 10.8 cm. Greywacke.
Provenance: Liversidge Collection.
Liversidge no. 44.22.
Register: 'Hokianga'.

Type I C
Quadrangular, tanged. Lugs or lateral shoulders where butt meets blade.

1382 **Plate 153**
+4774. Length 24.5 cm. Volcanic.
Provenance: Presented by A.W. Franks (F.H. Butler), 8 October 1890.

Type I D
Quadrangular, tanged. Long and narrow, tendency to rounded section ('Southland type').

1383
+4775. Length 34.5 cm. Basalt.
Provenance: Presented by A.W. Franks (F.H. Butler), 8 October 1890.

1384
+4777. Length 34.5 cm. Argillite.
Provenance: Presented by A.W. Franks (F.H. Butler), 8 October 1890.

Robertson/White Collection (1385–1388)

1385 1912.5-25.6. Length 24.5 cm. Greywacke.
Register: 'Murdering Beach'.
1386 1912.5-25.8. Length 22.5 cm. Basalt.
Register: 'Puapuke [Ruapuke Island]'.
1387 **Plate 153**
1912.5-25.11. Length 34.5 cm. Argillite.
Register: 'Mid Island; Lake Wakatipu'.
1388 912.5-25.12. Length 26.9 cm. Greywacke.
Register: 'Southland'.

1389
1949 Oc.9.15. Length 30 cm. Argillite.
Provenance: Presented by E. Cave, Thurrock Public Library.

Type II A
Quadrangular, without tang. Rectangular section, front wider than back, possible incipient tang, small and thin.

Hector/Colonial Museum Collection (1390–1393)

1390 NZ 10. Length 10.5 cm. Argillite.
Register: 'Found near Wellington Jail N.Z.'
1391 NZ 18. Length 6 cm. Argillite.
Register: 'From camping place of the Maories while Moa-hunting.'
1392 NZ 19. Length 7.5 cm. Argillite.
Register: 'Found at moa-hunting camp of the Maories.'
1393 NZ 32. Length 8 cm. Argillite.
Register: 'From Moa bone cave. Sumner nr Christchurch.'

1394
4676. Length 15 cm. Argillite.
Provenance: Presented by Charles Falconer (ex Dr Hugh Falconer Collection), January 1868.

1395 **Plate 152**
7989. Length 11.5 cm. Argillite.
Provenance: Presented by F.W. Franks (Isaacson), 29 March 1873.
Register: 'Bought of Isaacson with 3 other implements. Isaacson had the four from a sailor who said 3 came from Poverty Bay, New Zealand, the 4th from Savage I.'

1396
7990. Length 7.5 cm. Argillite.
Provenance: As 1395 (7989).

1397
9190. Length 11 cm. Argillite.
Provenance: Presented by A.W. Franks, 24 January 1875.

1398
9339. Length 11 cm. Argillite.
Provenance: Sparrow Simpson Collection.

1399

9346. Length 9 cm. Argillite.
Provenance: Sparrow Simpson Collection.

1400

+4244. Length 5.5 cm. Basalt.
Provenance: Presented by A.W. Franks (Weston), 6 July 1889.
Register: 'Found at Mangere'.

1401

+4245. Length 6.5 cm. Argillite.
Provenance: Presented by A.W. Franks (Weston), 6 July 1889.
Register: 'Found at Papatoitoi [Papatoetoe], Auckland'.

Meinertzhagen Collection (1402–1457)

1402 1895-768. Length 6 cm. Argillite.
1403 1895-773. Length 8.5 cm. Argillite.
1404 1895-774. Length 8.5 cm. Argillite.
1405 1895-775. Length 9 cm. Argillite.
1406 1895-776. Length 9 cm. Argillite.
1407 1895-777. Length 9.5 cm. Argillite.
1408 1895-778. Length 9 cm. Argillite.
1409 1895-779. Length 9 cm. Argillite.
1410 1895-780. Length 8.5 cm. Argillite.
1411 1895-781. Length 7.5 cm. Argillite.
1412 1895-783. Length 8 cm. Argillite.
1413 1895-784. Length 7.7 cm. Argillite.
1414 1895-785. Length 7 cm. Argillite.
1415 1895-786. Length 6.8 cm. Argillite.
1416 1895-787. Length 6.5 cm. Argillite.
1417 1895-788. Length 7.7 cm. Argillite.
1418 1895-790. Length 6.5 cm. Argillite.
1419 1895-792. Length 7.5 cm. Argillite.
1420 1895-793. Length 6.8 cm. Argillite.
1421 1895-794. Length 5.5 cm. Argillite.
1422 1895-795. Length 5.8 cm. Argillite.
1423 1895-797. Length 6.5 cm. Argillite.
1424 1895-798. Length 5.7 cm. Argillite.
1425 1895-799. Length 5 cm. Argillite.
1426 1895-800. Length 5.5 cm. Argillite.
1427 1895-801. Length 5.2 cm. Argillite.
1428 1895-802. Length 5.9 cm. Argillite.
1429 1895-803. Length 5.5 cm. Argillite.
1430 1895-805. Length 4.7 cm. Argillite.
1431 1895-806. Length 4.5 cm. Argillite.
1432 1895-807. Length 6 cm. Argillite.
1433 1895-808. Length 4.6 cm. Argillite.
1434 1895-809. Length 5 cm. Argillite.
1435 1895-810. Length 5 cm. Argillite.
1436 1895-811. Length 5.7 cm. Argillite.
1437 1895-813. Length 4 cm. Argillite.
1438 1895-814. Length 3.7 cm. Argillite.
1439 1895-815. Length 3.5 cm. Argillite.
1440 1895-816. Length 3.8 cm. Argillite.
1441 1895-817. Length 3.7 cm. Argillite.
1442 1895-818. Length 3.5 cm. Argillite.
1443 1895-819. Length 3.6 cm. Argillite.
1444 1895-820. Length 3.3 cm. Argillite.
1445 1895-822. Length 4.2 cm. Argillite.
1446 1895-823. Length 3.6 cm. Argillite.
1447 1895-824. Length 4.2 cm. Argillite.
1448 1895-825. Length 3.8 cm. Argillite.
1449 1895-826. Length 4.4 cm. Argillite.
1450 1895-827. Length 3.8 cm. Argillite.
1451 1895-828. Length 4.2 cm. Argillite.
1452 1895-846. Length 16.2 cm. Argillite.
1453 1895-847. Length 15.1 cm. Argillite.
1454 1895-854. Length 12.7 cm. Argillite.
1455 1895-857. Length 10.3 cm. Sandstone.
1456 1895-858. Length 9.3 cm. Argillite.
1457 1895-861. Length 6.7 cm. Argillite.

1458

1898-5. Length 10.2 cm. Argillite.
Provenance: Presented by Spencer G. Perceval, 20 March 1898.

1459

1912.5-24.27. Length 8.5 cm. Argillite.
Provenance: Robertson/White Collection.

1460

1928.1-10.93. Length 11.5 cm. Argillite.
Provenance: Liversidge Collection.
Liversidge no. 44.15.
Register: 'Hokianga'.

1461

Q1981 Oc.1878. Length 13 cm. Argillite.
Provenance: Unknown.

1462

Q1981 Oc.1881. Length 8.7 cm. Argillite.
Provenance: Unknown.

Type II B

Quadrangular, without tang. Cross section between rectangular and lenticular.

Hector/Colonial Museum Collection (1463–1467)

1463 NZ 6. Length 21.5 cm. Gabbro.
Register: 'Found in Nelson province.'
1464 NZ 8. Length 13.5 cm. Fine-grained volcanic.
Register: 'From Wellington, New Zealand. Kapu Maori adze.'
1465 NZ 31. Length 10.5 cm. Sandstone.
Register: 'From a Moa bone Cave. Sumner nr Christchurch. Canterbury NZ.'
1466 NZ 33. Length 7 cm. Sandstone.
Register: 'From a Moa bone Cave. Sumner nr Christchurch. Canterbury NZ.'
1467 NZ 34. Length 10.5 cm. Sandstone.
Register: 'From a Moa bone Cave. Sumner nr Christchurch. Canterbury NZ.'

1468

1705. Length 15.5 cm. Basalt.
Provenance: Unknown.

1469

5464. Length 1.5 cm. Sandstone.
Provenance: Presented by A.W. Franks (Anderson), 27 May 1869.

Sparrow Simpson Collection (1470–1475)

1470 9340. Length 11 cm. Basalt.
1471 9341. Length 17 cm. Greywacke.
1472 9342. Length 27.5 cm. Argillite.
1473 9343. Length 30.9 cm. Basalt.
Marked: 'New Zealand. W.S.S.'
1474 9344. Length 11 cm. Argillite.
1475 9345. Length 6.5 cm. Basalt.

1476

+89. Length 9.2 cm. Basalt.
Provenance: Presented by Hon. R. Marsham, 12 February 1877.

1477

+4243. Length 9 cm. Greywacke.
Provenance: Presented by A.W. Franks (Weston), 6 July 1889.
Register: 'Found at Raglan, Waikato R[iver].'

1478

+4246. Length 7.5 cm. Greywacke.
Provenance: Presented by A.W. Franks (Weston), 6 July 1889.
Register: 'Found at Ngaruawahia, Waikato River.'

1479

+4247. Length 8 cm. Sandstone.
Provenance: Presented by A.W. Franks (Weston), 6 July 1889.
Register: 'Found at Howick, Manukau, Auckland.'

1480

+5621. Length 10.5 cm. Argillite.
Provenance: Presented by A.W. Franks (Victoria Government), 13 August 1891.

1481

+5622. Length 9 cm. Sandstone.
Provenance: Presented by A.W. Franks (Victoria Government), 13 August 1891.

1482

+5916. Length 16 cm. Argillite.
Provenance: Presented by H.O. Forbes, 7 November 1892.
Register: 'From Hon. Capt. Fraser.'

Meinertzhagen Collection (1483–1495)

1483 1895-791. Length 6.5 cm. Greywacke.
1484 1895-804. Length 5 cm. Greywacke.
1485 1895-812. Length 4.7 cm. Sandstone.
1486 1895-840. Length 18.2 cm. Greywacke.
1487 1895-845. Length 16.3 cm. Basalt.
1488 1895-849. Length 13.6 cm. Greywacke.
1489 1895-851. Length 14.2 cm. Greywacke.
1490 1895-852. Length 13 cm. Greywacke.
1491 1895-855. Length 11.5 cm. Greywacke.
1492 1895-856. Length 11.6 cm. Greywacke.
1493 1895-860. Length 7.6 cm. Greywacke.
1494 1895-862. Length 5.8 cm. Argillite.
1495 1895-863. Length 12.5 cm. Argillite.

1496

1912-107. Length 12.6 cm. Greywacke.
Provenance: Presented by C. Saunders.
Register: 'Found on the beach at Awhitu, North Island, New Zealand.'

1497

1926-19. Length 12.1 cm. Sandstone.
Provenance: Presented by C.W. Brown.
Register: 'From Firth of Thames. Auckland.'

1498

1854.12-29.63. Length 10.2 cm. Sandstone.
Provenance: Grey Collection.

1499

1854.12.29.69. Length 15.3 cm. Greywacke.
Provenance: Grey Collection.

1500

1863.2-9.3. Length 14.1 cm. Argillite.
Provenance: Presented by Revd R. Taylor.

1501

1878.11-1.612. Length 20.8 cm. Basalt.
Provenance: Meyrick Collection.

1502 Plate 152

1896.11-19.8. Length 14.3 cm. Greywacke.
Provenance: William Strutt Collection.
Register: 'Purchased at New Plymouth from a Maori 1856.'

1503

1903.12-15.28. Length 9.1 cm. Argillite.
Provenance: Presented by Sir W. Ingram.

1504

1915.10-8.108. Length 8.1 cm. Basalt.
Provenance: Presented by E.L. Gruning.
Register: 'N. Auckland, N. Zealand'.

Liversidge Collection (1505–1523)

1505 1928.1-10.34. Length 13.6 cm. Diorite.
Register: 'Ploughed up at Tammatawiwi [Taumatawiwi].'
References: Liversidge 1894: 239, pl XXV, bottom left, pl. XXVI, bottom.

1506 1928.1-10.38. Length 11.8 cm. Hornblende-granite.
Register: 'Ploughed up at Tammatawiwi [Taumatawiwi].'
References: Liversidge 1894: 240, pl. XXVIII, bottom.

1507 1928.1-10.39. Length 12.5 cm. Basalt.
Register: 'Ploughed up at Tammatawiwi [Taumatawiwi].'
References: Liversidge 1894: 240.

1508 1928.1-10.40. Length 9.6 cm. Greywacke.
Register: 'From Wairoa'.
References: Liversidge 1894: 241, pl. XXVIII, top.

1509 1928.1-10.79. Length 29.1 cm. Basalt. Liversidge no. 44.1.
Register: 'From Hokianga. Used for felling large trees and making canoes. From J.W. Webster [18]97.'

1510 1928.1-10.81. Length 17.2 cm. Basalt. Liversidge no. 44.3.
Register: 'Hokianga'.

1511 1928.1-10.82. Length 16.3 cm. Gabbro. Liversidge no. 44.4.
Register: 'Hokianga'.

1512 1928.1-10.84. Length 13.8 cm. Gabbro. Liversidge no. 44.6.
Register: 'Hokianga'.

1513 1928.1-10.85. Length 14.4 cm. Gabbro. Liversidge no. 44.7.
Register: 'Hokianga'.

1514 1928.1-10.87. Length 11.3 cm. Gabbro. Liversidge no. 44.9.
Register: 'Hokianga'.

1515 1928.1-10.88. Length 12.3 cm. Gabbro. Liversidge no. 44.10.
Register: 'Hokianga'.

1516 1928.1-10.91. Length 10.3 cm. Gabbro. Liversidge no. 44.13.
Register: 'Hokianga. Collected by J. Webster.'

1517 1928.1-10.94. Length 12.5 cm. Greywacke. Liversidge no. 44.16.
Register: 'Hokianga'.

1518 1928.1-10.95. Length 11.6 cm. Gabbro. Liversidge no. 44.17.
Register: 'Hokianga'.

1519 1928.1-10.96. Length 10.9 cm. Gabbro. Liversidge no. 44.18.
Register: 'Hokianga'.

1520 1928.1-10.97. Length 8.5 cm. Gabbro. Liversidge no. 44.19.
Register: 'Hokianga'.

1521 1928.1-10.98. Length 8.1 cm. Greywacke. Liversidge no. 44.20.
Register: 'Hokianga'.

1522 1928.1-10.99. Length 8.9 cm. Gabbro. Liversidge no. 44.21.
Register: 'Hokianga'.

1523 1928.1-10.101. Length 8.4 cm. Gabbro. Liversidge no. 44.23.
Register: 'Hokianga'.

1524 1942 oc.5.1. Length 15.6 cm. Greywacke.
Provenance: Presented by C.C.B. Simonds.

1525 Q1981 oc.1879. Length 12 cm. Argillite.
Provenance: Unknown.

1526 Q1981 oc.1880. Length 15.4 cm. Sandstone.
Provenance: Unknown.
Old labels: 'Cook's Straits, South Island', 'T.W.U.R.'

1527 Q1999 oc.1884. Length 17.1 cm. Gabbro.
Provenance: Unknown. Marked: 'N. Zealand Sea Shore, from finder. W.G.S. 9-97'.

1528 Q1999 oc.37. Length 8.5 cm.
Provenance: Unknown. Marked: 'Per Mr Skelton'.

1529 Q1999 oc.38. Length 9.3 cm.
Provenance: Unknown. Marked: 'Per Mr Skelton'.

Hawke's Bay type
Rounded quadrangular section, incipient tang, some with decoration on poll.

1530 9604. Length 25 cm. **Plate 153**
Greywacke. Double spiral on poll.
Provenance: Presented by J.P. Collings, 11 November 1875.
Register: 'Wanganui [Whanganui] Wellington'.

Meinertzhagen Collection (1531–1539)

1531 1895-832. Length 30.1 cm. Greywacke. Grooved and ridged on poll; long ridge down full length of both sides.
Comments: Perhaps this is the adze which Meinertzhagen might have shown to Franks or others during his visit to the Museum in December 1870 and of which Campbell writes: 'He says his collection of stone adzes was very much prized at home – All the big wigs were in raptures about that big Okai Hau axe.' (Campbell: 24 February 1872).

1532 1895-833. Length 29 cm. Greywacke.

1533 1895-834. Length 24.5 cm. Greywacke. Remnants of double spiral on poll.

1534 1895-836. Length 21 cm. Greywacke.

1535 1895-837. Length 19.5 cm. Greywacke.

1536 1895-839. Length 18.5 cm. Greywacke.

1537 1895-842. Length 16.5 cm. Greywacke.

1538 1895-843. Length 14.5 cm. Greywacke.

1539 1895-853. Length 12 cm. Greywacke.

1540 1854.12-29.68. Length 21 cm. Greywacke.
Provenance: Grey Collection.

Type II C
Quadrangular, without tang. Sub-rectangular, back wider than front.

1541 +5918. Length 13 cm. Argillite.
Provenance: Presented by H.O. Forbes, 7 November 1892.

1542 1895-835. Length 26.5 cm. Argillite.
Provenance: Meinertzhagen Collection.

1543 1910-291. Length 10 cm. Argillite.
Provenance: London Missionary Society Collection.

1544 Q1981 oc.1885. Length 15 cm. Argillite. **Plate 152**
Provenance: Unknown.

Type III B
Triangular, apex to back. No tang.

1545 1895-870. Length 18.4 cm. Argillite.
Provenance: Meinertzhagen Collection.

1546 1895-871. Length 20.7 cm. Argillite. **Plate 152**
Provenance: Meinertzhagen Collection.

1547 1912.5-24.1. Length 30 cm. Basalt.
Provenance: Robertson/White Collection.

Type III C
Triangular, apex to back. Tanged, tapered sides below shoulder to form narrowed blade.

1548 NZ 38. Length 16.2 cm. Argillite.
Provenance: Hector/Colonial Museum Collection.
Register: 'From a Moa-bone Cave at Sumner, near Christchurch, Canterbury N.Z.'

Type IV A
Triangular, apex to front, 'hog-backed', tanged. Narrow cutting edge.

1549 NZ 13. Length 29 cm. Argillite.
Provenance: Hector/Colonial Museum Collection.
Register: 'Found on the South bank of the Teramakau [Taramakau] River, West Coast, S.I.'
References: Davidson 1996: 15.

1550 7991. Length 21 cm. Argillite.
Provenance: Presented by A.W. Franks (Isaacson), 29 March 1873.
Register: 'Bought from Isaacson together with three others for £3.10.0. Isaacson had them from a sailor, who said 3 were from Poverty Bay, New Zealand, & 1 from Savage Island.'

1551 1895-872. Length 17 cm. Basalt.
Provenance: Meinertzhagen Collection.
Register: 'Otago'.

1552 1895-873. Length 20.5 cm. Greywacke. **Plate 152**
Provenance: Meinertzhagen Collection.

1553 1863.2-9.1. Length 11.7 cm. Argillite.
Provenance: Presented by Revd R. Taylor.

1554 1912.5-25.9. Length 22 cm. Argillite.
Provenance: Robertson/White Collection.
Register: 'Waituru, Southland'.

1555 1945 oc.2.1. Length 24 cm. Argillite.
Provenance: Presented by Mrs C.J. Marshall.

Type IV B
Triangular, apex to front, 'hog-backed', tanged. Wide cutting edge.

1556 NZ 36. Length 19 cm. Argillite.
Provenance: Hector/Colonial Museum Collection.
Register: '?From Moa-bone Cave, Sumner, near Christchurch, Canterbury NZ.'

1557

+1202. Length 17.1 cm. Argillite.
Provenance: Unknown. Presented 1880.

1558

1912.2-25.10. Length 14 cm. Greywacke.
Provenance: Robertson/White Collection.
Register: 'Murdering Beach'.

Type V
Tanged, side-hafted.

1559 **Plate 153**

NZ 12. Length 21 cm. Argillite.
Provenance: Hector/Colonial Museum Collection.
Register: 'Found near Wellington, New Zealand.'
References: Davidson 1996: 15; Skinner 1919: 240–1.

Type VI
Circular cross section.

1560 **Plate 152**

1912.5-24.8. Length 16.7 cm. Greywacke.
Provenance: Robertson/White Collection.
Register: 'Near Auckland'.

Broken stone adze blades
Type II A

1561

1895-821. Length 3.5 cm. Argillite (blade only). Meinertzhagen Collection.

1562

1895-829. Length 2.5 cm. Argillite (blade only). Meinertzhagen Collection.

Type II B

Liversidge Collection (1563–1567)

1563 1928.1-10.83. Length 13.3 cm. Gabbro (blade only). Liversidge no. 44.5.
 Register: 'Hokianga'.

1564 1928.1-10.86. Length 11.8 cm. Gabbro (blade only). Liversidge no. 44.8.
 Register: 'Hokianga'.

1565 1928.1-10.89. Length 9.8 cm. Greywacke (blade only). Liversidge no. 44.11.
 Register: 'Hokianga'.

1566 1928.1-10.90. Length 9.6 cm. Gabbro (butt only). Liversidge no. 44.12.
 Register: 'Hokianga'.

1567 1928.1-10.92. Length 6.6 cm. Gabbro (blade only). Liversidge no. 44.14.
 Register: 'Hokianga. Collected by J. Webster.'

1568

1960 oc.5.1. Length 10.1 cm. Mudstone (blade only).
Provenance: Presented by C.A. Burland (Dr Lauder Lindsay).
Label: 'From Dr Lauder Lindsay, 1877. In clay 6 or 8 inches below surface: in cutting Main South road near Abbot's Creek Bridge, Otago. Renwick, Nov.11, 1861.'

1569

Q1981 oc.1882. Length 7.9 cm. Argillite (blade only).
Provenance: Unknown.

Other types

1570

NZ 35. Length 5.8 cm. Argillite (portion of adze).
Provenance: Hector/Colonial Museum Collection.

Register: 'From a Moa bone Cave at Sumner near Christchurch Canterbury. N.Z.'

1571

7748. Length 8 cm. Argillite (blade only, Type I A?).
Provenance: Presented by J.G. Waller, 19 January 1872.
Register: 'Stated to have been found in the River Thames, between Lambeth & Vauxhall bridges.'

1572

1895-830. Length 2.6 cm. Argillite.
Provenance: Meinertzhagen Collection.

1573

1895-869. Length 19 cm. Argillite (adze blank).
Provenance: Meinertzhagen Collection.

Liversidge Collection (1574–1576)

1574 1928.1-10.33. Length 14.1 cm. Trachyte (butt only).
 Register: 'Ploughed up at Tammatawiwi [Taumatawiwi].'
 References: Liversidge 1894: 239.

1575 1928.1-10.35. Length 11.5 cm. Basalt or argillite (blade only, Type IVB?).
 Register: 'Ploughed up at Tammatawiwi [Taumatawiwi]'.
 References: Liversidge 1894: 240, pl. XXVII, bottom.

1576 1928.1-10.43. Length 10.3 cm. Basalt (butt only).
 Register: 'From Moa Hunters' Camp. South Rakaia.'
 References: Liversidge 1894: 241.

Chisels and gouges
Nephrite chisels

1577

9352. Length 10 cm. Flat quadrangular cross section.
Provenance: Sparrow Simpson Collection.

1578

9353. Length 9.2 cm. Rounded quadrangular cross section, small knob at proximal end.
Provenance: Sparrow Simpson Collection.

1579

9354. Length 2.5 cm. Circular cross section.
Provenance: Sparrow Simpson Collection.

1580

+5980. Length 6.1 cm. Oblong cross section.
Provenance: Presented by H.O. Forbes, 28 November 1892.
Register: 'From Monck's Cave, Sumner. H.O.F.'

1581

1895-248. Length 22.7 cm. Rounded triangular cross section.
Provenance: Presented by A.W. Franks, 2 September 1895.
Label: 'Brought from Taranaki 1830–40.'

Meinertzhagen Collection (1582–1593)

1582 1895-711. Length 8.2 cm. Flattish triangular cross section.

1583 1895-719. Length 4.4 cm. Quadrangular cross section. Two chisels: unfinished, still in one piece, unseparated.

1584 1895-720. Length 4.9 cm. Flat quadrangular cross section.

1585 1895-722. Length 3.5 cm. Very flat quadrangular cross section.

1586 1895-723. Length 3.6 cm. Flat quadrangular cross section.

1587 1895-724. Length 5.4 cm. Flat quadrangular cross section.

1588 1895-725. Length 3.1 cm. Flat quadrangular cross section.

1589 1895-726. Length 7.1 cm. Rounded cross section.

1590 1895-727. Length 2.8 cm. Rounded quadrangular cross section, distal part only.

1591 1895-729. Length 1.8 cm. Rounded quadrangular cross section, distal part only.

1592 1895-731. Length 4 cm. Rounded cross section.

1593 1895-732. Length 2.3 cm. Quadrangular cross section, distal tip only.

1594

1910.11-6.5. Length 10.6 cm. Oblong cross section, small hole in tapered proximal end.
Provenance: Presented by Library Committee of City of London (ex Guildhall Museum).

Robertson/White Collection (1595–1599)

1595 **Plate 154**
 1912.5-24.9. Length 10.9 cm. Rounded cross section.

1596 1912.5-24.14. Length 7 cm. Rounded square cross section.
 Register: 'Murdering Beach'.

1597 1912.5-24.15. Length 8.5 cm. Rounded quadrangular cross section.
 Register: 'Murdering Beach'.

1598 1912.5-24.17. Length 4.7 cm. Quadrangular cross section.
 Register: 'Otakou'.

1599 1912.5-24.19. Length 5.9 cm. Rounded cross section.

1600

1928.1-10.44. Length 2.6 cm. Rounded quadrangular cross section, distal end only.
Provenance: Liversidge Collection.
Register: 'From Hokianga'.
References: Liversidge 1894: 241, pl. XXV, bottom right.

1601

1945 oc.5.2. Length 7.3 cm. Rectangular cross section.
Provenance: Bequeathed by Oscar Raphael.

1602

1973 oc.4.2. Length 7.9 cm. Oblong cross section.
Provenance: Purchased from Dr G.B. Wood Walker.

Nephrite gouges

1603

9124. Length 20.4 cm. Circular cross section. Marked: '98'.
Provenance: Presented by A.W. Franks, 24 December 1874 (Cutter).
References: Edge-Partington 1969 I: 379.3.

1604

1895-730. Length 2.9 cm. Quadrangular cross section.
Provenance: Meinertzhagen Collection.

1605 **Plate 154**
1912.5-24.10. Length 7.3 cm. Rounded cross section.
> Provenance: Robertson/White Collection.
> Register: 'M.B. [Murdering Beach]'.

1606
1912.5-24.11. Length 5 cm. Rounded cross section.
> Provenance: Robertson/White Collection.

1607
1912.5-24.12. Length 3 cm. Rounded cross section.
> Provenance: Robertson/White Collection.

1608
1934.12-5.12. Length 8.5 cm. Circular cross section.
> Provenance: Bequeathed by T.B. Clarke Thornhill.

1609
1934.12-5.13. Length 5.1 cm. Oblong cross section.
> Provenance: Bequeathed by T.B. Clarke Thornhill.

Miscellaneous stone tools
Grindstones and files

1610
+5264. Length 9 cm. Grindstone/polishing stone. Sandstone.
> Provenance: Presented by A.W. Franks.
> Label: 'Govt. of Victoria 13 Aug. 1891.'

1611
1895-736. Length 9 cm. Grindstone. Sandstone.
> Provenance: Meinertzhagen Collection.

1612
1895-738. Length 9.5 cm. Grindstone. Sandstone.
> Provenance: Meinertzhagen Collection.

1613
1895-898. Length 6.3 cm. Grindstone for red ochre. Mudstone.
> Provenance: Meinertzhagen Collection.

Robertson/White Collection (1614–1618)

1614 **Plate 154**
> 1912.5-24.36. Length 14.7 cm. Grindstone. Mudstone.

1615 1912.5-25.20. Length 6.4 cm. Grindstone. Siltstone.

1616 1912.5-25.23. Length 4.1 cm. Grindstone. Mudstone.

1617 1912.5-25.24. Length 5.6 cm. Grindstone. Sandstone.

1618 1912.5-25.25. Length 12 cm. Grindstone for red ochre. Volcanic.

Meinertzhagen Collection (1619–1622)

1619 1895-737. Length 14.3 cm. File. Sandstone.

1620 1895-739. Length 5 cm. File. Sandstone.

1621 1895-740. Length 7.3 cm. File. Sandstone.

1622 1895-741. Length 4.9 cm. File. Sandstone.

1623
1912.5-25.17. Length 8.3 cm. File. Schist.
> Provenance: Robertson/White Collection.

1624
1895-655. Collection of 20 sandstone files (some broken).
> Provenance: Meinertzhagen Collection.

Hammer stones

1625 **Plate 154**
1912.5-25.26. Length 9.5 cm. Volcanic.
> Provenance: Robertson/White Collection.

1626
1912.5-25.27. Diameter 9 cm. Sandstone.
> Provenance: Robertson/White Collection.
> Label: 'Warrington E.R.[?]'.

1627
1954 0c.6.293. Diameter 23 cm. Greywacke.
> Provenance: Wellcome Collection.
> Register: 'Pelorus Sound, Marlborough. Mysterious relic.'

1628
1954 0c.6.294. Length 13 cm. Granite.
> Provenance: Wellcome Collection.
> Label: 'Mysterious relics. Pelorus Sound, Marlborough, New Zealand.'

1629
1954 0c.6.295. Diameter 12 cm. Metamorphic.
> Provenance: Wellcome Collection.
> Label: 'Mysterious relic. Pelorus Sound. Marlborough, New Zealand.'

Drill points and borers

1630
1895-744. Length 3.6–6.4 cm. Thirty drill points: 19 argillite, 11 chert/flint.
> Provenance: Meinertzhagen Collection.

1631
1912.5-24.18. Length 9.3 cm. Basalt drill point.
> Provenance: Robertson/ White Collection.

1632
1912.5-24.20. Length 6 cm. Argillite drill point.
> Provenance: Robertson/White Collection.

1633
1944 0c.2.864. Length 5.7 cm. Quartzite drill point.
> Provenance: Beasley Collection. Beasley no. 1494/1.
> Beasley catalogue 1494/1, registered 10 November 1924, 'From a camp site at Shag River (Otago) … obtained from H.D. Skinner, Otago Museum in exchange for No. 1475 [Rotuma club].'

1634a–c **Plate 154**
1895-652 (a), 1895-653 (b), 1895-654 (c). Lengths 7.7, 6 and 5.7 cm. Greywacke. Three borers.
> Provenance: Meinertzhagen Collection.
> Register: 'Specimens of a boring instrument possibly used for enlarging the holes in the ears, large holes betokening a chief in the habit of wearing heavy greenstone.'

Spalls

1635
5078, 5079. Lengths 9.1 and 9.7 cm. Two, with grinding edge. Greywacke.
> Provenance: Grey Collection.
> Register: 'Presented by Sir George Grey 6.11.1868. Collected by him. Found associated with Moa & other bones in Maori ovens of ancient days.'

1636
7982. Length 8.6 cm. Greywacke, with grinding edge.
> Provenance: Presented by Dr Otto Finsch of Bremen Museum, 27 April 1872.
> Register: 'Found in a kitchen midden at Rakaia, prov. of Canterbury.'

1637
1895-874. Length 9.8 cm. Greywacke, with grinding edge.
> Provenance: Meinertzhagen Collection.

1638 **Plate 154**
1912.5-25.21. Length 9.5 cm. Greywacke, with grinding edge.
> Provenance: Robertson/White Collection.
> Register: 'Warrington'.

1639
1912.5-25.22. Length 5.5 cm. Greywacke, with grinding edge.
> Provenance: Robertson/White Collection.

1640
1928.1-10.44a. Length 9.8 cm. Greywacke, with grinding edge.
> Provenance: Liversidge Collection.
> Register: 'From Moa Hunters' camp, South Rakaia.'
> References: Liversidge 1894: 241.

1641
Q2006 0c.1, Q2006 0c.2, Q2006 0c.3. Lengths 10, 9.7 and 12 cm. Three, without grinding edge. Greywacke.
> Provenance: Unknown.
> Labels: 'Moa hunter camp. South Rakaia' for first two and 'Moa hunter camp, near mouth of Rakaia. Canterbury' for third.

Knives

1642 **Plate 154**
1912.5-24.38. Length 12.9 cm. Slate.
> Provenance: Robertson/White Collection.
> Register: 'Cromwell'.

1643
1912.5-25.16. Length 18.5 cm. Slate.
> Provenance: Robertson/White Collection.
> Register: 'Nugget Bay, Port Molyneux, 60 miles S. of Dunedin.'

Flakes and flake implements
Flake knives

Hector/Colonial Museum Collection (1644–1646)

All annotated in Register: 'Found on Maniototto [Maniatoto] Plains, Otago, at a Moa-hunting camp of the Maories.'

1644 NZ 22. Length 15.5 cm. Quartzite.

1645 NZ 23. Length 12.8 cm. Quartzite.

1646 NZ 24. Length 11.1 cm. Quartzite.

Grey Collection (1647–1650)

All annotated in Register: 'Found associated with Moa and human bones in the interior of Otago. Collected by W. Murison Esq.'; presented 6 November 1868.

1647 5074. Length 15.3 cm. Quartzite.

1648 5075. Length 9.7 cm. Quartzite.

1649 5076. Length 9 cm. Quartzite.

1650 5077. Length 9.1 cm. Quartzite.

1651
1895-750. Length 12.3 cm. Quartzite.
> Provenance: Meinertzhagen Collection.
> Register: 'Macrae's Flat, Otago 1872', 'Kiripaka'.

Robertson/White Collection (1652–1656)

1652 1912.5-24.31. Length 20.5 cm. Quartzite.

1653 1912.5-24.32. Length 16.7 cm.
Quartzite.
Register: 'Warrington'.
1654 1912.5-24.33. Length 14.6 cm.
Quartzite.
1655 1912.5-24.34. Length 12.2 cm.
Quartzite.
1656 1912.5-24.35. Length 6 cm. Quartzite.

Other flaked implements

Hector/ Colonial Museum Collection (1657–1671)

All from moa-hunting camps:
1657 NZ 25. Length 6.8 cm. Argillite.
1658 NZ 26. Length 6.9 cm. Chert.
1659 NZ 27. Length 7.1 cm. Chert.

All from moa-bone cave, Sumner, near Christchurch:
1660 NZ 31. Length 7.9 cm. Sandstone.
1661 NZ 39. Length 6.5 cm. Argillite.
1662 NZ 40. Length 5.6 cm. Argillite.
1663 NZ 41. Length 7.9 cm. Argillite.
1664 NZ 42. Length 6.7 cm. Argillite.
1665 NZ 43. Length 8.8 cm. Argillite.
1666 NZ 44. Length 6 cm. Argillite.
1667 NZ 45. Length 5.6 cm. Argillite.
1668 NZ 46. Length 7 cm. Flint.
1669 NZ 47. Length 5.8 cm. Flint.
1670 NZ 48. Length 4.9 cm. Argillite.
1671 NZ 49. Length 6.5 cm. Argillite.

1672

7983. Length 5.9 cm. Flint.
Provenance: Presented by Dr Otto Finsch of Bremen Museum, 27 April 1872.
Register: 'Found in a kitchen midden at Rakaia, province of Canterbury.'

1673

+5625. Length 4.1 cm. Argillite.
Provenance: Presented by A.W. Franks, 13 August 1891 (Victoria Government).
Register: 'From midden. N. Zealand.'

1674

1895-899. Length 7 cm. Flint core.
Provenance: Meinertzhagen Collection.

Robertson/White Collection (1675–1677)

1675 1912.5-24.29. Length 5.9 cm. Argillite.
1676 1912.5-25.18. Length 9.1 cm. Argillite.
Register: 'Warrington'.
1677 1912.5-25.19. Length 9 cm. Argillite.

1678

1928.1-10.102. Length 4.2 cm. Obsidian.
Provenance: Liversidge Collection.
Register: 'From Wangarei [Whangarei], S. of Bay of Islands. Collected by J. Webster.'

1679

1974 Oc.2.1, 2, 3. Lengths 13.5, 12.6 and 12 cm. Three quartzite blades.
Provenance: Transferred from British Museum's Department of Prehistoric and Romano-British Antiquities.
Label: 'Moeraki Beach'.

Provenance unknown (1680–1682)

1680 Q1981 Oc.1888. Length 8.7 cm. Obsidian.
1681 Q1981 Oc.1891. Length 5.6 cm. Flint.
1682 Q1991 Oc.4. Length 3.9 cm. Obsidian.

Small collections of flaked implements

Hector/Colonial Museum New Zealand (1683–1690)

From moa-hunting camps:
1683 NZ 28. Five flakes of flint.

1684 NZ 29. Six flakes of obsidian (one from Rakaia River).

All from moa-bone cave, Sumner, near Christchurch, Canterbury:
1685 NZ 50. Four flakes of sandstone.
1686 NZ 51. Eleven flakes of chert, quartz and flint.
1687 NZ 52. Eight flakes of chert and argillite.
1688 NZ 53. Four flakes of flint.
1689 NZ 54. Two flakes of chert.
1690 NZ 55. Eleven obsidian flakes.

Meinertzhagen Collection (1691–1697)

1691 7015. Surface collection of small flakes of obsidian (13), jasper (1) and flint (5). Presented by F.H. Meinertzhagen, 31 December 1870.
Register: 'Found on Shell heaps or "Middens" near old Maori encampments at Hawke's Bay, North Island of New Zealand.'
1692 1895-646. Unlocalized surface collection of small flakes of obsidian (mostly) and flint.
1693 1895-647. Surface collection of assorted flakes of chert, quartzite, argillite, flint and greywacke from North and South Rakaia moa-hunter camps; also one argillite drill point from Sandhills, Dunedin.
1694 1895-648. Unlocalized surface collection of very small flakes of obsidian, jasper, argillite and flint.
1695 1895-742. Surface collection: 5 obsidian flakes and 2 flint flakes.
Register: 'N. Island'.
1696 1895-743. Surface collection of small flakes of obsidian, argillite, chert and jasper.
Register: 'Hawke's Bay, North Island'.
1697 1895-745. Surface collection of flakes, obsidian, flint and greywacke.
Register: 'Wellington 1872'.

1698

1928.1-10.44 b, c. Surface collection of obsidian flakes and core.
Provenance: Liversidge Collection.
Register: (b) 'Found on sandhills opposite Tammatawiwi [Taumatawiwi] Hokianga. Brought from S. part of the Northern Island for making knives'; (c) 'From Moa Hunters' camp, South Rakaia.'
References: Liversidge 1894: 241.

1699

1944 Oc.2.869–896. Surface collection of flakes of obsidian, chert and argillite.
Provenance: Beasley Collection. Beasley nos 430–432.
Beasley catalogue 430–432, registered 18 December 1909, 'From middens near Sumner, Christchurch. Bt F. Hornan/Homan[?] … Dorchester.'

Worked bone, nephrite, shell
Worked bone

Meinertzhagen Collection (1700–1726)

1700, 1701, 1709–1713, 1715 and **1716** (1895-396, 397, 627–631, 633 and 634) no longer in the British Museum's collections; repatriated to Museum of New Zealand Te Papa Tongarewa in November 2008.
1700 1895-396. Length 19.7 cm. Human thigh (?) bone, sawn off square at narrow end.

1701 1895-397. Length 16.4 cm. Human thigh (?) bone, cut off at one end, weathered.
1702 1895-569. Length 6.9 cm. Straight, weathered, one end sharpened.
1703 1895-570. Length 5.2 cm. Flat, both end pointed.
1704 1895-614. Length 4.8 cm. Flat, weathered, one end rounded, other cut off obliquely. Small hole near rounded end (blank? ornament?).
1705 1895-617. Length 6.6 cm. Flattish, weathered, pointed one end, much broader at other.
1706 1895-620. Length 3.5 cm. Straight, hollow, triangular cross section, notched on one edge.
1707 1895-625. Length 5 cm. Cylindrical, blackened by fire.
1708 1895-626. Length 4.4 cm. Solid, greyish (blackened by fire?), triangular cross section, one end cut off.
1709 1895-627. Length 7.6 cm. Human femur, sawn off each end.
1710 1895-628. Length 9 cm. Oblong, roughly rectangular, one side rough; human bone.
1711 1895-629. Length 5 cm. Rectangular piece of human bone, curved longitudinal depression on one side.
1712 1895-630. Length 5 cm. Human skull fragment, ground down on one side, partially blackened by fire; broken into two pieces glued together.
1713 1895-631. Length 2.5 cm. Human cranium fragment, blackened by fire on one side.
1714 1895-632. Length 5 cm. Flattish, weathered, angular point at one end, blackened by fire.
1715 1895-633. Length 4.3 cm. Flat human-bone piece, sawn across one end.
1716 1895-634. Length 4.2 cm. Concavo-convex human-bone piece, sawn or cut across both ends.
1717 1895-635. Length 3.8 cm. Flat, brownish, rounded off at one end.
1718 1895-636. Length 3.2 cm. Flat, rounded off at one end.
1719 1895-637. Length 3.6 cm. Slightly concave on smooth side; other, rougher, side ground down.
1720 1895-638. Length 5.8 cm. Hollow, cylindrical, cut across one end.
1721 1895-639. Length 6.4 cm. Weathered, rectangular cross section, pointed at one end.
1722 1895-640. Length 6.5 cm. Straight, slender, weathered, blunt at both ends.
1723 1895-641. Length 5 cm. Straight, slender, pointed at one end.
1724 1895-642. Length 2.7 cm. Comb fragment? Two tines extant.
1725 1895-643. Length 2.5 cm. Ornament fragment? Irregular shape; on curved edge blackened by fire; small three-sided projection near end; across projecting lower end double band of decorative triangles.
1726 1895-644. Length 0.9–9.4 cm. Thirty-two pieces of worked bone, some blackened by fire.

Beasley Collection (1727–1736)

1727–1731 11944 oc.2.851 to oc.2.855. Lengths 4.2, 3.3, 4.5, 6 and 3.3 cm. Blanks, marked 'D.24.1674. Nuggets', 'D.25.2216', 'D.25.2213', 'D.25.2217' and 'D.25.2218'. Beasley no. 1572. Label: 'Blanks of Moa Bone for Fish Hook barbs and shanks.' Beasley catalogue 1572, registered 29 January 1926, 'Obtained in exchange with H.D. Skinner, Otago University Museum. Dunedin N.Z.'

1732–1736 1944 oc.2.858 to oc.2.862. Lengths 5.7, 5, 5, 5 and 5.5 cm. Blanks, marked 'D.22.124. Shag River', 'D.24.605. Shag River', 'D.24.604. Shag River', 'D.24.603. Shag River' and 'D.24.606. Shag River'. Beasley no. 1494/1. Beasley catalogue 1494/1, registered 10 November 1924, '"From a camp site at Shag River, South Island (Otago)" … obtained from H.D. Skinner, Otago Museum, in exchange for No. 1475 [Rotuma club].'

1737
Q1981 oc.1364. Length 8.6 cm. Triangular, polished. Harpoon point?
Provenance: Presented by Dr J.H. Gibson.
Label: 'Bone spear-head: found in a "Run" on the Waiteiki [Waitaki?] River: 60 miles from Dunedin. Presd by Dr J.H. Gibson.'

1738
Q1981 oc.1365. Length 2.4–3.4 cm. Blank broken into three pieces.
Provenance: Unknown.

Worked nephrite

1739
NZ 93. Length 17.2 cm. Adze-blade shape, sharp cutting edge on one end, other end rough, sign of sawing on one side; polished.
Provenance: Unknown.

1740
9335. Length 4 cm. Trapezoidal shape, polished.
Provenance: Sparrow Simpson Collection.

Meinertzhagen Collection (1741–1750)

1741 1895-650. Length c.3 cm. Two chips, one oblong piece.

1742 1895-712. Length 7.2 cm. Flat, oblong, sharp irregular ends. Marked: 'Gnahati [Ngahati], Kaiapoi'.

1743 1895-713. Length 6.6 cm. Quadrangular cross section, oblong, one end pointed [chisel?].

1744 1895-714. Length 7.8 cm. Oblong, smooth, one end with asymmetrical point, other narrower, irregular.

1745 1895-716. Length 5.2 cm. Flat, oblong, pointed ends (bowenite chisel?).

1746 1895-717. Length 3 cm. Very flat sliver, oblong, one end narrower with notch each side (chisel?).

1747 1895-718. Length 2.5 cm. Very thin, irregularly shaped, sliver.

1748 1895-721. Length 2.9 cm. Rectangular, very flat (chisel?).

1749 1895-728. Length 3.2 cm. Quadrangular cross section, oblong, one end pointed (chisel?).

1750 1895-752. Length 20.5 cm. Slab of trapezoidal outline, one end cut off smoothly and polished.

1751
1906-168. Length 8.2 cm. Multi-faceted cylindrical, rough ends.
Label: '287'.
Provenance: Presented by C.H. Read.
Comments: Identified as bowenite by Dr Y. Marshall (pers.comm. 28 June 2005).

1752
1854.12-29.26. Length 35 cm. In process of being sawn into two thin slabs; oblong, diagonally cut ends, polished.
Provenance: Grey Collection.

1753
1854.12-29.62. Length 10.6 cm. Thin adze-blade shape, all sides cut straight; smooth.
Provenance: Grey Collection.

1754
1912.5-24.16. Length 6.1 cm. Quadrangular cross section, slim, one end very narrow, pointed (chisel?).
Provenance: Robertson/White Collection.

1755
1912.5-24.26. Length 6 cm. Rhomboidal shape, rough.
Provenance: Robertson/White Collection.

1756
1912.5-24.37. Width 11 cm. Flat, irregular heart shape, irregular edges; polished. Marked: 'Kaiapoi'.
Provenance: Robertson/White Collection.

1757
1944 oc.2.824. Length 39 cm. Oblong, shaped for adze blade; cutting edge irregular, upper and lower surfaces polished, sides and butt rough.
Provenance: Beasley Collection. Beasley no. 1112.
Label: 'Charlton House, Charlton, Kent. A Axe used by the Natives of Pitcairn island in 23 deg 10 min South Latitude and 130 deg 250 min West Longitude.'
Beasley catalogue 1112, registered 25 February 1920, 'From the Maryon Wilson Coll. Charlton House, Charlton.'

1758
Q1999 oc.34. Length 4.2 cm. Flat, oblong, polished.
Label: '26 July 1867.JC'.
Provenance: Unknown.

Worked shell

Meinertzhagen Collection (1759–1761)

1759 1895-519 to 522. Lengths 6.6–7.3 cm. Five flattish pointed oval pieces of haliotis shell; 1895-521 has perforation at one end

1760 1895-523. Length 5.4 cm. Flattish rectangular oblong (of pearl shell?); nick at each longitudinal side.

1761 1895-606 to 609. Diameter 3.2 cm. Four discs of white shell, slightly concave.

Weaving implements, clothing, basketry, related fibre items, mats and samples

The primary material used by Maori is New Zealand flax, *harakeke* (*Phormium tenax*), of which there are many varieties, well known to experts, and each suitable for a particular purpose. For basketry and mats, strips of leaf are used; for garments, leaves are stripped of their outer layer and the remaining fibre, known as *muka*, is cleaned, soaked in water and beaten with a stone beater (*patu muka*) to soften it. In addition to flax, other plants were also used: leaves of the rambling climber kiekie (*Freycinetia baueriana*) and the bright-yellow sedge *pingao* (*Desmoschosenus spiralis*) for baskets, mats and *tukutuku* panels, and the cabbage tree (*Cordyline* sp.) for baskets, rain capes and warriors' capes. The traditional colours are black, from crushed and soaked

bark of *hinau* (*Elaeocarpus dentatus*) tree; red/brown, from *tanekaha* (*Phyllocladus trichomanoides*) bark; and yellow, from the trunk and roots of *Coprosoma* species, this last less popular and in the past not used in all areas of New Zealand; the undyed fibre provides a fourth choice. In the nineteenth century coloured wools and feathers were introduced into garments, and synthetic dyes are used today, especially for baskets and mats, as they are easily accessible and simple to use.

A range of plying, braiding and netting techniques were used, but two have always held a special place in Maori fibre work. They are plaiting, known as *raranga*, and used in the construction of mats and baskets, and *whatu*, the twining

or 'finger-weaving' method used for the manufacture of clothing, in particular *whatu kakahu* or cloak-weaving.

Maori garments are normally made with a twining technique which may be included in the general class of weaving, in that it consists of vertical warps (*whenu*) and horizontal wefts (*aho*). However, in twining, the multiple weft threads that hold the warps together are also twined around each other, and the term twined-weaving clearly separates it from loom weaving. No loom is used in Maori twined-weaving; instead the work is suspended from a frame or, traditionally, from a pair of vertical pegs (*turuturu*) that hold the warp threads in position while the work proceeds. A foundation cord was tied between the pegs and the warps suspended from it. The wefts were then twined across the garment, a pair of wefts enclosing each warp in turn and holding it in place. If the garment was large, two more pegs were required to keep it off the ground. The pegs were sometimes simple sticks driven into the ground, but others were finely carved. Almost nothing is recorded of the latter in use. Possibly they were reserved for cloaks of special importance made under strict tapu and not to be observed by outsiders – some early descriptions suggest that the writers had not actually seen the process (weaving in seclusion continued in some families into the late twentieth century). There are a few early drawings depicting plain weaving pegs in use, but apparently not of carved ones. It is not understood how these were secured in the ground firmly enough to hold them in position. Carved pegs show no sign of the damage that would be expected if they were hammered into the ground, nor are the pointed ends scratched or scarred in any way as would be expected if they were forced through earth firm enough to hold them upright.

A similar twining method was used by Maori for making a variety of rigid fish traps, but for these no frame is required.

Twining is a common technique that is (or has been) practised almost everywhere in the world. There are a number of variations, some of them difficult and rare. The simplest type, spaced or open single-pair twining (*whatu aho patahi*) is used by Maori for making functional rain capes and occasionally for finer garments as well. The wefts are spaced at regular intervals and the soft floppy warps of rolled-flax fibre are suspended so that they hang down. Each weft consisting of two threads (a single pair of wefts) is worked across the warps. One of the pair passes in front of each warp, and the other behind it, enclosing the warp between them. The two warps are then twined around one another with a single movement of the right hand. After each twist the weaver moves on to repeat the same movement around the next warp, and continues to repeat this movement until the end of the row is reached. The next and subsequent rows are worked at equally spaced distances beneath it. The wefts are spaced out, and the method can therefore be described as spaced (or open) single-pair twining. On completion the whole garment is inverted so that the first row becomes the bottom of the cloak.

For finer garments double-pair twining (*whatu aho rua*) is used. Each weft consists of four (two pairs) of threads. One pair passes behind each warp, the other pair passes in front. For each movement (*whatu*) the lower pair is separated and the upper pair is taken between the thumb and forefinger and taken down between them. The next warp to the right and each subsequent warp is treated in the same way to the end of the row.

Weaving implements

1762
Flax beater, *patu muka*
1895-875. Length 25.5 cm.

Basalt beater: circular cross section, marked shoulder beneath narrower grip, domed top with four concentric oval ridges, rounded bottom.

 Provenance: Meinertzhagen Collection.
 Comments: Northland, eighteenth century.
 References: Pendergrast 1996: 117.

1763
Flax beater, *patu muka*
1895-876. Length 22.5 cm.

Greywacke beater: rounded oblong cross section, markedly flattened on wider sides, narrower grip, slightly domed top with three concentric shallow oval ridges, rounded bottom.

 Provenance: Meinertzhagen Collection.
 Comments: Nineteenth century (RN).

1764
Flax beater, *patu muka*
1854.12-29.70. Length 23 cm.

Basalt beater: circular cross section, slightly marked shoulder below narrower grip, ridge around domed top with another across it, rounded bottom.

 Provenance: Grey Collection.
 Register: 'tuku-tuki for beating flax'.
 Comments: Taranaki? (DRS); eighteenth century.

1765
Flax beater, *patu muka*
1944 Oc.2.816. Length 23 cm.

Basalt beater: circular cross section, narrower grip, very slightly domed top with three concentric oval ridges and one across it, rounded bottom.

 Provenance: Beasley Collection. Beasley no. 847.
 Comments: Northland, eighteenth century
 Beasley catalogue: 847, registered 19 February 1914, 'Fern Root Pounder of Black Basalt called Potuki. Having the reke [? butt in Maori] worked as a Mere. From the Cumberland Clark Coll. sold at Sothebys 12.2.14. Lot 102. Bt W. Oldman … perhaps a flax pounder which would be called "Patu Hitau"' [*Whitau, hitau* are alternative terms for *muka*, flax fibre. MP.]

1766
Plate 155
Weaving peg, *turuturu*
NZ 67. Length 42.7 cm.

Wooden peg: brown, circular cross section, small flat knob at top broken off on two sides; girth increased towards median Janus *wheku* head with *pakura* on brows, eyes and upper jaw, four large carved teeth; tapering to pointed end.

 Provenance: Unknown.
 Comments: Taranaki/Northland, 1820s–30s (RN); South Taranaki, eighteenth century (DRS).

1767
Plate 155
Weaving peg, *turuturu*
NZ 68. Length 40.4 cm.

Wooden peg: brown, oval cross section, knob with rounded top; girth increasing towards median Janus *wheku* face with *pakura* on brows and upper jaw, large nostrils at both sides, four large square teeth; *pakura* with v-shaped angled *pakati*; tapering to pointed end.

 Provenance: Cook Collection.
 Comments: Northland style, eighteenth century.
 Register and Label: 'N. Zealand. Cook coll: Add. MS 15,508 Pl.28 No3'.
 References: Edge-Partington 1969 I: 389.7; Joppien and Smith 1985: 1.167; Kaeppler 1978: 205; Pendergrast 1996: 117; Starzecka 1979: fig. 65.

1768 **Plate 155**

Weaving peg, *turuturu*
1645. Length 41 cm.

Wooden peg: brown, circular cross section, unique curved shape; flat knob with line of *rauponga* around circumference. On either side of upper shaft, two full-length high-relief figures: one smaller, female, head up; one much larger, male, head down; both with high, domed heads, *wheku* faces, hands on chest. Indication of raised lizard with head between legs of male figure. Figures with *pakura* around mouth and on arms and legs, with ribs indicated, five fingers on all, four toes except for left foot of male figure with five toes. Tapering to slim, pointed end.

 Provenance: Arley Castle.
 Register: 'From Arley Castle.'
 Comments: Taranaki/Whanganui?, 1820s–30s (RN).

1769 **Plate 156**

Weaving peg, *turuturu*
6725. Length 34 cm.

Wooden peg: brown, circular cross section, raised knob with crack; below constricted neck, Janus face with four teeth in upper jaw; brow, jaw and upper third of shaft covered in curving *rauponga*, mostly with two *raumoa* and wide diamond-shaped *pakati*. Tapering to pointed end.

 Provenance: Presented by A.W. Franks, 12 July 1870 (Wareham).
 Comments: Taranaki, 1800s–30s, fine, detailed carving. (RN).

1770 **Plate 156**

Weaving peg, *turuturu*
9357. Length 40.7 cm.

Wooden peg: dark brown, large raised knob, slim shaft with circular cross section; below constricted neck, Janus mouth, upper jaw only, with four round teeth below; underneath on one side of shaft projecting *wheku* head with *pakura* on brows and jaws and vertical *rauponga* on face. Tapering to pointed end.

 Provenance: Sparrow Simpson Collection.
 Comments: Style uncertain, 1800–30s (RN); South Taranaki (DRS).
 References: Hooper 2006: 122.54.

1771 **Plate 156**

Weaving peg, *turuturu*
1895-378. Length 54 cm.

Wooden peg: light brown, circular cross section, large raised knob above constricted neck; slim shaft, with Janus face at widest girth: *pakura* on brows and upper jaw, two wide teeth in upper jaw each side, large nose. Tapering to pointed end.

 Provenance: Meinertzhagen Collection.
 Comments: East Coast; 1850s–60s (RN); 1840 (DRS).

1772 **Plate 156**

Weaving peg, *turuturu*
1895-379. Length 48.2 cm.

Wooden peg: dark-brown wood, red ochre, circular cross section, large knob above long narrow neck; below it, Janus face with large plain brow, eyes with *pakati* notching, plain spiral and *haehae* on upper jaw with four teeth in it, long narrow nose. Worn.

 Provenance: Meinertzhagen Collection.
 Comments: East Coast; 1820s–30s (RN); eighteenth century (DRS).

1773

Weaving peg, *turuturu*
Q1999 Oc.30. Length 43.5 cm.

Wooden peg: dark brown, plain, cylindrical knob, narrow constricted neck, shaft with circular cross section tapering to narrow end, tip broken off. White painted number '109'.

 Provenance: Unknown.

Clothing

Plaited garments, twined rain-capes and related dress cloaks

Plaited cloaks, rare in collections, are made in the same manner as plaited floor and sleeping mats. Because the strips of flax or kiekie used are not long enough to reach the full width of the mat, they are worked in a series of usually three to five panels. The end of each panel and the beginning of the next are joined with a *hono* join (a complicated join for which there is no English equivalent, used on most fine sleeping mats and floor mats) as the work progresses. The ends of the strips are left free, forming fringes on the outer surface.

For plaited rain-capes, the panels are narrower than those on mats, so that more joins are made and they are placed closer together. The ends of the strips that protrude at each join are not trimmed but left long, all pointing in the same direction, and downwards when the garment is worn, forming the water-shedding thatch on the outer surface. The largest and best example of a plaited rain-cape is in the Otago Museum. When it was documented by Te Rangi Hiroa (1950), he attributed it to the Moriori people of the Chatham Islands, apparently because he could not relate it to anything in the Maori tradition. Since his time, the examples in the British Museum and one in the Ethnographical Museum of Sweden, Stockholm, have come to light, linking the type to mainland

New Zealand. It is possible that other examples in early collections await identification.

The most common cloak in early times was the functional rain-cape worn for protection against cold weather, wind and rain. The simplest were quickly made, using roughly prepared fibre and widely spaced wefts. These were rarely collected, being seen as common and crude, and also perhaps because they were so much used and worn for rough and dirty work, that a well-cared for example would have been rare and new ones only made when required. Strips of plant material, usually strips of leaf are attached into the twined wefts and left lying as a thick water-shedding thatch on the outer surface. More carefully made ones woven from properly prepared material were more often collected. Among the most striking of the traditional examples are garments thatched with black-dyed fibre or strips of leaf, with individual or groups of bright naturally yellow strips of flax leaf, spaced at intervals against the black ground. However there are many other variations.

'Rain-capes' from mid to late nineteenth century show a remarkable diversity of materials and innovative arrangements of colour, as well as decorative and often non-functional elements: borders and surface decoration of wool that would gather

water rather than shed it, cylindrical tubes of rolled flax leaf that would let more rain in than wide flat strips of leaf, and tags of *houhi* (lacebark) bast that would gather water rather than disperse it. The suggestion is that many of these garments were in fact not intended to shed rain, but were perhaps a new form of dress cloak that could be worn by all. The best of them are beautiful, and much more than a purely functional, everyday work garment. They are among the most interesting to study because of the wide variety of materials used, the arrangement of them and their colour, and the many unusual, even quirky, elements that appear, apparently at the whim of the weaver. This may relate to a greater freedom of choice and innovation permitted to a group of garments not restricted to the high-born male, but made and used by individuals of both sexes and all classes.

Many different names have been applied to this type of garment, but exactly what type of rain-cape matches each name was seldom documented in detail. Among the names may be local variants describing quality, form, materials, technique, decoration and specific purposes. *Pake* is a term that appears to be quite common and used over a wide area and may be used as a general term.

1774 Colour plate 18

Plaited cloak with fringes, *kakahu raranga*

1921.10-14.18. Length 110 cm, width 125 cm.

Black and undyed strips of flax leaf plaited in form of mat; dextrals and sinistrals arranged in groups of thirteen black and thirteen undyed creating lattice, plaited in horizontal 2/2 twill. *Kaupapa* made of four panels joined in manner of mat, but fringes of single-ply rolled cords and *pokinikini* tags are added into joins. On side edges and bottom thick fringe of single-ply rolled cords has been added at every weft. At upper edge mat is folded so that rough edge is enclosed and made stronger; two cords are threaded through folded border so that one is visible at all times. Thick, tight, two-ply tie cords at top still in place.

Provenance: Yorkshire Philosophical Society Museum.

Register: 'Middle dress of N.Z. chief given to J. Everett by Mr White, a missionary.'

Comments: Early nineteenth century, very unusual, perhaps unique (MP).

References: Pendergrast 1996: 126.

1775

Plaited rain-cape

Q1980 Oc.904. Width 116.5 cm.

Strips of flax leaf plaited in manner of plaited mats, with four joined panels. At joins, ends of all strips are plaited so that they all point in one direction forming thatch which sheds water. Work is fine and neat, strips being 2–3 mm in width, plaited in horizontal 2/2 twill with decorative horizontal bands of *mahitihiti*. Upper edge with decorative braid of red and brown wool. Badly decayed and very fragile.

Provenance: Unknown.

Comments: Late eighteenth or early nineteenth century; for similar, see Buck 1950: pl.IX (MP).

References: Ryden 1963: 84, fig. 34, left.

1776

Cape, *pihepihe*

1644. Length 82.3 cm, width 122 cm.

Woven from flax fibre in double-pair twining; commencement is row of double-pair twining at bottom, where row of *pokinikini* tags are attached. There are no prepared warps, as fibrous ends of tags are used for this purpose. Additional *pokinikini* tags are added on every second row and thickness of warp maintained by fibre from their ends. There are four warps per centimetre and wefts are spaced at 2–3 cm intervals. Final two rows at top carry running cords of black and undyed flax fibre and red wool just below braided border. There are no waist cords extending from braid as there would be were this a waist mat. Tags deteriorated and fragile

Provenance: Unknown.

Register: 'War dress made of flax. For description see Angas's N. Zealanders, pl. XXVI where it is worn by a woman.'

Comments: Nineteenth century (MP); early nineteenth century, waist cloak (DRS).

References: Fraser 1989: 105; Roth 1979: 108, no. 76, fig. 95, pl. XV.

1777 Plate 157

Rain-cape, with heavy flax thatch

+4348. Length 92 cm, width 120 cm.

Woven in single-pair twining with four loosely rolled warps per centimetre, wefts spaced at 2.5 cm intervals. Very fibrous tags form upper surface of flax leaf, dyed pale brown, with interspersed paler tags of thin flax leaf, perhaps *wharariki,* which has also been scraped, but both surfaces are in place. Tags are attached to every third weft for lower third of cape; for rest they are added to every weft. Additional lengths have been added to warp as required. Thick braided finish at upper edge.

Provenance: Edge-Partington Collection; presented 28 September 1889.

Comments: Nineteenth century (MP); eighteenth/nineteenth century (DRS).

References: Pendergrast 1996: 130; Roth 1979: 99, no. 57, fig. 81.

1778

Black rain-cape

+5029. Length 90 cm, width 104 cm.

Woven in single-pair twining; commencement at bottom with braided finish at upper edge. Outer surface, covered in thatch of black tags of crinkly unidentified strips, has appearance of being shrivelled. There are 3.5 cm between wefts and two warps per centimetre. Two areas of shaping, very bold because of spaces between wefts: one consisting of three short wefts, other not visible until unfolded (too fragile to unfold).

Provenance: Purchased from G.R. Harding, 24 April 1891 (Noldwritt).

Comments: Nineteenth century (MP).

References: Roth 1979: 99, no. 58, fig. 82, pl. XI.

1779

Cape, *pihepihe*

+6883. Length 67 cm, width 102 cm.

Selvedge commencement is at bottom, where *pokinikini* tags are linked together with row of single-pair twining. No warps have been prepared, fibre ends of tags being used for this purpose. Additional tags have been added to next eight wefts, which have been dyed yellow, pale blue and pink. At top, ninth, black-dyed, weft holds complete row of tags, which form outer surface. Above this, two rows of single-pair twining, using very thick black cords, treat groups of three warps as unit. Three-strand braid at top does not extend into waist-tie band, making it cape rather than *piupiu*.

Provenance: Presented by A.W. Franks, 7 November 1893 (Jackson).

Comments: Nineteenth century (MP); Taranaki, *c.*1900, *piupiu* (DRS).

Collected for the Museum by H.G. Jackson in New Zealand at the request of C.H. Read (BM PE correspondence: H.G. Jackson, 26 December 1892).

References: Roth 1979: 111, no. 84, fig. 101, pl. XVI.

1780 Plate 157

Cloak, *pihepihe*

1847.11-28.1. Length 85 cm, width 133 cm.

Woven in double-pair twining with undyed wefts spaced at 1.4 cm intervals on black-dyed warps. Single area of shaping about one-third way down from top, consisting of

seven short wefts. No prepared warp, fibre ends of cylindrical *pokinikini* tags being utilized for this purpose and forming thrum commencement at bottom edge. First row of tags is 11 cm long, for remainder of surface they range from 11 to 20 cm long, and are spaced sparsely on alternate wefts. No knot at commencement of each weft, but they are tied with simple knot at end of each weft. At lower right side, on third weft, seven short lengths of red wool have been added. Towards the top is a dense *kurupatu* fringe (of 20 cm long *pokinikini* tags, one attached to each warp), which is followed by two more wefts, each carrying three red woollen cords immediately beneath three-strand braid finish at upper edge. Original tie cords of black-dyed two-ply rolled cords still in place.

Provenance: Purchased from F. Milson.

Register: 'From Wellington in New Zealand. It belonged to Eh Puni [Te Puni], a friendly chief, belonging to the Pah at Ki Warra Warra [Kaiwharawhara]. It is made of native Flax, and is only worn by the Chiefs as a mark of Distinction.'

Label: 'From Wellington, New Zealand'.

Comments: First half of nineteenth century (MP); mid nineteenth century (DRS).

1781

Rain-cape

1854.12-29.132. Length 114 cm, width 162 cm.

Woven in double-pair twining throughout with thrum commencement at bottom. First five wefts that carry running cords of red wool are closer together at 8 mm between wefts than rest of weaving. Tags attached to each alternate row mainly black, but interspersed with yellow. Beginning and end of each warp is simply knotted off. There is wide shaping consisting of 21 short wefts in shoulder area. On each side is a border of looped coloured wool, and at the top a thick *kurupatu* collar of dense yellow and black tags, to which ends of warps are added. After completion, row of single-pair twining carries single row of looped red wool and rolling cord. Black fibre badly deteriorated.

Provenance: Grey Collection.

Register: 'For use in wet weather.'

Comments: Mid nineteenth century (MP); North Island, nineteenth century (DRS).

Perhaps this is one of the cloaks mentioned by Davis:

> On Saturday, the 24th instant [1853], a deputation of Native Chiefs from Rotorua waited on His Excellency … the parties were all respectably attired in European clothing, except a mat or two carelessly thrown over the dress, and intended as a parting gift to the Governor.
>
> While reading a certain clause in the Address, Rangikaheke broke off abruptly, took the mat that was thrown over his shoulder and laid it at the Governor's feet; another was immediately placed with it, by a party on the opposite side of the apartment…
>
> (Davis 1855: 1, 2).

References: Roth 1979: 99, no. 59, fig. 83, pl. XII.

1782

Rain-cape

1921.10-14.15. Length 126 cm, width 168 cm.

Woven in double-pair twining with six warps per centimetre and wefts spaced at 8 mm intervals; eight rows of shaping just above middle; shaping of eight short wefts at shoulders. Thrum commencement is at bottom, where 5 cm fringe of ends of warps protrude; later additional row of single-pair twining has been added, spaced 8 mm below initial row, which treats pairs of warps as unit and adds fringe of red, blue and raw wool; below this, single weft of double-pair twining, which is bottom row. Upper edge finished with very thick braid. Thatch is of mainly black-dyed flax strips (upper surface of leaf only), relieved by yellow strips; it is very fibrous and forms natural roll.

Provenance: Yorkshire Philosophical Society Museum.

Comments: Nineteenth century (MP); mid nineteenth century (DRS).

1783

Rain-cape

1921.10-14.16. Length 108 cm, width 155 cm.

Woven in double-pair twining with seven warps of soft *muka* per centimetre and wefts spaced at 1.4 cm intervals. Thrum commencement is at bottom where ends of warps extend 11 cm below garment. *Kaupapa* is covered with heavy thatch of harshly scraped flax tags, darkly dyed, light in weight, upper surface of leaf only used (perhaps *wharariki*). Between these tags, which are on every third weft, are tags of one-ply rolled fibre cords spaced at 8 cm intervals on weft following each row of thatch; these are hardly visible unless thatch is lifted. Each weft is knotted near end, and ends are left as ornaments to which other single-ply rolled cords are added in groups of three; these form tags up to 19 cm long and are added to every weft. Red ochre staining on inner surface. Carefully braided ties still in place.

Provenance: Yorkshire Philosophical Society Museum.

Register and Label: 'Outer Dress of a New Zealand Chief. Given to J. Everett by Mr White, a Missionary.'

Comments: Nineteenth century; red ochre makes this one of few garments showing signs of use (MP).

1784

Rain-cape

1921.10-14.17. Length 71 cm, width 124 cm.

Woven from flax in single-pair twining with three black-dyed warps per centimetre and black wefts spaced at 2.3 cm intervals, with an area of shaping of three short wefts. Commencement is at lower border where *pokinikini* tags provide black fibre for warp; additional fibre is added to thicken warp as required. Tags, added on every weft, have only short cylindrical section, 1–2 cm in length, remaining 10–15 cm being split very finely. Braided finish at top.

Provenance: Yorkshire Philosophical Society Museum.

Comments: Late nineteenth century (MP).

1785

Cloak, *pihepihe*

1944 Oc.2.833. Length 88 cm, width 133.4 cm.

Woven in double-pair twining, with black-dyed warps and undyed wefts. *Pokinikini* tags are attached to fourth weft and succeeding nineteen wefts; last weft carries decorative undyed cord. Bold shaping near middle at six short wefts; thrum commencement at bottom. Above tagged area, 3-cm-wide band of patterned true finger-weaving, bounded above and below by row of double-pair twining. Final weft carries three undyed decorative cords; finish at top is three-strand braid. After completion additional row of double-pair twining has been added at bottom, which carries very fine added *pokinikini*-type tags, with a few thicker ones.

Provenance: Beasley Collection. Beasley no. 3308.

Comments: Mid nineteenth century (MP).

Beasley catalogue: 3308, registered 15 August 1933, 'Bought from Moyse Hall Museum, Bury St Edmunds … collected by John Shirley & I. Deck prior to 1850.'

1786

Rain-cape

1960 Oc.11.8. Length 70 cm, width 103 cm.

At selvedge commencement at bottom edge bundles of kiekie fibre are linked together with row of single-pair twining. From third weft, thatch of kiekie fibre is added at each weft. Long bundles of kiekie fibre are folded in half where they are attached to weft. Thatch is dense and 78 cm long. At top thick *kurupatu* thatch fringe is added. Wefts are widely spaced at 5 cm intervals. Altogether there are only thirteen wefts, including two shortened shaping wefts. End of warps are brought into thick braid at top.

Provenance: Transferred from Royal Botanic Gardens, Kew.

Register: 'Cloak made from Phormium tenax. Sir E. Home.'

Comments: Example of purely functional garment, which takes comparatively little time to make and results in very efficient rain-cape, not common in collections as collectors presumably sought finer and more decorative pieces (MP); North Island, nineteenth century (DRS).

1787 Plate 158

Warrior's cape, *kahu toi*

1960 Oc.11.70. Length 98 cm, width 125.5 cm.

Woven entirely from black-dyed fibre of *toi* (*Cordyline indivisa*). There are five warps per centimetre and wefts are spaced at 5 mm intervals. Large area of shaping at shoulders consists of six short wefts. Thrum commencement is at the bottom, but there are no prepared warps, ends of bundles of fibre serving this purpose. When required, warps are lengthened by introducing new bundle of fibre; at other times thatch tags are doubled and added.

Provenance: Transferred from Royal Botanic Gardens, Kew.

Label: 'Garment made of the fibre of the leaves of Cordyline utilis [*indivisa*], wc. And dyed with the Bark of a species of Fagus. New Zealand.3933. Rev. W. Colenso.'

Comments: Early nineteenth century (MP); eighteenth/nineteenth century (DRS).

Kew Gardens register transcript:

> 39.1851. No. 3933. A fine (and to them) valuable garment made of the fibres of very fine cordyline (No. 1508). These are only made by the Mountain Tribes; are everlasting, greatly prized and realise a high price. It is called Toi (pronounced Tooe). The black dye is from the bark of the large leaved *Fagus*, prob. F. *robusta* or F. *fusea*.
>
> (Eth.Doc.589).

1788

Rain-cape

1994 Oc.4.90. Length 93 cm, width 129 cm.

Woven in single-pair twining, warp of sisal fibre, weft of commercial cotton string. Thatch of strips of mixed materials (flax?, reeds?, tussock?, etc.). Thatch threads attached to two adjacent warps by twist of weft, alternating with two clear warps. At top, ends of warps looped through each other and finished with row of three-strand braid, their lower half left unbraided. Two ties of twisted strings of flax fibre at top and at top corners of unfinished fibre.

Provenance: Collected in the field.

Comments: Made by Eddie Maxwell of Whakatane. Contemporary art.

1789

Rain-cape

Q1982 Oc.741. Length 81.5 cm, width 112 cm.

Woven in double-pair twining, with thrum commencement at lower edge. Next three wefts carry looped wool – purple, blue, green and yellow; looped wool also forms side borders of red, green, blue, yellow, purple and grey. Flat tags cover *kaupapa* and are attached to alternate wefts; tags are black, yellow, now faded and possibly *wharariki*, and groups of butt end of leaf, now brown but possibly *pingao*. Shaping area consists of three short wefts towards top, where there is a fringe of alternating bundles of black fibre, yellow and black flax with *pingao*.

Provenance: Meinertzhagen Collection.

Comments: Nineteenth century (MP).

1790

Cloak, *pihepihe*

Q1982 Oc.744. Length 64 cm, width 93 cm.

Thrum commencement is at lower edge, where *pokinikini* tags provide fibre for *kaupapa*. First row is woven in double-pair twining and second in single-pair twining, rest is in double-pair twining with *pokinikini* tags added to each alternate row providing fibre for maintenance of thickness of warps. Tags and wefts have been dyed black so entire *kaupapa* is black. Three side warps on each edge are of multiple fine cords of wool, red and brown. There is single short weft just above middle. At the top is a border of seven rows of thick black cords carrying bundles of crinkled red wool before braided finish. The braid's end is taken into *kaupapa* to finish, showing that this is shoulder cape rather than waist garment.

Provenance: Unknown.

Comments: Nineteenth century (MP).

1791

Cloak, *pihepihe*

Q1999 Oc.28. Length 70 cm, width 110 cm.

Woven in single-pair twining, with thick widely spaced wefts, in black-dyed flax fibre. Thick braid across top, fine *pokinikini* tags over whole body on outer side. No shoulder ties.

Provenance: Presented by Mrs Penruddock. Ex Duplicate Collection.

Label: 'Presented by Mrs Penruddock. Petticoat of an Indian chief. 20 shilling. If not sold to be sent to Blackmore Museum.'

1792

Cloak, *pihepihe*

Q1999 Oc.29. Length 98 cm, width 150 cm.

Woven in double-pair twining in flax fibre, with black-dyed warps and undyed wefts. Widely spaced thick *pokinikini* tags over all outer surface, side edges decorated with fringe of very fine twisted flax; thick black-dyed braid across top, no obvious shoulder ties. Bad condition, hole in centre of *kaupapa*.

Provenance: Unknown. Ex Duplicate Collection.

Dog-skin cloaks, *kahu kuri* and close-weft cloaks, *pukupuku*, with *taniko*

These early cloaks, some of which were collected and recorded by Captain Cook and his scientists and artists at the end of the eighteenth century, are treated here as a single unit. They are a group about which little is known, including how they relate to each other and to earlier and later styles. The names of particular types were rarely recorded; nor were the localities in which they were seen or collected. While there are many similarities with later garments, we do not know if they were regarded as part of any particular group. For example, should the closely twined garments with wide patterned borders in black, worked in a complex variation of *taniko* be classed with the better known *kaitaka* cloaks with *taniko* borders, or with closely twined *pukupuku* 'war cloaks'?

Early dress cloaks are remarkable for the complexity and competence of their workmanship, the attention to detail and the restraint and delicacy shown in the decorative elements. The overall apparent simplicity of design suggests a highly developed sense of artistry, and a robust tradition of consciously refined good taste, very firmly controlled by tradition and the tapu of the chiefly men who owned and wore these garments.

1793 Plate 158

Dog-skin cloak, *kahu kuri*

NZ 125. Length 108.5 cm, width 118.5 cm.

Flax cloak with strips of dog skin. Woven in very fine close single-pair twining, five warps per centimetre and ten wefts per centimetre; two outer warps on each side are thicker. Both upper and lower edges finished with very fine braid. Above lower braid, black and white border with simple pattern, probably in single-pair twining (typical of *kahu kuri*) rather than full *taniko*; pattern is on inside of garment and border is covered on outside by fringe of rawhide held in place with row of single-pair twining, which treats parts of wefts as units, and adds to fringe, consisting of projecting strips from main surface. Hair is now missing from skin, which is cut into precise narrow strips 2–9 mm wide; strips have been sewn into place with two threads, one passing in front and other behind, but details are difficult to discern.

Provenance: Cook Collection.

Register: 'Cook Coll. No. 62'.

Comments: Late eighteenth century (MP).

References: Fraser 1989: 63, 69; Kaeppler 1978: 171; Roth 1979: 91, no. 47, fig. 72.

1794 Plate 159

Cloak, *pukupuku*

NZ 137. Length 128.3 cm, width 153.8 cm.

Woven from flax in close single-pair twining, six warps per centimetre and eight wefts per centimetre. Commencement is at upper edge and carries brown and undyed fibre cords. Narrow plaited side borders are of brown and undyed fibres, which have been attached to ends of wefts from *kaupapa* during weaving. There are areas of shaping, but not easy to distinguish because of fineness of work. Size of warps has been reduced at bottom before they continue into *taniko* border, which allows *taniko* weaving to be finer than single-pair twining on *kaupapa*. Although *taniko* appears restrained, it is very fine and complex, with patterns formed in black areas, giving embossed appearance. Due to some loss in black resulting from deterioration, parts of black patterns appear to include undyed elements; these are undyed threads beneath becoming exposed where black has broken away from them.

Provenance: Cook Collection.

Register: 'Cook Coll. No. 1'.

Comments: Late eighteenth century (MP).

References: Fraser 1989: 79, 114; Hamilton 1901: 336, PL. XLIII, fig. 2, bottom; Kaeppler 1978: 171; Roth 1979: 95, no. 48, fig. 73.

1795

Dog-skin cloak, *kahu kuri*

1837.11-11.1. Length 95 cm, width 114 cm.

Flax cloak with strips of dog skin. Selvedge commencement is at bottom, entire surface is woven in close single-pair twining, each weft in contact with previous and following weft. On each side is a border of close single-pair twining worked on wefts of main surface and treating them as warps. Strips of skin (hair destroyed by insects) 4–9 cm wide, in fairly short lengths, are arranged in three bands, although some strips do not conform to this pattern; each strip on cloak usually consists of three lengths of skin. They are sewn into place after completion of garment with two fibre cords, one of which loops around other, which travels directly across front of cloak. Active cord loops around other and passing behind warp, after passing in front of skin. Fourteen rows of single-pair twining are between final tie of skin at top and beginning of collar, which attaches short doubled lengths of dog skin. Shape forced into rawhide indicates that skin was damp when attached and has dried to shape it was stitched to.

Provenance: Presented by A.T. Sherlock.

Register: 'This cloak is completely moth eaten, the fur dropping off.'

Comments: Late eighteenth or early nineteenth century (MP).

References: Roth 1979: 96, no. 53.

1796 Plate 159

Cloak, *pukupuku*

Q1982 Oc.691. Length 109.2 cm, width 143.5 cm.

Woven in close single-pair twining, each weft in touch with weft on each side of it, very fine commencement at top. Finish at both ends of wefts very neat, with no knot commencement or finish visible. Brown, black and undyed 9 cm-wide *taniko* border is particularly fine. Dog-skin decoration, now largely missing, has been at each lower corner and appears to have been sewn on at each end of *taniko* and 20 cm along bottom from each side. Near top and bottom a horizontal brown line, each consisting of two rows of single-pair twining, using brown-dyed fibre. Traces of red ochre on surface suggest it is from early period.

Provenance: Unknown.

Comments: Late eighteenth or early nineteenth century (MP).

References: Pendergrast 1996: 134; Roth 1979: 96, no.52, fig. 77?

1797

Dog-skin cloak, *kahu kuri*

Q1991 Oc.44. Length 93 m, width 139.5 cm.

Flax cloak with strips of dog skin. Woven in close single-pair twining, commencement appears to be at top with fine selvedge. There are six warps and nine wefts per centimetre; two outside warps on each side are flax-fibre braids. Weft, also carrying dog skin, appears to have been woven into place with single-pair twining, 1.1 cm between wefts carrying dog-skin strips. Strips of dog skin (hair missing) range in width from 2 to 8 mm; skin must have been damp when sewn into place, as can be seen by way rawhide dried to shape.

Provenance: Unknown.

Comments: Late eighteenth /early nineteenth century (MP).

1798

Cloak, *pukupuku*

Q1999 Oc.27. Length 108 cm, width 139 cm.

Woven from flax in close single-pair twining, 8 warps per centimetre, 8 wefts per centimetre, plain, with bias weft shaping, flax braid across upper edge with braided tie cords; 14.5 cm-wide *taniko* border at lower edge, side borders of narrow 2.5–2 cm-wide *taniko*. *Taniko* pattern of triangles interspersed with diamonds in black and natural on bottom border, triangles only on side borders. Several scattered very small remnants of red wool on one side (possibly remnants of decoration).

Provenance: Unknown. Ex Duplicate Collection.

Label: '415'.

Comments: Early nineteenth century (MP).

Cloaks, *kaitaka: patea* and *paepaeroa*, and *huaki*

Kaitaka are very finely woven from flax fibre carefully selected for its fineness, glowing sheen and golden colour. The work is

normally in double-pair twining, although there are rare examples worked in single-pair twining. The flax fibre used is not beaten as it is for other fine garments, nor is it rolled into cord; the fibre for each warp is simply sorted into a small bundle and used as it is. The shiny surface of *kaitaka* is due to the selection and preparation of the fibre, and the rejection of the beating and rolling processes. A few rather vague descriptions suggest that the fibre was much handled and rubbed between the palms over a long period before it was used.

A feature of *kaitaka* is a coloured *taniko* border, and the garments were commonly called 'taniko cloaks' by nineteenth-century Europeans. Early writers also used the term, a reasonable one since *taniko* was not used on other garments. The decorative borders in twined *taniko* are worked from flax fibre, undyed and dyed black, chocolate-brown and red-brown. A yellow dye was known but rarely used in early times. The main, and the widest, border is at the bottom, and usually narrower bands form a border on each side edge. Occasionally there is other *taniko* work including rectangles at the lower corners.

Old photographs and paintings showing *taniko* bands at the top and across the shoulders are not a Maori form, but a manipulation by European artists and photographers, permitting them to include the pattern-work in their portraits. The garment is arranged upside-down and/or folded in various ways.

The main surface of the *kaitaka* is completely undecorated, and relies for its beauty on its high sheen, golden colour and the fineness and perfection of its workmanship. Apart from the introduction of coloured wool into the *taniko* borders, these garments generally retained their traditional form in both style and decoration. Rather diffident experiments in non-traditional decoration on the main surface suggest that meddling with the traditional form and decoration was unacceptable. This was probably due to the prestige and mana associated with the garments. Like the other possessions of chiefly men, they were not handled or even touched by others, as the tapu of the owners permeated the garments and made them dangerous to persons of lesser power.

This tradition of tapu sacredness survived in some areas until at least the middle of the twentieth century. Family cloaks were not worn or displayed without good reason, were never loaned outside the family and when handling was necessary it was done with great respect. If they needed to be moved into storage they were handled carefully and afterwards the hands washed and water scattered from the fingertips to remove the effects of the tapu.

There are three types of garments in the *kaitaka* class. The *patea* is worked with horizontal wefts. The commencement is at the top. There is a wide *taniko* border at the bottom, and usually a narrower one each side. The *paepaeroa* is worked with vertical wefts. To attain this effect, the commencement is from one side edge, arranged horizontally between the weaving pegs. The wefts are worked horizontally across the surface until the other side is reached. *Paepaeroa* means a 'long horizontal length', perhaps referring to the long length of each weft. After completion the garment is turned so that the wefts become vertical. The *taniko* borders are as for the *patea*. *Huaki* is a garment with two, or sometimes more, bands of *taniko* at the lower edge, and there may be more than one border on each side. Otherwise it is made in the same way as either *patea* or *paepaeroa*.

1799 Plate 160
Cloak, *kaitaka*

NZ 135. Length 126 cm, width 158 cm.

Paepaeroa with restrained decorative elements. Thrum commencement at one side with two close rows of double-pair twining and similar finish at other side. Fine weaving is in double-pair twining throughout, with six warps per centimetre and wefts spaced at 1.1 cm intervals. Finely plaited band forms upper border, lower border is three-ply rolled cord of brown dyed fibre. At the lower corners are small motifs, probably in single-pair twining rather than full *taniko*. At the upper corners is evidence of dog-skin ornamentation, which is on inside of garment and probably would be seen when corners hung down. Across main surface are three bands of brown warp added part way across. Towards one side of the garment is a small area of shaping in the form of a wedge from upper edge of four short wefts; other shaping takes form of minor adjustments to shape with single short weft.

Provenance: Cook Collection.

Register: 'Cook Coll. No. 65'.

Comments: Eighteenth century; northern South Island (DRS).

References: Fraser 1989: 63, 99; Hamilton 1901: 336, pl. LXIII, fig. 1, top left and centre; Kaeppler 1978: 171; Pendergrast 1996: 136; Roth 1979: 57, no. 1, figs 35 and 35A; Simmons 1981: 48, fig. 8; Starzecka 1979: fig. 57.

1800
Cloak, *kaitaka*

NZ 136. Length 121 cm, width 147 cm.

Plain *paepaeroa*. Commencement at one side and finish at other, both finely worked selvedge edges. Woven in double-pair twining, with nine warps per centimetre and wefts spaced at 8 mm intervals. Warp on upper edge consists of two brown-dyed rolling cords, lower edge is bordered with fine-plaited band, both of which have been added during manufacture. There are six minor shaping areas, the only ornamentation being narrow bands of dog skin (hair missing) bordering lower corners.

Provenance: Unknown.

Comments: Late eighteenth/early nineteenth century (MP).

References: Roth 1979: 72, no. 16, fig. 50.

1801
Cloak, *kaitaka*

NZ 138. Length 88 cm, width 154.6 cm.

Plain *patea*, unfinished. Very fine even weaving in double-pair twining, seven warps per centimetre and wefts spaced at 6 mm intervals; no shaping. Selvedge commencement at upper edge; side edges with tightly rolled two-ply cords dyed brown; lower edge with fringe.

Provenance: Unknown.

Comments: Late eighteenth/early nineteenth century (MP); Queen Charlotte Sound, eighteenth century (DRS).

1802 Plate 160
Cloak, *kaitaka*

NZ 139. Length 112.5 cm, width 172.5 cm.

Patea, with lower border of *taniko*. Woven in double-pair twining with occasional weft of single pair, with fine braid-like commencement carrying rolled cords at upper edge. Warp at each side edge consists of three brown rolled cords; at bottom, 8.5 cm-wide *taniko* border in traditional colours. Two areas of shaping at one-third and two-thirds way down, both consisting of three short wefts. Some small holes in centre towards top.

Provenance: Unknown.

Comments: Early nineteenth century (MP).

References: Hamilton 1901: 336, pl. XLIII, fig. 2, second bottom and second top right; Roth 1979: 87, no. 38, pl. VIII, lower.

1803
Cloak, *kaitaka*

NZ 142. Length 116 cm, width 154 cm.

Patea, with lower border of *taniko* and dog skin. Finely woven in double-pair twining, seven warps per centimetre, wefts widely spaced at 2.2 cm intervals. Selvedge commencement at upper edge carries narrow decorative border of running cords of brown flax fibre; beneath, narrow band-ends of brown fibre from decorative cord are allowed to join warps of *kaupapa* for short distance. Each side border is three-strand brown-dyed braid of rolled cords. Two areas of shaping: one of two short wefts a third of way down, another of three short wefts just above lower border. There are three rows of double-pair twining before *taniko*, which has simple pattern of triangles in traditional colours and three narrow strips of dog skin (some hair remaining) at each end.

Provenance: Unknown.

Comments: Late nineteenth/early twentieth century (MP).

References: Hamilton 1901: 336, pl. XLIII, fig. 2, second top left; Roth 1979: 72, no. 19, fig. 53, pl. V, lower.

1804
Cloak, *kaitaka*

+5027. Length 115 cm, width 123 cm.

Unfinished *paepaeroa* with narrow band of *taniko*. Commencement at one side, with narrow band of *taniko*, other side unfinished. Woven in double-pair twining throughout, with wefts spaced at 5 to 9 mm. Three more short bands of close-patterned *taniko* enter *kaupapa* from bottom corner. Threads intended to become warps for wider *taniko* at lower edge have been brought into thick three-strand braid to prevent them becoming tangled before they are needed. Upper edge carries usual rolling double cord, which forms thicker side warps. Two areas of shaping are on the completed section, both wedge-shaped, one from top, other from bottom. Fibre for unfinished side is loose and has become tangled. Warps have not been beaten or rolled.

Provenance: Purchased from J.F. Noldwritt.

Label: 'New Zealand 1 cloak, New Zealand flax. J.F. Noldwritt.'

Comments: Late eighteenth/early nineteenth century (MP).

References: Hamilton 1901: 336, pl. XLIII, fig. 1, top right; Roth 1979: 72, no. 15.

1805 Colour plate 19
Cloak, *kaitaka*

1897-1. Length 130.3 cm, width 151.4 cm.

Paepaeroa, with three *taniko* borders and six horizontal pairs of narrow brown weft lines. Commencement on one side with band of *taniko* and finish with another band on other side. Woven in double-pair twining throughout, warps spaced at 6 mm intervals and eight wefts per centimetre. Top edge carries rolling cord of brown and undyed fibre. Two areas of shaping from upper edge, one to each side, both wedge-shaped; each consists of seven short wefts. Six spaced bands of brown warp in *kaupapa*, unusually fine *taniko* in wide lower border, different *taniko* patterns on each of side borders.

Provenance: Presented by A.W. Franks, 1 January 1897 (Inman, 28 September 1871).

Comments: Early nineteenth century (MP).

References: Hamilton 1901: 336, pl. XLIII, fig 1, bottom: lower border; centre: side border and fig. 2, top: two side borders; Roth 1979: pl. III, lower.

1806 Colour plate 18
Cloak, *kaitaka*

1854.12-29.133. Length 143.5 cm, width 206 cm.

Patea, with *taniko* borders and feather and woollen ornamentation. Commencement is with narrow plaited band at upper edge. Weaving is in double-pair twining with narrow *taniko* bands on each side and 22 cm-wide *taniko* border at bottom, which is woven in black and a variety of browns, with some red wool and a single small triangle in green; pompoms are an unusual addition on the black areas at each end of *taniko*. Garment shows early appearance of *ngore*-type pompoms of red wool, which are attached with dark fluffy feathers (placed upwards) to body of cloak. There are two areas of shaping, one close to top, one at bottom; both consist of five short wefts.

Provenance: Grey Collection.

Comments: Early nineteenth century. Addition of pompoms and feathers is early experiment into decoration of traditionally plain surface on fine cloaks; also suggests link with *pekerangi*-type of cloak, where small groups of feathers are used as ornamentation (MP).

See also comments for rain-cloak **1781** (1854.12-29.132).

References: Blackman 1998: 76, fig. 9; Pendergrast 1996: 138; Roth 1979: 72, no. 18, figs 51 and 52, pl. IX, lower.

1807
Cloak, *kaitaka*

1921.10-14.11. Length 111 cm, width 102.5 cm.

Unfinished *paepaeroa*, with narrow *taniko* side border and corner decoration. Commencement is with band of *taniko* at one side, followed by five short twined bands of pattern, projecting from bottom corner. *Kaupapa* is woven in double-pair twining. After first ten wefts and

immediately after twined pattern at bottom is an area of shaping: it begins at upper edge and consists of nine interpolated, interrupted wefts placed alternately between full wefts. Two horizontal bands, 27 cm down from upper edge, consist of short vertical rows of running woollen cords, largely missing through age. Narrow upper and lower borders are plaited rather than woven, lower and wider one being 1.5 cm wide.

Provenance: Yorkshire Philosophical Society Museum.

Comments: Early nineteenth century (MP).

1808 Plate 161
Cloak, *kaitaka*

1923.12-8.1. Length 173 cm, width 137.5 cm.

Paepaeroa, with wide *taniko* borders on three sides. Commencement starts at one side with *taniko*, then it is woven in double-pair twining to finish at opposite side. Future warps for bottom border of *taniko* are added during weaving, and these are later used to weave *taniko* on. All borders are in black and undyed flax, with multicoloured wool. Towards each end of lower border are examples of embossed effect of black-on-black. Shaping takes form of two wedge shapes from upper edge. Some areas of deterioration.

Provenance: Presented by Lady Donoughmore.

Metal disc: '17/17'; diamond-shaped metal tag: '17/13'.

Comments: Early nineteenth century, such wider-than-usual side-border *taniko* is believed to be post-contact development (MP); Taranaki, 1830–40 (DRS).

1809
Cloak, *kaitaka*

1933.4-5.1. Length 157 cm, width 194.5 cm.

Paepaeroa, with *taniko* borders on three sides. Woven in double-pair twining, with nine warps per centimetre, and wefts spaced at 7 mm intervals. Upper edge is pair of rolling cords, one black (now largely missing) and one brown. There are three wedge-like areas of shaping from upper edge; from left to right they are of nine, seven and nine short wefts. Side borders are almost as wide as lower one; black in them all has deteriorated so badly that very little remains in place.

Provenance: Presented by Miss M.E. Ashby.

Register: '…collected at least 100 yrs ago, possibly on Cook's voyages.'

Comments: Late eighteenth/early nineteenth century (MP); Taranaki, c.1800 (DRS).

1810 Plate 161
Cloak, *kaitaka*

1938.7-7.1. Length 164.5 cm, width 195.5 cm.

Paepaeroa, with three *taniko* borders. Woven in double-pair twining, with seven warps per centimetre and 8–10 mm between wefts. There are two wedge-like areas of shaping from upper edge, each of seven short wefts. Upper edge is pair of rolled cords dyed brown; *taniko* is black, brown and undyed flax fibre, and coloured wool. At centre of garment a word (name?) has been embroidered in blue wool, now illegible.

At one side of *taniko* band is area of *paheke* decoration in wool, and minor evidence of others, unusual on *kaitaka* cloaks.

Provenance: Purchased from Bishop C. Abraham.

Register: 'Given to collector's father, when living near Auckland between 1850 and 1860.'

Comments: Early nineteenth century (MP); nineteenth century (DRS).

1811 Plate 162
Cloak, *kaitaka*

1938.10-1.78. Length 148.6 cm, width 236 cm.

Patea, with *taniko* narrow side borders and wide lower border. Woven in double-pair twining, with three areas of shaping: first is 15 wefts down from upper commencement edge and consists of seven short wefts, second is two-thirds way down and consists of eight short wefts, and third is just above wide lower border and consists of five short wefts. *Taniko* is in traditional black, brown and undyed fibre, with red, green and yellow wool. Narrow side borders are of black and undyed fibre. At centre of garment is diamond shape, created with small bundles of red, green and blue wool, woven into weft. Marked in one top corner 'Eliza'.

Provenance: Presented by Miss E.K.B. Lister.

Register: '[The collection was made] by donor's father & brother (in whose memory they are given).'

Label: 'Maori chief's cloak, sent to E.K. Bateson from J.A. Lister, 1850. Made of flax, J.K.B.L. 1894.'

Comments: Early nineteenth century (MP); East Coast, nineteenth century (DRS).

1812 Colour plate 19
Cloak, *kaitaka*

1938.10-1.79. Length 136 cm, width 211 cm.

Patea, with *taniko* narrow side borders and wide lower border. Braided selvedge at top followed immediately by row of single-pair twining in brown and undyed flax fibre, followed by double-pair twining. A shaped area of eight short wefts is after fifth weft, only 4.5 cm from commencement. At the bottom is another shaped area of four short wefts. Three close rows of double-pair twining separate *kaupapa* from lower border *taniko*, which is in traditional black, brown and undyed fibre, with triangles of red wool; in centre of border is black-on-black *taniko* pattern; at the bottom corners are two short bands of running woollen cords. Evidence of very small tufts of red wool is scattered across upper part of cloak, but they have nearly disappeared and only four remain visible.

Provenance: Presented by Miss E.K.B. Lister.

Register: '[Collection made] by donor's father & brother (in whose memory they are given).'

Label sewn on: 'Maori mat (chief's cloak). J.A. Lister, about 1842 flax J.K.B.L. -1894.'

Comments: Early nineteenth century (MP).

References: Blackman 1998: 78, fig. 12; Pendergrast 1996: 136–7.

1813 **Colour plate 19**
Cloak, *kaitaka*
1941 Oc.4.1. Length 166 cm, width 187 cm.

Paepaeroa, with three *taniko* borders, on sides and bottom. Woven in double-pair twining throughout, with six warps per centimetre and 8 mm between wefts. Upper edge is rolling cord of red and black wool, which has been added during weaving. Two small wedge-shaped areas of four short wefts are at the upper border; there is a single short weft at bottom. *Taniko* is worked in black and undyed flax fibre, with multicoloured wool.

Provenance: Presented by H. Blampied.
Register: 'Given to donor's father by a Maori chief between 1880 and 1890.'
Comments: Early nineteenth century (MP); Taranaki, *c.*1840 (DRS).

The cloak was given to my Father Mr Geo. H. Blampied in N.Z. by a Maori chief whom he had befriended … it must have been in the 1880s for my Father was then sailing to & from N.Z. in the Shaw Savill ship of which he was an officer. He brought the cloak Home here & gave it to his sister, my Aunt, who passed it on to me some years ago when I arrived here as a N.Z. soldier in the last war.
(BM AOA correspondence: H.H. Blampied, 16 September 1941).

1814 **Plate 162**
Cloak, *kaitaka*
1944 Oc.2.832. Length 82 cm, width 126 cm.

Patea, with narrow *taniko* bands form side borders, and wider one with four small elements in wool forms lower border. Selvedge commencement at upper border carries weft of red and green wool. *Kaupapa* is woven in single-pair twining, wefts are spaced at 6 mm intervals, and there are six unrolled warps per centimetre. Small area of shaping consisting of four short wefts is placed near top and another of three near bottom; third at centre has four short wefts.

Provenance: Beasley Collection. Beasley no. 2282.
Label: 'He Korowai given to me by Renata Kawepo principal chief of Ngati Upikoiriri [Ngati Te Upokoiri] of Hawkes Bay – from personal regard.'
Comments: Early nineteenth century, single-pair twining is very unusual for this class of cloak (MP); Taranaki, *c.*1850 (DRS).

Beasley catalogue: 2282, registered 2 February 1929, '… presented to Judge Fenton about 1850 by the Ngatiwpikoiriri [Ngati Te Upokoiri] tribe. Ex Peek Collection. Bought Glendinnings Rooms ex Lot 391.'

1815 **Colour plate 19**
Cloak, *kaitaka*
1960 Oc.11.7. Length 101 cm, width 169 cm.

Patea, with *taniko* borders and tassels of dog hair. Finely worked in double-pair twining, with eleven warps per centimetre and wefts spaced at 6 mm intervals. There are three areas of shaping, one of five short wefts near top, another of five about halfway down, and third of four short wefts at bottom just above *taniko*. Narrow band of *taniko* at each side and wider one at bottom, in brown, black and undyed flax fibre. Before the lower border are four rows of double-pair twining that include blue and brown wool, and two areas of black-on-black patterning.

Beneath lower border and extending up its ends is a cord with dog-hair tassels, except for 43 cm in middle.

Provenance: Transferred from Royal Botanic Gardens, Kew.
Comments: Late eighteenth/early nineteenth century (MP); Northland, *c.*1800 (DRS).
References: Blackman 1998: 77, fig. 11.

1816 **Colour plate 19**
Cloak, *kaitaka*
Q1982 Oc.690. Length 127.8 cm, width 177 cm.

Patea, with *taniko* borders. Plaited commencement at top; woven in double-pair twining throughout, with area of shaping consisting of three short wefts interpolated towards top and another of same size just above bottom border. Wefts are spaced at 1 cm intervals and there are eight warps per centimetre. There are three rows of close double-pair twining just before lower *taniko* border of black, brown and undyed flax fibre and red wool. Near top, darned repair in red, brown, dark blue and light blue wool; it is treated as ornamental element and made more obvious on outer surface.

Provenance: Franks Collection. Ex Duplicate Collection.
Labels: 'A.W. Franks (Wareham 14.2.71 - ?72)'; '35'.
Comments: Early nineteenth century (MP).

1817
Cloak, *kaitaka*
Q1982 Oc.700. Length 119 cm, width 170 cm.

Plain *paepaeroa* with no ornamentation. Seven rows of single-pair twining included among 203 of double-pair, with addition of two close rows of double-pair twining at each side to prevent unravelling. Top edge is finished with roll, bottom edge with braid. Weaving is fine: 5 mm between wefts and eight warps per centimetre. There are only two separate short wefts, which appear to correct shape.

Provenance: Unknown. Ex Duplicate Collection.
Comments: Early nineteenth century. This cloak is unusual in being completely undecorated, usually cloaks of this type have three *taniko* borders (MP).
References: Pendergrast 1996: 129.

1818 **Colour plate 20**
Cloak, *kaitaka*
Q1982 Oc.718. Length 88 cm, width 127.5 cm.

Huaki, with two bands of *taniko* around three sides, characteristic of *huaki* form. At the top is another *taniko* band, but this has been added later, not woven as part of the garment. All *taniko* is in traditional colours with elements of coloured wool. *Kaupapa* is woven in fine double-pair twining, with ten warps per centimetre, and wefts are spaced at 3–4 mm. It is decorated with strips of cured animal skin cut in 1-cm-wide strips, with long, fine, wavy hair attached to them with linen (?) thread. On a traditional garment these would be strips of dog-tail skin but in this instance they are angora goat hair, which is long, up to 18 cm.

Provenance: Unknown.
Comments: Foundation is early nineteenth century, additions of top *taniko*

and goat hair are later (MP); Taranaki, *c.*1910 (DRS).
References: Pendergrast 1996: 138.

1819
Cloak, *kaitaka*
Q1982 Oc.728. Length 111 cm, width 194 cm.

Paepaeroa, with *taniko* side borders in traditional brown, black and undyed wefts. Woven in double-pair twining throughout, with wefts spaced at 9 mm and nine warps per centimetre. Lower edge is decorated with band of black and undyed fibre cords, plaited in twill; at one lower corner, a motif is created by combining bands of spaced double-pair twining among *taniko*. Rolling three-ply warp forms upper edge.

Provenance: Franks Collection. Ex Duplicate Collection.
Label: 'A.W. Franks (Wareham 13.2.72) 38'.
Comments: Early nineteenth century (MP).

1820 **Colour plate 20**
Cloak, *kaitaka*
Q1995 Oc.7. Length 101 cm, width 169 cm.

Huaki, with double *taniko* borders at sides and bottom. At commencement at upper border is a narrow band of six-strand braid of coloured wool into which warps are incorporated; following this is a row of twilled purple and red wool. First four wefts are single-pair twining and rest of *kaupapa* is worked in double-pair twining, with wefts spaced at 9 mm intervals and six warps per centimetre. *Taniko*, in black and undyed fibre with yellow, red, green and blue wool, has been woven into *kaupapa* and not attached after completion. There are three areas of shaping: one of six short wefts near commencement at top, one of five short wefts one-third of way down and one of six short wefts two-thirds of way down. Bunches of white dog hair, scattered over *kaupapa*, are not part of cloak and have been sewn on to surface.

Provenance: Unknown.
Comments: Early nineteenth century (MP).

1821
Cloak, *kaitaka*
Q1995 Oc.8. Length 78.2 cm, width 116 cm.

Huaki, with *taniko* borders on all sides and strips of dog skin. Weaving commenced with one side *taniko* border and worked through to other; during weaving warps for upper and lower *taniko* bands are added in preparation for weaving them after completion of *kaupapa*. *Taniko* is in traditional black, brown and undyed fibre, with red, blue and yellow wool. Initials 'TA' are incorporated into *taniko* border on left side, just above its wide part. Two bands of vertical dog-skin strips with straight hair are attached on *kaupapa*; skin has been cured and precisely cut into strips, which are tacked into vertical lines with cotton.

Provenance: Unknown.
Comments: Early nineteenth century (MP).

1822 **Colour plate 19**
Cloak, *kaitaka*
Q1995 Oc.9. Length 94 cm, width 150 cm.

Patea, with three *taniko* borders. Selvedge commencement carrying purple and black rolling cords is at upper edge. Woven in

double-pair twining, with two areas of shaping, one with six short wefts halfway down, and other of three short wefts just above lower border. Narrow side *taniko* borders are of black and undyed fibre, wide lower border is of black fibre with coloured wool, mostly red.

Provenance: Unknown.

Comments: Early nineteenth century (MP).

1823 Plate 163
Cloak, *kaitaka*
QI995 OC.IO. Length 75 cm, width 154 cm.

Patea, with woollen borders. Fine braided commencement at top is held in place with row of single-pair twining; rest of garment is woven in double-pair twining. Warps for planned *taniko* have been added during manufacture on each side for later completion. Side *taniko* borders are narrow black bands broken by small triangles; wide *taniko* lower border is simple repeating pattern in coloured wool on black flax-fibre background.

Provenance: Unknown.

Comments: Early twentieth century (MP).

1824 Plate 163
Cape in style of *kaitaka*
QI995 OC.II. Length 52.3 cm, width II2 cm.

Wool with wefts of flax fibre. Selvedge commencement at top carries thick running cords of orange and black. *Kaupapa* is of woollen warps, including two groups of orange ones, which are woven with flax-fibre wefts in double-pair twining. At the top are three short wefts, which curve upper edge. Halfway down is a group of eight short wefts. Warp cords for intended *taniko* borders on each side have been added in traditional manner while work was in progress. Side borders were woven on warps after rest of *kaitaka* had been completed.

Provenance: Unknown.

Comments: This is an interesting piece as *kaitaka* are normally large garments and a sheen of flax is one of their main attractions. It appears that it may have been made by an old expert after *kaitaka* proper were no longer being made; she may have been too frail to gather and prepare traditional material and not willing to start a full-size *kaitaka*. Whatever reason for size and material, the maker obviously understood traditional technique and *taniko* design. A good piece for cloak makers looking for details of this style (MP).

References: Partington 2003: 30.

Cloaks, *korowai*, *ngore* and their variants
Korowai and the related *karure* and *ngore* appear to have developed from the beginning of the nineteenth century, soon after the time of Captain Cook's visit. The group quickly became popular, and by 1844 when artist George French Angas painted many images of Maori dressed in fine cloaks, the most common types were *korowai* and *ngore*, along with *korowai ngore*, a form that included the decorative elements of both. They had become the most prestigious garments, a position they held until the advent of the feather cloak, *kahu huruhuru*.

All three are often large garments, usually finely woven. The surface of the *korowai* is decorated with black tags, *hukahuka*. These are S-ply rolled cords of black-dyed flax fibre (*muka* or *whitau*), attached into the wefts at spaced intervals as the weaving progresses.

The *karure* is similar, but the black *karure* cords usually consist of three elements, and are rolled in reverse with a Z-ply. Both the *korowai* and the *karure* have a thick collar of rolled cords along the upper edge, and similar but not so heavy bands down each side; at the bottom there is usually a row of shorter black tags forming a border. A cloak with undyed tags is called *hihima*.

The *ngore* appears quite distinct from the *korowai* and *karure*, decorated as it is with small pompoms of wool, usually red, arranged across the surface. Examination, however, shows that the three – *korowai*, *karure* and *ngore* – are worked within a common framework, apart from their decoration.

The design of these garments, although quite formalized, was not as restricted as that of the *kaitaka*, and the makers were allowed more freedom to innovate and experiment. The introduction of coloured wool carried by the wefts, looped or arranged in other ways, soon became a feature, usually as borders on each side and across the bottom.

1825 Colour plate 21
Cloak, *korowai*
TRH 84 / 1902 L.I.84 / Royal Collection no. 74077. Length 85.5 cm, width 103 cm.

Cloak of candlewick and wool, with *hukahuka*, ornamentation of wool, and wefts of flax fibre. Thrum commencement is at bottom where warps are linked with double-pair twining, which continues throughout. On each side is a band where warps are of coloured wool. Narrow finish at top adds *kurupatu* fringe of black wool, which extends over pale warps, warp fringes at each top corner. Main surface is decorated with *hukahuka* tags of black wool and coloured *paheke*. Two-thirds of way down from the top is a single area of shaping. Next four wefts carry looping of multicoloured woollen cords, which continues up each side, forming borders.

Provenance: Royal Loan, Prince and Princess of Wales.

Pinned-on ribbon label: 'To Their Royal Highnesses the Duke & Duchess of Cornwall. From their beloved Rangitane Tribe.'

1826 Plate 164
Cloak, *korowai*
926. Length 165 cm, width 163 cm.

Cloak with black tags. Thrum commencement at bottom, and protruding 12 cm below woven surface, followed by double-pair twining throughout. Warps are of one-ply lightly rolled cords, in vertical alternating black and undyed bands. Sparsely arranged rolled *hukahuka* tags are attached so that they protrude up and out from surface, except for lower ones, which are arranged with one end up and other down. Wefts are spaced at 2.3 cm intervals. There are two areas of shaping: one near top consists of seven short wefts; other placed near bottom causes marked curve in lower edge. A heavy black *kurupatu* collar is at the top border,

with decorative fringe formed from ends of warps at each end, and a rolled finish above *kurupatu*. After completion, a row of black one-ply cord tags has been added as fringe over white commencement fringe.

Provenance: Unknown.

Comments: Interesting and unusual cloak, with its intentional curved lower edge and striking vertical bands (MP); East Coast, late nineteenth century (DRS).

Registered also as NZI59a.

1827
Cloak, *korowai ngore*
1643. Length 155 cm, width 165 cm.

Cloak combining black cord decoration of *korowai* and red pompoms of *ngore*. Thrum commencement at bottom, where row of double-pair twining links warps, leaving 10 cm fringe below projecting single-ply warps. Later on additional weft has been added below initial row. This is in single-pair twining, which treats pairs of warps as a unit and adds an additional fringe of fine, black, two-ply rolled *hukahuka*. Weaving throughout is in double-pair twining, with seven warps per centimetre and wefts spaced at 6 mm intervals. *Kaupapa* is decorated with *hukahuka* tags placed on every fourth weft. In addition, more widely spaced red *ngore* tufts of wool were added by looping wool through five successive *whatu* twists. At sides, *hukahuka* are attached to every weft to form borders; also at side, borders are rectangles of small red tags of wool, which were probably applied as looping and then trimmed. Thirteen short wefts form shaping area at centre; towards top is another, consisting of eight short wefts. *Kurupatu* at upper edge is thick fringe of fine *hukahuka* tags, with undyed warp fringe at each upper corner.

Provenance: Unknown.

Comments: North Island, c.1835 (DRS).

1828 Plate 164
Cloak, *ngore*
2263. Length 167 cm, width 165 cm.

Cloak with red pompoms and coloured borders. Woven in double-pair twining throughout. Selvedge commencement row at bottom carries decorative red woollen cord and next two rows have large loops in red, green and white wool. Subsequent ten wefts carry *paheke* decoration in red and green wool. Side borders are decorated with red, green and white wool, arranged in loops, and six rectangles of red and green *paheke* are arranged close to borders. In the centre is an area of shaping consisting of sixteen short wefts. Before a rolled finish at the top are six further rows of *paheke*, and at each top corner is a warp fringe.

Provenance: United Service Institution Museum.

Label: 'USM Nootka Sound no. II, New Zealand.'

Comments: East Coast, c.1850 (DRS).

1829
Cloak, *korowai ngore*
+5028. Length 148 cm, width 204 cm.

Cloak with red pompoms and black tags. Woven in double-pair twining, with eleven warps per centimetre and wefts spaced at 8 mm. Selvedge commencement is at bottom, leaving warp-end fringe of 10 cm below. A

single weft, treating groups of three warps as unit, has been added later. It carries a fringe of fine, black, rolled cords, which combine with undyed fringe already in place. There is a lower-border pattern of six rows of running cords of red wool. There are two areas of shaping, one of seven short wefts near top, the other of ten short wefts two-thirds of way down. *Kaupapa* is decorated with red woollen pompoms and fine, black *hukahuka*, which are mostly missing. Side borders are of looped wool, with which black *hukahuka* have been combined; these attachments are made on each weft. *Kurupatu* fringe of fine, black, rolled cords is now lost. Above it is a band of red woollen running cords and, on this band, large, red *ngore* pompoms are attached. Upper edge is a rolling finish with no tags, except for an undyed warp fringe at each corner.

Provenance: Purchased from Noldwritt, 24 April 1891.

Comments: Central North Island, *c*.1835 (DRS).

1830
Cloak, *hihima*
1897-2. Length 110 cm, width 126.2 cm.

Cloak with undyed tags. Thrum commencement at lower edge, where row of double-pair twining links together warps. Below this is another weft adding additional tags to fringe, which must have been worked later. Weaving throughout is fine, with wefts spaced at 5 mm intervals and nine warps per centimetre. *Hukahuka* tags, which decorate the main surface, take a number of forms. They vary in thickness, most are fine, but some are thicker, especially towards top, and they include one-ply, two-ply and three-ply rolled cords, some knotted at end, others not. Some are crinkly and appear to be a tighter form of *karure*. They are also attached in a variety of ways: one type is in first row only, another covers the rest of the cloak, being larger and placed more densely towards top. At the beginning of each weft, its ends are tied off, while the ends of threads are left as a decorative border elements. Four *whatu* twists nearest to each edge carry tags, which add to this border. At the upper edge is a fine finish but no *kurupatu* fringe. However, at each upper corner, the warp fringe is retained and held secure by three close rows of double-pair twining. There are three tie cords, one near one end and two near other. There are two small areas of shaping, one consisting of four short wefts about one-third of way down, another of five short wefts near top.

Provenance: Presented by A.W. Franks, 1 July 1897.

Label: 'A.W. Franks. Inman 28.9.71'.

Comments: Cook Strait (?), eighteenth century (DRS).

1831
Plate 165
Cloak, *ngore*
1854.12-29.134. Length 126 cm, width 149 cm.

Cloak with red pompoms and woollen borders on all four sides. Woven in double-pair twining throughout, with seven warps per centimetre and wefts spaced at 9 mm intervals. Thrum commencement is at bottom, with row of double-pair twining carrying cords of orange and red threads. This is covered by two rows of red and yellow woollen fringes, which would have been woven on as looping and later cut. Above this are six rows of running woollen cords. At each bottom corner is a rectangle of mainly red woollen looping, which includes black and white feathers. Side borders are of red and dark blue woollen looping and inside these on each side is wide band of running thread. Across *kaupapa* are red *ngore* pompoms arranged in groups of four, with dark blue one in centre. There are also very small touches of red wool through two adjacent twists. Groups of three doubled black *hukahuka* tags are spaced across centre of *kaupapa*, each of them in association with a pair of small red tags. Towards the top is an area of shaping consisting of three short wefts; one-third of way down is another of nine short wefts. Also towards top is a black *kurupatu* fringe, and above this a further border of running wool with rolling finish without fringe, except for usual warp fringe at each top corner. Original tie cords in place.

Provenance: Grey Collection.

Comments: *c*.1835 (DRS).

See also Comments for rain-cloak **1781** (1854.12-29.132).

1832
Cloak, *korowai ngore*
1854.12-29.135. Length 152 cm, width 170 cm.

Cloak with black tags and red pompoms. Selvedge commencement at bottom, woven throughout in very fine double-pair twining, with 6 mm between wefts and eleven warps per centimetre. Second weft carries bundles of unrolled wool; next four wefts carry decorative *paheke* patterns in red and green wool. Across main surface fine, black tags are spaced sparsely; some of them are *miro* rolled cords, others are very loose *karure* cords, which give impression of unravelling; also interspersed are small red and green tags, and red woollen pompoms. There is one area of shaping consisting of two short wefts placed one-third of way down from top, and another halfway down. Rolled finish at top with thick, black *kurupatu* of black tags, *karure* and *miro*. At each top corner is a fringe of warp ends; after completion warps have been brought into small bundles by a row of single-pair twining, which also carries fringe of black tag cords.

Provenance: Grey Collection.

Comments: North Island, mid nineteenth century (DRS).

See also Comments for rain-cloak **1781** (1854.12-29.132).

References: Roth 1979: 63, no. 13, figs 49 and 49a.

1833
Colour plate 22
Cloak, *ngore*
1921.10-14.12. Length 126 cm, width 166 cm.

Cloak with red pompoms. Thrum commencement at bottom, *kaupapa* of single-ply rolled cords of flax fibre in double-pair twining throughout; wefts spaced at 1.2 cm, but rather closer for first nineteen rows; ends of each weft knotted at each end. Red, black, blue and green *paheke* running cord ornamentation arranged in rectangles near bottom of cloak; *paheke* borders at each side edge, mostly red; bands of red *paheke* decoration across top before rolled finish. Informally arranged red pompoms of wool spaced over main surface. Decorative fringe consisting of ends of warps 23 cm long at each end of top edge. After completion, a row of thick, red woollen loops has been added to form bottom border; these are held in place with single row of double-pair twining, which treats pairs of warps as single unit. An area of shaping consisting of two short wefts is towards bottom; another of same size is near top.

Provenance: Yorkshire Philosophical Society Museum.

Label: 'Pikerangi'.

Comments: *Pekerangi* cloak in which small groups of feathers are used as ornamentation (MP).

1834
Plate 165
Cloak, *korowai ngore*
1921.10-14.13. Length 123 cm, width 176 cm.

Cloak with black tags and red pompoms. Commencement at bottom leaves 10-cm-long fringe of warp ends protruding beneath. A later row of single-pair twining treating pairs of warps as unit has been added below; this weft carries a fringe of black rolled cords combined with very fine *pokinikini* tags. On *kaupapa*, *hukahuka* tags are added to every third weft; *pokinikini* tags are placed intermittently among black cords. The *pokinikini* are attached in a variety of ways, which relate to how fibre sections are spaced. They are up to 18 cm long; some are of pale-yellow colour, but most are bright red/brown, which appears to be the natural colour, as the fibre is pale; yet another group may be dyed, as fibre and leaf surface are brown. At side borders two types of tags are added alternately to every second weft. A thick *kurupatu* fringe is at the top; it is carried by a row of single-pair twining, which treats three warps as unit, and adds six black rolled cords and two *pokinikini*; *pokinikini* are placed first and black cords on top of them. When garment is worn, black cords hang down with paler *pokinikini* falling over them and showing up against black background. At warp fringe at upper corners, both black cords and *pokinikini* are added.

Provenance: Yorkshire Philosophical Society Museum.

Comments: Waikato, *c*.1840 (DRS).

1835
Plate 166
Cloak, *hihima*
1921.10-14.14. Length 129 cm, width 135 cm.

Cloak woven in double-pair twining throughout and decorated with sparse undyed tags. Thrum commencement at bottom leaves 10 cm long fringe of one-ply rolled cords, which are ends of warps; these are covered with fringe of one-ply black cords (now largely missing), which have been added later with a row of single-pair twining. There are five unrolled and unbeaten warps per centimetre, and wefts are spaced at 1 cm intervals. After the first thirteen wefts is an area of shaping consisting of eighteen wefts; the second area of shaping, of nine short wefts, is placed towards top; and third, of five short wefts, near top. Tags are mostly one ply, unknotted at ends and up to 36 cm long; they are attached in pairs, some quite straight, some more tightly rolled and crinkled. Pairs of tags are also added to every weft at both sides and combine with loose ends of wefts

to form borders. There is a rolled finish at the upper edge, but no fringe except for usual warp fringe at each upper corner.

Provenance: Yorkshire Philosophical Society Museum.

Comments: Cook Strait (?), eighteenth century (DRS).

1836 Plate 166
Cloak, *korowai*
1922.11-11.1. Length 153 cm, width 154.5 cm.

Cloak with black tags and red woollen ornamentation. Thrum commencement at bottom forms fringe of warp ends protruding 9 cm. Weaving throughout is fine in double-pair twining, 10 warps per centimetre and 8 mm spacing between wefts; first row carries black *hukahuka*, which combine with undyed warp cords beneath to form bottom fringe. Second and third wefts carry red running cords of wool; third weft is much coarser than others and treats groups of three warps as unit. This row and those beneath it were probably added after completion. There is no added ornamentation until ninth weft, where *hukahuka* tags begin. On side borders, decoration of red running cords on every weft. A rolled finish is at the top, with black *kurupatu* fringe and warp fringe at each top corner, to which black tags have been added.

Provenance: Presented by Miss C. Nias and Mrs I. Baynes.

Register: 'Formerly owned by Sir Joseph Nias.'

Label: 'The New Zealand rugs now offered were brought back from the annexation of New Zealand in 1840 in the "Herald" (information supplied by Miss Nias). An account of Sir Joseph Nias (1793–1879), their former owner[,] is given in the Dictionary of National Biography, Vol. XL, 1887.'

1837
Cloak, *korowai*
1938.10-1.77. Length 162 cm, width 157 cm.

Cloak with black tags. Woven in double-pair twining throughout, with seven warps per centimetre and wefts spaced at 1.2 cm intervals. Thrum commencement is at bottom, leaving fringe of warp cords projecting 10 cm from lower edge. At later time, additional weft of single-pair twining has been added beneath commencement row. Groups of three wefts are treated as unit and thick fringe of *hukahuka* tags is added to undyed warp fringe already in position. *Kaupapa* is decorated with fine, black *hukahuka* on alternate wefts, and small rectangles of *paheke* ornamentation of red wool, now largely missing, are spaced across it. Two vertical rows of *hukahuka* form side borders. There are two areas of shaping: single short weft near top, and second of nine short wefts about one-third way down. There is a black *kurupatu* fringe at upper finish with undyed warp fringes at each upper corner.

Provenance: Presented by Miss E.K.B. Lister.

Register: '[Collection made] by donor's father and brother (in whose memory they are given).'

Label: 'Maori mat (chief's cloak), J.A. Lister about 1842 flax J.K.B.L. – 1894.'

Comments: Taranaki, *c.*1820 (DRS).

1838 Plate 167
Cloak, *korowai karure*
1960 Oc.11.10. Length 127 cm, width 166 cm.

Cloak with admixture of curly *karure* tags among *hukahuka*. Thrum commencement at bottom; very fine weaving with wefts spaced at 1.5 cm intervals and ten warps per centimetre. *Miro*-rolled *hukahuka* placed on every third weft until about one-third of way up, when they become interspersed with curly *karure* tags. At the top is a *kurupatu* fringe of both *miro* and *karure* tags. A single row of single-pair twining carrying single row of black tags added at bottom after completion, treating groups of two or three warps as a unit. On each side of garment, a fringe of unusually arranged *hukahuka* tags has been added. There is one large area of shaping one-third of way down from top, consisting of eighteen short wefts. An unusual element is a single blue glass bead threaded onto warp during manufacture.

Provenance: Transferred from Royal Botanic Gardens, Kew.

Label: 'A Porowai [*korowai*], Native Garment made of New Zealand Flax. Presented by Mr H. Churton, of Wanganui [Whanganui], New Zealand. No Plata tenei Porowai nana I homai moku [This *korowai* is from Plata (possibly transliteration of Parata), he gave it to me]. 1849.'

1839
Cloak, *korowai*
Q1982 Oc.693. Length 127 cm, width 175 cm.

Cloak with woollen ornamentation. Woven in double-pair twining with selvedge commencement at bottom. Second and third wefts carry multicoloured looped woollen ornamentation; fourth weft is same but also carries running woollen cords of red and blue; fifth to seventh wefts carry running coloured woollen cords. Border on each side is of red, blue, yellow, green, black and white looped woollen decoration; inside these every weft carries running woollen cords, which form second vertical border on each side. Main surface is covered with black woollen *hukahuka* tags and rectangles of coloured woollen *paheke* decoration. Finish at top is braided and carries groups of coloured wool to form a *kurupatu* fringe. Single area of shaping, third of way down from top, consists of nine interpolated short wefts.

Provenance: Meinertzhagen Collection.

1840
Cloak, *korowai*
Q1982 Oc.694. Length 70 cm, width 89.5 cm.

Woollen cloak with tags and blue border. Thrum commencement at bottom where weft links warps with double-pair twining. Second to sixth wefts carry decorative loops in blue and white wool, which form pattern of triangles. Blue and white looping continues up both sides to form borders. At the top is a rolled finish carrying blue and pink woollen cord, which covers quills of row of rooster feathers. At each end of top edge is a fringe consisting of protruding warps. Above blue and white border at bottom are two wefts, which carry decorative pink and blue cords. Main surface is covered with four bold horizontal bands consisting of blocks of thick, black, woollen *hukahuka* tags and blocks of

rooster feathers with pink and blue running cords. Three quarters of way down is single area of shaping consisting of four short wefts.

Provenance: Unknown.

1841
Cloak, *korowai*
Q1982 Oc.695. Length 95 cm, width 117.5 cm.

Cloak made entirely from non-traditional materials. Selvedge commencement at bottom is *taniko* border with red, green, purple, yellow, white and black wool on warps of candlewick. Main area is woven throughout in double-pair twining using cotton or linen wefts on candlewick foundation warps. Both side edges have border of fowl feathers arranged in blocks according to colour. At the top is a *kurupatu* fringe of thick, black, rolled-wool cords with red and black decorative cords carried in finish. At each upper corner is a warp fringe. Body is covered with black and coloured woollen *hukahuka* tags, rectangles of coloured woollen *paheke* ornamentation and small clumps of feathers.

Provenance: Unknown.

1842
Cloak, *korowai*
Q1982 Oc.696. Length 110 cm, width 127 cm.

Cloak with woollen tags and collar, kiwi feather side borders and bright woollen lower border. Thrum commencement at bottom with row of double-pair twining which is used throughout. Next five wefts carry heavy decoration in brightly coloured wools. Side edge warps consist of double cord, one black and one white. There is one area of shaping consisting of ten short wefts. Finish at top carries heavy row of thick, black, rolled-wool *hukahuka* tags. A short warp fringe with an added band of maroon and yellow is at each top corner.

Provenance: Unknown.

1843
Cloak, *korowai*
Q1982 Oc.697. Length 97 cm, width 109.5 cm.

Candlewick cloak with woollen tags and three borders of kiwi feathers. Selvedge commencement at bottom; double-pair twining used throughout. Third to tenth wefts carry kiwi feathers, which form lower border. Above this are six rows of woollen decoration. Kiwi feathers are added on alternate wefts to form side borders. At the top is a *kurupatu* fringe of thick, black, woollen *hukahuka* and at each upper corner a small warp fringe. Single area of shaping consisting of three short wefts is a third of way down from top. Main surface is covered with thick, black, rolled woollen *hukahuka* tags and widely spaced horizontal rows of alternating running pink and blue cords carried on wefts.

Provenance: Unknown.

1844
Cloak, *korowai*
Q1982 Oc.699. Length 130 cm, width 121 cm.

Cloak with black tags. Woven in double-pair twining, thrum commencement at bottom where warps are linked together with row of double-pair twining. One area of shaping two-thirds of way down from top. Side warp is of red wool and flax fibre. Black rolled *hukahuka* tags are attached to wefts across

the main surface, with thick border of them on each side.

Provenance: Meinertzhagen Collection.

1845
Cloak, *korowai*
Q1982 oc.701. Length 140 cm, width 158 cm.

Cloak with black tags. Thrum commencement at bottom, with row of double-pair twining, followed by seven wefts with *paheke* decoration in multicoloured wool. Weaving is fine, with six warps per centimetre and wefts spaced at 5 mm intervals. Both ends of wefts are tied off with knots. Rolled-cord tags are attached across main surface, and on side borders rolled-*hukahuka* tags are attached to each weft so that they project sidewise.

Provenance: Meinertzhagen Collection.
Comments: North Island, 1860 (DRS).
References: Pendergrast 1996: 131.

1846
Cloak, *korowai*
Q1982 oc.706. Length 104 cm, width 129 cm.

Cloak with black tags. Selvedge commencement is at bottom; beneath this is one row of single-pair twining where pairs of warps are treated as units and black fringe has been added after completion of garment. Weaving is in double-pair twining throughout, with two areas of shaping: one of three short wefts at top, one of eight short wefts at middle. *Hukahuka* tags are added across main surface and one added at both ends of weft to form side fringe. At the top is a braided finish and a thick *kurupatu* fringe of long, black *hukahuka*, and at each top corner a short warps fringe.

Provenance: Unknown.

1847 Plate 167
Cloak, *korowai*
Q1982 oc.707. Length 121 cm, width 130 cm.

Cloak of wool with flax-fibre wefts and black and red/yellow tags. Warps are of wool; band on each side is yellow. Selvedge commencement is at bottom where warps are linked by row of single-pair twining. Weaving continues in single-pair for second to eighth wefts carrying looped woollen decoration in red, pink and black. This is followed by eight more wefts carrying decorative running cords of yellow, black and red wool. Looped decoration continues up both sides of cloak, forming red, black and pink borders on yellow foundation warps. At the top is a rolled finish carrying red element and thick, black woollen *hukahuka* fringe; at each top corner is a pale warp fringe. Main surface is covered with combination of black and red/yellow *hukahuka* tags and small rectangles of *paheke* decoration. There is a single area of four short wefts near top.

Provenance: Unknown.

1848
Cloak, *korowai*
Q1982 oc.708. Length 101 cm, width 131 cm.

Cloak with woollen ornamentation and tags. Selvedge commencement is at bottom; second to sixth wefts carry black and yellow woollen ornamentation, which continues up both side borders. Weaving is fine, with wefts spaced at 4 mm, and 8 mm between warps; there is no shaping. Body is covered with black woollen *hukahuka* tags. At the

top is a fine rolled finish with a heavy, black, woollen *kurupatu* fringe and a short warp fringe at each top corner.

Provenance: Unknown.

1849
Cloak, *korowai*
Q1982 oc.709. Length 130.5 cm, width 130 cm.

Cloak of candlewick with flax-fibre wefts and black tags. Selvedge commencement is at bottom, with immediate additional coloured cords, which continue on first six wefts and up side border. Braided finish at top carries coloured running cords and thick, black *kurupatu* fringe; there are no warp fringes at top corners. Main surface is covered with thick, black *hukahuka* tags and large, brightly coloured *paheke* motifs, some suggesting flowers. There is also one motif, which has been embroidered on after completion. Short wefts are few and appear to be arranged to keep edges straight rather than for shaping.

Provenance: Unknown.
References: Pendergrast 1996: 146.

1850
Cloak, *korowai*
Q1982 oc.710. Length 135 cm, width 156 cm.

Cloak of wool with coloured borders and black tags. Selvedge commencement is at bottom; second to seventh wefts carry looped woollen decoration in red and green; eighth to tenth wefts carry *paheke* decoration in red, green and yellow wool; same ornamentation is used on side borders. Weaving throughout is in single-pair twining, using flax fibre for weft threads. Single area of shaping consisting of ten short wefts is just below halfway down. Thick, black *hukahuka* tags are spaced across main surface and upper edge carries *kurupatu* fringe of same material. Red and green fringe takes place of usual fringe of warp ends.

Provenance: Unknown.
Label: 'Kingi Topea [Topia] Turoa'.
Comments: Taranaki, c.1900 (DRS).

1851 Plate 168
Cloak, *korowai* (?)
Q1982 oc.712. Length 123.5 cm, width 178.5 cm.

Red ochre-stained cloak with tags. Thrum commencement at bottom in double-pair twining, which is continued throughout, with wefts spaced at 1.2 cm intervals, and six warps per centimetre. At beginning and end of each weft, ends are knotted off and tails rolled into cords, which become decorative elements; rolled ends of wefts are also knotted and trimmed to length. On the main surface are three types of tags attached on every third weft: tightly rolled two-ply cords, quite thick and heavy, which do not unroll at un-knotted ends; loosely rolled two-ply *karure*-type cords; tightly rolled one-ply cords, which are sometimes so tightly rolled that they develop kinks. In addition to these, ends of added short wefts are also rolled into cord to become tag.

Provenance: Unknown.
Comments: This apparently unique specimen may be an early form of *korowai* (MP); Northland?, eighteenth century (DRS).

References: Pendergrast 1996: 140; Roth 1979: 80, no. 25.

1852
Cloak, *korowai*
Q1982 oc.713. Length 119 cm, width 169.5 cm.

Cloak with black tags and coloured woollen border. Thrum commencement is row of double-pair twining at bottom; next two wefts are of single-pair twining and carry looping of black, red, blue, yellow and mauve wool. Weaving on *kaupapa* is in both single- and double-pair twining, with wefts spaced at 5 mm intervals, and six warps per centimetre. Each weft is tied off at both ends with knot. Black, rolled-cord *hukahuka* tags are spaced across *kaupapa* and two rows of *hukahuka* form border up each side. Single area of shaping at centre consists of thirteen short wefts. At the upper border is a rolled finish carrying *kurupatu* fringe of black *hukahuka*, which continues to both ends and combines with a warp fringe at each corner.

Provenance: Meinertzhagen Collection.

1853 Plate 168
Cloak, *karure*
Q1982 oc.714. Length 128 cm, width 156 cm.

Cloak, with curly tags and woollen ornamentation. Woven in double-pair twining throughout, with four vertical bands consisting of woollen warps. At each side is a border of black flax-fibre warps concealed by decorative looping of red, green, black and yellow wool. Selvedge commencement is at bottom and carries red and green cords of wool; above this is a row of short woollen thrums, followed by six wefts carrying running cords of coloured wool. Wefts are spaced at 5 mm intervals, and there are three warps per centimetre. Curly three-ply *karure* rolled tags of black-dyed flax fibre are spaced across *kaupapa*. There is no shaping. At the upper edge is a thick fringe of *karure* tags with a short fringe of coloured wool replacing usual warp fringe at each top corner.

Provenance: Unknown.
Comments: East Coast, nineteenth century (DRS).

1854
Cloak, *korowai*
Q1982 oc.719. Length 112 cm, width 139.5 cm.

Cloak with black tags. Woven in double-pair twining throughout, with six warps per centimetre and wefts spaced at 6 mm intervals. Selvedge commencement is at bottom, followed by three rows of red, yellow and blue looped wool; above this is band of small *paheke* motifs in red and blue wool. Side borders are also of looped wool: blue, yellow and black. *Kaupapa* is decorated with fine *hukahuka* tags, with *kurupatu* fringe at upper edge; warp fringe in each upper corner has been (later?) reduced in size. There is one area of shaping.

Provenance: Meinertzhagen Collection.

1855
Cloak, *korowai*
Q1982 oc.720. Length 122 cm, width 155 cm.

Cloak with black tags. Woven in double-pair twining throughout, with seven warps per centimetre and wefts spaced at 5 mm intervals and knotted off at end of each row.

Thrum commencement at bottom leaves fringe of warp ends protruding 6 cm below; above is single row of single-pair twining, which treats pairs of warps as unit and adds another fringe of black rolled cords on top of original fringe. *Hukahuka* tags are spaced regularly on every fifth weft; borders on each side are also of black rolled cords arranged in two vertical rows and placed on every alternate weft. There are two areas of shaping: one of eight short wefts one-third of way down from top, another of four short wefts two-thirds of way down. At the upper edge is a *kurupatu* fringe, which continues to each corner where it combines with the warp fringe.

Provenance: Meinertzhagen Collection.

1856
Cloak, *korowai*
Q1982 oc.721. Length 76 cm, width 96 cm.

Cloak with black tags and kiwi-feather borders. Woven in double-pair twining, with five warps per centimetre and wefts spaced at 8 mm intervals and knotted off at both ends. Selvedge commencement at bottom is decorated with black and yellow cords of wool; third weft carries row of kiwi feathers, which continue up both sides to form borders; fourth weft carries looped black and yellow cord of wool and covers quills of feathers. *Kaupapa* is decorated with black rolled *hukahuka* tags. There are two areas of shaping: one of three short wefts near top, another of same size near bottom. At the upper edge is a *kurupatu* fringe of black rolled cords and a decorative black and yellow running cord of wool; there is a small warp fringe at each top corner with black tags added.

Provenance: Unknown.

1857
Cloak, *korowai*
Q1982 oc.722. Length 56 cm, width 77 cm.

Cloak of candlewick with woollen and feather decoration. Woven in double-pair twining, with five candlewick warps per centimetre and flax-fibre wefts spaced at 8 mm intervals. Selvedge commencement is at bottom edge before multicolour woollen border. Side borders are also of multicolour wool. On *kaupapa* are black woollen *hukahuka* tags, spaced pheasant feathers and a variety of *paheke* decorations. Just below halfway down is an area of shaping consisting of four short wefts. Upper edge carries fringe of black woollen tags, but the warp fringe at each top corner is missing.

Provenance: Unknown.
Comments: East Coast, 1800s (DRS).

1858
Cloak, *korowai*
Q1982 oc.723. Length 133 cm, width 150 cm.

Cloak with woollen ornamentation. Woven in double-pair twining, with six warps per centimetre and 7–10 mm between wefts. Selvedge commencement is at bottom. Lower and side borders are multicoloured woollen fringes, probably applied by looping and then cutting. *Kaupapa* is covered with *hukahuka* tags of two-ply rolled cords of wool, black and white, and black and yellow. There is a rolled finish with black woollen fringe at upper edge.

Black wool has been added in front of warp fringe at each top corner.

Provenance: Meinertzhagen Collection.

1859
Cloak, *korowai*
Q1982 oc.730. Length 59 cm, width 97 cm.

Cloak with woollen and feather ornamentation. Woven in double-pair twining, selvedge commencement at bottom. Lower border is of rooster feathers with running-cord border of wool above. Side borders are also of kaka and white feathers. *Hukahuka* tags on *kaupapa* and *kurupatu* fringe at upper edge are of blue woollen rolled cords. Small warp fringe at each top corner has wool attached in front of it. There is an area of shaping consisting of three short wefts one-third of way down.

Provenance: Unknown.
Comments: Child's *korowai*, twentieth century (DRS).

1860
Cloak, *korowai*
Q1982 oc.740. Length 162 cm, width 167 cm.

Cloak with *pokinikini* tags. Thrum commencement is at lower edge, which allows ends of one-ply rolled warps to protrude below as fringe. Later, another row of black tags has been added beneath this, covering initial black tags; black has now been lost. Remainder of cloak is worked in double-pair twining. Black, now fragile, tags are two-ply rolled cords, which have been tightly rolled so that some are quite curly; interspersed with these are *pokinikini* tags, now mainly lost.

Provenance: Unknown.

1861
Cloak, *korowai*
Q1995 oc.12. Length 102 cm, width 118 cm.

Cloak with woollen borders and feathers. Woven in double-pair twining, with thrum commencement at bottom. Purple and red wool forms looped decoration for lower and side borders. At upper edge is a thick *kurupatu* fringe of maroon and black wool and a much reduced warp fringe with coloured wool added at each end. Black flax rolled-cord *hukahuka* tags and a sparse arrangement of rooster feathers are spread across *kaupapa*. The single area of shaping consisting of six short wefts is at the middle.

Provenance: Unknown.

1862
Cloak, *korowai*
Q1995 oc.13. Length 96 cm, width 136 cm.

Cloak with woollen and feather ornamentation. Woven in double-pair twining, with thrum commencement at bottom, followed by lower border of pheasant and fowl feathers; side borders are looped pink and blue wool. At upper border is heavy fringe of pink, purple and green wool, with reduced warp fringe at each end, with wool added. *Hukahuka* tags on *kaupapa* are pink, purple and blue wool, sparsely interspersed with rooster feathers. There are three areas of shaping: one, two-thirds of way down, consists of six shorts wefts; another of four short wefts is at middle; and third of six short wefts is near top.

Provenance: Unknown.

1863
Cloak, *korowai*
Q1995 oc.14. Length 99 cm, width 136 cm.

Cloak with woollen and feather decoration. Woven in double-pair twining, with selvedge commencement at lower edge. Bottom and side borders are of red, yellow and blue wool, looped and later cut to form fringes. Above bottom and inside side borders is woollen *paheke* decoration. Black woollen tags are spaced across *kaupapa*, with black feathers and small tufts of red wool. At upper edge is a *kurupatu* fringe of black wool; at each end, warps have been eliminated and replaced with coloured wool. At middle, five short wefts form area of shaping.

Provenance: Unknown.

1864 Plate 169
Cloak, *korowai*
Q1995 oc.15. Length 129.3 cm, width 135 cm.

Cloak of wool with flax tags. Woollen warps are arranged in red, maroon and black vertical bands, with six warps per centimetre; flax wefts are spaced at 7 mm intervals and worked in horizontal groups of double- and single-pair twining, some carrying red woollen running cords. *Kaupapa* is decorated with fine black flax-fibre *hukahuka* tags, which are also mingled with woollen side borders. Braided finish at top drops ends of coloured warps to form fringe, and adds to them outer layer of rolled black flax-fibre cords. An area of shaping consisting of six short wefts is near the top, and another, of eight short wefts, three-quarters of way down.

Provenance: Unknown.

1865
Cloak, *korowai*
Q1995 oc.16. Length 123.5 cm, width 135.5 cm.

Cloak of wool with coloured borders. Woven in double-pair twining. Woollen warps are arranged in vertical band of black and white; there are six warps per centimetre and flax-fibre wefts are spaced at 8 mm intervals. Thrum commencement is at bottom edge, followed by coloured border of five wefts carrying woollen ornamentation. Side borders are of woollen looping, yellow and green, and *kaupapa* is decorated with black woollen *hukahuka* tags. An area of shaping consisting of four short wefts is at the top, and another of five short wefts is two-thirds of the way down. At the upper edge is a *kurupatu* fringe of rolled woollen cords with warp fringe at each end.

Provenance: Unknown.

1866 Colour plate 22
Cloak, *korowai ngore*
Q1995 oc.17. Length 114.5 cm, width 130 cm.

Cloak with tags and woollen pompoms and borders. Woven in double-pair twining, with four black warps per centimetre and undyed flax wefts spaced at 1–1.3 cm intervals. Selvedge commencement at bottom allows ends of warps to project 10 cm beneath weaving. First weft above this adds another row of black tags, which cover commencement fringe; no knots are tied at ends. Next three wefts carry *paheke* decoration in orange, yellow and white. Side borders are of orange and yellow woollen looping. *Kaupapa* is decorated with

black rolled-flax-fibre *hukahuka* tags and *ngore* pompoms of yellow, orange and white wool. Halfway down is the single area of shaping consisting of thirteen short wefts. At the upper edge is a rolling finish, which attaches a *kurupatu* fringe of rolled black flax-fibre cords with clumps of orange and yellow tags and rolling yellow cords.

Provenance: Unknown.

1867
Cloak, *korowai*
Q1995 oc.18. Length 155 cm, width 204 cm.

Cloak with woollen tags and borders. Woven in double-pair twining; selvedge commencement is at bottom. *Hukahuka* tags are of black wool; borders and *paheke* decoration are of coloured wool. At upper edge is thick *kurupatu* fringe of black wool.

Provenance: Unknown.

1868
Cloak, *korowai*
Q1995 oc.19. Length 59.8 cm, width 86 cm.

Cloak with woollen tags and borders. *Kaupapa* begins with thrum commencement and is woven in single-pair twining. Black *hukahuka* tags are of wool. Purple, red and white fringe borders have probably been applied as looping and ends cut after completion. Finish at top carries black woollen *kurupatu* fringe and much reduced warp fringes at each corner.

Provenance: Unknown.

1869
Cloak, *korowai karure*
Q1995 oc.20. Length 99 cm, width 108.5 cm.

Cloak with tags, including crinkly ones, and woollen ornamentation. Woven in double-pair twining, with selvedge commencement at lower edge. Bottom and side borders are of looped yellow and blue wool. *Kaupapa* is decorated with black woollen *hukahuka* tags, brown-dyed flax-fibre crinkly *karure* tags, and unusual *paheke* in wool, mainly black and yellow – shape of motifs is suggestive of bees. *Kurupatu* fringe at upper edge is of pale-brown *karure* tags combined with wool; warp fringe at each end has been eliminated and replaced with woollen loops.

Provenance: Unknown.

1870 Plate 169
Cloak, *korowai ngore*
Q1995 oc.21. Length 87.5 cm, width 114 cm.

Cloak of candlewick with woollen ornamentation. Thrum commencement in double-pair twining is at second weft from bottom; later bottom weft has been added, carrying blue, red and white looped wool which adds to original thrum finish. Blue and white looping continues up both sides as borders. *Kaupapa* is woven from candlewick warps with cotton wefts, in double-pair twining. Decoration is running-cord *paheke* in red and blue wool, and unusual *ngore* in red, white and blue.

Provenance: Unknown.

1871
Cloak, *korowai*
Q1995 oc.22. Length 110.5 cm, width 118.7cm.

Cloak with woollen tags and borders. Woven in double-pair twining; above selvedge commencement at bottom is a

lower border of looped green and orange wool, which continues into side borders. *Kaupapa* carries thick black woollen tags, which are also used for *kurupatu* fringe at rolled finish at top; at each upper corner black wool is added to warp fringes. There are three areas of shaping: single short weft at top, group of four short wefts third of way down, and group of seven short wefts three-quarters of way down.

Provenance: Unknown.

1872
Cloak, *korowai*
Q1995 oc.23. Length 99.5 cm, width 124.5 cm.

Cloak with woollen tags and borders. Woven in double-pair twining; thrum commencement at lower edge. Bottom and side borders are of black and white wool. At upper edge is thick black and white *kurupatu* fringe, with warp fringe at each end. *Hukahuka* tags are of black rolled wool.

Provenance: Unknown.

1873
Cloak, *karure*
Q1995 oc.24. Length 141 cm, width 185.4 cm.

Cloak with woollen decoration. Woven in double-pair twining, with seven warps per centimetre and wefts spaced at 5 mm intervals. At the bottom is thrum commencement and a border of coloured wool, which extends up each side. Coloured wool is used for *paheke* motifs across *kaupapa*, but crinkly *karure* cords are of rolled, black flax fibre. *Kurupatu* at top is thick fringe of black flax *karure* cords, with short warp fringe at each corner to which wool has been added.

Provenance: Unknown.

1874 Plate 170
Cloak, *karure*
Q1995 oc.25. Length 130.5 cm, width 163.4 cm.

Cloak with woollen decoration. Woven in double-pair twining; commencement is at bottom where border of looped and running woollen cords is added; same ornamentation continues up both side borders. Woollen *paheke* motifs are distributed across *kaupapa*, which also carries black-dyed flax-fibre crinkly *karure* tags. At upper edge is *kurupatu* fringe of black wool, with coloured woollen fringe replacing warp fringe at each top corner.

Provenance: Unknown.

1875
Cloak, *korowai*
Q1995 oc.26. Length 120 cm, width 142 cm.

Cloak with woollen borders. Woven in double-pair twining, with selvedge commencement at lower edge. Bottom and side borders are of looped wool, and *paheke* decoration in wool is also applied above bottom border. There are two areas of shaping at the top, and a rolled finish at the *kurupatu* fringe of black flax-fibre cords; warp fringe is reduced.

Provenance: Unknown.

1876
Cloak, *korowai*
Q1995 oc.27. Length 107 cm, width 162 cm.

Cloak with woollen borders. Woven in double-pair twining, with selvedge commencement at lower edge. Lower and side borders are of black and yellow

looped wool. *Kaupapa* carries *hukahuka* tags of black rolled-flax fibre, and spaced *paheke* patterns in wool. At the upper edge is a *kurupatu* fringe of long black rolled-flax-fibre cords; the warp fringe has been eliminated and replaced with coloured wool.

Provenance: Unknown.

1877
Cloak, *korowai*
Q1995 oc.28. Length 117 cm, width 149 cm.

Cloak with woollen borders. Woven in double-pair twining; selvedge commencement at bottom, with woollen border, which continues up both sides. *Kaupapa* is decorated with black flax-fibre *hukahuka* tags and woollen *paheke* motifs. *Kurupatu* fringe at top edge is of black rolled-flax cords; warp fringe at each end is much reduced in size, and with wool added.

Provenance: Unknown.

1878
Cloak, *korowai*
Q1995 oc.29. Length 90.5 cm, width 133 cm.

Cloak with woollen borders. Woven in double-pair twining, with four warps per centimetre and wefts spaced at 8 mm intervals. Selvedge commencement is at bottom, with woollen border, which continues up both sides. *Kaupapa* is decorated with black-dyed rolled-flax-fibre *hukahuka* tags. Braided finish at upper edge carries *kurupatu* fringe of thick black flax-fibre cords, with small warp fringe at each end.

Provenance: Unknown.

1879
Cloak, *korowai karure*
Q1995 oc.30. Length 109 cm, width 141 cm.

Cloak with tags, including crinkly ones. Woven in double-pair twining, with commencement at lower edge leaving warp fringe protruding beneath; later single-pair weft has been used to add black fringe on top of original one, but black has deteriorated and is mostly missing; yet another row, this time of double-pair, has been added beneath single-pair row. *Karure* and *miro* rolled-cord tags are spaced across *kaupapa*. Side borders and *kurupatu* fringe at upper edge are also of black cords; warp fringe at each top corner. There are three areas of shaping: one of two short wefts near top, another of six short wefts at middle, and third of five short wefts near bottom.

Provenance: Unknown.

1880
Cloak, *korowai*
Q1995 Oc.31. Length 122 cm, width 165 cm.

Cloak with tags. Woven in double-pair twining, with thrum commencement at bottom, which leaves fringe of warp ends protruding beneath; later row of single-pair twining, carrying black cords, has been added below, increasing thickness of fringe already in place. Above this bottom fringe is a band of plain weaving in black and undyed fibre. Side borders consist of three vertical rows of black cords and inside these on each side are four rectangles of woollen running-cord *paheke* patterns. Flax-fibre *hukahuka* tags are arranged in pairs across *kaupapa*. At top border is a small band holding fringe

of black rolled-flax cords, which hide very short fringe from end of wefts.

Provenance: Unknown.

1881
Cloak, *korowai*
QI995 OC.32. Length 128 cm, width 166 cm.

Cloak with tags. Woven in double-pair twining, with selvedge commencement at bottom; later row of single-pair twining adds fringe of 8 cm long rolled cords. Side borders consist of double row of black flax-fibre tags, and same tags are also used for *hukahuka* on *kaupapa*. At upper edge is *kurupatu* fringe of black tags, with warp fringe at each end. At the middle is an area of shaping consisting of eight short wefts.

Provenance: Unknown.

1882
Cloak, *korowai*
QI995 OC.33. Length 83 cm, width 129 cm.

Cloak with tags. Woven in double-pair twining, with thrum commencement at lower edge leaving fringe of warp ends protruding beneath; later single weft of single-pair twining, carrying fringe of 12-cm-long black rolled cords, has been added. *Hukahuka* tags of rolled black-dyed flax are placed in pairs across *kaupapa*; side borders are also of black cords. At upper edge is rolled finish with red and white rolling woollen cords carrying *kurupatu* fringe of black flax-fibre cords; at each end is reduced warp fringe with added black tags. An area of shaping consisting of nine short wefts of rolled cords is just below the middle, and another of four short wefts near top.

Provenance: Unknown.

1883
Cloak, *korowai*
QI995 OC.34. Length 102 cm, width 127 cm.

Cloak with tags. Woven in double-pair twining, with thrum commencement at bottom, which leaves fringe of warp ends protruding beneath; this has later been covered with 12-cm-long fringe of black-fibre rolled cords, which are carried by row of single-pair twining. *Kaupapa* carries *hukahuka* tags of black rolled-flax fibre, and black cords are also used at each side to form side borders. At upper edge is *kurupatu* fringe of black flax cords, with reduced warp-end fringe at each end. There are two areas of shaping.

Provenance: Unknown.

1884
Cloak, *korowai*
QI995 OC.35. Length 103 cm, width 148 cm.

Cloak with tags. Selvedge commencement at bottom allows fringe of warp ends to protrude beneath; later additional row of single-pair twining, carrying fringe of black flax-fibre cords, has been added to initial fringe. Woven in double-pair twining with black rolled-cord *hukahuka* tags over main surface and double vertical row of same tags forming side borders. At the upper edge is a fringe of black flax-fibre cords held by a rolling finish, which carries black and undyed decorative flax-fibre cords; the warp fringe is reduced in size. There is one area of shaping, of five short wefts, in middle.

Provenance: Unknown.

Feather cloaks, *kahu huruhuru, kahu kiwi*

Feather garments, *kahu hururhuru*, especially the red cloak, *kahu kura*, appear in the mythology and traditions of the Maori, but their existence in ancient times cannot be proven and there appear to be no feather cloaks in museum collections that are firmly dated to before the 1850s. Early explorers, including Cook and his scientists, mention 'feather cloaks' and 'cloaks decorated with feathers', but the feathers on those that were collected and survive in museum collections are few and often placed only at the lower corners of the garment. A few have feathers attached at widely spaced intervals across the surface.

Cloaks with the outer surface covered with feathers appeared and developed very quickly from about the middle of the nineteenth century, some of them covered entirely with kiwi feathers (known as *kahu kiwi* and considered to be the most prestigious), others with various feathers forming colour patterns. By the end of the century they were in great demand and have continued to be so to the present day. As many native birds became threatened by loss of habitat and introduced predators, the feathers generally used were from introduced species such as the domestic fowl, pheasant or peacock.

The feather cloak of the late nineteenth century relates most closely to fine rain-capes of the same period and appear to be a development of them. However, the finest feather cloaks are finer than the finest rain-capes; and the roughest rain-capes are rougher than the roughest feather cloaks.

1885
Feather cloak, *kahu kiwi*
NZ 133. Length 95 cm, width 129 cm.

Cloak with kiwi feathers, woven in double-pair twining, thrum commencement is at bottom, but thrums have later been brought into a braid which is now coming undone. Feathers are attached on each alternate weft but many are coming loose.

Provenance: Unknown.

Comments: Rotorua, *c*.1870 (DRS).

1886 Colour plate 21
Feather cloak, *kahu huruhuru*
NZ 134. Length 115 cm, width 165 cm.

Woven in double-pair twining, with selvedge commencement at bottom, and seven warps per centimetre and wefts spaced at 7 mm intervals. Edge warp at each side is a pair of cords, one of undyed flax, other of red wool. Wefts are knotted at each end and feathers placed on alternate wefts. Most of *kaupapa* is covered with kiwi feathers, with wide band of white feathers at bottom and on both sides, on which rectilinear pattern of tui feathers is arranged. At the centre is a group of five interpolated short wefts forming an area of shaping. Red, yellow and green woollen cords are included in finish; there are no warp fringes at top corners.

Provenance: Unknown.

Comments: Whanganui, *c*.1880 (DRS).

References: Pendergrast 1996: 143.

1887
Feather cloak, *kahu huruhuru*
1895-486. Length 137.8 cm, width 103.7 cm.

Cloak with three *taniko* borders. Commencement is at bottom with *taniko* band of black and undyed flax fibre with red, yellow and green wool. Warps from *taniko* continue directly into *kaupapa*, and warps for *taniko* border on each side are added during weaving and *taniko* worked on to them later; side borders are of brown, black and undyed flax fibre. Weaving of *kaupapa* is in double-pair twining, with nine warps per centimetre and wefts spaced at I cm intervals; it is covered with quite large weka and rooster feathers. Just below middle, five short wefts make area of shaping. At the upper edge is a roll finish with thrum fringe at each end.

Provenance: Meinertzhagen Collection.

1888 Colour plate 23
Feather cloak, *kahu huruhuru*
1913.6-12.1. Length 59 cm, width 87.4 cm.

Short cloak or cape, woven in double-pair twining, with six warps per centimetre and wefts spaced at I cm intervals. Selvedge commencement is at bottom edge and two side warps on each side are of black-dyed fibre. A single area of shaping consisting of three short wefts is placed one-third of way down. Kaka, pigeon and white feathers are attached to each alternate weft, white feathers forming large vertical zigzag pattern. A rolled finish is at the upper edge, with reduced warp fringe at each corner.

Provenance: Presented by C.H. Waterlow.

Comments: Whanganui, *c*.1910 (DRS).

References: Pendergrast 1996: 142.

1889
Feather cloak, *kahu kiwi*
1913.6-12.2. Length 82 cm, width 117 cm.

Cloak with kiwi feathers and woollen band at bottom. Selvedge commencement is at bottom; woven in double-pair twining throughout. Second weft carries row of multicoloured woollen loops, which extend below bottom edge. Each side warp is double, consisting of one cord of flax fibre and another of purple wool. Wefts are knotted off at each end. An area of shaping of eight short wefts is at the centre. Kiwi feathers are attached over entire main surface, usually in bunches of two or three. A rolling finish at the top carries a thick green decorative woollen element; at each upper corner is a fringe of warp ends.

Provenance: Presented by C.H. Waterlow.

Comments: Rotorua, *c*.1890 (DRS).

1890 Plate 170
Feather cloak, *kahu kiwi*
1914.12-15.1. Length 104 cm, width 141.5 cm.

Cloak with kiwi feathers with three woollen borders. Woven in double-pair twining, with five warps per centimetre and wefts spaced at 7 mm intervals. Selvedge commencement with red, black, yellow and purple running cords at lower edge forms border. There are narrow side borders of looping of red, yellow, purple, green, blue and black wool. Edge warp on each side is double cord of red wool and undyed flax fibre; both ends of each weft are knotted. One area of shaping,

of nine short wefts, is one-third of way down, and another, of twelve short wefts, is two-thirds of way down. Finish at upper edge carries running cords of blue and black wool; there are no warp fringes.

Provenance: Presented by Mrs H.J. Tozer.

1891

Feather cloak, *kahu huruhuru*

1933.3-15.31. Length 79 cm, width 124.6 cm.

Cloak with candlewick and cotton base. Woven in double-pair twining, with candlewick warps at four per centimetre and cotton wefts spaced at 7 mm intervals, thrum commencement at bottom edge. Pheasant feathers, with some peacock and other feathers, are arranged in horizontal bands according to colour, and attached to every fourth weft. An area of shaping of five short wefts is towards the top. At the upper edge is a braided finish with a warp fringe at each end.

Provenance: Bequeathed by William Leonard Loat per Mrs Loat.

1892

Feather cloak, *kahu kiwi*

1933.10-17.1. Length 117.5 cm, width 152 cm.

Cloak with kiwi feathers and woollen decoration. Selvedge commencement is at bottom, with woollen decoration introduced immediately and carried on first ten wefts in form of running cord, giving effect of braiding. Woven in double-pair twining, with kiwi feathers on alternate wefts; no knot at beginning of each weft, but knotted off at end. Warp at each side is of black and white wool. There are two areas of shaping: one of eleven short wefts towards bottom, and another, of eight short wefts, towards top. A band of woollen decoration is at the top, before a rolled finish.

Provenance: Presented by Mrs A.E. Long.

Register: 'Mid 19th century. Collected by donor's father in 1878 and said to be old then.'

1893 Plate 171

Feather cloak, *kahu huruhuru*

1936.6-7.1. Length 109.5 cm, width 149.8 cm.

Woven in double-pair twining, with selvedge commencement at bottom. Feathers are kakapo, with black and white feathers and maroon-dyed fowl feathers, all of which are arranged in vertical rows. An area of shaping consisting of eight short wefts is halfway down, and braided finish is at the upper edge, one end of which is coming unravelled.

Provenance: Presented by Sir Herbert Daw.

Register: 'Presented by the Maori chiefs for the funeral of the Hon. R.J. Seddon, one of several capes brought by Maori chiefs & deposited as a tribute on the coffin of the late Hon. R.J. Seddon, Prime Minister of New Zealand.'

Comments: Twentieth century (DRS).

1894

Feather cloak, *kahu kiwi*

1938.11-14.1. Length 111 cm, width 148 cm.

Cloak with kiwi feathers. A rolled-selvedge commencement is at the bottom, with additional purple (now faded) and black rolling woollen cords. Warp at each side is thick, black and undyed. The specialized commencement knot at each weft is a prominent round knot, which throws ends behind feathers on *kaupapa*; wefts are also knotted off at end. Feathers are attached from third weft and then on each alternate weft throughout. Rather small dark-coloured feathers are attached in pairs. A single area of shaping consisting of two short wefts is about one-third of way down from the top, which has a rolled finish with added woollen cords. A fringe at each top corner is made up from warp ends; there are woollen tie cords.

Provenance: Presented by Mrs E. Carey-Hill.

Label: 'Kiwi cloak, from the Gisborne district, East Coast, N.Z. (King Country). Presented to donor's husband about 1875, but said to have been of some age at the time (probably not later than 1850). Offered as gift by Mrs E. Carey-Hill 11/10/38. In memory of her husband William Carey-Hill.'

Comments: Unusual rolled-selvedge commencement; 1850 would be very early for *kahu kiwi*, 1860 more likely (MP); Central North Island, nineteenth century (DRS).

> I have a Maori Kiwi Mat (i.e. a Maori Chief's cloak) in perfect condition which I should like to present to the British Museum, in remembrance of my husband, William Carey-Hill, one of the Early pioneers of New Zealand who fought in the 1860 campaign. … This particular one came from the Gisborne district, on the East Coast of N.Z.
>
> (BM AOA correspondence: E. Carey-Hill, 12 August 1938).

1895

Feather cloak, *kahu huruhuru*

1993 Oc.3.69. Length 97 cm, width 140 cm.

Woven in double-pair twining; warp is of candlewick, except for 7.5 cm at each side which is of flax fibre; weft is of white commercial yarn. Upper edge is finished with braid and warp ends form fringe. A three-strand braid of candlewick, threaded through groups of three or more warps in space of *c*.1 cm at the top, terminates at each side as ties. Feathers of pheasant, fowl, pukeko, duck and hawk are attached to every second row of wefts, forming horizontal bands.

Provenance: Collected in the field.

Comments: Made by Mrs A.N. (Niki) Lawrence of Kaitaia, Northland. Contemporary art.

1896 Plate 171

Feather cloak, *kahu huruhuru*

1994 Oc.4.87. Length 115 cm, width 127 cm.

Cloak made entirely of flax fibre, woven in double-pair twining. Feathers, in overall *whakapae* (horizontal bands) pattern, form rectangular outline, with three bands: blue and white of pukeko and red of pheasant (red inside, blue outside). Within it, blue feathers are attached in groups forming parallelograms alternating with blank spaces. An extra line of blue feathers, below red, is at the top. Upper edge braided, with warp ends inside held with a row of double-pair twining. Between upper edge and feathers are two rows of openwork, with four-strand braid threaded through them and terminating as ties at each corner. At the bottom are two rows of openwork, with

taniko in black, brown, yellow and natural between them. A braided edge at bottom is the same as top one. Side edges finished with two-ply black and natural cord.

Provenance: Collected in the field.

Comments: Made by Mrs Diggeress Te Kanawa, of Kinohaku sub-tribe of Ngati Maniapoto, of Oparure, Te Kuiti, who describes this cloak as *korowai kakahu* (Eth. Doc. 1051). Contemporary art.

References: Pendergrast 1996: 146.

1897

Feather cloak, *kahu huruhuru*

Q1982 Oc.692. Length 81 cm, width 116.5 cm.

Cloak with woollen borders. Selvedge commencement is at bottom, where warps are linked with row of double-pair twining; same technique continues throughout. Bottom border consists of seven rows of looped black and white wool forming a pattern of triangles. Looped decoration continues up side borders in black and red wool; inside each of these is another vertical band of black and white fowl feathers. Main surface is covered with pieces of peacock feathers: 'eye' from ends of tail feathers, and fine, thread-like, side branches stripped from large feathers; due to large size of feather fragments they are quite widely spaced. Rolling finish at top carries black woollen element; a short fringe of warp ends is at each top corner. Single area of shaping is of four short wefts.

Provenance: Unknown.

1898

Feather cloak, *kahu huruhuru*

Q1982 Oc.698. Length 51 cm, width 75 cm.

Cape with selvedge commencement at bottom; woven throughout in double-pair twining, with unusual shaping in middle. First weft red, carrying black woollen loops; following two, red and black running cords. There is also red and black woollen looped decoration on each weft for side border. Rooster feathers are attached in four vertical bands of dyed maroon, natural white, natural black and dyed orange.

Provenance: Unknown.

1899

Feather cloak, *kahu kiwi*

Q1982 Oc.704. Length 85 cm, width 117 cm.

Woollen cloak with kiwi feathers. *Kaupapa* is of cream-coloured woollen warps and flax-fibre wefts, thrum commencement at bottom. Wefts are spaced at 9 mm intervals except towards bottom where they are 5–7 mm apart. First three wefts carry no feathers, fourth weft begins with 3 cm of red kaka feathers, which are not visible on finished cloak since they are hidden by kiwi feathers. Small kiwi feathers are attached, usually in bunches of three, on alternate wefts. There is no knot at commencement at beginning of each row, but at finish knot is tied on inside of last warp and so is hidden by feathers. There are three areas of shaping, each of three short wefts, placed near bottom, in middle and near top. At the top finish is a short fringe of warp ends at each corner; original braid tie cords are in place; rolled finish. Final row of feathers covers ends of warps as they are dropped across top.

Provenance: Unknown.

1900

Feather cloak, *kahu huruhuru*

Q1982 oc.715. Length 89 cm, width 105 cm.

Woollen cloak with peacock feathers. Woven in double-pair twining, with warps of wool and linen (?) wefts. Thrum commencement is at bottom, with a row of double-pair twining; next three wefts carry green peacock feathers. Side borders are of blue peacock feathers, with a few other feathers. *Kaupapa* has been heavily decorated with peacock feathers, but they are almost all missing. There are three areas of shaping: one of four interpolated short wefts near bottom; another of same size near centre; and third, of two short wefts, near top. At the upper edge is a fine, braided finish with *kurupatu* fringe of black woollen *hukahuka*; short warp fringes are at upper corners.

Provenance: Unknown.

1901

Feather cloak, *kahu huruhuru*

Q1982 oc.716. Length 77 cm, width 103 cm.

Candlewick cloak with three feather borders. Woven in double-pair twining, with selvedge commencement at bottom. Lower and side borders are of pukeko and brown feathers; *kaupapa* is decorated with horizontal bands of pink, blue and black woollen running cords. No upper fringe, except for warp fringe at each upper corner; a single shaping of six short wefts is two-thirds of way down.

Provenance: Unknown.

Comments: This is late nineteenth century cloak, related in style to *korowai* and *ngore*, but as it is devoid of tags or pompoms it is included here (MP).

1902 **Plate 172**

Feather cloak, *kahu huruhuru*

Q1982 oc.717. Length 93 cm, width 111 cm.

Cloak with woollen borders. Woven in double-pair twining; selvedge commencement at bottom, followed by six wefts carrying purple, green, yellow and maroon woollen cords forming lower border. Side borders are formed in same way, in maroon, purple and yellow. *Kaupapa* is covered with 'eye' feathers of peacock and fine fragments stripped from sides of feathers. Single area of shaping, of six short wefts, is in centre. Upper edge carries rolling finish with thick running cords of maroon, purple and yellow wool.

Provenance: Unknown.

1903 **Plate 172**

Feather cloak, *kahu huruhuru*

Q1982 oc.724. Length 98.3 cm, width 125.5 cm.

Woven in double-pair twining, with selvedge commencement at lower edge, and five warps per centimetre and wefts spaced at 8 mm intervals; ends of wefts are woven back into *kaupapa*. This is covered with emu feathers, placed so that tips turn out away from surface; among them are small groups of selected gold feathers from cock pheasant, which are placed so that they lie flat, as they do on bird. There are borders on all four edges consisting of smaller pheasant feathers of various colours, placed flat; there are no warp fringes at top corners. There are two areas of shaping, one of six short wefts one-third of way down, and

another, of four short wefts, two-thirds of way down.

Provenance: Unknown.

1904 **Plate 173**

Feather cloak, *kahu huruhuru*

Q1982 oc.725. Length 89 cm, width 112 cm.

Woven in double-pair twining, with selvedge commencement at bottom. The edge warp on each side consists of black and red rolled cords. Feathers of pheasant, fowl and peacock are placed on alternate wefts, which are knotted off at each end. At the middle is an area of shaping consisting of six short wefts. A thick band of feathers at the upper edge consists of three rows of feathers added to alternate wefts; this is followed by a rolled finish carrying black and white woollen cords; there are no warp fringes at top corners.

Provenance: Unknown.

1905 **Plate 174**

Feather cloak, *kahu huruhuru*

Q1982 oc.726. Length 113 cm, width 129.5 cm.

Cloak with *taniko* border. Commencement is with *taniko* border at lower edge; its warps are of flax fibre, and wefts of undyed flax fibre and black, green, maroon, white and pink wool. *Kaupapa* is of vertical bands of black and white wool with wefts of cotton (?); weaving is in double-pair twining and outside warp at each side is of black-and-white wool. Feathers (fowl? possibly spotted kiwi?) are attached in small bundles on every third weft. There is an area of shaping consisting of seven short wefts two-thirds of way down, and another, of four short wefts, towards top. At the top is a border of running woollen cords in pink, green and white that are carried on closer wefts.

Provenance: Unknown.

1906 **Plate 173**

Feather cloak, *kahu huruhuru*

Q1982 oc.727. Length 94 cm, width 132 cm.

Woven in double-pair twining, with selvedge commencement at bottom. Warp at each side edge is of purple and white wool. Feathers (of pheasant, peacock, fowl and dyed feathers) are attached at every third weft and are arranged in vertical bands with large, shiny, black turkey (?) feather band in centre. A third of the way down is an area of shaping consisting of twelve interpolated short wefts. At the upper edge is a braided finish; pink and green wool has been added to warp fringe at each top corner; tie cords are of wool.

Provenance: Unknown.

Label: 'Heni Pokuku Moeraki'.

Comments: Taranaki, *c.*1930 (DRS).

Presumably made by, or belonged to, Heni Pokuku of Moeraki.

1907

Feather cloak, *kahu huruhuru*

Q1982 oc.729. Length 71 cm, width 83 cm.

Woven in double-pair twining from candlewick, with flax-fibre wefts; warps at each side are of pink and black wool. *Kaupapa* is covered with rooster feathers, white in main area and coloured on borders. In the middle is an area of shaping consisting of five short wefts. At the upper edge is a rolled finish with pink, yellow and black running cords; warp fringes have been eliminated.

Provenance: Unknown.

1908 **Plate 175**

Feather cloak, *kahu huruhuru*

Q1982 oc.731. Length 101 cm, width 150 cm.

Woven in double-pair twining, with seven warps per centimetre and wefts spaced at 8 mm intervals; selvedge commencement is at bottom. Edge warp on each side is of brown and undyed cords. *Kaupapa* is covered with brown rooster feathers, with dyed feathers interspersed; these are attached on every third weft. Border on all four sides is of shiny blue-black rooster (?) feathers, with scattering of dyed and pheasant feathers. There are four areas of shaping, each consisting of four short wefts, arranged at equal spacing down *kaupapa*. Rolled finish at top carries thick, brown-dyed cords; a thrum fringe is at each top corner.

Provenance: Unknown.

1909 **Plate 175**

Feather cloak, *kahu kiwi*

Q1982 oc.732. Length 105 cm, width 124.7 cm.

Cloak with kiwi feathers and *taniko* borders. Woven in double-pair twining, with warps of wool and wefts of flax fibre. *Kaupapa* is covered with kiwi feathers, with green-dyed feathers placed sparsely between them. *Taniko* borders on three sides are of undyed flax fibre with black, maroon and pink wool. Just below the middle is an area of shaping consisting of a group of four short wefts and another single short weft close by; at the top is a group of three short wefts.

Provenance: Unknown.

Comments: Taranaki, *c.*1930 (DRS).

1910

Feather cloak, *kahu huruhuru*

Q1982 oc.733. Length 95 cm, width 144.4 cm.

Cloak with woollen border. Woven in double-pair twining, with selvedge commencement at bottom. *Kaupapa* is covered with tips of peacock-tail feathers; there is band of tui feathers at each side edge and inside these is second band, of white feathers. Lower border is of looped wool. One-third of way down is an area of shaping consisting of ten short wefts.

Provenance: Unknown.

1911 **Plate 176**

Feather cloak, *kahu huruhuru*

Q1982 oc.734. Length 115.3 cm, width 144.5 cm.

Woven in double-pair twining, with six warps per centimetre and wefts spaced at 1 cm intervals and knotted off at end of each row; selvedge commencement is at lower edge. Mainly tui and pheasant feathers are attached to alternate wefts. Towards each side are two vertical bands of kaka and white feathers; some split green duck feathers are also included. Along each side edge is narrow band of mixed feathers, including duck, pukeko, kaka and fowl. At the middle is an area of shaping consisting of eight interpolated short wefts; a reduced warp fringe is at each top corner.

Provenance: Unknown.

1912 **Plate 176**

Feather cloak, *kahu huruhuru*

Q1982 oc.735. Length 100.3 cm, width 139.5 cm.

Woven in double-pair twining, with six warps per centimetre and wefts, knotted off at both end, spaced at 9 mm intervals;

thrum commencement at bottom. *Kaupapa* is covered with kereru feathers, with side borders of short, alternating horizontal bands of white fowl (?), red kaka and black fowl (?) feathers. Just above the middle is an area of shaping consisting of five short wefts. At finish at the top is a warp fringe at each corner.

Provenance: Unknown.

1913 **Plate 177**
Feather cloak, *kahu kiwi*
Q1982 oc.736. Length 76 cm, width 122.5 cm.
Cloak with kiwi feathers and three *taniko* borders. Woven in double-pair twining, with commencement at bottom as a *taniko* border of brown, black and undyed flax fibre; *taniko* bands on side borders are black, yellow and undyed fibre. On the inside of each of three *taniko* borders is a band of yellow and black dyed flax in unrolled cords. Pattern on lower border is of triangles, those on sides are check. *Kaupapa* is covered with kiwi feathers, with patches of white albino kiwi feathers, arranged in four horizontal bands. Red and black wool is included in the finish at the upper edge; short warp fringes are in the top corners, but they are covered with red and green wool; tie cords are of yellow and white wool.

Provenance: Unknown.

1914 **Plate 177**
Feather cloak, *kahu kiwi*
Q1982 oc.737. Length 114.5 cm, width 128 cm.
Cloak with kiwi feathers. Woven in double-pair twining, with six warps per centimetre and wefts spaced at 1.1 cm intervals and knotted off at each end; warp at each side edge is a pair of cords, one black and one undyed. Thrum commencement is at lower edge, and *kaupapa* is covered with kiwi feathers, with patches of albino kiwi feathers arranged in white bundles in four horizontal rows. One quarter of the way down is an area of shaping of three short wefts. A braided finish at the top, with warp fringe at each top corner.

Provenance: Unknown.
Comments: Whanganui, c.1890 (DRS).

1915 **Plate 178**
Feather cloak, *kahu huruhuru*
Q1982 oc.738. Length 77.5 cm, width 133 cm.
Woven in double-pair twining, with five warps per centimetre and wefts spaced at 1 cm intervals and knotted off at each end, leaving short tassel; selvedge commencement at lower edge. *Kaupapa* is covered with black tui-tail and white feathers, attached on alternate wefts, and forming checkerboard pattern. An area of shaping consisting of seven short wefts is one-third of the way down. At the upper edge is a rolled finish with short length of warp fringe at each end.

Provenance: Unknown.

1916
Feather cloak, *kahu huruhuru*
Q1982 oc.739. Length 136 cm, width 117 cm.
Feathers of fowl, pheasant, peacock, duck, kereru and kaka are machine-sewn on to a black-and-white plaid cloth. Reverse side is backed with blue cloth with cloth rosettes; red and blue tie cords.

Provenance: Unknown.

Label: 'Patasi Kaihau Maire hapu: Uritaniwha tribe: Ngapuhi county: Teriti o Waitangi, Bay of Islands. Name of garment: Paki.'
Comments: Twentieth century (DRS).

1917
Feather cloak, *kahu kiwi*
Q1995 oc.4. Length 85 cm, width 127 cm.
Cloak with kiwi feathers. Woven in double-pair twining, with selvedge commencement at lower edge followed by a narrow band of tui feathers; rest of *kaupapa* is covered with kiwi feathers. There are three areas of three interpolated short wefts: one near top, another halfway down, and third about three-quarters of way down. A rolled finish at the top has reduced warps at each end. Areas of feathers are fading where garment has apparently been on display with objects and/or labels laid on it; these areas have remained dark and surrounding areas are faded.

Provenance: Unknown.

1918 **Plate 178**
Feather cloak, *kahu huruhuru*
Q1995 oc.5. Length 94 cm, width 129 cm.
Woven in double-pair twining, with selvedge commencement at bottom; four warps at each side area are of black-dyed flax fibre. Feathers covering *kaupapa* are kereru, arranged in block pattern, with some kaka and tui feathers. There are two areas of shaping: one of two short wefts a quarter of the way down, and another, of three short wefts, at centre.

Provenance: Unknown.

1919
Feather cloak, *kahu huruhuru*
Q1995 oc.6. Length 72 cm, width 119.5 cm.
Woven in double-pair twining, with selvedge commencement at lower edge. *Kaupapa* is well covered with fowl feathers, and some others, including peacock and pheasant. Un-braided finish at upper edge is coming undone.

Provenance: Unknown.

1920
Feather cloak, *kahu huruhuru*
Q2005 oc.1. Length 47.8 cm, width 57 cm.
Woven in double-pair twining, with selvedge commencement at lower edge. Weka feathers cover *kaupapa*, but many are now missing. There is no shaping.

Provenance: Unknown. Ex Duplicate Collection, numbered 24 10/46.

Comments: There is no information on the use of these small cloaks, but in some areas they are made for ceremonial unveiling of gravestones or memorial plaques; also figures at bottom on central posts in carved houses are sometimes dressed in a small cloak or *piupiu* (MP).

1921
Feather cloak, *kahu huruhuru*
Q2005 oc.2. Length 92 cm, width 111 cm.
Woven in single-pair twining, with candlewick warps and flax-fibre wefts; thrum commencement at bottom. At the lower edge is a border of fowl and kiwi feathers, followed by another band of blue and white running cords. Side borders and two additional vertical bands are of rooster feathers. In the middle of the *kaupapa* are

two horizontal bands of blue and white woollen cords, combined with band of blue pheasant feathers; other feathers, including some of kaka, are spaced across surface.

Provenance: Unknown. Ex Duplicate Collection, numbered 254.

Other items of clothing
Maori men and women wore two basic garments: the rain-cape around the shoulders and upper body; and the similar *rapaki*, made in the same manner, but worn around the waist and reaching to or below the knees. The term *rapaki* was later applied to waist mats of commercial cloth, often a piece of blanket. The *piupiu*, a waist garment consisting of long tags of dried flax leaf or rolled-flax fibre that hangs loose from a waist cord, apparently evolved from waist mats and *pihepihe* cloaks with a thatch of cylindrical tags of dried flax. Their weaving was as for cloaks, but at some time in the late nineteenth century the lower bands of twining were omitted and longer tags allowed to hang free. By the end of the century the twining had been further reduced, until the tags hung from a single braided cord at the waist. This is the *piupiu*: the word refers to the way in which the skirt swings as the body moves. The *piupiu* is now the main feature of 'traditional' Maori costume, often worn by dance groups and on ceremonial occasions.

Most of the belts, *tatua*, worn by men are plaited from strips of flax, kiekie, or, less often, *pingao*. A narrow rectangular mat is worked, often with decorative patterns, and then folded in from the top and from the bottom. The two halves were then folded together, making a band of four thicknesses, with an opening (usually along top), that could be used to hold small objects. Prestigious twined examples, larger and worked in close single-pair twining and often stained red with ochre, were the property of men of mana.

Women wore girdles, *tu*, made of multiple cords braided from plant fibre or very narrow strips of leaf. The belts illustrate accepted standards of modesty. Men often went naked, but could wear only the belt. If a woman wore only the girdle, some form of covering was required for the genitals, even if just a bunch of leaves was attached. To protect feet on rough or thorny ground, and for crossing passes in snow-bound mountains, plaited sandals, *paraerae*, were worn. The most hard-wearing were made from cabbage-tree leaves, but flax was also used.

1922 **Plate 179**
Waist garment with tags, *piupiu*
+5626. Length 48 cm, width 72 cm.
Kaupapa of black-dyed, but not rolled, flax fibre (or perhaps loosely rolled in single ply); seven wefts of single-pair twining, one area of shaping consisting of single shortened weft. *Pokinikini* tags have been cut transversely, but fibre is not exposed, so they remain stiff but clearly marked off in pale and dyed areas, and are attached to bottom weft and then to alternate wefts. At waistband finish groups of four warps are treated as one and used as weft for one twist, before being taken into three-strand braided finish.

Provenance: Presented by A.W. Franks, 13 August 1891 (Government of Victoria).

Label: 'Maori Woman's mat or dress of New Zealand Flax Phormium tenax, De Beer Collection, New Zealand, 192.'

Comments: Interesting early dated piece. Small for a woman, perhaps made for collector? (MP)

1923 Plate 179

Waist garment with tags, *piupiu*

1909-159. Length 61 cm, width 71 cm.

Commencement is at bottom, with row of double-pair twining that attaches black-dyed crinkly *karure* cords at each *whatu* twist. Second weft also adds another *karure* cord at each *whatu* and, less regularly, on third weft. On both third and fourth wefts short excess lengths of added cords are worked so they hang down and do not thicken warp; they also cover white double-pair twining of previous wefts. There are nine more wefts with feathers, mainly kiwi, laid flat as when on bird, and pattern of three arrangements of shiny blue-black tui feather and two kereru feathers with white feathers surrounds. Final row of feathers consists of selected red/brown pheasant feathers. After rolled finish at top, end of warps are caught up on outside of garment and cut off short, just long enough to cover quills of last row of feathers. Feathers are added with quills extending upwards and not folded down and caught in next *whatu* twist to make them secure as is normal. Three thick rolled cords of red, maroon and yellow wool hang down from beneath feather band.

Provenance: Presented by A.W.F. Fuller.

Comments: *c*.1900 (DRS).

1924 Plate 180

Waist garment with tags, *piupiu*

1925-22. Length 64 cm, width 102 cm.

Kaupapa consist of twenty-two rows of single-pair twining with well-prepared and precise *pokinikini* tags attached on first, fifth, eleventh and twentieth rows of wefts. There is rolling coloured woollen ornamentation on last two wefts before three-strand braid finish, and tie cords are of red and blue woollen braid.

Provenance: Presented by A. Findlay.

Comments: Early twentieth century (MP); Central North Island, twentieth century (DRS).

1925

Waist garment with tags, *piupiu*

1933.3-11.1. Length 57 cm, width 71 cm.

Kaupapa has three rows of single-pair twining, with *pokinikini* tags attached to first two wefts, and feathers (now missing) on third and last wefts. *Pokinikini* have scratched or lightly cut surface hatching and larger areas where back of leaf strip is removed, but in many cases fibre is not fully released (cleaned); they are arranged in groups according to colour: brown/red (probably *tanekaha* dye), dark grey (possibly mordant only, or very poor take of mud dye *paru*) and undyed.

Provenance: Presented by Mrs Young.

Comments: Chatham Islands, twentieth century (DRS).

'They were brought to this country between 20 and 30 years ago, by the donor's late husband, who was Mayor of Sunderland at that time.' (BM AOA correspondence: Mr Deas, Director of Sunderland Museum, 18 January 1933).

1926 Plate 180

Waist garment with tags, *piupiu*

1947 Oc.2.1. Length 64 cm, width 131 cm.

Pokinikini tags forming outer surface are very fine and each is divided into small, black and undyed sections. Commencement is with weft where fibre ends of tags, usually in pairs, are linked together, three per centimetre, with double-pair twining using undyed flax-fibre cords. Subsequent wefts are spaced at 3 cm intervals and additional tags are added as required to maintain even coverage. At final and thirteenth wefts, tag is attached to each warp, making a dense outer layer. Above this is waistband, where pairs of warps are treated as units and twined together with very thick cords. Tie cords of undyed flax are attached at each end. Two apparently later ties of long strips of cloth are sewn to top of waistband towards one end.

Provenance: Presented by Lady Mabel Berry.

Register: 'Collected by the late Sir James Berry F.R.C.S. about 30–40 years ago.'

Comments: Later cloth ties were perhaps attached to allow garment to be used to cover breasts for photography, as often seen on postcards etc. (MP); late nineteenth century (DRS).

'My late husband Sir James Berry when he visited New Zealand over 50 years ago was presented with some Maori dresses which were then old. I believe they had belonged to some well-known chief.' (BM AOA correspondence: M. Berry, 23 September 1946).

1927

Waist garment with tags, *piupiu*

1986 Oc.2.46. Length 58 cm, width 87 cm.

Typical mid-twentieth-century *piupiu* of flax. At the waistband are two rows of double-pair twining in black and undyed flax fibre, before braided finish.

Provenance: Purchased from Royal Institution of Cornwall through County Museum, Truro.

1928 Plate 181

Waist garment with tags, *piupiu*

1994 Oc.4.112. Length 66 cm, width 82 cm.

Contemporary *piupiu* with *taniko* waistband. *Pokinikini* of undyed flax, with two groups of three black-dyed horizontal bands; *taniko* waistband with a pattern in brown, yellow, white and black, with black braided ties.

Provenance: Collected in the field.

Comments: Made by Kahutoi [Kahu] Te Kanawa of Auckland.

1929 Plate 181

Waist garment with tags, *piupiu*

Q1982 Oc.703. Length 75 cm, width 84 cm.

Commencement is at bottom, where rolled cords, both *miro* and *karure* types, are linked with a row of double-pair twining. Next wefts have a few cords attached, but sixth weft has cords attached to all warps including five groups of brown, *tanekaha*-dyed cords. Final weft, worked in single-pair twining, carries brown and undyed decorative cords. Lower ends of all cords are knotted.

Provenance: Unknown.

1930 Plate 182

Waistcoat

Q1982 Oc.702. Length 46 cm, width 43 cm.

Made of commercial cloth and flax leaf, machine sewn. Front is covered with plaitwork of flax-leaf strips, which has been cut to required shape from flat mat-like piece. Zigzag pattern of purple-dyed dextrals and undyed sinistrals is from arrangement of vertical and horizontal 2/2 twill. Black cloth binding around edge prevents it from unravelling.

Provenance: Possibly Royal Loan 1902.

Comments: Taranaki, *c*.1900 (DRS). Waistcoats based on European models were made in the late nineteenth century, usually from kiekie, less often from flax. It is not known how often they were made, but a number survive in museum collections. (MP)

References: Imperial Institute 1902: 43.257?

1931

Headband, *tipare*

1994 Oc.4.78. Length 25.5 cm (doubled), width 3 cm.

Contemporary headband with *taniko*-style decoration: black fabric backing, over it *koru* pattern in white and red, short length of black elastic at back.

Provenance: Collected in the field.

Comments: Made by Wahine Mackey of Ruatoria.

1932

***Taniko* border fragment**

1927.3-7.20. Length 56 cm, width 24 cm (main part).

Pattern of vertical zigzags of brown and undyed flax fibre, with some red wool, and embossed effect on black areas; presumably cut from cloak.

Provenance: Presented by Mrs J.E. Birch.

Register: 'Collected by Alfred Clay 1867–1877.'

Comments: *Kaitaka* hem, Taranaki, *c*.1830 (DRS).

References: Ford n.d.: fig. 12-5, top left; Pendergrast 1996: 134.

1933

***Taniko* border fragment**

1927.3-7.21. Length 17.5 cm, width 6.5 cm.

Pattern in light and dark brown, with concentric diamonds in brown, red and blue.

Provenance: Presented by Mrs J.E. Birch.

Register: 'Collected by Alfred Clay 1867–1877.'

1934

***Taniko* border fragment**

1954 Oc.6.305. Length 204 cm, width 23.5 cm.

Traditional black- and brown-dyed and undyed flax fibre, with three sections of pattern separated by two black-on-black areas: outer sections with large, concentric diamonds, small solid triangles and zigzag lines; middle section of small diamonds bordered on each side by two parallel zigzag lines.

Provenance: Wellcome Collection. Wellcome Museum no. 54308.

Comments: Nineteenth century. Probably border from *kaitaka* cloak; it is wide and heavy and has likely torn away from garment at weakest point, breaking edge warps. Black 'engraved' pattern is unusual; it is on lower level than surface and on back it looks as though additional diagonal warps have been laid on top of main *taniko* and twined into place; perhaps tension pulls outer surface weft below main level (MP). *Kaitaka* hem, Cook Strait, eighteenth century (DRS).

References: Ford n.d.: fig.12-5, bottom right.

1935
Belt, *tatua*

NZ 126. Length 111.3 cm, width 8.8 cm.

Man's belt, plaited from strips of kiekie leaf; opening along upper side is sewn closed with thick braid of brown-dyed flax fibre; three-strand braided ties also of flax fibre

Provenance: Unknown.

Register: 'Chief's war belt…'

Comments: Nineteenth century (MP).

1936
Belt, *tatua*

NZ 127. Length 121 cm, width 10 cm.

Man's belt, plaited in twill from strips of flax leaf, with commencement on inside; three-strand flax-fibre braids, 12 at one end, 14 at other, combining into three-strand braided ties.

Provenance: Unknown.

Comments: Nineteenth century (MP).

1937 Plate 182
Belt, *tatua*

NZ 128. Length 112 cm, width 9.5 cm.

Man's belt, plaited from strips of flax leaf, with geometrical pattern on both sides formed by undyed and black-dyed strips; flat braiding for tie cords unfinished.

Provenance: Cook Collection.

Register: 'Matted belts No. 69. New Zealand.'

Comments: Late eighteenth century (MP).

References: Kaeppler 1978: 175.

1938 Plate 182
Belt, *tatua*

NZ 129. Length 114 cm, width 10 cm.

Man's belt, plaited from strips of flax leaf, with pattern of horizontal bands bordered at each end by vertical ones on both sides, formed by undyed and black-dyed strips; six flat braids of flax fibre attached at each end lead to tie cords.

Provenance: Unknown.

Comments: Nineteenth century (MP).

References: Pendergrast 1996: 125.

1939
Belt, *tatua*

NZ 130. Length 101 cm, width 8.3 cm.

Man's belt, plaited from strips of flax leaf (perhaps *wharariki*), with one longitudinal edge serrated; from each end 14 three-strand braids of brown fibre lead to three-strand braided tie cords; brown fibre vertical zigzag is at each end.

Provenance: Unknown.

Comments: Nineteenth century (MP).

References: Edge-Partington 1969 II.1: 231.4.

1940 Plate 182
Belt, *tatua*

NZ 131. Length 219 cm, width 14 cm.

Man's belt, finely twined with flax fibre and stained with red ochre. Woven in flat rectangle, in close double-pair twining. There is no selvedge so it is possible that it was cut from larger piece, but shaping suggests it was made specifically as belt. Weaving is fine, with six warps per centimetre and six wefts of double-pair twining to 1 cm. At each end, cord is attached to woven area by ten narrow finely braided bands, which are sewn through weaving and doubled to make twenty braids, and gathered into five-strand braid as tie cord. Long sides have been folded in so that belt is in reality four layers thick; ends have also been folded in before ties were attached.

Provenance: Cook Collection.

Comments: Late eighteenth century (MP).

References: Edge-Partington 1969 II.1: 231.6; Kaeppler 1978: 175; Pendergrast 1996: 125; Roth 1979: 96 (described as 'Possibly a sling.').

1941
Belt, *tatua*

NZ 132. Length 129 cm, width 11.8 cm.

Man's belt, woven from flax fibre, in close double-pair twining, with shaping. All four edges are thrum and appear to have been cut; they have all been folded in: a short distance at each end, but at sides almost to centre. At ends, flat braids, eight at one end, eleven on other, merge into braided ties.

Provenance: Cook Collection.

Comments: Late eighteenth century (MP).

References: Kaeppler 1978: 175.

1942
Belt, *tatua*

NZ 169. Length 115.2 cm, width 9.5 cm.

Man's belt, plaited in twill from strips of kiekie leaves; three-strand braids, five at one end, six at other, merge into three-strand braided ties.

Provenance: Unknown.

Comments: Nineteenth century (MP).

1943
Belt, *tatua*

NZ 170. Length 118 cm, width 10 cm.

Man's belt, plaited from strips of flax leaf. Different plaited pattern in black (now almost entirely faded) and undyed strips on each side; cords leading to braided tie cords are used as warps for twined area.

Provenance: Unknown.

Comments: Nineteenth century (MP).

1944 Plate 182
Belt, *tatua*

1854.12-29.98. Length 125 cm, width 11.5 cm.

Man's belt, plaited from strips of flax leaf, using black and undyed strips to produce pattern of horizontal bands with small black-and-white diamonds on one side, and rhomboid forms on other, and small sections of vertical bands near each end; eleven fine flat braids at one end and eight at other are taken into three-strand braided tie cords.

Provenance: Grey Collection.

Comments: Nineteenth century (MP).

References: Edge-Partington 1969 II.1: 231.5 (?); Pendergrast 1996: 125.

1945
Belt, *tatua*

1921.10-14.20. Length 116 cm, width 10 cm.

Man's belt, plaited from black and undyed strips of flax leaf to produce pattern of five horizontal bands on one side and horizontal zigzag on other; ochre-stained triangular ends of plaited fibre transform into three-strand braided ties.

Provenance: Yorkshire Philosophical Society Museum.

Comments: Nineteenth century (MP).

1946
Belt, *tatua*

1944 Oc.2.835. Length 98 cm, width 9 cm.

Man's belt, plaited from strips of kiekie leaf; flat braids, nine at one end, eight at other, lead to three-strand braided tie cords.

Provenance: Beasley Collection. Beasley no. 2015.

Comments: Early nineteenth century (MP).

Beasley catalogue: 2015, registered 15 July 1927, '… Brought to England prior to 1824 by Captain Valentine Starbuck of the South Sea Whaler L'Aigle. Bt Miss Eva P. Starbuck [great-granddaughter] …'

1947
Belt, *tatua*

1960 Oc.11.12. Length 84.5 cm, width 5 cm.

Man's belt, plaited from *pingao* leaves, in horizontal twill; two doubled cords lead from each end of plaited area to three-strand braided tie cords of flax fibre.

Provenance: Transferred from Royal Botanic Gardens, Kew.

Register: 'Kew Colln. No.6 – 1894.'

Comments: Nineteenth century (MP).

Kew register transcript:

6 1894. Specially woven belt made from *Desmoschoenus spiralis* Hook.f. The long, orange coloured leaves of this spreading seaside plant afforded a good material for the Maoris for weaving strong and useful belts (see Trans. N.Z. Inst. Vol. XXIV 1891 p.451) W. Colenso, Napier, New Zealand

(Eth.Doc.589).

1948
Belt, *tatua*

1994 Oc.4.79. Length 96.5 cm, width 3.5 cm.

Modern belt, with *taniko*-style decoration of *whakaniho* (teeth pattern) in yellow on black, backed with synthetic black leather, which extends at both ends of *taniko*, with five holes at one end, and metal buckle at other.

Provenance: Collected in the field.

Comments: Made by Wahine Mackey of Ruatoria. Contemporary art.

1949
Belt, *tatua*

Q1981 Oc.1437. Length 96 cm, width 8.4 cm.

Man's belt, plaited in check from *pingao* leaves; six twisted cords lead from each end of plaited area to three-strand braided ties (one cut off near base).

Provenance: Meinertzhagen Collection.

Comments: Nineteenth century (MP).

1950
Belt, *tatua*
QI981 OC.1438. Length 113 cm, width 8.4 cm.

Man's belt, plaited in check from *pingao* leaves; three-strand braided ties of flax fibre.

Provenance: Meinertzhagen Collection.
Comments: Nineteenth century (MP).

1951
Belt, *tatua*
QI981 OC.1439. Length 82.4 cm, width 6.7 cm.

Man's belt, plaited in check from *pingao* leaves; one three-strand braided tie, other torn off.

Provenance: Meinertzhagen Collection.
Comments: Nineteenth century (MP).

1952
Belt, *tatua*
QI995.OC.38. Length 88 cm, width 12 cm.

Taniko-style belt of wool: black background with two rows of opposing triangles in white, maroon and orange; ties of four-strand braids of white, black, orange and blue wool, ending in tassels.

Provenance: Unknown.
Comments: Late nineteenth/early twentieth century (MP).

1953
Pair of sandals, *paraerae*
7012. Length 28 cm.

Plaited from flax, three layers for each weft.
Provenance: Meinertzhagen Collection (presented 31 December 1870).
Comments: Nineteenth century (MP).

1954 Plate 182
Pair of sandals, *paraerae*
1854.12-29.97. Length 28 cm.

Plaited very tightly, in 2/2 twill; multiple thickness for each weft; round 'braided' edges; straps not assembled.
Provenance: Grey Collection.
Comments: Nineteenth century (MP); Otago, early nineteenth century (DRS).

1955
Sandal, *paraerae*
1863.2-9.8. Length 25 cm.

Plaited from flax in check, with change of surface at edges. Back of heel made in normal way, but then split and another strip of flax woven through to form check.
Provenance: Presented by Revd R. Taylor.
Label: '7 a native snow shoe or sandal made from Ti leaves'; also old printed exhibition (?) label: 'From Wellington, New Zealand, No. 7, List 1 Parearera or snow shoes. Exhibited by Revd. R Taylor.'
Comments: Nineteenth century (MP); Otago, early nineteenth century (DRS).

The label probably refers to the 1865 'New Zealand Exhibition' in Dunedin to which Taylor contributed.

1956
Pair of sandals, *paraerae*
QI981 OC.1395. Length 28 cm.

Plaited from flax, each weft of three strips of flax leaf.
Provenance: Meinertzhagen Collection.
Comments: Nineteenth century (MP); Otago (DRS).

1957
Pair of sandals, *paraerae*
QI981 OC.1396. Length 28 cm.

Plaited from flax, each weft is of three strips of flax leaf.
Provenance: Meinertzhagen Collection.
Comments: Nineteenth century (MP).

1958
Pair of sandals, *paraerae*
QI981 OC.1397. Length 21.5 cm.

Plaited from cabbage tree? Multiple layers for wefts.
Provenance: Unknown. Ex Duplicate Collection.
Comments: Nineteenth century, used, shorter and thicker than others (MP); Otago (DRS).

Basketry, related fibre items, mats, samples

Baskets, *kete*, have the form of a satchel-shaped container plaited from strips of leaf: flax, kiekie, or cabbage tree. Baskets of other shapes are usually known by other names. *Kete* were used extensively by both men and women to carry food and most other commodities that could be fitted into them. Handles were not common on work baskets, as women, commoners and slaves carried heavy loads on their backs, slung in a flax carrying-strap, *kawe*, or held in place with braided cord. *Kawe* were used on the West Coast, but in the east two separate cords were used, each tied to one of the loops (or 'handles') at each end of the basket; the end of each cord is threaded through the other outer handles, then taken over the shoulders, crossed behind the back, brought to the front and tied at the waist (James William (Bill) Maxwell, Torere: pers. comm. 2006). In the case of a basket without handles, one cord must have been tied around each end, and the cords brought over the shoulders, crossed at the back and tied in front as above. Men of

standing and warriors carried loads on the shoulder. Instead of handles, a row of loops around the rim enabled the contents to be laced in with a strip of leaf, so they could not fall out.

Work baskets were rarely collected, but the prestigious patterned baskets are often included in collections. Documented in the nineteenth and early twentieth century as *putea*, they are now usually known as *kete whakairo*, *whakairo* meaning patterned.

Small fibre bags, made using the twining technique adapted from the cloak-making tradition, appeared about the middle of the nineteenth century, and in the late nineteenth and early twentieth centuries they were produced in large numbers for the curio and tourist trades. The flax fibre they are made from is known as *muka* or *whitau*, depending on the regional dialect, and the bags as *kete muka* or *kete whitau*. Teapot cosies, letter pouches and wall hangings were also made in the same way.

Plaited baskets, *kete*

1959
Plaited basket, *kete*
1863.2-9.10. 44 × 28.4 cm.

Plaited from strips of undyed kiekie leaf 3–5 mm wide, horizontal 2/2 twill, three-strand braid commencement at bottom; round braid at rim, thick twisted-fibre handles added after completion.
Provenance: Presented by Revd R. Taylor.
Register: 'A Kiekie kete. A kete made of Kie-Kie leaf. R.T.'; also old printed

exhibition? label: 'From Wellington, New Zealand, No. 9, List 1 ... Exhibited by Revd. R. Taylor.'
Comments: Nineteenth century (MP).
The label probably refers to the 1865 'New Zealand Exhibition' in Dunedin to which Taylor contributed.
References: Edge-Partington 1969 II.1: 233.13.

1960
Plaited basket, *kete*
1993 OC.3.77. 39.5 × 24 cm.

Plaited from strips of undyed flax leaf 8 mm wide, plain check, three-strand braid commencement at bottom; braided flax-fibre handles added after completion.
Provenance: Collected in the field.
Comments: Made by Dame Rangimarie Hetet while 100 years old; purchased from Ohaki Craft Centre owned by her family. Contemporary art.

1961

Plaited basket, *kete*

1994 oc.4.73. 31 × 23 cm.

Plaited in check from strips of boiled flax leaf 4–5 mm wide. Pattern formed in natural colours, either using upper and lower surface for contrast, or selected strips of different colour leaf. At commencement, the layout of strips dictates the pattern; dextrals all white, sinistrals laid out in alternating strips of light and dark plaited in plain check. Serrated rim, fine join in bottom; braided flax-fibre handles added after completion.

 Provenance: Collected in the field.

 Comment: Made by Mana Rangi of Tikitiki; purchased from Waiapu Community Arts. Contemporary art.

Patterned plaited baskets, *kete whakairo*

1962

Patterned plaited basket, *kete whakairo*

NZ 203. 46 × 28.5 cm.

Plaited from strips of kiekie (*Freycinetia baueriana*), dextrals undyed, sinistrals dyed black, in pattern of alternating rectangles of horizontal and vertical bands of twill. Band of large triangles in 3/1 twill across bottom; braided finish inside rim and two very thin two-ply rolled handles of black-dyed strips of kiekie leaf. Bottom closed with rather unusual fine join, its end taken outside basket to be knotted off.

 Provenance: Unknown.

 Register: 'Tahiti'.

 Label: 'Basket of undressed Flax. New Zealand. 1870.'

 Comments: Despite its Tahitian association in Register, it is now considered to be Maori and attributed to New Zealand (MP).

1963 Plate 183

Plaited basket, *kete whakairo*

1928. 34 × 18.2 cm.

Plaited from strips of flax leaf 2 mm wide, twilled, dextrals dyed black and reversed, sinistrals undyed, producing pattern of vertical and horizontal 2/2 twill; fine join at the bottom; three-strand braid finish inside rim carrying three loops of braided-flax fibre on each side.

 Provenance: Transferred from Royal Botanic Gardens, Kew.

 Label: 'A Frail or Basket made of split leaves of New Zealand Flax, Phormium tenax, FORST. Used by the natives for carrying their books in to Church and school, the women their sewing etc. New Zealand. Rev. W. Colenso.'

 Comments: Nineteenth century (MP).

 References: Edge-Partington 1969 II.1: 233.12.

1964 Plate 183

Patterned plaited basket, *kete whakairo*

1895-385. 39 × 21 cm.

Plaited from strips of flax leaf 3 mm wide, twilled, dextrals dyed, sinistrals undyed brown and reversed; pattern of three horizontal bands of diamonds with bands of horizontal and vertical 2/2 twill. Fine join to close bottom; three-strand braid finish inside rim. Handles of three-strand braid

of flax fibre attached during construction. Hole near bottom.

 Provenance: Meinertzhagen Collection.

 Comments: Nineteenth century (MP).

1965 Plate 183

Patterned plaited basket, *kete whakairo*

1854.12-29.127. 47.5 × 32.8 cm.

Plaited from strips of flax leaf 2 mm wide, twilled, dextrals undyed, sinistrals dyed black and reversed. Design of four concentric rectangles. Fine join to close bottom; braided finish inside rim, thin black and natural four-strand braided handles.

 Provenance: Grey Collection.

 Comments: Nineteenth century (MP).

 References: Ford n.d.: fig. 12-5, top right.

1966 Plate 183

Patterned plaited basket, *kete whakairo*

1854.12-29.128. 54.7 × 32.2 cm.

Plaited from strips of flax leaf less than 2 mm wide, twilled, dextrals dyed black and reversed, sinistrals undyed; pattern of horizontal bands of horizontal and vertical variable twill. Fine join to close bottom, braid finish inside rim; five braided flax-fibre loops on each side of rim.

 Provenance: Grey Collection.

 Comments: Nineteenth century (MP).

1967 Plate 183

Patterned plaited basket, *kete whakairo*

1863.2-9.11. 44 × 31 cm.

Plaited from strips of flax leaf 4 mm wide in horizontal 2/2 twill; dextrals undyed, sinistrals undyed with interspersed groups of four dyed-black strips, resulting in design of five diagonal bands; three-strand braid commencement in bottom; braided flax-fibre handles.

 Provenance: Presented by Revd R. Taylor.

 Old printed exhibition (?) label: 'From Wellington, New Zealand, No. 10, List 1 … Exhibited by Revd. R. Taylor.'

 Comments: Nineteenth century (MP).

 The label probably refers to the 1865 'New Zealand Exhibition' in Dunedin to which Taylor contributed.

1968 Plate 183

Patterned plaited basket, *kete whakairo*

1960 oc.11.5. 84 × 42.5 cm.

Plaited from strips of flax leaf 2–3 mm wide, twilled, dextrals undyed, sinistrals dyed black and laid so that underside of leaf strip is exposed; bottom closed with fine join after completion. Complex pattern of multiple vertical bands, with horizontal band at rim and bottom. There are three braids around rim, laid on top of one another; series of twelve loops is caught up at 8 cm intervals and taken into middle one of three braids, which form rim finish; they travel within braid for 4 cm and then emerge for another loop. Looped cord is made from two-ply loosely rolled flax-fibre cords, which are made into three-strand braid. Loops were used to lace basket closed so that, when full, it could be conveniently carried, perhaps in carrying strap, or put into storage; loose three-strand braid attached to top of basket used to lace it closed.

 Provenance: Transferred from Royal Botanic Gardens, Kew.

 Label: 'Ornamental basket made of leaves of Phormium tenax. These are

only used by Chiefs, and by them only occasionally, to carry their clothes etc. in. Native name Kete. Rev. W. Colenso. No. 3936. 223.1851.'

 Comments: Nineteenth century (MP).

 Kew register transcript: 'No. 3936 An ornamental basket [as on label] They are now getting very scarce ….' (Eth.Doc.589).

 References: Pendergrast 1996: 122.

1969 Colour plate 23

Patterned plaited basket, *kete whakairo*

1991 oc.1.1. 33 × 25 cm.

Plaited from strips of kiekie leaf 3–4 mm wide, dextrals undyed, sinistrals dyed brown, fine join in bottom. Three horizontal bands of pattern, composed of pale diamonds on dark background (*taimana whakawhiti* – crossing diamonds); brown-dyed flax-fibre handles of three-strand braid.

 Provenance: Presented by David John Lee.

 Label: 'Taonga Maori Conference, Taimona [taimana] whakawhiti, Extended diamond pattern, Made from kiekie – an indigenous Native plant.'

 Comments: Made by Eva Anderson of Otorohanga and presented to donor during Taonga Maori Conference held in New Zealand in November 1990. Contemporary art.

 References: Pendergrast 1996: 123.

1970 Colour plate 23

Patterned plaited basket, *kete whakairo*

1991 oc.2.1. 34.5 × 24.5 cm.

Plaited from strips of kiekie leaf 3-4 mm wide, dextrals undyed, sinistrals dyed pink, complex twill to form step pattern (*poutama*); fine join in bottom, three-strand braided handles of undyed-flax fibre.

 Provenance: Presented by D.C. Starzecka.

 Comments: Made by Eva Anderson of Otorohanga and presented to donor during Taonga Maori Conference held in New Zealand in November 1990. Contemporary art.

 References: Pendergrast 1996, 1998: 123.

1971 Colour plate 23

Patterned plaited basket, *kete whakairo*

1993 oc.3.70. 38 × 23.5 cm.

Plaited from undyed strips of kiekie leaf 3–4 mm wide in all-over twilled pattern forming seven horizontal bands of diamonds, with band of check plaiting at rim; fine join at bottom, handles of braided-flax fibre.

 Provenance: Collected in the field.

 Comments: Made by Christina Hurihia (Tina) Wirihana of Rotoiti. Contemporary art.

 References: Pendergrast 1998: 123.

1972 Colour plate 23

Patterned plaited basket, *kete whakairo*

1993 oc.3.71. 27 × 18.5 cm.

Plaited from strips of flax leaf 3 mm wide, alternating undyed and dyed green, to form concentric diamonds pattern (*karu taniwha* – eye of monster); fine join at bottom, handles of undyed braided-flax fibre.

 Provenance: Collected in the field.

 Comments: Made by Christina (Tina) Hurihia Wirihana of Rotoiti. Contemporary art.

 References: Pendergrast 1996, 1998: 123.

1973

Patterned plaited basket, *kete whakairo*

1993 OC.3.72. 33 × 23.5 cm.

Plaited from strips of undyed flax leaf *c.*5 mm wide, to form three horizontal bands of decorative plaiting alternating with bands of 2/2 twill, check weave at base and rim; fine join at bottom; handles of braided flax fibre.

 Provenance: Collected in the field.

 Comments: Made by Christina (Tina) Hurihia Wirihana of Rotoiti. Contemporary art.

1974 Plate 184

Patterned plaited basket, *kete whakairo*

1993 OC.3.73. 37 × 22.5 cm.

Plaited from strips of kiekie 3–4 mm wide, undyed and dyed black, in horizontal 2/2 twill to form vertical zigzag pattern (*koeaea* – type of whitebait); fine join at bottom; handles of braided flax fibre.

 Provenance: Collected in the field.

 Comments: Made by Christina (Tina) Hurihia Wirihana of Rotoiti. Contemporary art.

1975 Plate 184

Patterned plaited basket, *kete whakairo*

1993 OC.3.74. 38.5 × 25.5 cm.

Plaited from strips of flax leaf 4–5 mm wide, undyed and arranged in three horizontal bands of patterns: middle band of check with diagonal openwork lines, enclosed at bottom and top by bands of horizontal and vertical 2/2 twill; fine join at bottom; handles of braided flax fibre.

 Provenance: Collected in the field.

 Comments: Made by Christina (Tina) Hurihia Wirihana of Rotoiti. Contemporary art.

1976 Plate 184

Patterned plaited basket, *kete whakairo*

1993 OC.3.75. 38 × 26 cm.

Plaited from strips of flax leaf 3–5 mm wide, dextrals dyed black, sinistrals red; middle band of 2/2 vertical twill, enclosed above and below by horizontal band of black diamonds and variable twill at top and bottom; fine join at bottom; braided handles of black-dyed flax fibre.

 Provenance: Collected in the field.

 Comments: Made by Donna Campbell, purchased from Heitiki Gallery, Rotorua. Contemporary art.

 References: Pendergrast 1996: 123.

1977 Plate 184

Patterned plaited basket, *kete whakairo*

1993 OC.3.76. 26 × 22.5 cm.

Plaited from *pingao* leaves 3–4 mm wide, five horizontal bands of 2/2 twill alternating with six bands of check; fine join at bottom, braided handles of undyed-flax fibre added after completion.

 Provenance: Collected in the field.

 Comments: Made by Ruhia Oketopa of Rotorua; purchased in Auckland. Contemporary art.

1978 Plate 184

Patterned plaited basket, *kete whakairo*

1994 OC.4.71. 36 × 28 cm.

Plaited from strips of flax leaf 5–6 mm wide, dextrals undyed, sinistrals in undyed and purple bands, in check with some rows of horizontal bands of variable twill, forming pattern of diagonal alternate bands of white and purple; fine join in bottom, serrated rim; handles of white and purple, braided flax leaf.

 Provenance: Collected in the field.

 Comments: Made by Mana Rangi of Tikitiki, purchased from Waiapu Community Arts, East Coast. Contemporary art.

1979 Plate 184

Patterned plaited basket, *kete whakairo*

1994 OC.4.72. 36 × 22 cm.

Plaited from strips of kiekie leaf 3–4 mm wide, dextrals undyed, sinistrals dyed brown; central horizontal band carries step pattern with *mahitihiti* (crossing over) changes, with check work above and below it; fine join in bottom; handles of undyed, braided flax fibre.

 Provenance: Collected in the field.

 Comments: Made by Kimihia Doel, Tokomaru Bay, purchased from Waiapu Community Arts, East Coast. Contemporary art.

1980 Plate 184

Patterned plaited basket, *kete whakairo*

1994 OC.4.74. 44 × 27.5 cm.

Plaited from strips of flax leaf 5–6 mm wide, dextrals undyed, sinistrals dyed red, to form horizontal bands of patterns: four bands of *papakirango* (fly swat) pattern alternating with bands of check; fine join in bottom, serrated rim; handles of undyed, braided flax fibre.

 Provenance: Collected in the field.

 Comments: Made by Lena and Paul Weka of Tikitiki. Contemporary art.

1981 Plate 185

Patterned plaited basket, *kete whakairo*

1994 OC.4.75. 42 × 27 cm.

Plaited from strips of flax leaf 4–6 mm wide, dextrals undyed, sinistrals dyed red in five groups of 10 or 11 alternating with five groups of 8 undyed, to form diagonal alternate bands, white, and red with pattern of squares arranged diagonally; undyed bands all check, dyed bands in check and twilled motifs; fine join in bottom, serrated rim; handles of undyed, braided flax fibre.

 Provenance: Collected in the field.

 Comments: Made by Lena and Paul Weka of Tikitiki. Contemporary art.

1982 Plate 185

Patterned plaited basket, *kete whakairo*

1994 OC.4.93. 36.5 × 25 cm.

Plaited from strips of flax leaf 8–10 mm wide, dextrals undyed, sinistrals dyed black, twilled pattern of three rows of white diamonds on black background bordered above and below by check work; fine join in bottom; braided, black-dyed flax-fibre handles.

 Provenance: Collected in the field.

 Comments: Made by M. Murray of Te Hapua, Northland, purchased in Wellington. Contemporary art.

1983 Plate 185

Patterned plaited basket, *kete whakairo*

1994 OC.4.94. 39 × 18 cm.

Plaited from strips of *pingao* and red-dyed flax leaf 4–8 mm wide, sinistrals natural yellow, dextrals in four groups of 8 red alternating with four groups of 6 yellow, to form diagonal alternating bands of yellow check and red-and-yellow bands in check with twilled motifs; fine join in bottom; loop, braided of strips, and large knob, of plaited fibre, at rim for fastening.

 Provenance: Collected in the field.

 Comments: Made by M. Murray of Te Hapua, Northland, purchased in Wellington. Contemporary art.

1984 Plate 185

Patterned plaited basket, *kete whakairo*

1994 OC.4.95. 50 × 39 cm.

Plaited from strips of flax leaf 8–11 mm wide, dextrals dyed purple, sinistrals undyed, in vertical 2/2 twill, with bands of check above and below; trapezoidal shape, fine join in bottom; one long handle of undyed braided flax-leaf strips.

 Provenance: Collected in the field.

 Comments: Made by Maro Brown, Te Hapua, Northland, purchased from Te Taumata Gallery, Auckland. Contemporary art.

1985 Colour plate 24

Patterned plaited basket, *kete whakairo*

1994 OC.4.107. 42.5 × 26 cm.

Plaited from strips of flax leaf 4–5 mm wide, alternating black and white dextrals and sinistrals. Concentric diamond pattern (*karu hapuku/taniwha* – groper/monster eye); fine join in bottom; handles of braided purplish black-dyed flax fibre.

 Provenance: Collected in the field.

 Comments: Made by Aroha (Sam) Mitchell of Ohinemutu. Contemporary art.

1986 Colour plate 24

Patterned plaited basket, *kete whakairo*

1994 OC.4.108. 37 × 24.5 cm.

Plaited from strips of flax leaf 4–6 mm wide, dyed purple or yellow, dextrals in reddish purple, sinistrals in four bands of 8 bluish purple alternating with four bands of 12 yellow in vertical 2/2 twill, and resulting in alternating bands of *whakatutu* (vertical) pattern, with four dominant diagonal bands of purple; fine join in bottom; handles of undyed and purple, braided flax fibre.

 Provenance: Collected in the field.

 Comments: Made by Aroha (Sam) Mitchell of Ohinemutu. Contemporary art.

1987 Colour plate 24

Patterned plaited basket, *kete whakairo*

1994 OC.4.109. 32 × 23 cm.

Plaited from strips of kiekie 3–4 mm wide, dextrals dyed black, sinistrals red, in check with two horizontal and three narrow vertical twilled bands; fine join in bottom; handles of red-and-black, braided flax fibre.

 Provenance: Collected in the field.

 Comments: Made by Aroha (Sam) Mitchell of Ohinemutu. Contemporary art.

1988 Colour plate 24

Patterned plaited basket, *kete whakairo*

1994 OC.4.111. 33 × 25 cm.

Plaited from strips of flax leaf 4–5 mm wide, dextrals dyed black, sinistrals undyed, to form *mawhiti* (crossing over) pattern; fine join in bottom; handles of undyed, braided flax fibre.

 Provenance: Collected in the field.

 Comments: Made by Kepariki (Kepa) Konui of Otukou, Lake Rotoaira. Contemporary art.

1989 **Colour plate 24**
Patterned plaited basket, *kete whakairo*
1994 oc.4.113. 34 × 20 cm.

Plaited from strips of green-dyed kiekie and *pingao* leaf 3–5 mm wide, sinistrals green, dextrals arranged in groups of 10 green alternating with groups of 10 yellow, plaited in horizontal bands of vertical and horizontal 2/2 twill, forming pattern of diagonal alternating bands of solid green and green-and-yellow; fine join at bottom; handles of undyed, four-strand, braided flax fibre.

 Provenance: Collected in the field.
 Comments: Made by Kahutoi (Kahu) Te Kanawa of Auckland. Contemporary art.

1990 **Colour plate 24**
Patterned plaited basket, *kete whakairo*
1995 oc.5.1. 32.5 × 26 cm.

Plaited from strips of flax leaf 5–6 mm wide, dextrals undyed, sinistrals dyed black, with pattern using *mahitihiti* to change over from horizontal to vertical 2/2 twill; band of check plaiting at rim; fine join in bottom; handles of undyed, braided flax fibre.

 Provenance: Presented by D.C. Starzecka.
 Comments: Made by Katarina Monica Kepa Konui, commissioned from maker by Mick Pendergrast as gift to donor. Contemporary art.

1991 **Colour plate 24**
Patterned plaited basket, *kete whakairo*
1995 oc.5.2. 29 × 17 cm.

Plaited from strips 6 mm wide, of yellow *pingao* and red-dyed flax; sinistrals yellow, dextrals red, with three yellow strips on each side, in check with three horizontal bands of twilled triangles (*nihoniho* – tooth) and one diagonal dextral band of yellow; fine join in bottom; handles of red-dyed, braided flax fibre.

 Provenance: Presented by D.C. Starzecka.
 Comments: Made by M. Murray of Te Hapua, Northland, purchased in Museum of New Zealand Te PapaTongarewa by Dr Janet Davidson as gift to donor. Contemporary art.
 References: Pendergrast 1998: 123.

1992 **Plate 183**
Decorated plaited basket, *kete whakairo*
Q1982 oc.484. 37 × 26 cm.

Plaited from strips of flax leaf 2–3 mm wide, twilled, dextrals dyed black and reversed, sinistrals undyed; design of five horizontal bands, of diamonds interspersed with smaller repetitive pattern; fine join in bottom, three-strand braid on inside of rim. No handles, but three loops of braided flax fibre on each side of rim. Two holes in bottom, one in top corner.

 Provenance: Unknown.

Woven bags, *kete muka*

1993 **Plate 186**
Woven bag, *kete muka*
+4057. 31 × 23.5 cm.

Woven from flax fibre in double-pair twining; yellow-dyed fibre cord used for rolling decoration on every third weft; fringe around four sides, handles of two-ply string.

 Provenance: Edge-Partington Collection, presented 15 April 1889.
 Comments: *c.*1850–80 (MP).

1994 **Plate 186**
Woven bag, *kete muka*
1919-8. 25 × 17 cm.

Woven from flax fibre in single-pair twining and made in one piece; decorated with kaka, kiwi and white feathers. Handles of flax-fibre braid.

 Provenance: Presented by Mrs Frank Morley, 12 June 1919.
 Comments: Second half of nineteenth century (MP).

1995 **Plate 186**
Woven bag, *kete muka*
1919-9. 24 × 17 cm.

Woven from flax fibre as two rectangles, later joined together to make bag, decorated with kaka and white feathers. Handles of flax-fibre braid.

 Provenance: Presented by Mrs Frank Morley, 12 June 1919.
 Comments: Second half of nineteenth century (MP).

1996 **Plate 186**
Woven bag, *kete muka*
1908.12-14.1. 40 × 30 cm.

Woven from flax fibre in double-pair twining as flat rectangle commencing at centre, with kiwi feathers added on alternate wefts. Small albino kiwi feathers are added in clumps along top. After weaving was completed, rectangle was folded and sides sewn up. Small handles of flax-fibre braid.

 Provenance: Presented by Mrs Eustace Smith.
 Comments: Second half of nineteenth century (MP).

1997
Woven bag, *kete muka*
1933.3-11.2. 30.7 × 23.8 cm.

Woven from flax fibre in double-pair twining, warps arranged in black and undyed bands. Made in one piece, outer surface covered with kiwi feathers attached on alternate wefts. Handles of black-dyed flax-fibre braid.

 Provenance: Presented by Mrs Young.
 Comments: *c.*1850–1930 (MP).
 'They were brought to this country between 20 and 30 years ago, by the donor's late husband, who was Mayor of Sunderland at that time.' (BM AOA correspondence: Mr Deas, Director of Sunderland Museum, 18 January 1933).

1998
Woven bag, *kete muka*
1944 oc.2.834. 40.3 × 21.5 cm.

Woven from flax fibre in single-pair twining, unfinished – yet to be folded in half and fringe added to one side; handles of two-ply string already in place.

 Provenance: Beasley Collection. Beasley no. 2922.
 Comments: *c.*1850–1930 (MP).
 Beasley catalogue: 2922, registered 30 October 1931, 'A specimen of flax plaited work with two carrying loops & the edges fringed. An article of clothing? Bought: Rev. A.I. Hopkins, Melanesian Mission, The Parsonage … Crawley, Sussex.'

1999 **Plate 186**
Woven bag, *kete muka*
1949 oc.9.12. 26 × 27 cm.

Woven from flax fibre in single-pair twining, with purple-dyed running cords on every third weft; fringe on three sides, handles of two-ply string.

 Provenance: Presented by E. Cave.
 Comments: *c.*1850–1930 (MP).

2000
Woven bag, *kete muka*
1992 oc.7.1. 34 × 39 cm (flap extended).

Hanging bag with flap, woven from natural flax fibre in double-pair twining, with tasselled loops of two-ply fibre cord for suspension; fringe along all three outer edges and flap.

 Provenance: Presented by Mrs Margaret Isobel Massey Stewart.
 Comments: Second half of nineteenth century (MP). Collected between 1912 and 1920 by donor and her mother, Mary Judith Massey.

2001 **Plate 186**
Woven bag, *kete muka*
1993 oc.3.78. 26 × 17 cm.

Woven from flax fibre, dyed with *tanekaha* bark dye, in double-pair twining with openwork; decorated with three horizontal rows of pheasant feathers. Lined with yellow cotton cloth. Handles of three-strand flax braid.

 Provenance: Collected in the field.
 Comments: Made by Puti Hineaupounamu Rare of Auckland. Contemporary art.
 References: Starzecka 1996: 153.

2002 **Plate 186**
Woven bag, *kete muka*
1994 oc.4.98. 23 × 16.5 cm.

Woven from black-dyed flax fibre in double-pair twining with openwork, decorated with a *taniko* border in black, brown, yellow and white below rim and two rows of pheasant feathers near bottom. Handles of three-strand black-dyed flax-fibre braid.

 Provenance: Collected in the field.
 Comments: Made by Erenora Puketapu Hetet. Contemporary art.
 References: Pendergrast 1998: 123.

2003 **Plate 187**
Woven bag, *kete muka*
1994 oc.4.114. 28 × 23 cm.

Woven in double-pair twining from undyed and *tanekaha*-dyed flax fibre, with some openwork and decoration of rectangles of kaka and kereru feathers; dyed fibre forms two broad vertical stripes on both sides. Handles are four-strand braid in brown and white.

 Provenance: Collected in the field.
 Comments: Made by Kahutoi [Kahu] Te Kanawa of Auckland. Contemporary art.

2004 **Plate 187**
Woven bag, *kete muka*
Q1981 oc.1402. 33 × 25.5 cm.

Woven from double-pair twining, with warp of flax fibre and weft of cotton; outer surface decorated with fowl, pukeko and pheasant feathers. Tasselled handles of flax-fibre braid.

 Provenance: Unknown.
 Comments: *c.*1850–1930 (MP).

2005 Plate 187
Woven bag, *kete muka*

QI981 OC.I403. 34 × 27.8 cm.

Woven from flax fibre in single-pair twining; bottom and one side sewn up, fringes along four edges attached after completion of weaving. Black turkey and yellow-dyed feathers (now faded) have been woven into one surface; other surface includes some yellow warps, which were diverted during weaving to form pattern. Handles of two-ply string.

 Provenance: Unknown.

 Comments: *c.*1850–1930 (MP).

2006 Plate 187
Woven bag, *kete muka*

QI981 OC.I404. 49 × 32 cm.

Woven in double-pair twining, with woollen warps and flax-fibre wefts; *taniko* of undyed flax and black wool, with some yellow, red, green, blue and purple wool; *kaupapa* carries peacock, tui and other feathers, with fragments of pheasant feathers spaced across main surfaces. Strip of goat (?) skin with hair is attached around sides and bottom, around rim is strip of synthetic (?) 'fur'. Handles are made from similar cloth, with synthetic fibre giving effect of red feathers. Lined with pink cloth.

 Provenance: Unknown.

 Comments: *c.*1850–1930. Exhibiting a strong relationship to *kaitaka*-class cloaks; in fact it may be made from *kaitaka* fragment (MP).

2007
Woven bag, *kete muka*

QI995 OC.I. 28 × 28 cm.

Woven from flax fibre in single-pair twining, with fringe on three sides. Handles missing.

 Provenance: Unknown.

 Comments: *c.*1850–1930 (MP).

2008 Plate 187
Woven bag, *kete muka*

QI995 OC.36. 38 × 25.5 cm.

Woven from flax fibre in double-pair twining with openwork of triangular shape, with coloured (red, purple and green) fibre fringe. Tasselled cords, four on each side, at fringe, and fibre rosette with tassels on body of bag, one each side. Handle of three-strand fibre braid, terminating in two-ply cords and tassels.

 Provenance: Unknown.

 Comments: *c.*1850–1930 (MP).

2009 Plate 187
Woven bag, *kete muka*

QI999 OC.25. 28.5 × 23.5 cm.

Woven from natural flax fibre in single-pair twining, with natural warp and pink, blue and natural weft; three openwork bands on each side, fringe along three sides; handles of two-ply fibre string.

 Provenance: Unknown.

 Comments: *c.*1850–1930 (MP).

2010
Woven basket, *kete muka*

QI999 OC.26. 32.5 × 23 cm.

Woven from natural flax fibre in single-pair twining, with coloured (green, purple and red) additional wefts; fringe along three edges; handles of three-strand braid.

 Provenance: Unknown.

 Comments: *c.*1850–1930 (MP).

Miscellaneous baskets and bags

2011 Plate 187
Basket with flap lid

1895-487. 33.5 × 20.5 cm.

Plaited from strips of flax leaf 4–7 mm wide in check and twill. Groups of six brown strips arranged on both dextrals and sinistrals, creating lattice pattern on pale ground; fine join in bottom. Flap lid with serrated edge and four tassels of flax fibre; single longitudinal handle of two-ply rolled-flax-fibre cord.

 Provenance: Meinertzhagen Collection.

 Register: 'New Zealand 1870.'

 Comments: *Kete* with flap lid are called *kopa* in some areas; tassels are an innovation; late nineteenth century (MP).

2012 Plate 188
Long basket

1854.12-29.129. 44 × 106.1 cm.

Plaited in 2/2 twill from alternating black and undyed strips of flax leaf, 4 mm wide. A fine join is on the inside of both long sides; on one short side is an opening 23.5 cm long.

 Provenance: Grey Collection.

 Comments: Similar but smaller, or model, bag in Hawkes Bay Museum (37/834), presented by F.J. Williams, Waipare, is of East Coast type described by Williams as 'used for conveying wheat 1840–65' (MP).

2013 Plate 188
Basket with shoulder straps

1863.2-9.9. 25 × 24 cm.

Plaited in 2/2 twill from strips of flax leaf 4–5 mm wide, some reversed, using shiny and dull sides of strip to provide contrast. Three-strand braid commencement is at one side of basket, mat-join finish at other; three-strand braided shoulder straps, ends of which are knotted back into basket near its lower corners.

 Provenance: Presented by Revd R. Taylor.

 Old printed exhibition (?) label: 'From Wellington, New Zealand, No. 8, List 1, A Basket used in Travelling … Exhibited by Revd R. Taylor.'

 Comments: Nineteenth century. Basket and its straps are very small and if travel-bag description is correct, it must be model (MP).

 The label probably refers to the 1865 'New Zealand Exhibition' in Dunedin to which Taylor contributed.

 References: Edge-Partington 1969 II.I: 233.I0.

2014 Plate 188
Basket without handles

1896.II-19.6. 29.5 × 18 cm.

Plaited from flax-leaf strips 4–5 mm wide in check, in *patikitiki*-type pattern, using shiny and dull sides of strips to provide contrast by laying out both dextrals and sinistrals alternately; three-strand braid commencement in bottom. No dye, no handles, braid on inside of rim.

 Provenance: William Strutt Collection.

 Label: 'Toy Kit made of New Zealand Flax. The larger ones made on same model are used for carrying wheat, potatoes & produce to market. [reverse] This toy Kit was no doubt made for the use of a Maori Child – New Plymouth, Taranaki. New Zealand – 1856.'

2015 Plate 188
Woven bag

1933.3-13.I. 25 × 19.5 cm.

Woven in double-pair twining from strips of *houhi*, lace bark (*Hoheria* sp.) bast, with criss-cross decoration on outer surface, looped fringe around three sides, and two two-ply twisted handles at top.

 Provenance: Presented by Mrs Holdsworth.

 Comments: Early nineteenth century (MP).

2016 Plate 188
Taniko-style bag

1994 OC.4.77. 20.5 × 12 cm.

Woven from man-made fibre; lower two-thirds on both sides with diagonal zigzag in dark blue and red, and thin diagonal lines in white; upper one-third in plain dark blue with New Zealand Post Office logo in red and white, and red lettering '3 Dec' on one side, and '1986' on other. Lined with black plastic; shoulder strap of similar black plastic on white cloth base; black zip fastening.

 Provenance: Collected in the field.

 Comments: Made by Wahine Mackey of Ruatoria, on her retirement from the Post Office after 31 years' service. Contemporary art.

2017
Plaited purse

1994 OC.4.91. 28 × 10.5 cm.

Plaited from kiekie strips 2–3 mm wide, in complex twill with diagonal stepped pattern; thin tassel at each upper corner, black plastic zip. Decorative pattern in four horizontal bands on both sides of purse.

 Provenance: Collected in the field.

 Comments: Made by Eddie Maxwell of Whakatane. Contemporary art.

2018 Plate 188
Taniko bag

QI995 OC.37. 23 × 14.5 cm.

Woven from flax fibre and wool. Both sides with black background, lower one-third plain and coarse, upper two-thirds finer, with decorative motifs of zigzags and triangles in maroon, white and orange. In one lower corner, on one side, weft worn away to reveal purple warp; handles of three-strand woollen braid in orange and green.

 Provenance: Unknown.

 Comments: Late nineteenth/early twentieth century (MP). Sewn from pieces of *taniko* cloak border? (DCS).

Related fibre items

2019
Carrying strap, *kawe*

3971. Length 132 cm (folded in half).

Plaited from flax leaf (probably mountain flax, *Phormium colensoi*), doubled strips with shiny surface exposed on both sides; terminal two-thirds of straps of flax fibre in three-strand braid narrowing towards ends and then changing into rolled-cord tips.

 Provenance: Unknown.

 References: Edge-Partington 1969 II.I: 233.II.

2020 Plate 189

Carrying strap, *kawe*

1896.11-19.7. Length 106 cm (folded in half).

Plaited from flax leaf, doubled strips with shiny surface exposed on both sides; terminal two-thirds of straps of flax fibre in three-strand braid narrowing towards ends and then changing into rolled-cord tips.

Provenance: William Strutt Collection.

Label: 'Slings. Made of New Zealand Flax, by Maories of Taranaki. N.Z. Used to carry burdens on back principally the flax made Kits both by natives & white settlers. [reverse] The slings I used myself when in the Bush, New Plymouth, New Zealand, W. Strutt 1856.'

2021

Carrying strap, *kawe*

1921.10-14.19. Length 128 cm (folded in half).

Plaited from mountain flax (*wharariki, Phormium colensoi*) leaf, doubled strips with shiny surface exposed on both sides; fibre from *Phormium tenax* forms terminal two-thirds of straps, three-stranded, narrowing towards ends and then changing to rolled cords for tips, except one.

Provenance: Yorkshire Philosophical Society Museum.

2022 Plate 189

Teapot cosy?

Q1981 Oc.1401. Width 27 cm, height 20 cm.

Woven from flax in single-pair twining, with white feathers; lined with silky maroon machine-sewn quilting, which is shaped and does not reach bottom of bag. Small suspension loop of braided cord at top, no handles.

Provenance: Probably part of Royal Loan 1902.

Comments: It seems to be depicted in Beattie photograph B25a GN672 23 (Auckland Museum Collection), Rotorua, June 15, 1901, which shows the Duchess of Cornwall and York receiving it (MP).

If it is the same object, then it is a personal gift from Te Rongokahira and Te Paerakau Haerehuka (see Loughnan 1902: 87).

References: Loughnan 1902: 87.

2023

Feather muff

Q1981 Oc.1405. Width 23.7 cm, height 17.5 cm.

Woven in single-pair twining, with kaka feathers. Lined with machine-sewn silky maroon double-folded textile, stitched to fibre base.

Provenance: Probably part of Royal Loan 1902.

References: Imperial Institute 1902: 257 (?).

Mats, *whariki*

A variety of plaited mats were made, usually from strips of flax or kiekie leaf, or from whole *kuta* stems. Some were used for everyday purposes, such as for serving food or for coverings in the earth oven. Others were used as floor coverings, sitting mats and sleeping mats. All of these, as well as rush and fern-leaf floor coverings, were known as *whariki*, which simply means to spread out. Today the term *whariki* is mainly applied to finely patterned mats once known as *takapau*. These are the most common in collections.

Whariki are worked in panels; as each individual panel is completed, the succeeding one is worked into it with a *hono* join, extending the width of the mat. Most have from three to five panels, but they may have more or fewer.

Some meeting houses still keep a set of *whariki* that are spread when guests arrive. The local people take pride in them, the visitors admire and respect them. Only a very ignorant person would walk on them with shoes on. A modern mattress is now laid over the mats for each guest.

2024

Mat, *wharki*

1854.12-29.130. Length 177 cm, width 147 cm.

Rectangular, plaited in 3 mm wide twilled strips of flax leaves, in three panels.

Provenance: Grey Collection.

2025

Mat, *wharki*

1960 Oc.11.6. Length 87 cm, width 74 cm.

Oval-shaped; made from long braid of flax fibre to which additional fibre has been added on one side at each stroke. Braid has been sewn into oval coil with rolled-fibre cord; central area is undyed, surrounded by brown and then black band.

Provenance: Transferred from Royal Botanic Gardens, Kew.

Comments: This is not traditional Maori method (MP); twentieth century (DRS).

2026 Plate 190

Mat, *wharki*

1960 Oc.11.9. Length 194 cm, width 120 cm.

Rectangular, plaited in horizontal twill in four panels, from strips of kiekie 3 mm wide.

Provenance: Transferred from Royal Botanic Gardens Kew. Kew collection no. 2-1847.

Labels: 'Doormat made of New Zealand "hemp" or "flax", Phormium tenax L.f. Used by Maori women for the floors of Chiefs' houses and for chapels: some of these mats are over 80' long and 40' wide. New Zealand. 2-1847. Rev. W. Colenso.'

'I a plain door mat <u>now</u> more than 45 years old.'

'"2.1897. The larger strong plain doormat is a sample of what the Maori women used to make for the floor of their Chiefs' houses, - and for my own dwelling house, and particularly for their Chapels after they had received Christianity. In some of my larger chapels these mats were more than 80 ft long by say 30–40 feet wide, the congregation sitting on the floor without raised seats. Every Monday morning the [reverse] big mats were rolled carefully up, underneath them were strewed Bulrush leaves (Typha)." Extract of letter from W. Colenso to Director, Dated, Napier, N. Zealand 19.8.96.'

Another, shorter, label repeats information contained in last.

2027

Mat, *wharki*

1960 Oc.11.11. Length 184 cm, width 130 cm.

Rectangular, plaited in 3 mm wide twilled strips of kiekie leaves, in four panels. Pattern of arrangements of vertical and horizontal 2/2 twill. Join of old type; edge at one end is unusual serrated finish.

Provenance: Transferred from Royal Botanical Gardens Kew.

Register: 'Mat made of 'kie kie' leaves. Rev. W Colenso.'

Label: '3934'.

2028 Plate 190

Mat, *wharki*

1994 Oc.4.89. Length 261 cm, width 138 cm.

Rectangular mat, plaited from strips of flax leaf in 2/2 twill, in four panels, each with three diagonal, wide bands of green-dyed flax in decorative pattern.

Provenance: Collected in the field.

Comments: Made by Christina (Tina) Hurihia Wirihana of Rotoiti; the pattern is *Te Mamaru. Te Hera o te waka o Tainui* (The sail of the Tainui canoe). Contemporary art.

2029 Plate 190

Mat, *wharki*

1994 Oc.4.110. Length 210 cm, width 140 cm.

Rectangular mat, plaited from strips of flax leaf in 2/2 twill, in three panels, with two parallel wide bands of zigzag decoration with pattern in black.

Provenance: Collected in the field.

Comments: Made by Katarina (Biddy) Konui of Turangi; the pattern is *kauwae ngarara* (dragon's jaw), traditional pattern used in artist's family. Contemporary art.

References: Pendergrast 1996: 121.

Samples

2030

Two bundles of flax fibre

NZ 141. Lengths 90 and 74 cm.

With sample of leaf attached to smaller bundle.

Provenance: Cook Collection.

Parchment label: 'Hemp. No. 73. New Zealand.'

Comments: Eighteenth century; presumably for cloak making (MP).

References: Kaeppler 1978:175.

2031

Two pieces of fern root

1505. Lengths 18.5 and 12.5 cm.

Provenance: Unknown.

Label: 'Fern Root. Eaten by Natives of New Zealand as Bread. Brought home by Mr Earle 1830.'

2032

Two twisted hanks of flax fibre

7013. Lengths 84 and 107 cm.

Provenance: Meinertzhagen Collection. Presented by F.H. Meinertzhagen, 21 December 1870.

Label: 'Fibre of Phormium tenax. New Zealand. [reverse] F.H. Meinertzhagen Esq.'

Comments: Also numbered, mistakenly, Q1981 Oc.1398.

2033

Kauri gum sample

7014. Length 14 cm.

Provenance: Meinertzhagen Collection. Presented by F.H. Meinertzhagen, 21 December 1870.

Register: 'Lump of "Fossil Gum" used described as "Kauri Gum" which Mr Meinertzhagen says it is not.'

Dante Bonica Collection

2034 Three fire ploughs. 1999 Oc.1.18. Lengths 45.5, 20.5 and 24 cm.

2035 Totara wood sample. 1999 OC.1.19. Length 33.5 cm.

2036 Totara wood shavings. 1999 OC.1.20.

2037 Totara wood tinder. 1999 OC.1.21.

2038 Flax-fibre threads. 1999 OC.1.1. Length 130 cm.

2039 Flax-fibre threads, twisted into strings. 1999 OC.1.2. Length 86 cm.

2040 Two mussel shells. 1999 OC.1.5. Lengths 11.5 and 10 cm.

2041 Two mussel-shell knives. 1999 OC.1.6. Lengths 15 and 10 cm.

2042 Two bivalve shells, *tuatua*. 1999 OC.1.7. Lengths 7.6 and 7.5 cm.

2043 Three bivalve shells, *pipi*. 1999 OC.1.8. Lengths 6–6.3 cm.

2044 Bivalve shell, haliotis, for mixing pigment. 1999 OC.1.13. Length 15 cm. Covered entirely in red-ochre pigment.

2045 Hammer stone, of quartzite. 1999 OC.1.7. Length 6 cm.

2046 Four flint knives. 1999 OC.1.3. Length 2–3 cm.

2047 Collection of flint pieces. 1999 OC.1.4. Length 1–6 cm.

2048 Red ochre sample. 1999 OC.1.9. Length 14 cm.

2049 Red ochre sample. 1999 OC.1.10. Length 11.8 cm.

2050 Two yellow ochre samples. 1999 OC.1.11. Lengths 6.5 and 5.5 cm.

2051 Kaolin clay sample. 1999 OC.1.12. Length 12 cm.

2052
Ten feathers

Q1981 OC.1291. Lengths 17.5–30.5 cm.

Back section of quill of each feather has been removed, and in seven of them the point of another (also with back removed) thrust inside first, resulting in a 'double feather'. There are five pairs of white feathers prepared in this way and two pairs of white feathers with black central band treated same way.

Provenance: Unknown.

Comments: There is nothing to confirm that these are New Zealand feathers – if they are, they may be from seabird, perhaps even domestic fowl. Little is known of traditional feather use, so they may be important (MP).

2053
Seven moa (?) feathers

Q1981 OC.1292. Length 12 cm, width 8 cm.

Enclosed between two sheets of glass.

Provenance: Unknown.

Comments: They are not kiwi, so the only reason that they are preserved in this way must be that they are moa (MP).

2054
Two kauri gum lumps

Q1981 OC.1391. Lengths 12 and 8 cm.

Provenance: Unknown.

2055
Two bundles of fibre

Q1981 OC.1399.

Tied with cloth tape marked: 'Other [?] of No. 1'; within it one bundle tied with cloth tape marked 'No. 1'.

Provenance: Unknown.

Comments: Smooth one is flax, other perhaps also flax but threshed by mill? (MP).

2056
Length of fibre

Q1981 OC.1400. Length 28 cm (folded).

Tied-on cloth tape marked: 'No 2'.

Provenance: Unknown.

Comments: *Cordyline*? (MP).

This object is probably related to **2055**.

Modern ceramics

Ceramic work was never part of the traditional material culture of the Maori in New Zealand. Their distant Polynesian forebears in Fiji, Tonga and Samoa produced the distinctive Lapita pottery of the first millennium BC but this tradition was not carried any further during their migrations into Eastern Polynesia. By the time the first Polynesians reached New Zealand, pottery knowledge was no longer part of their culture.

In very recent times, beginning in the 1980s, a small group of contemporary Maori artists from various tribal areas began to experiment with clay as a material for producing innovative pottery forms initially inspired by established Maori carving styles. Since then, practising artists such as Baye Riddell, Manos Nathan, Wi Te Tau Pirika Taepa, Colleen Waata-Urlich, Paerau Corneal and other members of Nga Kaihanga Uku, the Maori clay workers' collective, have continued to develop new forms of pottery vessels and figurative sculptural compositions.

2057 **Plate 191**
Pot

1994 OC.4.84. Diameter 13 cm.

Spherical pottery container: oblate, top with small circular opening; lower half black, upper half changing from grey to pinky tan and decorated with carved *pitau* with *unaunahi*. Small circular indentation at bottom.

Provenance: Collected in the field.

Comments: Made by Manos Nathan and purchased from Te Taumata Gallery, Auckland. Contemporary art.

References: Starzecka 1998: 153.

2058
Pot

1994 OC.4.85. Diameter 14 cm.

Spherical pottery container: oblate, terracotta-coloured, top with small circular opening with ring of rough surface; upper half with carved *pitau* with *unaunahi*. Small circular indentation at bottom with incised inscription: 'Manos Nathan 1992. Tu...'.

Provenance: Collected in the field.

Comments: Made by Manos Nathan and purchased from Te Taumata Gallery, Auckland. Contemporary art.

References: Starzecka 1998: 153.

2059 **Plate 191**
Pottery globe

1994 OC.4.86. Diameter 8 cm.

Solid pottery sphere with flattened bottom: terracotta-coloured, upper half with incised two-tone ornamentation of *pitau*. Incised on bottom: 'MN 193'.

Provenance: Collected in the field.

Comments: Made by Manos Nathan and purchased from Ohaki Craft Centre, Oparure, Te Kuiti. Contemporary art.

References: Starzecka 1998: 153.

2060 **Plate 191**
Pot

1998 OC.1.1. Width 42.5 cm, height 25 cm.

Spherical pottery vessel: flattened bottom, equatorial shoulder; upper part extending into flat, vertical, fan-like projection with plain integral spout at one end, remainder in openwork: *manaia* head with haliotis-shell eyes within circular space and parallel horizontal bands with oblong spaces. Small circular indentation at bottom. Repair to openwork top.

Provenance: Presented by Manos Nathan

Comments: Made by Manos Nathan and named *Ipu waiora* – vessel for living water. Brought to Britain for exhibition of contemporary Maori art held in New Zealand House, London, 24 June – 2 July 1998, but not exhibited due to damage in transit. Contemporary art.

Chatham Islands

The prehistoric indigenous inhabitants of the Chatham Islands, known as Moriori and calling their own islands Rekohu, were an isolated group of Polynesians closely related to New Zealand Maori. But while very similar, they were a distinct people who spoke a separate but closely related Polynesian dialect. Moriori and Maori were unaware of each other until the European rediscovery of the Chathams Islands in 1791. Sutton has recently argued, as a result of his archaeological investigations on the islands, that the Chathams were probably settled from New Zealand between AD 1000 and 1200, and became completely isolated after about AD 1400. But this dating may need to be revised in view of new evidence for the New Zealand mainland being first settled in the second half of the thirteenth century. Others favour a date of about AD 1500 for Moriori arrival from the southern area of New Zealand. Nor can the possibility of direct settlement from elsewhere in East Polynesia be entirely excluded. In 1835, about 900 Maori traveling on European ships from the Wellington area of the North Island invaded the Chatham Islands, where they settled, killing and enslaving many Moriori. Since then, the material culture collected from the Chatham Islands has been a mix of indigenous Moriori and introduced Maori items.

Most distinctive of Moriori artistic expression are the ancestor figures carved into the bark of *kopi* trees, although their exact cultural significance is uncertain. The four examples in the British Museum, despite their worn condition, are important representatives of an art form that has almost disappeared from their home islands. Listed among the weapons are stone clubs of schist, some with a bird form, which have also been interpreted as seal-killing clubs. Simple one-piece bone fish-hooks are very distinctive of Moriori material culture and are also strongly suggestive of a relationship to archaic Maori fish-hooks from the New Zealand mainland. Similarly, many of the stone adze blades can be matched by archaic adze forms from the mainland. Flaked stone tools, modified to be used as a hand tool or hafted in a wooden handle, answered a wide variety of utilitarian needs, especially butchering seals and small beached whales.

Ceremonial objects

2061 Plate 192
Dendroglyph
1898.10-21.79. 88 × 32 cm.

Roughly rectangular piece of bark (one top corner cut off): originally had schematic human (male?) figure engraved (triangular head with eyes only indicated, raised arms, legs bent with knees raised to trunk), now almost entirely obliterated. Multiple cracks, large abrasion in middle of panel.
 Provenance: Williams Collection.
 Comments: Early nineteenth century (RN).

2062 Plate 192
Dendroglyph
1898.10-21.80. 77 × 29 cm.

Roughly rectangular piece of bark: originally had schematic stick-like male human figure engraved (blank face, outstretched arms, legs bent at knees, large genitals), now almost entirely obliterated. Multiple cracks.
 Provenance: Williams Collection.
 Comments: Early nineteenth century (RN).

2063 Plate 192
Dendroglyph
1898.10-21.81. 67 × 22 cm.

Sawn-off tree trunk with design engraved on bark: in upper half, two X motifs and some horizontal marks; in lower half, schematic human figure with arms outstretched and holding two vertical projections rising from knees of bent legs.
 Provenance: Williams Collection.
 Comments: Early nineteenth century (RN).

2064 Plate 192
Dendroglyph
1898.10-21.82. 98 × (32+18) 50 cm.

Rectangular piece of bark (now split into two separate parts): originally had schematic male human figure engraved (oblong face with eyes only indicated, four vertical projections on top of head, outstretched arms, horizontal projections at waist, legs bent at knees, genitals), now almost entirely obliterated. Multiple splits and abrasions.
 Provenance: Williams Collection.
 Comments: Early nineteenth century (RN).

2065 Plate 192
Staff,*tokotoko*
1895-373. Length 56 cm.

Wooden staff/walking stick: light colour; handle with projecting *koruru* head with surface decoration of *raumoa*, rest of handle with rudimentary *rauponga*, end of handle cut off recently to form point; shaft broken off at end.
 Provenance: Meinertzhagen Collection.
 Comments: Late nineteenth century? (RN).

Ornaments

2066 Plate 193
Pendant,*rei*
+7049. Length 13.5 cm.

Whale-tooth pendant: perforated, with marked curvature; deeply undercut on convex side near hole.
 Provenance: Presented by A.W. Franks, 11 July 1893 (H.O. Forbes).
 Comments: Eighteenth century (RN).
 References: Edge-Partington 1969 II.I: 234.7

2067 Plate 193
Pendant,*rei*
1898.10-21.65. Length 16.6 cm.

Whalebone pendant: hook-shaped, flat, perforation in upper end.
 Provenance: Williams Collection.
 References: Skinner 1923: pl. VII, i (where it is mistakenly attributed to University Museum, Cambridge).

2068 Plate 193
Pendant,*rei*
1898.10-21.74. Length 9.7 cm.

Whale-tooth pendant: perforated, very slightly curved.
 Provenance: Williams Collection.

Comments: Nineteenth century (RN).
References: Skinner 1923: pl. VII, d.

2069 Plate 193
Pendant,*rei*
1898.10-21.75. Length 8.6 cm.

Whale-tooth pendant: curved, thick, perforated; dark-yellow patina.
 Provenance: Williams Collection.
 Comments: Nineteenth century (RN).

2070 Plate 193
Pendant,*rei*, or cloak pin
1898.10-21.76. Length 15.5 cm.

Whalebone, perforated, curved, blunt tip.
 Provenance: Williams Collection.
 Comments: Nineteenth century (RN).

2071 Plate 193
Pendant,*rei*, or cloak pin
1898.10-21.77. Length 13 cm.

Whalebone, perforated, blunt tip. Possibly cloak pin.
 Provenance: Williams Collection.
 Comments: Nineteenth century (RN).

2072 Plate 193
Pendant,*rei*, or cloak pin
1898.10-21.78. Length 10.6 cm.

Pig-tusk, thin, deeply curved, perforated; dark-brown patina.
 Provenance: Williams Collection.
 Comments: Nineteenth century (RN).
 References: Skinner 1923: pl. VII, a.

2073 Plate 193
Pendant,*rei*
1944 Oc.2.906. Length 11.2 cm.

Whale-tooth pendant: large hole, abrasions near curved point, tip worn/broken off.
 Provenance: Beasley Collection. Beasley no. 1568.
 Label: '"Rei" whale-tooth pendant, Te Rae, Chatham Isld. coll. & pres. R. Hough, D.24.118.'
 Comments: Eighteenth century (RN).
 Beasley catalogue: 1568, registered 29 January 1926, 'Obtained in exchange with H.D. Skinner, Otago University Museum, Dunedin, N.Z.'

Weapons

Wooden clubs

2074 Plate 194
Short club, *kotiate*
1895-369. Length 30 cm.

Wooden club: brown, inner curve at each side edge of blade, butt carved as human head with large, flat, round eyes, and surface ornamentation of *rauponga* and plain spirals on face and mouth; longitudinal central ridge on both sides of blade. One side of blade marked: 'Chathams'.
 Provenance: Meinertzhagen Collection.
 Comments: Nineteenth century (RN).

2075 Plate 194
Short club, *wahaika*
1895-370. Length 37.5 cm.

Wooden club: brown, one edge recessed, other with inner curve, butt with shallow carving of incipient human face; straight hole drilled through grip; coarse workmanship. One side of blade marked: 'Chathams'.
 Provenance: Meinertzhagen Collection.
 Comments: Nineteenth century (RN).

2076 Plate 194
Short club, *wahaika*
1895-371. Length 37 cm.

Wooden club: brown, narrow blade, one edge recessed with rudimentary human face in low relief below (only eyes and nose indicated by straight lines), other with inner curve, butt carved as human head (plain face, big round eyes, plain mouth and tongue out); no surface ornamentation. One side of blade marked: 'Chathams'.
 Provenance: Meinertzhagen Collection.
 Comments: Nineteenth century (RN).

Whalebone clubs

2077 Plate 194
Short club
1898.10-21.62. Length 31 cm.

Bill-hook-shaped blade, curved handle with pointed butt; multiple scratches on both sides of blade.
 Provenance: Williams Collection.
 Comments: Eighteenth century (RN).
 References: Skinner 1923: pl. XXX, b.

2078 Plate 194
Short club
1898.10-21.63. Length 32.2 cm.

Spatulate blade deeply serrated all around edges, butt carved as bird's head.
 Provenance: Williams Collection.
 Comments: Eighteenth century (RN).
 References: Skinner 1923: pl. XXIX, e (where it is mistakenly attributed to Canterbury Museum), Skinner 1974: 166, II.III.

Stone clubs

2079
Short club of schist, *pohatu taharua*
Chat 4. Length 30 cm.

Oblong blade narrowing to butt, no shoulders.
 Provenance: Hector/Colonial Museum Collection.
 Label: 'Fern beater – Stone found at Whangaroa & Raiangaroa.'

References: Edge-Partington 1969 II.I: 235.4.

2080
Short club of schist, *pohatu taharua*
Chat 5. Length 29 cm.

Blade cut straight in middle, its distal half missing, slight shoulders, long handle.
 Provenance: Hector/Colonial Museum Collection.

2081
Short club of schist, *pohatu taharua*
9186. Length 24.8 cm.

One edge of blade rounded, other straight, plain handle.
 Provenance: Presented by A.W. Franks, 18 February 1875.

2082 Plate 195
Short club of schist, *okewa*
+4345. Length 29.5 cm.

Bill-hook-shaped blade, curved handle with pointed butt.
 Provenance: Presented by Revd William Greenwell DCL, 26 August 1889 (obtained from William A. Baker, New York).
 References: Davidson 1996: 24; Edge-Partington 1969 II.I: 235.1; Skinner 1923: pl. XXXI, a.

2083
Short club of schist, *pohatu taharua*
+6082. Length 36 cm.

Wide oblong blade with two crescent shapes carved near handle, bifurcate butt.
 Provenance: Presented by A.W. Franks, 26 September 1892 (H.O. Forbes).
 References: Edge-Partington 1969 II.I: 235.2; Skinner 1923: pl. XXIX, b.

2084 Plate 195
Short club of schist, *pohatu taharua*
1895-903. Length 35.5 cm.

Wide oblong blade, bifurcate butt. Marked: 'Chathams'.
 Provenance: Meinertzhagen Collection.
 References: Skinner 1923: pl. XXIX, c.

2085
Short club of schist, *okewa*
1895-904. Length 24.5 cm.

Bill-hook-shaped blade, straight handle and butt.
 Provenance: Meinertzhagen Collection.

2086 Plate 195
Short club of schist, *pohatu taharua*
1898.10-21.56. Length 35.8 cm.

Wide oval blade, shoulders, plain handle and butt; weathered.
 Provenance: Williams Collection.

2087
Short club of schist, *pohatu taharua*
1898.10-21.57. Length 36 cm.

Flat, broad, oblong blade; plain handle and butt; weathered.
 Provenance: Williams Collection.
 Register: 'Moriori Club – 14'.
 Comments: Williams's list: '14, Club, found at Operau.'

2088 Plate 195
Short club of schist, *pohatu taharua*
1898.10-21.58. Length 21.5 cm.

Oblong blade, convex sides, concave edges, strongly marked shoulders, rounded butt; weathered.

Provenance: Williams Collection.
 Label: 'Moriori club 15'.
 Comments: Williams's list: '15, Club, found at Operau.'
 References: Skinner 1923: pl. XXVIII, c.

2089
Short club of schist, *okewa*
1898.10-21.59. Length 24 cm.

Bill-hook-shaped blade, handle and butt missing; weathered.
 Provenance: Williams Collection.
 Label: '20'.
 Comments: Williams's list: '20, Club, found at Te Whanga Lagoon.'

2090 Plate 195
Short club of schist, *pohatu taharua*
1898.10-21.60. Length 27.2 cm.

Oblong blade with concave edges, straight distal end, shoulders, handle tapering to plain butt.
 Provenance: Williams Collection.
 Label: 'Moriori Club 21';.
 Comments: Williams's list: '21, Club, found at Operau.'
 References: Skinner 1923: pl. XXVIII, a.

2091 Plate 195
Short club of schist, *pohatu taharua*
1898.10-21.61. Length 25.6 cm.

One edge straight and continuous with handle, other curved and narrowing towards plain butt.
 Provenance: Williams Collection.
 Label: '12'.
 Comments: Williams's list: '12, Club, found at Operau.'
 References: Skinner 1923: pl. XXXI, f.

2092
Short club? of schist
1928.1-10.32. Length 22 cm.

Rough-out (?), roughly triangular in shape, slightly curved blade.
 Provenance: Liversidge Collection.
 References: Liversidge 1894: 239.

2093
Short club of schist, *pohatu taharua*
1944 Oc.2.903. Length 35 cm.

Wide, flat, spatulate blade narrowing to handle, very slight shoulders, bifurcate butt.
 Provenance: Beasley Collection.
 Comments: Eighteenth century (RN). Beasley no. 1461. Beasley catalogue: 1461, registered 16 July 1924, 'The Northesk Collection. Lot 555. Sold at Christies. For many years at the Winchester Corporation Museum & later at the Tudor House Museum. Southampton.'

2094
Short club of schist, *pohatu taharua*
1944 Oc.2.904. Length 25 cm.

Rough-out, spatulate blade.
 Provenance: Beasley Collection.
 Comments: Eighteenth century (RN). Possibly Beasley no. 1887. Beasley catalogue: 1887, registered 30 September 1926: 'Patu shaped ... 9 5/8 [inch]. Chatham Isl. objects collected by J.V. Hodgson, late Curator of the Plymouth Museum who accompanied Capt. R.F. Scott as Biologist to the Expedition of the Discovery to the South Pole 1901–4. Note: These came from Sir Joseph Kinseys Coll. Christchurch N.Z.'

2095

Short club of schist, *okewa*

1944 Oc.2.905. Length 30.5 cm.

Rough-out, bill-hook-shaped blade.
Provenance: Beasley Collection.
Comments: Eighteenth century (RN).
Beasley no. 1886. Beasley catalogue: 1886, registered 30 September 1926: 'Chatham Isl. objects collected by J.V. Hodgson, late Curator of the Plymouth Museum who accompanied Captain R.F. Scott as Biologist to the Expedition of the Discovery to the South Pole 1901–4. Note: These came from Sir Joseph Kinseys Coll. Christchurch N.Z.'

Hunting and fishing equipment

Bird-spear points

2096

Bird-spear point, *uata*

+6078. Length 13 cm.

Bone (albatross wing-bone?), five sharp barbs on one side, longitudinal curve.
Provenance: Presented by A.W. Franks, 28 September 1892 (H.O. Forbes).
Comments: Nineteenth century (RN).
References: Edge-Partington 1969 II.1: 234.1; Skinner 1923: pl. X, e.

2097

Bird-spear point, *uata*

1898.10-21.64. Length 20 cm.

Whalebone, five shallow barbs on one side.
Provenance: Williams Collection.
Comments: Nineteenth century (RN).
References: Skinner 1923: X, i.

Sinkers and float

2098

Schist sinker

1898.10-21.54. Length 16.3 cm.

Ovoid, with equatorial groove, above which half of narrower part has been cut away.
Provenance: Williams Collection.

2099

Iron pyrites sinker

Q1981 Oc.1923. Length 5.1 cm.

Ovoid, with equatorial groove.
Provenance: Franks Collection.
Label: 'AWF [A.W. Franks] 26 Sept. [18]92.'

2100

Pumice float

+7061. Length 11.5 cm.

Carved in form of human head; neck end partly hollowed out into cone, horizontal groove around neck.
Provenance: Presented by A.W. Franks, 11 July 1893 (H.O. Forbes).
Comments: Late nineteenth century, fresh cuts, manufactured recently before collecting (RN).

Fish-hooks, *matau*

One-piece bone fish-hooks

2101 **Plate 196**

+6077. Length 5.9 cm. Unbarbed, shank head with knob and small groove above it.
Provenance: Presented by A.W. Franks, 26 September 1892.

References: Beasley 1928: pl. I, middle left; Edge-Partington 1969 II.1: 234.9.

2102 **Plate 196**

+7059. Length 9 cm. Unbarbed, shank head with knob, outer curve notched.
Provenance: Presented by A.W. Franks, 11 July 1893 (H.O. Forbes).
References: Beasley 1928: pl. I, bottom left; Edge-Partington 1969 II.1: 234.8.

2103 **Plate 196**

+7060. Length 5.2 cm. Unbarbed, shank head with two grooves.
Provenance: Presented by A.W. Franks, 11 July 1893 (H.O. Forbes).
References: Beasley 1928: pl. I, top left; Edge-Partington 1969 II.1: 234.10.

Williams Collection (2104–2107)

2104 **Plate 196**

1898.10-21.66. Length 6.3 cm. Three external barbs, shank head with knob.
References: Beasley 1928: pl. I, bottom right.

2105 1898.10-21.67. Length 6.2 cm. Unbarbed, unusual perforation in flattened shank head.
References: Beasley 1928: pl. I, middle right.

2106 1898.10-21.68. Length 5.8 cm. Unbarbed, shank head with small knob.
References: Beasley 1928: pl. I, top right.

2107 1898.10-21.69. Length 4.3 cm. Unbarbed, shank head with knob.
References: Beasley 1928: pl. I, centre.

Beasley Collection (2108–2115)

Beasley catalogue: 1567A–E, registered 29 January 1926, 'Obtained in exchange with H.D. Skinner, Otago University Museum, Dunedin, N.Z.'; 1254, registered 7 November 1922, obtained from same source.

2108 **Plate 196**

1944 Oc.2.243. Length 6.4 cm. Unbarbed, shank head with knob, tip of point broken off; middle section of outer edge notched. Marked: 'D.25.1715 Chathams'. Beasley no. 1567B.

2109 1944 Oc.2.244. Length 6.5 cm. Unbarbed, shank head with knob; weathered. Marked: 'D.20.36'. Beasley no. 1567A. Label: 'John White Collection'.

2110 1944 Oc.2.245. Length 6 cm. Unbarbed, top of shank head broken off, outer curve beneath it notched; weathered. Marked: 'D 21-306'. Beasley no. 1567C.

2111 1944 Oc.2.246. Length 5.5 cm. Unbarbed, top of shank head notched. Marked: 'D 21-312'. Beasley no. 1567D.

2112 1944 Oc.2.247. Length 7 cm. Unbarbed, shank head with knob, blackened. Marked: 'D 19.32…'. Beasley no. 1567E. Label: 'John White Collection'.

2113 1944 Oc.2.248. Length 6.1 cm. Unbarbed, shank head with knob. Marked: 'D.21-313'. Beasley no. 1254. Register: 'ex Otago Museum'.

2114 1944 Oc.2.249. Length 5.5 cm. Unbarbed, top of shank head broken off. Marked: 'D 21-310'. Beasley no. 1254. Register: 'ex Otago Museum'.

2115 1944 Oc.2.250. Length 5.1 cm. Unbarbed, top of shank head with two grooves. Marked: 'D 21-311'. Beasley no. 1254. Register: 'ex Otago Museum'.

Fish-hook parts: bone points

2116

+7055. Length 11.2 cm. Unbarbed point of composite fish-hook (sea-mammal rib bone?).
Provenance: Presented by A.W. Franks, 11 July 1893 (H.O. Forbes).
References: Skinner 1923: pl. XII ,c.

2117

1898.10-21.71. Length 6.8 cm. Point of one-piece hook, one external barb.
Provenance: Williams Collection.

Beasley Collection (2118–2120)

Beasley catalogue: 2021, registered 20 July 1927, 'Bt Stevens Room ex Lot 549'.

2118 1944 Oc.2.251. Length 5 cm. Unbarbed, outer curve finely notched.
Beasley no. 2021.

2119 1944 Oc.2.252. Length 4.3 cm. Unbarbed, outer curve finely notched.
Beasley no. 2021.

2120 1944 Oc.2.253. Length 4.6 cm. One barb, two notches below on opposite side.
Beasley no. 2021.

Fish-hook parts: shanks

2121

+7056. Length 16.5 cm. Bone (sea-mammal rib?) shank of composite fish-hook, two opposing barbs at end for attachment of line.
Provenance: Presented by A.W. Franks, 11 July 1893 (H.O. Forbes).
References: Skinner 1923: pl. XII, a (where it is described as shank but it is possible that it might be point of large composite hook with wood shank).

Williams Collection (2122–2124)

2122 1898.10-21.70. Length 5.9 cm. Shank part of one-piece bone hook, slight knob.

2123 1898.10-21.72. Length 12 cm. Bone shank of trolling hook.
Label: '37'; Williams's list: '37, Bone implement used in making flax mats, found at Manukau'.

2124 1898.10-21.73. Length 9.9 cm. Haliotis-shell shank of trolling hook/inlay for *pa kahawai*.
Label: '36'; Williams's list: '36, Bait for Barracouta, found at Operau'.

Tools

Bone implements

2125

Shark teeth

1944 Oc.2.907. Length 4.6 cm. Two perforations. Marked: 'D 21-329'.
1944 Oc.2.908. Length 4.4 cm. One perforation. Marked: 'D.24.112. Kaingaroa. Chat. Isd.'

1944 oc.2.909. Length 3 cm. One perforation.
Marked: 'D.24.114. Kaingaroa. C.Id.'
1944 oc.2.910. Length 3.1 cm. One
perforation. Marked: 'D 21-330'.
1944 oc.2.911. Length 2.8 cm. One perforation.
Marked: 'Kaingaroa D.24-115. C.Id.'
1944 oc.2.912. Length 3 cm. One perforation
and another started; above one perforation
broken off. Marked: 'D.21-331'.
Provenance: Beasley Collection. Beasley
no. 1569.
Register: 'ex Otago Museum. Kaingaroa;
part of the blade of a knife.'
Comments: Eighteenth century (RN).
Beasley catalogue: 1569, registered 29
January 1926, 'Obtained in exchange with
H.D. Skinner, Otago University Museum
Dunedin N.Z.'

2126
Awl
+6079. Length 6.5 cm.

Flat, narrow, hollow bone, triangular cross
section, pointed.
Provenance: Presented by A.W. Franks,
26 September 1892.

**Presented by A.W. Franks, 11 July 1893
(H.O. Forbes) (2127–2134)**

2127 +7048. Length 8 cm. Curved hollow
tusk.
2128 +7050. Length 12.2 cm. Curved solid
tusk.
2129 +7051. Length 24 cm. Shellfish
opener, hollow bone, cut at angle at
both ends.
References: Edge-Partington 1969
II.I: 234.6; Skinner 1923: pl. IX, d.
2130 +7052. Length 19 cm. Needle, hollow
bone, cut at angle and pointed at one
end, other end cut straight with small
transverse slit near it on one side.
References: Edge-Partington 1969
II.I: 234.5.
2131 +7053. Length 11.3 cm. Awl. Hollow
bone, flattish.
References: Edge-Partington 1969
II.I: 234.4.
2132 +7054. Length 9.2 cm. Awl. Solid
curved bone.
References: Edge-Partington 1969
II.I: 234.3.
2133 +7057. Length 8.7 cm. Awl/picker.
Hollow bird bone.
References: Skinner 1923: pl. IX, e,
lower.
2134 +7058. Length 8.5 cm. Awl/picker.
Solid mammalian bone.
References: Skinner 1923: pl. IX, e,
upper.

2135
Q1980 oc.1287. Length 16.5 cm. Worked
bone. Piece of narwhal tusk/bone, cut flat
on one side and polished at tip; longitudinal
grooves and ridges on convex side.
Provenance: Unknown.

Chisels, *whao*

2136
+6085. Length 9.7 cm. Sandstone.
Provenance: Presented by A.W. Franks,
26 September 1892 (H.O. Forbes).
References: Skinner 1923: pl. XXV, l–m.

2137
+7062. Length 9.3 cm. Sandstone?
Provenance: Presented by A.W. Franks,
11 July 1893 (H.O. Forbes).
References: Edge-Partington 1969
II.I:236.2; Skinner 1923: pl. XXV, j–k.

2138
1895-933. Length 7.1 cm. Flint?
Circular cross section.
Provenance: Meinertzhagen Collection

2139
1898.10-21.52. Length 3.2 cm. Chert? Point
only.
Provenance: Williams Collection.

Grindstones

2140
Chat 7. Length 20 cm. Sandstone. Broken in
half and glued together.
Provenance: Hector/Colonial Museum
Collection.
Label: 'Stone used by Mori-ories to
sharpen axes. Pitt Island.'

2141
+6080. Length 10.2 cm. Schist.
Provenance: Presented by A.W. Franks,
26 September 1892 (H.O. Forbes).

2142
+6081. Length 21.5 cm. Sandstone.
Provenance: Presented by A.W. Franks,
26 September 1892 (H.O. Forbes).
References: Edge-Partington 1969 II.I:
236.3 (grinder illustrated with grindstone
cannot be identified).

2143
1898.10-21.55. Length 14.8 cm. Sandstone.
Provenance: Williams Collection.
Label: '1'; Williams's list: '1, Polishing
stone used in manufacture of cutting
implements.'

Blubber knives, *mata*

Beasley Collection (2144–2147)

2144 1944 oc.2.899. Length 20 cm.
Greywacke. Rough-out. Marked:
'D.24.2653'. Beasley no. 1562.
Label: 'Blubber knife "Mata" Otago
Museum 1562.'
Comments: Eighteenth century (RN).
Beasley catalogue: 1562, registered
29 January 1926, 'Obtained in
exchange with H.D. Skinner, Otago
University Museum, Dunedin, N.Z.'
2145 1944 oc.2.900. Length 20 cm. Schist.
Rough-out. Marked: 'D.24.227. Te
Wakaru Chat. Isd.' Beasley no. 1563.
Label: 'Blubber knife "Mata". Otago
Museum 1563.'
Comments: Eighteenth century (RN).
Beasley catalogue: 1563, registered
29 January 1926, 'Obtained in
exchange with H.D. Skinner, Otago
University Museum, Dunedin, N.Z.'
2146 **Plate 196**
1944 oc.2.901. Width 24.5 cm. Schist.
Rough-out.
Comments: Eighteenth century (RN).
Possibly Beasley no. 1892. Beasley
catalogue: 1892, registered 30
September 1926: 'Chatham Isl.
objects collected by J.V. Hodgson late
Curator of the Plymouth Museum,
who accompanied Capt. R.F. Scott
as Biologist to the Expedition of the

"Discovery" to the South Pole 1901-
4.'; 'Blubber knife of Schist. 9 ½".'
Measurement and small sketch of
this piece in Beasley's catalogue
correspond to 1944 oc.2.901.
2147 1944 oc2.902. Width 9 cm. Chert?
Rough-out. Marked: 'D.25.310'.
Beasley no. 1565.
Label: '1565'.
Register: 'ex Otago Museum'.
Comments: Eighteenth century (RN).

Flakes, *mata*

2148
Chat 6. Width 11.5 cm. Limestone?
Provenance: Hector/Colonial Museum
Collection.
References: Skinner 1923: pl. XXVI, d.

2149
9187. Length 7.6 cm. Chert.
Provenance: Presented by A.W. Franks,
18 February 1875.

2150
+6083. Length 11.2 cm. Chert.
Provenance: Presented by A.W. Franks,
26 September 1892 (H.O. Forbes).
References: Edge-Partington 1969
II.I:237.1.

2151
+6084. Length 13.6 cm. Chert.
Provenance: Presented by A.W. Franks,
26 September 1892 (H.O. Forbes).

**Presented by A.W. Franks, 11 July 1893
(H.O. Forbes) (2152–2163)**

2152 +7064. Length 8.5 cm. Chert.
References: Skinner 1923: pl. XXVI, f.
2153 +7065. Length 10 cm. Chert.
2154 +7066. Length 8.8 cm.Chert.
2155 +7067. Length 10 cm. Chert.
2156 +7071. Length 12.8 cm. Chert.
References: Edge-Partington 1969
II.I: 237.2.
2157 +7072. Length 13 cm. Chert.
2158 +7073. Length 6.2 cm. Chert.
2159 +7074. Length 7.5 cm. Flint.
2160 +7075. Length 8.8 cm. Flint.
2161 +7076. Length 6.4 cm. Chert.
2162 +7077. Length 4.1 cm. Flint.
2163 +7078. Length 3.6 cm. Chert.

2164
1895-934. Length 11.5 cm. Flint.
Provenance: Meinertzhagen Collection.

2165
1895-935. Length 7.5 cm. Chert.
Provenance: Meinertzhagen Collection.

2166
1898.10-21.51. Length 5.5 cm. Basalt.
Provenance: Williams Collection.

2167
1898.10-21.53. Length 14.5 cm. Flint.
Provenance: Williams Collection.
Label: '13'; Williams's list: '13, Blubber
knife, found at Tuapanga.'

Stone adze blades
Classification follows that of R. Duff's *The
Moa-Hunter Period of Maori Culture*; stone-
type determinations by Roger Neich from
hand-specimen examination only.

Type I A
Quadrangular, tanged. Thick, massive,
sometimes with lugs on poll, 'horned'.

Hector/Colonial Museum Collection (2168–2170)

2168 Chat 21. Length 18 cm. Basalt. Label: 'Found on Pitts Island.'

2169 Chat 22. Length 17.2 cm. Basalt.

2170 Chat 23. Length 22 cm. Basalt. Register: 'Pitts Island.'

Presented by A.W. Franks, 26 September 1892 (H.O. Forbes) (2171–2176)

2171 +6089. Length 24.7 cm. Basalt.

2172 +6090. Length 24 cm. Basalt.

2173 +6091. Length 22.8 cm. Basalt.

2174 +6093. Length 16.2 cm. Basalt.

2175 +6096. Length 17.3 cm. Basalt. References: Skinner 1923: pl. XVIII, f–g.

2176 +6098. Length 10.9 cm. Greywacke.

2177

+7040. Length 19.5 cm. White stone. Provenance: Presented by A.W. Franks, 11 July 1893 (H.O. Forbes)

Meinertzhagen Collection (2178–2186)

2178 1895-905. Length 25 cm. Basalt (with lugs).

2179 1895-907. Length 24 cm. Greywacke. References: Skinner 1923: pl. XXIII, c–d.

2180 1895-909. Length 22.3 cm. Basalt.

2181 1895-910. Length 18 cm. Basalt. References: Skinner 1923: pl. XVI, g–i.

2182 1895-915. Length 16.7 cm. Basalt.

2183 1895-916. Length 13.8 cm. Argillite.

2184 1895-921. Length 12.7 cm. Argillite.

2185 1895-924. Length 11.2 cm. Basalt.

2186 1895-925. Length 10.5 cm. Greywacke.

Williams Collection (2187–2192)

2187 **Plate 197**
1898.10-21.2. Length 35 cm. Basalt. References: Skinner 1923: pl. XVI, a–c.

2188 1898.10-21.3. Length 31 cm. Basalt.

2189 1898.10-21.5. Length 14.6 cm. Basalt.

2190 1898.10-21.9. Length 17 cm. Basalt. Label: '11'; Williams's list: '11, Adze, found at Wharekauri.'

2191 1898.10-21.30. Length 10 cm. Sandstone.

2192 1898.10-21.31. Schist. Length 8.9 cm. Register: '17'; Williams's list: '17. Chisel, found at Manukau.'

2193

1944 Oc.2.898. Length 5.5 cm. Basalt. Marked: 'D.21…453'.
Provenance: Beasley Collection. Beasley no. 1557.2.
Register: 'ex Otago Museum'.
Comments: Beasley catalogue: 1557.2, registered 29 January 1926, '…obtained in exchange with H.D. Skinner, Otago University Museum, Dunedin, N.Z.'

Type II A
Quadrangular, without tang. Rectangular section, front wider than back, possible incipient tang, small and thin.

2194

+6094. Length 20.4 cm. Basalt. Provenance: Presented by A.W. Franks, 26 September 1892.

2195

+7063. Sandstone. Length 8 cm. Provenance: Presented by A.W. Franks, 11 July 1893 (H.O. Forbes). References: Edge-Partington 1969 II.1: 237.5.

Meinertzhagen Collection (2196–2199)

2196 1895-912. Length 17.8 cm. Basalt.

2197 1895-913. Length 15.2 cm. Basalt.

2198 **Plate 197**
1895-927. Length 10.2 cm. Basalt.

2199 1895-931. Length 7.6 cm. Basalt.

Type II B
Quadrangular, without tang. Cross section between rectangular and lenticular.

Hector/Colonial Museum Collection (2200–2205)

2200 Chat 14. Length 7.5 cm. Basalt. Register: 'Main Island'.

2201 Chat 15. Length 7 cm. Basalt.

2202 Chat 16. Length 13.5 cm. Basalt. Label: 'Axe used by Mori-ories for carving. Main Island.'

2203 Chat 17. Length 17 cm. Basalt. Register: 'Pitts Island'.

2204 Chat 18. Length 17.4 cm. Basalt. Label: 'Found on Main Island.'

2205 **Plate 197**
Chat 20. Length 12.6 cm. Greywacke.

Presented by A.W. Franks, 26 September 1892 (H.O. Forbes) (2206–2222)

2206 +6092. Length 20 cm. Sandstone.

2207 +6095. Length 17.5 cm. Basalt. References: Skinner 1923: pl. XVIII, d–e.

2208 +6097. Length 12.3 cm. Basalt.

2209 +6099. Length 14.8 cm. Greywacke.

2210 +6100. Length 9.4 cm. Basalt.

2211 +6101. Length 11.8 cm. Basalt.

2212 +6102. Length 9.5 cm. Basalt.

2213 +6103. Length 7 cm. Basalt.

2214 +6104. Length 7.5 cm. Basalt.

2215 +6105. Length 9.3 cm. Basalt.

2216 +6106. Length 8 cm. Basalt.

2217 +6107. Length 8.5 cm. Sandstone.

2218 +6108. Length 6.3 cm. Argillite.

2219 +6115. Length 6.8 cm. Basalt.

2220 +6116. Length 11 cm. Basalt.

2221 +6117. Length 9 cm. Basalt.

2222 +6118. Length 12 cm. Basalt.

Presented by A.W. Franks, 11 July 1893 (H.O. Forbes) (2223–2232)

2223 +7035. Length 9.3 cm. Basalt. References: Edge-Partington 1969 II.1: 237.3.

2224 +7036. Length 15.7 cm. Basalt.

2225 +7037. Length 7.3 cm. Basalt.

2226 +7038. Length 7.5 cm. Basalt. References: Edge-Partington 1969 II.1: 236.6.

2227 +7039. Length 9 cm. Basalt. References: Edge-Partington 1969 II.1: 236.4.

2228 +7041. Length 17.7 cm. Breccia. References: Edge-Partington 1969 II.1: 236.5.

2229 +7042. Length 11.5 cm. Sandstone.

2230 +7043. Length 9 cm. Basalt.

2231 +7044. Length 11.5 cm. Basalt.

2232 +7045. Length 8.8 cm. Basalt. References: Edge-Partington 1969 II.1: 237.4.

Meinertzhagen Collection (2233–2244)

2233 1895-911. Length 9 cm. Basalt.

2234 1895-914. Length 16.3 cm. Basalt.

2235 1895-917. Length 14.3 cm. Basalt.

2236 1895-919. Length 12.6 cm. Basalt?

2237 1895-920. Length 12.5 cm. Argillite.

2238 1895-922. Length 10.7 cm. Basalt.

2239 1895-923. Length 10.8 cm. Greywacke.

2240 1895-926. Length 11.7 cm. Greywacke.

2241 1895-928. Length 8 cm. Sandstone.

2242 1895-929. Length 8.5 cm. Basalt.

2243 1895-930. Length 7 cm. Sandstone.

2244 1895-932. Length 5.4 cm. Basalt.

Williams Collection (2245–2266)

2245 1898.10-21.7. Length 19.7 cm. Basalt. Label: '5'; Williams's list: '5, Squaring Axe, found at Operau.'

2246 1898.10-21.8. Length 19.6 cm. Basalt. Register and label: '16'; Williams's list: '16, Adze, found at Waipurua.'

2247 1898.10-21.10. Length 12.7 cm. Basalt. Label: '28'; Williams's list: '28, Adze Rough, found at Waitangi West.'

2248 1898.10-21.11. Length 14.7 cm. Basalt. Label: '18'; Williams's list: '18, Adze, found at Manuakau [Manukau].'

2249 1898.10-21.12. Length 13.8 cm. Basalt. Label: '27'; William's list: '27, Adze, found at Te Raki.'

2250 1898.10-21.13. Length 11.8 cm. Basalt.

2251 1898.10-21.14. Length 24.5 cm. Basalt. Label: '25'; Williams's list: '25, Squaring Axe, found at Ngatikitiki.'

2252 1898.10-21.15. Length 25.6 cm. Basalt.

2253 1898.10-21.26. Length 12.5 cm. Basalt. Label: '6'; Williams's list: '6, Canoe Adze, found at Te Raki.'

2254 1898.10-21.28. Length 9.3 cm. Basalt.

2255 1898.10-21.29. Length 12.3 cm. Basalt (broken).

2256 1898.10-21.32. Length 8 cm. Basalt. Label: '2'; Williams's list: '2, Canoe chisel, found at Waihi Beach.'

2257 1898.10-21.33. Length 6.8 cm. Basalt.

2258 1898.10-21.35. Length 7.3 cm. Basalt. Register: '23'; Williams's list: '23, Chisel, found at Waihi.'

2259 1898.10-21.38. Length 6.6 cm. Basalt. Label: '10'; Williams's list: '10, Graving Tool, found at Wharekauri.'

2260 1898.10-21.39. Length 6.8 cm. Sandstone.

2261 1898.10-21.40. Length 6 cm. Basalt. Label: '19'; Williams's list: '19, Carving implement, found at Wareama.'

2262 1898.10-21.41. Length 6 cm. Basalt. Label: '24'; Williams's list: '24, Small chisel, found at Te Raki.'

2263 1898.10-21.42. Length 6.3 cm. Basalt.

2264 1898.10-21.44. Length 9.6 cm. Basalt.

2265 1898.10-21.46. Length 7.2 cm. Basalt.

2266 1898.10-21.47. Length 6.3 cm. Sandstone.

2267

1928.1-10.41. Length 8.8 cm. Basalt. Provenance: Liversidge Collection. References: Liversidge 1894: 241, pl. XXVI, top.

2268

1944 Oc.2.897. Basalt. Length 18.2 cm. Marked: 'D.24.37'. Provenance: Beasley Collection. Beasley no. 1558. Register: 'ex Otago Museum'.

2269

Q1981 Oc.1920. Length 7.3 cm. Basalt. Provenance: Franks Collection. Label: 'AWF [A.W. Franks] 26 Sept. 92.'

2270

Q1981 Oc.1924. Length 10.2 cm. Sandstone. Provenance: Unknown. Label: 'Adze blade 41.'

Hawke's Bay type

Rounded quadrangular section, incipient tang, some with decoration on poll.

2271 **Plate 197**

1895-906. Length 22.5 cm. Basalt.
 Provenance: Meinertzhagen Collection.
 References: Skinner 1923: pl. XXIII, a–b.

Type III A

Triangular, apex to back, tanged.

2272 **Plate 198**

1895-918. Length 16 cm. Argillite.
 Provenance: Meinertzhagen Collection.

Type III B

Triangular, apex to back, no tang.

2273 **Plate 198**

+6114. Length 6 cm. Basalt.
 Provenance: Presented by A.W. Franks,
26 September 1892 (H.O. Forbes).

Type IV A

Triangular, apex to front, 'hog-backed', tanged. Narrow cutting edge.

2274 **Plate 198**

1895-908. Length 23.5 cm. Basalt.
 Provenance: Meinertzhagen Collection.

Type IV B

Triangular, apex to front, 'hog-backed', tanged. Wide cutting edge.

2275 **Plate 198**

1898.10-21.1. Length 22.5 cm. Basalt.
 Provenance: Williams Collection.
 References: Skinner 1923: pl. XX, a–c.

Rough-outs

**Hector/Colonial Museum Collection
(2276–2281)**

2276 Chat 8. Length 31.8 cm. Basalt.
 Label: 'Found at Pitts Island.'

2277 Chat 9. Length 24.5 cm. Schist.
 Label: 'Found at Pitts Island.'
2278 Chat 10. Basalt. Length 20.5 cm.
 Label: 'Found at Pitts Island.'
2279 Chat 11. Length 15.3 cm. Basalt.
 Label: 'Found at Pitts Island.'
2280 Chat 12. Length 8.3 cm. Basalt.
 Label: 'Found at Pitts Island.'
2281 Chat 13. Length 10.8 cm. Basalt.

**Presented by A.W. Franks, 26 September
1892 (H.O. Forbes) (2282–2289)**

2282 +6086. Length 12.8 cm. Basalt.
2283 +6087. Length 16.8 cm. Basalt.
2284 +6088. Length 13 cm. Basalt.
2285 +6109. Length 8.8 cm. Sandstone.
2286 +6110. Length 17.5 cm. Schist.
2287 +6111. Length 12 cm. Sandstone.
2288 +6112. Length 19.7 cm. Basalt.
2289 +6113. Length 13.5 cm. Sandstone.

**Presented by A.W. Franks, 11 July 1893
(H.O. Forbes) (2290–2294)**

2290 +7046. Length 16.5 cm. Basalt.
2291 +7047. Length 10.7 cm. Basalt.
2292 +7068. Length 7.8 cm. Basalt.
2293 +7069. Length 5.6 cm. Basalt.
2294 +7070. Length 12 cm Sandstone.
 Blank.
 References: Edge-Partington 1969
II.I: 236.I.

Williams Collection (2295–2313)

2295 1898.10-21.6. Length 21.3 cm. Basalt.
 Label: '26'; Williams's list: '26, Rough
 squaring axe, found at Waipurua.'
2296 1898.10-21.16. Length 26 cm. Basalt.
 Label: '22'; William's list: '22, Rough
 Adze, found at Bush Morerua.'
2297 1898.10-21.17. Length 22.2 cm. Basalt.
 Register: '29'; Williams's list: '29,
 Adze Rough, found at Operau.'
2298 1898.10-21.18. Length 17.4 cm. Basalt.

Label: '30'; Williams's list: '30, Adze
 Rough, found at Operau.'
2299 1898.10-21.19. Length 15.3 cm. Basalt.
 Label: '34'; Williams's list: '34, Rough
 Chisel, found at Operau.'
2300 1898.10-21.20. Length 13 cm. Basalt.
 Label: '33'; Williams's list: '33, Rough
 Adze, found at Operau.'
2301 1898.10-21.21. Length 12 cm. Basalt.
 Label: '31'; Williams's list: '31, Rough
 Chisel, found at Operau.'
2302 1898.10-21.22. Length 12.7 cm. Basalt.
 Label: '32'; Williams's list: '32, Rough
 Chisel, found at Operau.'
2303 1898.10-21.23. Length 12.5 cm. Basalt.
2304 1898.10-21.24. Length 12 cm. Basalt
 (broken).
 Label: '9'; Williams's list: '9, Rough
 Tomahawk, found at Operau.'
2305 1898.10-21.25. Length 15.2 cm. Basalt.
2306 1898.10-21.27. Length 10 cm.
 Sandstone.
2307 1898.10-21.34. Length 7.8 cm. Basalt.
2308 1898.10-21.36. Length 8.2 cm. Basalt.
 Label: '7'; Williams's list: '7, Chisel,
 found at Tuapanga.'
2309 1898.10-21.37. Length 7.4 cm. Basalt.
2310 1898.10-21.43. Length 8.2 cm. Basalt.
 Label: '8'; Williams's list: '8, Chisel,
 found at Kaingaroa.'
2311 1898.10-21.48. Length 11 cm. Basalt.
 Label: '4'; Williams's list: '4, Rough
 Tomahawk, found at Waipurua.'
2312 1898.10-21.49. Length 9.8 cm.
 Sandstone.
2313 1898.10-21.50. Length 4.3 cm. Basalt
 (broken portion).

2314

Q1981 Oc.1921. Length 7.8 cm. Sandstone.
 Provenance: Franks Collection.
 Label: 'AWF [A.W. Franks] 26 Sept. 92.'

Maori-style objects

Maori-style objects made by non-Maori constitute a diverse and complex field, subject to all the ambiguities and shifting fashions of the questions of falseness and authenticity. The three basic categories of objects covered by this field are:

1 fakes and forgeries, deliberately made to deceive; objects definitely known to have been made by persons of non-Maori descent with the intention to deceive are the easiest to deal with;
2 replicas of authentic Maori items, and
3 art objects of recognizable form inspired by Maori art but with innovations and variations beyond the traditional.

 It is often very difficult to distinguish between these categories, especially 1 and 2. This distinction depends on knowing the original intention of the producer, and given the usual absence of any original documentation, consequently becomes a subjective opinion based on prior experience and cultural knowledge. Even more problematic is the frequent situation in which the innocent intention of the replica producer is subverted, misconstrued or deliberately misrepresented by later owners or commentators. The situation in which replicas and fakes have been accepted as authentic by Maori is also difficult. This would include

some category 3 objects that have no actual precedent in traditional Maori material culture, but which have become accepted into contemporary Maori culture and are valued by some Maori as authentic. Examples are naturalistic portrait heads of Maori carved out of kauri gum by late nineteenth-century gumdiggers and other amateur artists, and category 3 modern art objects, especially personal ornaments and musical instruments, such as those made in New Zealand by Brian Flintoff of Nelson (represented in the British Museum) and Owen Mapp of Wellington.

 All of these three categories are defined here for convenience as if made by persons of non-Maori descent. Of course people of Maori descent were sometimes involved in making replicas, fakes and innovative art objects. Again, it is often very difficult to determine the ethnic origin of the producers and it simply becomes a matter of opinion. It is especially challenging to distinguish an item made by an untrained Maori from a European attempt. Objects that could be classified as fakes or replicas, but which are considered by the authors to have been made by persons of Maori descent, are included under their typological category in the main catalogue, usually with a comment as to their status.

Fakes and replicas have been made in New Zealand, England and Germany, and possibly other places too, from the early years of contact until the present. Early replicas include the nephrite *mere* clubs, *hei-tiki* and other pendants made in New Zealand by the Devlin brothers of Dunedin and in Germany by master craftsmen in the gem-cutting centre of Idar-Oberstein. Many of these nephrite items were acquired by Maori families, where they became regarded as tribal heirlooms and often eventually ended up in museum collections, including perhaps the British Museum. Wooden carvings are the most susceptible to replica making and faking. New Zealand museums and tourist venues have often employed European woodcarvers to produce replicas:

Thomas Chappe Hall at Auckland and Dunedin museums in the 1920s and 1930s and Cliff Curtiss at Wellington in the 1960s and 1970s. There is a long and honourable tradition of European woodcarvers in the Maori style working in New Zealand, some as amateur hobbyists, such as Arthur Percy Godber and Jock McEwen, both of whom also produced carvings for Maori buildings. The two most blatant fakers operated in England: James Frank Robieson from New Zealand after the First World War and the Englishman James Edward Little in the earlier twentieth century produced a wide range of wood and bone carvings. Both of these men have their work represented in the British Museum collection (see Skinner 1974).

2315
Bailer
Q1981 Oc.1382. Length 43 cm.

Wooden bailer: long, shallow, scoop-shaped, of very light wood; crude face on posterior rim, its tongue forming median handle.
Provenance: Wellcome Collection?
Register: '[Wellcome coll.?] 15003 Lot 393'.
Label: 'K 191556', reverse: 'MA HH A'.
Comments: Fake (RN); reproduction (DRS).

2316 Plate 199
Figure
1927.1-7.1. Height 28 cm.

Wooden male figure: standing, naturalistic face with tattoo and haliotis-shell eyes and nipples, three-fingered hands on abdomen, heavy lower body with pronounced genitals, short legs; free-standing, supported by legs and testicles; surface decoration of *rauponga* and *whakarare*, with spirals on sides of buttocks.
Provenance: Presented by Miss Hirst.
Comments: Fake, carved by J.E. Little, see Legge and Nash 1969 (RN); similar in Taranaki Museum, New Plymouth, New Zealand, no. A46.830 (DCS).
References: Jones 1990: 233.255.

2317
Head
1960 Oc.1.1. Length 10 cm.

Pumice human head: flat back, overhanging brow, no eyes, prognathous jaw, sharp, fresh cut under nose. Marked: '3/8 56 J.R.H.'
Provenance: Presented by Miss J.R. Harding.
Register: 'Found while excavating a moa-hunter site at the mouth of the Kaikorai River, Green Island District, near Dunedin, Otago, New Zealand.'
Comments: Sharp, fresh cuts on facial details, non-Maori style of carving (RN).
References: Harding 1957: 119.

2318 Plate 199
Bowl with lid
Q1981 Oc.1392. Height 33 cm.

Wooden bowl: circular, supported on shoulders of two outward opposing naturalistic human figures, sitting on third figure, which is on all fours, with foreshortened body and *wheku* (?)-style face. All figures have haliotis-shell eyes (one missing); male figures have face tattoo, arms with three-fingered hands raised to support bowl. Entire piece is blackened and has surface ornamentation of spirals, *rauponga* and *whakarare*.
Provenance: Wellcome Collection?
Register: 'Possibly from Wellcome Collection. A115683 R48854.'
Comments: Fake, carved by J.E. Little (RN).

2319
Treasure-box lid
Q1980 Oc.1289. 51 × 19.5 cm.

Wooden lid: rectangular, with two opposing prone human figures, carved as separate pieces, *wheku*-style faces, line of *pakati* along centre of trunks serving as handles; each figure nailed to lid in two places.
Provenance: Unknown.
Register: 'Written on reverse of lid: "Fake lid made for the feather box from the Devizes Museum 1925–44 [217] the lid of which was stolen.' (Eth.Doc.588.).
Comments: Fake, carved by J.E. Little (see Skinner 1974:188) (RN).

2320
Pendant
1953 Oc.5.4. Length 13.6 cm.

Anthropomorphic bone pendant: *hei-tiki* style, head to right, left hand on chest, right near genital area; haliotis-shell eyes set in red sealing wax, flat, brown-stained back with perforation for suspension cord at top.
Provenance: Bequeathed by G.C. Nickels per Messrs Miller, Taylor and Holmes.
Comments: Fake.

2321
Pendant
1982 Oc.1.10. Length 5.6 cm.

Anthropomorphic nephrite pendant: *hei-tiki* style, homogenous dark green; head to left, hands on hips, sharply cut features, flat-cut back. Marked 'R 10192/1936'.
Provenance: Transferred from Wellcome Museum of Medical Science.
Comments: 'One green soap tiki made by Miss E. Richmond' (Eth.Doc.960).
Machine-made fake (RN).

2322
Pendant
1884.3-11.1. Length 8 cm.

Anthropomorphic glass pendant: *hei-tiki* style, mottled dark green; head to left, pearl-shell eyes, no face features, hands on hips; lower part of body broken off.

Provenance: Presented by R.H. Soden Smith.
Comments: Reproduction (RN); European (DRS).

2323
Pendant.
1899-16. Length 9.8 cm.

Whale-tooth pendant: *aurei* style, raised, twisted human face carved in middle; perforation for cord at top.
Provenance: Presented by C.H. Read, 22 June 1899.
Comments: Fake? (RN).

2324 Plate 200
Pendant
1994 Oc.4.101. Length 9 cm.

Whale-tooth pendant: carved in openwork; thin, black-braided suspension cord with two small whale-tooth toggles.
Provenance: Collected in the field.
Comments: Carved by Brian Flintoff of Richmond, Nelson. Pendant is named Te Puoro Hou and illustrates story of Raukatauri, goddess of flute music. At the top it is carved in an ancient style adapted from an early South Island whale tooth carving. Below, Kokako [New Zealand wattlebird, *Callaeas cinerea*] is carved in a contemporary style. Similarly, classic manaia faces representing the whakapapa of the words, are shown along one side. These contrast with the ancient style manaia on the other side which represent the whakapapa of the tunes. The manaia at the top represent the concept of Hani and Puna, while the centre holes are the spirit of Raukatauri (carver's description, Eth. Doc.1051).

2325
Three necklaces
1979 Oc.6.1–3. Lengths 57, 38 and 37 cm (doubled).

Brown seeds of *Planchonella costata* strung on thin, brown, twisted string.
Provenance: Presented by A.T. Porter.
Register: 'This necklace of seeds of *Planchonella costata* (Maori name – *tawapou*) is a facsimile of one in the Auckland Museum which was given by Sir George Grey about 1864. As far as is known at present, the Grey necklace is the only known museum specimen of Maori origin in existence.' (Eth.Doc.1178).

2326

Hafted tattoo chisel

1953 oc.5.5. Length 17.2 cm.

Wooden handle: flat, pointed end, top carved as human head with haliotis-shell eyes. Shark tooth lashed in its mouth as blade; surface ornamentation of curved band of *rauponga*.

Provenance: Bequeathed by G.S. Nickels.

Comments: Fake (RN).

References: Barrow 1962: 254–5; Barrow 1969: fig. 165.

2327

Flute

1994 oc.4.100. Length 14 cm.

Deer-bone *koauau*-style flute, carved all over.

Provenance: Collected in the field.

Comments: Carved by Brian Flintoff of Richmond, Nelson. Flute is named Te Kai Puoro and illustrates story of Raukatauri, goddess of flute music: near blowing end Maui is shown as hawk, with other birds around him; near other end is kokako (New Zealand wattlebird, *Callaeas cinerea*), with *manaia* face representing *toutouwai* (bush robin, *Petroica australis*); large face encircling blowing end is *koauau*'s face, and face with two noses at other end signifies two breaths (player's and instrument's) needed to make music; two *manaia* around centre represent dual tradition of words and music; finger holes are carved as raised faces (carver's description, Eth.Doc.1051).

2328

Flute

1994 oc.4.99. Length 47 cm.

Wooden *putorino*-style flute, of two pieces fitted together (glued?) and lashed with bands of flat, braided, brown synthetic cord; central face and human figure with haliotis-shell eyes.

Provenance: Collected in the field.

Comments: Carved by Brian Flintoff of Richmond, Nelson. Flute is named Te Tungou Puoro and illustrates story of Raukatauri, goddess of flute music: its shape resembles her incarnation as case moth (*Oeceticus omnivorous*) and she is shown as face at central hole, whereas male moth is carved as human figure at top; two *manaia* faces at other end remind that it takes two breaths to make music, that of player and that of instrument (carver's description, Eth.Doc.1051).

2329

Trumpet

1954 oc.6.291. Length 29 cm.

Hourglass-shaped gourd: large scalloped opening at wide end, flat braided vegetable-fibre wrapping covered with red resin (?) near mouthpiece of whale ivory, carved with two semicircles, their convex outer edge with parallel line of small notches, one each side, and between them pointed ovals filled with similar notching; round braided cord at waist of gourd.

Provenance: Wellcome Collection. Wellcome Museum no. 193572.

Comments: Fake, probably carved by J.F. Robieson (RN).

2330

Trumpet

1954 oc.6.292. Length 35 cm.

Triton-shell *putatara*-style trumpet: whale-tooth mouthpiece, carved with two triangles filled with spirals, one each side, and V-shaped rows of *pakati* between them, flat braided-flax (?) cord lashing; hole in body of shell filled in with haliotis shell, fixed with strips of shark skin (?) and pinkish paste; suspension-cord hole near scalloped side of opening.

Provenance: Wellcome Collection. Wellcome Museum no. 241617.

Comments: Fake, probably carved by J.F. Robieson (RN).

2331

Genealogical staff

1982 oc.1.8. Length 85 cm.

Bone staff, carved at top with naturalistic figure in the round, standing, hands on lower abdomen, with curved parallel lines below it; large central part scalloped on one side, with 21 shallow chevroned projections, on each side of which there is a wavy line of notching, following shape of scallops; lower part of staff plain. Marked: 'R 3794/1937'.

Provenance: Transferred from Wellcome Museum of Medical Science.

Comments: Fake, probably carved by J.F. Robieson (see Skinner 1974: 182–7) (RN).

2332

Ceremonial adze

1709. Length 45.5 cm.

Hafted adze: brown wooden shaft of circular cross section with non-traditional surface ornamentation; sharply squared and bevelled blade of dark green mottled nephrite. Haft in three parts: squared foot, lashed to shaft with thin braided cord, decorated with geometric design and 'fern-leaf' pattern, heel with rounded projection carved with notches creating 'pine cone', underneath plain triangular piece of lighter wood nailed to it; shaft with diagonal criss-cross narrow bands of notches and two longitudinal bands of 'fern-leaf' pattern; proximal end of shaft rounded, with notches forming 'pine cone', and lashing of thin plain braid above it.

Provenance: Unknown.

Comments: A European-made imitation (RN); Wanganui, a late tourist adze with separate head (DRS).

2333

Hand club

1923.5-7.1. Length 38.2 cm.

Whalebone *patu*-style club: thick blade, very slightly marked shoulders; non-traditional butt decoration of openwork *manaia*, with *whakarare* and haliotis-shell eyes, ending in five-fingered hand; large round hole, black stain in grooves.

Provenance: Presented by James Baird. Register: 'Obtained by donor's father in New Zealand.'

Comments: Replica, 1900s (RN); reproduction *patu paraoa* (DRS).

2334

Hand club

Q1981 oc.1380. Length 31.5 cm.

Nephrite *mere pounamu*-style club: very dark green; wide, rather blunt blade, no shoulders, wide butt with five grooves, hole for cord in centre of grip/neck.

Provenance: Unknown.

Comments: Fake.

References: Jones 1990: 233.256 b.

2335 Plate 200

Hand club

1936.2-6.1. Length 36.5 cm.

Bronze *patu onewa*-style club, with coat of arms and 'Ios. Banks Esq. 1772' engraved on blade.

Provenance: Beasley Collection. Presented by H.G. Beasley.

Comments: European, cast for Sir Joseph Banks in Eleanor Gyles's foundry, Shoe Lane, London, and engraved by Thomas Orpin, Engraver, Strand, London (Coote 2008: 54) in anticipation of Captain Cook's second voyage, in which Banks did not take part.

The *patu* has the flattened butt found on Northern South Island clubs. The original would appear to have been a First Voyage *patu* from northern South Island (DRS).

References: Coote 2008: 49, 54, 58, 62; Joyce 1936: 174–5; Newell 2003: 252, fig. 239; Newell 2005: 83, pl. 6.

2336

Hand club

1944 oc.2.821. Length 40 cm.

Iron *patu*-style club: butt with two grooves, hole in centre of neck/grip, flat blade; traces of paint.

Provenance: Beasley Collection. Beasley no. 301.

Comments: European manufacture, probably for same purpose as **2335** (1936.2-6.1).

Beasley number in Register is transcribed incorrectly; it should be 307. Beasley catalogue: 307, registered 4 November 1907, 'Bt A.E. Jamrach'.

References: Beasley 1927: 297–8; Coote 2008: 64.

2337

Hand club

1944 oc.2.822. Length 37.5 cm.

Iron *patu*-style club, butt with two grooves, thick blade, narrow neck/grip with hole; many traces of green paint.

Provenance: Beasley Collection. Beasley no. 306.

Comments: European manufacture, probably for same purpose as **2335** (1936.2-6.1).

Beasley catalogue: 306, registered 4 November 1907, 'Bt A.E. Jamrach'.

References: Beasley 1927: 297–8; Coote 2008: 64.

2338

Fish-hook

1954 oc.6.297. Length 8.7 cm.

Bone one-piece fish-hook: asymmetrical; point cut diagonally, notched and pointed at both ends; three groves in shank head.

Provenance: Wellcome Collection. Wellcome no. 48957.

2339

Composite adze

1954 oc.6.290. Length 40.5 cm.

Bone haft with stylized human face on butt and hole for cord behind it, heel carved with

spiral on each side; nephrite blade, dark green, lashed to haft with flax fibre.

Provenance: Wellcome Collection. Wellcome Museum no. 211819.

Comments: Fake (RN); European piece (DRS).

2340
Hafted chisel
1944 Oc.2.823. Length 19.1 cm.

Nephrite blade: very thin, homogeneous translucent medium green. Wooden haft: brown, distal half with binding of thin commercial cord, proximal half with binding of thick, braided coconut fibre, butt carved as face with large open mouth and protruding tongue, one haliotis-shell eye.

Provenance: Beasley Collection.

Label: '15 11/26'.

Comments: Reconstruction, non-functional blade (RN).

Beasley catalogue: material registered 15 November 1926, 'The Peek collection. Collected between 1850–80 of Rousden, Devon, purchased of the Grandson. Sir Wilfrid Peek. Bart'; addition next to this collection: 'A greenstone chisel mounted in a wooden handle. The end carved with a mask having one shell eye. The lashings although contemporary are partly sennit. A piece of doubtful origin. Was in the Peek Collection 1850–1883.'

2341
Decorated basket
1994 Oc.4.70. Width 50 cm, length 34 cm.

Rectangular basket: *kete whakairo*-style, plaited from strips of flax leaf 3–4 mm wide, dextrals dyed green, sinistrals red, decorated with concentric rectangles of twilled patterns, with superimposed three-strand braid of dyed-green fibre; nine broken univalve shells on one side. Handles of dyed-green fibre in flat nine-strand braid; lining of brown hessian attached to rim of basket with narrow black leather strip.

Provenance: Collected in the field.

Comments: Made by Sandra Paratene of Manutuke, East Coast, and affiliated to Rongowhakaata by marriage.

Kauri-gum carvings

2342
Male head
+5767. Height 32 cm.

Naturalistic, larger than life-size head with neck, with incised and carved face tattoo; very dark brown, eyes lighter brown.

Provenance: Presented by A.W. Franks, 8 September 1892 (Harding).

Register: 'Obtained in the Maori war.'

2343
Male head
1934.5-5.8. Height 9 cm.

Naturalistic small head, with incised unconventional male face tattoo; uneven, flattish back.

Provenance: Presented by Miss Marion Darby.

Register: 'Collected by donor's father between 1880–82.'

2344
Carved plaque
1934.12-5.1. Width 23 cm, length 19.5 cm.

Rectangular black plaque. Glued to it is high-relief carving of upper half of woman's body, wrapped in cloak and carrying baby on her back. Woman's face with black-painted lips and chin tattoo, painted black hair and white-and-black eyes; similar hair and eyes in baby. Cloak of *korowai ngore*-type, with tags and pompoms painted black.

Provenance: Bequeathed by T.B. Clarke Thornhill.

2345
Male head
1934.12-5.2. Height 12 cm.

Small naturalistic head, with incised and painted black face tattoo, carved moustache, eye painted white and black.

Provenance: Bequeathed by T.B. Clarke Thornhill.

2346
Male head
1934.12-5.3. Height 10.5 cm.

Small naturalistic head on pedestal (broken off), with painted black hair and face tattoo, eyes painted white and black.

Provenance: Bequeathed by T.B. Clarke Thornhill.

2347
Female head
1934.12-5.4. Height 9.5 cm.

Small naturalistic head on low pedestal, with painted black lips and chin tattoo; long hair painted black, face yellowish brown, eyes painted white and black.

Provenance: Bequeathed by T.B. Clarke Thornhill.

2348
Male head
1945 Oc.5.4. Height 10.3 cm.

Small naturalistic head, with crude and poorly carved face tattoo, back cut off flat; translucent gum.

Provenance: Bequeathed by Oscar Raphael.

2349
Male head
1946 Oc.6.1. Height 34.5 cm.

Larger than life-size head and neck on low circular pedestal (with piece broken off it); incised face tattoo.

Provenance: Presented by Miss L.M. Vickers.

2350
Male head
1946 Oc.6.2. Height 35 cm.

Life-size head and neck on low oblong pedestal (back of head, neck and pedestal broken off in two pieces); carefully executed incised face tattoo, carved moustache.

Provenance: Presented by Miss L.M. Vickers.

2351
Plaster cast of man's face
1854.12-29.93. Length 25 cm.

Painted brown; tattoo, eyebrows and lashes painted in black; tattoo pattern incomplete.

Provenance: Grey Collection.

Comments:

Plaster cast impression of Te Taupua, eldest son of Te Whanoa and descendant of Pukaki of Ngati Whakaue, Rotorua. Te Taupua was a renown carver of Ngati Whakaue who lived in Ohinemutu and met with Sir George Grey in late December 1849 at Te Ngae, where he was persuaded to have his tattooed face cast: 'Moko purewa'; Te Taupua had no issue.

(Information provided by Paul Tapsell, descendant of Pukaki, of Auckland Museum, February 1996.)

Collectors, donors, vendors, institutions

Abbreviations

ADB – *Australian Dictionary of Biography – Online Edition*

BM – British Museum

BM AOA – British Museum, Department of Africa, Oceania and the Americas (formerly Department of Ethnography)

BM PE – British Museum, Department of Prehistory and Europe (formerly Department of Medieval and Later Antiquities); correspondence includes Incoming letters in boxes, arranged alphabetically by year, and Out letters, in bound volumes, arranged by year and date within it.

BMQ – *British Museum Quarterly*

DNZB – *Dictionary of New Zealand Biography*

ODNB – *Oxford Dictionary of National Biography*

RAI – Royal Anthropological Institute of Great Britain and Ireland

Abraham, Charles John (1814–1903) – ordained 1839, went to New Zealand in 1850, consecrated Bishop of Wellington in 1857, returned to England in 1870. (McLintock 1966)

Andrade, C. – dealer, active in the 1920–1930s.

Angas, George French (1822–86) – artist and naturalist, sailed to Australia in 1843, where he travelled intensively, also visiting New Zealand in 1844. Watercolour drawings resulting from his travels were published in 1847 and are important documents illustrating local flora, fauna and material culture. He was also a collector, his large collection of shells and entomological specimens is in the Natural History Museum in London. (Tregenza 1980)

Arley Castle – large collection formed by George Annesley (1770–1844), 2nd Earl of Mountnorris, at Arley Castle, Staffordshire; items from this collection were sold mainly to Joseph Mayer, but some were acquire by the Museum in 1854 and through the Christy Collection in the 1860s. (BM Merlin database)

Bateman, Thomas (1821–61) – antiquary and archaeologist; established museum in his house, Lomberdale House, near Middleton, for his collection, which was dispersed after his death: Sheffield Museum purchased archaeological material, other artefacts auctioned by Sotheby's in 1893, rest sold in 1895 after his son's death. (ODNB)

Beasley, Harry G. (1882–1939) – wealthy brewery owner and collector, with particular interest in Pacific cultures, his collection was displayed in his own Cranmore Ethnographical Museum in Chislehurst, Kent, which was bombed during Second World War, though the collection survived and was housed in the British Museum for safekeeping. In 1944 the collection, left to Mrs Beasley on her husband's death, was offered to six museums in Britain, the British Museum having first choice. In 1975 Beasley's daughters presented his own four-volume catalogue to the Museum. (Waterfield and King 2006: 79–92)

Bennet, George (1775–1841) – member of the London Missionary Society deputation which visited LMS stations around the world from 1821–9, he contributed to an ethnographical collection made by the Society, a large part of which came to the British Museum in 1890, first on loan, then purchased in 1911. (Woroncow 1981)

Boynton, Thomas – FSA, Hon. Curator of York Museum.

Blackmore Museum – established in 1860, by the family of the financier William Blackmore; amalgamated with the Salisbury and South Wiltshire Museum in 1902; in 1931 its American antiquities were purchased by the British Museum and its ethnographical part by Beasley. (Waterfield and King 2006: 14)

Braunholtz, Hermann Justus (1888–1963) – British Museum staff member between 1913 and 1953; first with T.A. Joyce as assistant to O.M. Dalton at the Department of British and Medieval Antiquities and Ethnography, from1938 as Deputy Keeper in charge of Ethnography at the Department of Oriental Antiquities and Ceramics, and finally from 1946 as Keeper of the Department of Ethnography. (Wilson 2002)

Bragge, William (1823–84) – civil engineer and steel manufacturer, collector of books, gems, pipes and smoking apparatus (ODNB). Part of his collection was given to the Sheffield Museum in 1881 and some objects were presented by him to the Christy Collection in 1869. (BM central archives: Original papers vol. 1, 1870. Reg. no. 1442)

Brenchley, Julius Lucius (1816–73) – traveller, author, collector; travelled in New Zealand in 1846; bequeathed bulk of his collection to Maidstone, his home town. (ODNB)

Buller, Sir Walter Lawry (1838–1906) – ornithologist, author of *History of the Birds of New Zealand*, and collector of natural-history specimens, especially birds; he presented his collection of bird skins to the Colonial (later Dominion and now Museum of New Zealand Te Papa Tongarewa) Museum of New Zealand. (McLintock 1966)

Campbell, Walter Lorne (1845?–74) – school friend and partner of Frederick Huth Meinertzhagen in Waimarama, Hawkes Bay, with whom he arrived in New Zealand in 1866; died in an accident in Waimarama. (Grant 1977; Campbell's Journal)

Casimir, L. – London dealer, active in the 1930s.

Christie's – auction house, established in London in 1776 by James Christie.

Christy, Henry (1810–65) – banker, textile manufacturer, collector, anthropologist, travelled widely. His collection was housed at his private museum at 103 Victoria Street, London. On his death the ownership of the collection was transferred by his Trustees to the British Museum, although the collection itself stayed at Victoria Street until 1884 when it was moved to the British Museum. (ODNB)

Clarke Thornhill, Thomas Bryan (1857–1934) – secretary in Diplomatic Service 1881–1900 and collector; his notable collection of English and Irish coins was left to the British Museum in 1936 (BMQ 1936: 156–60; BM Merlin database).

Colenso, William (1811–99) – missionary of the Church Missionary Society, explorer, botanist, printer, scholar of Maori culture; went to New Zealand in 1834, travelled on missionary business, took part in local politics. (McLintock 1966)

Cook, Captain James (1728–79) – naval officer and explorer, commanded three Pacific expeditions, 1768–71, 1772–5, 1776–80. Some of the ethnographical material collected on these voyages came to the British Museum. (ODNB; Kaeppler 1978)

Cumberland Museum – see Wallace Collection/Museum.

Cuming, Hugh (1791–1865) – naturalist, traveller, collector of natural-history specimens; built his own yacht and sailed in the Pacific for a year in 1826 and in Asia from 1835; his collection dispersed among museums in Britain and abroad. (ODNB)

Cutter – a family of London dealers; Franks often bought from them for donations to the Christy Collection at the British Museum in the second half of the nineteenth century. (Waterfield and King 2006: 59)

Dalton, Ormond Maddock (1866–1945) – British Museum staff member between 1895 and 1927, at the Department of British and

Medieval Antiquities and Ethnography, from 1921 as Keeper of British and Medieval Antiquities; scholar of Early Christian and Byzantine antiquities, author of numerous catalogues on the subject. (Wilson 2002)

Distington Museum – see Wallace Collection/Museum.

Edge-Partington, James (1854–1930) – traveller, collector and expert on Pacific material culture, author of *An Album of the Weapons … of the Natives of the Pacific Islands*. From 1891 until the early 1900s at the British Museum as supernumerary working on ethnographical collections and helping in examining collections offered to the Museum; travelled in the Pacific and New Zealand in 1879–81 and 1897. Parts of his private collection were acquired by the British Museum in 1913 and 1915, but the bulk of it was purchased by the Leys family for the Auckland Museum in 1924. (Neich 2009)

Engel, Carl (1818–82) – German musicologist, organologist and collector, moved to England in 1844–5; formed an exceptional library and instrument collection which he sold in 1881, the majority of his instruments acquired by the Victoria and Albert Museum with which he had been connected since 1864 as its organological adviser. (Bate 1980: 166)

Fenton, S. – London dealer, established 1880, still active in the first quarter of the twentieth century

Fisher, F.O. – went to New Zealand in 1876 as a Worcester Cadet, entered the Survey Department in 1878, qualified as Authorized Surveyor, carried out Native Land Court surveys, visited the Maori King in 1883 and lived in the King's country for 12 months. (BM AOA correspondence: F.O. Fisher, 24 May 1922)

Forbes, Henry Ogg (1851–1932) – scientist and explorer, studied medicine in Edinburgh, scientific collector in Portugal 1875–77, collected in East Indies 1878–84, did exploration in New Guinea between 1885 and 1887; in 1890–93 was Director of the Canterbury Museum in Christchurch, New Zealand; after return to England became Consulting Director of Museums in Liverpool. (ADB)

Fowler, Alfred – member and employee of manufacturing family (agricultural engineering firm) John Fowler and Co. in Leeds; travelled abroad on business. (Davis 1951)

Franks, Sir Augustus Wollaston (1826–97) – member of the British Museum staff between 1851 and 1897, initially at the Department of Antiquities and from 1866 as Keeper of the Department of British and Medieval Antiquities and Ethnography; scholar of prehistory and medieval antiquities, but also with considerable interest in ethnography, and one of the Museum's greatest benefactors. (Caygill and Cherry 1997; King 1997)

Fuller, Captain Alfred Walter Francis (1882–1961) – private collector, mainly of Pacific material culture; his collection was sold to the Field Museum, Chicago, in 1958. (Force and Force 1971; Waterfield and King 2006: 93–104)

Gerrard, Edward & Sons – London firm of taxidermists and makers of anatomical models, also dealers in artefacts, active in the second half of the nineteenth century and the beginnings of the twentieth. (BM Merlin database)

Giglioli, Enrico Hillyer (1845–1909) – scientist and zoologist, from 1847 Professor of Zoology and Comparative Anatomy of Vertebrates at Florence, well known and with many connections in international scientific circles, including Franks and Read at the British Museum. (Read 1910)

Glendinnings – dealer, active in the first part of the twentieth century.

Godley, John Robert (1814–61) – lawyer, administrator, colonizer, public servant; founder of the Canterbury Association promoting colonization of New Zealand, where he was active between 1850 and 1853, when he returned to London. (DNZB)

Greenwell, William (1820–1918) – cleric and archaeologist, between 1879 and 1907 he presented the artefacts he excavated and collected to the British Museum, where they are one of the foundation collections of British prehistory. (ODNB)

Grey, Sir George (1812–98) – colonial governor in Australia and South Africa, twice Governor of New Zealand, 1845–53 and 1861–8, later active in New Zealand in local politics, became premier in 1877; left New Zealand in 1904 (ODNB). His Maori collection was presented to the British Museum in 1854; his later collection is in Auckland Museum.

Haast, Sir Julius von (1822–87) – German-born geologist, explorer, archaeologist, man of varied interests, arrived in New Zealand in 1858; founder and first director (from 1869) of Canterbury Museum, Christchurch. (McLintock 1966)

Hamilton, Augustus (1853–1913) – ethnologist, biologist, collector; emigrated to New Zealand in 1875; author of numerous scientific papers, and from 1903, after the retirement of Sir James Hector, Director of the Colonial (later Dominion and now Museum of New Zealand Te Papa Tongarewa) Museum in Wellington, in which he deposited his own private collection of Maori artefacts. Author of *Maori Art*. (DNZB)

Harding, George R. (formerly W. Wareham) – London dealer, active late nineteenth/early twentieth century.

Haslar Hospital – library and museum established in 1827 at the Haslar Royal Naval Hospital in Gosport near Portsmouth, containing books, medical specimens and artefacts collected by men serving in the Royal Navy. Its large ethnographical collection was presented by the Lords of the Admiralty to the British Museum in 1855. The Hospital still exists but its original library and museum were destroyed during the Second World War in 1941. (Lloyd and Coulter 1963: 26–8)

Hector, Sir James (1834–1907) – geologist, explorer, scientific administrator, physician. After exploration in Canada, in 1862 he arrived in New Zealand, where he conducted geological exploration of Otago; in 1865 he was appointed Director of the New Zealand Geological Survey, and of the Colonial Museum (from which he retired in 1903 and was replaced by Augustus Hamilton). (McLintock 1966)

Higgins, Charles Longuet (1806–85) – benefactor, eldest son of John Higgins of Turvey Abbey, who formed a collection which included some objects from Cook's voyages; qualified as doctor and practiced at Turvey; involved in charitable projects, built a local museum in 1852. (ODNB)

Hocken, Thomas Morland (1836–1910) – physician, bibliographer and collector; worked as ship's doctor from 1860 until 1862, when he settled in Dunedin to practise his profession and to pursue his private interests by conducting research on New Zealand history and ethnology. In 1897 he presented his extensive collection of books, papers, paintings etc. to the people of Dunedin (now the Hocken Library) and his collection of Maori ethnographic material to the Otago Museum. (McLintock 1966)

Home, Sir James Everard (1798–1853) – Captain RN, CB, Baronet, son of Sir Everard Home, 1st Baronet, surgeon. Senior Naval Officer on the Australian Station, entered the navy in 1810; while Captain of HMS *North Star* and later of HMS *Calliope* he participated in New Zealand wars in the 1840s and early 1850s; Fellow of the Royal Society, known also for his interest in botany, he left his valuable books to Sir George Grey, on condition that they would go to public libraries. (BM Merlin database)

Hooper, James Thomas (1897–1971) – collector, mainly of Polynesian material, established the Totems Museum at Arundel (1957–63); his collection was sold at Christie's in 1976–83. (Phelps 1976; Waterfield and King 2006: 111–22)

Howie, Mrs Fanny Rose, née Porter (Poata) = Princess Te Rangi Pai Poata – Maori singer (contralto) and composer, came to London in 1901 and in 1903 toured the British Isles, returned to New Zealand in 1905. (DNZB)

Jamrach, A.E. – London dealer, active second half of the nineteenth century, early 1900s, son of Charles Jamrach, dealer in wild animals. (ODNB)

Janson, E.W. – London dealer.

Joyce, Thomas Athol (1878–1942) – British Museum staff member 1902–38, first in the Department of British and Medieval Antiquities and Ethnography, later Deputy Keeper in charge of ethnography in the Department of Ceramics and Ethnography (1921–33) and subsequently in the Department of Oriental Antiquities and Ethnography (1933–38). (Wilson 2002)

Lister – family of William Lister Lister (1859–1943), Australian artist, son of John Armitage Lister and his wife, Eliza Kirkby, née Bateson; John Armitage Lister returned to his native Yorkshire with his family in 1868. William Lister Lister, after studying engineering and art in Britain, returned to Australia in 1888 where he worked as an artist until his death. (ADB)

Little, James Edward (1876–1953) – British, furniture restorer, dealer, faker of Maori artefacts (Skinner 1974: 181–92).

Liversidge, Archibald (1846–1927) – chemist and geologist, professor, University of Sydney, promoter of science in Australia; retired and returned to England in 1907. (ODNB)

Luce, John Proctor (1827–69) – naval officer, joined the Royal Navy in 1840, as Captain of HMS *Esk* took part in the New Zealand wars of the 1860s. (RAI archives, MS 280)

London Missionary Society – Missionary Society established in 1791 and renamed London Missionary Society in 1818; had its own museum containing objects sent back home by its members. In 1890 a large LMS collection was placed on loan at the British Museum which the Museum purchased in 1911. (Hasell 2004b)

Makereti – see Papakura, Makereti.

Manning, C. – Captain?

Marsden, Samuel (1765–1838) – chaplain, magistrate, agriculturalist, missionary; ordained in 1792, in 1794 arrived in Australia, where he farmed and acted as a magistrate and chaplain; became interested in promoting missionary work among the Maori and, despite the lack of interest from missionary organizations, in 1814 bought his own ship the *Active* and sailed for New Zealand; during the subsequent years, from 1815 with the support of the Church Missionary Society, he visited New Zealand frequently, establishing more mission stations, exploring the country and continuing his missionary and educational work. (DNZB; ODNB)

Meinertzhagen, Frederick Huth (1845–95) – collector and sheep-breeder, arrived in New Zealand in 1866 and from 1868 farmed in Waimarama (with his partners, his school friend Walter Lorne Campbell until 1874 and then with his brother-in-law, Thomas Richard Moore); returned to England in 1881 and after his death his collection was sold to the British Museum by his daughter, Gertrude. (Grant 1977)

Meyrick, Augustus – Lieutenant-Colonel, second cousin of Sir Samuel Rush Meyrick (1783–1848), who was an antiquary and historian of arms and armour, collector, builder of Goodrich Court near Ross, Hertfordshire, where he displayed his collection; on his death his collection was inherited by William Henry Meyrick, and then on his death in 1865 by Augustus Meyrick, who offered it to the British Government; as it was refused, it was broken up and some of it was given to the British Museum in 1878. (ODNB; King 1981: 37)

Nias, Sir Joseph (1793–1879) – Admiral; entered the navy in 1807, served with Sir William Parry during the latter's Arctic exploration; in 1840 accompanied Captain William Hobson to New Zealand and took part in the formal proceedings leading to the proclamation of New Zealand as a British colony. (ODNB)

Noldwritt, J.F. – dealer, active 1890s.

Northesk Collection – private collection formed by the Northesk family, probably in the late eighteenth century, in Rosehill near Winchester (Force and Force 1971: 95); loaned to the Winchester Corporation Museum and then to the Tudor House Museum in Southampton, it was finally sold at Christie's on 16 July 1924. (Waterfield and King 2006: 86)

Oldman, William Ockelford (1879–1949) – English collector and dealer, amateur anthropologist, with particular interest in Pacific material culture; retired from business in 1927 but continued collecting; his extensive Pacific collection was sold to the New Zealand Government in 1948 and divided among the major museums in New Zealand (Auckland, Canterbury in Christchurch, Otago in Dunedin, and Dominion, later National, Museum in Wellington). (Waterfield 2006: 65–78)

Papakura, Makereti (1872–1930) – Maori scholar, born Margaret Pattison Tom, later known as Makareti (or Maggie) Papakura, daughter of an Englishman and a high-born Te Arawa woman; worked as a tourist guide in Whakarewarewa, Rotorua (one of the guides during the Royal visit of the Duke and Duchess of Cornwall and York in 1911), travelled to Sydney in 1910 with a cultural group to set up a model Maori village, then on to London for the coronation celebrations of 1911. In 1912 she married English landowner Richard Charles Staples-Brown and settled in England, in 1926 enrolled as a student at the University of Oxford to study anthropology; died suddenly in 1930, her thesis was published in 1938 as *The Old-time Maori*. (DNZB)

Parry, Sir (Frederick) Sydney (1861–1941) – civil servant and grandson of Sir William Edward Parry. (*Who was Who*)

Parry, Sir William Edward (1790–1855) – naval officer and Arctic explorer, hydrographer; in 1829 he resigned to accept employment as commissioner of the Australian Agricultural Company, where he spent four years; from 1846 to 1852 he was Captain-Superintendent of Haslar Royal Naval Hospital. (ODNB)

Passmore, Arthur Dennis (1877–1958) – amateur collector and archaeologist, interested primarily in British antiquities, but also travelled and collected in North Africa and Afghanistan, was member of the Wiltshire Archaeological and Natural History Society. His collections are in the Ashmolean Museum of Art and Archaeology, Oxford, Bristol Museum and Art Gallery, the British Museum, and others. (Phillips 2004)

Peek, Sir Henry William, 1st Bt (1825–98) – partner in Messrs Peek Brothers & Co, colonial merchants, and Member of Parliament 1868–84 (ODNB). Formed collection between 1850 and 1880 in Rousden, Devon. (BM AOA archives: Beasley catalogue, 15 November 1926)

Peek, Sir Cuthbert Edgar, 2nd Bt (1855–1901) – astronomer and meteorologist; travelled extensively in Australia and New Zealand, where he collected artefacts for his father's museum in Rousdon, Devon. (ODNB; Rudler 1901)

Peek, Sir Wilfrid , 3rd Bt (1884–1927) – Major, late Royal 1st Devon Yeomanry, served in the Second World War. (*Who was Who*)

Ralls, Adelaide (1849–1935) – second wife of Captain George Tolman Ralls (1838–1927) who – in command of the ship *City of Auckland*, built for the immigrant trade between London and New Zealand – made five return voyages between London and Auckland in 1873–77. (http://freepages.genealogy.rootsweb.com/~ralls/family/ralls/captgeorge.html, accessed 21 June 2010)

Raphael, Oscar E. (1874–1941) – collector of Oriental antiquities, ceramics and glass; he left his entire art collection (which included also some fine ethnographical objects) to be shared between the British Museum and the Fitzwilliam Museum, Cambridge. (Wilson 2002: 230; BM Merlin database)

Read, Sir Charles Hercules (1857–1929) – British Museum staff member 1880–1921, first assistant and from 1896 Keeper of the Department of British and Medieval Antiquities and Ethnography; before joining the Museum formally, he was employed privately as a clerk (to register ethnographic collections) by A.W. Franks, who trained him and was his mentor. (ODNB; Wilson 2002)

Robertson, J. Struan – see John White.

Robieson, James Frank (1880–1966) – New Zealand carver and faker of Maori artefacts, especially in bone; taught to carve by Maori experts at Rotorua. (Skinner 1974: 181–92)

Rollin & Feuardent – company founded by Claude Camille Rollin, a French dealer in coins, gems and antiquities, active in Paris. When Rollin took Félix Feuardent into partnership, they opened a branch in London in 1867. After Rollin's death in 1883, the firm continued in Paris until about 1953. (BM Merlin database)

Rosenheim, Max – collector and head of the first 'Friends of the British Museum', formed in 1901 to buy objects for the Museum after Franks's death; in 1904 the Friends merged with the National Art Collections Fund. (Caygill and Cherry 1997: 100)

Sadler, F.W.R. – RN, Captain of HMS *Buffalo*, a supply ship which in the 1830s sailed regularly between Sydney and the Bay of Islands, where Sadler became friendly with Ngapuhi chief Titore, who presented him with some gifts, and entrusted him with delivery of other gifts to King William IV.

Salford Museum – in Salford, near Manchester, opened in 1850. (Myres 1902)

Simpson, William Sparrow (1827–97) – cleric, amateur collector and scholar, who spent most of his life as minor canon and librarian of St Paul's Cathedral; interested primarily in stone implements, but with a good eye for ethnographic objects, which he also collected and many of which found their way into the British Museum. (Simpson 1899)

Skinner, Henry Devenish (1886–1978) – ethnologist, university lecturer, museum curator, one of the most influential figures in New Zealand's museum and anthropological scene; interested in antiquities from early age, he was acting curator of the Otago University Museum in 1912–13; fought in the First World War, invalided from active service to Britain, in 1917 enrolled as a postgraduate student at Christ's College, Cambridge; after returning to New Zealand he spent the rest of his working life until retirement in 1953 at the Otago Museum, becoming its Director in 1937. His main interest was in Maori and Polynesian material culture and resulted in numerous publications; his research into the Moriori of the Chatham Islands produced a major work on the subject published in 1923. (DNZB)

Smith, Robert Henry Soden (1822–90) – museum curator and collector; joined the South Kensington (now Victoria and Albert) Museum in 1857, was appointed Keeper of National Art Library in 1868; active in the Society of Antiquaries and the Archaeological Institute, friend of A.W. Franks and C.H. Read; collected finger rings, Chinese and Japanese bronzes, and English pottery. (ODNB)

Sotheby's – auction house, established in 1744 by Samuel Baker; on his death in 1778, his estate was divided between his partner George Leigh and his nephew, John Sotheby. (Sotheby's website)

Sparrow Simpson, William – see Simpson, William Sparrow.

Stanley, Owen (1811–50) – Captain RN; while in command of the *Britomart* 1837–43, he helped to establish the colony of Port Essington in Australia and visited and conducted surveys in New Zealand; from 1846 he continued the surveys with the *Rattlesnake* in New Guinea and the Torres Straits. For his surveying and observation work he was made a Fellow of the Royal Society and the Royal Astronomical Society. (ADB)

Stevens – London auction house, established in about 1759 by Samuel Paterson; after several changes of ownership it was joined by J.C. Stevens in 1831; under his son Henry, Stevens became the major auction house for natural history and ethnography; it closed down in the 1940s. (ODNB; Allingham 1924)

Stokes, John Lort (1812–85) – naval officer; his early years were spent on the *Beagle* (including the period when Charles Darwin was naturalist on board), from 1837 surveying in Australasian waters; between 1847 and 1851 he was in command of the steamer *Acheron* engaged on surveys in New Zealand. (ODNB, DNZB, McLintock 1966)

Strutt, William (1825–1916) – artist, British-born, in Australia between 1850 and 1862, with a period in New Zealand in 1855/56. (ADB)

Taylor, Richard (1805–73) – missionary and scholar of Maori culture; after ordination accepted by the Church Missionary Society in 1835 for work in New Zealand which he reached – after a spell in Australia – in 1839 and where he spent all his life; published on New Zealand natural history and Maori culture, also collected (McLintock 1966). While in London in 1871 he visited the Christy Collection of the British Museum. (BM AOA archives: Visitors Christy Collection 1866 – Sept.1880)

Tollemache, Algernon (1805–92) – between 1830 and 1871 was in New Zealand, from where he wrote letters to his elder brother, Frederick, which are now in the possession of Mrs Rance of Streatley, Berkshire. (AOA correspondence: Sir Lyonel Tollemache, 18 April 1996)

United Services Institution/Museum – founded in 1831 under the auspices of the Duke of Wellington as the Naval and Military Museum at Whitehall Yard; changed to United Service Institution in 1839 and Royal United Service Institution in 1860, now Royal United Services Institute for Defence Studies. In 1858 the museum was divided into departments, one of them devoted to ethnography and antiquities; part of the collection was sold at Sotheby's on 24 July 1861, and during the second half of the nineteenth century many objects from the museum were acquired by the British Museum. (Bidwell 1991; Waterfield and King 2006: 40)

Völkner, Carl Sylvius (1819–65) – missionary, German-born, came to New Zealand in 1847 under the auspices of the North German Mission Society, but in 1852 offered his services to the Church Missionary Society; killed during the 1860s wars. (DNZB)

Wallace Collection/Museum – established in 1835 at Distington near Whitehaven, Cumberland (now Cumbria), offered for sale in 1896–7 following the death of its founder, Mr Wallace (BM PE correspondence: R. Ferguson, 1896–7); in 1898 an offer of sale of the museum as a whole was made to the British Museum but it was turned down (BM PE correspondence: C.H. Read to Miss Wallace, 24 March 1898).

Wareham, William – London dealer, active second half of the nineteenth century.

Wellcome, Henry S. (1853–1936) – American founder of pharmaceutical firm Burroughs-Wellcome, collector and benefactor. His main interest was in research, which he fostered and supported, and in collecting, which he started at an early age, founding in 1913 the Wellcome Historical Medical Museum. He collected, through his many agents, obsessively, widely and indiscriminately in all fields. After his death the non-medical material of this unwieldy and random collection was dispersed to various institutions, including the British Museum. (James 1944; Bywaters 1987; Russell 1987; Symons 1987; ODNB)

White, John (–1904) – New Zealand barrister and collector. In 1894 he offered his collection for sale to the British Museum, but the offer was declined (BM PE correspondence: J. White, 20 August 1894). After his death part of the collection was sold to J. Struan Robertson (Leach 1972: 5), on whose death the British Museum acquired some material (nephrite and stone implements) from his sisters, Miss Robertson and Mrs Erskine, in 1912.

Whitely, John (1806–69) – Wesleyan missionary, in New Zealand from 1833 until his death; fluent in the Maori language and with genuine concern for the welfare of the Maori people; died during the 1860s wars. (DNZB)

Williams, Joseph Walter – schoolmaster at Waitangi West, Chatham Islands in the 1890s, amateur collector.

Wood, John George (1827–89) – natural historian and microscopist, studied in Oxford, was ordained priest in 1854; from the 1850s developed a career in natural history on which he lectured in England and America; wrote over 70 books, the majority on natural history, including *The Natural History of Man, being an account of the manners and customs of the uncivilized races of men*, published in 1868–70. (ODNB)

Wright, B.M. – dealer, active second half of the nineteenth century.

Yorkshire Philosophical Society Museum – the society was founded in 1822, the museum opened in 1830. The ethnographical collections were sold to the British Museum in 1921; the rest was transfered to Yorkshire Museum in 1961. (Eth.Doc.1912)

Tribal map of New Zealand

By Roger Neich and Te Warena Tana

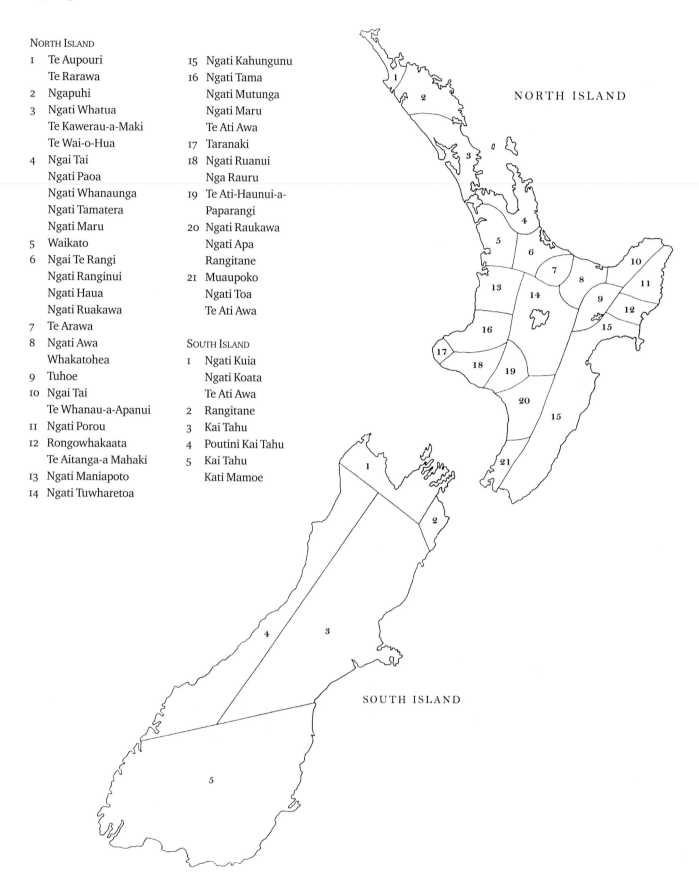

NORTH ISLAND

1 Te Aupouri
 Te Rarawa
2 Ngapuhi
3 Ngati Whatua
 Te Kawerau-a-Maki
 Te Wai-o-Hua
4 Ngai Tai
 Ngati Paoa
 Ngati Whanaunga
 Ngati Tamatera
 Ngati Maru
5 Waikato
6 Ngai Te Rangi
 Ngati Ranginui
 Ngati Haua
 Ngati Ruakawa
7 Te Arawa
8 Ngati Awa
 Whakatohea
9 Tuhoe
10 Ngai Tai
 Te Whanau-a-Apanui
11 Ngati Porou
12 Rongowhakaata
 Te Aitanga-a Mahaki
13 Ngati Maniapoto
14 Ngati Tuwharetoa

15 Ngati Kahungunu
16 Ngati Tama
 Ngati Mutunga
 Ngati Maru
 Te Ati Awa
17 Taranaki
18 Ngati Ruanui
 Nga Rauru
19 Te Ati-Haunui-a-
 Paparangi
20 Ngati Raukawa
 Ngati Apa
 Rangitane
21 Muaupoko
 Ngati Toa
 Te Ati Awa

SOUTH ISLAND

1 Ngati Kuia
 Ngati Koata
 Te Ati Awa
2 Rangitane
3 Kai Tahu
4 Poutini Kai Tahu
5 Kai Tahu
 Kati Mamoe

NORTH ISLAND

SOUTH ISLAND

Plates

Plate 1 Frederick Huth Meinertzhagen. Private Collection.
Henry Christy. Department of Africa, Oceania and the Americas. British Museum.
Augustus Wollaston Franks. Department of Coins and Medals, British Museum.

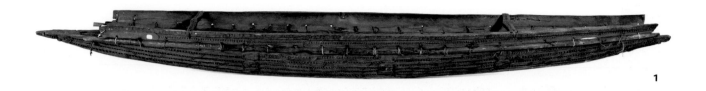

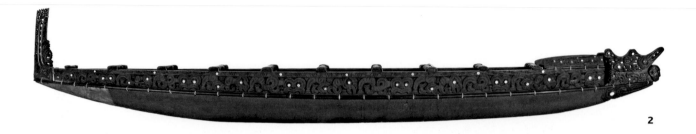

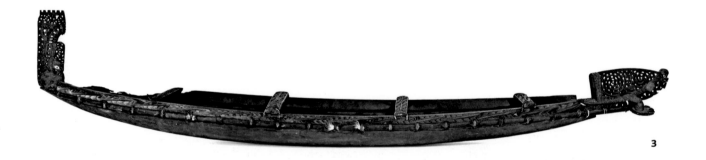

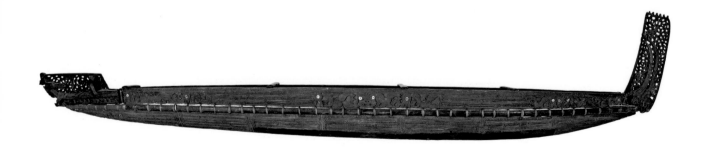

Plate 2 Model war canoes, *waka taua* (**1–4**).
2: The Royal Collection © 2009 Her Majesty Queen Elizabeth II.

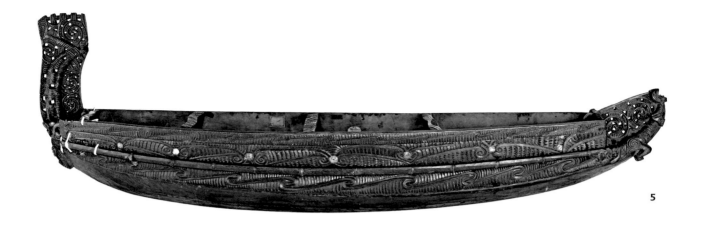

5

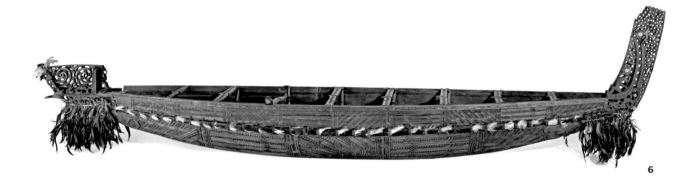

6

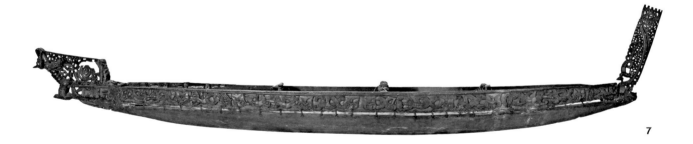

7

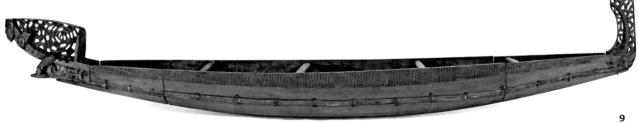

9

Plate 3 Model war canoes, *waka taua* (**5–7, 9**).

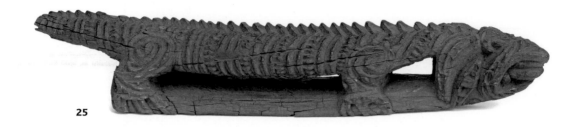

25

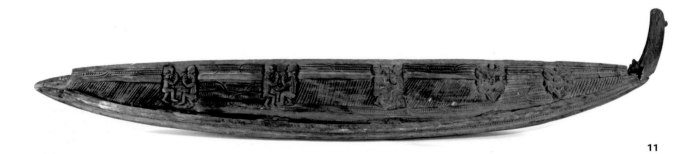

11

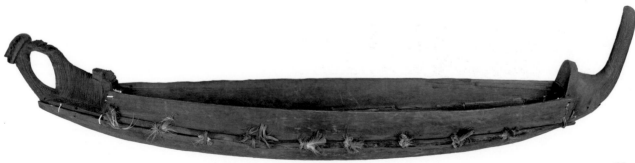

12

Plate 4 War canoe thwart, *taumanu* (**25**); model fishing canoes, *waka tete* (**11**, **12**).

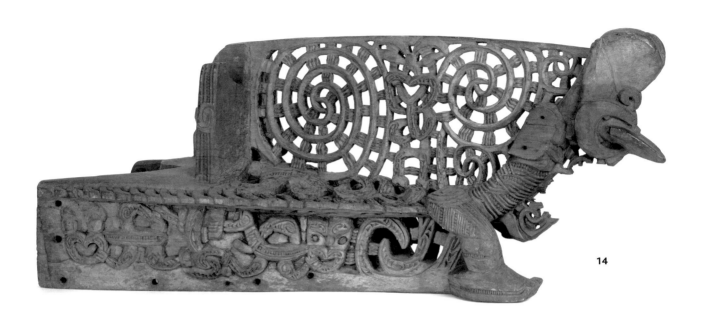

14

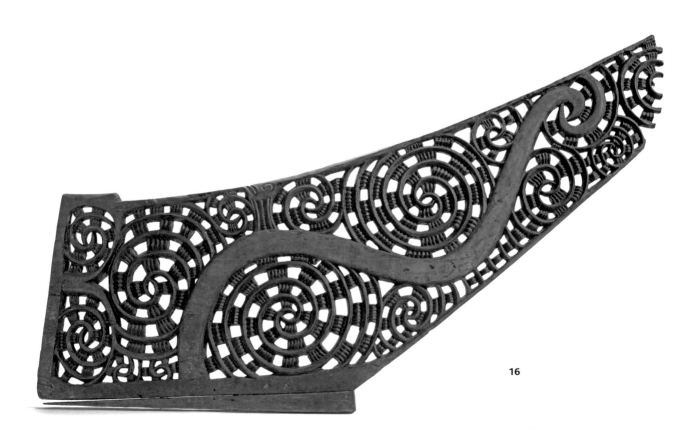

16

Plate 5 War canoe prows, *tauihu* (**14**, **16**).

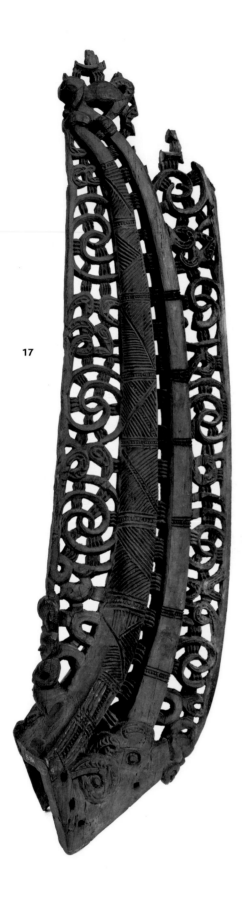

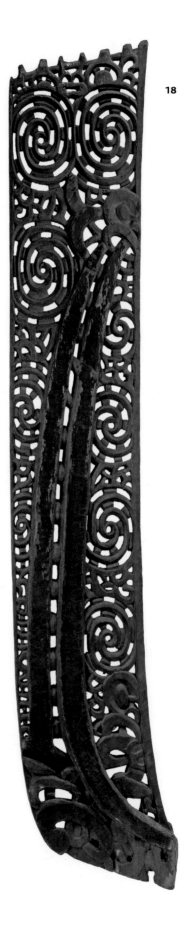

Plate 6 War canoe sterns, *taurapa* (**17**, **18**).

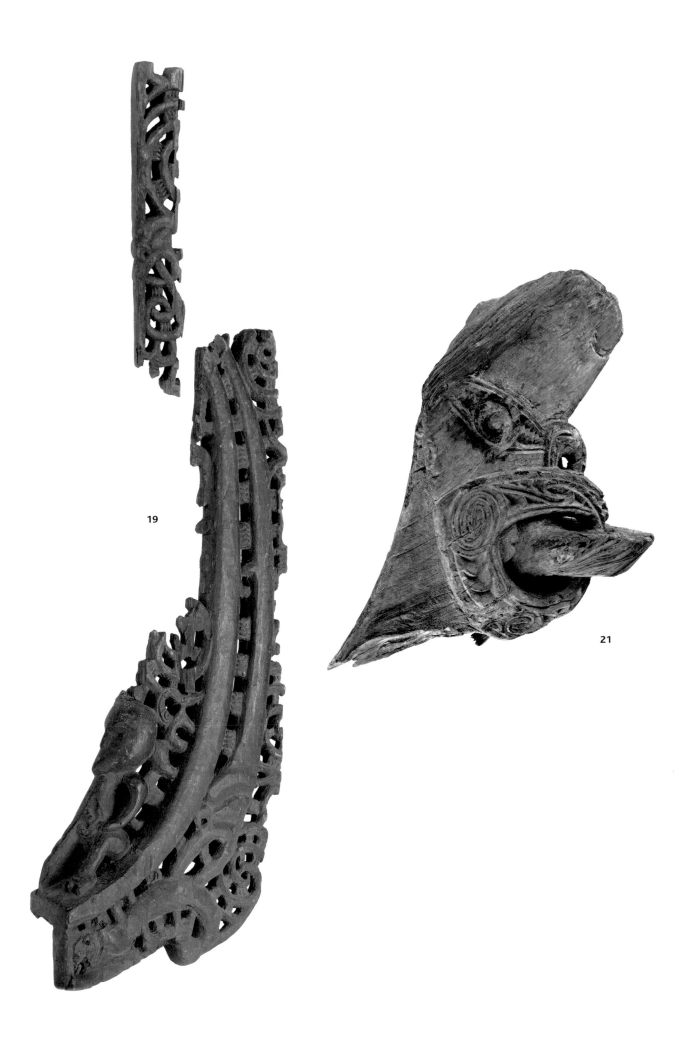

Plate 7 War canoe stern, *taurapa* (**19**); fishing canoe prow, *tauihu* (**21**).

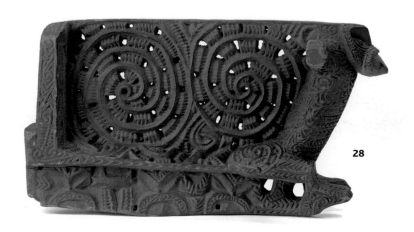

28

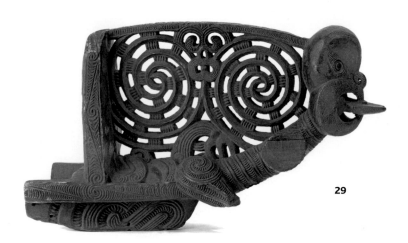

29

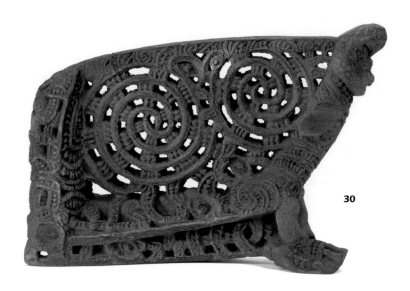

30

Plate 8 Model war canoe prows, *tauihu* (**28–30**).

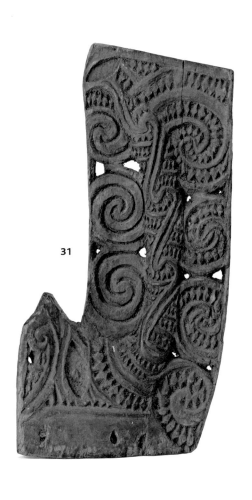

31

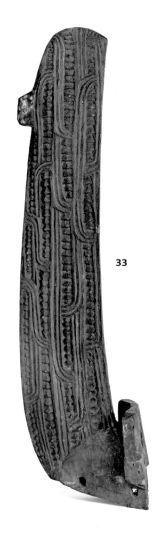

33

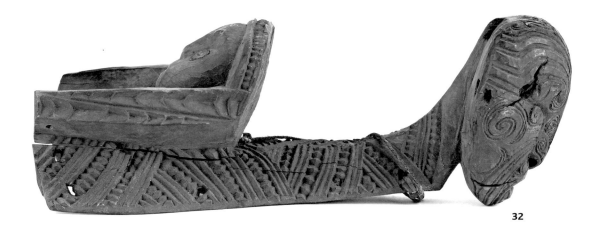

32

Plate 9 Model war canoe stern, *taurapa* (**31**); model fishing canoe prow, *tauihu* (**32**) and stern, *taurapa* (**33**).

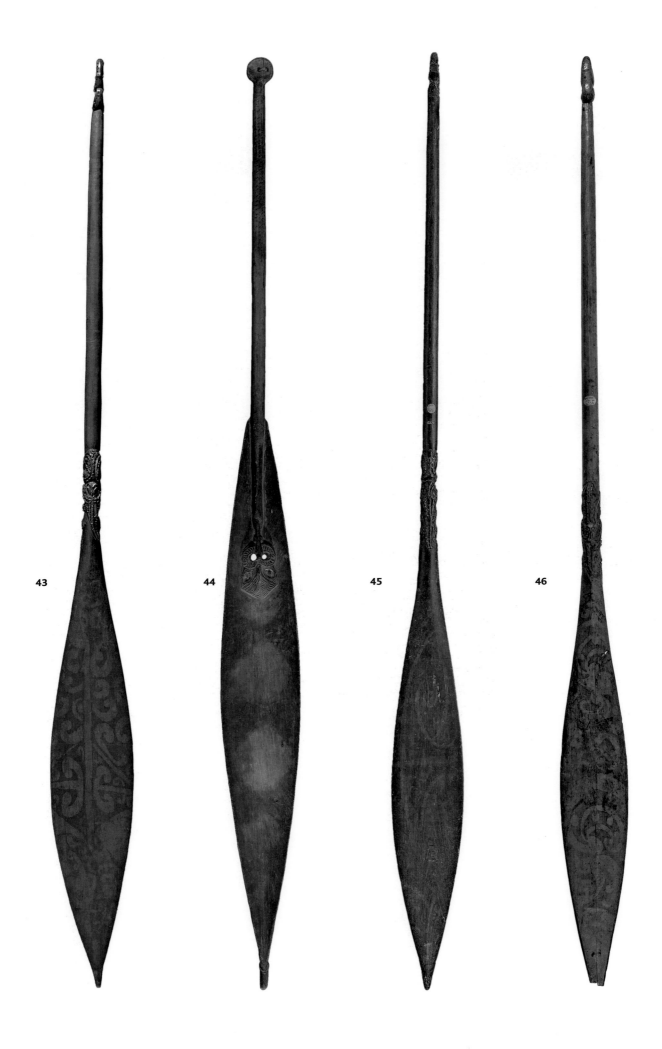

43

44

45

46

Plate 10 Painted paddles, *hoe* (**43–46**).

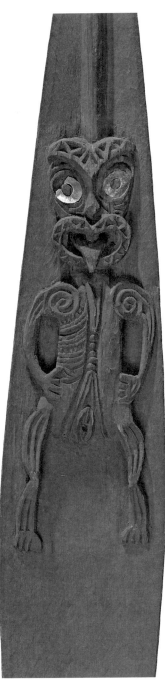

48

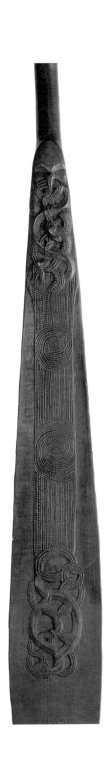

49

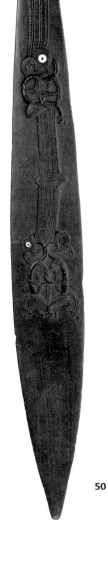

50

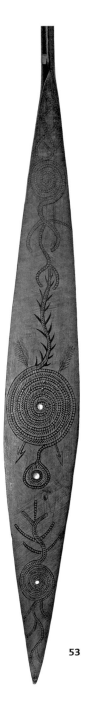

53

Plate 11 Blades of carved paddles, *hoe* (**48–50**, **53**).

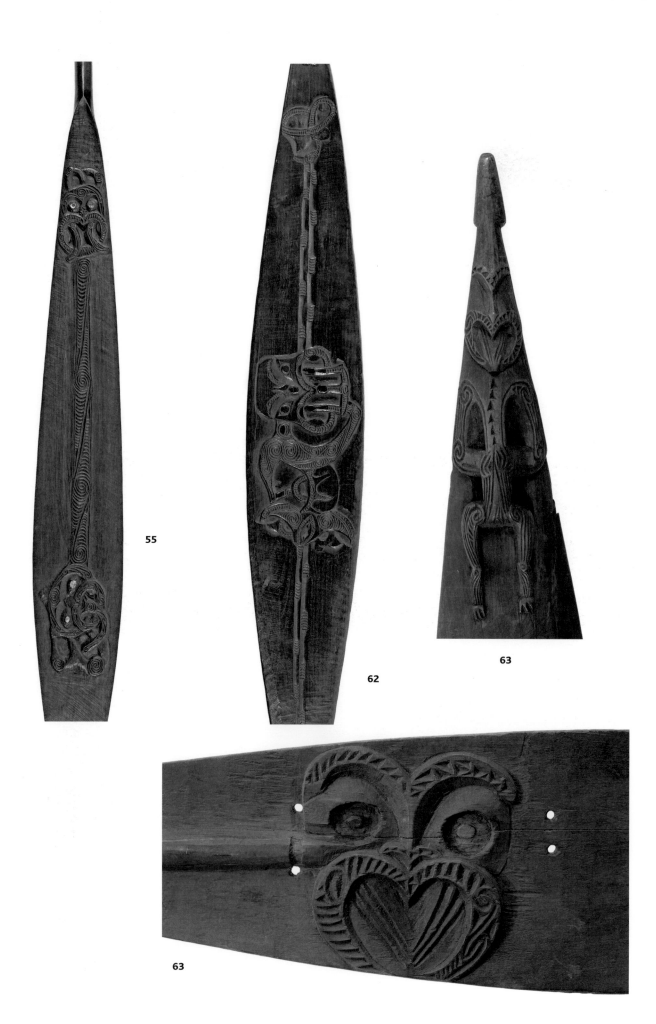

55

62

63

63

Plate 12 Blades of carved paddles, *hoe* (**55**, **62**, **63**).

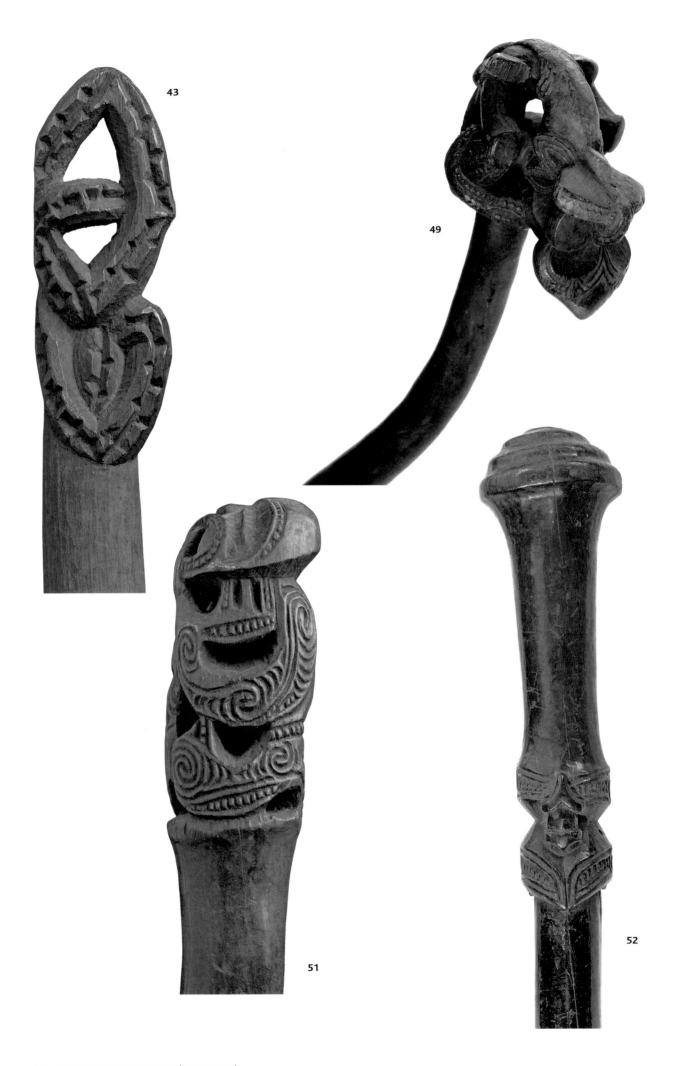

Plate 13 Carved butts of paddles, *hoe* (**43**, **49**, **51**, **52**).

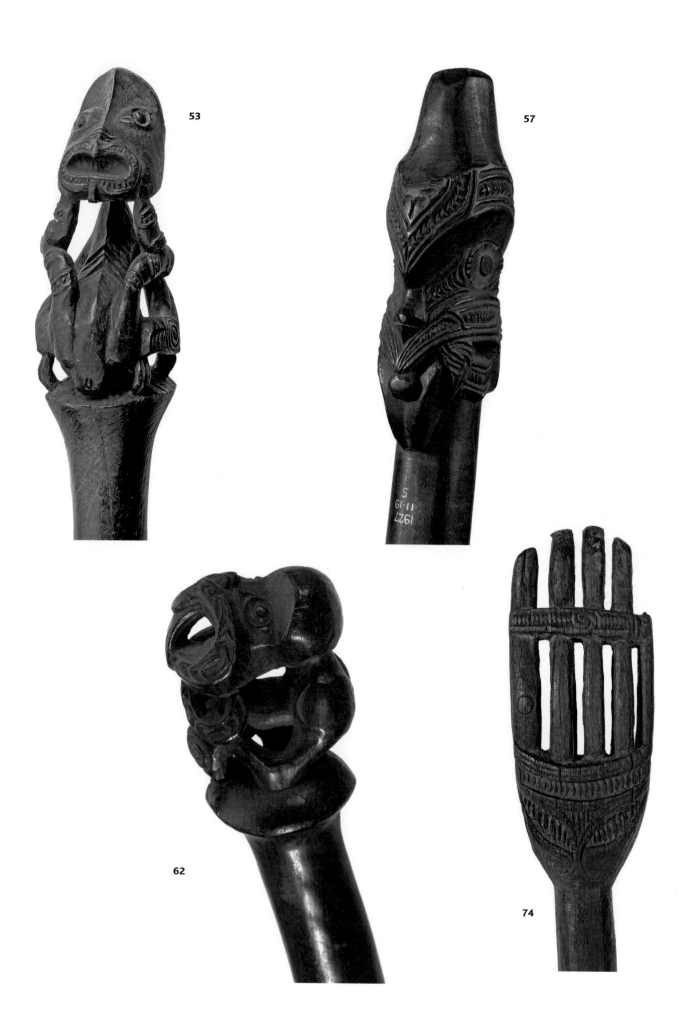

Plate 14 Carved butts of paddles, *hoe* (**53**, **57**, **62**, **74**).

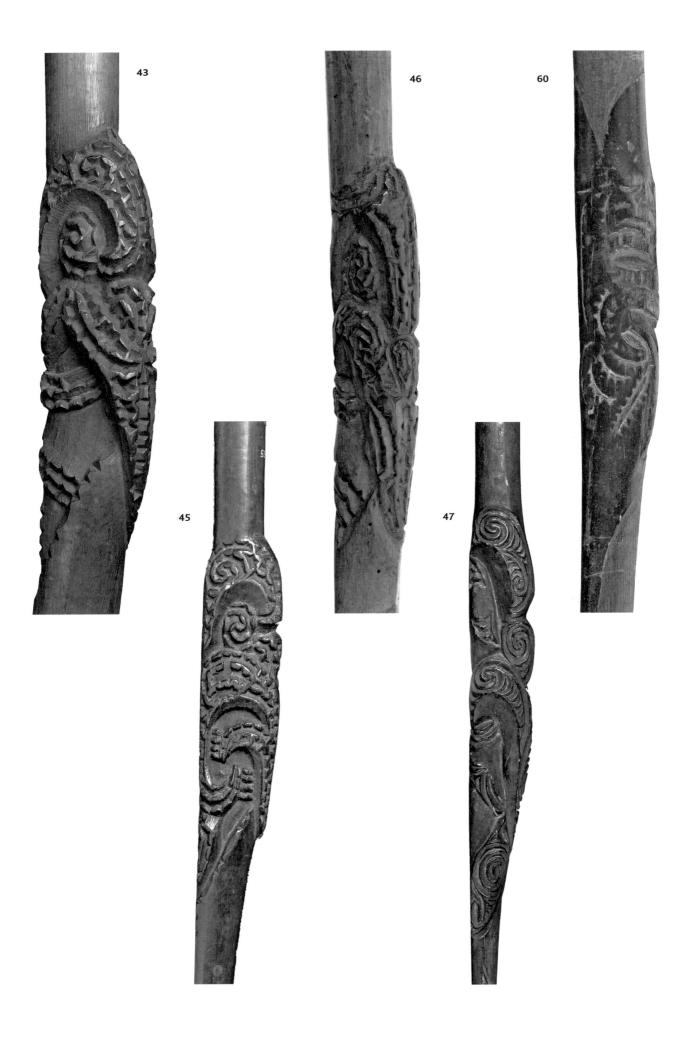

Plate 15 Carved looms of paddles, *hoe* (**43**, **45–47**, **60**).

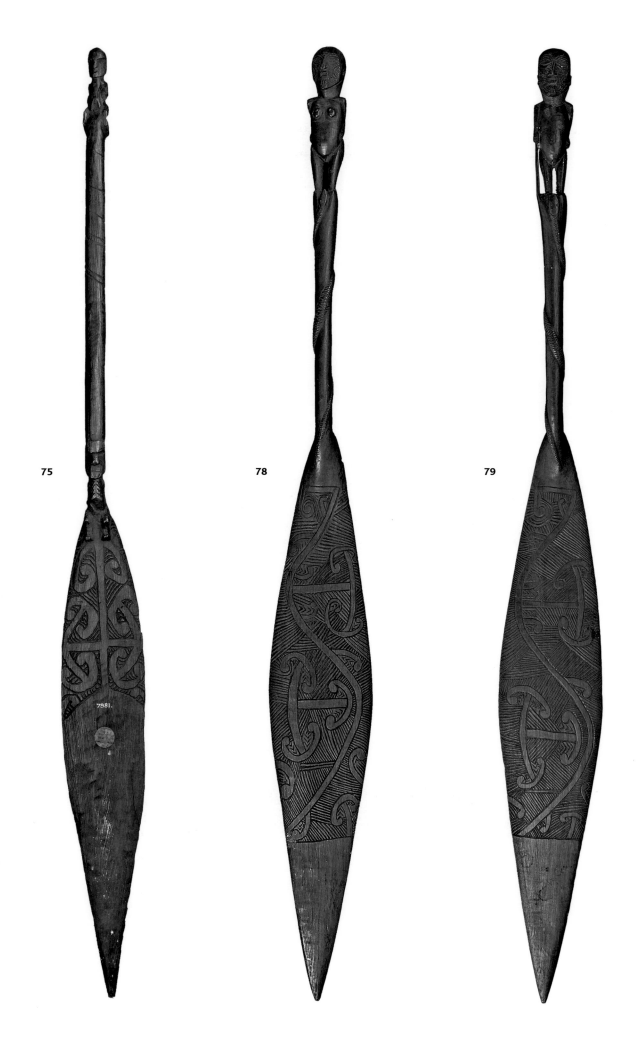

Plate 16 Model paddles, *hoe* (**75**, **78**, **79**).

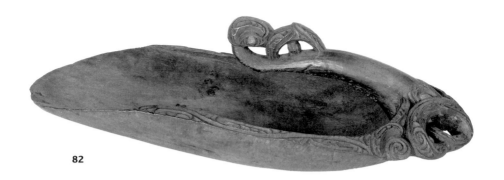

82

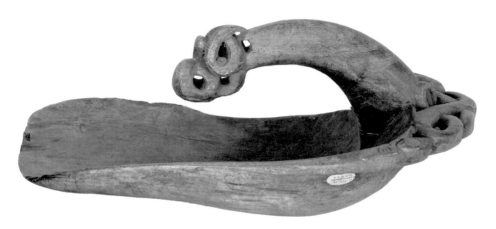

83

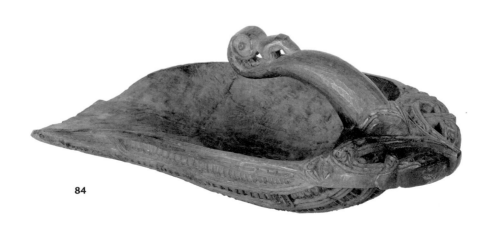

84

Plate 17 Bailers, *tiheru* (**82–84**).

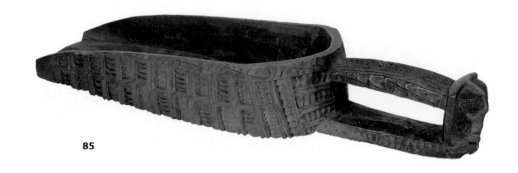

85

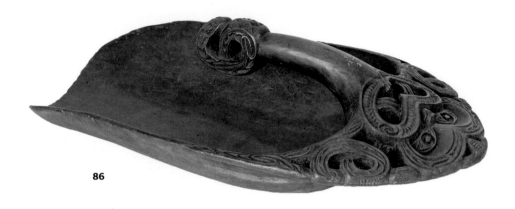

86

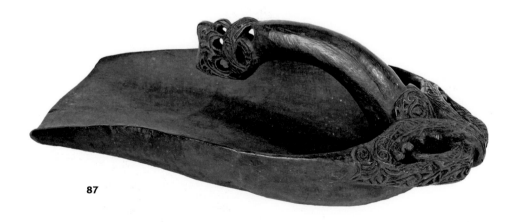

87

Plate 18 Bailers, *tiheru* (**85–87**).

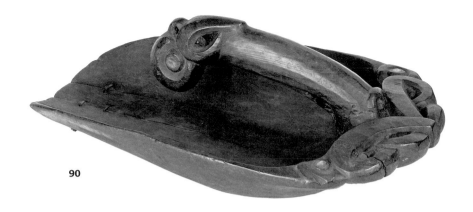

90

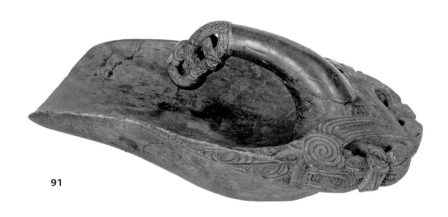

91

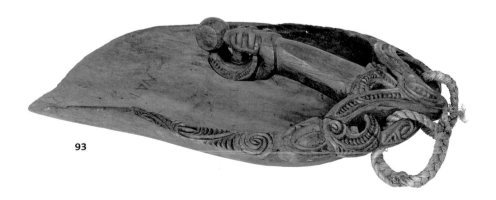

93

Plate 19 Bailers, *tiheru* (**90**, **91**, **93**).

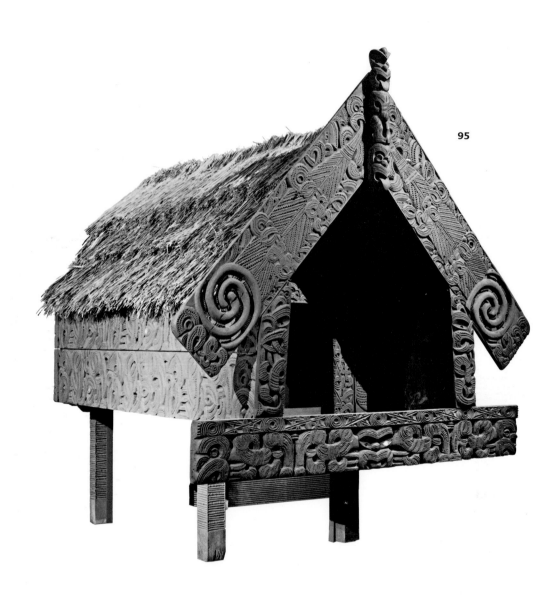

95

Plate 20 Model storehouse, *pataka* (**95**).

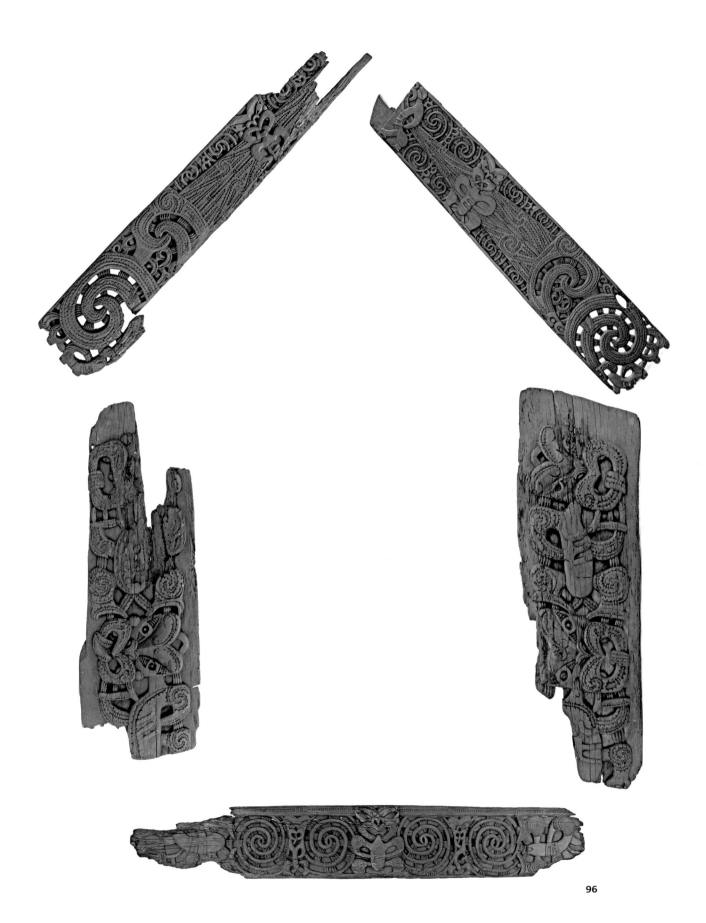

96

Plate 21 Storehouse, *pataka*, front parts: two *maihi*, two *epa*, and *paepae* (**96**).

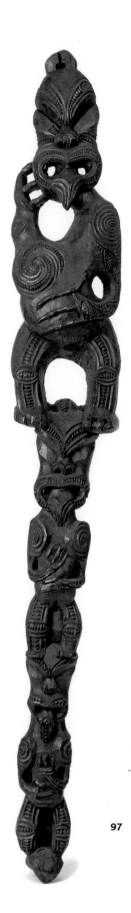

97

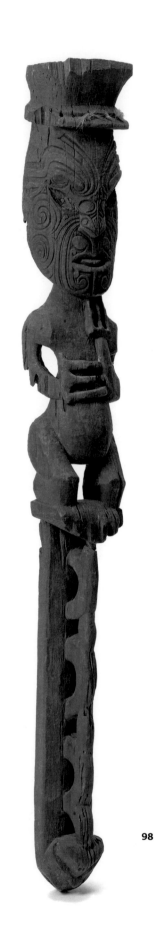

98

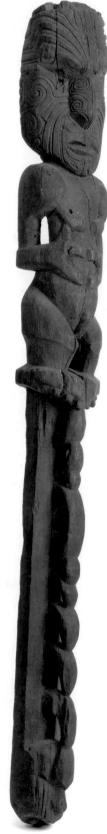

99

Plate 22 Storehouse gable figures, *tekoteko pataka* (**97–99**).

100

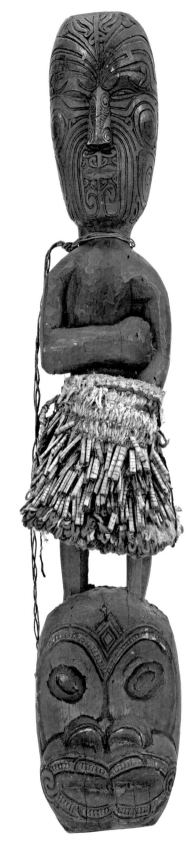

102

Plate 23 Storehouse gable figure, *tekoteko pataka* (**100**) and side post, *pataka amo* (**102**).

101

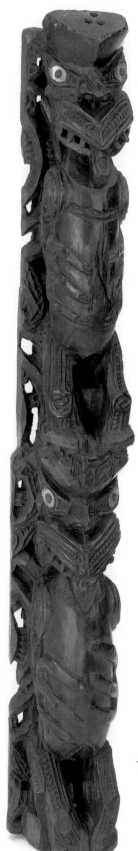

103

Plate 24 Storehouse side post, *pataka amo* (**101**) and door jamb, *whakawae* (**103**).

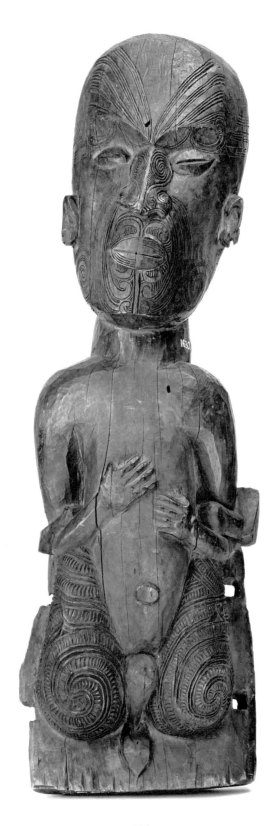

104

Plate 25 Entrance of semi-subterranean storehouse, *rua tahuhu* (**104**).

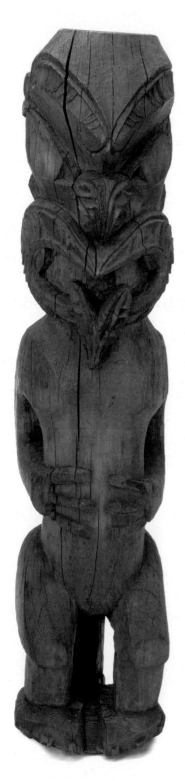

106

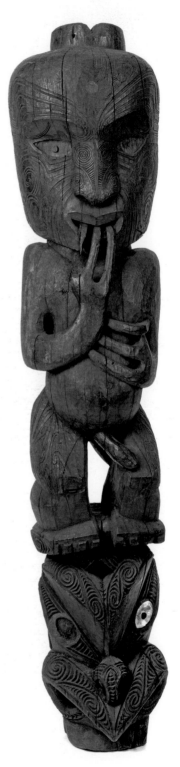

107

Plate 26 House gable figures, *tekoteko* (**106**, **107**).

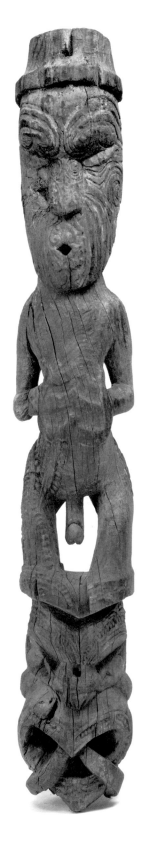

109

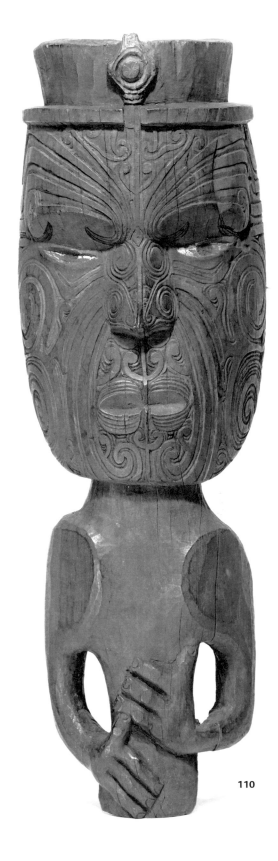

110

Plate 27 House gable figures, *tekoteko* (**109**, **110**).

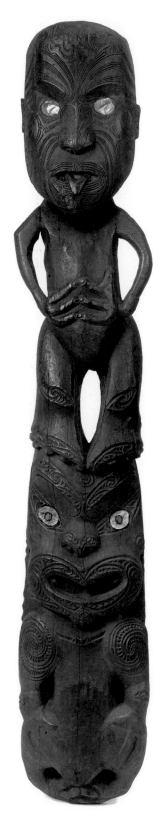

112

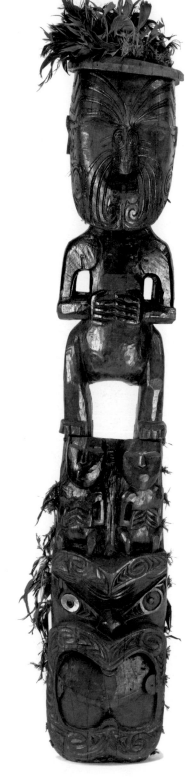

113

Plate 28 House gable figures, *tekoteko* (**112**, **113**).

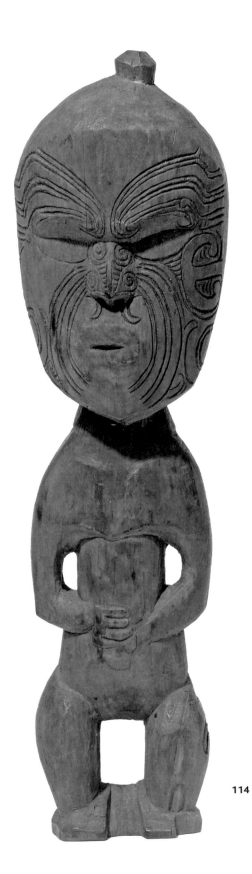

114

115

Plate 29 House gable figures, *tekoteko* (**114**, **115**).

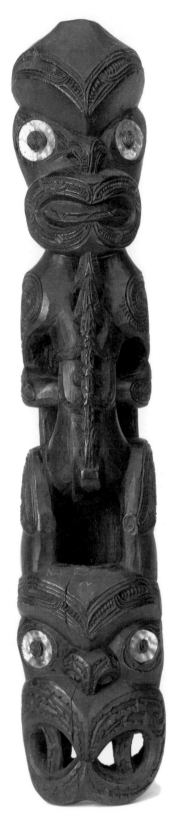

116

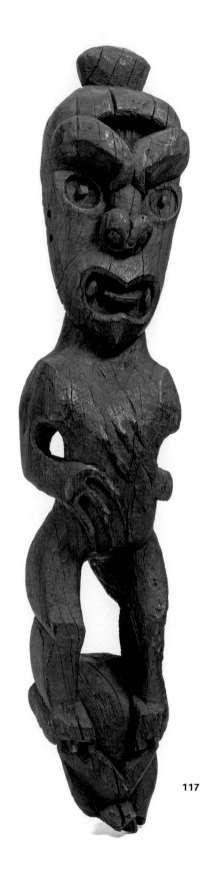

117

Plate 30 House gable figures, *tekoteko* (**116**, **117**).

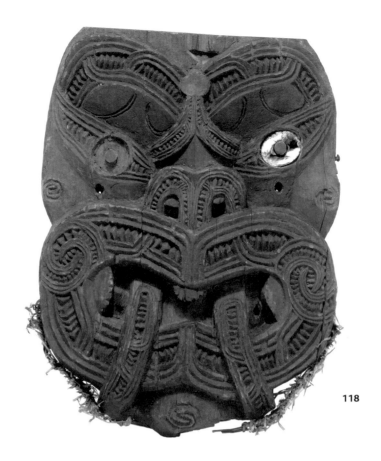

118

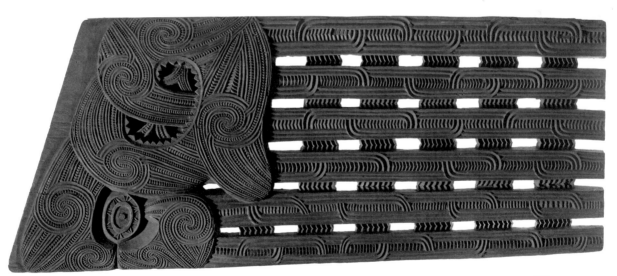

123

Plate 31 House gable mask, *koruru* (**118**); bargeboard end, *raparapa* (**123**).

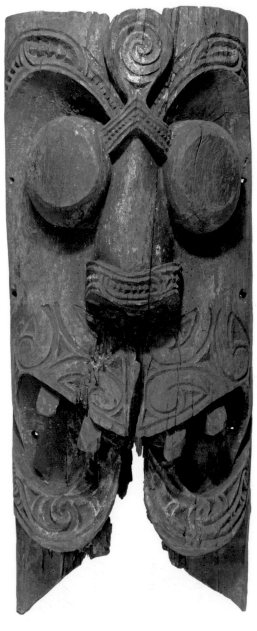

120

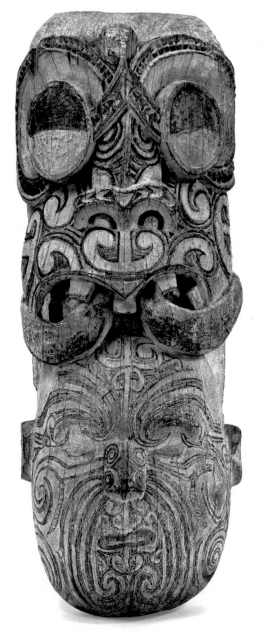

122

Plate 32 House gable masks, *koruru* (**120**, **122**).

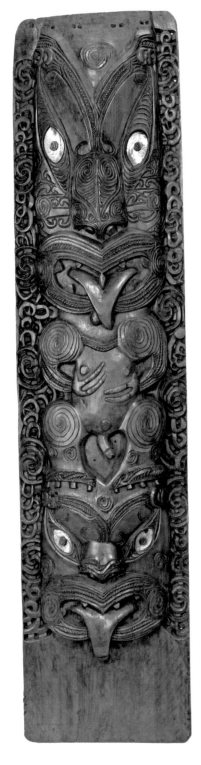

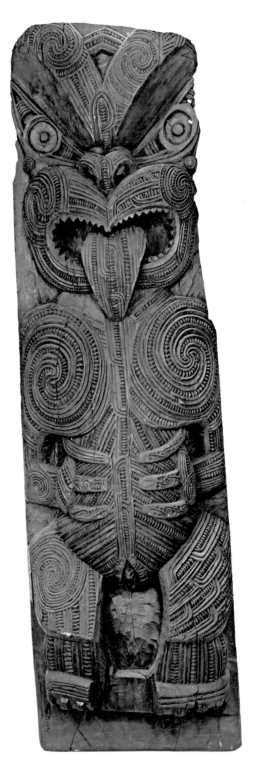

124

125

Plate 33 Ridgepole, *tahuhu* (**124**), and front side post, *amo* (**125**).

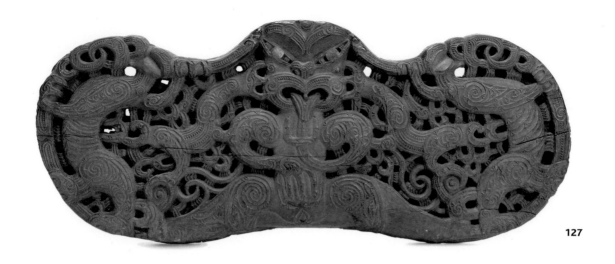

127

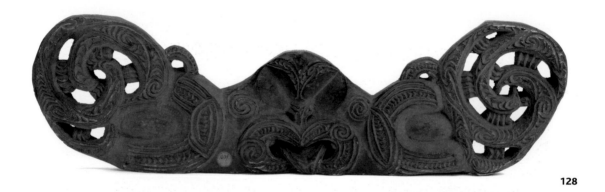

128

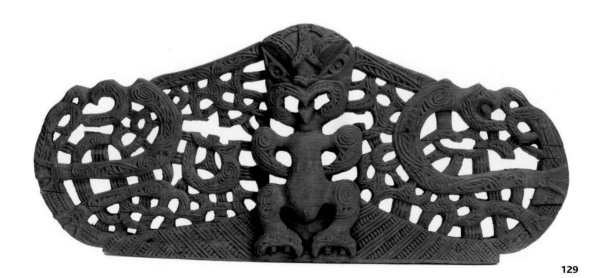

129

Plate 34 Lintels, *pare* (**127–129**).

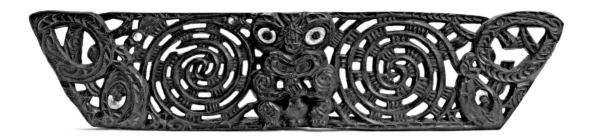

132

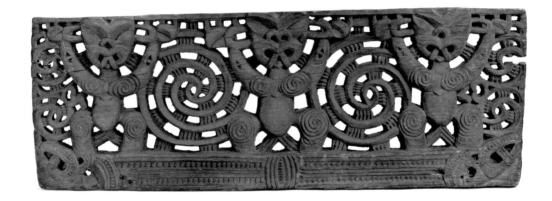

133

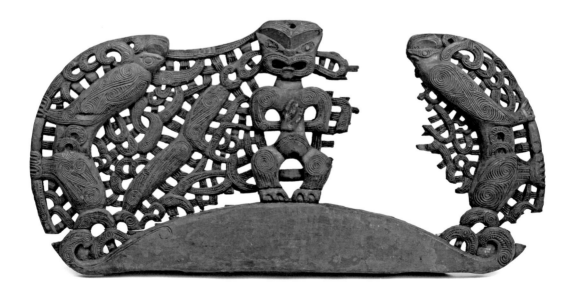

134

Plate 35 Lintels, *pare* (**132–134**).

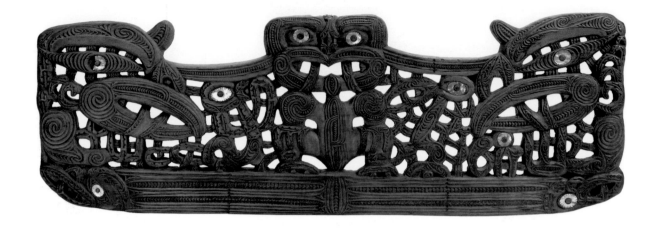

135

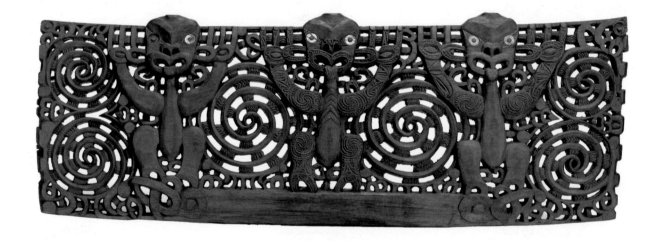

136

Plate 36 Lintels, *pare* (**135**, **136**).

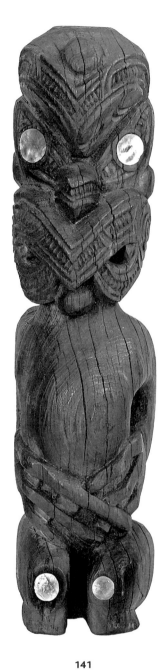

141

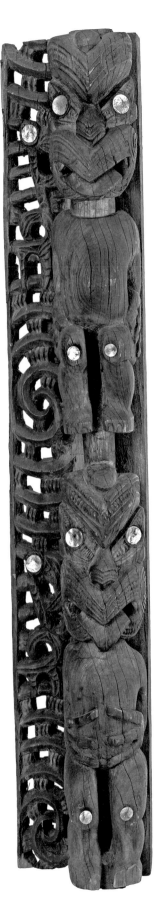

140

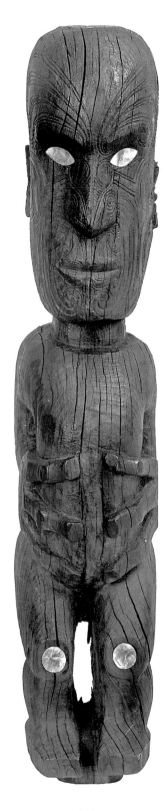

142

Plate 37 Door jambs, *whakawae* (**141**, **140**, **142**).

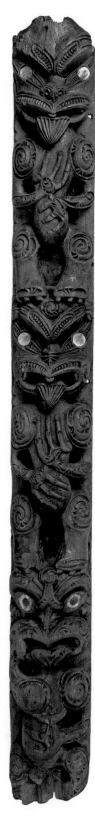

143

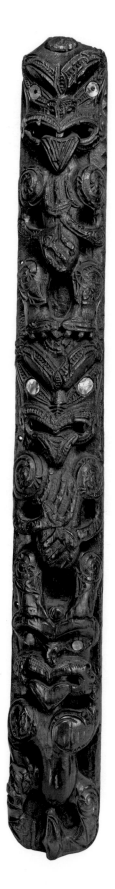

144

Plate 38 Door jambs, *whakawae* (**143, 144**).

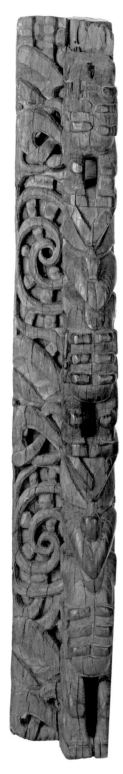

145

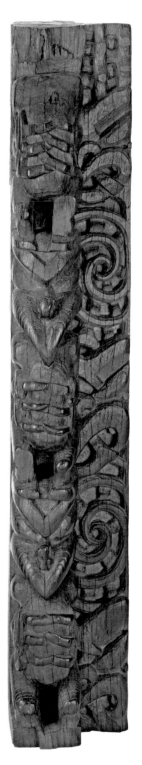

145

Plate 39 Pair of door jambs, *whakawae* (**145**).

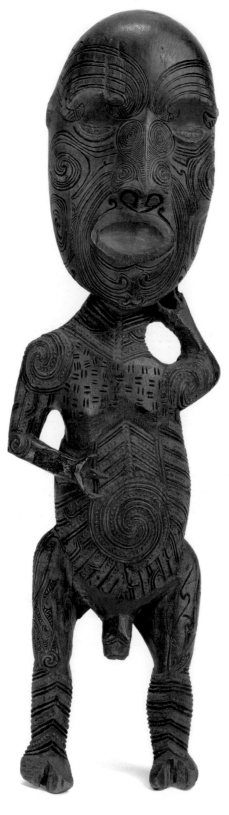

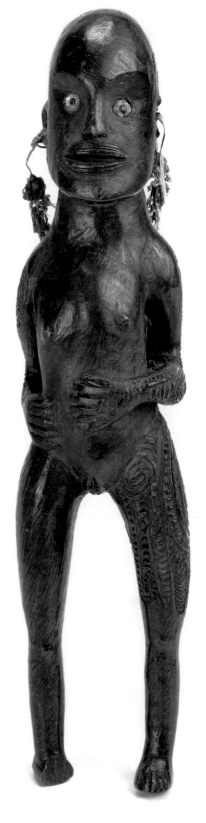

147

148

Plate 40 Interior central post figures, *poutokomanawa* (**147**, **148**).

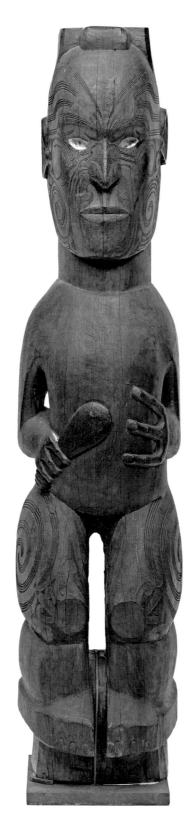

149

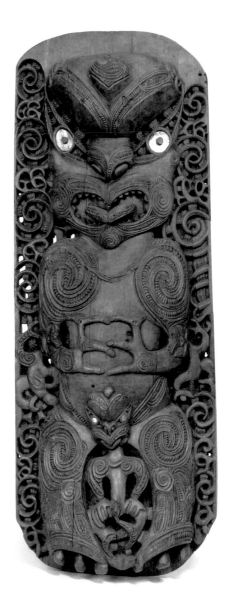

154

Plate 41 Interior central post figure, *poutokomanawa* (**149**); side-wall panel, *poupou* (**154**).

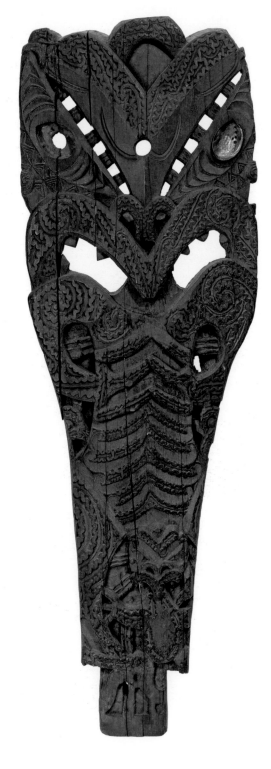

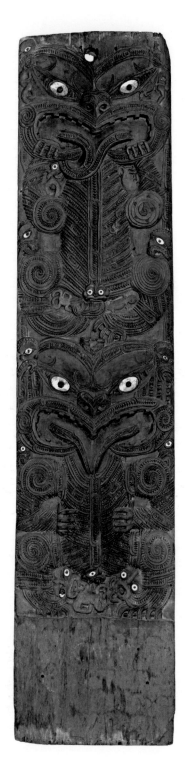

151

153

Plate 42 Side-wall panels, *poupou* (**151**, **153**).

157

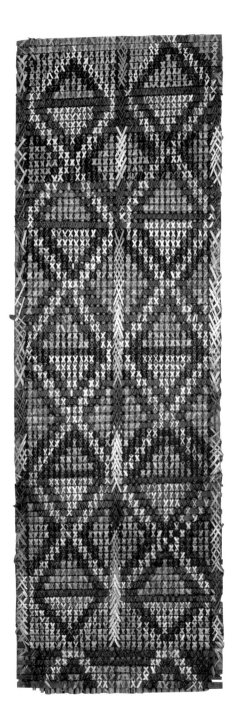

158

Plate 43 Plaited side-wall panels, *tukutuku* (**157**, **158**).

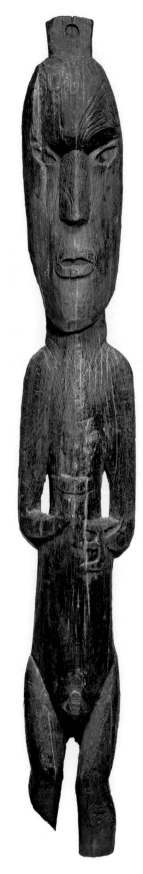

163

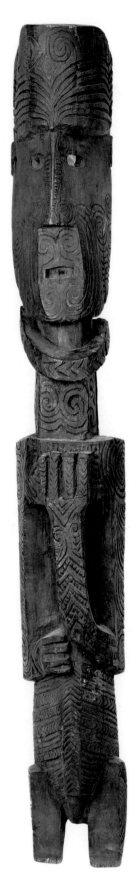

164

Plate 44 Palisade posts, *pou whakarae/himu* (**163**, **164**).

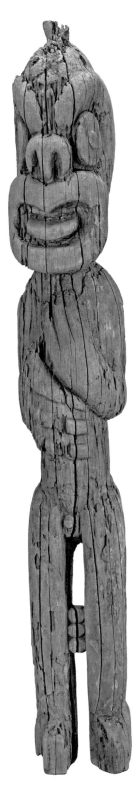

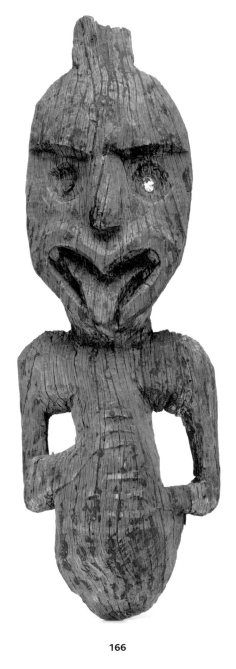

166

165

Plate 45 Palisade posts, *pou whakarae/himu* (**165**, **166**).

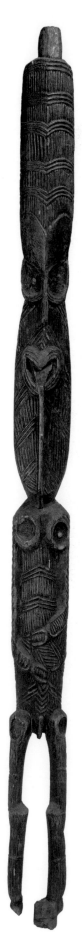

167

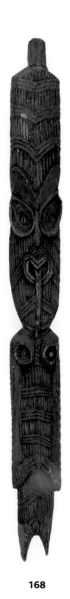

168

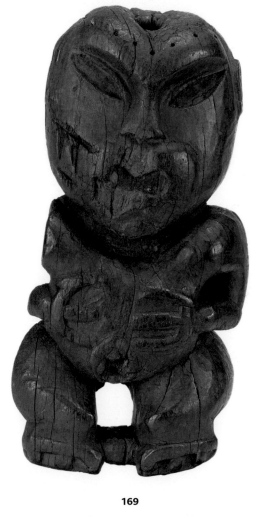

169

Plate 46 Figures (**167–169**).

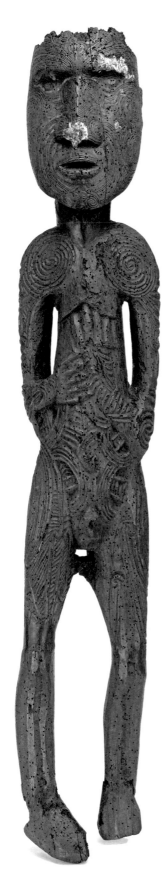

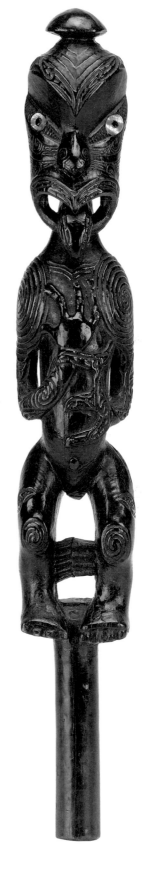

170

171

Plate 47 Figures (**170**, **171**).

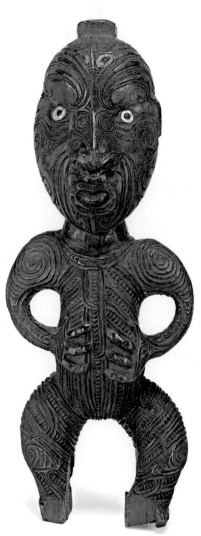

172

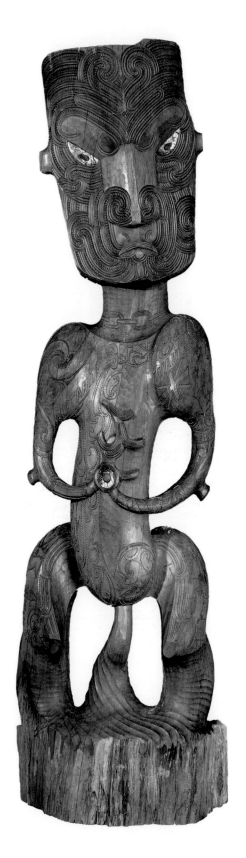

174

Plate 48 Figures (**172**, **174**).

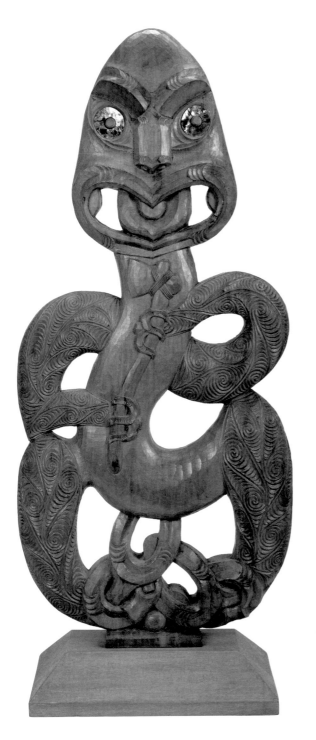

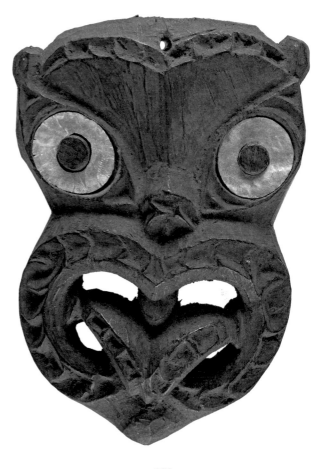

175

176

Plate 49 Figure named 'Te Tiriti' (**175**); mask (**176**).
175: The Royal Collection © 2009 Her Majesty Queen Elizabeth II.

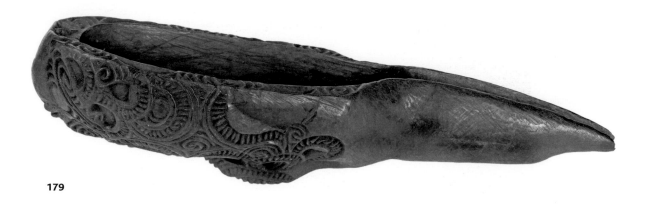

179

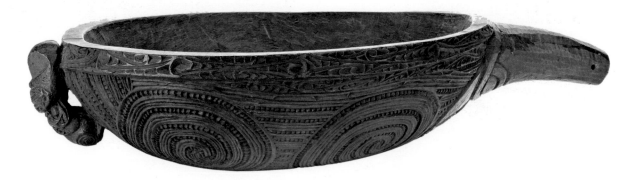

180

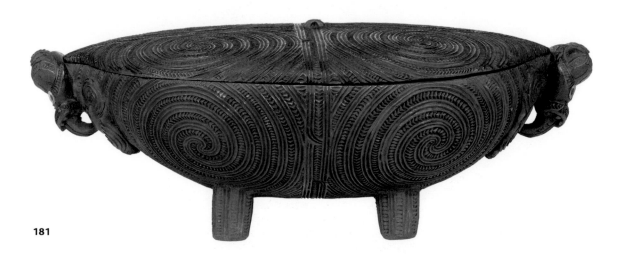

181

Plate 50 Spouted bowl, *kumete/ipu* (**179**) and bowls, *kumete* (**180**, **181**).

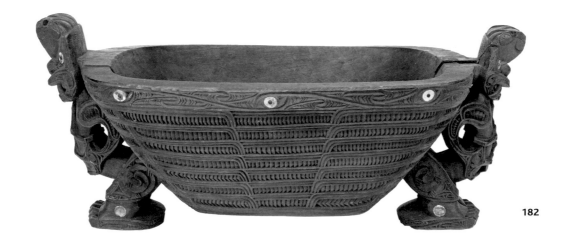

182

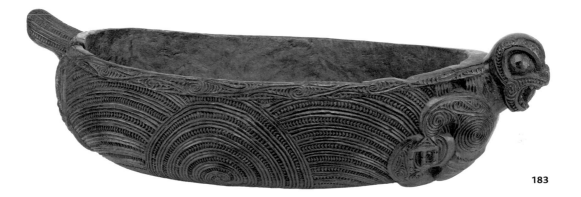

183

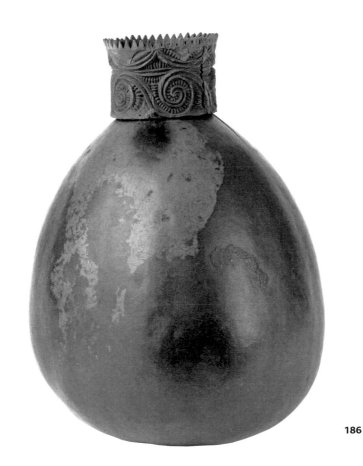

186

Plate 51 Bowls, *kumete* (**182**, **183**) and gourd container, *taha huahua* (**186**).

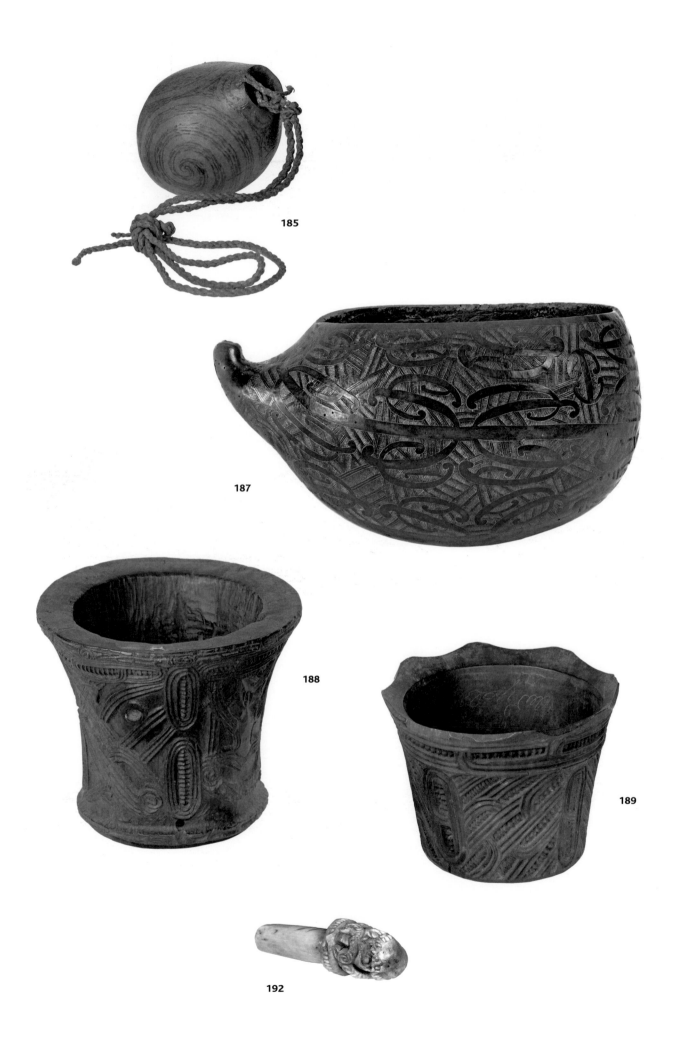

Plate 52 Small gourd container, *ipu* (**185**); gourd container, *hue* (**187**); two gourd mouthpieces, *tuki taha* (**188**, **189**); and stopper/peg, *puru* (**192**).

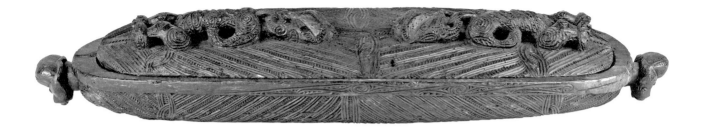

195

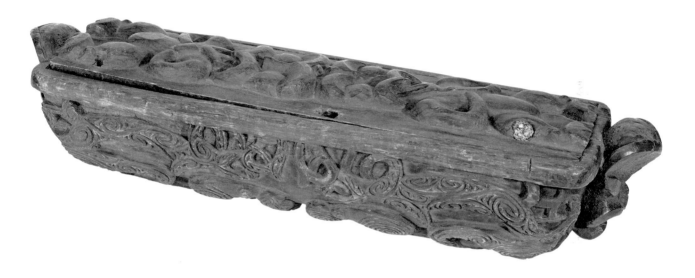

197

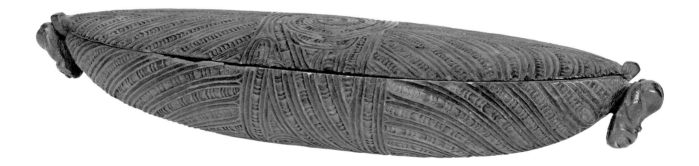

198

Plate 53 Treasure boxes: *wakahuia* (**195**, **198**) and *papahou* (**197**).

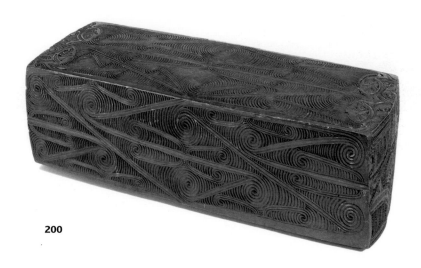

200

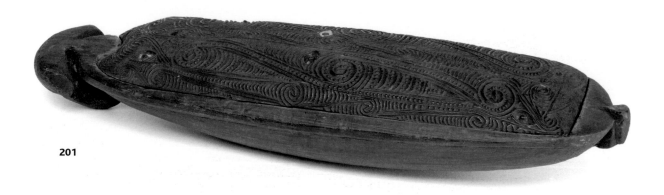

201

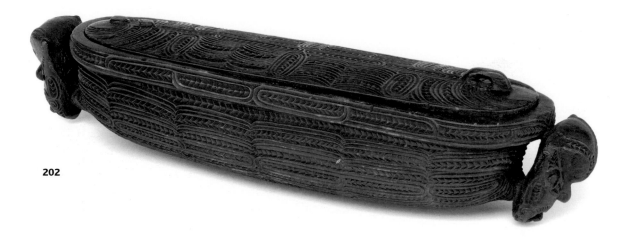

202

Plate 54 Treasure boxes: *papahou* (**200**) and *wakahuia* (**201**, **202**).

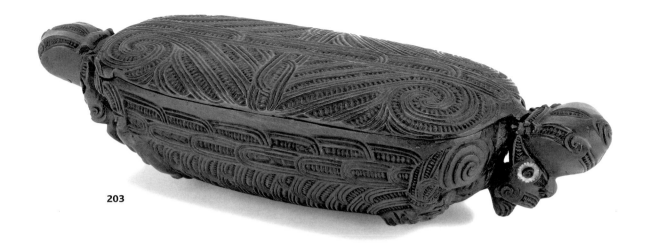

203

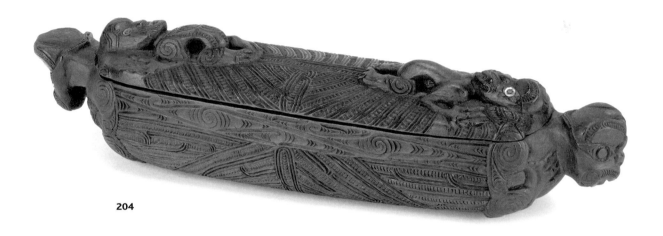

204

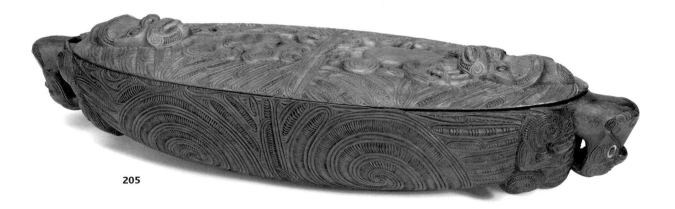

205

Plate 55 Treasure boxes: *wakahuia* (**203**, **205**) and *papahou* (**204**).

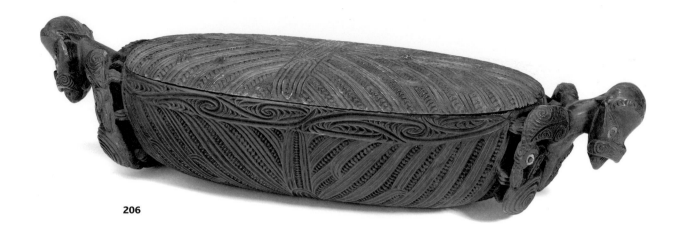

206

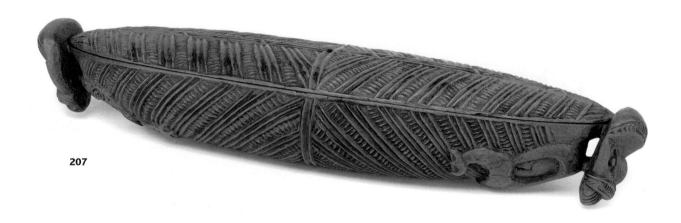

207

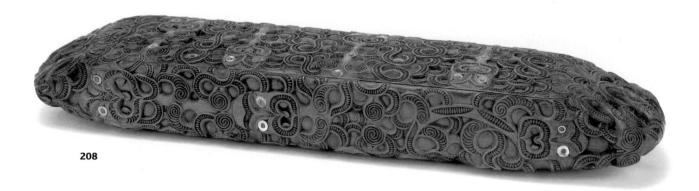

208

Plate 56 Treasure boxes: *wakahuia* (**206**, **207**) and *papahou* (**208**).

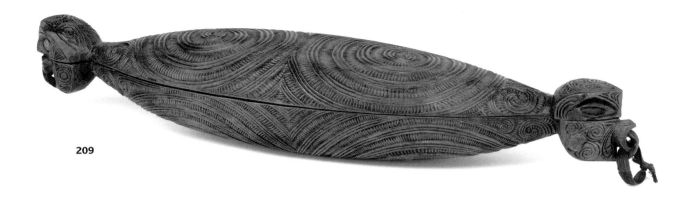

209

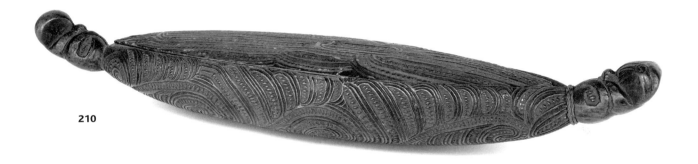

210

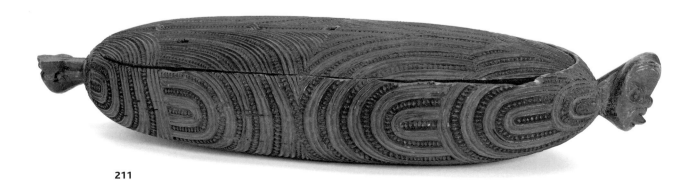

211

Plate 57 Treasure boxes: *wakahuia* (**209–211**).

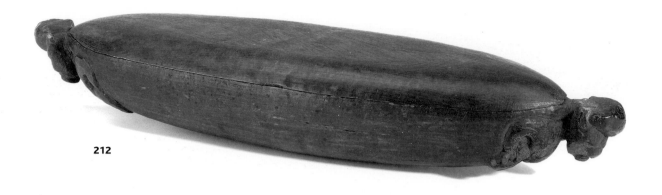

212

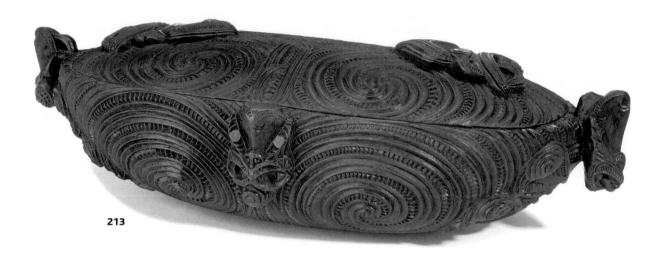

213

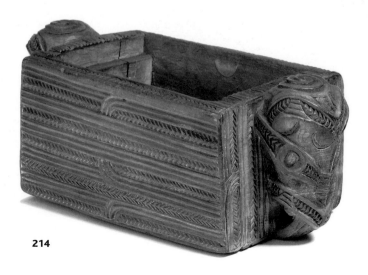

214

Plate 58 Treasure boxes: *wakahuia* (**212**, **213**) and trinket box, *powaka whakairo* (**214**).

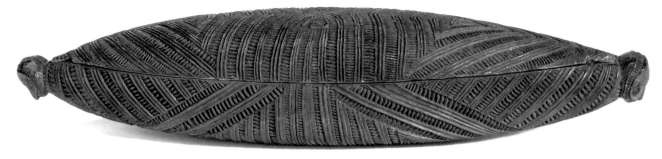

215

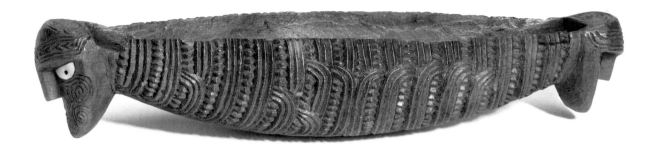

216

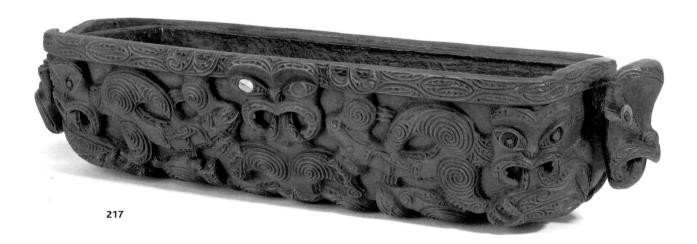

217

Plate 59 Treasure boxes: *wakahuia* (**215**, **216**) and *papahou* (**217**).

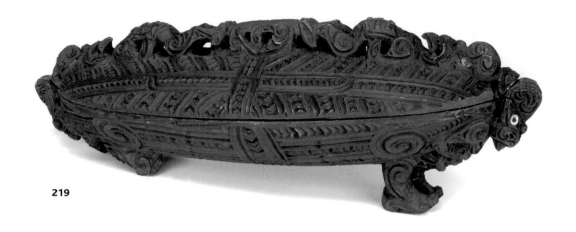

219

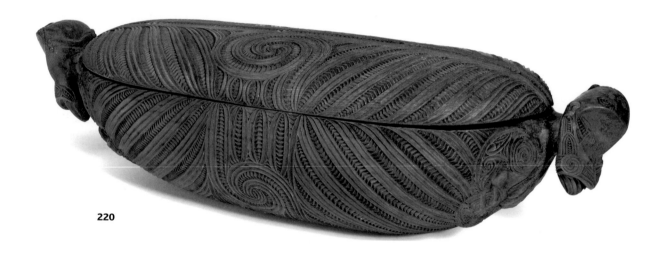

220

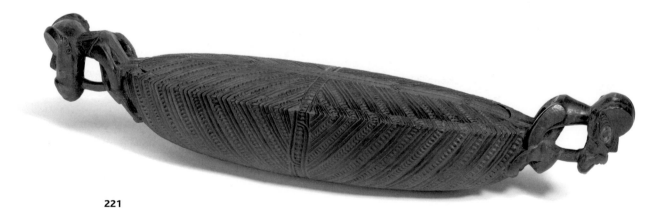

221

Plate 60 Treasure boxes: *wakahuia* (**219–221**).

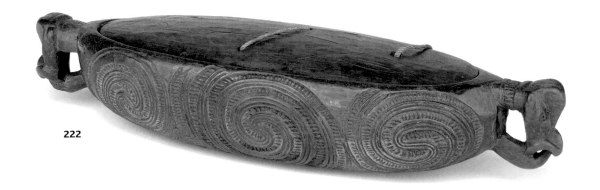

222

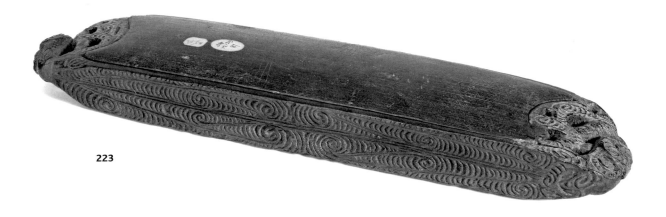

223

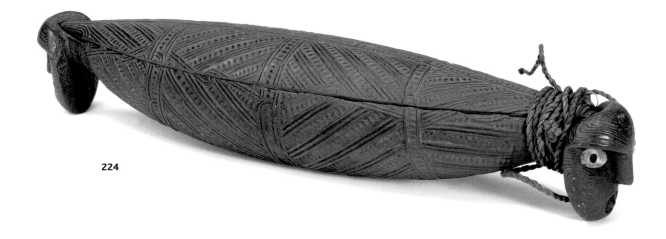

224

Plate 61 Treasure boxes: *wakahuia* (**222**, **224**) and *papahou* (**223**).

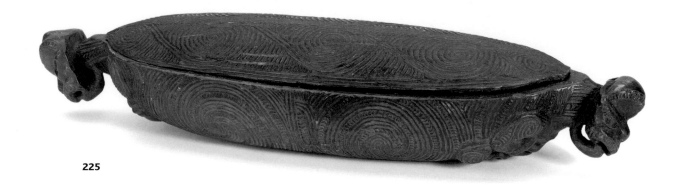

225

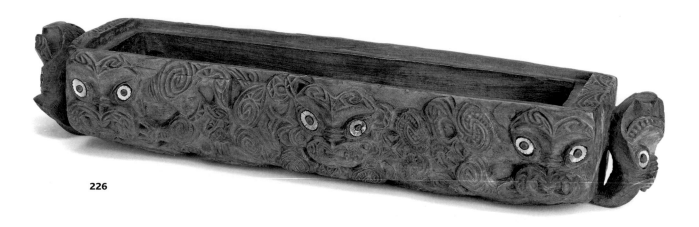

226

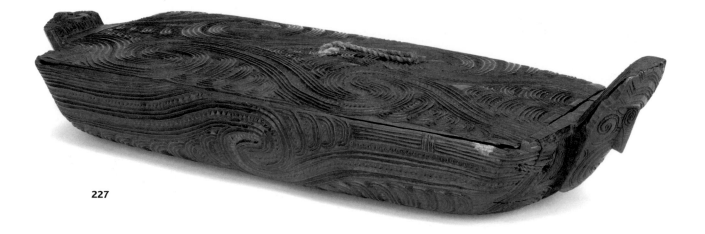

227

Plate 62 Treasure boxes: *wakahuia* (**225**) and *papahou* (**226**, **227**).

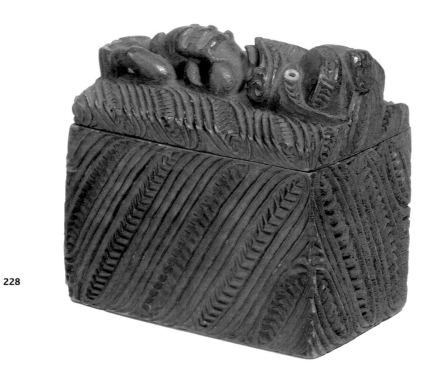

228

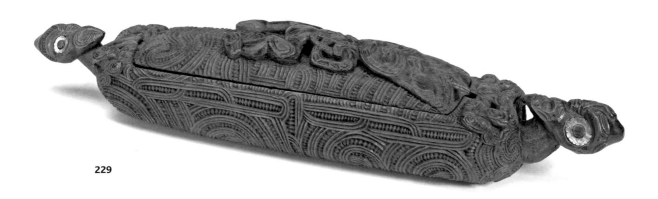

229

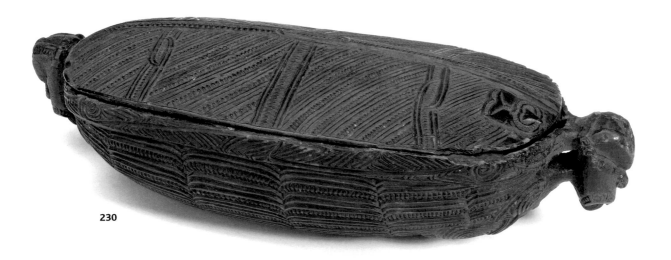

230

Plate 63 Trinket box, *powaka whakairo* (**228**) and treasure boxes, *wakahuia* (**229**, **230**).

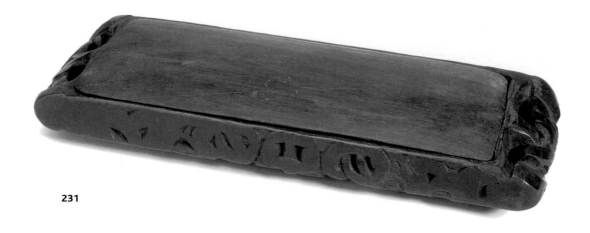

231

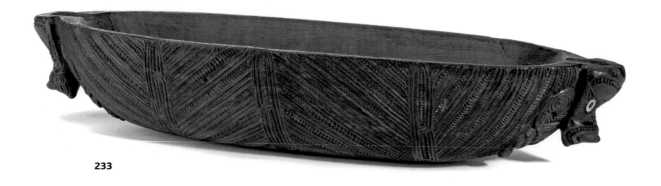

233

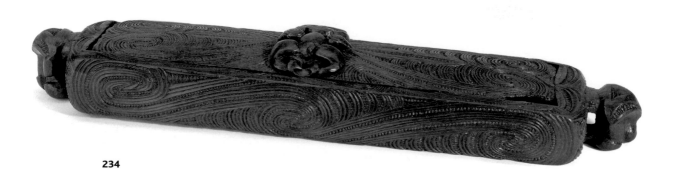

234

Plate 64 Treasure boxes: *papahou* (**231**, **234**) and *wakahuia* (**233**).

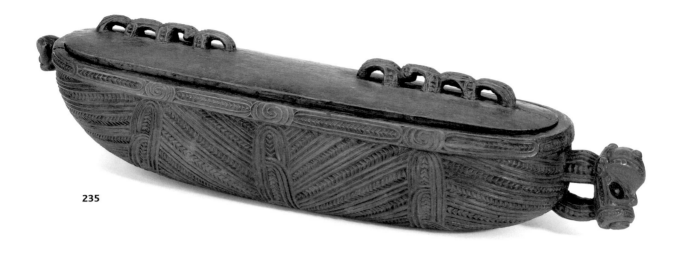

235

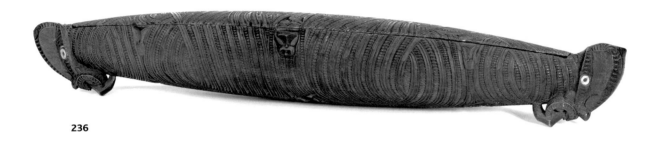

236

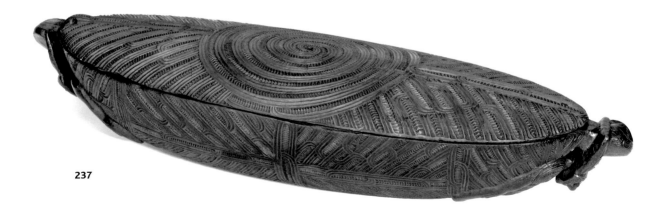

237

Plate 65 Treasure boxes: *wakahuia* (**235–237**).

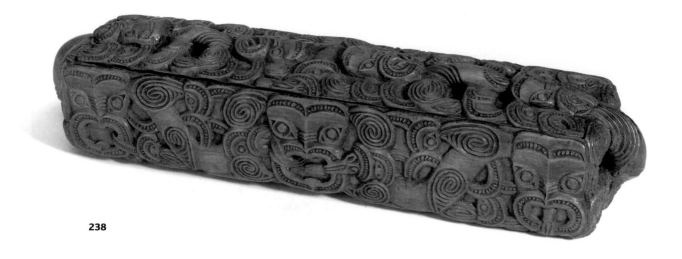

238

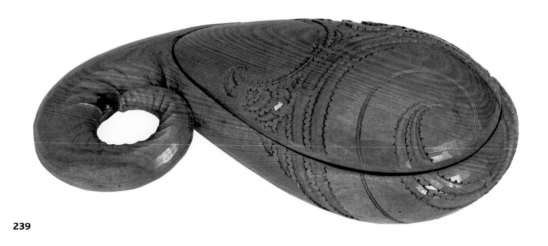

239

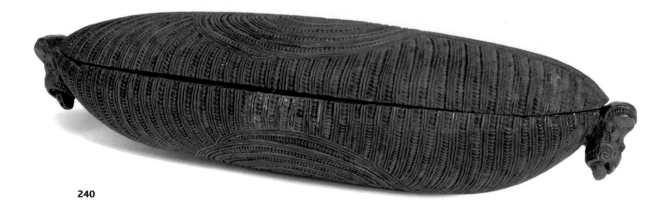

240

Plate 66 Treasure boxes: *papahou* (**238**) and *wakahuia* (**239**, **240**).

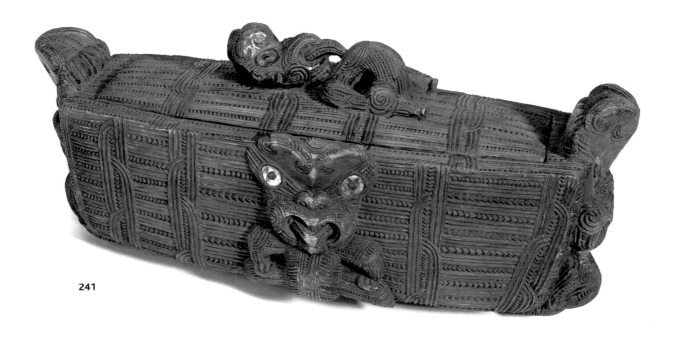

241

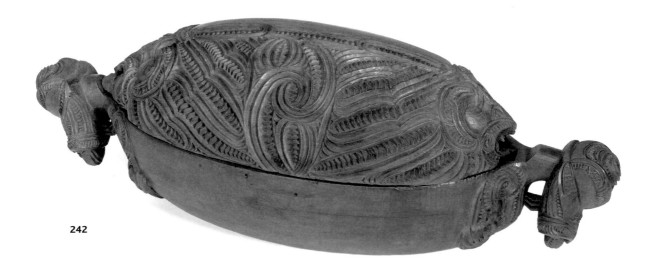

242

Plate 67 Treasure boxes: *papahou* (**241**) and *wakahuia* (**242**).

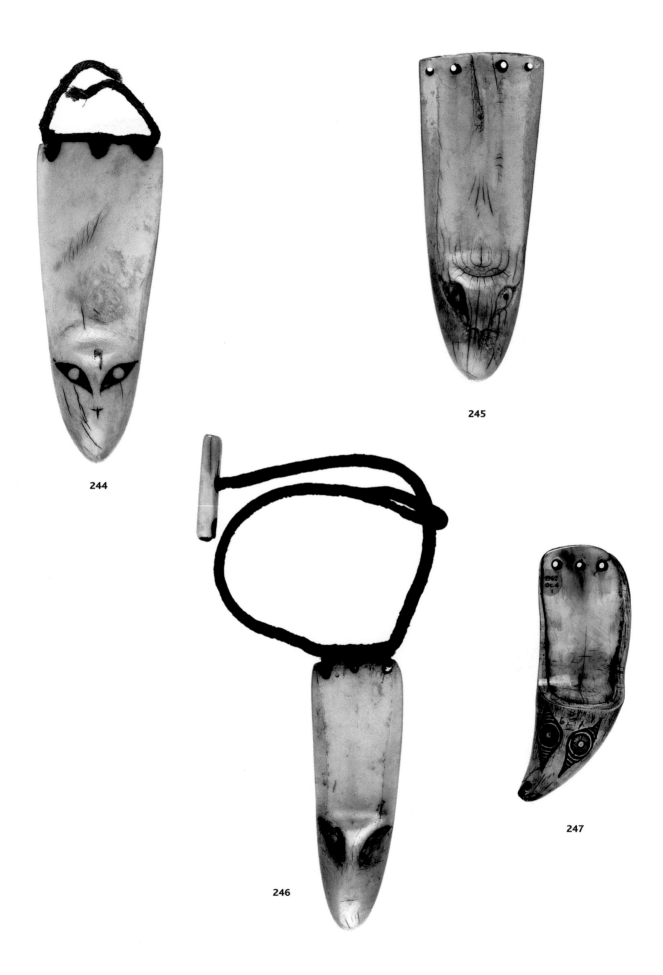

244

245

246

247

Plate 68 Pendants: *rei puta* (**244–247**).

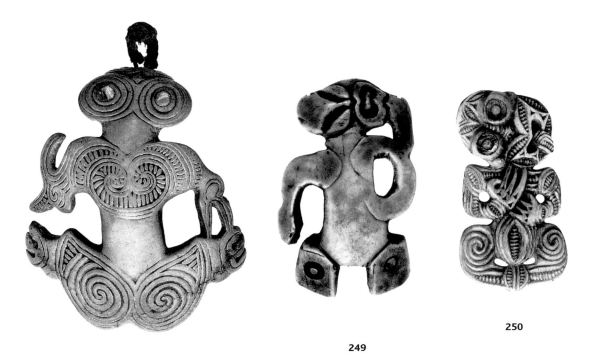

250

249

248

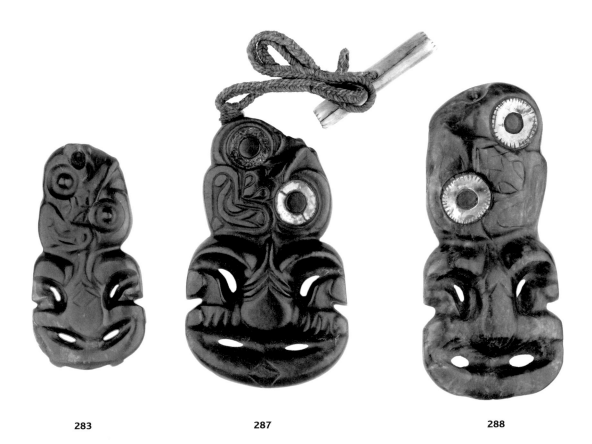

283

287

288

Plate 69 Pendants: *hei-tiki* (**248–250**, **283** back view, **287**, **288**).

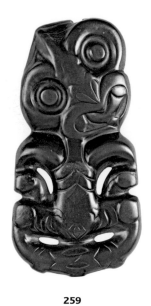

259

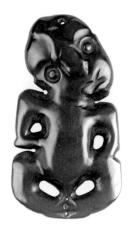

263

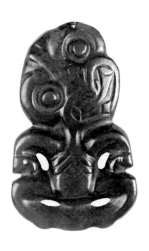

264

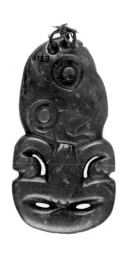

265

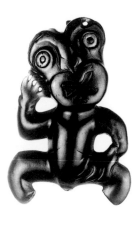

266

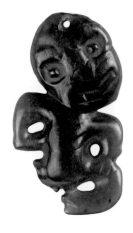

267

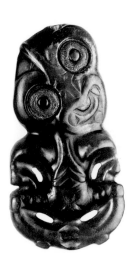

283

Plate 70 Pendants: *hei-tiki* (**259**, **263–267**, **283**).

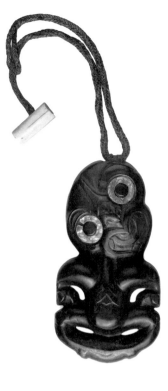

269

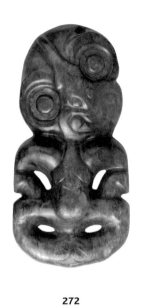

272

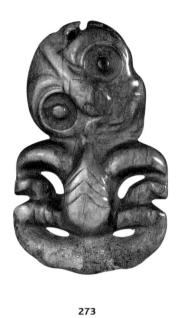

273

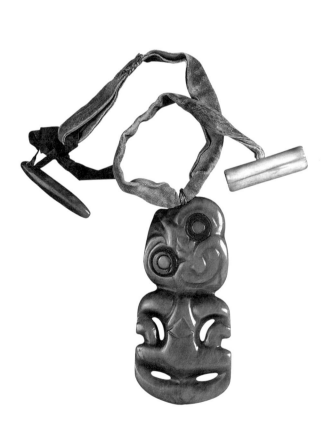

274

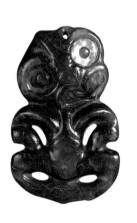

275

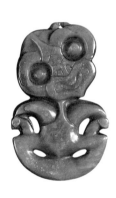

276

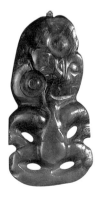

284

Plate 71 Pendants: *hei-tiki* (**269**, **272–276**, **284**).

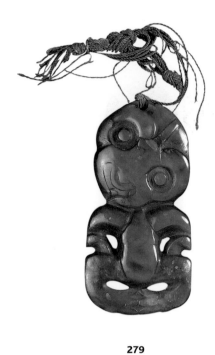

279

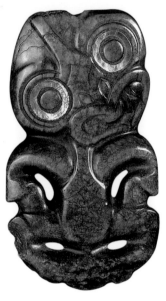

280

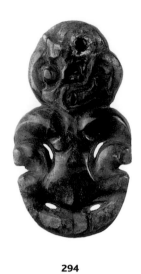

294

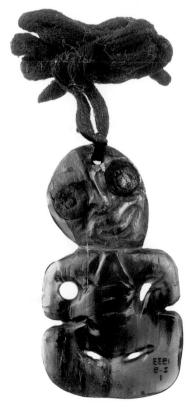

295

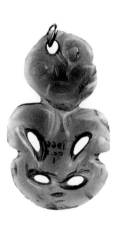

296

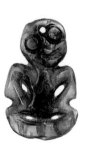

297

Plate 72 Pendants: *hei-tiki* (**279, 280, 294–297**)

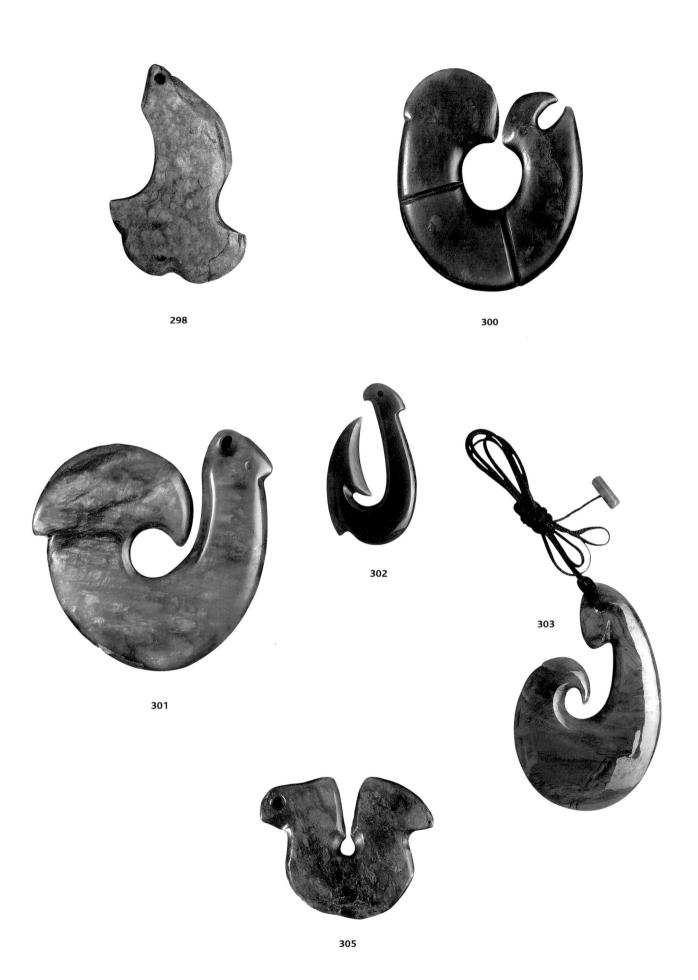

298

300

301

302

303

305

Plate 73 Pendants: *hei-matau* (**298**, **300–303**, **305**).

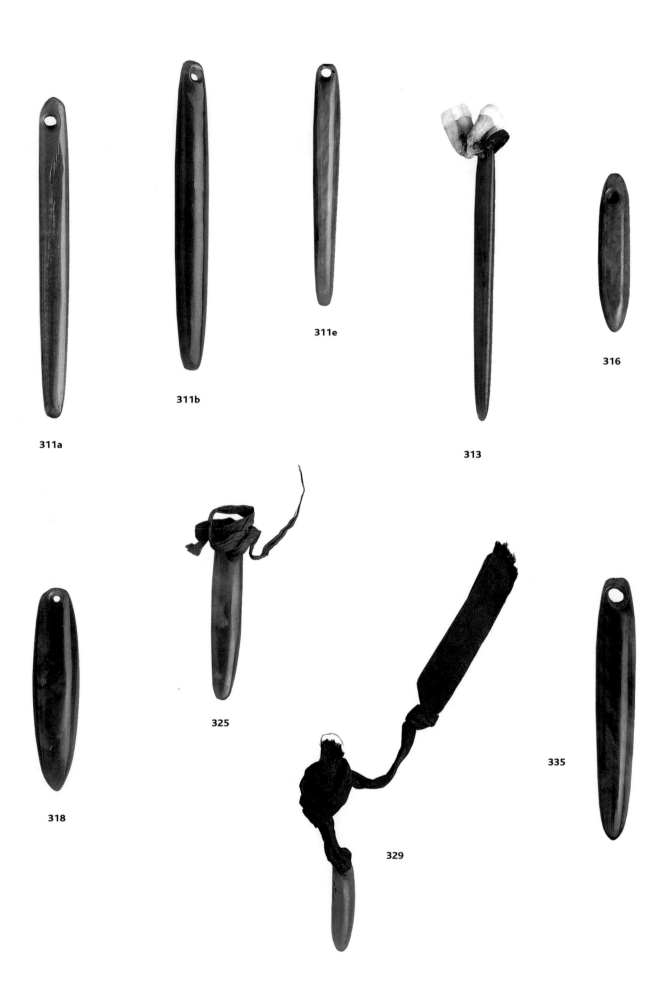

311e

316

311b

311a

313

325

318

329

335

Plate 74 Pendants: *kuru* (**311a, b, e, 313, 316, 318, 325, 329, 335**).
335: The Royal Collection © 2009 Her Majesty Queen Elizabeth II.

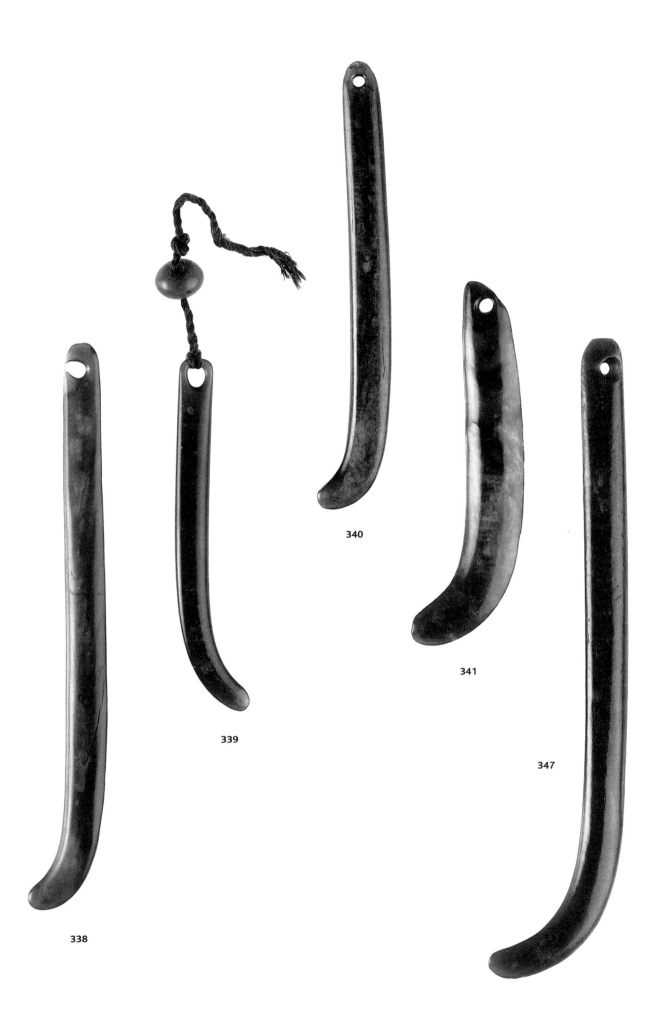

340

341

339

347

338

Plate 75 Pendants: *kapeu* (**338–341**, **347**).
340: The Royal Collection © 2009 Her Majesty Queen Elizabeth II.

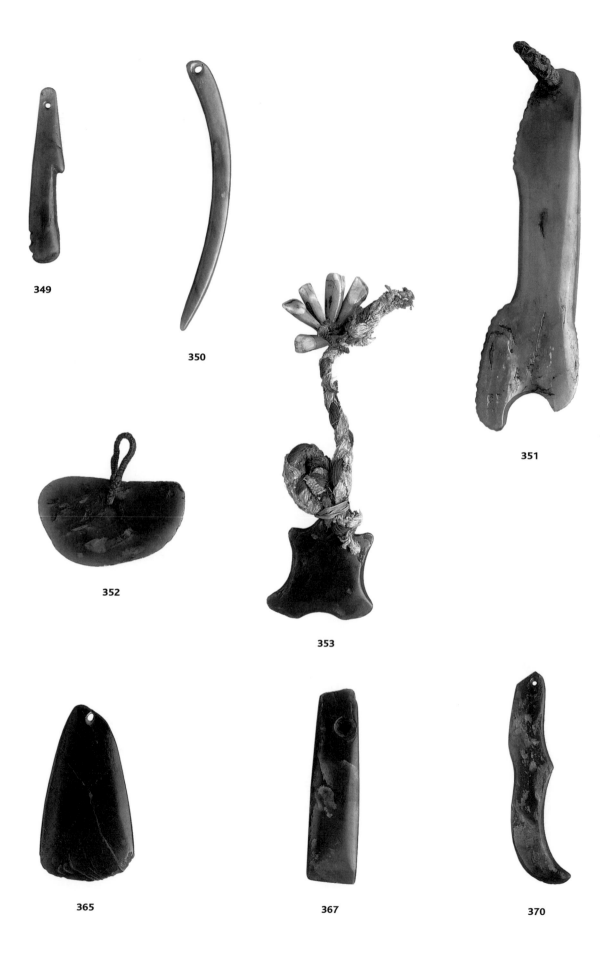

Plate 76 Pendants (**349**, **351**, **353**), *aurei* (**350**), *haro muka* (**352**), *hei-pounamu* (**365**, **367**), *whakakaipiko* (**370**).

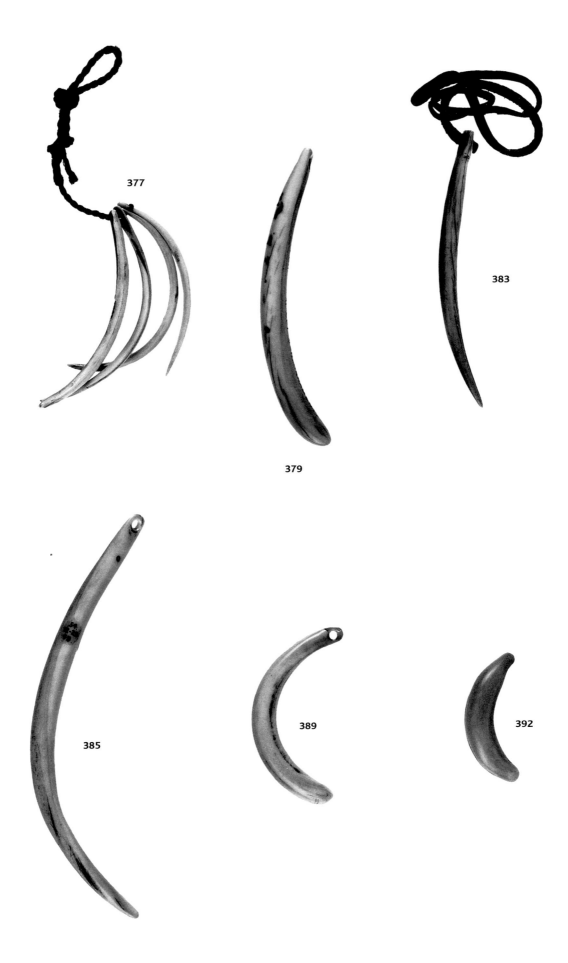

Plate 77 Cloak pins, *aurei* (**377**, **379**, **383**, **385**, **389**, **392**).

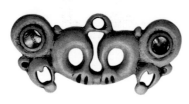

306

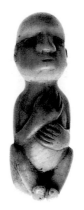

394

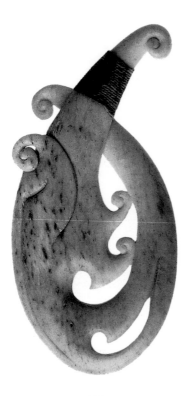

395

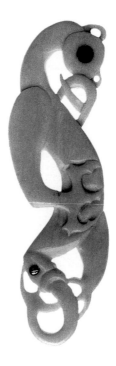

396

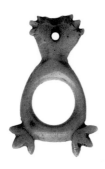

439

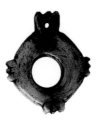

440

Plate 78 Pendants (**394–396**), *pekapeka* (**306**) and parrot rings, *kaka poria* (**439**, **440**).

404

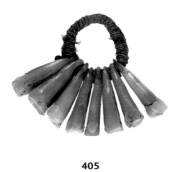

405

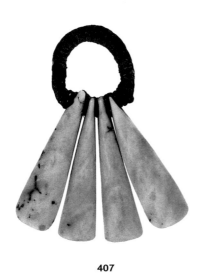

407

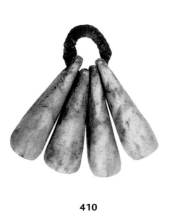

410

411

413

414

Plate 79 Ear pendants, *mau taringa* (**404**, **405**, **407**, **410**, **411**, **413**, **414**).

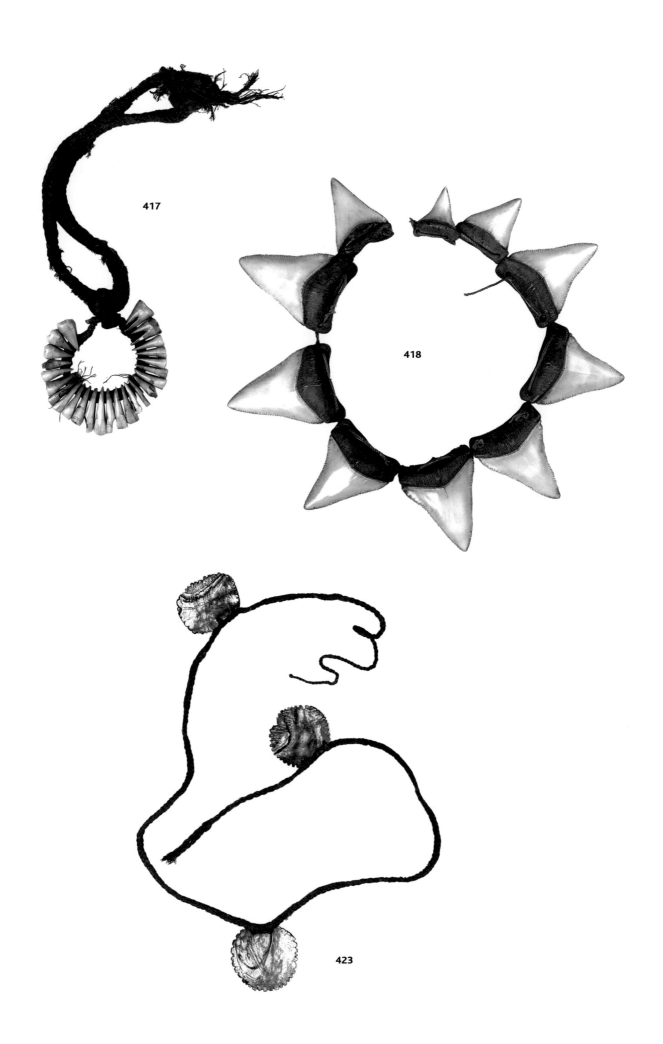

Plate 80 Necklaces (**417**, **418**, **423**).

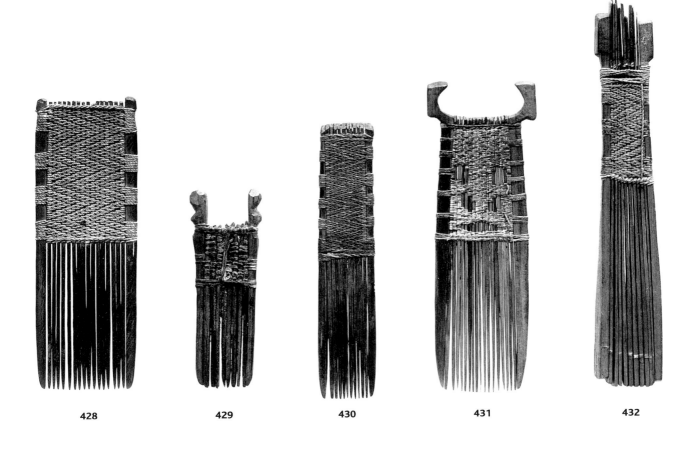

428 429 430 431 432

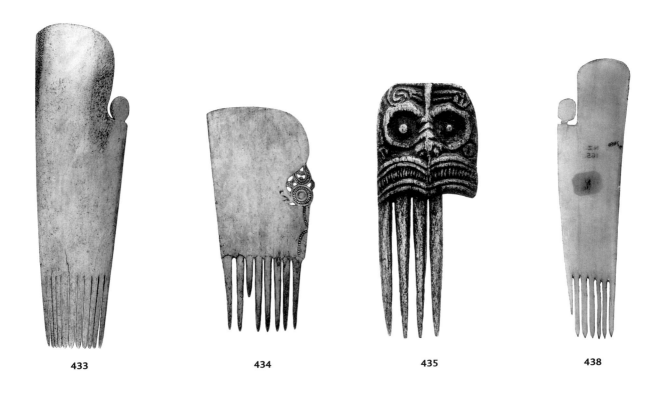

433 434 435 438

Plate 81 Combs, *heru* (**428–435**, **438**).

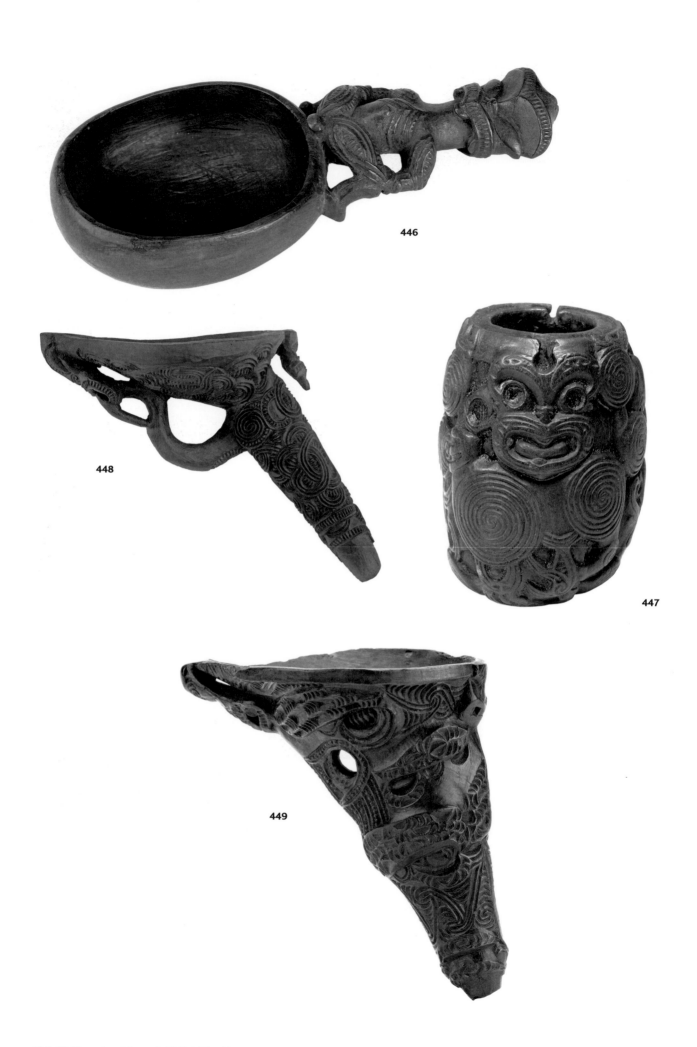

Plate 82 Pigment containers, *oko* (**446**, **447**) and feeding funnels, *korere* (**448**, **449**).

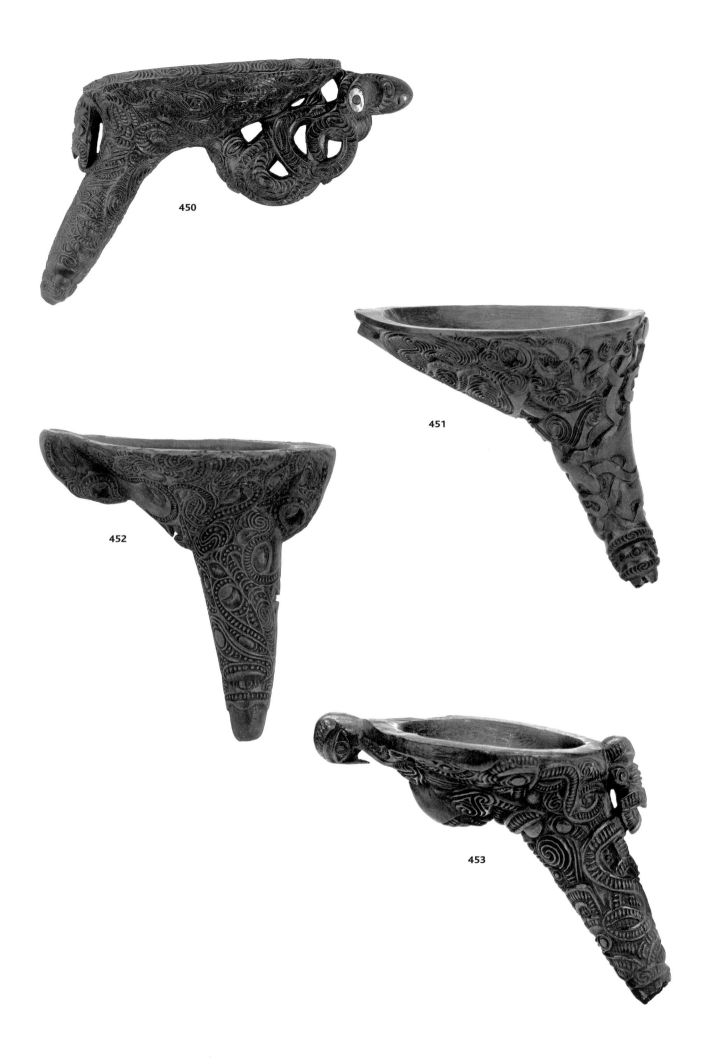

Plate 83 Feeding funnels, *korere* (**450–453**).

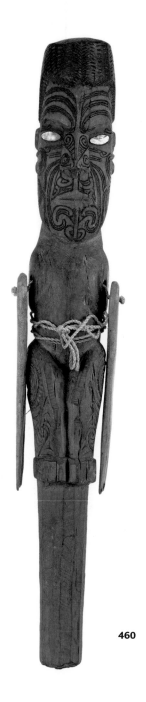

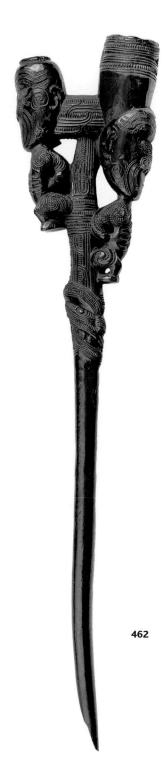

460

462

Plate 84 Puppet, *karetao* (**460**) and tobacco pipe, *paipa* (**462**).
460: The Royal Collection © 2009 Her Majesty Queen Elizabeth II.

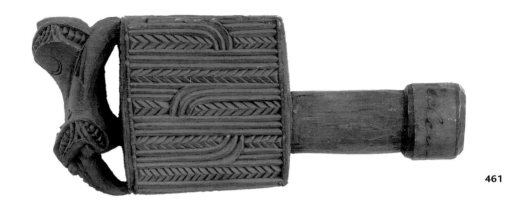

461

463

464

Plate 85 Tobacco pipes, *paipa* (**461**, **463**, **464**).

465

468

470

Plate 86 Cigarette holder (**465**) and poi balls (**468**, **470**).

477

478

479

480

481

482

483

484

Plate 87 End-blown curved flutes, *nguru* (**477–484**).

541

542

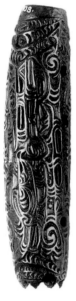

485

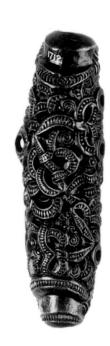

487

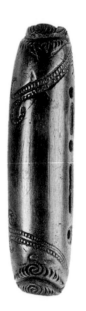

488

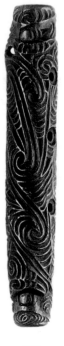

489

Plate 88 Whistle/weka calls (**541, 542**) and end-blown straight flutes, *koauau* (**485, 487–489**).

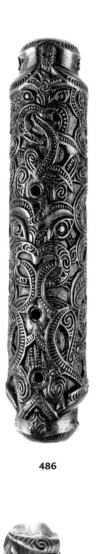

486

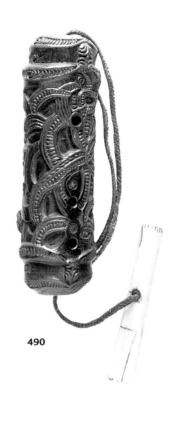

490

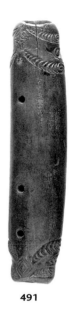

491

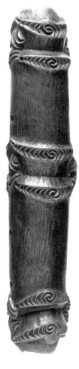

492

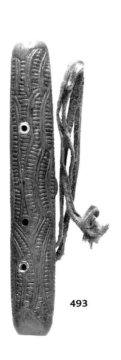

493

494

495

Plate 89 End-blown straight flutes, *koauau* (**486**, **490–495**).

496

497

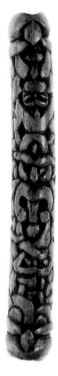

498

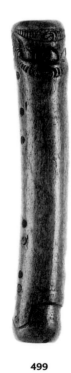

499

500

Plate 90 End-blown straight flutes, *koauau* (**496–500**).

503

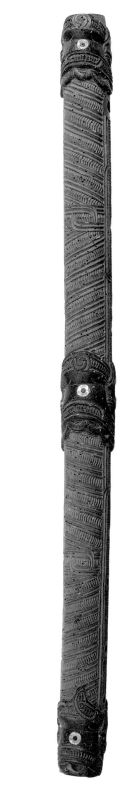

502

504

Plate 91 End-blown long flutes, *porutu* (**502**, **503**) and transverse flute, *rehu* (**504**).

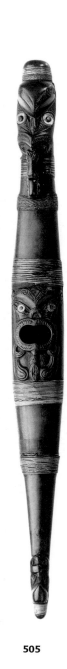

505

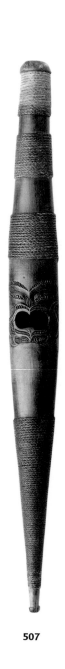

507

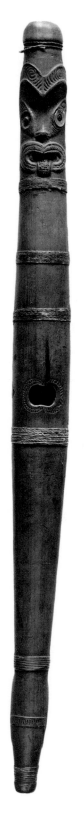

508

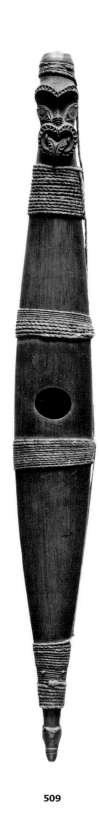

509

Plate 92 Trumpets/flutes, *putorino* (**505**, **507–509**).

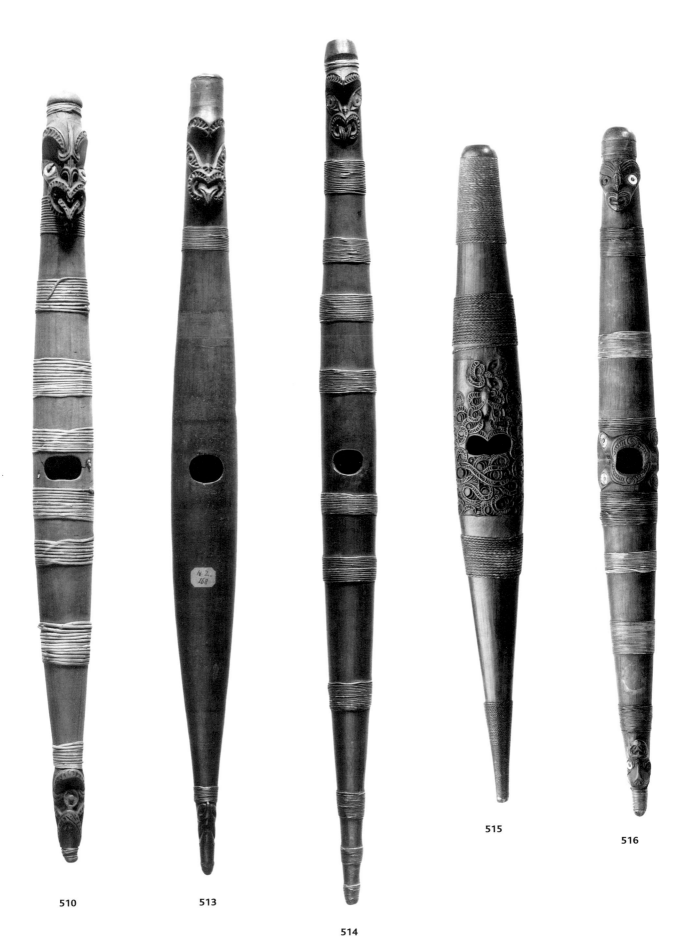

510

513

514

515

516

Plate 93 Trumpets/flutes, *putorino* (**510**, **513–516**).

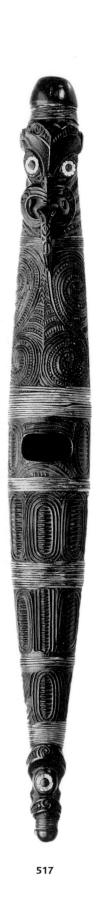

517

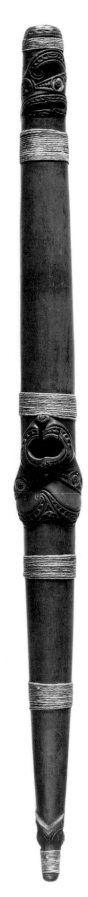

518

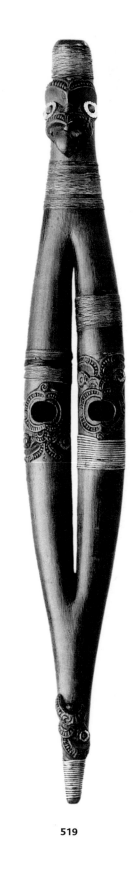

519

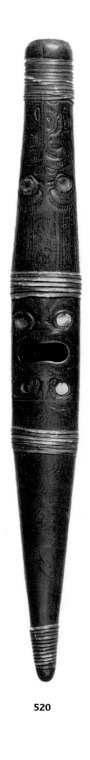

520

Plate 94 Trumpets/flutes, *putorino* (**517–520**).

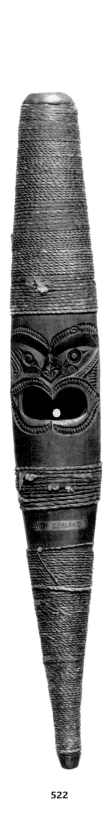
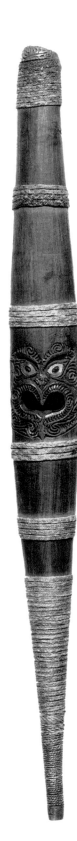
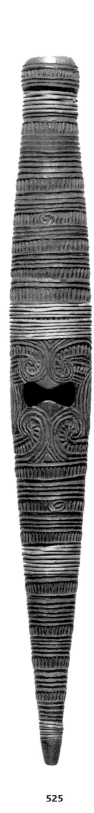
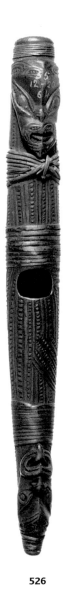
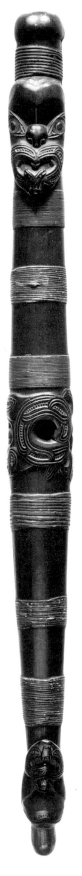

522

524

525

526

527

Plate 95 Trumpets/flutes, *putorino* (**522**, **524–527**).

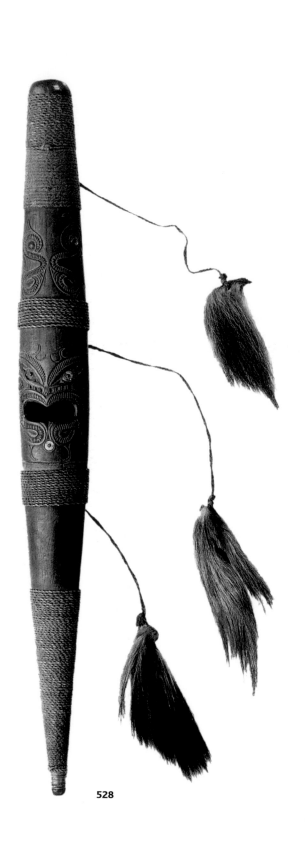

528

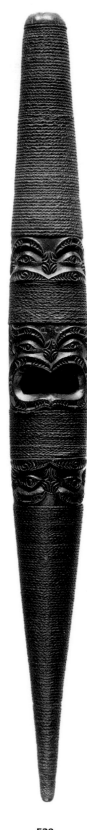

529

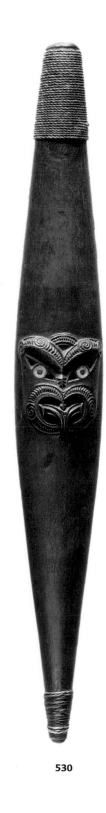

530

Plate 96 Trumpets/flutes, *putorino* (**528–530**).

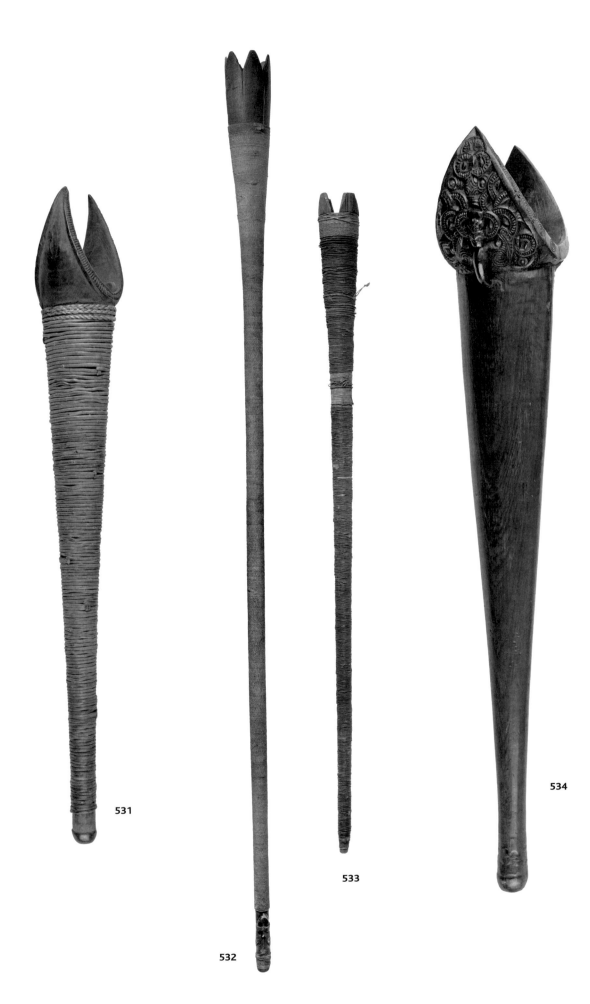

531

532

533

534

Plate 97 Long trumpets, *pukaea* (**531–534**).

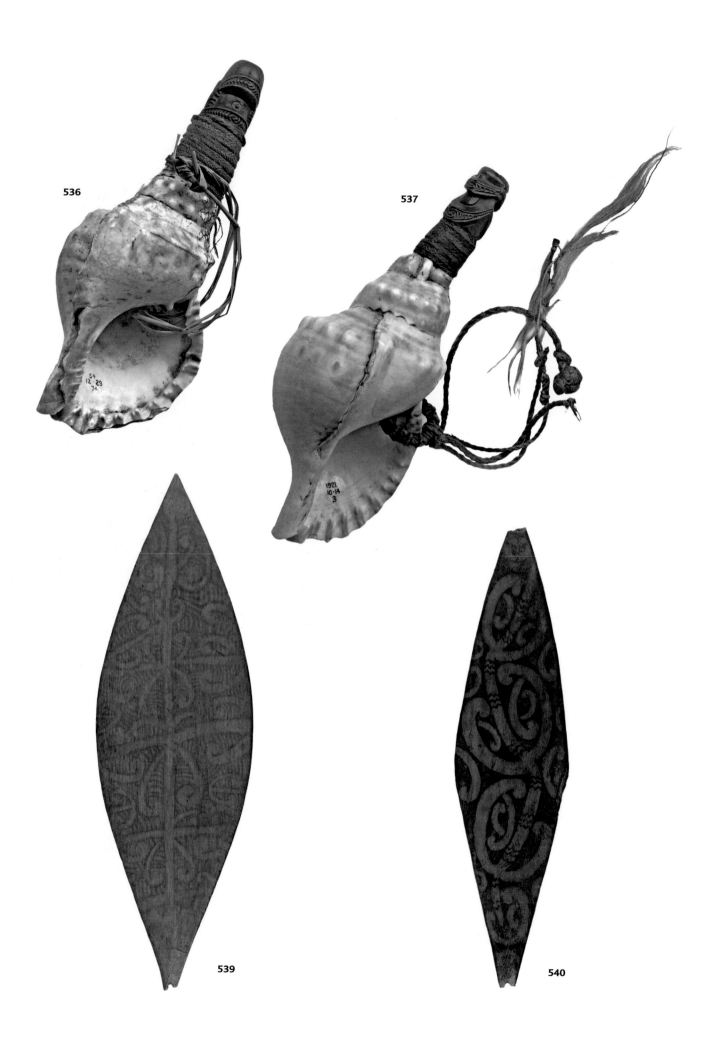

Plate 98 Shell trumpets, *putatara* (**336**, **337**) and bullroarers, *purorohu/purerehua* (**539**, **540**).

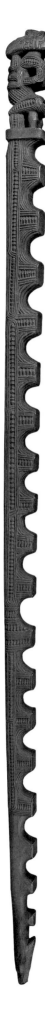

544

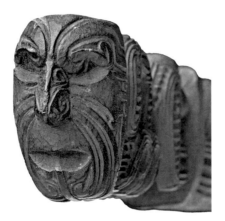

544 (detail)

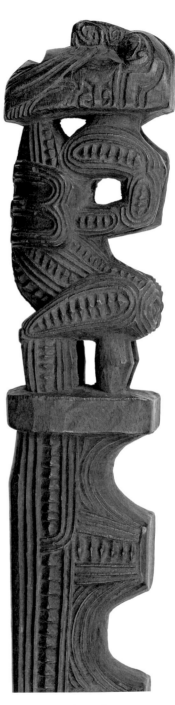

544 (detail)

Plate 99 Genealogical staff, *rakau whakapapa* (**544**).

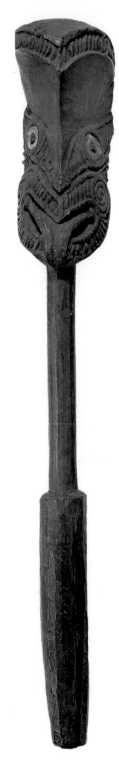

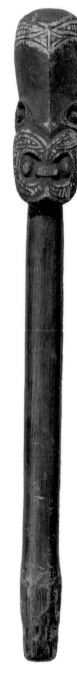

545

546

547

Plate 100 Godsticks, *whakapakoko atua* (**545–547**).

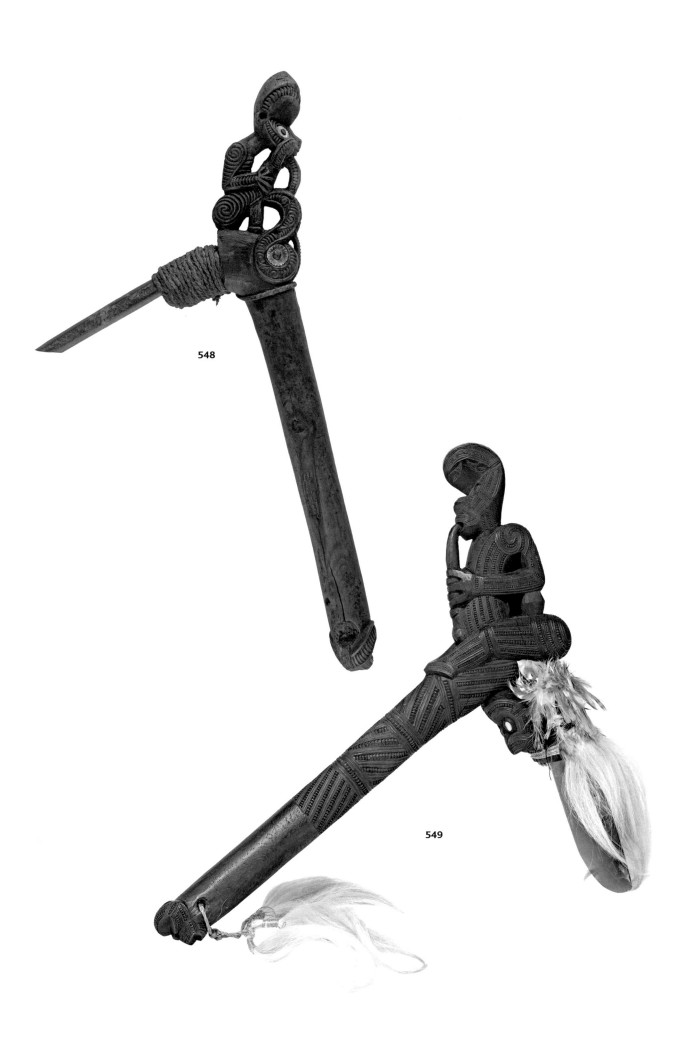

548

549

Plate 101 Ceremonial adzes, *toki poutangata* (**548**, **549**).
549: The Royal Collection © 2009 Her Majesty Queen Elizabeth II.

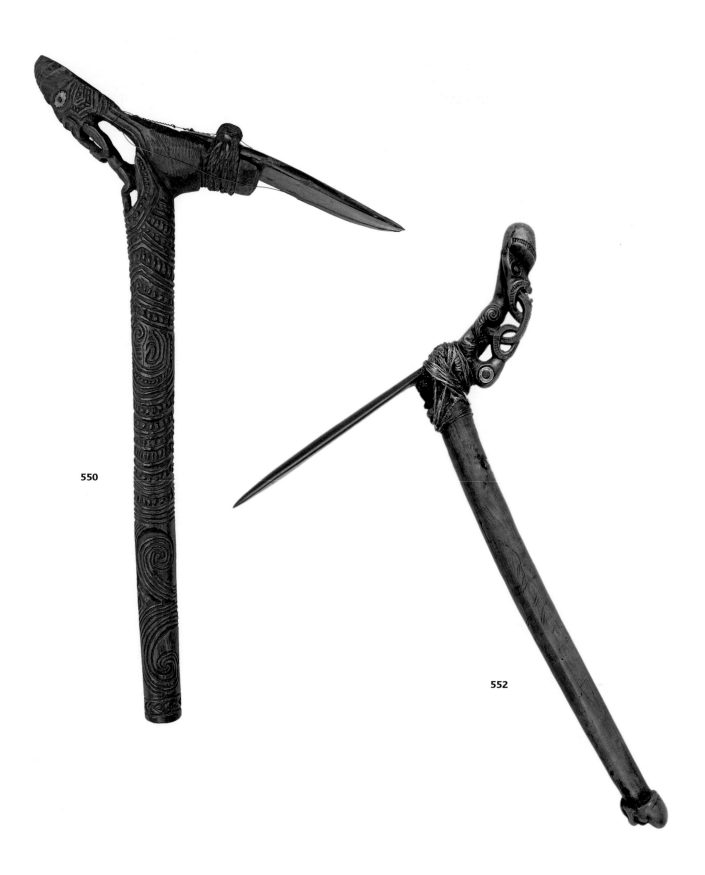

550

552

Plate 102 Ceremonial adzes, *toki poutangata* (**550**, **552**).

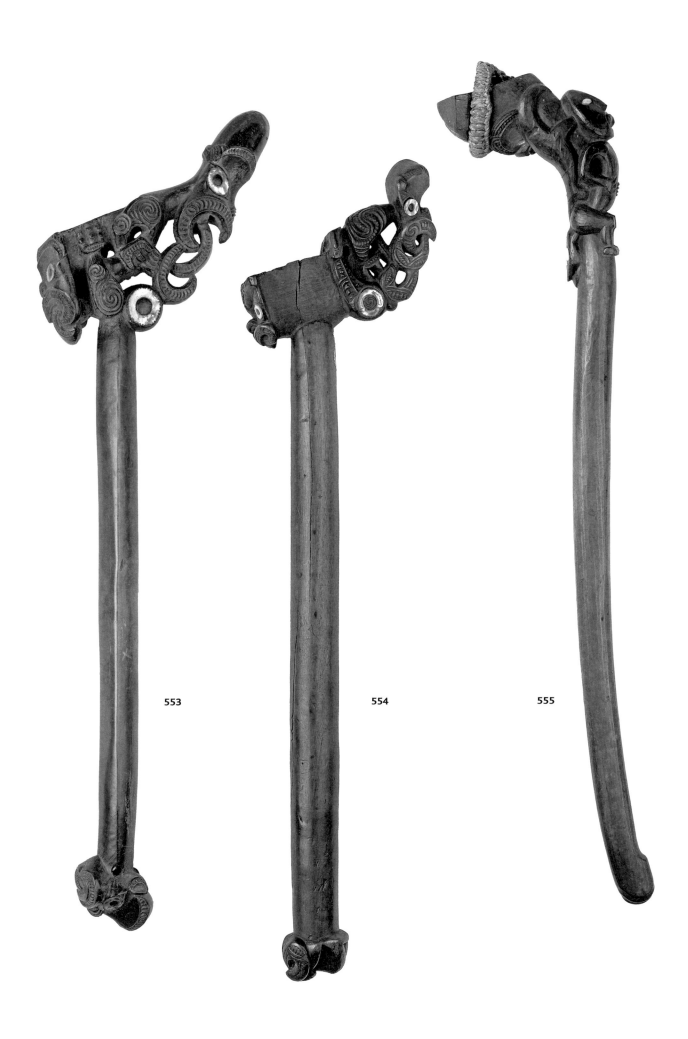

553

554

555

Plate 103 Hafts of ceremonial adzes, *toki poutangata* (**553–555**).

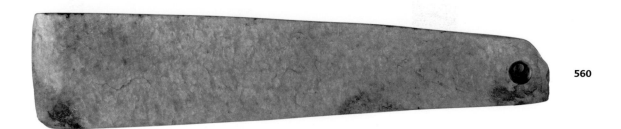

560

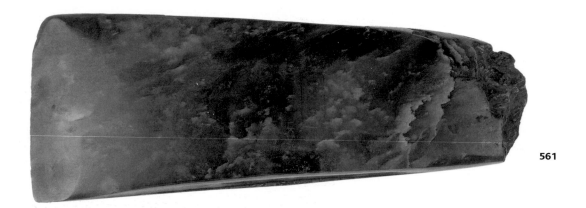

561

562

Plate 104 Blades of ceremonial adzes, *toki poutangata* (**560–562**).

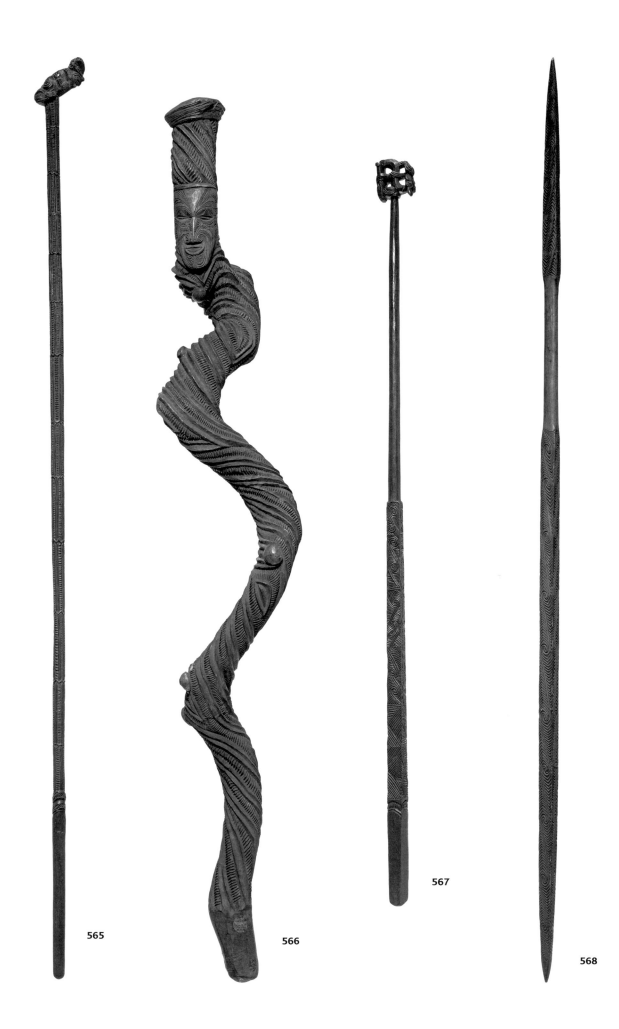

Plate 105 Staves, *tokotoko* (**565–568**).

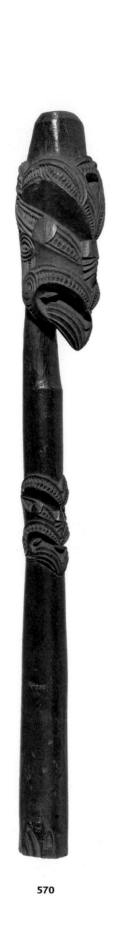

570

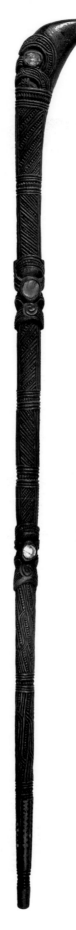

571

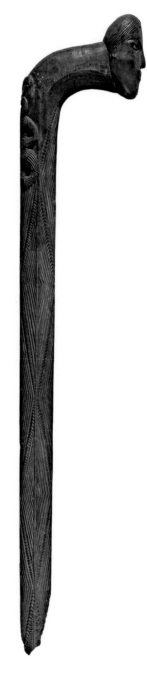

572

Plate 106 Staves, *tokotoko* (**570–572**).

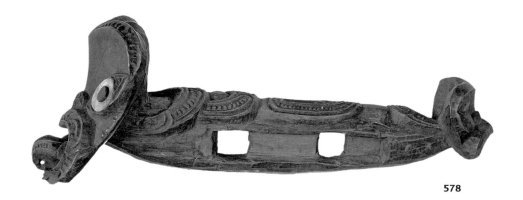

578

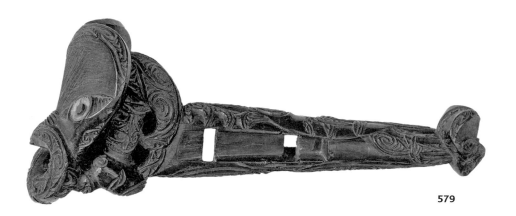

579

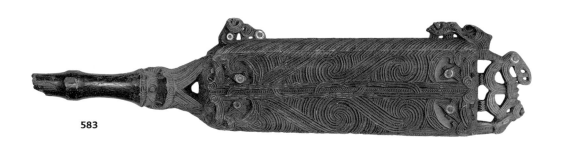

583

Plate 107 Latrine bars (?), *paepae tapu* (?) (**578**, **579**) and relic box (?) (**583**).

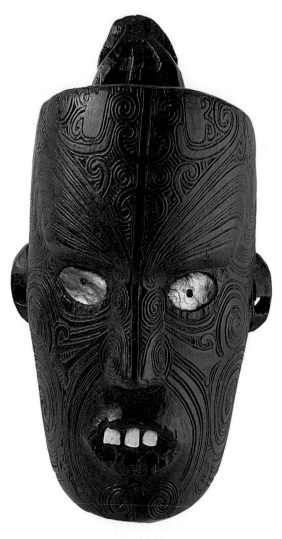

580

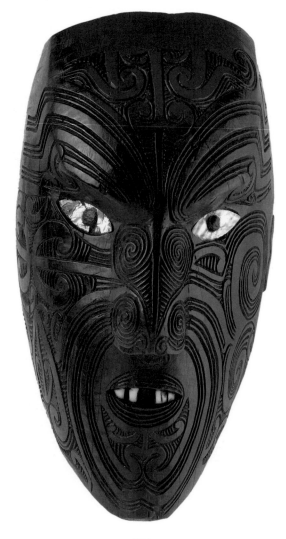

581

Plate 108 Carved head, *whakapakoko rahui* (**580**) and another head (**581**).

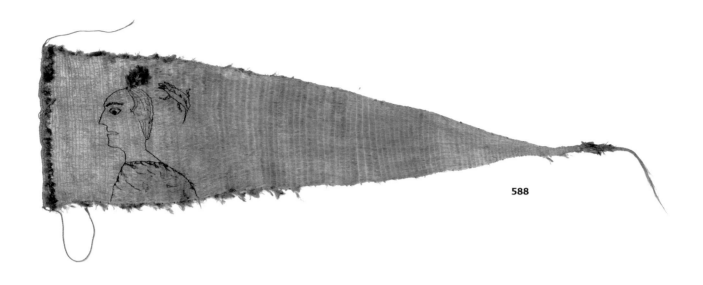

588

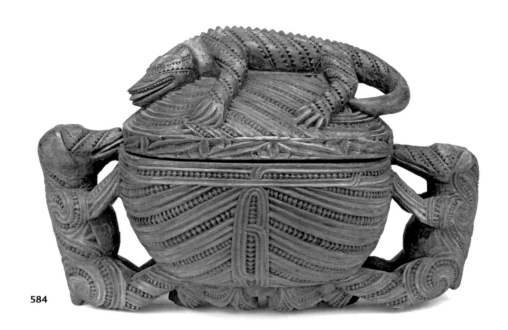

584

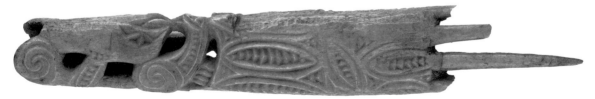

577

Plate 109 Pennant (**588**), bowl with lid, *kumete whakairo* (**584**) and fork (**577**).

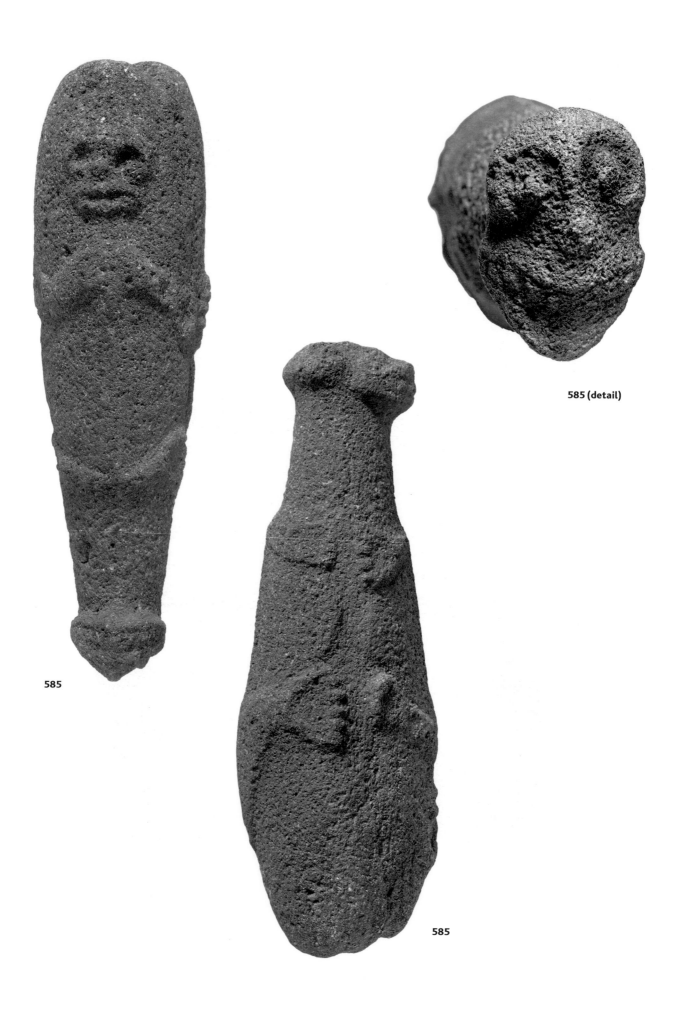

585

585 (detail)

585

Plate 110 Ceremonial flax beater, *patu muka*, or weapon (?) (**585**).

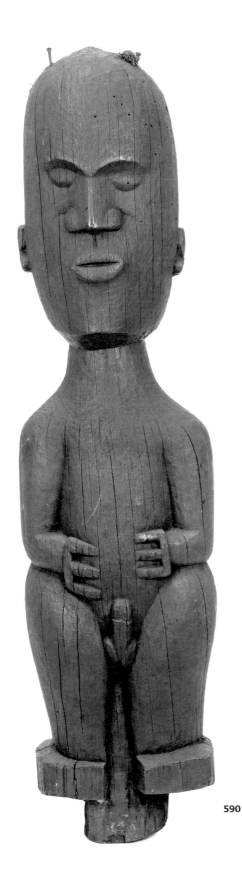

590

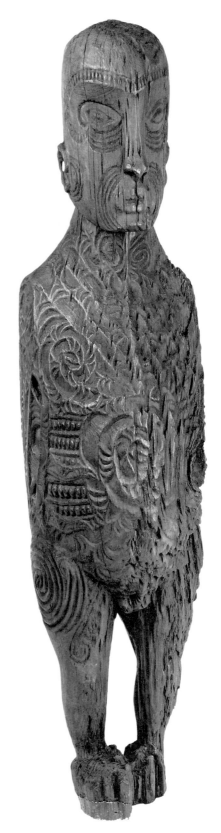

592

Plate 111 Tomb figure (**590**) and burial chest, *waka koiwi* (**592**).

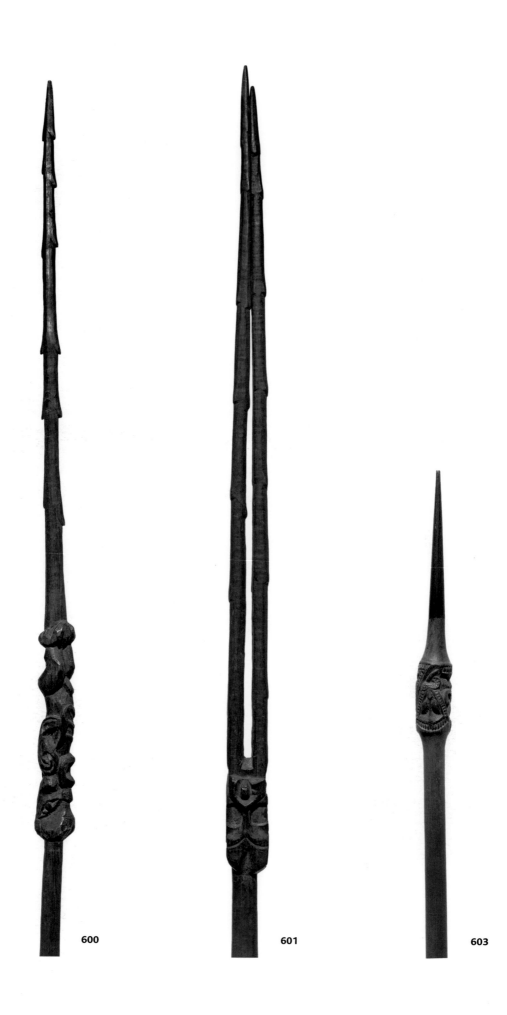

600

601

603

Plate 112 Spears, *tao* (**600**, **601**, **603**).

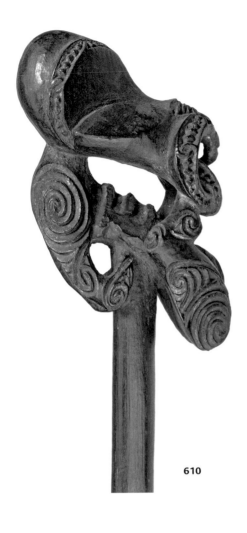

610

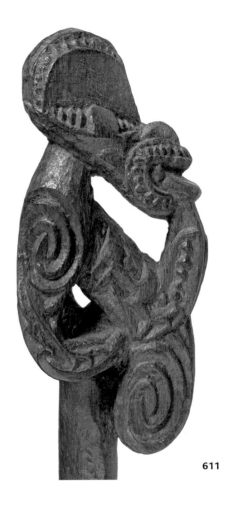

611

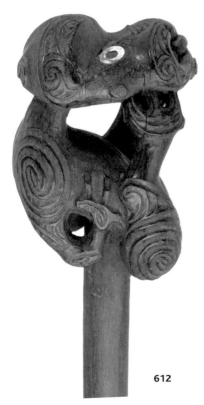

612

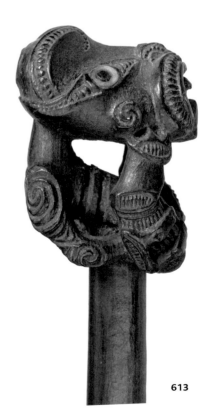

613

Plate 113 Tops of whipslings, *kotaha* (**610–613**).

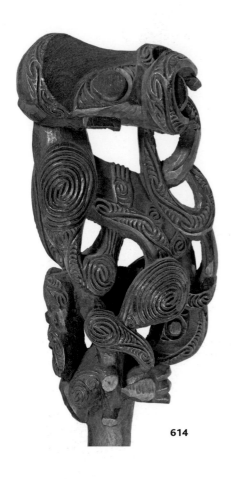

614

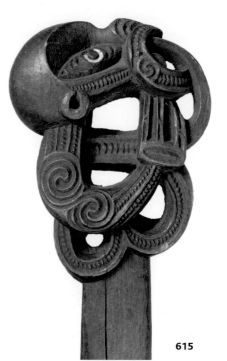

615

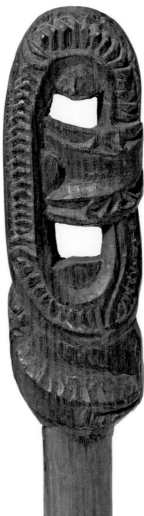

616

Plate 114 Tops of whipslings, *kotaha* (**614–616**).

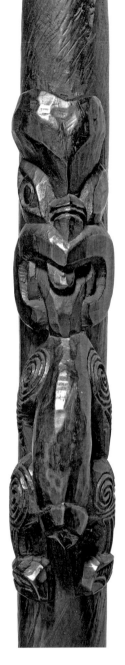

614

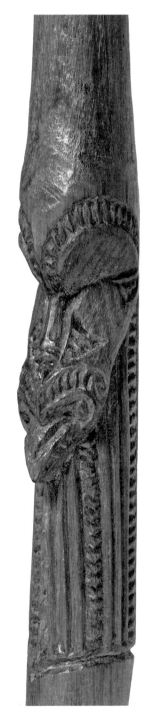

616

612

Plate 115 Mid-shafts of whipslings, *kotaha* (**612**, **614**, **616**).

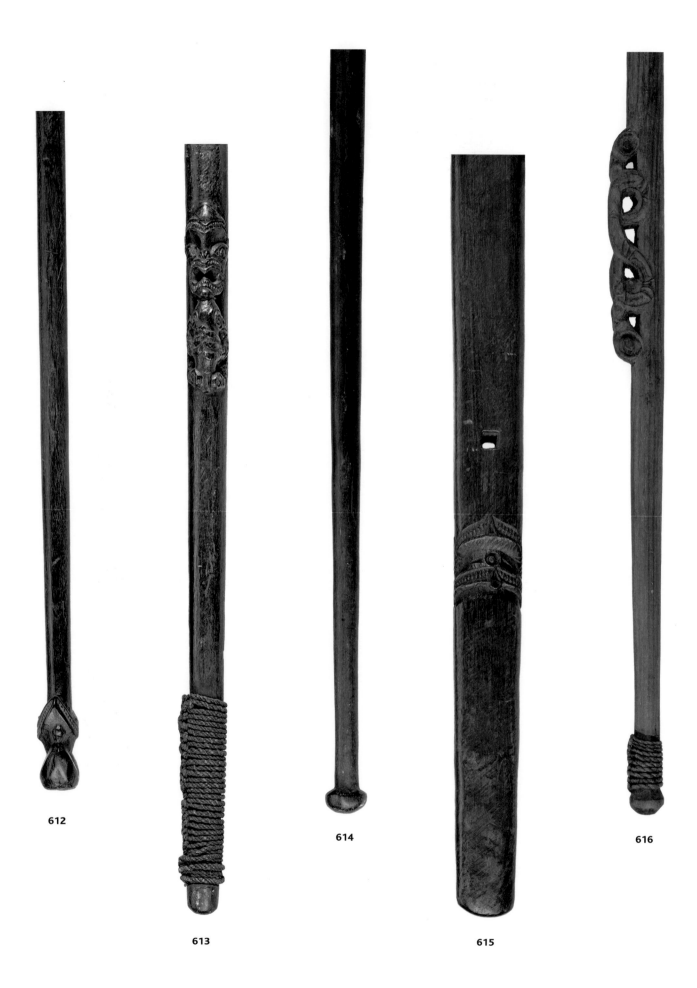

612

613

614

615

616

Plate 116 Shaft ends of whipslings, *kotaha* (**612–616**).

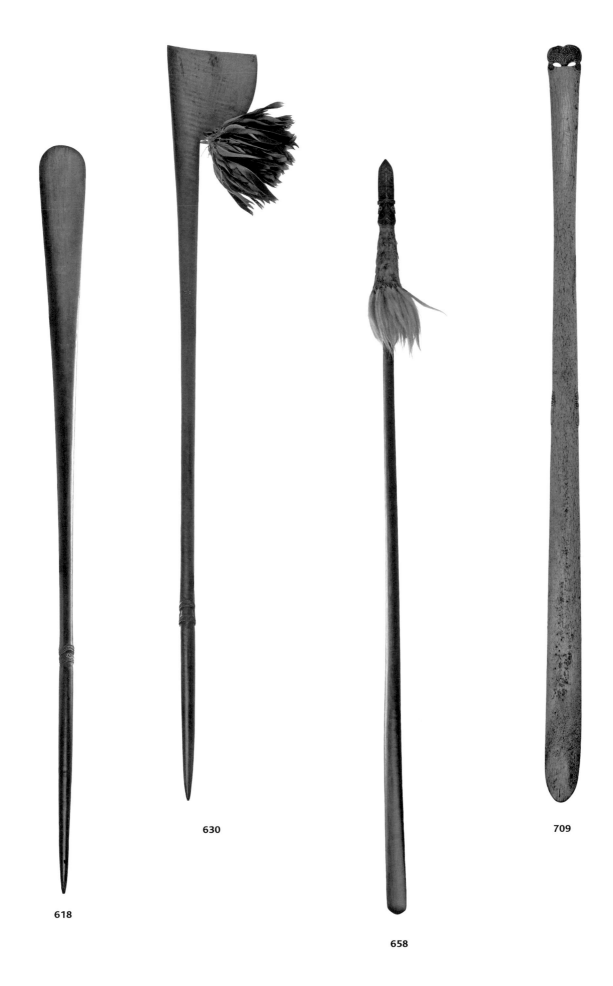

618

630

658

709

Plate 117 Long clubs: *pouwhenua* (**618**), *tewhatewha* (**630**), *taiaha* (**658**), and *hoeroa* (**709**).

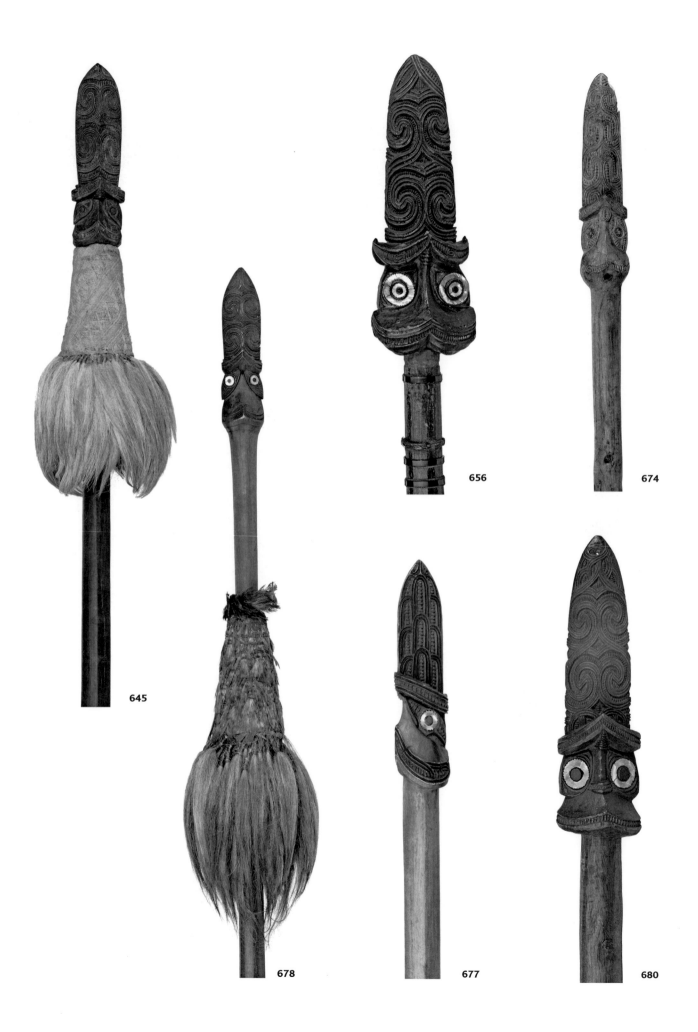

Plate 118 Points of long clubs, *taiaha* (**645, 656, 674, 677, 678, 680**).
645: The Royal Collection © Her Majesty Queen Elizabeth II.

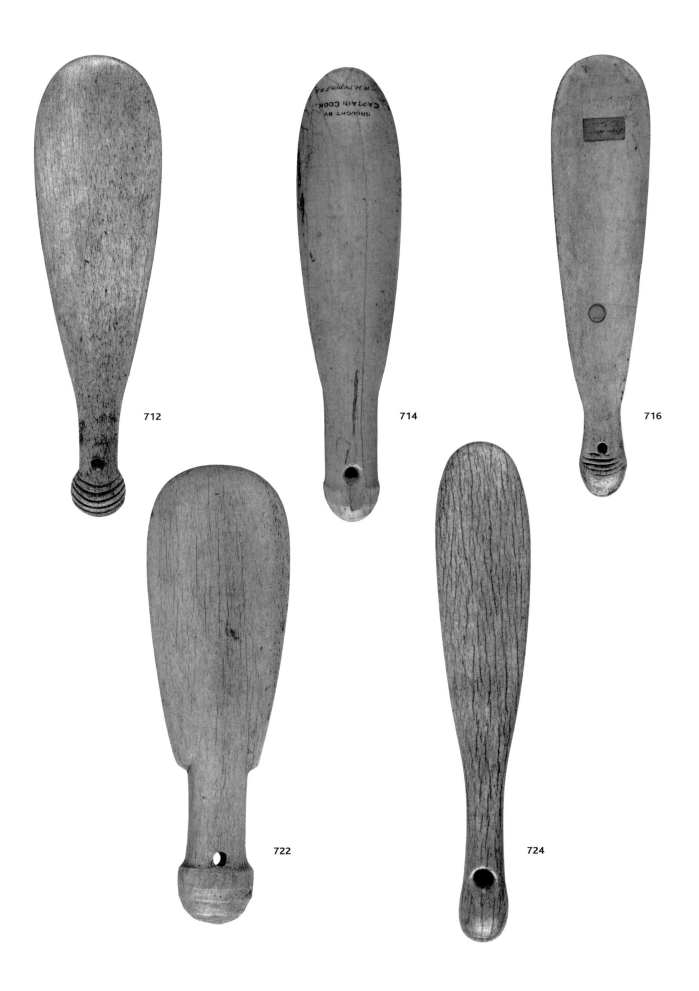

712

714

BROUGHT BY
CAPTAIN COOK.
W.H.Pepys.Fr̄s

716

722

724

Plate 119 Short whalebone clubs, *patu paraoa* (**712**, **714**, **716**, **722**, **724**).

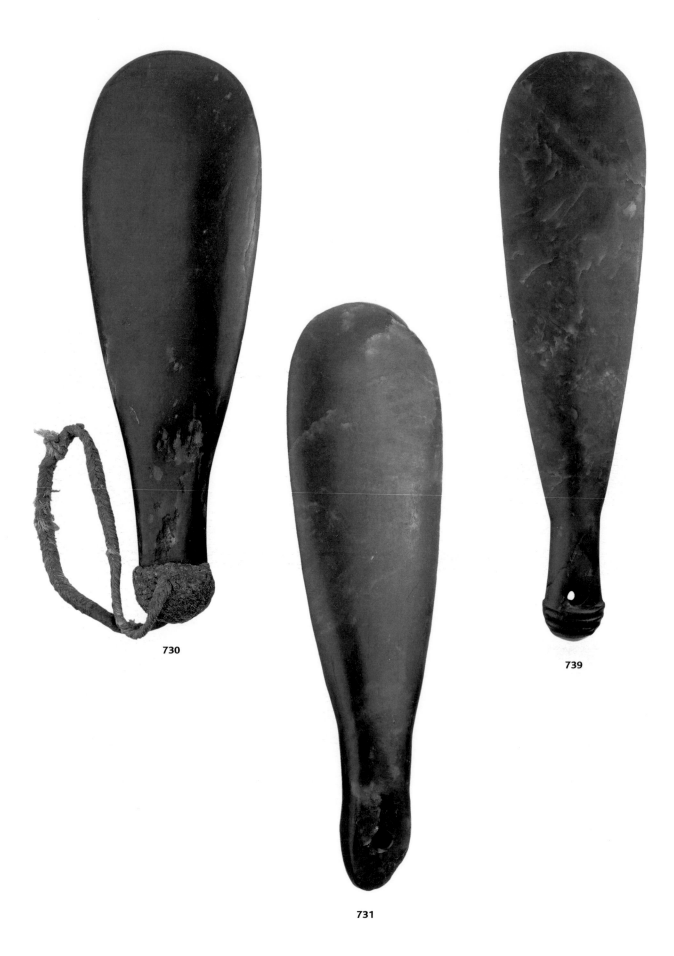

730

731

739

Plate 120 Short nephrite clubs, *mere pounamu* (**730**, **731**, **739**).

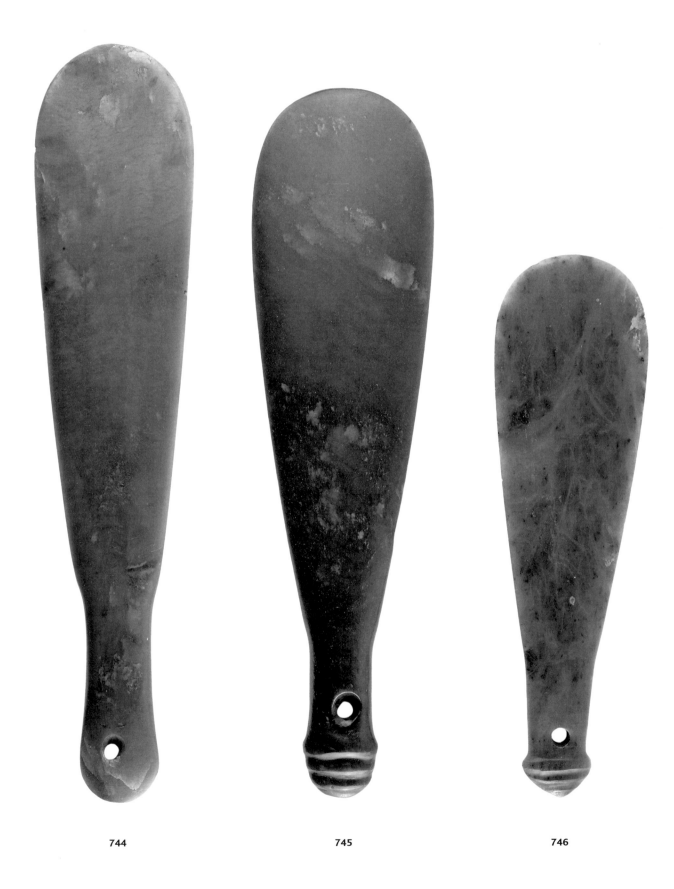

744 745 746

Plate 121 Short nephrite clubs, *mere pounamu* (**744–746**).

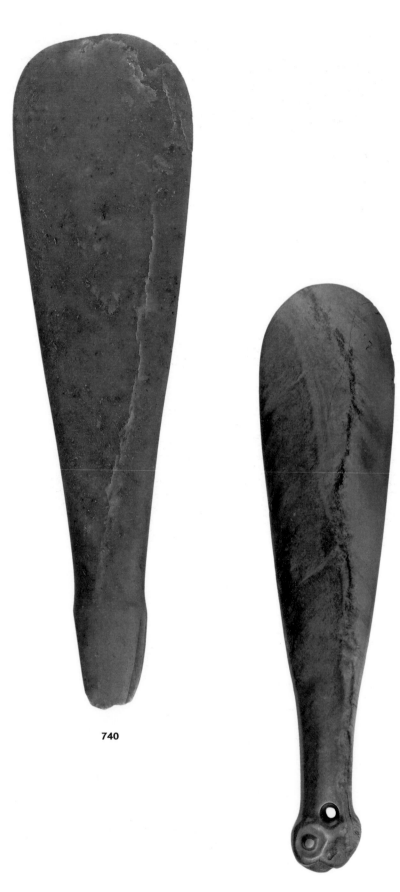
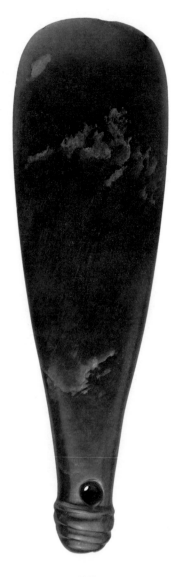

740

747

748

Plate 122 Short nephrite clubs, *mere pounamu* (**740**, **747**, **748**).

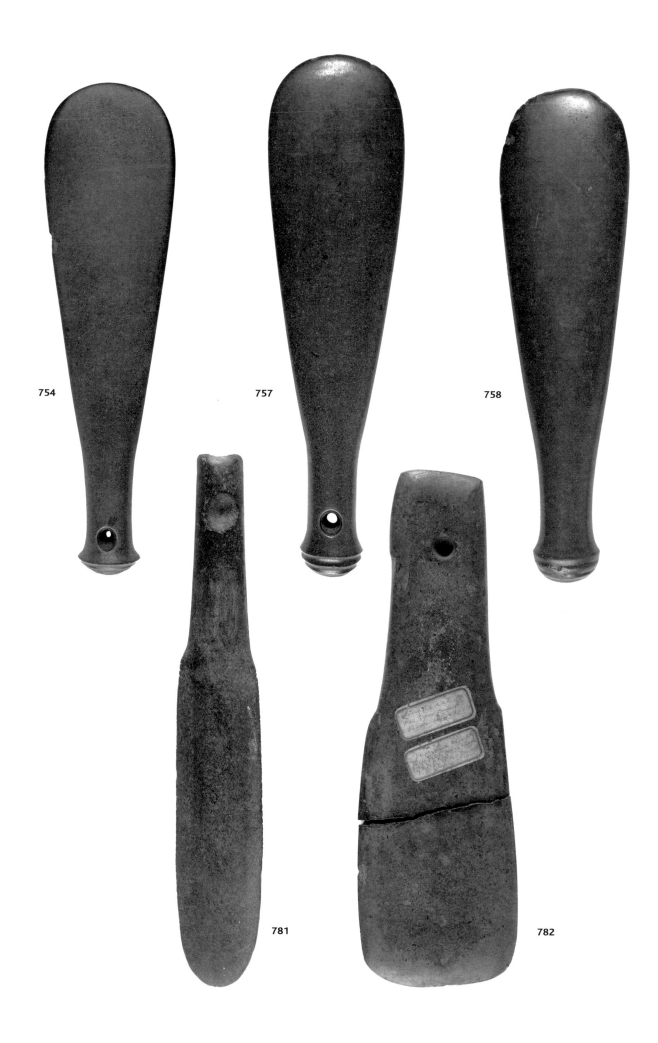

Plate 123 Short stone clubs: *patu onewa* (**754**, **757**, **758**) and *patu miti* (**781**, **782**).

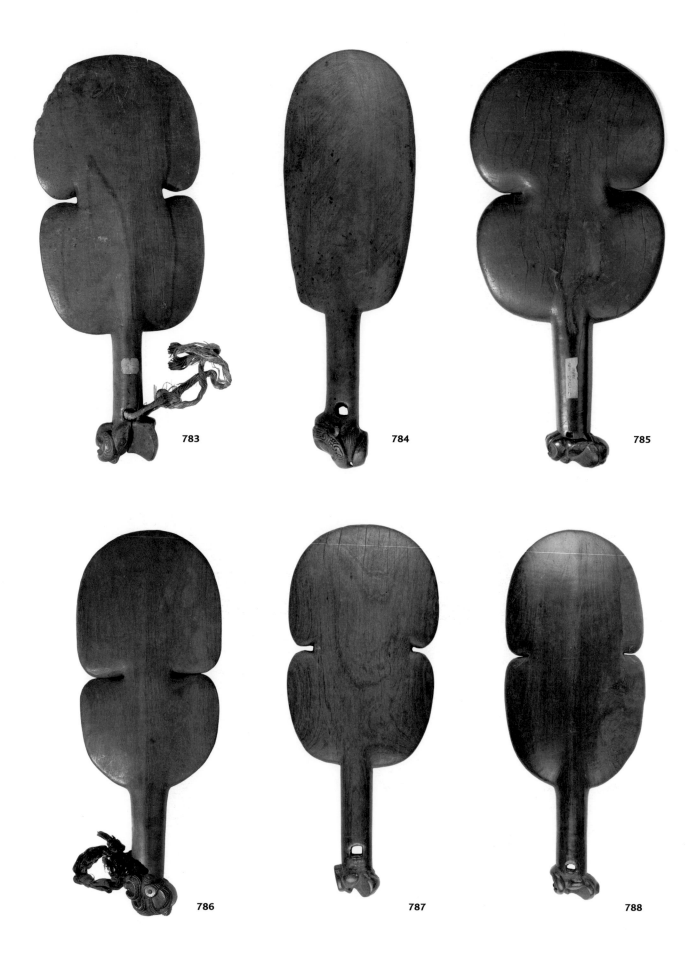

Plate 124 Short wood clubs, *kotiate* (**783–788**).

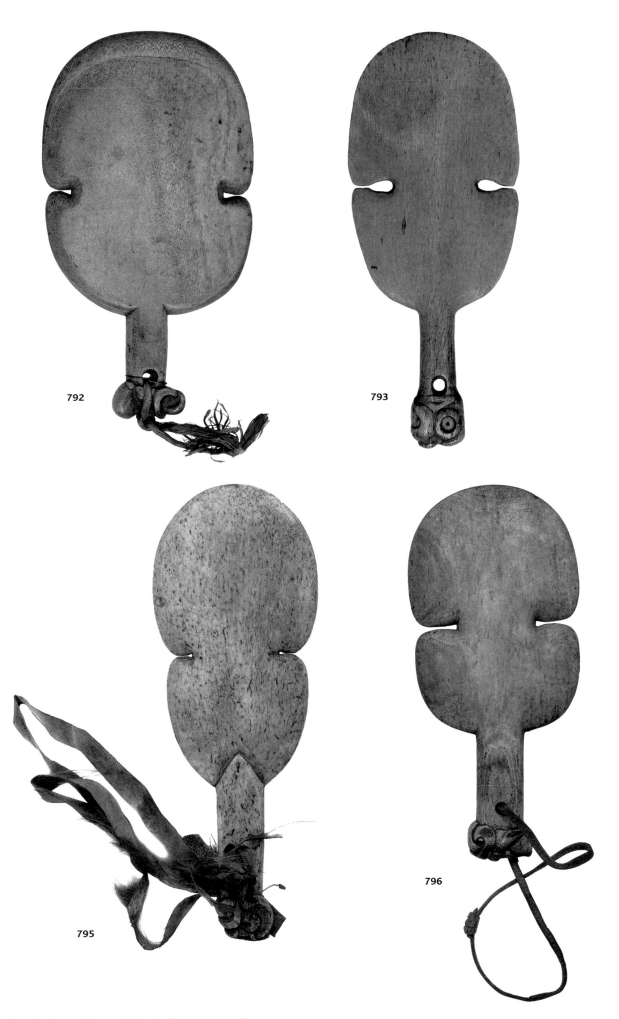

Plate 125 Short whalebone clubs, *kotiate* (**792**, **793**, **795**, **796**).
793: The Royal Collection © Her Majesty Queen Elizabeth II.

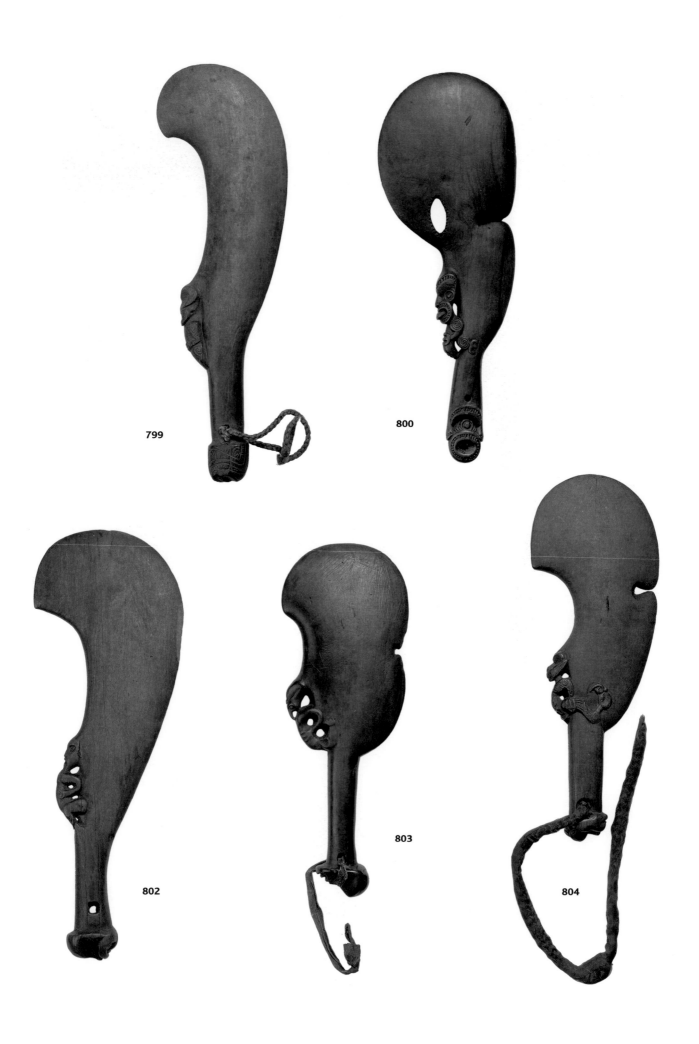

Plate 126 Short wood clubs, *wahaika* (**799**, **800**, **802–804**).

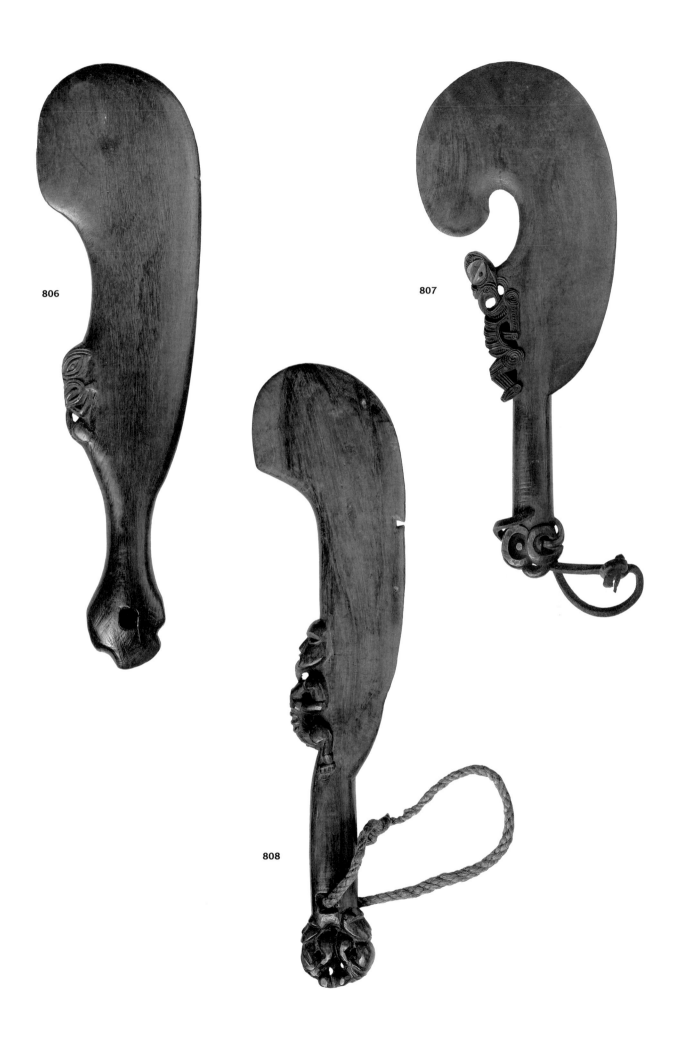

Plate 127 Short wood clubs, *wahaika* (**806–808**).

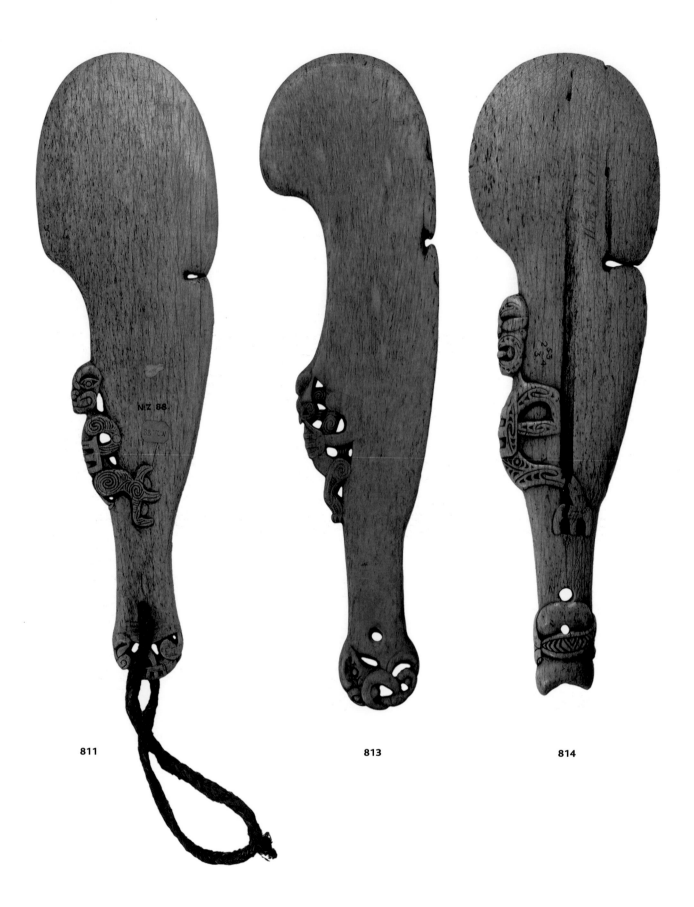

811 **813** **814**

Plate 128 Short whalebone clubs, *wahaika* (**811**, **813**, **814**).

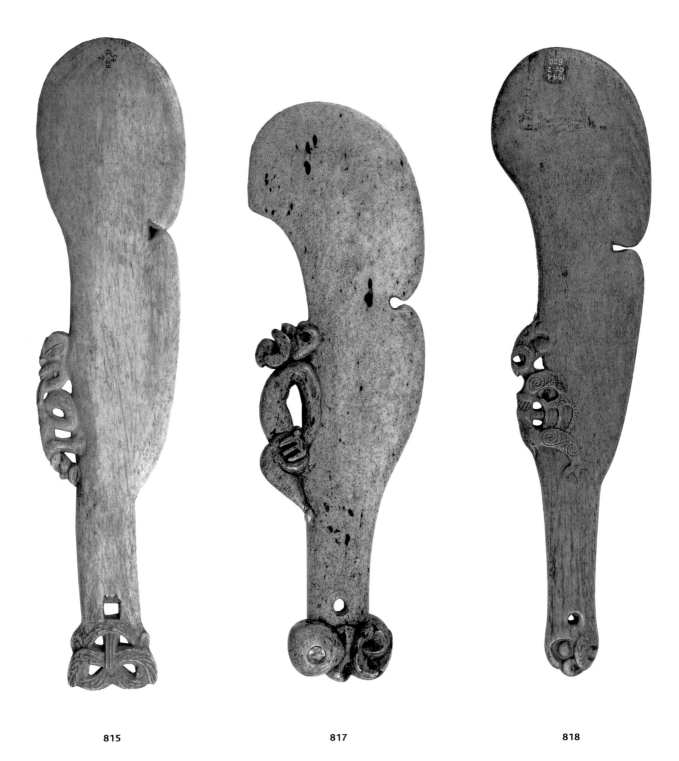

815 **817** **818**

Plate 129 Short whalebone clubs, *wahaika* (**815**, **817**, **818**).

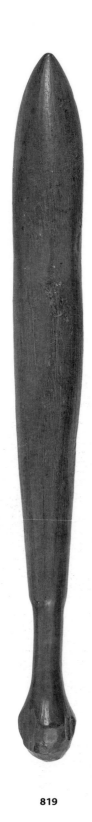

819

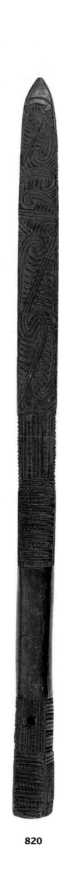

820

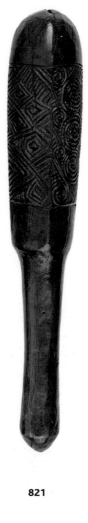

821

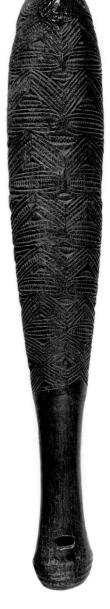

822

Plate 130 Short clubs, *patuki* (**819–822**).

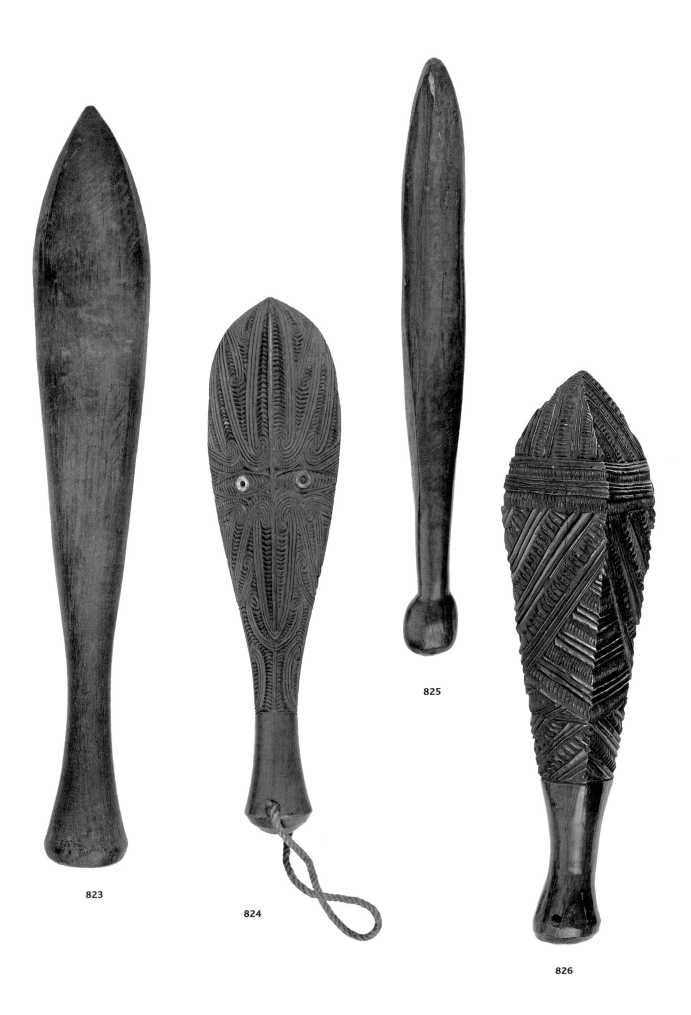

823

824

825

826

Plate 131 Short clubs, *patuki* (**823–826**).

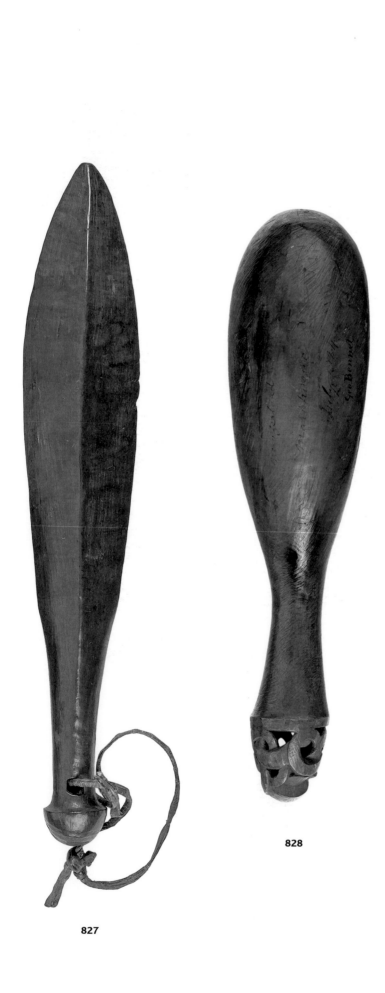
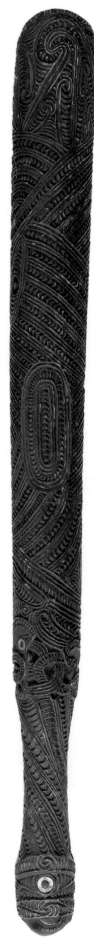

827

828

829

Plate 132 Short clubs: *patuki* (**827**) and *patu rakau* (**828**, **829**).

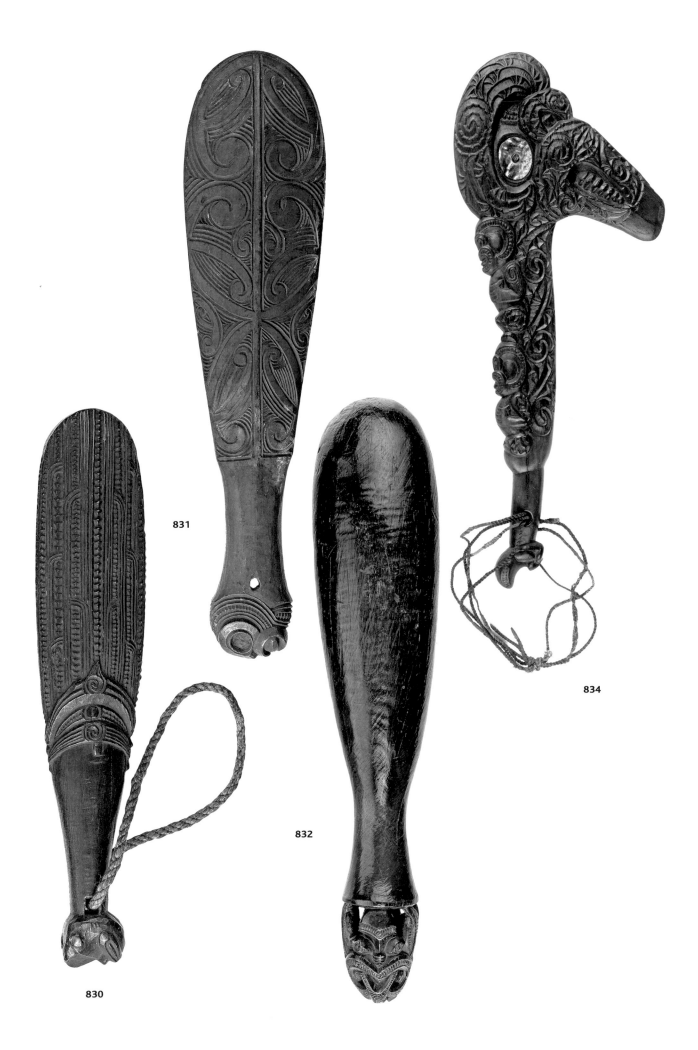

Plate 133 Short clubs, *patu rakau* (**830**–**832**) and bill-hook club, *patu rakau* (**834**).

830

831

832

834

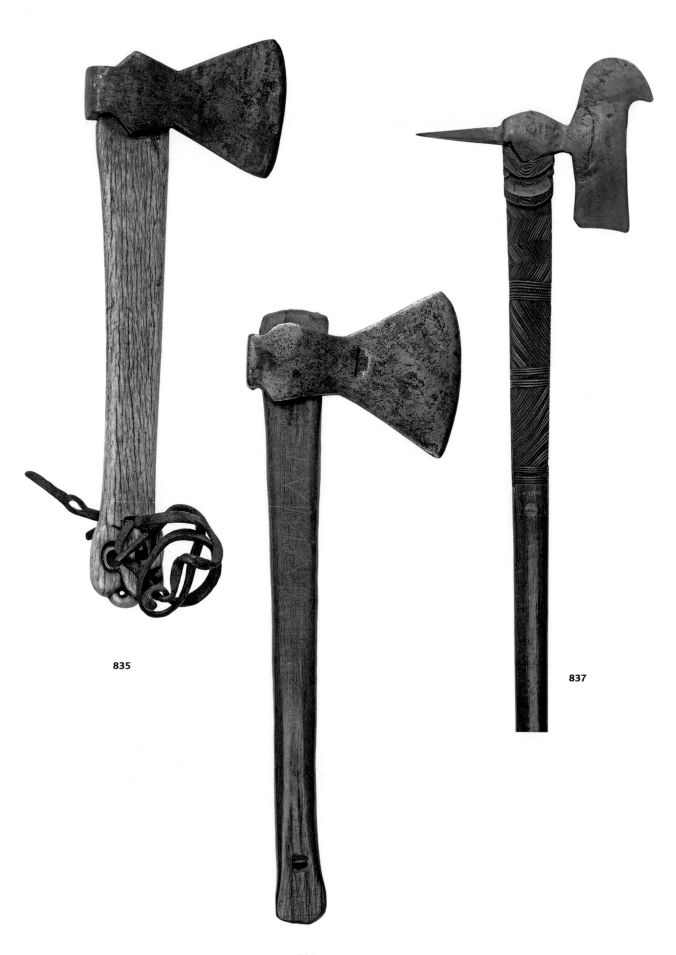

835

836

837

Plate 134 Axes, *patiti* (**835**, **836**) and long axe, *kakauroa* (**837**).

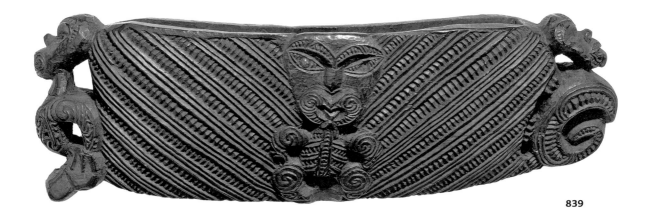

839

840

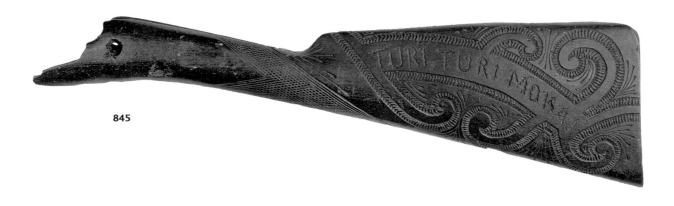

845

Plate 135 Cartridge boxes, *hamanu* (**839**, **840**) and rifle butt (**845**).

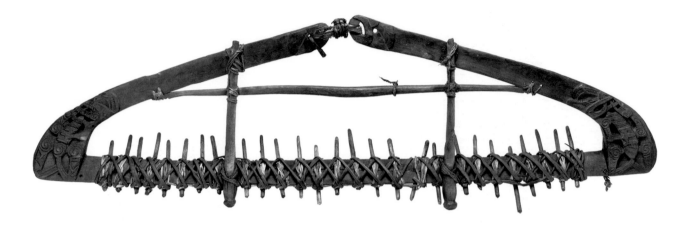

846

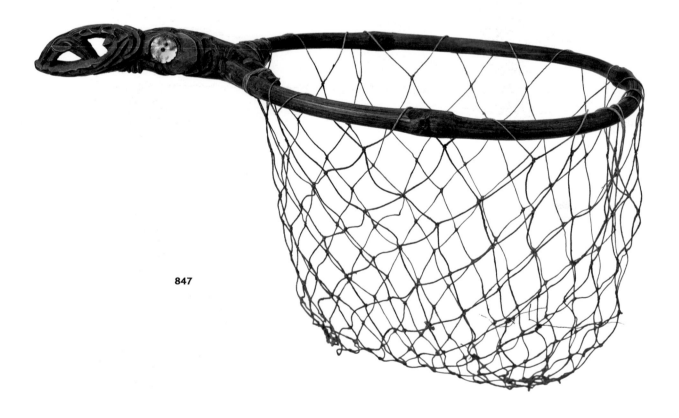

847

Plate 136 Freshwater mussel dredge, *rou kakahi* (**846**) and hand fishing net, *kupenga* (**847**).

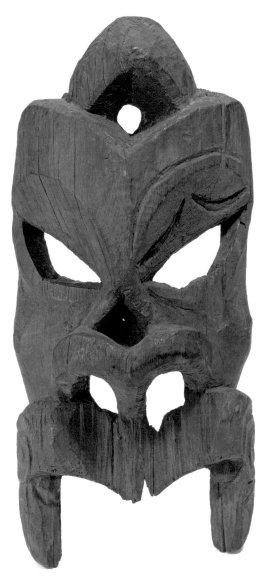

850

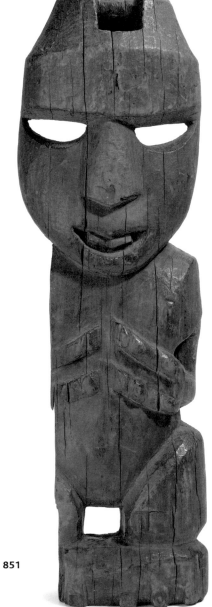

851

Plate 137 Fishing floats, *poito* (**850**, **851**).

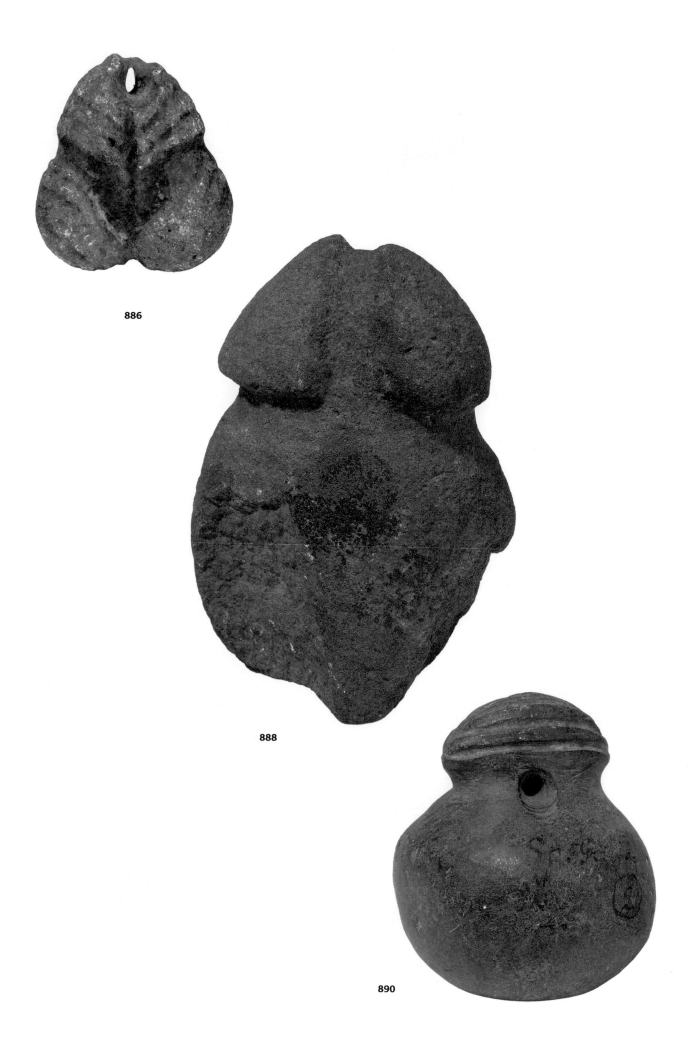

886

888

890

Plate 138 Sinkers, *mahe* (**886**, **888**, **890**).

897

899

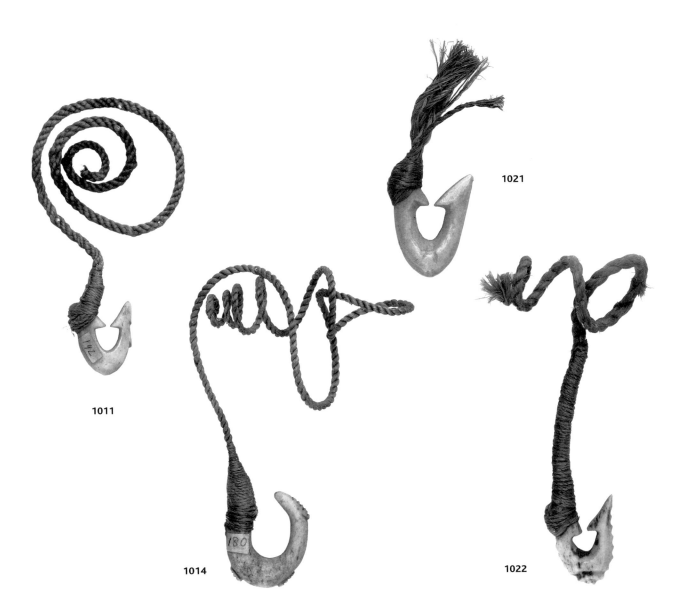

1021

1011

1014

1022

Plate 139 Fish-hook shanks (**897**, **899**) and fish-hooks, *matau* (**1011**, **1014**, **1021**, **1022**).

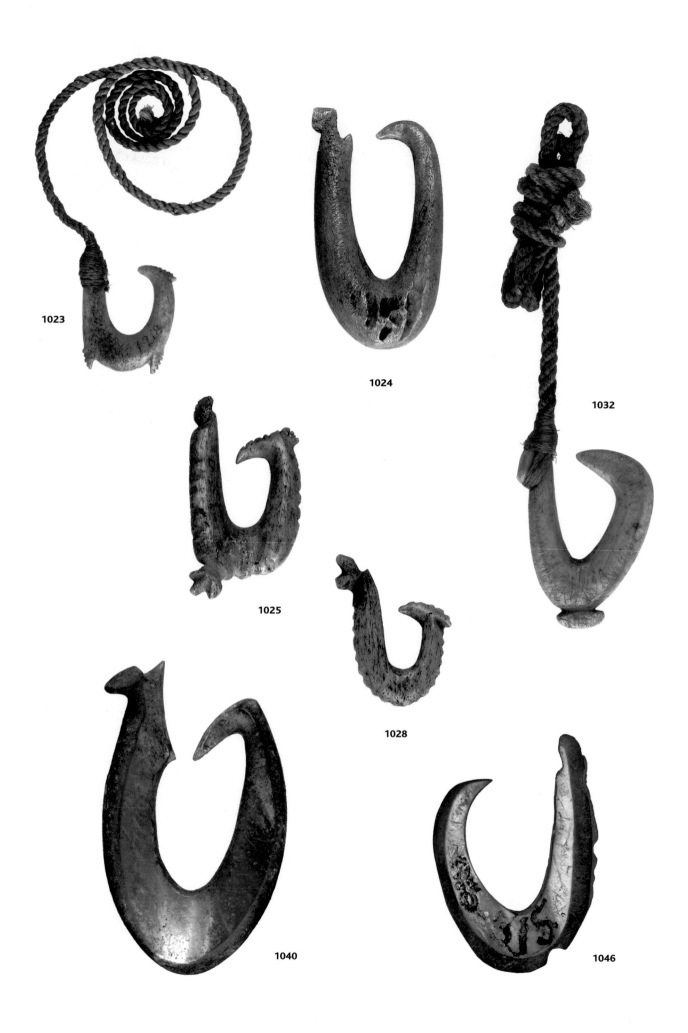

Plate 140 Fish-hooks, *matau* (**1023–1025**, **1028**, **1032**, **1040**, **1046**).

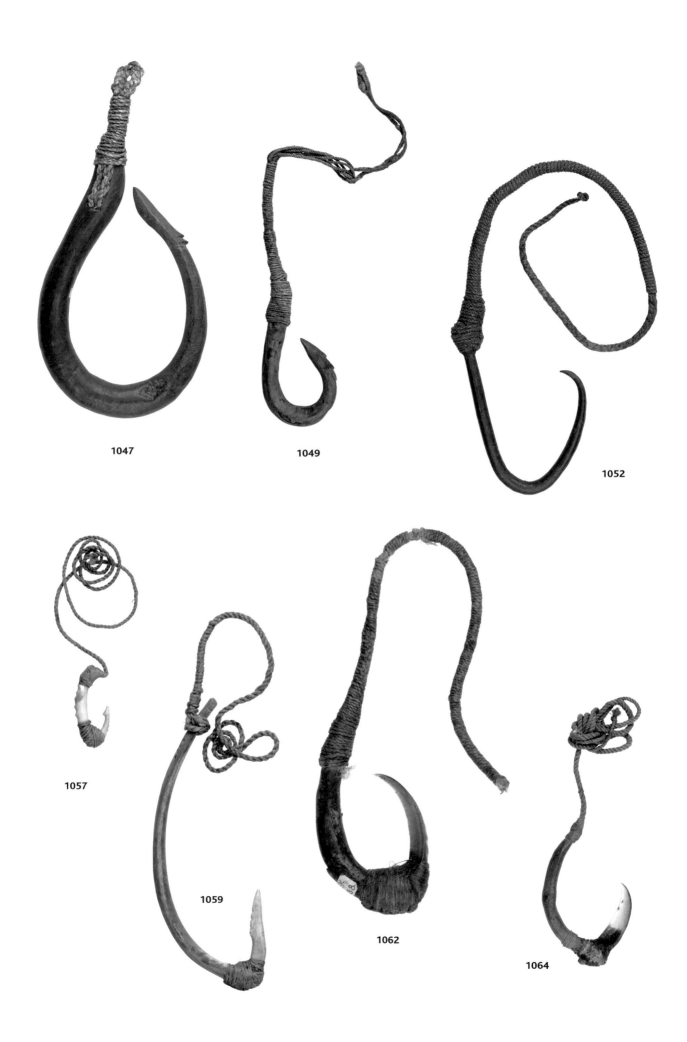

Plate 141 Fish-hooks, *matau* (**1047**, **1049**, **1052**, **1057**, **1059**, **1062**, **1064**).

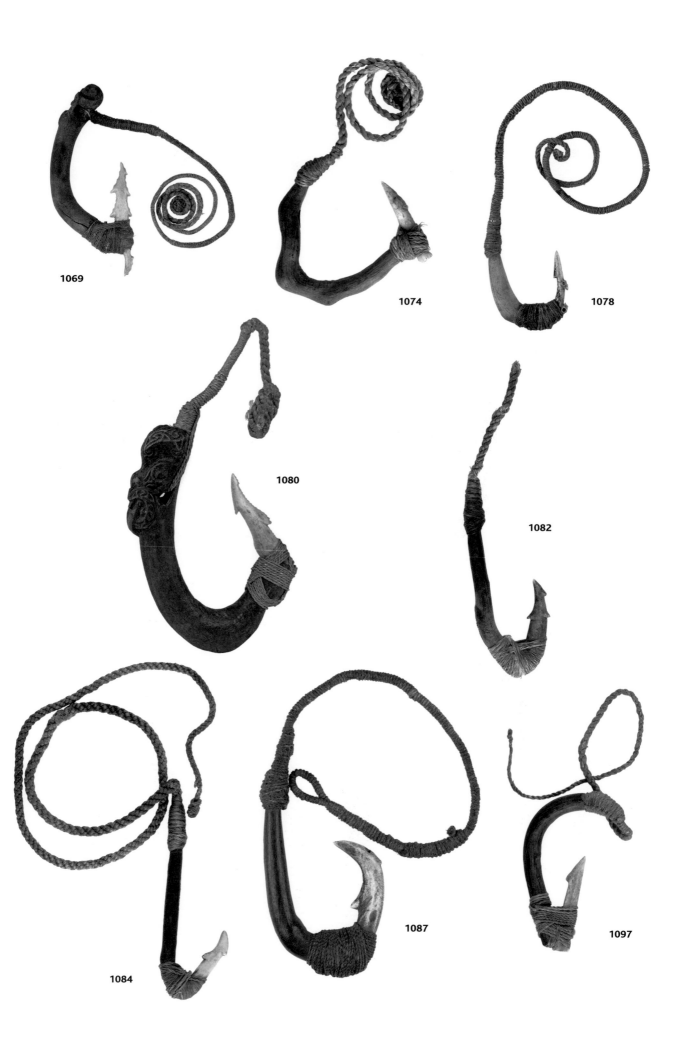

Plate 142 Fish-hooks, *matau* (**1069**, **1074**, **1078**, **1080**, **1082**, **1084**, **1087**, **1097**).

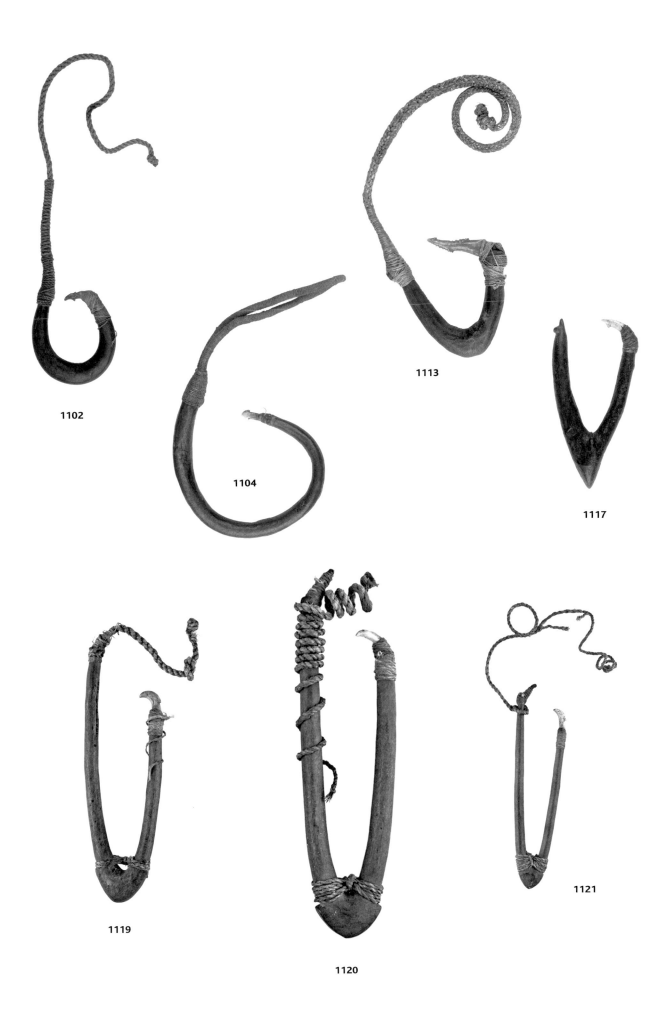

Plate 143 Fish-hooks, *matau* (**1102**, **1104**, **1113**, **1117**, **1119**, **1120**, **1121**).

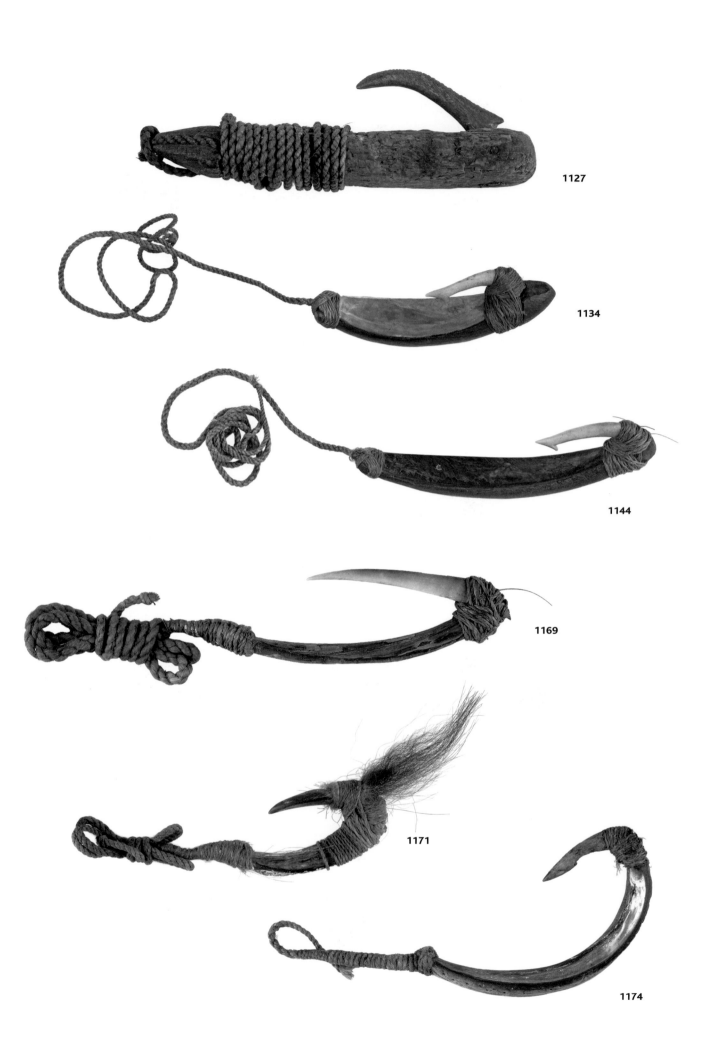

Plate 144 Fish-hooks, *matau* (**1127, 1134, 1144, 1169, 1171, 1174**).

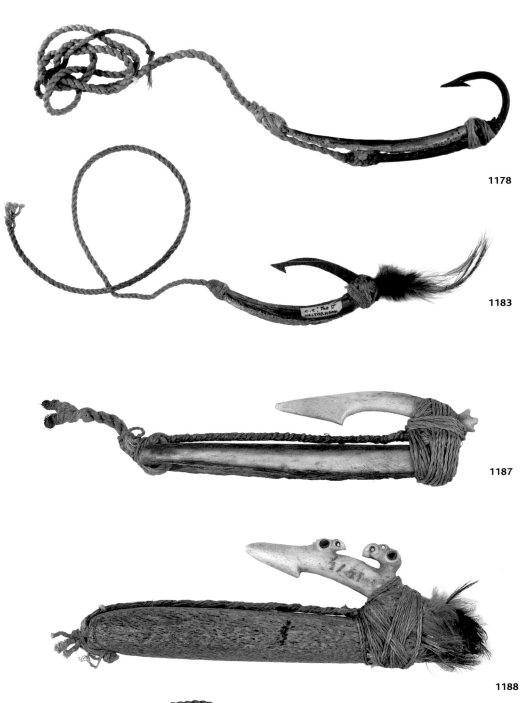

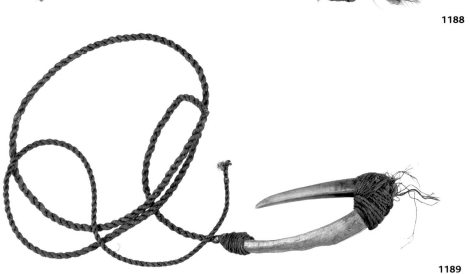

Plate 145 Fish-hooks, *matau* (**1178**, **1183**, **1187–1189**).

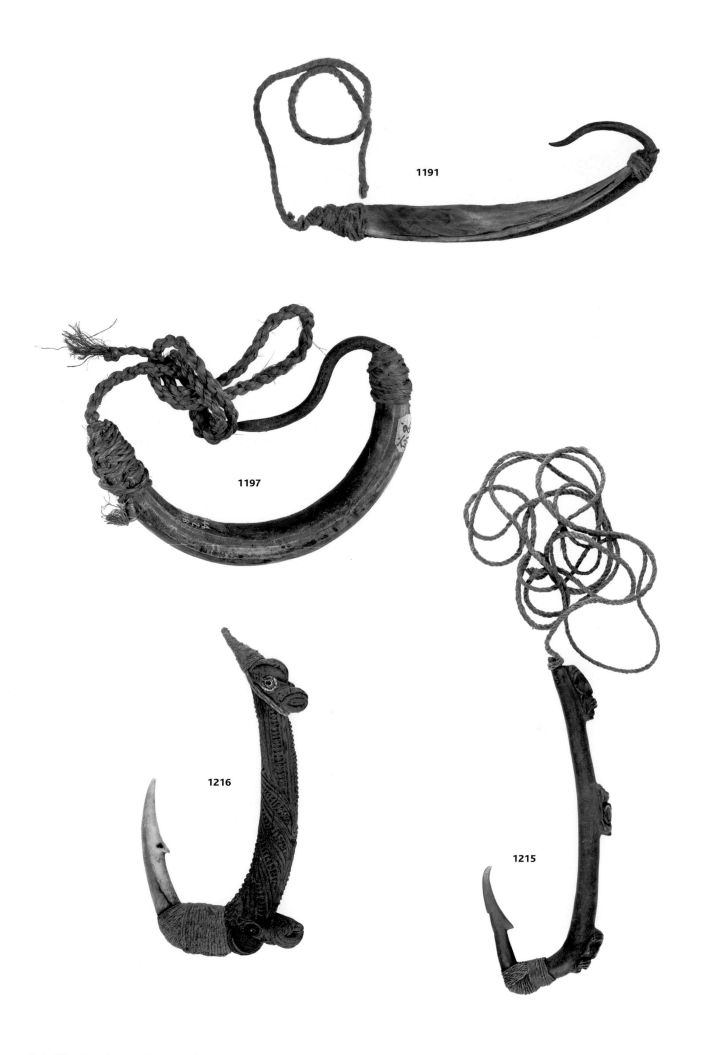

Plate 146 Fish-hooks, *matau* (**1191**, **1197**) and albatross hooks (**1215**, **1216**).

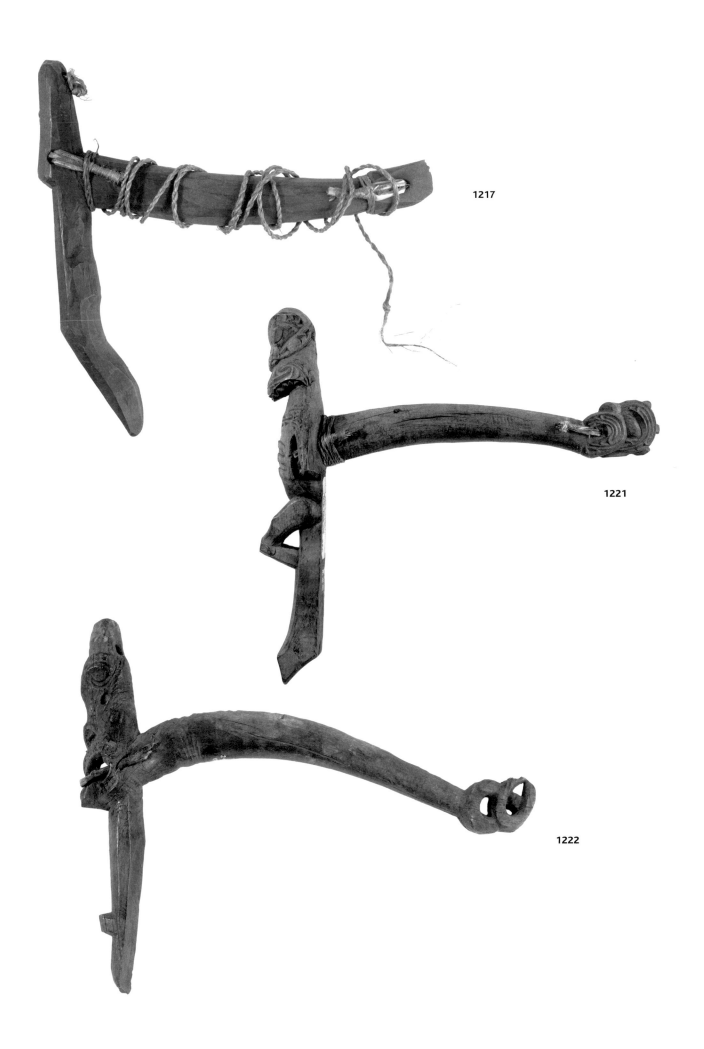

Plate 147 Bird-snare perches, *mutu kaka* (**1217**, **1221**, **1222**).

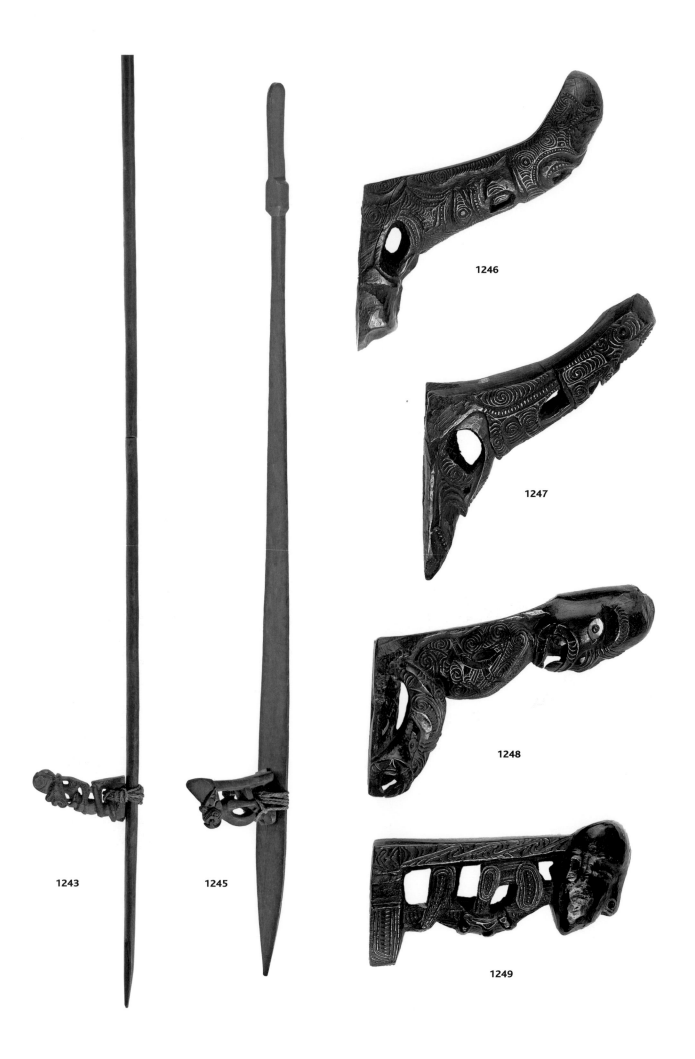

1246

1247

1248

1249

1243

1245

Plate 148 Digging sticks, *ko* (**1243**, **1245**) and digging-stick steps, *teka* (**1246–1249**).

1250

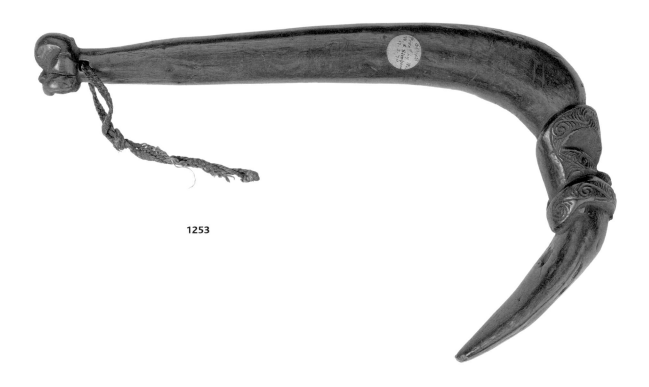

1253

Plate 149 Digging-stick step, *teka* (**1250**) and grubber, *timo* (**1253**).

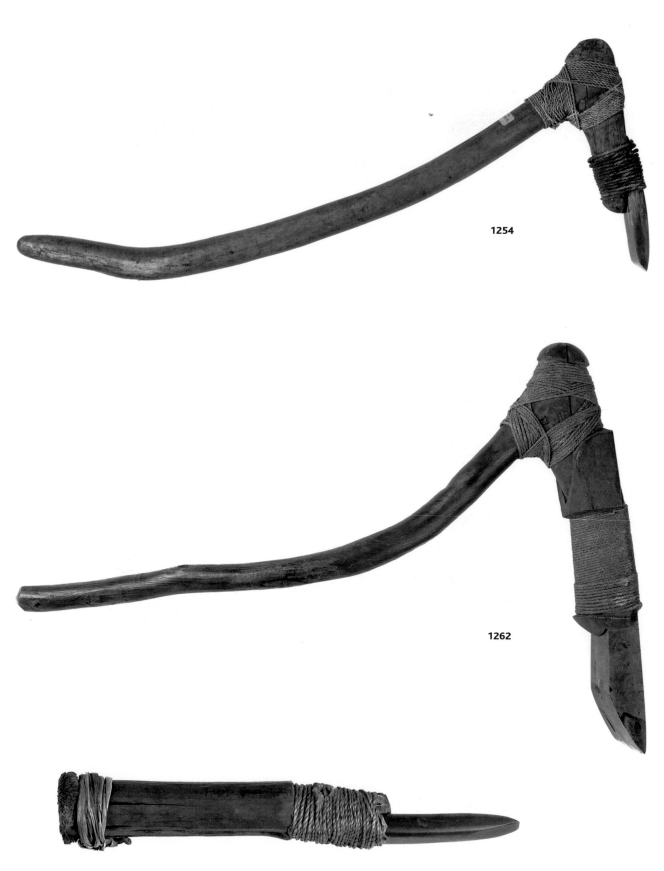

1254

1262

1263

Plate 150 Hafted adzes: *toki pounamu* (**1254**) and *toki* (**1262**), and hafted chisel, *whao* (**1263**).

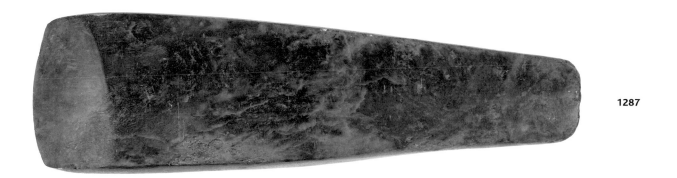

1287

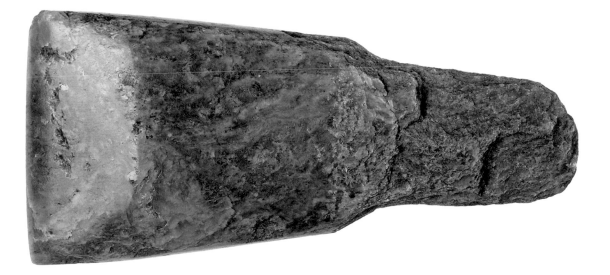

1289

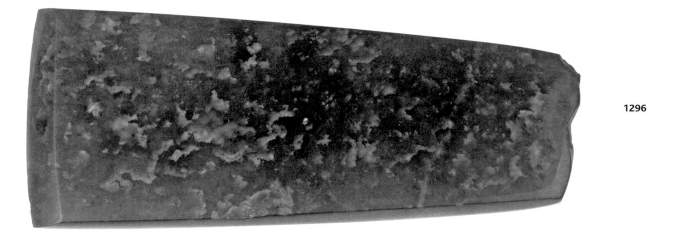

1296

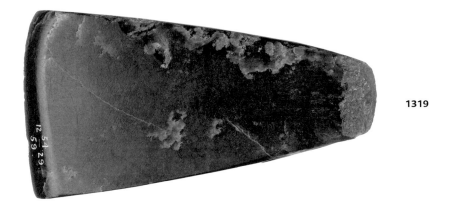

1319

Plate 151 Nephrite adze blades (**1287**, **1289**, **1296**, **1319**).

1377

1395

1502

1544

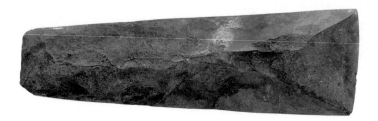

1546

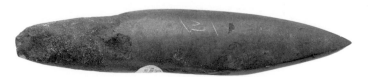

1552

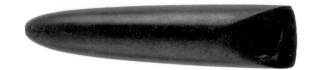

1560

Plate 152 Stone adze blades (**1377**, **1395**, **1502**, **1544**, **1546**, **1552**, **1560**).

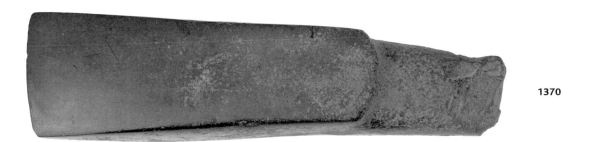

1370

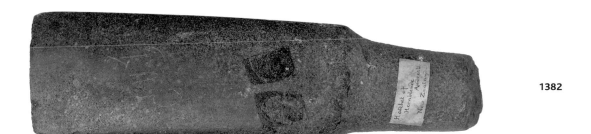

1382

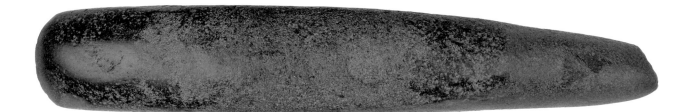

1387

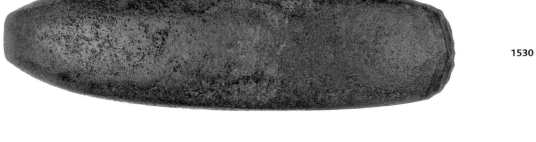

1530

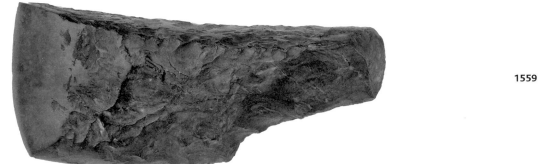

1559

Plate 153 Stone adze blades (**1370**, **1382**, **1387**, **1530**, **1559**).

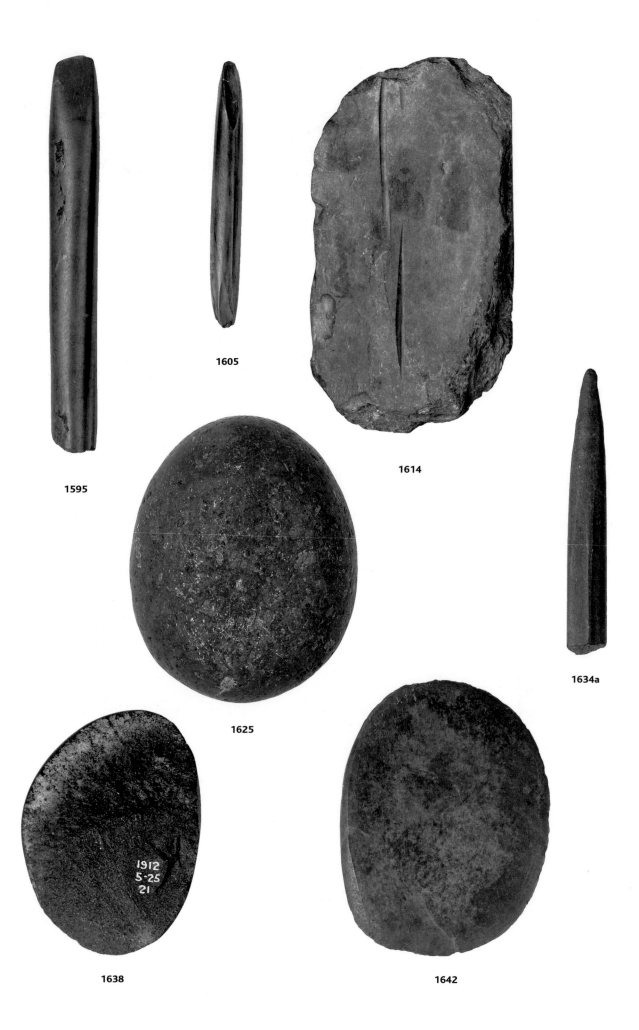

Plate 154 Nephrite chisel (**1595**) and gouge (**1605**); stone grindstone (**1614**), hammer stone (**1625**), borer (**1634a**), spall (**1638**) and knife (**1642**).

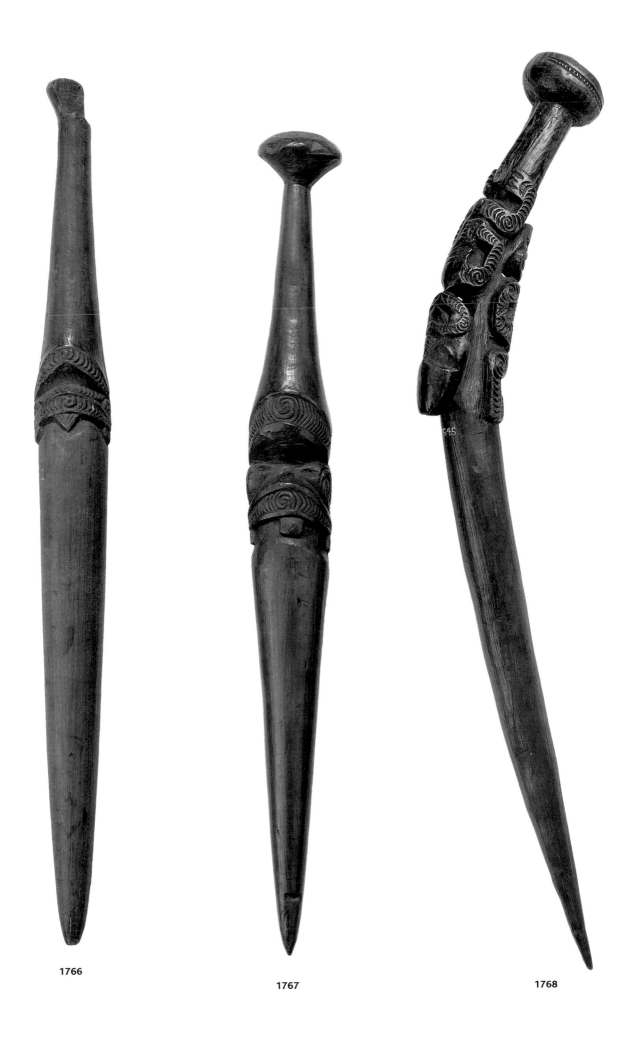

1766

1767

1768

Plate 155 Weaving pegs, *turuturu* (**1766–1768**).

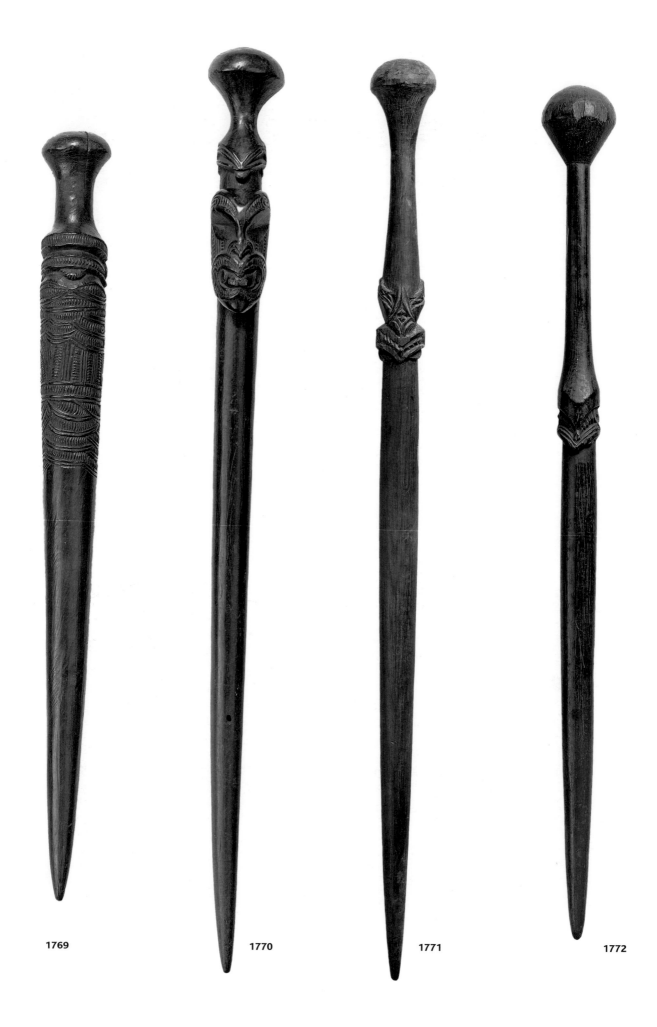

1769 1770 1771 1772

Plate 156 Weaving pegs, *turuturu* (**1769–1772**).

1777

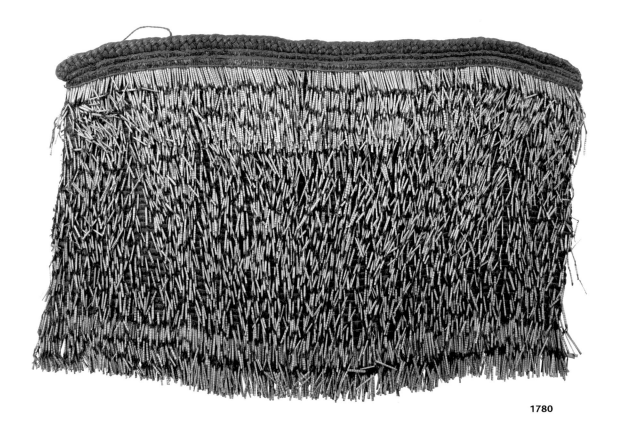

1780

Plate 157 Rain-cape (**1777**) and cloak, *pihepihe* (**1780**).

1787

1793

Plate 158 Warrior's cape, *kahu toi* (**1787**) and dog-skin cloak, *kahu kuri* (**1793**).

1794

1796

Plate 159 Cloaks, *pukupuku* (**1794, 1796**).

1799

1802

Plate 160 Cloaks, *kaitaka* (**1799**, **1802**).

1808

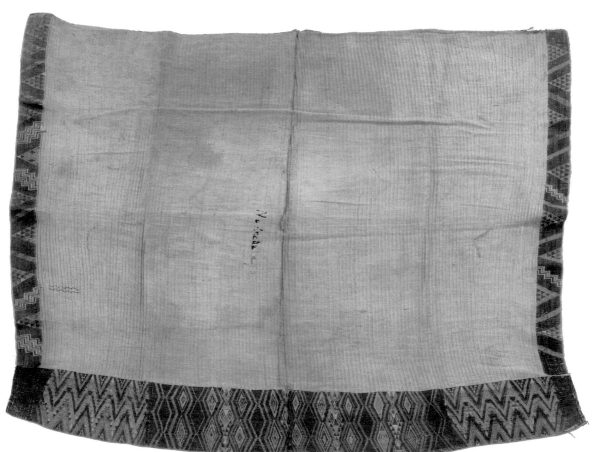

1810

Plate 161 Cloaks, *kaitaka* (**1808**, **1810**).

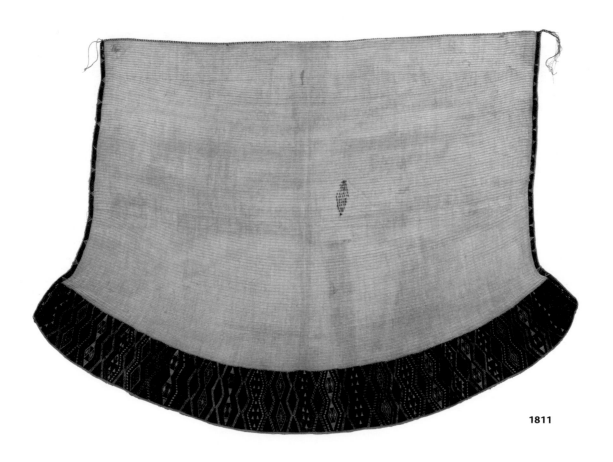

1811

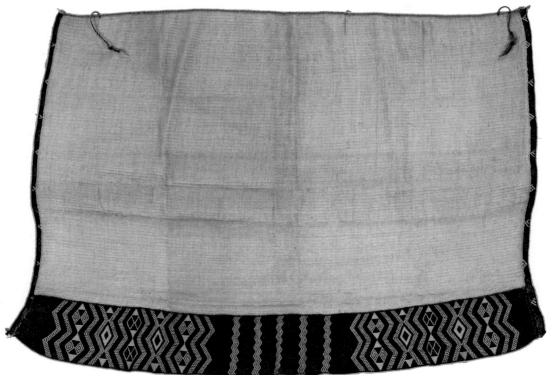

1814

Plate 162 Cloaks, *kaitaka* (**1811**, **1814**)

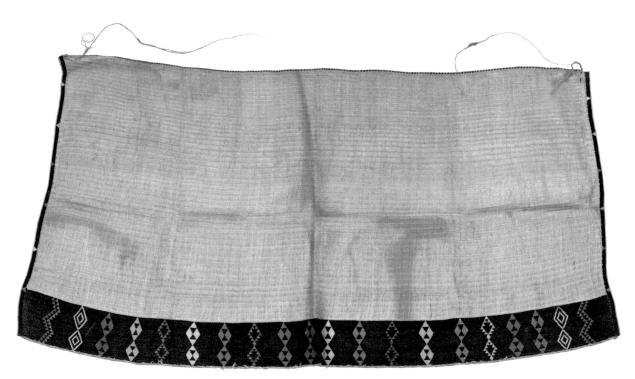

1823

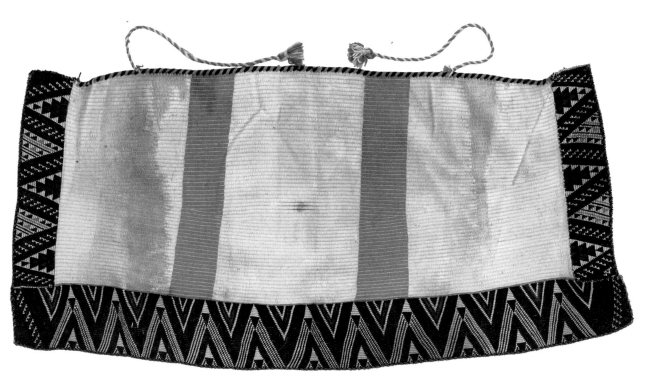

1824

Plate 163 Cloak and cape, *kaitaka* (**1823**, **1824**).

1826

1828

Plate 164 Cloaks: *korowai* (**1826**) and *ngore* (**1828**).

1831

1834

Plate 165 Cloaks: *ngore* (**1831**) and *korowai ngore* (**1834**).

1835

1836

Plate 166 Cloaks: *hihima* (**1835**) and *korowai* (**1836**).

1838

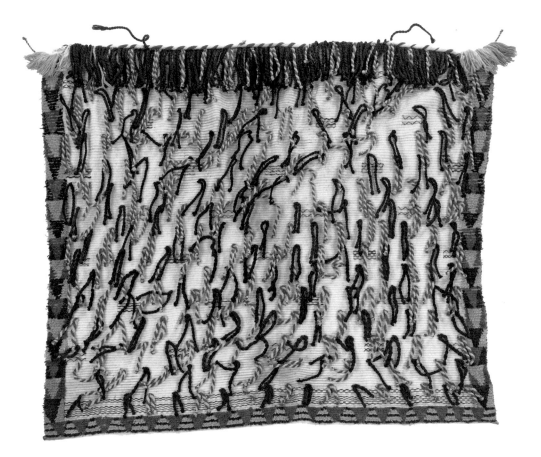

1847

Plate 167 Cloaks: *korowai karure* (**1838**) and *korowai* (**1847**).

1851

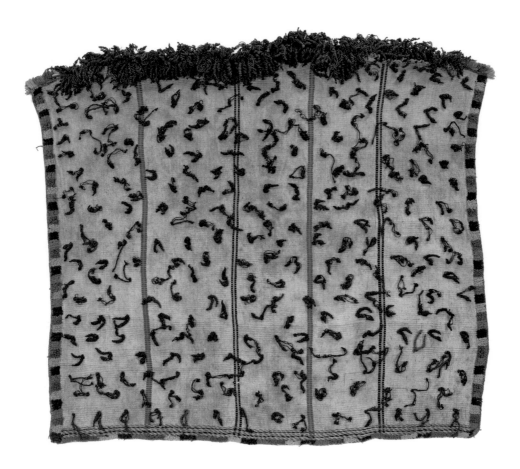

1853

Plate 168 Cloaks: *korowai* (?) (**1851**) and *karure* (**1853**).

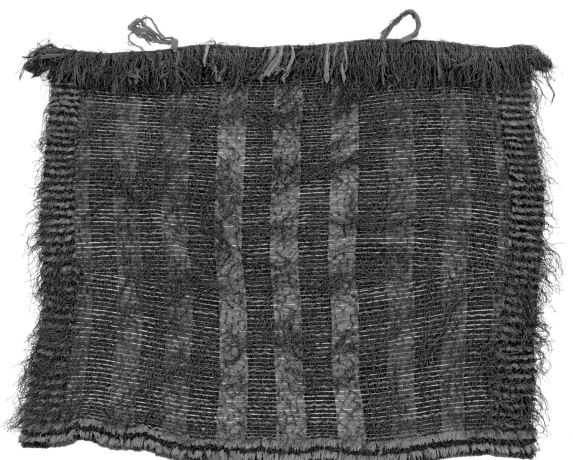

1864

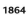

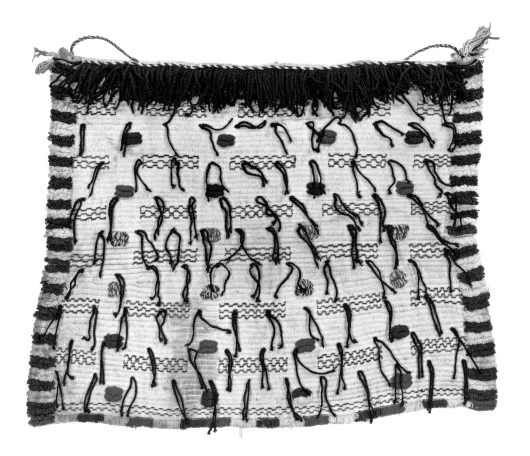

1870

Plate 169 Cloaks: *korowai* (**1864**) and *korowai ngore* (**1870**).

1874

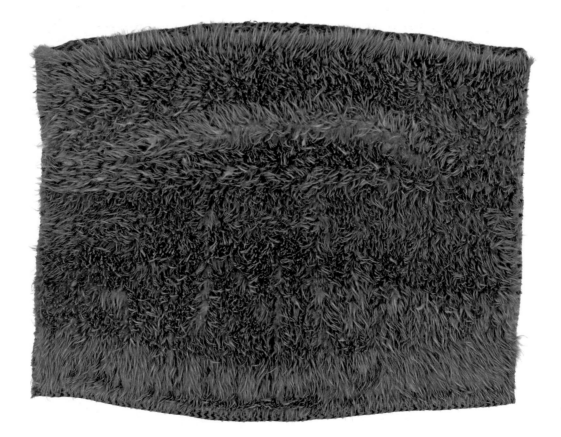

1890

Plate 170 Cloaks: *karure* (**1874**) and feather cloak *kahu kiwi* (**1890**).

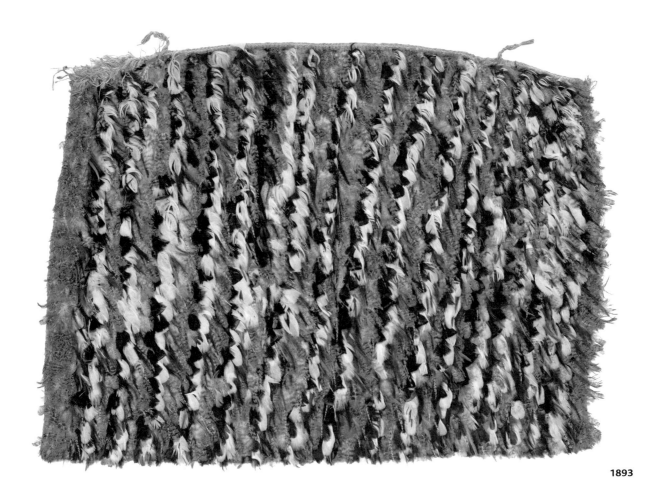

1893

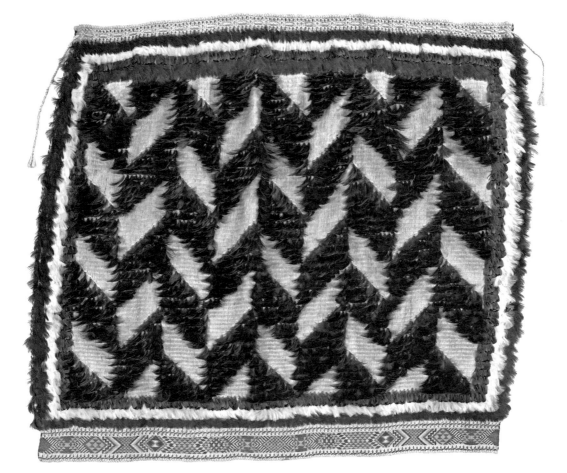

1896

Plate 171 Feather cloaks, *kahu huruhuru* (**1893**, **1896**).

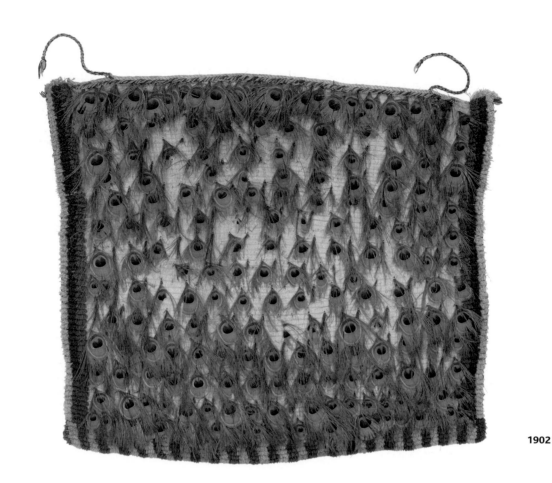

1902

1903

Plate 172 Feather cloaks, *kahu huruhuru* (**1902**, **1903**).

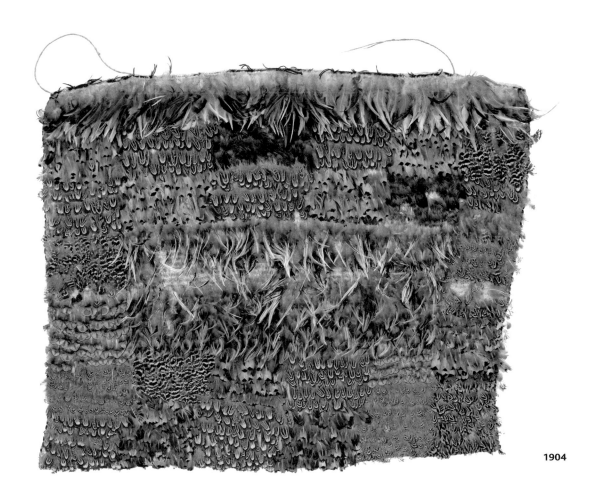

1904

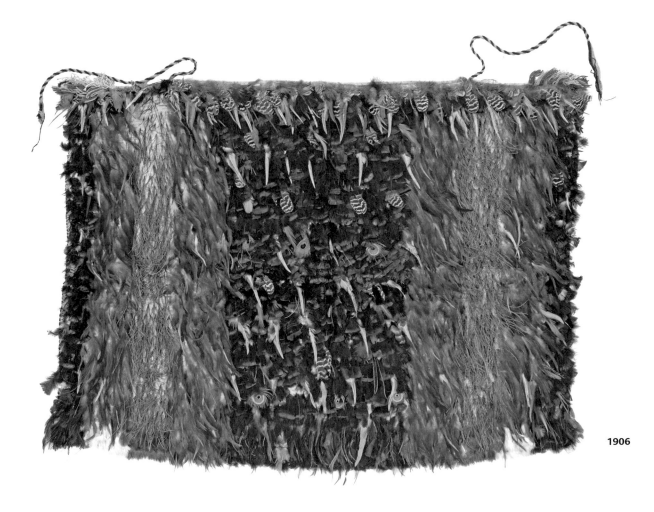

1906

Plate 173 Feather cloaks, *kahu huruhuru* (**1904**, **1906**).

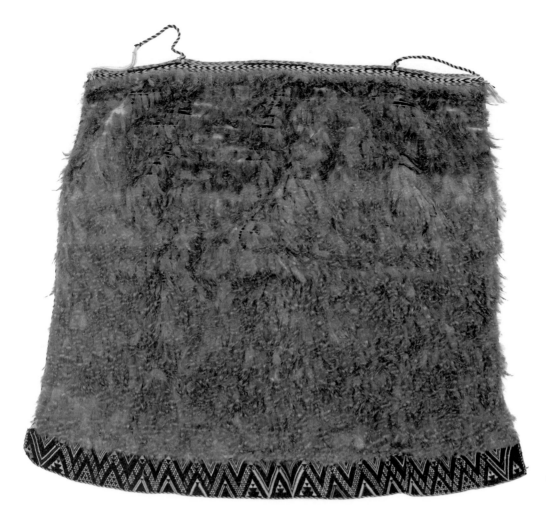

1905 front

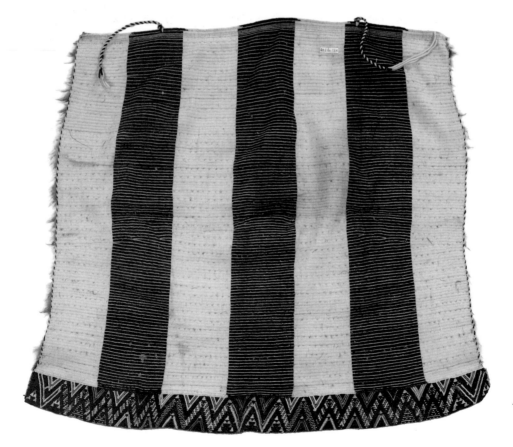

1905 back

Plate 174 Feather cloak, *kahu huruhuru* (**1905**, front and back).

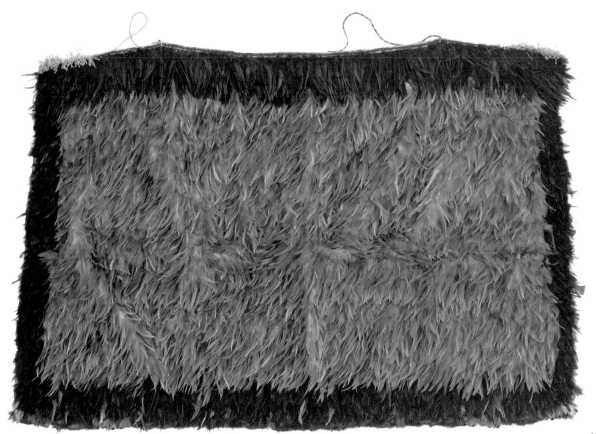

1908

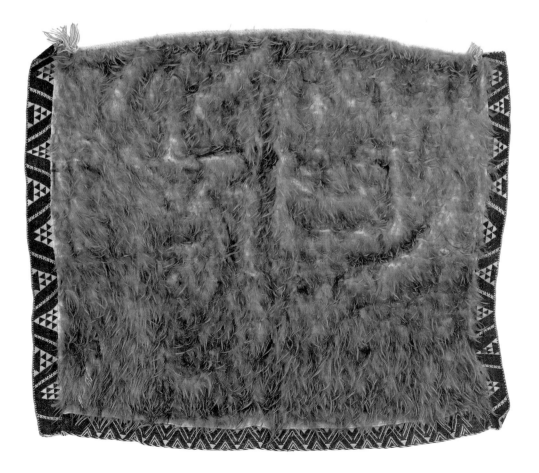

1909

Plate 175 Feather cloaks: *kahu huruhuru* (**1908**) and *kahu kiwi* (**1909**).

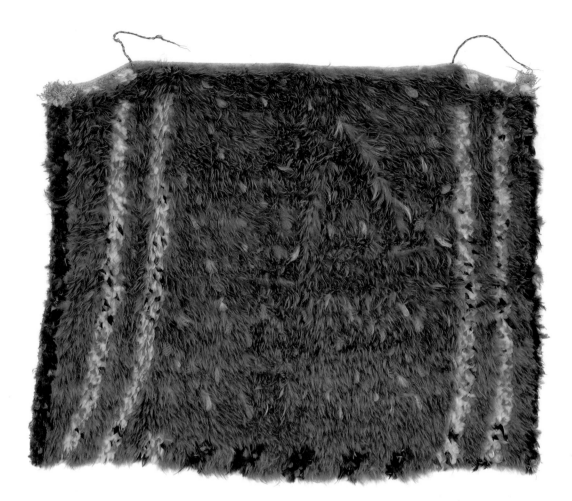

1911

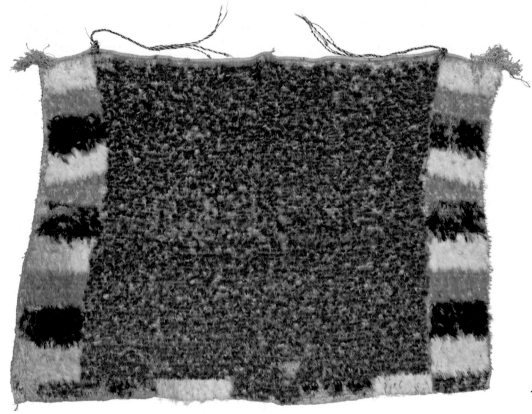

1912

Plate 176 Feather cloaks, *kahu huruhuru* (**1911**, **1912**).

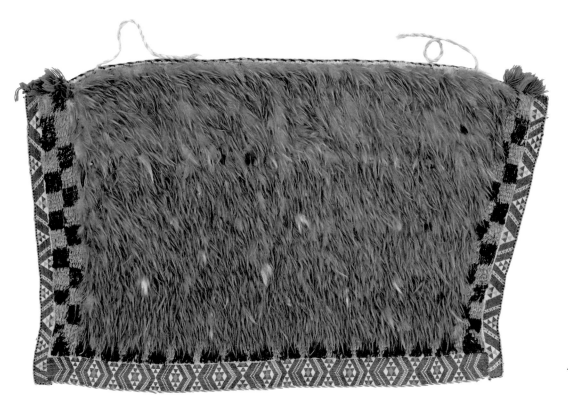

1913

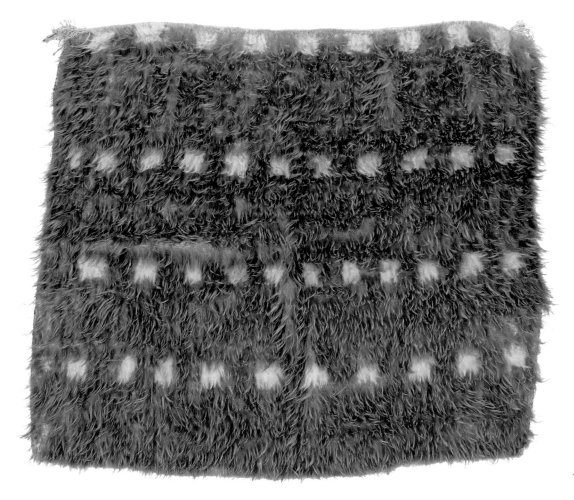

1914

Plate 177 Feather cloaks, *kahu kiwi* (**1913**, **1914**).

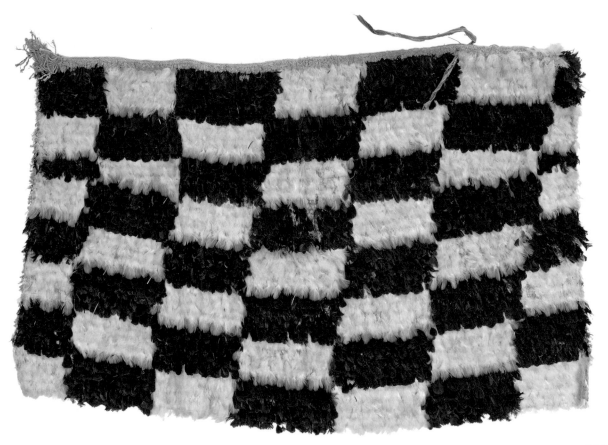

1915

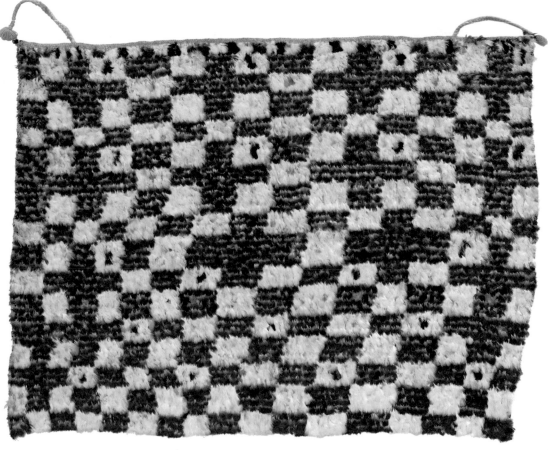

1918

Plate 178 Feather cloaks, *kahu huruhuru* (**1915**, **1918**).

1922

1923

Plate 179 Waist garments with tags, *piupiu* (**1922**, **1923**).

1924

1926

Plate 180 Waist garments with tags, *piupiu* (**1924**, **1926**).

1928

1929

Plate 181 Waist garments with tags, *piupiu* (**1928**, **1929**).

1930

1937

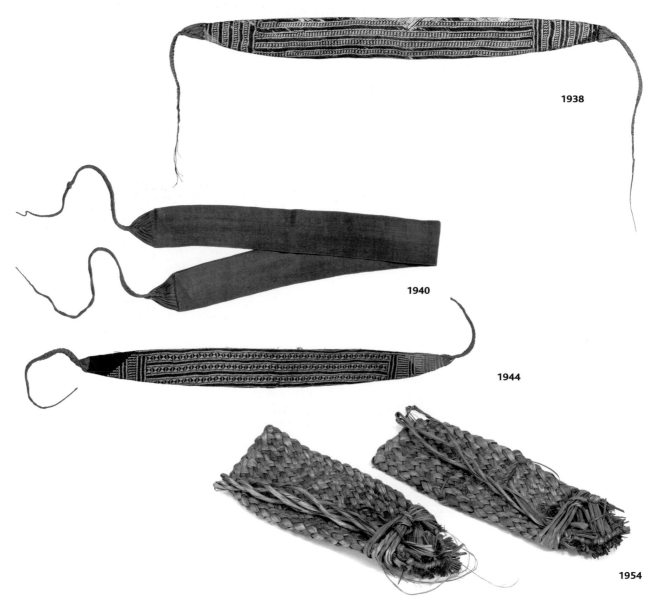

1938

1940

1944

1954

Plate 182 Waistcoat (**1930**), belts, *tatua* (**1937**, **1938**, **1940**, **1944**) and sandals, *paraerae* (**1954**).

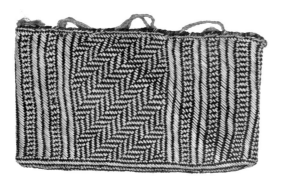

1963

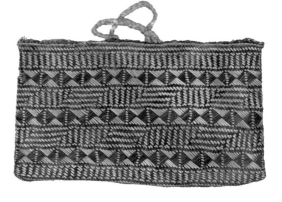

1964

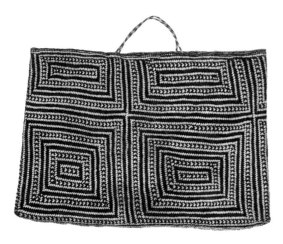

1965

1966

1967

1968

1992

Plate 183 Patterned plaited baskets, *kete whakairo* (**1963–1968**, **1992**).

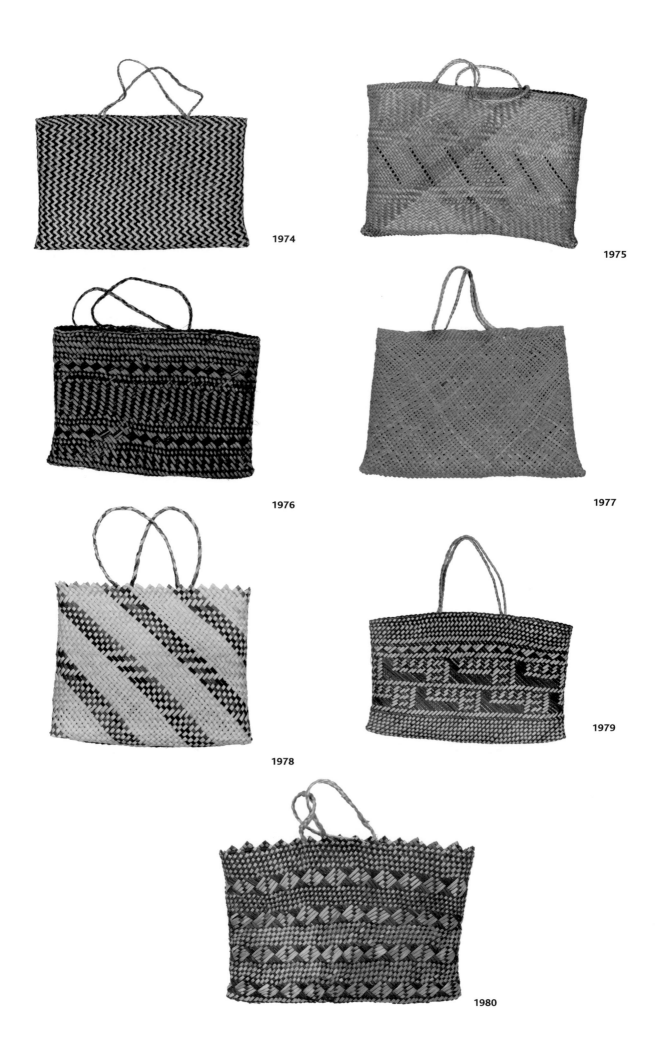

1974

1975

1976

1977

1978

1979

1980

Plate 184 Patterned plaited baskets, *kete whakairo* (**1974–1980**).

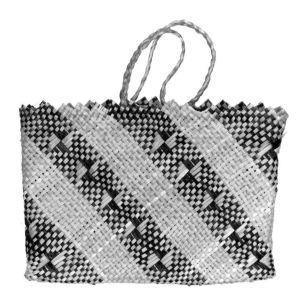

1981

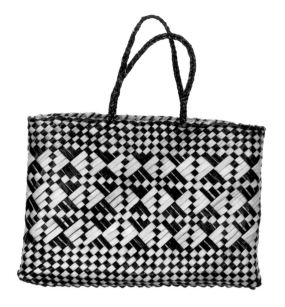

1982

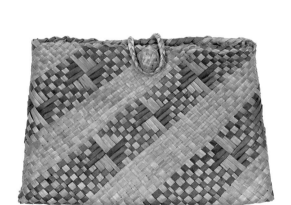

1983

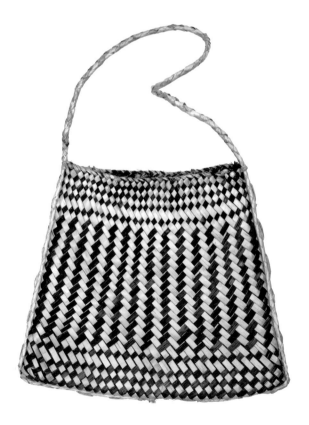

1984

Plate 185 Patterned plaited baskets, *kete whakairo* (**1981–1984**).

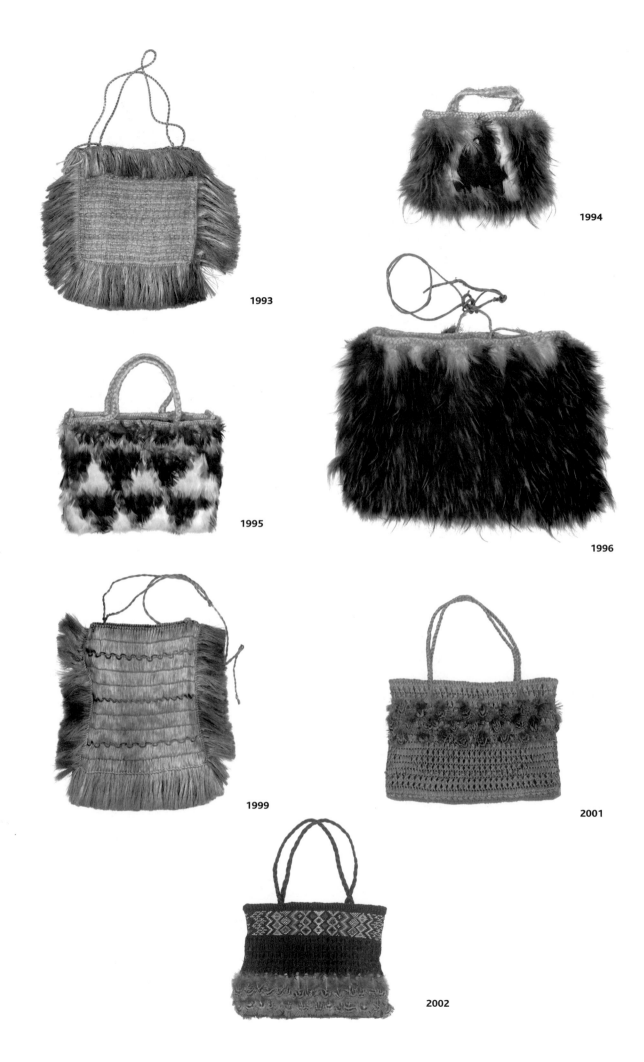

1993

1994

1995

1996

1999

2001

2002

Plate 186 Woven bags, *kete muka* (**1993–1996**, **1999**, **2001**, **2002**).

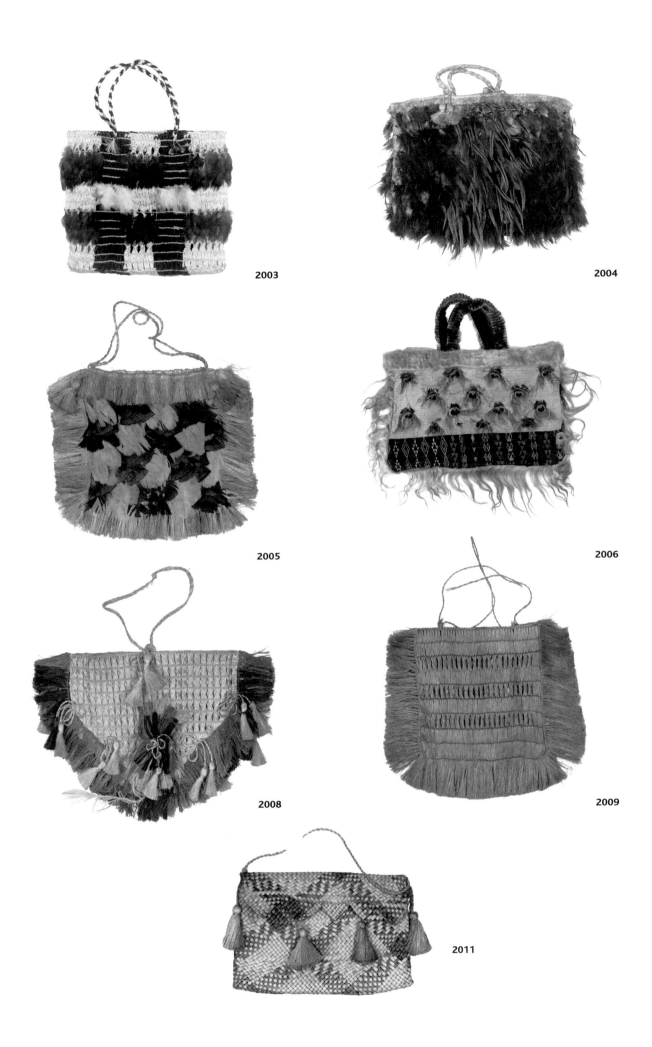

2003

2004

2005

2006

2008

2009

2011

Plate 187 Woven bags, *kete muka* (**2003–2006**, **2008**, **2009**) and basket with flap lid (**2011**).

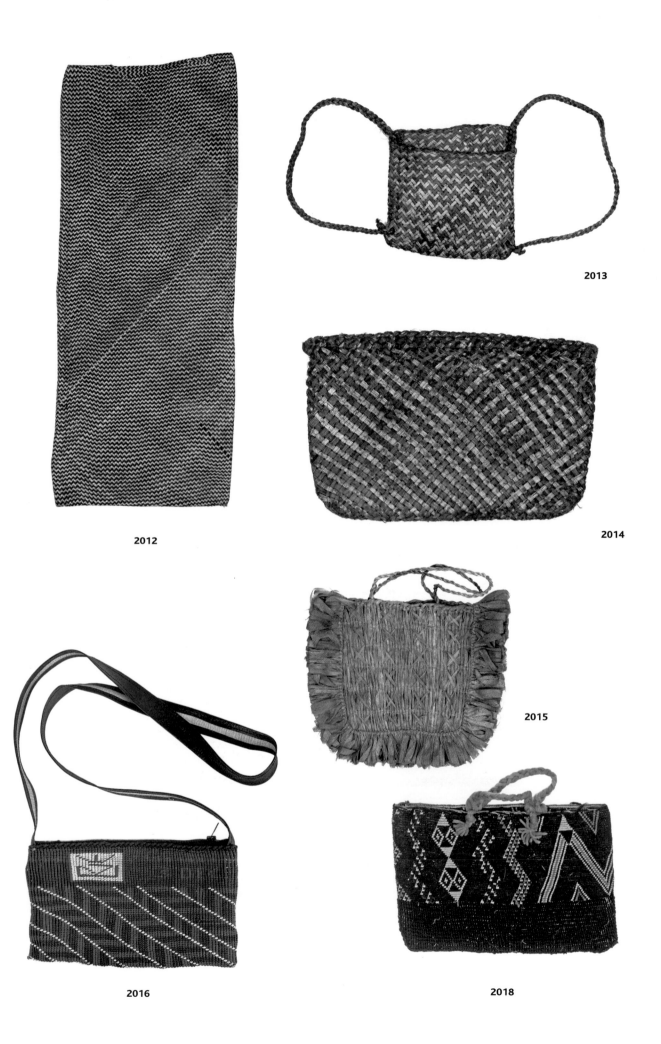

2012

2013

2014

2015

2016

2018

Plate 188 Long basket (**2012**), basket with shoulder straps (**2013**), basket without handles (**2014**), woven bag (**2015**), *taniko*-style bag (**2016**) and *taniko* bag (**2018**).

2020

2022

Plate 189 Carrying strap, *kawe* (**2020**) and teapot cosy (?) (**2022**).

2026

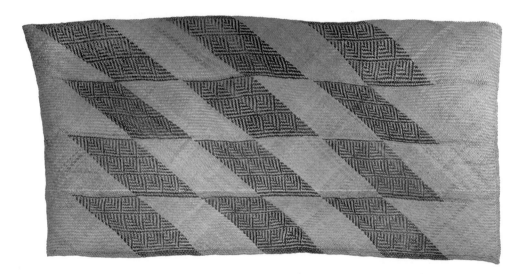

2028

2029

Plate 190 Mats, *whariki* (**2026**, **2028**, **2029**).

2057

2059

2060

Plate 191 Ceramic pots (**2057**, **2060**) and pottery globe (**2059**).

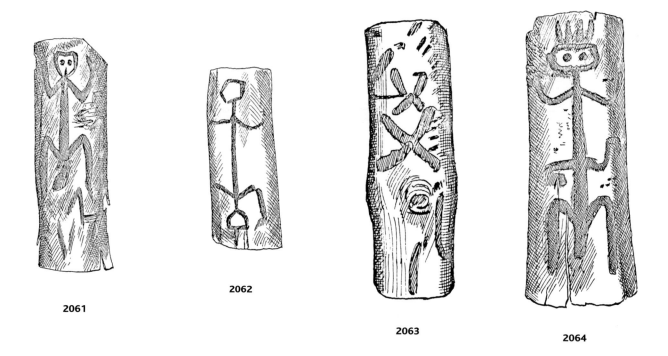

2061

2062

2063

2064

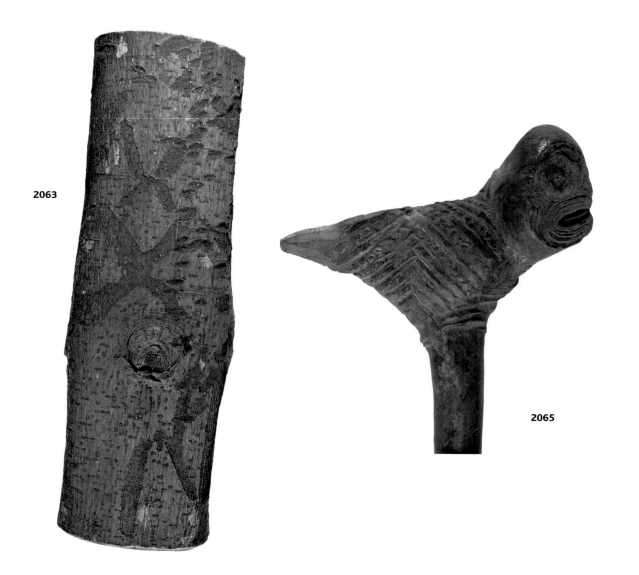

2063

2065

Plate 192 Register drawings, probably done by O.M. Dalton, of dendroglyphs (**2061–2064**), dendroglyph (**2063**) and staff, *tokotoko* (**2065**).

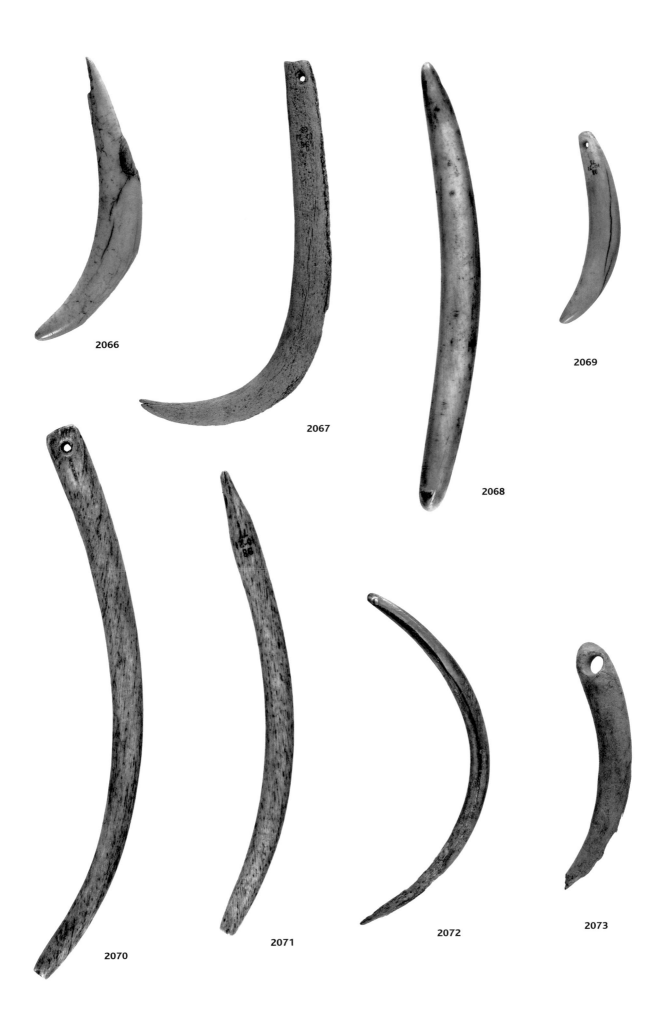

2066

2067

2068

2069

2070

2071

2072

2073

Plate 193 Pendants, *rei* (**2066–2073**).

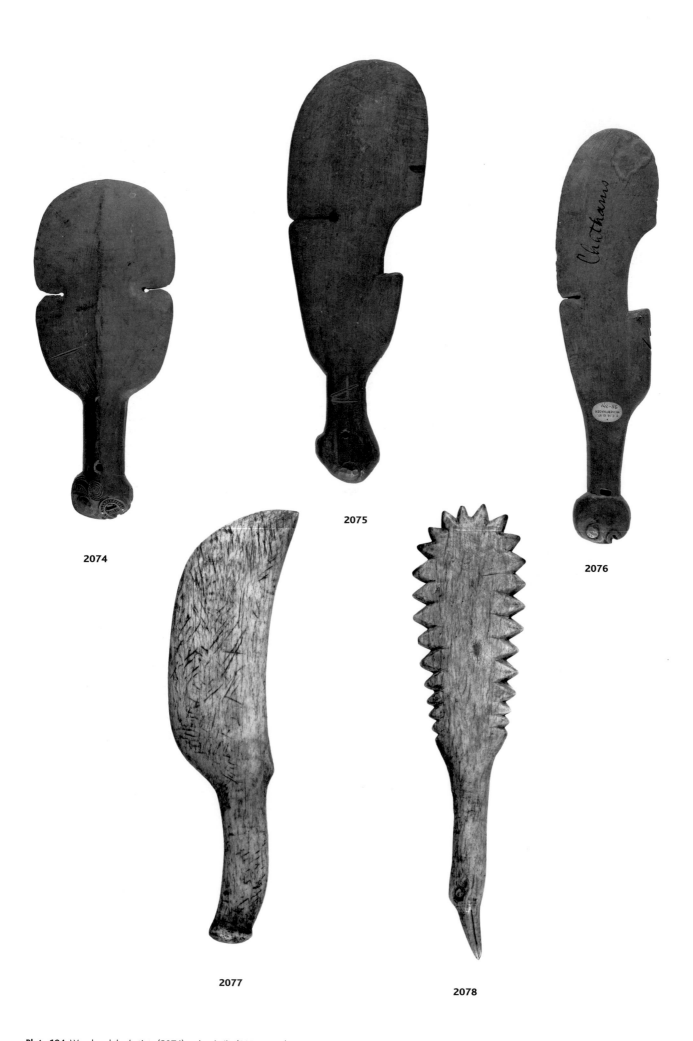

2074

2075

2076

2077

2078

Plate 194 Wooden clubs: *kotiate* (**2074**) and *wahaika* (**2075**, **2076**), and whalebone clubs (**2077**, **2078**).

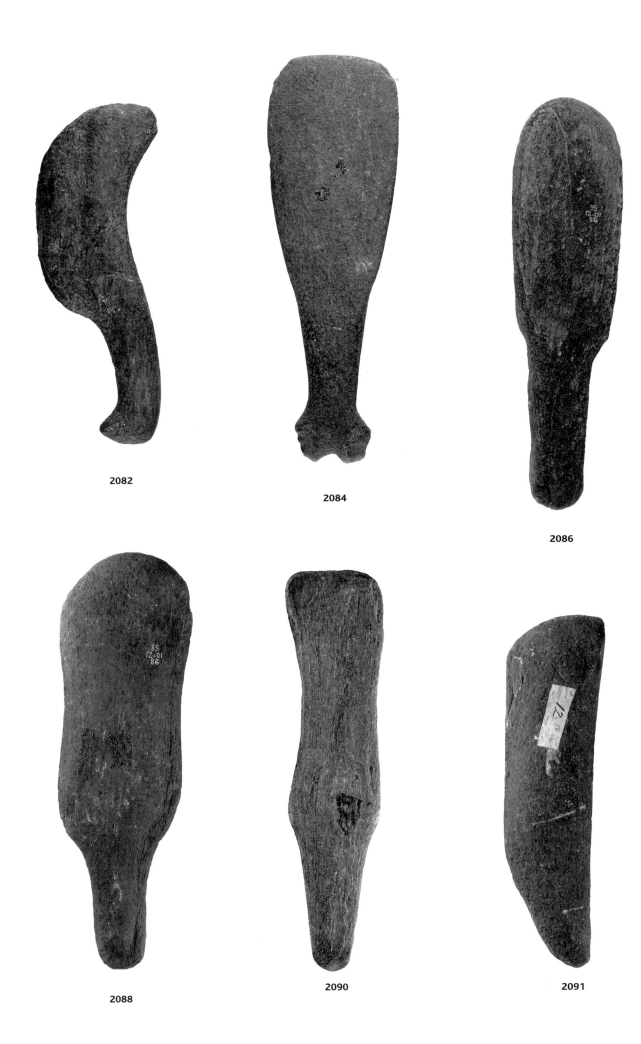

2082

2084

2086

2088

2090

2091

Plate 195 Stone clubs: *okewa* (**2082**) and *pohatu taharua* (**2084**, **2086**, **2088**, **2090**, **2091**).

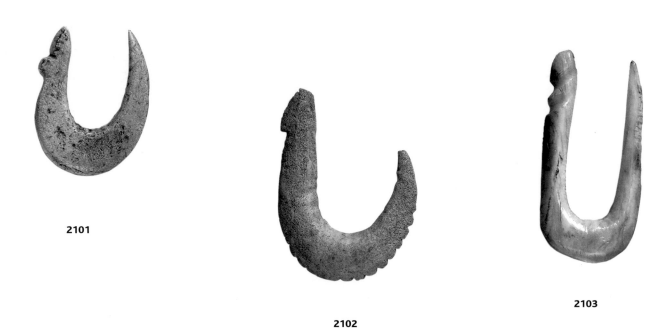

2101

2102

2103

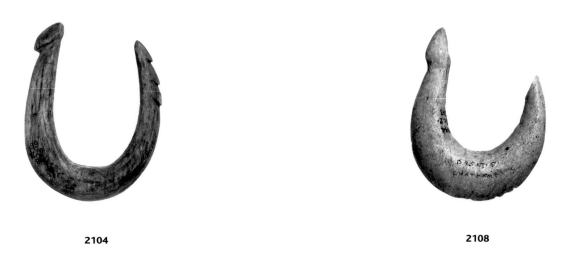

2104

2108

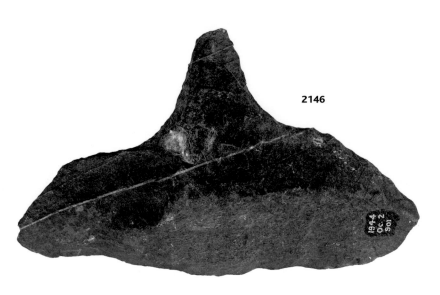

2146

Plate 196 Fish-hooks, *matau* (**2101–2104**, **2108**) and stone blubber knife, *mata* (**2146**).

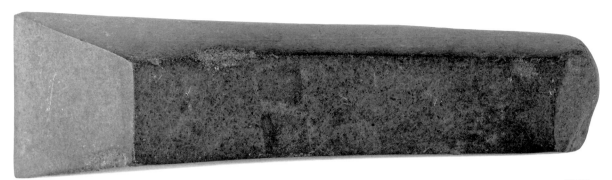

2187

2198

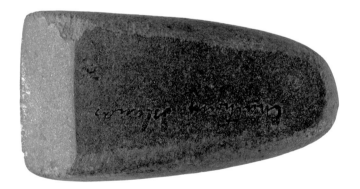

2205

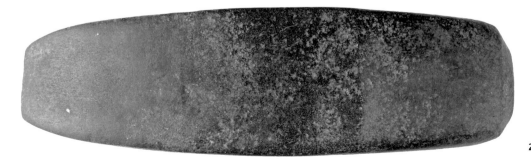

2271

Plate 197 Stone adze blades (**2187**, **2198**, **2205**, **2271**).

2272

2273

2274

2275

Plate 198 Stone adze blades (**2272–2275**).

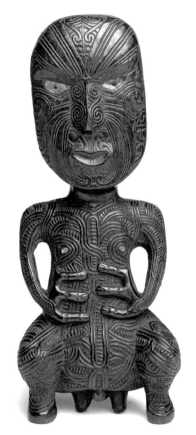

2316

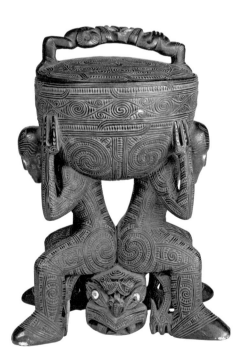

2318

Plate 199 Maori-style figure (**2316**) and bowl (**2318**).

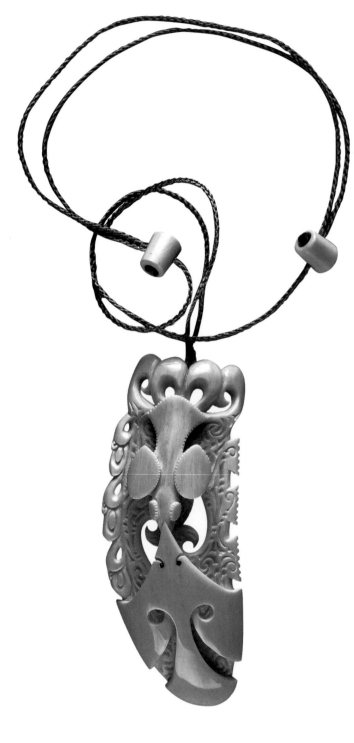

2324

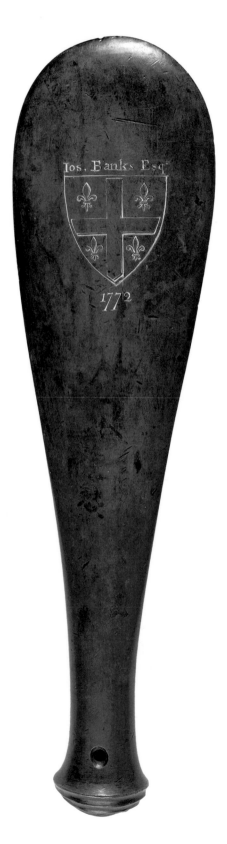

2335

Plate 200 Maori-style whale-tooth pendant (**2324**) and bronze *patu onewa*-style club (**2335**).

Meeting house diagram

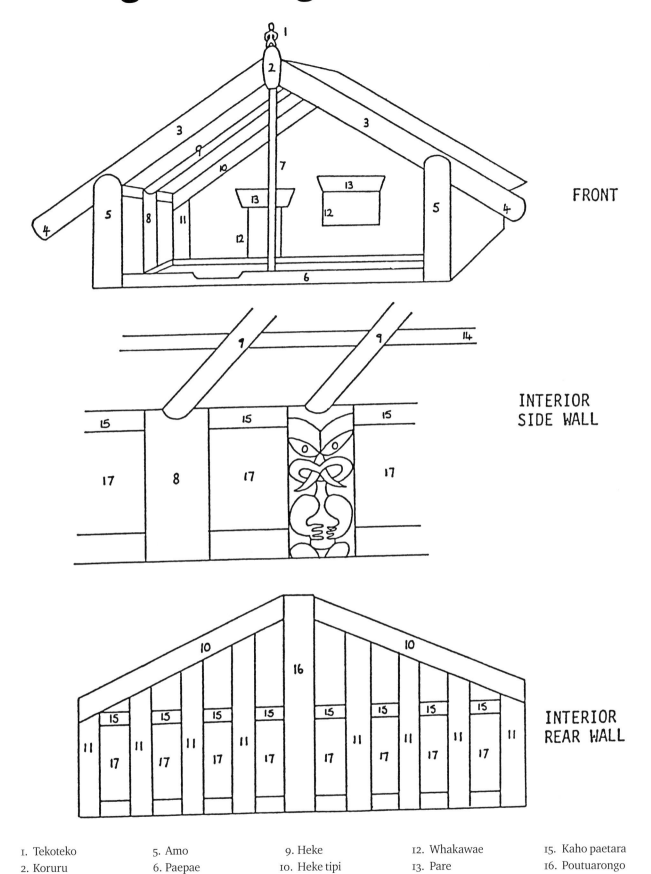

FRONT

INTERIOR SIDE WALL

INTERIOR REAR WALL

1. Tekoteko
2. Koruru
3. Maihi
4. Raparapa
5. Amo
6. Paepae
7. Poutouaroaro
8. Poupou
9. Heke
10. Heke tipi
11. Epa
12. Whakawae
13. Pare
14. Kaho
15. Kaho paetara
16. Poutuarongo
17. Tukutuku

Source: Roger Neich, 1993, *Painted Histories: Early Maori Figurative Carving*, Auckland University Press. Reproduced with permission.

Maori carving motifs

Surface patterns of wood
carving.
a *Taratara-a-kai*
b *Rauponga*
c *Pakura*
d *Unaunahi*
e *Ritorito*

Drawings by R. Jewell,
after McEwen 1966.

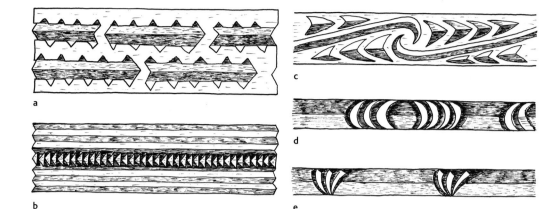

Frontal tiki and profile *manaia*
figures illustrating tribal carving
styles: **a**, **b**, **c**, central and eastern
'square' styles; **d**, **e**, **f**, northern and
western sinuous styles.
a Te Arawa
b Tuhoe
c Ngati Porou
d North Auckland
e Taranaki
f Hauraki

Drawings by R. Jewell after
McEwen 1966; Mead 1986;
Simmons 1985.

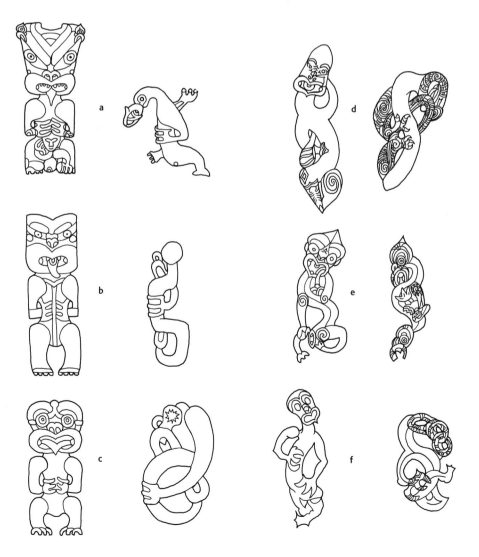

Plaiting techniques

a

b

c

d

e

Plaiting techniques (*raranga*)
a Close checkerwork: the strips pass over one, then under one; they are placed close together
b Open checkerwork: the strips pass over one, then under one; there are open gaps between them
c Close 2/2 twill: the strips pass over two, then under two; they are placed close together
d Plaited patterns are created by varying the length of the strokes
e Open, three-directional plaiting: the strips are laid in three directions and there are open gaps between them

Drawings by M. Pendergrast

Weaving techniques

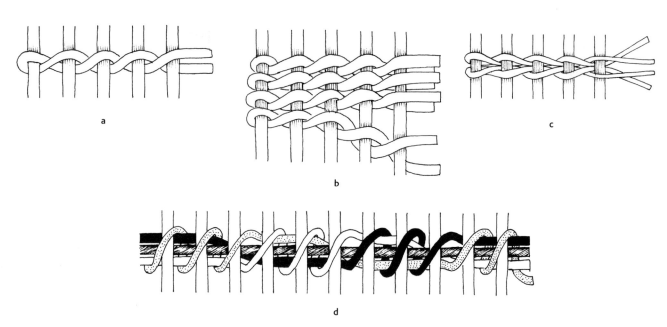

Maori cloak-weaving techniques (*whatu kakahu*)
a Single-pair twining: the weft consists of two (a pair of) threads
b Close single-pair twining: each weft is placed close to and touching the previous one
c Double-pair twining: each weft consists of four (two pairs of) threads
d *Taniko* weaving: besides the flexible coloured wefts an additional straight thread is carried behind
Drawings by M. Pendergrast

To allow the garment to fit closely and snugly, insets of additional short wefts are included. On cloaks with horizontal wefts these occur at the shoulders and buttocks, and may be grouped together
a The first short weft is made at the centre and each subsequent weft is longer than the previous one. In an alternative arrangement short wefts are interpolated between full-length warps
b The number of short wefts is decided by the artist. There are usually two groups of short wefts, one placed to accommodate the shoulders and the other for the buttocks. However, some garments may have up to five groups of short wefts. These make the cloak more concave, clinging to the body, but may also help the cloak to drape more gracefully
c On *paepaeroa* garments with vertical wefts, wedge-shaped inserts of short wefts widened towards the top and bottom of the cloak
Drawings by M. Pendergrast

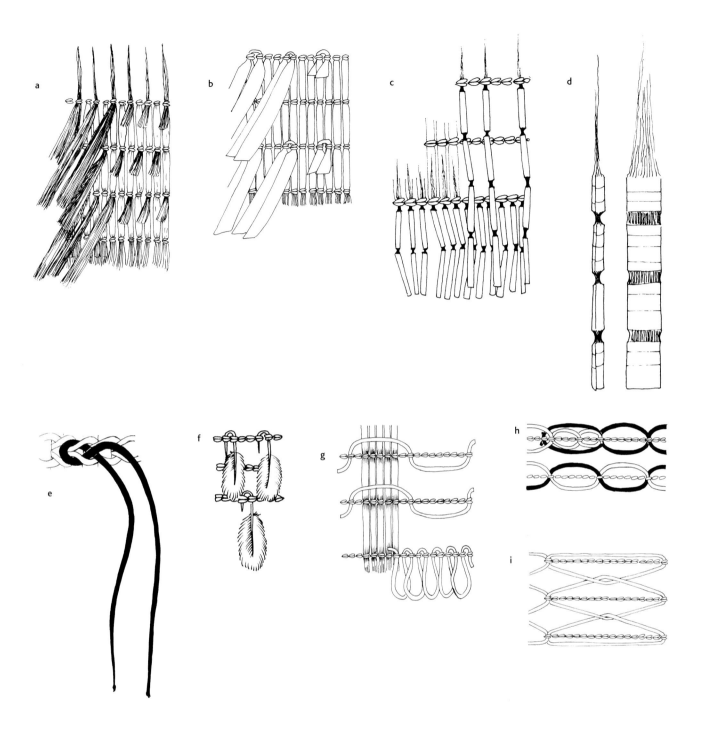

Attachment techniques

a For rain capes of the simplest type, no warps are used but bundles of roughly prepared fibre are treated as warps and twined together, and in subsequent rows similar bundles are added to form the thatch

b Alternatively, the warps may be prepared beforehand and the tags attached during the weaving of the cloth

c, d On related garments a popular tag was the *pokinikini*, similar to those used on modern *piupiu*

e, f Rain capes are related to feather cloaks and *korowai*, and the cords and feathers are attached in a similar manner

g–i Examples of the type of decoration known as *paheke*. The coloured threads are woven into the weft as the weaving progresses

Note: The attachments are shown in the position they take when the cloak is worn. To see their position during weaving, the drawings should be viewed upside down.

Drawings by M. Pendergrast

Glossary of Maori terms

Maori words included in *Oxford Dictionary of English*, 2nd edition, revised 2005, are not italicized.

aho	weft in weaving; fishing line
amo	front side-panel supporting the bargeboard of a house
Aotearoa	The Land of the Long White Cloud, Maori name for New Zealand
au ika	fish stringer
aurei	cloak pin
epa	wooden panels at front and rear of a house, with angled top to fit under the slope of the roof
haehae	smooth groove of surface pattern of wood carving
haka	posture dance
hamanu	cartridge box
hani	another name for *taiaha*
harakeke	New Zealand flax, *Phormium tenax*, plant most used in Maori fibre work
haro muka	flax scraper
hei-matau	pendant in form of fish-hook
hei-pounamu	adze-form nephrite pendant
hei-tiki	pendant in form of stylised human figure
heke	rafter
heru	comb
heru iwi/paraoa	bone/whalebone comb
hihi	long projecting wands decorated with feathers on war canoes
hihima	cloak with undyed tags
himu	palisade post
hinau	tree, *Elaeocarpus dentatus*, bark of which produces mordant used on flax and kiekie with black mud dye
hitau	flax fibre
hoe	paddle
hoeroa	long, slightly curved, staff or club of whalebone
hongi	pressing noses together, Maori greeting
hono	complicated join used in plaiting
houhi	lace bark, *Hoheria sp.*
huaki	figure at rear of canoe prow, facing into the canoe; *kaitaka* cloak with horizontal wefts and double *taniko* borders on three sides
hue	fruit of gourd
huia	wattlebird, *Heteralocha acutirostris*
hukahuka	tag attachments on cloak, either rolled cords or strips of leaf
inanga	bluish light-green nephrite
ipu	small container
kaheru	spade
kahu huruhuru	feather cloak
kahu kiwi	cloak with kiwi feathers
kahu kura	red cloak, either stained with red ochre or covered with red feathers
kahu kuri	dog-skin cloak
kahu raranga	plaited cloak
kahu toi	warrior's cloak of black-dyed fibre of *toi*, mountain cabbage tree
kaitaka	cloak of finest flax, with *taniko* border
kaka	native parrot, *Nestor meridionalis*
kaka poria	ring for tame bird
kakahu	garments, clothing
kakahu raranga	plaited garment
kakauroa	long-handled axe
kanuka	small evergreen tree, *Leptospermum ericoides/ Kunzea ericoides*

kape	*kowhaiwhai* pattern of crescent shapes containing evenly spaced circular spaces
kapeu	pendant with curved lower end
karetao	puppet
karu hapuku	eye of *hapuku* (groper fish), concentric diamond pattern used in plaiting
karure	cord with unravelled appearance; cloak decorated with such cords
karu taniwha	eye of monster, concentric diamond pattern used in plaiting
kaunoti/hika	fire plough
kaupapa	foundation, body, main surface of cloak
kauri	large tree, *Agathis australis*, used in Maori carving
kauwae ngarara	dragon's jaw, pattern used in plaiting
kawakawa	dark-green nephrite
kawe	carrying strap, to carry on back
kereru	bush pigeon, *Hemiphaga novaeseelandiae*
kete	basket or bag, plaited from strips of flax or other material
kete muka	basket or bag, woven of flax fibre
kete whakairo	basket with decorative pattern
kete whitau	basket or bag, woven of flax fibre
kiekie	climbing plant, *Ferycinetia baueriana*, used in cloak, basket and mat making
ko	digging stick
koauau	short straight flute
koeaea	type of whitebait, vertical zigzag pattern used in plaiting
kopa	basket with flap lid
kopi	tree, *Corynocarpus laevigata*
korere	feeding funnel
koropepe	spiral pendant
korowai	cloak ornamented with black rolled cords
korowai ngore	cloak with tags and pompoms
koru	*kowhaiwhai* pattern of a curving stalk with a bulb at one end
koruru	carved face at apex of bargeboard of a house
kotaha	whipsling, dart thrower
kotiate	short club, figure-of-eight shape
kowhaiwhai	abstract curvilinear painted pattern
kumara	sweet potato, *Ipomoea batatas*
kumete	bowl
kupenga	fishing net
kura	red, precious, something treasured and excellent
kuri	Polynesian dog, introduced to New Zealand by Maori
kuru	straight pendant
kurupatu	neck fringe on a cloak
kuta	a rush, *Eleocharis sphacelata*
mahe	sinker
mahiti	fine cloak with tassels of hair from *kuri*'s tail
mahitihiti	change/cross over, a technique used in plaiting
maihi	bargeboard of a house
mako	shark, shark-tooth ear pendant
mana	power, prestige, authority
manaia	an art figure in which the face and sometimes the body is shown in profile
manawa	continuous undulating line of *kowhaiwhai* design serving as a base for scroll offshoots
mangemange	*Lygodium articutaum*, a climbing fern
manuka	shrub or small tree, *Leptospermum scoparium*
manu tukutuku	kite
marae	open space in front of a meeting house
maripi	knife with inserted shark teeth

mata	large tanged flake tool of stone; blubber knife; obsidian flake
matai	tree, *Podocarpus spicatus*
matau	fish-hook
mauri	essential spirit, life force
mau taringa	ear pendant
mawhiti	cross/change over, a technique used in plaiting
mere	spatulate short club
mere pounamu	nephrite club
miro	rolled cord, also the rolling process
moko	tattoo
moko kuri	facial tattoo pattern
mokomokai	preserved human head
muka	flax fibre
mutu kaka	bird-snare perch
ngore	cloak decorated with pompoms
nguru	short flute with curved end
niho	(real) teeth pendant
niho kakere	(imitation) teeth pendant
nihoniho	teeth, triangles pattern used in plaiting
okewa	bill-hook-shaped stone club (Moriori)
oko	pigment pot
pa	fortified village
paepae	threshold beam of a house
paepaeroa	*kaitaka* cloak with vertical wefts
paepae tapu	latrine bar
paheke	cloak ornamentation of rolling and running coloured cords
paipa	tobacco pipe
pa kahawai	type of trolling fish-hook
pakati	notched ridge of *rauponga* surface pattern
pake	rain-cape
pakura	wood-carving surface pattern in which a plain spiral is extended by repeating curved or angular sections of the spiral
pakuru	pair of tapping sticks
pane	portion of the ridge-pole of a house projecting over the porch
papahou	rectangular carved container for valued items; treasure box
papakirango	fly-swat pattern used in plaiting
paraerae	footwear, plaited sandals
pare	lintel panel over door or window
paru	dense black swamp sediment used to produce black dye
pataka	raised storehouse
pataka amo	side post of a storehouse
patea	*kaitaka* cloak with wide *taniko* border along bottom and narrower ones on each side
patikitiki	pattern of series of large diamonds used in plaiting
patiti	fighting axe
patu	short thrusting club
patu aruhe	fern-root beater
patuki	short club
patu miti	stone club
patu muka	stone beater for pounding flax fibre
patu onewa	short club of stone
patu paraoa	short club of whalebone
patu rakau	short wooden club
paua	univalve iridescent shell of *Haliotis sp.*
pekapeka	bat-shaped pendant
pekerangi	cloak with spaced-out tufts of feathers
pihepihe	garment with ornamental cylindrical *pokinikini* tags
pingao	sedge, *Desmoschoenus spiralis*, with bright-yellow leaves, used in Maori plaiting
pipiwharauroa	pale silvery green nephrite, with fish-scale pattern
pitau	openwork spiral; canoe prow with openwork spirals
piupiu	flax skirt with *pokinikini* tags
pohatu taharua	short stone club (Moriori)
poi	light ball on string, swung rhythmically in song or dance
poito	fishing float
pokinikini	strips of flax leaf, which have rolled into cylinders while drying, with intervals of exposed inner fibre dyed black
poro toroa	toggle
porutu	long straight flute
potaka	spinning top
pounamu	New Zealand nephrite; the term is used more broadly to cover also bowenite (*tangiwai*) used for ornaments; often loosely translated as greenstone or jade
poupou	side-wall panel of a house
poutama	step pattern in plaiting
poutokomanawa	interior central post of a house, supporting the ridge-pole
pou whakarae/himu	palisade post
pouwhenua	long club with widening head
powaka whakairo	trinket box
puhoro	pattern of extended stalks linked with bulbs; especially used under the prow of war canoes and also as a tattoo pattern on the thighs of men
pukaea	long wooden trumpet
pukeko	swamphen, *Porphyrio porphyrio*
pukupuku	compacted single-pair twining; closely woven flax cloak
pungawerewere	spiral form of *ritorito* wood-carving surface pattern
purorohu/purerehua	bullroarer
puru	stopper
putara	plain shell trumpet
putatara	conch-shell trumpet
putea	patterned plaited basket, *kete whakairo*
putorino	trumpet flute
ra	canoe sail
rakau whakapapa	genealogical staff
rangatira	chief
rapaki	waist mat
raparapa	bargeboard end of a house
rape	spiral tattoo pattern used on the buttocks of men
raranga	plaiting technique used for making baskets and mats
raumoa	plain ridge of wood-carving surface pattern
raupo	bulrush, *Typha angustifolia*
rauponga	wood-carving surface pattern in which a notched ridge is bordered by parallel plain ridges and grooves
rehu	transverse flute
rei	pendant (Moriori)
rei puta	whale-tooth pendant, tongue-shaped
Rekohu	Moriori name for the Chatham Islands
ritorito	wood-carving surface pattern in which short curved ridges radiate across a plain groove
rou kakahi	freshwater mussel dredge
rua tahuhu	semi-subterranean storehouse
ruru	carved design of a face with circular eyes and owl-like ears
taha huahua	gourd container for preserved birds
tahuhu	ridge-pole of a house; main line of genealogy
taiaha	long staff or club used for close combat
taimana whakawhiti	crossing diamonds, pattern used in plaiting
takapau	finely patterned mat
takarangi	carved openwork spiral design
tanekaha	tree, *Phyllocladus trichomanoides*, bark of which is used to produce reddish-brown dye
tangata whenua	people of the land, original inhabitants
tangiwai	bowenite, used to make ornaments
taniko	decorative Maori weaving technique
tao	spear
taonga	possession, property, anything highly prized, particularly cultural property, treasure
taowaru	carving pattern of openwork arcades
tapu	under religious restriction, sacred
tara/makoi	bird-spear point
taratara-a-kai	wood-carving surface pattern in which a zigzag ridge runs between plain ridges
tatua	man's belt

tauihu	war canoe prow; fishing canoe prow
taumanu	thwart of a canoe
taurapa	war canoe stern-post
teka	dart; cartridge-loading pin; digging-stick step
tekoteko	carved figure on the front apex of the bargeboards of a house
tekoteko pataka	carved figure on the front apex of the bargeboards of a storehouse
tewhatewha	long club with axe-like blade
tiheru	canoe bailer
tiki	human figure form in carving
timo	grubber
tipare	headband
toetoe	tall grass, *Cortaderia sp.*
tohunga	an expert in either ritual or practical matters
tohunga ta moko	tattooing expert
tohunga whakairo	wood-carving expert
toi	mountain cabbage tree, *Cordyline indivisa*
toki	adze
toki pounamu	nephrite adze
toki poutangata	ceremonial adze
tokotoko	orator's staff; walking stick
toko wananga	staff indicating a school of learning in progress
totara	tree, *Podocarpus totara*, timber used in carving
tu	woman's belt of multiple cords
tuere	type of war canoe prow with central longitudinal panel
tui	bird, honeyeater, *Prosthemadera novaeseelandiae*
tuki taha	mouthpiece for a gourd container
tukutuku	decorative latticework panels of a house
turuturu	weaving stick
uata	bird-spear point (Moriori)
uhi	tattoo chisel
unaunahi	wood-carving surface pattern in which a series of short curved ridges cross a plain groove at spaced intervals

wahaika	short club, with crescent-shaped blade
waka	canoe; loose association of tribes
wakahuia	small oval-shaped carved container for valued items; treasure box
waka koiwi	carved container for the bones of a dead person, burial chest
waka taua	war canoe
waka tete	fishing canoe
waka tiwai	single-tree dugout canoe
weka	woodhen, *Gallirallus australis*
whakairo	ornament with a pattern
whakakaipiko	kinked pendant
whakaniho	tooth pattern
whakapakoko atua	godstick
whakapae	pattern of horizontal bands
whakapakoko rahui	human head carved in wood, set up as sign against trespassing
whakapapa	genealogy, line of descent
whakarare	variety of *rauponga* wood-carving surface pattern in which the plain ridges of one side curve across the notched ridge
whakatara	carved design of linked triangles likened to the peaks of a range of hills
whakatutu	vertical pattern in plaiting
whakawae	door jamb
whao	chisel
wharariki	mountain flax, *Phormium colensoi*
whare whakairo	carved house, meeting house
whariki	plaited sleeping or floor mat, floor covering
whatu	twining technique used to weave Maori garments
whatu aho patahi	single-pair twining
whatu aho rua	double-pair twining
whatu kakahu	cloak weaving
wheku	carved design of a face with angled sloping eyebrows meeting at the nose
whenu	warp
whitau	flax fibre

References

Alexander Turnbull Library (National Library of New Zealand, Wellington). MS papers 0037-119.

Allingham, E.G. 1924. *A Romance of the Rostrum, Being the Business Life of Henry Stevens …together with Some Account of Famous Sales….* London: H.F. & G. Witherby.

Andersen, J. C. 1934. *Maori Music: with its Polynesian Background.* New Plymouth: Polynesian Society Memoir 10.

Angas, G.F. 1847. *New Zealanders Illustrated.* London: Thomas McLean.

Anon. 1926. An unknown Maori artefact. *Journal of the Polynesian Society* 35(140): 351.

Anon. 1929. Carved Maori artifacts. *Journal of the Polynesian Society* 38: 291–2.

Anson, D. 2004. What's in a name? The house carvings that Dr Hocken gave to the Otago Museum. *Journal of the Polynesian Society* 113(1): 73–90.

Archey, G. 1933. Evolution of certain Maori carving patterns. *Journal of the Polynesian Society* 42(167): 171–90.

Archey, G. 1938. Tau rapa: the Maori canoe stern-post. *Auckland Institute and Museum Records* 12(3): 171–5.

Archey, G. 1956. Tauihu: the Maori canoe prow. *Auckland Institute and Museum Records* 4(2): 365–79.

Archey, G. 1958. Tiki and pou: free sculpture and applied. *Auckland Institute and Museum Records* 5(1–2): 93–109.

Archey, G. 1960. Pare (door lintels) of human figure composition. *Auckland Institute and Museum Records* 5(3–4): 203–14.

Archey, G. 1962. Spiral-dominated compositions in pare (door lintels). *Auckland Institute and Museum Records* 5(5–6): 271–81.

Archey, G. 1967. Maori wood sculpture: the human head and face. *Auckland Institute and Museum Records* 6(3): 229–50.

Archey, G. 1977. *Whaowhia: Maori Art and its Artists.* London, Auckland: Collins.

Barrow, T. 1959. Maori godsticks collected by the Rev. Richard Taylor. *Dominion Museum Records in Ethnology* 1(5): 183–211.

Barrow, T. 1961a. Maori godsticks in various collections. *Dominion Museum Records in Ethnology* 1(6): 212–41.

Barrow, T. 1961b. Two hei tiki-matau amulets. *Journal of the Polynesian Society* 70(3): 353.

Barrow, T. 1962. A Maori shark-tooth implement. *Journal of the Polynesian Society* 71(2): 254–5.

Barrow, T. 1969. *Maori Wood Sculpture of New Zealand.* Wellington, etc.: A.H. & A.W. Reed.

Barrow, T. 1972. *Art and Life in Polynesia.* London: Pall Mall Press.

Barrow, T. 1984. *An Illustrated Guide to Maori Art.* Auckland: Heinemann Reed.

Bate, P. 1980. Engel, Carl. *The New Grove Dictionary of Music and Musicians. London, Macmillan Publishers*, vol. 6. London: Macmillan Publishers.

Beasley, H.G. 1915. Note on a Maori feather box (waka huia). *Man* XV(94): 166–7.

Beasley, H.G. 1919. A Maori food bowl 'kumete'. *Man* XIX(36): 70.

Beasley, H.G. 1924. Perches for tame parrots, pae-kuku. *Man* XXIV(50): 65–6.

Beasley, H.G. 1927. Metal mere. *Journal of the Polynesian Society* 36(143): 297–8.

Beasley, H.G. 1928. *Pacific Islands Records: Fish Hooks.* London: Seeley, Service & Co. Ltd.

Beasley, H.G. 1934. An unusual fern-root beater. *Journal of the Polynesian Society* 43(172): 294–5.

Beasley, H.G. 1935a. Two well-worked waka-huia (feather boxes) from New Zealand. *Journal of the Polynesian Society* 44(175): 189.

Beasley, H.G. 1935b. Weaving-peg, turuturu. *Journal of the Polynesian Society* 44(173): 65.

Beasley, H.G. 1935c. Whalebone wahaika with secondary figure. *Journal of the Polynesian Society* 44(173): 65.

Beasley, H.G. 1938. New Zealand: wooden bowls. *Ethnologia Cranmorensis* 3: 14–18.

Beasley, H.G. and Editors. 1929. Carved Maori artefacts. *Journal of the Polynesian Society* 38(152): 291–2.

Best, E. 1918. The land of Tara and they who settled it. Part V. *Journal of the Polynesian Society* 27(108): 165–77.

Best. E. 1924. *The Maori.* 2 vols. Wellington: Polynesian Society Memoir 5.

Best, E. 1925a. *Games and Pastimes of the Maori.* Wellington: Dominion Museum Bulletin 8.

Best, E. 1925b. *The Maori Canoe.* Wellington: Dominion Museum Bulletin 7.

Bidwell, S. 1991. The Royal United Services Institute for Defence Studies 1831–1991. *RUSI Journal* Summer 1991: 69–72.

Binney, J. 1995. *Redemption Songs. A Life of Te Kooti Arikirangi Te Turuki.* Auckland: Auckland University Press/Bridget Williams Books.

Blackman, M. 1998. The weft-twined structures of cloaks of the New Zealand Maori. *Creating Textiles: Makers, Methods and Markets. Proceedings of the Sixth Biennial Symposium of the Textile Society of America, Inc., New York 1998.* Earleville, Md: Textile Society of America Inc.

Bragge, W. 1880. *Bibliotheca Nicotiana; a Catalogue of Books about Tobacco Together with a Catalogue of Objects Connected with the Use of Tobacco in All its Forms.* Birmingham: Privately printed.

Braunholtz, H.J. 1952. The Beasley Collection. *British Museum Quarterly* 15: 103.

Brees, S.C. 1847. *Pictorial Illustrations of New Zealand.* London: John Williams & Co.

Brees, S.C. 1850. *Guide and Description of the Panorama of New Zealand: Illustrating the Country, Habits of the Colonists, Public Buildings, Farms and Clearings, Customs of the Natives, Pa's, Habitations, Canoes etc. and Life in the Colony and in the Bush.* London: Savill and Edwards.

British Museum. 1808–1903. *Synopsis of the Contents of the British Museum* (later *Guide to the Exhibition Rooms*). Various edns. London: British Museum.

British Museum. 1868. *Guide to the Christy Collection of Prehistoric Antiquities and Ethnography* [prepared by A.W. Franks]. London: British Museum.

British Museum. 1925. *Handbook to the Ethnographical Collections.* 2nd edn. London: British Museum.

Buller, W.L. 1893. Note on a remarkable Maori implement in the Hunterian Museum at Glasgow. *Transactions and Proceedings of the New Zealand Institute* 26: 570–2.

Bywaters, J. 1987. The Wellcome numbering system. *Museum Ethnographers Group Newsletter* 20: 46–53.

Campbell, W.L. 1862–3, 1866–74. Journal. Vols 1–3, 6–12. Private collection.

Canterbury Museum, Christchurch. Manuscripts Collection. Diary of Frederick Huth Meinertzhagen. ARC 1998.4.1: 2 April – 11 May 1867; 2: 12 May – 30 June 1867; 3: 2 July – 5 September 1867; 4: 27 March – 27 May 1869? [1874].

Capistrano. F. 1989. Ritual mutilation of power objects. The case of some Maori feather boxes. *Res* 17/18: 54–67.

Caygill, M. 1981. *The Story of the British Museum.* London: British Museum Publications Ltd.

Caygill, M. and J. Cherry. 1997. *A.W. Franks: Nineteenth-century Collecting and the British Museum.* London: British Museum Press.

Chadwick, N.K. 1931. The kite: a study in Polynesian tradition. *Journal of the Royal Anthropological Institute of Great Britain and Ireland* 61: 455–91.

Christy, H. 1862. *Catalogue of a Collection of Ancient and Modern Stone Implements and of Other Weapons, Tools, and Utensils of the Aborigines of Various Countries, in the Possession of Henry Christy, F.G.S., F.L.S. etc.* [arranged by M. Steinhauer]. London: Taylor and Francis, for private distribution.

Coote, J. 2008. Joseph Banks's forty brass patus. *Journal of Museum Ethnography* 20: 49–68.

Cranstone, B.A.L. 1952. An ancient Maori bone-chest. *British Museum Quarterly* 17(3): 58–9.

Davidson, J. 1996. Maori prehistory. In D.C. Starzecka (ed.) *Maori: Art and Culture.* London: British Museum Press.

Davis, C.L.B. 1855. *Maori Mementos; Being a Series of Addresses, Presented by the Native People, to His Excellency Sir George Grey, K.C.B., F.R.S. Governor and High Commissioner of the Cape of Good Hope, and Late Governor of New Zealand; with Introductory Remarks and Explanatory Notes, to Which is Added a Small Collection of Laments etc.* Auckland: Williamson and Wilson.

Davis, T. 1951. *John Fowler and the Business He Founded.* Privately printed.

Dennan, R. 1968. *Guide Rangi of Rotorua.* Wellington: Whitcombe & Tombs.

Duff, R.S. 1956. *The Moa-hunter Period of Maori Culture.* 2nd edn. Wellington: Government Printer.

Duff, R.S. 1969. *No Sort of Iron: Culture of Cook's Polynesians.* Christchurch: Art Galleries and Museums Association of New Zealand.

Edge-Partington, J. 1883. *Random Rot. A Journal of Three Years' Wanderings about the World.* Altrincham: Printed at the *Guardian* office, for private distribution.

Edge-Partington, J. 1899a. New Zealand kotahas or whip-slings, for throwing darts, in the British Museum. *Journal of the Anthropological Institute of Great Britain and Ireland* 29: 304–5.

Edge-Partington, J. 1899b. [Mistakenly attributed to C.H. Read] Note on a carved canoe head from New Zealand. *Journal of the Anthropological Institute of Great Britain and Ireland* 29: 305.

Edge-Partington, J. 1899c. Note on a stone battle-axe from New Zealand. *Journal of the Anthropological Institute of Great Britain and Ireland* 29: 305–6.

Edge-Partington, J. 1899d. Extracts from the Diary of Dr Samwell. *Journal of the Polynesian Society* 8: 250–63.

Edge-Partington, J. 1900a. New Zealand: cf. J.A.I. XXIX (N.S. II), 304–6. *Journal of the Anthropological Institute of Great Britain and Ireland* 30: Anthropological Reviews and Miscellanea 42: 35.

Edge-Partington, J. 1900b. New Zealand: Maori scroll patterns. *Journal of the Anthropological Institute of Great Britain and Ireland* 30: Anthropological Reviews and Miscellanea 41: 35.

Edge-Partington, J. 1900c. New Zealand: pataka. *Journal of the Anthropological Institute of Great Britain and Ireland* 30: Anthropological Reviews and Miscellanea 40: 34–5.

Edge-Partington, J. 1901a. Note on the Matuatonga in the Art Gallery, Auckland, New Zealand. *Man* I(30): 38–40.

Edge-Partington, J. 1901b. New Zealand: forgeries. *Man* I(92): 116.

Edge-Partington. J. 1901c. Review of 'The Long White Cloud' by William Pember Reeves. *Man* I(98): 119–21.

Edge-Partington, J. 1902. Ancient Maori houses: their use and abuse. *Man* II(99):137–8.

Edge-Partington, J. 1903a. Maori scroll pattern. *Man* III(21):40–1.

Edge-Partington, J. 1903b. A New Zealand flageolet. *Man* III(106): 186.

Edge-Partington, J. 1906. Note on the Maori canoe bailer described by H. St. George Grey in *Man*, 1906.5. *Man* VI(13): 24.

Edge Partington, J. 1907. A New Zealand box (waka). *Man* VII(23): 33.

Edge-Partington, J. 1909a. Maori forgeries. *Man* IX(31): 56.

Edge-Partington, J. 1909b. Maori burial chests (atamira or tupa-pakau). *Man* IX(18): 36–7.

Edge-Partington, J. 1910. Maori forgeries. *Man* X(31): 54–5.

Edge-Partington, J. 1913. An unusual form of tiki. *Man* XIII(98): 172.

Edge-Partington, J. 1915. Feather box (1907–23). *Man* XV(66):.121–2.

Edge-Partington, J. and C. Heape. 1969. *An Album of the Weapons, Tools, Ornaments, Articles of Dress of the Natives of the Pacific Islands.* 2 vols. London: Holland Press. Facsimile edition of original 3 series in 4 vols, Manchester, issued for Private Circulation, 1890, 1895, 1898.

Fagg, W. (ed.) 1970. *Sir Hans Sloane and Ethnography.* London: Trustees of the British Museum.

Firth, R. 1931. Maori canoe-sail in the British Museum. *Journal of the Polynesian Society* 40(159): 129–35.

Fletcher, H.J. 1913. Ngahue's ear-drop. *Journal of the Polynesian Society* 22(88): 228–9.

Force, R.W. and M. Force. 1968. *Art and Artifacts of the 18th Century: Objects in the Leverian Museum as painted by Sarah Stone.* Honolulu: Bishop Museum Press.

Force, R.W. and M. Force. 1971. *The Fuller Collection of Pacific Artifacts.* London: Lund Humphries.

Ford, J.B. n.d. *A Brief Essay on the History of Maori Art.* Wellington, Te Waka Toi – Council for Maori and South Pacific Arts.

Fox. A. 1983. *Carved Maori Burial Chests: A Commentary and a Catalogue.* Auckland Institute and Museum Bulletin 13.

Franks, A.W. 1997 [1893]. The Apology of my Life. In M. Caygill and J. Cherry (eds) *A.W. Franks: Nineteenth-century Collecting and the British Museum.* London: British Museum Press.

Fraser, D.W. 1989. *A Guide to Weft Twining, and Related Structures with Interacting Wefts.* Philadelphia: University of Philadelphia Press.

Gathercole, P. 1979. Changing attitudes to the study of Maori carving. In S.M. Mead (ed.) *Exploring the Visual Art of Oceania.* Honolulu: University Press of Hawaii.

Gathercole, P. and A. Clarke. 1979. *Survey of Oceanian Collection in the United Kingdom and the Irish Republic.* Paris: UNESCO.

Gathercole, P., A. L. Kaeppler and D. Newton. 1979. *The Art of the Pacific Islands.* Washington: National Gallery of Art.

Grant, S. 1977. *Waimarama.* Palmerston North: Dunmore Press.

Haddon, A.C. and J. Hornell. 1936 [1975]. *Canoes of Oceania.* Vol. 1. Honolulu: Bishop Museum Press. Bernice P. Bishop Museum Special Publication 27.

Hamilton, A. 1901. *Maori Art: The Art Workmanship of the Maori Race in New Zealand.* Dunedin: Fergusson and Mitchell for the New Zealand Institute.

Hamilton, A. 1909. On some armour presented to Titore, a Nga Puhi Chief, by H.M. William IV in 1835. *Transactions of the New Zealand Institute* 42: 40–6.

Hanson, A. and L. Hanson. 1990. The eye of the beholder: a short history of the study of Maori art. In A. Hanson and L. Hanson (eds) *Art and Identity in Oceania.* Honolulu: University of Hawaii Press.

Hanson, L. and F.A. Hanson. 1984. *The Art of Oceania: a Bibliography.* Boston, Mass.: Hall and Co.

Harding, J.R. 1957. A carved pumice head from New Zealand. *Man* LVII(119): 99–101.

Hasell, J. 2004a. From our archives: an overview of 19th- and early-20th century correspondence relating to ethnographic collections in the British Museum. *Journal of Museum Ethnography* 16: 122–6.

Hasell, J. 2004b. 'Trophies of Christianity': a history of the Polynesian collections of the London Missionary Society in the British Museum. Unpublished paper presented during the conference 'Polynesian collections: interpretations of the past in the present' at the Sainsbury Research Unit, University of East Anglia, 14–15 May 2004.

Hooper, S. 2006. *Pacific Encounters: Art & Divinity in Polynesia 1760 – 1860.* London: British Museum Press.

Idiens, D. 1982. *Pacific Art.* Edinburgh: Royal Scottish Museum Studies.

Imperial Institute. 1902. *Catalogue of the Gifts and Addresses Received by Their Royal Highnesses the Duke and Duchess of Cornwall and York During Their Visit to the King's Dominions Beyond the Seas, 1901.* London: William Clowes & Sons Ltd.

James, R.R. 1994. *Henry Wellcome.* London: Hodder and Stoughton.

Jessop, L. 2003. The exotic artefacts from George Allan's Museum, and other 18th century collections surviving in the Hancock Museum, Newcastle upon Tyne. *Transactions of the Natural History Society of Northumbria* 63(3): 89–166.

Jones, M. 1990. *Fake? The Art of Deception.* London: British Museum Publications.

Joppien, R. and B. Smith. 1985. *The Art of Captain Cook's Voyages.* Vol. I. *The Voyage of the Endeavour 1768–1771.* New Haven and London: Yale University Press.

Joyce, T.A. 1906. Note on a very unusual from of 'tiki'. *Man* VI(53): 81.

J[oyce], T.A. 1928. Maori wood-carvings. *British Museum Quarterly* 2(4): 103–4.

Joyce, T.A. 1936. A cast bronze mere from New Zealand. *British Museum Quarterly* 10(4): 174–5.

Kaeppler, A.L. 1978. *Artificial Curiosities.* Honolulu: Bishop Museum Press. Bernice P. Bishop Museum Special Publication 65.

Kaeppler, A.L. 1979. Tracing the history of Hawaiian Cook voyage artefacts in the Museum of Mankind. In T.C. Mitchell (ed.). *Captain Cook and the South Pacific,* pp. 167–186. London: British Museum (British Museum Yearbook 3).

Keyes, I.W. 1973. Ornamented composite adze hafts from the Taranaki District; with a discussion of adze haft styles in New Zealand. *Dominion Museum Records in Ethnology* 2(11): 113–32.

Keys, I.W. 1976. The ceremonial bone-fork: a little-known artefact type. *New Zealand Archaeological Association Newsletter* 19(4): 163–77.

Keys, I.W. 1980. Supplementary records of ceremonial bone forks. *New Zealand Archaeological Association Newsletter* 23(1): 38–45.

King, J.C.H. 1981. *Artificial Curiosities from the Northwest Coast of America.* London: British Museum Publications Ltd.

King, J.C.H. 1997. Franks and ethnography. In M. Caygill and J. Cherry (eds) *A.W. Franks: Nineteenth-century Collecting and the British Museum*. London: British Museum Press.

Leach, H.M. 1972. A hundred years of Otago archaeology: a critical review. *Records of the Otago Museum, Anthropology* 6: 1–19.

Legge, C.C. and E. Nash. 1969. James Edward Little – dealer in savage weapons, curios, horns, ivory etc.: an object lesson. *Field Museum of Natural History Bulletin* 40: 10–12.

Liversidge, A. 1894. Notes on some Australasian and other stone implements. *Journal of the Royal Society of New South Wales* 28: 232–45.

Lloyd, C. and J.L.S. Coulter. 1963. *Medicine and the Navy: 1200–1900*. Vol. 4, 1815–1900. Edinburgh and London: E&C Livingstone Ltd.

Loughnan, R.A. 1902. *Royalty in New Zealand: the Visit of Their Royal Highnesses the Duke and Duchess of Cornwall and York to New Zealand, 10th to 27th June, 1901*. Wellington: Government Printer.

McDougall, R. and J. Croft. 2005. Henry Ling Roth's and George Kingsley Roth's Pacific anthropology. *Journal of Pacific History* 40(2): 149–70.

McEwan, J.M. 1966. Maori art. In A.H. McLintock (ed.) *An Encyclopaedia of New Zealand*.

McLintock, A.H. 1966. *An Encyclopaedia of New Zealand*. 3 vols. Wellington: Government Printer.

Makereti, P. (Maggie Papakura). 1986. *The Old Time Maori*. With an introduction by Ngahuia Te Awekotuku. Auckland: New Women's Press; originally published 1938.

Malcolm, J.P. 1803. *Londinium Redivivum; or, an Antient History and Modern Description of London*. Vol. 2. London: J. Nichols and Son.

Maysmor, B. 1990. *Te Manu Tukutuku: A Study of the Maori Kite*. Wellington, London, etc.: Allen & Unwin.

Mead, S.M. 1986. *Te Toi Whakairo: The Art of Maori Carving*. Auckland: Reed Methuen.

Meinertzhagen, F. 1879. Notes and Description of a possibly new Species of *Aplysia. Transactions and Proceedings of the New Zealand Institute* XII: 270–1

Meinertzhagen, R. 1964. *Diary of a Black Sheep*. Edinburgh and London: Oliver & Boyd.

Miller, E. 1973. *That Noble Cabinet*. London: Andre Deutsch.

Mitchell Library (State Library of New South Wales), Sydney. William Strutt: autobiography and other papers 1778–1955. ML MS 867.

Montgomery, J. 1831. *Journal of Voyages and Travels by the Rev. Daniel Tyerman and George Bennet, Esq. Deputed from the London Missionary Society, to Visit Their Various Stations in the South Sea Islands, China, India, etc., Between the Years 1821 and 1829*. 2 vols. London: Frederick Westley and A.H. Davis.

Moschner, I. 1958. Katalog der Neuseeland-Sammlung (A. Reischek), Wien. *Archiv fur Volkerkunde* 13: 51–131.

Myres, J.L. 1902. Notes on the Ethnographical Collections of the Royal Museum, Peel Park, Salford. *Man* 2(28): 37–8.

National Archives, Kew, London. CO 406/14 f.67v.

Neich, R. 1990. The Maori carving art of Tene Waitere, traditionalist and innovator. *Art New Zealand* 57: 73–9.

Neich, R. 1991. Jacob William Heberley of Wellington: a Maori carver in a changed world. *Auckland Institute and Museum Records* 28: 69–148.

Neich, R. 1993. *Painted Histories: Early Maori Figurative Carving*. Auckland: Auckland University Press.

Neich, R. 1996a. Carved entrances of Maori semi-subterranean storehouses. *Auckland Institute and Museum Records* 33: 79–109.

Neich, R. 1996b. Wood Carving. In D.C. Starzecka (ed.) *Maori: Art and Culture*. London: British Museum Press.

Neich, R. 2001. *Carved Histories: Rotorua Ngati Tarawhai Woodcarving*. Auckland: Auckland University Press.

Neich, R. 2004. Nineteenth to mid-twentieth century individual Maori woodcarvers and their known works. *Auckland Museum Records* 41: 53–86.

Neich, R. 2005. Powaka whakairo: a third form of Maori treasure box. *Auckland Museum Records* 42: 49–66.

Neich, R. 2009. James Edge-Partington (1854–1930): an ethnologist of independent means. *Records of the Auckland Museum* 46: 57–110.

Newell, J. 2003. Irresistible objects: collecting in the Pacific and Australia in the reign of George III. In K. Sloan and A. Burnett (eds) *Enlightment: Discovering the World in the Eighteenth Century*. London: British Museum Press.

Newell, J. 2005. Exotic possessions: Polynesians and their eighteenth-century collecting. *Journal of Museum Ethnography* 17: 75–88.

Newell, J. 2006. The Maori 'Birdman' kite at the British Museum. *Pacific Arts* 1: 36–43.

Nicholas, D. and Kaa, K. 1986. *Seven Maori Artists*. Wellington: V.R. Ward, Government Printer.

Oldman, W.O. 2004. *The Oldman Collection of Maori Artifacts*. New Edition of Polynesian Society Memoir 14. Auckland: Polynesian Society.

Orange, C. 1987 [reprinted 1989]. *The Treaty of Waitangi*. Wellington: Allen and Unwin.

Parkinson, S. 1773. *A Journal of a Voyage to the South Seas in His Majesty's Ship The Endeavour*. London: Printed for Stanfield Parkinson the Editor.

Partington, W.H.T. 2003. *Te Awa: Partington's Photographs of Whanganui Maori*. Auckland: Random House.

Pendergrast, M. 1996. The fibre arts. In D.C. Starzecka (ed.) *Maori: Art and Culture*. London: British Museum Press.

Pendergrast, K. 1998. The fibre arts. In D.C. Starzecka (ed.) *Maori: Art and Culture*. 2nd edn. London: British Museum Press.

Phelps, S. 1976. *Art and Artefacts of the Pacific, Africa and the Americas: The James Hooper Collection*. London: Hutchinson.

Phillipps, W.J. 1944. Carved Maori houses of the Eastern District of the North Island. *Dominion Museum Records* 1(2): 69–119.

Phillipps, W.J. 1955. Notes with illustrations of Maori material culture. *Dominion Museum Records in Ethnology* 1(4): 123–82.

Phillips, L. 2004. An investigation into the life of A.D. Passmore, 'a most curious specimen'. *Wiltshire Archaeological and Natural History Magazine* 97: 273–92.

Pitt-Rivers, G. 1924. A visit to a Maori village. Being some observations on the passing of the Maori race and the decay of Maori culture. *Journal of the Polynesian Society* 33(129): 48–65.

Pitt-Rivers, G. 1927. *The Clash of Culture and the Contact of Races*. London: Routledge and Sons.

Pole, L.M. 1988. The Pacific. In J. Mack (ed.) *Ethnic Jewellery*. London: British Museum Publications.

Praetorius, C.J. 1900. Maori wood carving. *The Studio* 21(91): 15–21.

Praetorius, C.J. 1901. Maori houses. *The Studio* 22(95): 18–26.

Read, C.H. 1910. Enrico Hillyer Giglioli: Born June 13 1845; died December 16, 1909. *Man* 10(7):17.

Riegl, A. 1890. Neuseelandische Ornamentik. *Mitteilungen der Anthropologischen Gesellschaft* 20: 84–7.

Robley, H.G. 1896. *Moko: or Maori Tattooing*. London: Chapman and Hall.

Robley, H.G. 1915. *Pounamu, Notes on New Zealand Greenstone*. London: T.J.S. Guilford and Co.

Roth, H.L. 1901. Maori tatu and moko. *Journal of the Anthropological Institute of Great Britain and Ireland* 31: 29–64.

Roth, H.L. 1979. *The Maori Mantle*. Bedford: Carlton. Facsimile reprint of 1923 edition.

Royal Anthropological Institute of Great Britain and Ireland, London. Archives. Diaries of Captain J.P. Luce. MS 208.

Royal Archives. Windsor Castle. Diary of King George V.

Rudler, F.W. 1901. Obituary: Peek. *Man* 1(96): 118–19.

Russell, G. 1987. The Wellcome Historical Medical Museum's dispersal of non-medical material, 1936–1983. *Museum Ethnographers Group Newsletter* 20: 21–45.

Ryden, S. 1963. *The Banks Collection: An Episode in 18th-century Anglo-Swedish Relations*. Stockholm: Ethnographical Museum of Sweden Monograph Series, Publication No .8.

Simmons, D.R. 1981. Stability and change in the material culture of Queen Charlotte Sound in the 18th century. *Auckland Institute and Museum Records* 18: 1–61.

Simmons, D.R. 1985. *Whakairo: Maori Tribal Art*. Auckland, Oxford, etc.: Oxford University Press.

Simmons, D.R. 1986a. *Iconography of New Zealand Maori Religion*. Leiden: E.J. Brill.

Simmons, D.R. 1986b. *Ta Moko: the Art of Maori Tattoo*. Auckland: Reed Methuen.

Simmons, D.R. 1996. Draft catalogue of Maori material in English museums. Vol. I. British Museum, London. Prepared from records made in 1978, compiled in 1996 in Auckland. Photocopied typescript.

Simmons, D.R. 1997. *The Whare Runanga: The Maori Meeting House*. Auckland: Reed.

Simmons, D.R. 2001. *The Carved Pare: A Maori Mirror of the Universe*. Wellington: Huia Publishers.

Simmons, D.R. and Te Riria. 1983. Whakapakoko rakau: godsticks. *Auckland Institute and Museum Records* 20: 123–45.

Simpson, W.J.S. 1899. *Memoir of the Rev. W. Sparrow Simpson*. London: Longman, Green and Co.

Skelton, J. 1830. *Engraved Illustrations of Antient Arms and Armour, from the Collection of Llewelyn Meyrick at Goodrich Court, Herefordshire, after the Drawings and with the Descriptions of Dr Meyrick*. 2 vols. London: G. Schulze.

Skinner, H.D. 1916. Maori necklace and pendants of human and imitation teeth. *Man* XVI(80): 129–30.

Skinner, H.D. 1917. Maori and other Polynesian material in British museums. *Journal of the Polynesian Society* 26(103): 134–7.

Skinner, H.D. 1919. A Maori stone axe. *Journal of the Polynesian Society* 28(112): 240–1.

Skinner, H.D. 1923. *The Morioris of Chatham Islands*. Honolulu: Bernice P. Bishop Museum Memoir 9 (1).

Skinner, H.D. 1932. Maori amulets in stone, bone, and shell. *Journal of the Polynesian Society* 41(163): 202–19.

Skinner, H.D. 1933. Maori amulets in stone, bone, and shell. *Journal of the Polynesian Society* 42(167): 191–203.

Skinner, H.D. 1966. *The Maori Hei-tiki*. 2nd edn. Dunedin: Otago Museum.

Skinner, H.D. 1974. *Comparatively Speaking: Studies in Pacific Material Culture 1921–1972*. Dunedin: University of Otago Press.

Smith, S.P. 1913. Ngahue's ear-drop. *Journal of the Polynesian Society* 22(87): 167.

Starzecka, D.C. 1979. New Zealand. In H. Cobbe (ed.) *Cooks's Voyages and Peoples of the Pacific*. London: British Museum Publications.

Starzecka, D.C. 1996. The Maori collections in the British Museum. In D.C. Starzecka (ed.) *Maori: Art and Culture*. London: British Museum Press.

Starzecka, D.C. 1998. The Maori collections in the British Museum. In D.C. Starzecka (ed.) *Maori: Art and Culture*, 2nd edn. London: British Museum Press.

Symons, J. 1987. The Development of the Wellcome Collection. *Museum Ethnographers Group Newsletter* 20: 1–20.

Te Awekotuku, N. 1996. Maori: people and culture, In D.C. Starzecka (ed.) *Maori: Art and Culture*. London: British Museum Press.

Te Rangi Hiroa (P. H. Buck). 1931. Maori canoe-sail in the British Museum. Additional notes. *Journal of the Polynesian Society* 40(159): 136–40.

Te Rangi Hiroa (P. H. Buck). 1950. *The Coming of the Maori*. 2nd edn, reprinted 1974. Wellington: Whitcombe and Tombs.

Te Riria, K. and D. Simmons, 1989. *Maori Tattoo*. Auckland: The Bush Press.

Te Riria, K. and D. Simmons. 1999. *Moko Rangatira: Maori Tattoo*. Auckland: Reed.

Tregenza, J. 1980. *George French Angas: Artist, Traveller and Naturalist 1822–1886*. Adelaide: Art Gallery Board of South Australia.

Trotter, M.M. 1956. Maori shank barbed fish-hooks. *Journal of the Polynesian Society* 65(3): 245–52.

Waterfield, H. and J.C.H. King. 2006. *Provenance: Twelve Collectors of Ethnographic Art in England 1760–1990*. Paris: Somogy editions d'art.

Webster, K.A. 1948. *The Armytage Collection of Maori Jade*. London: Cable Press.

Wilson, D.M. 1984. *The Forgotten Collector: Augustus Wollaston Franks of the British Museum*. London: Thames and Hudson.

Wilson, D.M. 2002. *The British Museum: A History*. London: British Museum Press.

Williams, J.W. 1898. Notes on the Chatham Islands. *Journal of the Anthropological Institute of Great Britain and Ireland* 27: 343–5.

Williams, H.W. 1975. *A Dictionary of the Maori Language*. Reprint of 7th edn. 1971. Wellington: Government Printer.

Wood, J.G. 1868–1870. *The Natural History of Man, Being an Account of the Manners and Customs of the Uncivilized Races of Men. Australia, New Zealand, Polynesia, America, Asia and Ancient Europe*. London: G. Routledge and Sons.

Woroncow, B. 1981. George Bennet: 1775–1841. *Museum Ethnographers' Group Newsletter* 12: 45–58.

Yate, W. 1835. *An Account of New Zealand and of the Formation and Progress of the Church Missionary Society's Mission in the Northern Island*. London: R.B. Seeley and W. Burnside.

Index of persons

Page numbers are set in normal type; catalogue numbers are set in **bold** type. See also Index of Collections.

Index of tribal names

Page numbers are set in normal type; catalogue numbers are set in **bold** type.

Index of places

Index of collections

Index of institutions